DATE DUE

PRINTED IN U.S.A.

Children's
Literature
Review

Guide to Gale Literary Criticism Series

When you need to review criticism of literary works, these are the Gale series to use:

If the author's death date is: **You should turn to:**

After Dec. 31, 1959
(or author is still living)

CONTEMPORARY LITERARY CRITICISM

for example: Jorge Luis Borges, Anthony Burgess,
William Faulkner, Mary Gordon,
Ernest Hemingway, Iris Murdoch

1900 through 1959

TWENTIETH-CENTURY LITERARY CRITICISM

for example: Willa Cather, F. Scott Fitzgerald,
Henry James, Mark Twain, Virginia Woolf

1800 through 1899

NINETEENTH-CENTURY LITERATURE CRITICISM

for example: Fedor Dostoevski, George Sand,
Gerard Manley Hopkins, Emily Dickinson

1400 through 1799

LITERATURE CRITICISM FROM 1400 TO 1800
(excluding Shakespeare)

for example: Anne Bradstreet, Pierre Corneille,
Daniel Defoe, Alexander Pope,
Jonathan Swift, Phillis Wheatley

SHAKESPEAREAN CRITICISM

Shakespeare's plays and poetry

Gale also publishes related criticism series:

CONTEMPORARY ISSUES CRITICISM

Presents criticism on contemporary authors writing
on current issues. Topics covered include the social
sciences, philosophy, economics, natural science, law,
and related areas.

CHILDREN'S LITERATURE REVIEW

Covers authors of all eras. Presents criticism on
authors and author/illustrators who write for the
preschool to junior-high audience.

ISSN 0362-4145

volume 7

Children's Literature Review

Excerpts from Reviews,
Criticism, and Commentary
on Books for Children

Guest Essay, " 'The Same, Only Different': Canadian Children's
Literature in a North American Context,"
by Sheila A. Egoff

Gerard J. Senick
Editor

Gale Research Company
Book Tower
Detroit, Michigan 48226

STAFF

Gerard J. Senick, *Editor*

Susan Miller Harig, Melissa Reiff Hug, *Senior Assistant Editors*

Jeanne A. Gough, Sandra Liddell, *Assistant Editors*

Phyllis Carmel Mendelson, *Contributing Editor*

Robert J. Elster, Jr., *Production Supervisor*
Lizbeth A. Purdy, *Production Coordinator*
Denise Michlewicz, *Assistant Production Coordinator*
Eric Berger, Paula J. DiSante, Amy Marcaccio, *Editorial Assistants*

Karen Rae Forsyth, *Research Coordinator*
Jeannine Schiffman Davidson, *Assistant Research Coordinator*
Zinell Bridgette Beard, Kevin John Campbell, Victoria B. Cariappa,
Robert J. Hill, Harry Kronick, Rebecca Nicholaides, Pamela Rhea,
Yvonne Huette Robinson, Leslie Kyle Schell, Valerie J. Webster, *Research Assistants*

Linda M. Pugliese, *Manuscript Coordinator*
Donna D. Craft, *Assistant Manuscript Coordinator*
Rosetta Irene Carr, Colleen M. Crane, Maureen A. Puhl, *Manuscript Assistants*

L. Elizabeth Hardin, *Permissions Supervisor*
Janice M. Mach, *Permissions Coordinator*
Filomena Sgambati, *Permissions Associate*
Patricia A. Seefelt, *Assistant Permissions Coordinator, Illustrations*
Mary M. Matuz, Susan D. Nobles, *Senior Permissions Assistants*
Margaret A. Chamberlain, Sandra C. Davis, Josephine M. Keene, *Permissions Assistants*
H. Diane Cooper, Kathy Grell, Yolanda Parker, Diana M. Platzke, Mabel E. Schoening, *Permissions Clerks*

Arthur Chartow, *Art Director*

Frederick G. Ruffner, *Publisher*
James M. Ethridge, *Executive Vice President/Editorial*
Dedria Bryfonski, *Editorial Director*
Christine Nasso, *Director, Literature Division*
Laurie Lanzen Harris, *Senior Editor, Literary Criticism Series*

Library of Congress Catalog Card Number 75-34953
ISBN 0-8103-0332-9
ISSN 0362-4145

CONTENTS

Preface 3

Authors to Appear in Future Volumes 7

Guest Essay, " 'The Same, Only Different': Canadian Children's Books in a North American Context," by Sheila A. Egoff 9

Appendix 245

Cumulative Index to Authors 253

Cumulative Index to Nationalities 259

Cumulative Index to Titles 261

PREFACE

As children's literature has evolved into both a respected branch of creative writing and a successful industry, literary criticism has documented and influenced each stage of its growth. Critics have recorded the literary development of individual authors as well as the trends and controversies that resulted from changes in values and attitudes, especially as they concerned children. While defining a philosophy of children's literature, critics developed a scholarship that balances an appreciation of children and an awareness of their needs with standards for literary quality much like those required by critics of adult literature. *Children's Literature Review* (*CLR*) is designed and published to provide a permanent, accessible record of this ongoing scholarship. Those responsible for bringing children and books together can now make informed choices when selecting reading materials for the young.

Scope of the Series

Each biannual volume contains excerpts from published criticism on the literary works of authors and author/illustrators who create books for children from preschool to junior high age. The author list for each volume is international in scope and represents the variety of genres covered by children's literature—picture books, fiction, nonfiction, poetry, and drama. The literary careers of approximately fifteen to forty authors of all eras are represented in each volume. Although earlier volumes of *CLR* emphasized critical analysis published after 1960, recent volumes have expanded their coverage to encompass criticism written before 1960. Since many of the authors included in *CLR* are living and continue to write, it is necessary to update their entries periodically. Thus, future volumes will supplement the entries of selected authors covered in earlier volumes and present criticism on the works of authors new to the series.

Organization of the Book

An author section consists of the following elements: author heading, author portrait, author introduction, excerpts of criticism, and, when available, illustrations by author/illustrators.

- The **author heading** consists of the author's full name, followed by birth and death dates. The portion of the name outside the parentheses denotes the form under which the author is most frequently published. If the majority of the author's works for children were written under a pseudonym, the pseudonym will be listed in the author heading and the real name given on the first line of the author introduction. Also located at the beginning of the introduction are any other pseudonyms used by the author in writing for children and any name variations, including transliterated forms for authors whose languages use nonroman alphabets. Uncertainty as to a birth or death date is indicated by a question mark.

- An **author portrait** is included when available.

- The **author introduction** contains information designed to introduce an author to users of *CLR*. The introduction begins with a phrase describing the author's nationality and the genres in which he or she writes. The text of the introduction presents an overview of the author's themes and styles, biographical facts that relate to his or her literary career, a summary of critical response to the author's works, and major awards and prizes. Where applicable, introductions include references to additional entries in biographical and critical reference books published by Gale Research Company. These sources include past volumes of *CLR* as well as *Contemporary Authors, Something about the Author, Yesterday's Authors of Books for Children, Contemporary Literary Criticism, Twentieth-Century Literary Criticism, Nineteenth-Century Literature Criticism, Literature Criticism from 1400 to 1800, Dictionary of Literary Biography,* and *Authors in the News.*

- **Criticism** is located in three sections: **author's commentary** and **general commentary** (when available) and within individual **title entries,** which are preceded by **title entry headings.** Some excerpts are preceded by **explanatory notes,** and each excerpt is followed by a **bibliographical citation.** Criticism is arranged chronologically within each section. Titles by authors being profiled are highlighted in boldface type within the text for easier access by readers.

The **author's commentary** presents background material written by the author being profiled or by an interviewer. This commentary may cover a specific work or several works. Author's commentary on more than one work appears after the author introduction, while commentary on individual books follows their title entry headings.

The **general commentary** consists of critical excerpts that consider more than one work by the author being profiled. Starting with the present volume, general commentary is preceded by the critic's name in boldface type or, in the cases of unsigned criticism, by the title of the journal.

Title entry headings precede the criticism on a title and include publication information on the work being reviewed. Title headings list the work's title as it appeared in its country of origin; titles in languages using nonroman alphabets are transliterated. If the original title is in a language other than English, the English title follows in brackets. The work's first publication date is listed in parentheses following the title. U.S. or British titles which differ from the original English-language title follow the publication date within the parentheses.

Title entries consist of critical excerpts on the author's individual works, arranged chronologically by publication date. The entries generally contain two to six reviews per title, depending on the stature of the book and the amount of criticism it has generated. The editors select titles that reflect the entire scope of the author's literary contribution, covering each genre and subject. An effort is made to reprint criticism from sources that represent the full range of each title's publications history—from the year of its initial publication to current references. Thus, the reader is provided with a record of the author's critical history.

Selected excerpts are preceded by **explanatory notes,** which provide information on the critic or work of criticism to enhance the reader's understanding of the excerpt.

A complete **bibliographical citation** follows each piece of criticism. These citations are designed to facilitate the location of the original book or article. An asterisk (*) following a citation indicates that the essay or book contains information on more than one author.

• **Illustrations** are featured within the entries of authors who illustrate their own works. An effort has been made to select illustrations that represent the author's style as reflected in the criticism and to place each one as close as possible to its critical reference or a related statement. Each illustration is accompanied by a caption identifying the work in which it originally appeared and giving credit to copyright holders.

Other Features

• A list of **Authors to Appear in Future Volumes** follows the preface.

• A **guest essay** appears before the first author entry. These essays are written specifically for *CLR* by prominent critics on subjects of their choice. Past volumes have included essays by John Rowe Townsend and Zena Sutherland. Volume 7 contains Sheila A. Egoff's " 'The Same, Only Different': Canadian Children's Literature in a North American Context." The editors are honored to feature Dr. Egoff in this volume.

• An **appendix** lists the sources from which material has been reprinted in the volume. It does not, however, list every book or periodical consulted for the volume.

• Each volume of *CLR* contains **cumulative indexes** to authors and titles; *CLR* Volumes 1-5 contain a cumulative index to critics. Beginning with Volume 6, a cumulative nationality index accompanies cumulative indexes to authors and titles.

The **cumulative index to authors** lists authors who have appeared in *CLR* and includes cross-references to *Contemporary Authors, Something about the Author, Yesterday's Authors of Books for Children, Contemporary Literary Criticism, Twentieth-Century Literary Criticism, Nineteenth-Century Literature Criticism, Literature Criticism from 1400 to 1800, Dictionary of Literary Biography,* and *Authors in the News.*

The **cumulative nationality index** lists authors alphabetically under their respective nationalities. Author names are followed by the volume number(s) in which they appear. Authors who have changed citizenship or whose current citizenship is not reflected in biographical sources appear under both their original nationality and that of their current residence.

The **cumulative title index** lists titles covered in *CLR* followed by the volume and page number where criticism can be found.

New Features

Many of literature's most well-respected critics have analyzed books for children. Therefore, criticism in general commentary sections is now preceded by the name of the critic in boldface type to facilitate easier identification.

Acknowledgment to holders of illustration copyright now appears within the captions under each illustration.

Acknowledgments

No work of this scope can be accomplished without the cooperation of many people. The editors especially wish to thank the copyright holders of the criticism included in this volume, the permissions managers of many book and magazine publishing companies for assisting us in securing reprint rights, and the staffs of the Kresge Library at Wayne State University, the University of Michigan Library, and the Detroit Public Library for making their resources available to us. We are also grateful to Jeri Yaryan for her assistance with copyright research and Henrietta Epstein for her editorial assistance.

Suggestions Are Welcome

Readers are cordially invited to write the editor with comments and suggestions for enhancing the usefulness of the *CLR* series.

AUTHORS TO APPEAR IN FUTURE VOLUMES

Aardema, Verna 1911-
Abbott, Jacob 1803-1879
Adams, Adrienne 1906-
Adams, Harriet S(tratemeyer)
 1893?-1982
Adams, Richard 1920-
Adler, Irving 1913-
Aesop 620?BC-564?BC
Aliki 1929-
Anderson, C(larence) W(illiam)
 1891-1971
Arnosky, Jim 1946-
Asch, Frank 1946-
Asimov, Isaac 1920-
Avery, Gillian 1926-
Avi 1937-
Aymé, Marcel 1902-1967
Bailey, Carolyn Sherwin 1875-1961
Ballantyne, R(obert) M(ichael)
 1825-1894
Bang, Molly 1943-
Banner, Angela 1923-
Bannerman, Helen 1863-1946
Barrie, J(ames) M(atthew) 1860-1937
Baum, L(yman) Frank 1856-1919
Baumann, Hans 1914-
BB 1905-
Beatty, Patricia 1922- and John
 1922-1975
Behn, Harry 1898-1973
Belloc, Hilaire 1870-1953
Benary-Isbert, Margot 1889-1979
Benchley, Nathaniel 1915-1981
Bennett, John 1865-1956
Berenstain, Stan(ley) 1923- and
 Jan(ice) 1923-
Berger, Melvin 1927-
Berna, Paul 1910-
Beskow, Elsa 1874-1953
Bianco, Margery Williams 1881-1944
Bishop, Claire Huchet
Blades, Ann 1947-
Blos, Joan W(insor) 1928-
Blyton, Enid 1897-1968
Bodecker, N(iels) M(ogens) 1922-
Bond, Nancy 1945-
Bonham, Frank 1914-
Branley, Franklyn M(ansfield) 1915-
Brazil, Angela 1869-1947
Breinburg, Petronella 1927-
Briggs, Raymond 1934-
Bright, Robert 1902-
Brink, Carol Ryrie 1895-1981
Brooke, L(eonard) Leslie 1862-1940
Brown, Marc 1946-

Brown, Marcia 1918-
Brown, Margaret Wise 1910-1952
Buff, Mary 1890-1970 and Conrad
 1886-1975
Bulla, Clyde Robert 1914-
Burch, Robert 1925-
Burchard, Peter 1921-
Burgess, Gelett 1866-1951
Burgess, Thornton W(aldo) 1874-1965
Burnett, Frances Hodgson 1849-1924
Burningham, John 1936-
Burton, Virginia Lee 1909-1968
Busch, Wilhelm 1832-1908
Butterworth, Oliver 1915-
Carle, Eric 1929-
Carlson, Natalie Savage 1906-
Carrick, Donald 1929- and Carol 1935-
Charlip, Remy 1929-
Chönz, Selina
Christopher, Matt(hew) 1917-
Ciardi, John 1916-
Clark, Ann Nolan 1896-
Clarke, Pauline 1921-
Cleaver, Elizabeth 1939-
Cohen, Barbara 1932-
Colby, C(arroll) B(urleigh) 1904-1977
Colman, Hila
Cone, Molly 1918-
Conford, Ellen 1942-
Coolidge, Olivia 1908-
Coolidge, Susan 1835-1905
Cooney, Barbara 1917-
Courlander, Harold 1908-
Cox, Palmer 1840-1924
Cresswell, Helen 1934-
Crompton, Richmal 1890-1969
Cunningham, Julia 1916-
Curry, Jane L(ouise) 1932-
Dalgliesh, Alice 1893-1979
Daugherty, James 1889-1974
d'Aulaire, Ingri 1904-1980 and Edgar
 Parin 1898-
d'Aulnoy, Countess Marie 1650-1705
de la Mare, Walter 1873-1956
de Regniers, Beatrice Schenk 1914-
Dillon, Eilís 1920-
Dodge, Mary Mapes 1831-1905
Domanska, Janina
Duvoisin, Roger 1904-1980
Eager, Edward 1911-1964
Edgeworth, Maria 1767-1849
Edmonds, Walter D(umaux) 1903-
Epstein, Sam(uel) 1909- and Beryl 1910-
Ets, Marie Hall 1893-
Ewing, Juliana Horatia 1841-1885

Farber, Norma **1909-1984**
Farjeon, Eleanor 1881-1965
Farmer, Penelope 1939-
Fatio, Louise 1904-
Field, Eugene 1850-1895
Field, Rachel 1894-1942
Fisher, Dorothy Canfield 1879-1958
Fisher, Leonard Everett 1924-
Flack, Marjorie 1897-1958
Forbes, Esther 1891-1967
Freeman, Don 1908-1978
Fujikawa, Gyo
Fyleman, Rose 1877-1957
Garfield, Leon 1921-
Garis, Howard R(oger) 1873-1962
Garner, Alan 1935-
Gates, Doris 1901-
Gibbons, Gail 1944-
Giblin, James Cross 1933-
Giff, Patricia Reilly 1935-
Godden, Rumer 1907-
Goodall, John S(trickland) 1908-
Goodrich, Samuel G(riswold) 1793-1860
Gorey, Edward 1925-
Graham, Lorenz B(ell) 1902-
Gramatky, Hardie 1907-1979
Greene, Constance C(larke) 1924-
Grimm, Jacob 1785-1863 and Wilhelm
 1786-1859
Gruelle, Johnny 1880-1938
Guillot, René 1900-1969
Hader, Elmer 1889-1973 and Berta
 1891?-1976
Hale, Lucretia Peabody 1820-1900
Harnett, Cynthia 1893-1981
Harris, Christie 1907-
Harris, Joel Chandler 1848-1908
Haywood, Carolyn 1898-
Heide, Florence Parry 1919-
Hill, Eric
Hoff, Syd(ney) 1912-
Hoffman, Heinrich 1809-1894
Holling, Holling C(lancy) 1900-1973
Howe, James 1946- and Deborah
 1946-1978
Hughes, Langston 1902-1967
Hughes, Shirley 1929-
Hunter, Mollie 1922-
Ipcar, Dahlov 1917-
Iwasaki, Chihiro 1918-
Jackson, Jesse 1908-1983
Janosch 1931-
Jeschke, Susan 1942-
Johnson, Crockett 1906-1975
Johnson, James Weldon 1871-1938

Jones, Diana Wynne 1934-
Jordan, June 1936-
Judson, Clara Ingram 1879-1960
Juster, Norton 1929-
Keith, Harold 1903-
Kelly, Eric P(hilbrook) 1884-1960
Kennedy, Richard 1932-
Kent, Jack 1920-
Kerr, Judith 1923-
Kettelkamp, Larry 1933-
King, Clive 1924-
Kipling, Rudyard 1865-1936
Kjelgaard, Jim 1910-1959
Kraus, Robert 1925-
Krauss, Ruth 1911-
Krumgold, Joseph 1908-1980
Krüss, James 1926-
La Farge, Oliver 1901-1963
La Fontaine, Jean de 1621-1695
Lang, Andrew 1844-1912
Langton, Jane 1922-
Lauber, Patricia 1924-
Lavine, Sigmund A(rnold) 1908-
Leaf, Munro 1905-1976
Lenski, Lois 1893-1974
Levy, Elizabeth 1942-
Lewis, Elizabeth Foreman 1892-1958
Lightner, A(lice) M. 1904-
Lindsay, Norman 1879-1969
Lofting, Hugh 1866-1947
Lunn, Janet 1928-
MacDonald, George 1824-1905
Mann, Peggy
Marshall, James 1942-
Martin, Patricia Miles 1899-
Masefield, John 1878-1967
Mayer, Mercer 1943- and Marianna 1945-
Mayne, William 1928-
McClung, Robert M(arshall) 1916-
McCord, David 1897-
McDermott, Gerald 1941-
McNeer, May 1902- and Lynd Ward 1905-
Meader, Stephen W(arren) 1892-1977
Means, Florence Crannell 1891-1980
Meigs, Cornelia 1884-1973
Merriam, Eve 1916-
Merrill, Jean 1923-
Miles, Betty 1928-
Milne, Lorus 1912- and Margery 1915-
Minarik, Else Holmelund 1920-
Mizumura, Kazue

Mohr, Nicholasa 1935-
Molesworth, Mary Louisa 1842-1921
Montgomery, L(ucy) M(aud) 1874-1942
Morey, Walt(er) 1907-
Mukerji, Dhan Gopal 1890-1936
Munari, Bruno 1907-
Neville, Emily Cheney 1919-
Nic Leodhas, Sorche 1898-1969
Nichols, Ruth 1948-
North, Sterling 1906-1974
Olney, Ross R(obert) 1929-
Ormondroyd, Edward 1925-
Ottley, Reginald
Oxenbury, Helen 1938-
Parish, Peggy 1927-
Pearce, A(nn) Philippa 1920-
Peck, Robert Newton 1928-
Peet, Bill 1915-
Perl, Lila
Perrault, Charles 1628-1703
Petersham, Maud 1890-1971 and Miska 1888-1960
Pfeffer, Susan Beth 1948-
Picard, Barbara Leonie 1917-
Politi, Leo 1908-
Prelutsky, Jack
Price, Christine 1928-1980
Provensen, Alice 1918- and Martin 1916-
Pyle, Howard 1853-1911
Ransome, Arthur 1884-1967
Rau, Margaret 1913-
Reeves, James 1909-1978
Richards, Laura E(lizabeth) 1850-1943
Richler, Mordecai 1931-
Robertson, Keith 1914-
Rockwell, Anne 1934- and Harlow
Rodgers, Mary 1931-
Rollins, Charlemae Hill 1897-1979
Ross, Tony 1938-
Rounds, Glen 1906-
Saint-Exupéry, Antoine de 1900-1944
Sandburg, Carl 1878-1967
Sandoz, Mari 1896-1966
Sawyer, Ruth 1880-1970
Scarry, Huck
Scott, Jack Denton 1915-
Selden, George 1929-
Seredy, Kate 1899-1975
Seton, Ernest Thompson 1860-1946
Sharmat, Marjorie Weinman 1928-
Sharp, Margery 1905-

Shotwell, Louisa R(ossiter) 1902-
Sidney, Margaret 1844-1924
Silverstein, Alvin 1933- and Virginia 1937-
Simon, Seymour 1931-
Sinclair, Catherine 1880-1864
Skurzynski, Gloria 1930-
Slobodkin, Louis 1903-1975
Smith, Doris Buchanan 1934-
Snyder, Zilpha Keatley 1927-
Speare, Elizabeth George 1908-
Spence, Eleanor 1928-
Sperry, Armstrong W. 1897-1976
Spykman, E(lizabeth) C. 1896-1965
Spyri, Johanna 1827-1901
Steele, William O(wen) 1917-1979
Stevenson, James 1929-
Stevenson, Robert Louis 1850-1894
Stolz, Mary 1920-
Stratemeyer, Edward L. 1862-1930
Streatfeild, Noel 1897-
Taylor, Sydney 1904?-1978
Taylor, Theodore 1924-
Ter Haar, Jaap 1922-
Thomas, Ianthe
Titus, Eve 1922-
Tolkien, J(ohn) R(onald) R(euel) 1892-1973
Trease, Geoffrey 1909-
Tresselt, Alvin 1916-
Treviño, Elizabeth Borton de 1904-
Tudor, Tasha 1915-
Turkle, Brinton 1915-
Udry, Janice May 1928-
Unnerstad, Edith 1900-
Uttley, Alison 1884-1976
Ventura, Piero 1937-
Vincent, Gabrielle
Vining, Elizabeth Gray 1902-
Waber, Bernard 1924-
Wahl, Jan 1933-
Watanabe, Shigeo 1928-
Wiese, Kurt 1887-1974
Wilkinson, Brenda 1946-
Williams, Jay 1914-1978
Williams, Vera B. 1927-
Yates, Elizabeth 1905-
Yonge, Charlotte M(ary) 1823-1901
Zaffo, George J.
Zemach, Harve 1933-1974 and Margot 1931-
Zion, Gene 1913-1975

Readers are cordially invited to suggest additional authors to the editors.

GUEST ESSAY

'The Same, Only Different': Canadian Children's Literature in a North American Context
by Sheila A. Egoff

The general or "trade" publishing industries of Canada and the United States are very different, even when viewed quite superficially. Although publishing for children is only part of the whole industry, it reflects these national differences. Unlike the United States, Canada imports more than it publishes internally. Indeed, it is the greatest book-importing area in the world, despite its small population. The Canadian market is just large enough to be attractive to foreign publishers, so all large English and American firms have long had branch distribution outlets in Canada. Thus it can be readily appreciated that our local products face, right at home, enormous competition from abroad. Specifically in terms of children's books, this means that less than a hundred Canadian titles published annually in English must vie with close to three thousand from the United States and about another three thousand from other English-speaking countries.

There are other factors that put constraints upon our publishing industry, whether for adults or children or for writers or publishers. With a small local market, publishers cannot afford to take risks, especially with a new, unknown writer. Few have a popular or impressive backlist, the bread and butter of any major firm. The publishers of *Winnie-the-Pooh* or *Charlotte's Web*, for example, will continue to rake in a tidy sum each year indefinitely, with little or no effort. No Canadian publisher has a book in this kind of commercial league.

The existence of our two official languages—with a serious lack of translation from one to the other—compounds the economic ailment by reducing the profit margin for books in either English or French. The list goes on. There is our regionalism (far more pervasive in Canada than in the United States); our policy of actively encouraging multi-culturalism (which further fragments both publishing policies and the readership); and our huge distances and empty spaces which make the distribution of books difficult (90 percent of the population is spread in a thin band along our four-thousand-mile boundary with the United States).

It would seem that if pure laissez-faire economics governed the publishing of Canadian children's books, there would hardly be any. But a fairly rich and individualistic society cannot tolerate a situation in which foreign imports totally govern the cultural development of its children, and so government has had to intervene. Both the Canada Council and variations of Arts Councils at the provincial level provide grants to authors, illustrators, and publishers to keep the system afloat—barely. It need hardly be said that this injection of public money has both good and bad points, but there is no doubt that it is indispensable.

But the main questions to be asked throughout this short, short story of doom and gloom are: (1) have the difficulties adversely affected the quality of our children's literature and (2) do our books hold their own within the competitive world market? The answer to both is that we have done surprisingly well and are likely to do even better in the future. It has generally been accepted as an axiom that the more books published, the greater the possibility that a few will be of first-rate quality. Canada seems to have beaten the odds.

Writing for children did not begin as early here as in the United States. Canada suffered from its colonial ties at least until the beginning of the twentieth century. Certainly in our own literature we did not have the models and standards of a *Little Women* or a *Tom Sawyer* to which we could aspire. Once begun, in the middle of the nineteenth century, there was no steady progression, but rather we jerked along with long pauses and sudden leaps, such as the emergence in 1908 of L.M. Montgomery's *Anne of Green Gables*. But since the middle of the 1970s there has been a steady growth in numbers of titles, variety of themes, and quality of artistic illustration. In the content of our children's books there has also been a significant shift. Where the wilderness, isolation, and struggle against nature once formed the characteristic backdrop, today's protagonists are more likely to be urban sophisticates, befitting the post-industrial

society. These trends seem irreversible. The chief reason for this may well be the flowering of the Canadian novel for adults: children's literature tends to follow its adult counterparts.

Modern Canadian children's books are certainly not well known outside of Canada. But, interestingly enough, this was not so in the past. In the late nineteenth century the animal biographies of Ernest Thompson Seton, whose formative years were spent in Canada, and Charles G.D. Roberts revolutionized the animal story around the world after the publication of Seton's *Wild Animals I Have Known* (1898) and Roberts's *The Kindred of the Wild* (1902). Marshall Saunders's *Beautiful Joe* (1894), based consciously or unconsciously on the English *Black Beauty* by Anna Sewell, became an international bestseller, and an adoring, far-flung public not only devoured L.M. Montgomery's *Anne of Green Gables*, but also its seven sequels. The feminist and temperance advocate Nellie McClung gained a wide audience in the United States with *Sowing Seed in Danny* (1908). All these Canadian writers were originally published in the United States, a commentary on Canadian publishing of the period which needs no further elucidation. But their popularity does raise some speculation and some historical considerations.

In a literary sense, these authors wrote out of their own experience as Canadians, but their style and vision fitted the grand literary manner of the time; for in historical terms it was the age of outright sentimentality in the perception of what writing for children should be. While Canada was producing its fair share of "sweetness and light," writers in the United States were churning out such series as Kate Douglas Wiggin's *Rebecca of Sunnybrook Farm* (1903), Margaret Sidney's *The Five Little Peppers* (1881), Gene Stratton Porter's *A Girl of the Limberlost* (1909), and Eleanor Porter's *Pollyanna* (1913). In this period the type of literature produced was more important than national origin.

But only a handful of Canadian writers could leap boundaries, and this period was not to last. While American children's literature eventually subsumed all or most of the innovative and bustling activity in American life— remember *The Radio Boys, The Radio Girls, The Airplane Boys, The Airplane Girls, Ruth Fielding in the Movies?*—Canadian children's literature reverted to its original, basic formula. Almost all our books were concerned with boys or young men pitting themselves against the forces of nature whether in forest, on plain, sea, tundra, or ice. They also had two other characteristics that were to become constants: the protagonists' love for their vast and dangerous land and their determination to come to terms with it, not only successfully but exuberantly. This combination produced our classic Canadian "survival" story, and writers continued to use the formula long after the character of the country had changed and have continued to do so, with variations, up to the present. One of our best modern examples is *Lost in the Barrens* (1956) by Farley Mowat (also one of our best-known writers for adults). In a traditional, fast-moving plot, a white boy and an Indian boy face all the hostilities that a northern winter can impose upon the inexperienced. Somehow, they survive it all and grow up in the process, learning the most important lesson that one must conform to the North rather than fight it. James Houston's *Frozen Fire* (1977) has a similar but more immediate theme, as in the adventure of the two boys (one white and one Inuit) we see the modern culture clash between the Inuit and the white man.

James Houston is noted for his work in bringing Inuit art and sculpture to the attention of the international art community, but he has also become our most prolific spokesman for the Inuit in children's literature as well as the most artistic writer. Houston manages to distil the essence of the heroic in Inuit life in *Tikta'liktak* (1965). It is based on a story well known in the Arctic when James Houston first heard it. A young Inuit man escapes from an ice flow to an almost barren Arctic island. Then by courageous and ingenious means he makes his way back to the mainland and his family. Houston's *The White Archer* (1967) is a good example of the variations that can be played upon the survival story. A young Inuit boy escapes an Indian massacre of his family and lives and trains himself only for revenge. But under the influence of an old, wise, almost blind archer, Kungo's odyssey of hate is transmuted into an understanding of himself. Both *Tikta'liktak* and *The White Archer* are, in format, almost picture storybooks, illustrated by the author himself in a style so close to Inuit carvings that they almost demand to be lifted off the page.

Of the many possible variations on the theme of conflict against the wilderness, Inuit life has proved especially fruitful. Perhaps it is because the struggle of human beings with nature is here revealed at its starkest. Or it may be because Inuit life is so far removed from ordinary North American experience as almost to guarantee that only authors who really know their subject will dare to write about it. And who should know better than an Inuit? The first piece of Eskimo fiction to be published in English is *Harpoon of the Hunter* (1970) by Markoosie, who writes of the adventures of a sixteen-year-old boy in the not-so-distant past as if he had lived them himself. It may be described as the ultimate in survival literature, since no one does survive. The events themselves yield to one of the most moving reading experiences in the literature of the North—told in eighty-one illustrated pages.

Today, much of our survival literature can be as alien to a Canadian urban child as, say, Jean Craig's *Julie of the*

Wolves would be to any American child living outside of Alaska. But like Jean Craig, our best writers, too, can universalize what seems to be on the surface a unique experience. And some, like Jan Truss in *Jasmin* (1982), can bring the survival experience to one's doorstep. Jasmin is afraid that she will not pass into Grade 6. As the eldest child in a poor, noisy, rather slapdash family, she has too many responsibilities for her age. When her retarded brother (for whom she cares dearly) destroys her science project, she breaks under the pressure and flees from her home to a nearby but almost inaccessible Alberta wilderness. Here, with almost unconscious cunning, she survives for days, while all modern methods of search and rescue are instituted on her behalf. The ending has been criticized for being too easily resolved, but then this is a common complaint about much of children's literature (but not, one notices, from children themselves). The ending to Jan Hudson's *Sweetgrass* (1984) is perhaps more artistic, as it leaves one with a yearning for more. In this story of a young Blackfoot girl in the late nineteenth century, survival cannot be taken for granted. But after terrible events such as a tribal raid and the ravages of smallpox and famine have been told, it is Sweetgrass herself who lingers in the mind. We leave her, at age fifteen, poised on the threshold of love and marriage. What will happen to her? She is as loveable a heroine as Bright Morning in *Sing Down the Moon,* and Jan Hudson's style is as simply poetic as that of Scott O'Dell. The survival story has come a long, long way.

Indians, of course, have long attracted writers of children's books in both countries. The legacy of the pioneer days does not linger to any great extent in our modern children's books, but the early perception of the Indians has left an aura of suspicion and distrust which has been hard to dispel. Still, judging from the American books passing recently through our Canadian libraries and bookstores, it seems fair to suggest that Indian culture is of far more concern here than in the United States. Most notable in Canada has been the flowering of the Indian legend and the appearance of the single illustrated tale, which at least gives some variety to American and British single illustrated folktales such as *Snow White, Cinderella,* and *Puss in Boots.* Leaving aside the problems of translation, authenticity, and whether or not such Indian tales can really be interpreted by people outside the native culture, these pictures books have made some of our finest and most important legends available to a wide audience. Notable in this field is the work of William Toye with his simple, straightforward retellings of *The Mountain Goats of Temlaham* (West Coast), *How Summer Came to Canada* (East Coast), and *The Loon's Necklace* (Ontario). All these, published between 1969 and 1979, are brilliantly illustrated in collage (far more subtle than Ezra Jack Keats) by Elizabeth Cleaver, who is a Canadian award-winner for illustration. Another prize-winning book is *Ytek and the Arctic Orchid: An Inuit Legend* by Garnet Hewitt, with illustrations by Heather Woodall, which puts a marvellous fairy tale quality into the land of the great white bear. For older readers we have a wealth of Indian legends. No one has done more to popularize this genre than Christie Harris with her "mouse woman" tales. In such works as *Mouse Woman and the Vanished Princesses* (1976), *Mouse Woman and the Muddleheads* (1979), and *The Trouble with Adventurers* (1982), it can readily be seen that the Indian legend does indeed belong to the world's common stock of folk tales.

Like those of the United States, most of our folk tales have been imported from Europe. The French influence is apparent in Marius Barbeau's *The Golden Phoenix* (1958), but the tales underwent somewhat of a transformation as they passed through our French-Canadian culture. One of the stories, "The Princess of Tombose," is in the repertoire of almost every storyteller in Canada, but its popularity is due more to its humour than to any national origin. For many years, American publishers and illustrators have had a "hey-day" with the single illustrated folk tale, pouring out version after version with beautiful pictorial interpretations of the folktale heritage of Europe. The 1982/83 *Children's Books in Print* lists fourteen editions of *The Sleeping Beauty.* This idea of a fairly simple way to make money did not occur to Canadian publishers for a long time. However, spurred on no doubt by the success of the single Indian legend, our publishers now too have found a viable and readily exportable commodity. Two of our finest here are *The Twelve Dancing Princesses*, retold by Janet Lunn and illustrated by Laszlo Gal (somewhat in the style of Trina Schart Hyman), and a retelling of the ballet *Petrouchka* by Elizabeth Cleaver.

But what about stories of contemporary life? It is in this area, of course, that American writers in the middle 1960s brought such dramatic changes to children's literature with their accounts of urban children in crisis. They abandoned the adventure story with its standard literary conventions and embarked upon the fictional equivalent of the children's guide to problems—psychological, physical, and sociological. Almost none of this dramatic shift showed up in Canadian writing for almost twenty years. While American children—as seen through their books—were coping with disagreeable or ineffectual parents, no parents, one parent, being unhappy, growing up, tuning in, dropping out, or brushing up against drugs, alcohol, homosexuality, and racism, Canadian children were basically romping through holiday adventures in their great outdoors. Gradually, Canadian writers did begin to focus on protagonists for whom life became simply too much. The basically happy, extroverted child began to disappear. But in general their themes were not as harsh nor as harshly expounded as those in the American problem novel (Robert Cormier's *The Chocolate War*, for example). The Canadian books had a more poignant quality to them and a happier denouement. Our best

ones were also still firmly rooted in a recognizable landscape which contributed to the events of the story, unlike the anonymous urban settings of a Judy Blume or a Norma Klein.

Jan Truss's *Jasmin*, mentioned above, is an excellent example of this combination of regionalism and poignant problem. A somewhat similar American book that leaps to mind here is Vera and Bill Cleaver's *Where the Lilies Bloom*. The plot of Kevin Major's *Hold Fast* (1978) is now a familiar one—the young teenager outraged by the accidental death of his parents and so alienated from all other aspects of life. But it is strengthened by its Newfoundland locale and patterns of Newfoundland speech—not dialect, but rather a lilt that gives the protagonist's inward musings a poetic quality. *Hold Fast* has been criticized for its occasional coarse language—chiefly, one suspects, by those who are not accustomed to modern children's literature. But the language is not used gratuitously; it is in keeping with the boy's traumatic experience. The theme that links Jan Truss's *Jasmin*, Kevin Major's *Hold Fast*, and Monica Hughes's *Hunter in the Dark* (1982) is flight to the wilderness and a return to ordinary life with the unhappy and disparate pieces of the self put back together again. This is a strong thread in much Canadian literature, whether for adults or children. *Hunter in the Dark* is an especially moving story of a sixteen-year-old who has experiences on a lone deer-hunting expedition that finally allow him to face his terminal illness.

More in the American tradition are Brian Doyle's *You Can Pick Me Up at Peggy's Cove* (1979) and Frances Duncan's *Kap-Sung Ferris* (1977). But both books have recognizable settings which have some link with the plot. The young teenager in Doyle's book is banished to a Nova Scotian village for the summer and under a strong resentment from his father's neglect almost gets into serious trouble. He is eventually redeemed by the sterling qualities of some of the local characters who have befriended him. Kap-Sung Ferris (Kim) also comes to terms with herself as an adopted Korean child in Vancouver. But this problem is not the whole book. There are bonuses in the interesting glimpses of Kim as a budding ice-skating star and an exciting hunt through Vancouver's busy harbour. Speaking of children's books as literature and not sociological tracts or pot-boilers, it can be said that our writers do best when they speak from a sense of place as well as emotional experience. Many of our newer books with urban settings seem merely pale copies of the American problem novel, although not as attractively packaged.

One of the most interesting aspects of American children's literature these days is the rise of fantasy—both "pure" fantasy and science fiction fantasy. Much of it is extraordinarily good—one thinks here of Virginia Hamilton's *Sweet Whispers, Brother Rush*. Canada has never had a strong tradition of fantasy (the reasons are too numerous to relate here), but we do have a few fantasies that merit attention beyond our borders. Ruth Nichols's *A Walk Out of the World* (1969) and *The Marrow of the World* (1972) are in the tradition of George MacDonald and C.S. Lewis—those proponents of universal morality in fantasy. Both are also in the "new wave" of fantasy in that the imagined worlds contribute to the personal development of the protagonist, but they are far more clear-cut tales than, say, Susan Cooper's 1983 offering, *Seaward*. One that could be of special interest to American children is Janet Lunn's *The Root Cellar* (1983), since in this time fantasy much of the action takes place during the American Civil War. Her earlier book *Double Spell* (1968) is set in Toronto. Its milieu in no way inhibits the thrust of the plot, which is a fine mixture of the ordinary and the fabulous, rounded off with a touch of terror. Heather Kellerhals-Stewart's *Stuck Fast in Yesterday* (1983) certainly lives up to its title. Yesterday here are the horse-and-buggy days in a village outside of Toronto where Jennifer, in a series of terrifying events, finds herself as one of the "seen but not heard" children of several generations ago. Modern children should be especially interested in the schoolroom scenes. It has much of the charm of Francine Pascal's *Hangin' Out with Cici*, but with a sharper edge.

Considering the popularity of science fiction with the young, it is surprising that so few Canadian writers have tried their hand at it. However, we do have Monica Hughes (who came to Canada from England) who is among the best of those writing in this genre from any country. Her Isis trilogy has received wide acclaim. The first volume, *The Keeper of the Isis Light* (1981), has a theme quite common in science fiction—a fear and hatred of what is alien to us—but it is worked out in a memorable and moving way. Her newest book, *The Space Trap* (1983), is both fast-paced and thoughtful as a varied group of people from different planets find themselves trapped in a zoo and treated much as we treat our own zoo specimens. Unlike many writers of science fiction today, especially those from England such as John Christopher who consistently present our world in a state of regression, Hughes has an optimistic view of our future, chiefly based on the innate goodness, intelligence, and good sense of the young. Because science fiction deals chiefly with the future, it does not date as quickly as most fiction—H.G. Wells's *The War of the Worlds* is still an interesting and worthwhile "read." So is an early Canadian science fiction story for children, Suzanne Martel's *The City Underground* (1964), first published in Quebec. Here two intrepid young people are responsible for the meeting of two societies after hundreds of years of separation caused by an atomic devastation. The picture of a highly technical, rather arid civilization that developed under Montreal is most germane to our own time.

Neither the United States nor Canada has a children's poet of the quality of Walter de la Mare, but we each have our

popular and successful versifiers for young children—Shel Silverstein and John Ciardi in the United States and Dennis Lee in Canada. Lee is a noted poet for adults, and it is his craftmanship that can sustain one through a twentieth reading of one of his lilting verses. There is hardly a child in Canada who does not know "Alligator pie, Alligator pie,/If I don't get some I think I'm gonna die." His humorous, rollicking and often tender verses are to be found in *Alligator Pie* (1974), *Garbage Delight* (1977), and *Jelly Belly* (1983). Our finest anthology of poetry of interest to children is *The Wind Has Wings: Poems from Canada*, brilliantly illustrated by Elizabeth Cleaver. A new revised (both in text and illustration) edition is to be published fall, 1984.

Some Canadian children's books—like some wines—will not travel well. This statement does not apply to picture books, however. Art work speaks an international language and the creators of fine picture books manage to touch the common experience of childhood. The picture-book world developed slowly in Canada. For years, our children were brought up with such delights as *Curious George, Make Way for Ducklings,* and later, *Where the Wild Things Are.* The influx of foreign picture books into Canada has not by any means ceased, but since the 1970s these imports now have some competition from home-grown products.

Most of the credit for our picture book explosion goes to our small press publishers who saw the sudden interest in pre-schoolers and who were able to produce inexpensive picture books with a healthy dose of government funds. In addition, many major publishers became more aggressive in seeking joint publication, or foreign publication, of their more expensive productions. All this activity resulted in a growth in numbers and variety and in quite a few picture books of interest to the international market.

A forerunner of this new wave was Ann Blades's *Mary of Mile 18* (1971). Mile 18 is north on the Alaska Highway for seventy-three miles, then right for eighteen. Mary is a Mennonite child, subject to all work and no play until she acquires a wolf-pup for a pet. The simple text has an inner rhythm that supports full-page watercolors worthy of hanging in one's living room. *Mary of Mile 18* has won several awards and has been translated into several languages. Lindee Climo is a new author/illustrator award-winner. Her *Chester's Barn* (1982) is a stunning evocation of farm animals and farm life of a generation ago—some of which still lingers in Prince Edward Island, or New England. While the text is perhaps one of nostalgia, the illustrations are in the new mode with their touch of magic realism. *The Mare's Egg* (1981) by Carole Spray, illustrated by Kim La Fave, is a marvellous noodle-head pioneer story. Here is the naive pioneer (he could be Canadian or American) who is conned into buying a huge pumpkin in the belief that it will hatch a mare's egg. The title of Sue Ann Alderson's *Bonnie McSmithers, You're Driving Me Dithers* (1974) has now become a household phrase in Canada. With its small paper format and "mod" black and white pictures, it has a jaunty air suitable to Bonnie's mischievious disasters which are carried on in several sequels. New favourites with the younger set are Robert Munsch's light-hearted and humorous tales (published inexpensively in paperback) such as *The Paperbag Princess* (1980) and *The Mud Puddle* (1979). These are perfect for storytelling and puppet shows since they can be expanded by the addition of other details or incidents. All Munsch's stories are firmly rooted in the oral tradition. Expectations are high for Tim Wynne-Jones's *Zoom at Sea* (1983) in which an intrepid kitten has his fantasy fulfilled. Ken Nult's soft black and white line drawings show what can be done by an artist skilled in this medium. For those who are always seeking out a new story to replace "Twas the Night Before Christmas," there is an older Canadian one, perfect for young children, whether for showing, reading, telling, or puppets. This is *Johann's Gift to Christmas* (1972) by Jack Richards, which gives a delightful twist to the true story of how "Silent Night" came to be written.

We also have a reasonable number of Canadian classics which, like *Heidi, The Secret Garden,* and *Hans Brinker,* are rediscovered by new generations of readers. L.M. Montgomery's *Anne of Green Gables* may be our best known book, but her Emily books — *Emily of New Moon* (1923), *Emily Climbs* (1925), and *Emily's Quest* (1927)—are much more in the modern vein than the Anne books. Anne is really a cousin to Kate Douglas Wiggin's *Rebecca of Sunnybrook Farm* (1903), while Emily in her lonely struggles against entrenched adult attitudes and beliefs is kin to such heroines as those in Mollie Hunter's *A Sound of Chariots* and Katherine Paterson's *Jacob Have I Loved.* Sajo in *Sajo and Her Beaver People* (1935) is another unforgettable heroine. Written by George Stansfeld Belaney (who called himself Grey Owl), it has authentic animal and wilderness lore, including a forest fire. But it is really a love story—the love of the little Indian girl for her beaver pets and the love of the little beavers for one another. And still holding their own despite the new wave of sophisticated children's books are Farley Mowat's *The Dog Who Wouldn't Be* (1957) and *Owls in the Family* (1961). Words really do fail one when trying to describe that super-canine, Mutt, and the two owls Wol and Weeps—one an extrovert and the other an introvert. These older books are strongly Canadian in background, but the values they espouse are universal and understandable in a child's terms. There is one recent book that should not pose any barriers to an American reader. Ken Roberts's *Crazy Ideas* (1984) has the slightly larger-than-life aura of the works of Robert McCloskey, but with an invented city as its background. Mr. Roberts states that he was brought up on McCloskey, and Roberts's heroine does bear a strong resemblance to *Homer Price.*

But all in all Canadian books should have a special appeal for American children. Aside from our far North, we share the same physical environment—the mountains, rivers, and animals, the wilderness, the prairie, the fruits of earth and sea. Our populations are much the same—free, independent, and democratic. Since reading should broaden horizons, it will be all to the good if they are tantalized by the unfamiliar while being soothed by the familiar. And an occasional surprise will be an added bonus. So when children say of a Canadian book: "Will I like it?" (as they do about everything except a hamburger), you can say, "Well, I am *almost* sure."

Bibliography

American publishers (or distributors) of Canadian books have been given wherever possible. If the book has only been published in Canada, the publisher's address is listed following the bibliography. The Children's Book Centre, 229 College Street, 5th Floor, Toronto, Ontario, Canada, M5T 1R4, will be happy to answer all queries regarding Canadian publications for children.

Alderson, Sue Ann. *Bonnie McSmithers, You're Driving Me Dithers*. Illustrated by Fiona Garrick. Edmonton: Tree Frog Press, 1974.

Barbeau, Marius. *The Gold Phoenix and Other Fairy Tales from Quebec*. Toronto: Oxford, 1980.

Blades, Ann. *Mary of Mile 18*. Plattsburgh, N.Y.: Tundra Books of Northern New York, 1971.

Cleaver, Elizabeth. *Petrouchka*. New York: Atheneum, 1980.

Climo, Lindee. *Chester's Barn*. Plattsburgh, N.Y.: Tundra Books of Northern New York, 1982.

Doyle, Brian. *You Can Pick Me Up at Peggy's Cove*. Toronto: Groundwood, 1979.

Duncan, Frances. *Kap-Sung Ferris*. Toronto: Macmillan, 1977.

Harris, Christie. *Mouse Woman and the Mischief-makers*. Illustrated by Doug Tait. New York: Atheneum, 1977.

Harris, Christie. *Mouse Woman and the Muddleheads*. Illustrated by Doug Tait. New York: Atheneum, 1979.

Harris, Christie. *Mouse Woman and the Vanished Princesses*. Illustrated by Doug Tait. New York: Atheneum, 1976.

Harris, Christie. *The Trouble with Adventurers*. Illustrated by Doug Tait. New York: Atheneum, 1982.

Houston, James. *Frozen Fire*. New York: Atheneum, 1977.

Houston, James. *Tikta'liktak*. New York: Harcourt Brace, 1965.

Houston, James. *The White Archer*. New York: Harcourt Brace, 1967.

Hudson, Jan. *Sweetgrass*. Edmonton: Tree Frog Press, 1984.

Hughes, Monica. *The Guardian of Isis*. New York: Atheneum, 1982.

Hughes, Monica. *Hunter in the Dark*. Toronto: Clarke, Irwin, 1982.

Hughes, Monica. *Keeper of the Isis Light*. New York: Atheneum, 1981.

Hughes, Monica. *Space Trap*. Toronto: Groundwood, 1983.

Lee, Dennis. *Alligator Pie*. Illustrated by Frank Newfeld. Boston: Houghton Mifflin, 1975.

Lee, Dennis. *Garbage Delight*. Illustrated by Frank Newfeld. Boston: Houghton Mifflin, 1978.

Lee, Dennis. *Jelly Belly*. Illustrated by Juan Wijingaard. Toronto: Macmillan, 1983.

Lunn, Janet. *Double Spell*. Toronto: PMA Books, 1981.

Lunn, Janet. *The Root Cellar*. Toronto: Lester & Orpen, 1983.

Lunn, Janet. *The Twelve Dancing Princesses*. Illustrated by Laszlo Gal. New York: Methuen, 1980.

Major, Kevin. *Hold Fast*. New York: Delacorte, 1978.

Markoosie. *Harpoon of the Hunter*. Illustrated by Germaine Arnaktauyok. Montreal: McGill-Queen's University Press, 1970.

Montgomery, Lucy Maud. *Anne of Green Gables*. Boston: Page, 1908.

Montgomery, Lucy Maud. *Emily Climbs*. Toronto: McClelland and Stewart, 1924.

Montgomery, Lucy Maud. *Emily of New Moon*. Toronto: McClelland and Stewart, 1925.

Montgomery, Lucy Maud. *Emily's Quest*. Toronto: McClelland and Stewart, 1927.

Mowat, Farley. *The Dog Who Wouldn't Be*. Boston: Little, Brown, 1957.

Mowat, Farley. *Lost in the Barrens*. Boston: Little, Brown, 1956.

Mowat, Farley. *Owls in the Family*. Boston: Little, Brown, 1961.

Munsch, Robert. *The Mud Puddle*. Illustrated by Sami Suomalainen. Willowdale, Ont.: Annick Press, 1981.

Munsch, Robert. *The Paperbag Princess*. Illustrated by Michael Martchenko. Willowdale, Ont.: Annick Press, 1981.

Nichols, Ruth. *The Marrow of the World*. Toronto: Macmillan, 1977.

Nichols, Ruth. *A Walk Out of the World*. New York: Harcourt Brace, 1969.

Richards, Jack. *Johann's Gift to Christmas*. Illustrated by Len Norris. Vancouver: Douglas & McIntyre, 1972.

Roberts, Ken. *Crazy Ideas*. Toronto: Groundwood, 1984.

Spray, Carole. *The Mare's Egg: A New World Folk Tale*. Illustrated by Kim La Fave. Camden East, Ont.: Camden House Publishing, 1981.

Toye, William. *How Summer Came to Canada*. Illustrated by Elizabeth Cleaver. Toronto: Oxford, 1978.

Toye, William. *The Loon's Necklace*. Illustrated by Elizabeth Cleaver. New York: Oxford, 1977.

Toye, William. *The Mountain Goats of Temlaham*. Illustrated by Elizabeth Cleaver. Toronto: Oxford, 1969.

Truss, Jan. *Jasmin*. Toronto: Groundwood, 1982.

Wynne-Jones, Tim. *Zoom at Sea*. Illustrated by Ken Nult. Toronto: Groundwood, 1983.

Canadian Publishers

Annick Press Ltd., 5519 Yonge Street, Willowdale, Ontario, Canada M2N 5S3

Camden House Publishing, 7 Queen Victoria Road, Camden East, Ontario, Canada K0K 1J0

Douglas & McIntyre Ltd., 1615 Venables Street, Vancouver, British Columbia, Canada V5L 2H1

Groundwood Books Ltd., 26 Lennox Street, 3rd Floor, Toronto, Ontario, Canada M6C 1J4

Irwin Publishing, 180 West Beaver Creek Road, Richmond Hill, Ontario, Canada L4B 1B4

Lester & Orpen Dennys Ltd., 78 Sullivan Street, Toronto, Ontario, Canada M5T 1C1

McClelland and Stewart Ltd., 25 Hollinger Road, Toronto, Ontario, Canada M4B 3G2

McGill-Queen's University Press, 849 Sherbrooke Street West, Montreal, Quebec, Canada H3A 2T5

Macmillan of Canada, 146 Front Street West, Suite 685, Toronto, Ontario, Canada M5J 1G5

Oxford University Press (Canada), 70 Wynford Drive, Don Mills, Ontario, Canada M3C 1J9

PMA Books, 180 West Beaver Creek Road, Richmond Hill, Ontario, Canada, L4B 1B4

Tree Frog Press Ltd., 10144-89 Street, Edmonton, Alberta, Canada T5H 1P7

Sheila A. Egoff is a Canadian author, editor, critic, educator, librarian, and lecturer. She is Professor Emeritus at the School of Librarianship, University of British Columbia. Dr. Egoff is the author of *The Republic of Childhood: A Critical Guide to Canadian Children's Literature in English* (1967; second edition, 1975) and *Thursday's Child: Trends and Patterns in Contemporary Children's Literature* (1981). After coordinating the largest international conference on children's literature ever held in Canada (1976), she edited *One Ocean Touching: Papers from the First Pacific Rim Conference on Children's Literature* in 1979. With G.T. Stubbs and L.F. Ashley, she edited *Only Connect: Readings on Children's Literature* (1969; second edition, 1980). Dr. Egoff gave the May Hill Arbuthnot Lecture in 1979, and received the Alumni Association Jubilee Award in 1980 from the Faculty of Library Science at the University of Toronto.

Jan Adkins

1944-

American author/illustrator of fiction and nonfiction.

Adkins creates information books that make complex skills, systems, and equipment understandable through conversational explanations and accurate drawings. These works cover such diverse areas as written communication, machines, food, and sea-related topics, and detail the historical and economic evolution of their subjects as well as their technical and practical applications. Characterized by the breadth of Adkins's research and his infectious enthusiasm, the majority of these books are considered excellent introductions for young readers.

Adkins's love of the sea is evident in his nonfiction books on ships, sailing, and sandcastles, as well as in *Luther Tarbox* and *A Storm without Rain*, fiction set in New England coastal villages. He has been praised for successfully conveying the atmosphere of his settings, especially when he transports his characters to the nineteenth and early twentieth centuries. His first and probably most celebrated book, *The Art and Industry of Sandcastles*, relates the history of real castles and describes styles and techniques for constructing imitations from sand. In this and subsequent works, Adkins adds personal touches that reflect his involvement with book design. A former architect, art director, and graphics consultant, he often hand-letters his pages and invests them with subtle, whimsical humor. Several of Adkins's copyright pages, for example, contain tongue-in-cheek messages to his readers.

Adkins's critical reception is usually favorable. Reviewers acknowledge his research and applaud its smooth incorporation into his works. Some critics note that Adkins crowds his books with too many facts and not enough explanations, and occasionally fault him with oversimplification and overuse of humor. His illustrations, however, are almost invariably praised for their precision and appeal. Readers place Adkins's works among the most inviting learning tools for their clearly presented information, lively prose style, and detailed illustrations. Among the honors Adkins has been given is the 1972 Lewis Carroll Shelf Award for *The Art and Industry of Sandcastles*, which was a National Book Award finalist the same year. *Moving Heavy Things* received the New York Academy of Sciences Children's Science Book Award in 1981.

(See also *Something about the Author*, Vol. 8 and *Contemporary Authors*, Vols. 33-36, rev. ed.)

AUTHOR'S COMMENTARY

[Norma Bagnall:] You have said that you try to write books not just for children but for people; can you clarify that?

[Jan Adkins:] If I were trying really hard to write really well, with luck I could write a story that was so simple that anyone could read it, and yet so real that everyone would want to read it. The best illustration I know of that is *The Once and Future King* by T. H. White which is in five parts. The first part, *The Sword and the Stone*, is one of my favorite books on any level; my children (ages nine, eight, and three) love it. I don't think they would understand *The Ill-Made Knight*, another part, but

Photograph by Sally Stone Halvorson

it is the same writer, writing at the same level, with the same kind of words. (p. 561)

[N.B.] There has been a great deal said about sexism in children's books, and I am curious to know if that has had an impact on your writing.

[J.A.] You've hit on something that really bothers me. I don't want [my daughter] Sally to think she has to grow up to be a nurse; I want her to believe she can be anything she wants to be. "Be a doctor, dammit," I tell her, but she says, "I want to be a nurse." I am very concerned about her image of herself, especially when I am writing fiction. For example, in my books I try to show more affection between people—like Luther Tarbox and Jessie, his wife, in *Luther Tarbox*. In that book, even though I was writing about Luther because I know more about him (because I am a man), I showed his wife as a strong, important person. There is affection and a strong bond between them, and they express concern for each other.

Non-fiction is different, but when I did the baker's book, the bakers were not mom and sis; they were an uncle and a nephew.

[N.B.] I have found that in *The Bakers* you have hit upon something else you may not have been aware of. Because of the way you have written it, baking seems to be something we

do with someone else, and I like that. It becomes another way of creating bonds between people.

[J.A.] I think it is important to express affection between people, even between two men. We've kept away from that for a long time, but I like to bring it out. I like the old movies where men had sidekicks. Being a sidekick still seems like an honorable profession to me.

[N.B.] What about the demand for non-sexist language. How has that affected your writing?

[J.A.] If I'm writing about somebody chopping wood, I don't have the inclination to say "he or she can . . ." or "the woodsperson can. . . ." But it is serious to me, and I want to do it right. I think men have been victimized by just that kind of equivocation for a long time. They've been duped into the nervous, confining role of being responsible for everything mechanical, organizational, and financial. Damn. Some men just aren't good at that, and yet they persist because they think that's what they have to do to be a man. Very nervous stuff. I think women often have not been able to assume a useful role beside men because of rhetoric or because of culturization or whatever it is, and I am not going to have any part in furthering it. But, I will not use the non-genderal pronoun; one woman suggested I use "sher." Often there are times when I am going to say "the sailor does this, and the sailor does that, he can also . . ."; I'm not going to say "he or she." I say "he" or I say "she" whenever I can slip it in. Good writing means good reading. The hardest writing to do is easy reading for non-fiction. If I'm constantly saying "he or she . . ." or "the woodsperson," or "the carpentress," it sounds dumb. But it is a serious thing, and it is time to make changes. For fiction it doesn't mean a thing; I write what I know in the easiest and best way I can, but for non-fiction it is difficult; for me it is extremely hard.

I am persistent in believing that fiction and non-fiction are different kinds of writing. If I'm going to write non-fiction about how to do something, I have to make it clear that it is non-genderal. If I can show myself doing something, I can show anybody else doing it. I care about Sally; I want her to think she can do anything. I really worry about her getting into all this stereotyping business. Stereotyping is a natural mechanism of generalization, of ordering the world into groups of things to understand the whole, and it is difficult not to put yourself into one of the boxes. (pp. 563-64)

[N.B.] Are you ever concerned that children won't understand what you have written?

[J.A.] Something that bothers me about writing for children is that an editor will try to expunge everything that a child would not understand. I don't want children to understand everything; I want them to read the book. If they don't understand parts of it, they'll filter it out. The story will come through. If kids don't understand some of the stuff, let them get it in the second or third reading. If children understand everything the first time around, they'll throw the book away, and they ought to.

[N.B.] What about books for the very young; shouldn't they be simple?

[J.A.] Even books for very young children can be complex and exciting. For example, Where The Wild Things Are by Maurice Sendak is a fine book; his In the Night Kitchen is even better. I think it takes a brilliant and diseased mind to realize that both of the bakers had to be Oliver Hardy. Kids respect madness;

they don't want condescending fantasy written just for them; they want to look into someone's mind, the loopier the better.

[N.B.] Your own books represent such a range of interests: baking, building, engineering, calligraphy—and you seem to do them all so well. Is there some reason for this?

[J.A.] By profession I write and I draw, but what I really do is learn. I learn about something that interests me, something I can find wonder in, and I try to explain it clearly without losing the wonder. I'm a professional learner and looker, and a catcher in the rye, by vocation.

[N.B.] I agree. Adkins' books are expressions of his clear explanations "without losing the wonder." (p. 565)

> *Norma Bagnall, in an interview with Jan Adkins (copyright © 1980 by the National Council of Teachers of English; reprinted by permission of the publisher, Norma Bagnall, and Curtis Brown, Ltd. for Jan Adkins), in* Language Arts, *Vol. 57, No. 5, May, 1980, pp. 560-66.*

GENERAL COMMENTARY

MICHAEL DIRDA

I can't imagine any child or grown-up who wouldn't be thrilled to own [*Toolchest: A Primer of Woodcraft, The Craft of Sail, Inside: Seeing Beneath the Surface, The Craft of Making Wine,* and *Symbols: A Silent Language*]. In *Toolchest,* for instance, Adkins describes wood and its uses, explains the key woodworking techniques (tenon and mortise, dowelling), distinguishes the various tools for boring, planing and shaping, and does it all with detailed illustrations and succinct, humorous prose. The books on sailing and winemaking are really basic introductions to these skills, and as such can be usefully and pleasantly read by anyone. (p. 10)

> *Michael Dirda, in a review of "Toolchest: A Primer of Woodcraft," "The Craft of Sail," "Inside: Seeing Beneath the Surface," "The Craft of Making Wine," and "Symbols: A Silent Language," in* Book World— The Washington Post *(© 1984, The Washington Post), February 12, 1984, pp. 10-11.*

THE ART AND INDUSTRY OF SANDCASTLES: BEING AN ILLUSTRATED GUIDE TO BASIC CONSTRUCTIONS ALONG WITH DIVERS INFORMATION DEVISED BY ONE JAN ADKINS, A WILY FELLOW (1971)

It almost takes an adult to tolerate the straightforward instructions for the techniques of building sand castles as an ingredient of a book about the development and structure of the medieval castle. The terminology (and the hand-lettered text) make the book too difficult for young children; the sand castle pages make it too juvenile for the older child. There is information about castles, but not as much as there is in Boardman's book on the subject. The writing has some humor, and the drawings are very attractive, but the interspersion of pages about what is basically imaginative play is out of proportion. Probably the book will appeal most to the child who already is interested in castles.

> *Zena Sutherland, in a review of "The Art and Industry of Sandcastles," in* Bulletin of the Center for Children's Books *(reprinted by permission of The University of Chicago Press; © 1971 by The Uni-*

versity of Chicago), Vol. 24, No. 10, June, 1971, p. 149.

A ponderous title for an imaginative book. If you and your family are lucky enough to have a beach in your summer, your hours on the sand will be greatly enriched by this book that contains both the history of sandcastles and architects' plans for their construction. An unlikely combination, but Jan Adkins brings it off—and with great style.

A review of "The Art and Industry of Sandcastles," in Publishers Weekly *(reprinted from the July 5, 1971 issue of* Publishers Weekly, *published by R. R. Bowker Company, a Xerox company; copyright © 1971 by Xerox Corporation), Vol. 200, No. 1, July 5, 1971, p. 50.*

Designed with an unobtrusive mastery of form and line the text and illustrations together serve both as a sophisticated guide to making sandcastles and as a record of the evolution of castle building in Europe. The explanation of various processes used to make sand structures and to build various kinds of actual castles is given in a pleasing, skillfully presented book for all ages. . . .

A review of "The Art and Industry of Sandcastles: Being an Illustrated Guide to Basic Constructions along with Divers Information," in The Booklist *(reprinted by permission of the American Library Association; copyright © 1971 by the American Library Association), Vol. 67, No. 22, July 15, 1971, p. 913.*

Both the subject and format here may attract a wide range of readers, for differing reasons. The author's clear line drawings depict early fortifications: a Saxon fort; a Norman keep; the Towers of London and of Roumeli Hissar (in Turkey); the Great Wall of China; and the development of the castles of Restormel and Pembroke. After a brief description, floor plan or cross-section, Adkins gives directions for making modified examples of each type with wet sand—molded, sliced and dug. Both the building techniques and the tossed-off historical references are for older children or a family of sandcastle devotees. Social studies teachers who could expand on Adkins sometimes misleading oversimplifications (regarding castle life, the decline of castles, etc.) would find useful material here. Tiny figures of people in his sketches add whimsy; the chatty text, sometimes bordering on cuteness, is written in a legible, informal italic. . . . All in all, an instructive, fun-ramble on sandcastle building that is doubtless the definitive work on the subject.

Ruth M. McConnell, in a review of "The Art and Industry of Sandcastles," in School Library Journal, *an appendix to* Library Journal *(reprinted from the September, 1971 issue of* School Library Journal, *published by R. R. Bowker Co./A Xerox Corporation; copyright © 1971), Vol. 18, No. 1, September, 1971, p. 147.*

"The master sandbuilder's most important gift: a romantic nature" was plainly given to artist and author Adkins, who has made his sand-colored book into a small tour de force. Part practical guide to molding in sand with old buckets, part convincing sketches of real sand castles on small rocks or by a forest of sea grass, part loving study of medieval life and times, this book is all his own. Every word of the text is hand-lettered, even the title page and the copyright notice. It is a book of sweeping views and great interiors, peopled with castlefolk of high degree and low. Let Saxons and Normans contend; for

some readers the masterpiece will be the Great Sandy Wall of China, molded full eight inches high, stretching fathoms down the beach, past rocks and a curious duck.

Philip Morrison and Phylis Morrison, in a review of "The Art and Industry of Sand Castles," in Scientific American *(copyright © 1971 by Scientific American, Inc.; all rights reserved), Vol. 225, No. 6, December, 1971, p. 112.*

HOW A HOUSE HAPPENS (1972)

A fictional framework, slight and contributing little to the book, supports a clear and detailed explanation of the work of architects and contractors in building houses. . . . The organization and explanations are very good, the only weakness of the book being the hand-printing, just enough harder to read than type to be a detriment.

Zena Sutherland, in a review of "How a House Happens," in Bulletin of the Center for Children's Books *(reprinted by permission of The University of Chicago Press; © 1972 by The University of Chicago), Vol. 26, No. 1, September, 1972, p. 1.*

"When Rosie's geranium fell into Charlie's pot of stew, they decided that they needed more space, a new home." The Purlins . . . can't find a ready-made one that meets their needs so they decide to have a house built for them. Mortgage arrangements, selection of a site and an architect (Alexander Pushpin and Associates), planning, excavating and building are all covered in detail. Each page resembles an architect's sheet: page numbers are sheet numbers, the subject is given and the title block reads "Pushpin & Assoc./Purlin Residence." Clear diagrams and drawings include details of tools the workmen carry and a cross section of the roof and foundation. When the house is completed the author reflects: "A house is most of all the people in it. . . . The Purlin family make the Purlin house. A house is a place to live in." . . . [The] spirit of a family launching into a house-building project and what the roof and walls surrounding us really mean are nowhere captured as accurately as in Adkins' *How a House Happens.* (pp. 108-09)

Barbara Gibson, in a review of "How a House Happens," in School Library Journal, *an appendix to* Library Journal *(reprinted from the October, 1972 issue of* School Library Journal, *published by R. R. Bowker Co./A Xerox Corporation; copyright © 1972), Vol. 19, No. 2, October, 1972, pp. 108-09.*

The layout of this book is unconventional; the illustrations are excellent in their lucidity; and the text, full of iconoclastic and humorous information, is lettered by the author. His originality is apparent on every page, each titled on the side. There is plenty to see and to learn, about such things as mortgages, contractors, architects, blueprints, etc. Although a picture book in appearance, its concepts and information remain far from simple. *How a House Happens* is a visual dissertation.

Louise C. Maglione, in a review of "How a House Happens," in Appraisal: Children's Science Books *(copyright © 1973 by the Children's Science Book Review Committee), Vol. 6, No. 3, Fall, 1973, p. 5.*

A simple, straightforward, accurate and perfectly delightful description of the fairly complex process of building a house.

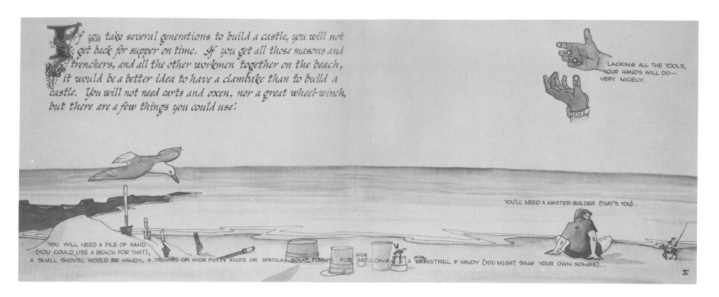

From The Art and Industry of Sandcastles, Being: An Illustrated Guide to Basic Construction Along with Divers Information Devised by One Jan Adkins, a Wily Fellow, *written and illustrated by Jan Adkins. Walker Publishing Company, Incorporated, 1971. Copyright © 1971 by that rascal, Jan Adkins. Used with permission from the publisher, Walker and Company.*

As technical as one would want for children, but no more than necessary.

> *David E. Newton, in a review of "How a House Happens," in* Appraisal: Children's Science Books *(copyright © 1973 by the Children's Science Book Review Committee), Vol. 6, No. 3, Fall, 1973, p. 5.*

The visual style is attractive but the matter-of-fact subject matter somewhat cramps Adkins' familiar flair for romance, and he has allowed his whimsy rather heavy play with dress, pets and names. A family brave enough to buck the current interest rates will find this book good reading for all, particularly for children in the early grades.

> *Philip Morrison and Phylis Morrison, in a review of "How a House Happens," in* Scientific American *(copyright © 1973 by Scientific American, Inc.; all rights reserved), Vol. 229, No. 6, December, 1973, p. 134.*

THE CRAFT OF SAIL (1973)

[A] very personal . . . introduction to wind, water and the craft of sailing. Adkins' affinity for his subject shows in every lovingly detailed and labeled drawing (many of specific boats), in his careful descriptions of the art of knot-tying and in his respect for weather. . . . Landsmen may have some trouble grasping the application of Bernoulli's "simple, subtle law of physics" to the hard realities of coming about and jibbing, but the glossary of sea terms, the page on the "sailorly skill" of choosing proper clothes and the lessons in navigation are designed to be pored over at leisure by seasoned salts and casual daydreamers alike.

> *A review of "The Craft of Sail: A Primer of Sailing," in* Kirkus Reviews *(copyright © 1973 The Kirkus Service, Inc.), Vol. XLI, No. 10, May 15, 1973, p. 569.*

As a book for the beginner, [*The Craft of Sail*] is not entirely successful. A novice sailor might well be discouraged by the discussion of vectors, airfoils, and detailed parts of a boat. And the book's usefulness is limited by its lack of a table of contents and its incomplete index (e.g., starboard is listed but not port). It is recommended, as additional reading for those people, regardless of age, who have been introduced to sailing and want to know more about the sport.

> *Inalea Mullen [later Inalea Weathers], in a review of "The Craft of Sail," in* Library Journal *(reprinted from Library Journal, August, 1973; published by R. R. Bowker Co. (a Xerox company); copyright © 1973 by Xerox Corporation), Vol. 98, No. 14, August, 1973, p. 2326.*

Ignoring racing rules and specialized tactics, this introduction to the art of sailing focuses on basic skills needed to handle a small boat. The sailboat is defined as a unique form of transportation—one which works in harmony with the forces of nature. The author clearly, easily, and pleasantly explains the reasons for specific actions and terms, as well as telling readers what to do. The illustrations will hold the attention of young readers, and older ones will also appreciate the brief, perspicuous explanations of difficult concepts.

> *Don Reaber, in a review of "The Craft of Sail," in* School Library Journal, *an appendix to* Library Journal *(reprinted from the October, 1973 issue of* School Library Journal, *published by R. R. Bowker Co./A Xerox Corporation; copyright © 1973), Vol. 20, No. 2, October, 1973, p. 111.*

[A] carefully designed introduction to the theories, techniques, and terminology of sailing. The author's organization, attention to visual detail, and ability to clarify complex principles and instructions with direct explanations and profuse drawings make this a pleasure to learn from for sailing buffs or beginners.

> *A review of "The Craft of Sail," in* The Booklist *(reprinted by permission of the American Library*

Association; copyright © 1973 by the American Library Association), Vol. 70, No. 3, October 1, 1973, p. 168.

Despite the visual handicap of text that appears handprinted and is often crowded, this is an excellent book on sailing. . . . Solidly packed with information, this is not for the casual reader but for a serious student of the craft of sail.

> *Zena Sutherland, in a review of "The Craft of Sail," in* Bulletin of the Center for Children's Books *(reprinted by permission of The University of Chicago Press; © 1974 by The University of Chicago), Vol. 27, No. 5, January, 1974, p. 73.*

TOOLCHEST: A PRIMER OF WOODCRAFT (1973)

"**Toolchest**" is one of the handsomest books to appear this season: a statement which will come as no surprise to those who remember Jan Adkins's "**Sandcastles.**" And, just as "**Sandcastles**" made you want to rush to the nearest beach to build one, so "**Toolchest**" arouses a passion for tools and woods and for the things you can create with them. "**Toolchest**" is a perfect example of how facts and style are combined to make a book of distinction.

> *Lavinia Russ, "How to Make Almost Everything," in* The New York Times Book Review *(copyright © 1973 by The New York Times Company; reprinted by permission), November 4, 1973, p. 62.**

Adkins introduces hand woodworking tools with the same evident devotion he applied to *The Art and Industry of Sandcastles* . . . and *The Craft of Sail*. . . . In the spirit of one who sees "the sawn board we buy for mere money at a lumber store" as "a cut out of life itself," he discusses grain (how it's formed, what it shows, how to work with it) and sets down in a chart the qualities (strength, hardness, finish, etc.) of 22 common woods, then explains in precise, practical terms and accurate, loving pictures the uses and habits of various measuring, cutting, shaping and other hand tools. There are no specific step-by-step projects here, but unlike existing saw-along-the-dotted-line primers, Adkins communicates a solid sense of rapport with his materials.

> *A review of "Toolchest," in* Kirkus Reviews *(copyright © 1973 The Kirkus Service, Inc.), Vol. XVI, No. 22, November 15, 1973, p. 1266.*

Meticulously illustrated with drawings that show exact details of tools, hardware, wood grains, and techniques, this is a superb first book for the amateur carpenter. . . . This most useful book concludes with advice on the care of tools. A fine piece of craftsmanship, both in example and in execution.

> *Zena Sutherland, in a review of "Toolchest: A Primer of Woodcraft," in* Bulletin of the Center for Children's Books *(reprinted by permission of The University of Chicago Press; © 1974 by The University of Chicago), Vol. 27, No. 8, April, 1974, p. 121.*

Demonstrating his respect and understanding for working with wood, the author gives a meticulous and practical primer on woods and hand tools. Profusely illustrated with precise and attractive drawings accompanied by descriptive and clear captions, the text and pictures are not only informative and helpful, but provide pleasure even for those who may never saw a board or drive a nail in straight.

> *Isabel McCaul, in a review of "Toolchest," in* Top of the News *(reprinted by permission of the American Library Association), Vol. 30, No. 3, April, 1974, p. 307.*

All sorts of tools are examined and explained. Illustrations are profuse, with exquisite detail. Well written text for the mature reader; illustrations a marvelous resource for the child interested in building.

> *A review of "Toolchest: A Primer of Woodcraft" (copyright 1979 by the International Reading Association, Inc.; reprinted with permission of the International Reading Association), in* The Reading Teacher, *Vol. 32, No. 8, May, 1979, p. 945.*

INSIDE: SEEING BENEATH THE SURFACE (1975)

Seeing things "in section," which Adkins describes as another way of looking inside with your special "third eye," is the organizing concept here. Otherwise there's not much connection among Adkins' informal mini-essays which range from what pencils are made of, how feather pens used to work and the merits and demerits of ballpoints, to the layout of an airliner or ocean liner and the view inside a wall or under a city street. Adkins' tendency to be cute (about the DC-9: ". . . and we can charge tickets on a credit card"), to sound off ("humans have little talent for satisfaction") or just to ramble begins to cloy here, without the integrity of a *Toolchest* or *How a House Happens* to keep him on a track; and despite the comparison of how an engineer and a cook see the inside of an apple pie his approach here is neither aesthetic nor really technical. In the end this is more a sales talk for the inner eye than a lesson in how to use it, and only a bare introduction to the concept of visualizing "in section." However with Adkins' usual handsome draftsmanship to make it all concrete, that's probably enough.

> *A review of "Inside: Seeing Beneath the Surface," in* Kirkus Reviews *(copyright © 1975 The Kirkus Service, Inc.), Vol. XLIII, No. 22, November 15, 1975, p. 1289.*

This is one very fine book. It teaches, not preaches, seeing with the inner eye, and—by extension—imagination and empathy. Warm, colloquial, factual, it leads the mind from the concept of sight to that of insight. It does so by revealing the various aspects of common things, by looking at them from different angles, by probing them in cross-section. . . .

Jan Adkins, using specifics, gets at the spirit of real interest in things. If I've ever encountered a book with the potential for convincing my kids it was fun to look and to think, this is it. (Now we'll see, won't we?) No nonsense. A fine book.

> *Louise Armstrong, in a review of "Inside: Seeing Beneath the Surface," in* The New York Times Book Review *(copyright © 1975 by The New York Times Company; reprinted by permission), November 16, 1975, p. 46.*

[Jan Adkins] has skillfully drawn such objects as half an apple, a submarine sandwich, pencils and pen, an airliner, a house, and a harbor, and has led his readers to look more insightfully below the surface of things. . . . The author-artist expresses his ideas well, accents them with discerning wit, and, putting together his two-color illustrations in half tones, comes up with a book to look at and think about for hours.

Barbara Elleman, in a review of "Inside: Seeing Beneath the Surface," in The Booklist *(reprinted by permission of the American Library Association; copyright © 1976 by the American Library Association), Vol. 72, No. 11, February 1, 1976, p. 763.*

Adkins' meticulously drawn pictures are finely detailed drawings of a random selection of objects . . . , all in cutaway diagrams. . . . The book gives information, the illustrations are precisely informative—but the random arrangement and the combination of factual material and reiterated statements about vision don't quite mesh. There is neither index nor table of contents to give access to topics.

Zena Sutherland, in a review of "Inside: Seeing Beneath the Surface," in Bulletin of the Center for Children's Books *(reprinted by permission of The University of Chicago Press; © 1976 by The University of Chicago), Vol. 29, No. 8, April, 1976, p. 121.*

THE BAKERS: A SIMPLE BOOK ABOUT THE PLEASURES OF BAKING BREAD (1975)

Adkins does more than tell you how [to make bread]. . . . [He] traces bread through history up to its unhappy, denatured appearance on supermarket shelves (he becomes a little strident here, but who can blame him?) and explains what each ingredient contributes to the baking process. There are recipes for bagels, pita and cornbread in addition to the longer, chattier one for a whole wheat loaf, and Adkins' characteristic drawings blend fondness and accuracy for an effect that, at its best, is reminiscent of Tunis. (pp. 135-36)

A review of "The Bakers," in Kirkus Reviews *(copyright © 1976 The Kirkus Service, Inc.), Vol. XLIV, No. 3, February 1, 1976, pp. 135-36.*

Adkins imparts knowledge, humor, and enthusiasm for a subject he obviously loves. . . . Adkins' personalized treatment of the history, content, and methods of breadbaking is just right. Only one discrepancy: the first—and main—bread recipe says that whole-wheat or white flour can be used interchangeably. Still, all potential breadbakers should read this loving book. . . .

Carolyn Jenks, in a review of "The Bakers," in School Library Journal *(reprinted from the March, 1976 issue of* School Library Journal, *published by R. R. Bowker Co./A Xerox Corporation; copyright © 1976), Vol. 22, No. 7, March, 1976, p. 98.*

It has become increasingly popular to bake one's own bread, and Adkins is an enthusiastic advocate of the art. His step-by-step instructions are preceded by an episodic history of bread-making that is mildly interesting but hardly necessary. . . . This isn't the most detailed or most comprehensive book on breadbaking that's available, but the brevity of the text and the informal writing style may attract some otherwise-reluctant bakers. The illustrations are not the author-artist's best work.

Zena Sutherland, in a review of "The Bakers," in Bulletin of the Center for Children's Books *(reprinted by permission of The University of Chicago Press; © 1976 by The University of Chicago), Vol. 29, No. 9, May, 1976, p. 137.*

I have never met Jan Adkins, but I suspect he is someone with whom I might enjoy a chat. His slender volume is written in understandable English, and he is no doubt sincere in his desire to encourage young readers to go into the kitchen to make an honest loaf. He couches his instructions in thoughtful phrases. . . .

When I first took Adkins's book into my kitchen I offered it to a friend, a good cook who has never baked a loaf in his life, and asked him if he would volunteer to follow the principal breadmaking technique outlined in **"The Bakers."** The friend was left more or less to his own devices, and the two loaves that resulted were quite edible. Not startlingly good, but acceptable.

Next morning another guest took a turn at the book's "Ship's Biscuits." These too were O.K., although they could have remained in the oven to good advantage much longer.

These were first efforts by rank amateurs and, as stated, acceptable. My only wonder is whether a book of 32 pages—although agreeable to read—is really needed to accomplish the basic purpose of **"The Bakers"**: to teach someone to bake a decent loaf. There are numerous, excellent, thorough-going volumes on breadmaking available in book stores. . . . They may be written in less elaborate but equally understandable terms, which to my mind could be comprehended quite easily by bakers ages 11 or 12 and up. There are only six recipes for baked breads in **"The Bakers,"** and all the rest is prose. That's a scant quarter-cup of recipes according to my measurements.

Craig Claiborne, in a review of "The Bakers," in The New York Times Book Review *(copyright © 1976 by The New York Times Company; reprinted by permission), May 2, 1976, p. 41.*

LUTHER TARBOX (1977)

"Luther Tarbox" is solidly in the tradition of Yankee craftsmanship. Trim pencil-and-wash sketches in a handsome binding introduce a cheerful lobsterman. . . . Luther's stock of New England lore and songs and the steadily growing parade of vessels make this a natural for reading aloud or alone.

Joyce Milton, in a review of "Luther Tarbox," in The New York Times Book Review *(copyright © 1977 by The New York Times Company; reprinted by permission), October 30, 1977, p. 34.*

Warm, richly detailed charcoal drawings of boats and ships are, unfortunately, left high and dry by a less than average story line.

Hayden Atwood, in a review of "Luther Tarbox," in School Library Journal *(reprinted from the November, 1977 issue of* School Library Journal, *published by R. R. Bowker Co./A Xerox Corporation; copyright © 1977), Vol. 24, No. 3, November, 1977, p. 42.*

A brisk and salty tale is illustrated with soft black and white drawings that, like the text, have a small surprise at the close. . . . Caught in a fog while pulling lobster traps, Luther is accosted by a series of people who can't find their way back to harbor. Luther makes them wait while he gets around to all his traps; he sings as he works; his retinue dutifully follows him: a motorboat, a cabin cruiser, and Coast Guard vessel, and more. Fortunately his wife has made enough chowder for everybody, so they are all happy, almost as happy as Luther. Adkins conveys the appeal of the sea, and the story moves along nicely;

it's not very substantial, but it's original and occasionally humorous.

*Zena Sutherland, in a review of "Luther Tarbox,"
in* Bulletin of the Center for Children's Books *(reprinted by permission of The University of Chicago
Press; © 1978 by The University of Chicago), Vol.
31, No. 6, February, 1978, p. 89.*

Luther's salty conversation is as canny as his navigation, and the exchanges among his fellow sailors characterize each of them with economy and humor. The language of the book is rich and rhythmic; some of the detailed black-and-white pictures are drawn from unexpected angles.

Charlotte W. Draper, in a review of "Luther Tarbox," in The Horn Book Magazine *(copyright ©
1978 by The Horn Book, Inc., Boston), Vol. LIV,
No. 1, February, 1978, p. 42.*

WOODEN SHIP (1978)

As attractive as the author-artist's previous work, the book is filled with meticulously drawn illustrations in pencil and pen-and-ink on cream-colored backgrounds. The writing has neither the light and playful tone of *The Art and Industry of Sandcastles* nor the clear directness of *Inside: Seeing Beneath the Surface*. . . . Attempting to combine the story of two nineteenth-century entrepreneurs with a technical description of the building of a ship, the text becomes at times too heavily laden with facts; and the imitation of the period style of narration adds to the ponderous effect. Yet a wealth of information may be gleaned from the pages; the visual presentation of the ship under construction is outstanding, reminiscent of the work of David Macaulay. Step-by-step drawings—all carefully labeled—show such events as laying the keel, fitting the timbers, caulking the seams, and stepping the mast. "Knowing how to build a ship is a skill that began six thousand years ago," and

From Luther Tarbox, *written and illustrated by Jan Adkins.*
Charles Scribner's Sons, *1977. Copyright © 1977 Jan Adkins. Reprinted with permission of Charles Scribner's Sons.*

the book reveals a deep respect and appreciation for that knowledge. (pp. 512-13)

*Karen M. Klockner, in a review of "Wooden Ship,"
in* The Horn Book Magazine *(copyright © 1978 by
The Horn Book, Inc., Boston), Vol. LV, No. 5, October, 1978, pp. 512-13.*

A beautifully illustrated story of the building of a wooden whaling ship, by an author who obviously has a deep reverence for traditional New England craftsmanship as practiced in the boatyards of the 19th Century. The pictures are lovely pencil and ink drawings, the diagrams of the ship's framing and timbers are clear, and the various tools used by the shipwrights of the 1860s are carefully labelled. There is a date at the bottom of the pages to indicate the chronological progress of the ship's construction. Not only are the technical aspects of ship building discussed, but the author presents the economic conditions that fostered the growth of the 19th-Century whaling industry. The text is brief and clear—Adkins gives shipbuilding the same sort of treatment that David Macaulay gives the building trades and architecture.

Phyllis Ingram, in a review of "Wooden Ship," in
School Library Journal *(reprinted from the October,
1978 issue of* School Library Journal, *published by
R. R. Bowker Co./A Xerox Corporation; copyright
© 1978), Vol. 25, No. 2, October, 1978, p. 152.*

Readers young or old, whose interests embrace 19th-century whaling and whale ships, will no doubt enjoy this fine new book by author-illustrator Jan Adkins. . . . Through beautiful ink and pencil illustrations and a detailed text, Mr. Adkins lovingly charts the birth of a fictitious 1870s wooden whale ship, the Ulysses. From the drafting of her plans by one Percival Knowlton, master shipbuilder, to the laying of her keel, the fitting of her ribs, the stitching of her sails and beyond, we are present at every major step of the Ulysses creation. Mr. Adkins is to be credited especially for re-creating the *feel* of the shipyard environment; one can practically hear the ring of the caulker's mallets, smell the oakum caulking as it's driven into place. My one complaint is that the text sometimes bogs down in all its shipbuilding terminology; a landlubbing reader like myself would have benefited enormously from a glossary. Otherwise, this is a lovely book, one to whet the imaginations of readers, present and future, of that other whaling book, "Moby Dick."

*William Jaspersohn, "If a Goose, a Dove, and a
Ship Could Talk," in* The Christian Science Monitor
(reprinted by permission from The Christian Science
Monitor; *© 1978 The Christian Science Publishing
Society; all rights reserved), October 23, 1978, p.
B2.**

If the clipper ship was a thing of beauty, what was the wooden whaling ship? Jan Adkins, in **"Wooden Ship,"** doesn't dwell on the beauty; instead, he tells us how the wooden whaling vessels were built. Fortunately, in the lexicon of shipbuilding there is no place for jargon. Every term is blunt and honest. Every stick, joint, beam, bolt, plank and timber must fit, and the oakum must stick. Building a wooden whaling ship is a precise and careful undertaking, and Mr. Adkins has laid it out precisely and carefully. . . .

How [the ship begins to take form] is set forth clearly and simply—one might say plank by plank, timber by timber—in **"Wooden Ship."** The text is brief and clear and the drawings

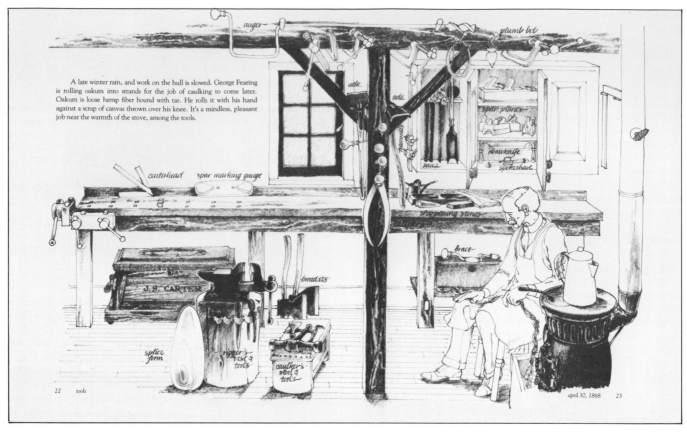

A late winter rain, and work on the hull is slowed. George Fearing is rolling oakum into strands for the job of caulking to come later. Oakum is loose hemp fiber bound with tar. He rolls it with his hand against a scrap of canvas thrown over his knee. It's a mindless, pleasant job near the warmth of the stove, among the tools.

From Wooden Ship, *written, designed and illustrated by Jan Adkins. Houghton Mifflin Company, 1978. Copyright © 1978 by Jan Adkins. Reprinted by permission of Houghton Mifflin Company.*

are large. The book is as clean and sturdy as the ship it tells you how to build. (p. 77)

> *Rex Benedict, "Trains and Boats," in* The New York Times Book Review *(copyright © 1978 by The New York Times Company; reprinted by permission), December 10, 1978, pp. 77, 91.*

SYMBOLS: A SILENT LANGUAGE (1978)

Reproductions of road signs, maps, math symbols, logos, trademarks, coats of arms, flags and insignia are haphazardly assembled here and fed to hapless readers with a commentary that defies decipherment. The author states that playing cards and chessmen are symbols—of what? "The striped shirts of the referees . . . are symbols of their functions," and "hand signals are important signs," Adkins states, using the terms symbol, sign, signal, code and trademark interchangeably—and erroneously. Visual inaccuracies include a strange looking dollar sign, a musical "flat" occupying two spaces of the staff, and the Scorpio symbol credited to the month of October. There is an unnecessarily complicated section on maps; religious symbols are presented as proprietary designs, on a par with heraldry and trademarks. The process of symbol creation, including not only the visual but also the auditory and conceptual spheres, is not hinted at. In any event, several biggies like A&P, AT&T and Pepsi will get some free publicity from this maelstrom of muddled thinking and ungrammatical meanderings.

> *Daisy Kouzel, in a review of "Symbols: A Silent Language," in* School Library Journal *(reprinted from the January, 1979 issue of* School Library Journal, *published by R. R. Bowker Co./A Xerox Corporation; copyright © 1979), Vol. 25, No. 5, January, 1979, p. 50.*

Symbols play a bigger role in our lives than we realize, says Adkins, and submits hundreds of examples to prove his point. . . . Some confusion results from combining semaphores and Braille markings for different letters on the same page, or musical notations and playing cards; and a few of the inclusions (black criss-crossed lines on a red field supposedly signifying "house") are puzzling because they lack explanation. However, the variety is entertaining, and an older audience than for Stewig's *Sending Messages* . . . will find that the implications shown here bring new awareness of symbology.

> *Barbara Elleman, in a review of "Symbols: A Silent Language," in* Booklist *(reprinted by permission of the American Library Association; copyright © 1979 by the American Library Association), Vol. 75, No. 11, February 1, 1979, p. 862.*

In a 32-page picture-book format, Adkins presents an introduction to symbols suited—in the sophistication of its concepts and expression—to a sixth- or seventh-grader. "There is," for example, "a variety of shapes for warning signs: triangles warn of specific hazards; circles restrict or prohibit; squares advise or require." Among the several hazards enclosed in a triangle are—with seeming unselectivity—"slippery" and "corrosive"; the single squared-off requirement (certainly not self-

explanatory) is "gloves must be worn." Another good idea gone astray is the internationally-legible auto dashboard: we see a multiplicity of gauges and controls, only some of which are decipherable at sight—and have, instead of keyed labels, a bottom-of-the-page list. In every case, moreover, the meanings of the symbols—whether "swamp," "handicapped access," or "Michelangelo"—appear in tiny, 6-point type. But that is just one more example of the very limited attention given to a child's interests, aptitudes, or frame of reference. A teacher, however, might find useful direction here, as well as a multiplicity of examples.

> *A review of "Symbols: A Silent Language," in* Kirkus Reviews *(copyright © 1979 The Kirkus Service, Inc.), Vol. XLVII, No. 3, February 1, 1979, p. 127.*

The author-artist discusses the history and development of symbols and stresses their value in the modern world. . . . Realistic pencil drawings contrast with the graphically simple symbols, effectively showing the importance of abstraction for quick communication. Though on one page the juxtaposition of different types of symbols is confusing, the book is well-designed on the whole, and even the copyright page is devised to indicate some of the many uses of symbols. A conceptual rather than a comprehensive study, with a short list of suggested reading. (pp. 203-04)

> *Kate M. Flanagan, in a review of "Symbols: A Silent Language," in* The Horn Book Magazine *(copyright © 1979 by The Horn Book, Inc., Boston), Vol. LV, No. 2, April, 1979, pp. 203-04.*

MOVING HEAVY THINGS (1980)

Many books deal with aspects of this subject in a chapter . . . , but few focus totally on the science and art of moving weighty objects. Traditional principles for multiplying strength and reducing friction are cataloged along with descriptions of clever and ingenious techniques. Included is a list of 16 commonsense precepts which should always be taken into account when tackling a moving problem. Clear, attractive and often humorous drawings enrich and increase understanding of the text.

> *Don Reaber, in a review of "Moving Heavy Things," in* School Library Journal *(reprinted from the August, 1980 issue of* School Library Journal, *published by R. R. Bowker Co./A Xerox Corporation; copyright © 1980), Vol. 26, No. 10, August, 1980, p. 73.*

If you know a youngster of ten or more with a ruminative turn of mind, a considerable technical vocabulary, and no objection to a 10 x 6¾" picturebook format (or a title out of second grade), you have a prospect, perhaps, for Jan Adkins' country-slicker coverage of how to expeditiously move heavy things beginning with proper use of the body. Actually, Adkins precedes that worthwhile information with 16 abstract precepts, including *"The Aristotelian Approach"* ("In short, think about it") and *"Applied Sloth"* ("Creativity germinates in indolence . . ."). Then, with friction, we get a whole catalogue of friction-lessening devices ranging in complexity from a tarpaulin to a cradle for moving a boat—whose structure and operation are illustrated and described in detail. Equally suggestive, though less extensive, are the sections on lines and knots, the block-and-tackle, levers, wedges, jacks, winches, and barrels. While it would be difficult to, say, pull a stump merely on the basis of the instructions here, this does provide an introduction to the principles and equipment involved. A philosophical primer,

then; and, as it happens, a much less efficient aid than those it recommends.

> *A review of "Moving Heavy Things," in* Kirkus Reviews *(copyright © 1980 The Kirkus Service, Inc.), Vol. XLVIII, No. 15, August 1, 1980, p. 980.*

This little book is an engaging, ingenious, beautifully drawn primer of engineless moving, set in the ambience of New England but as universal as the stars.

All the work begins with muscle and bone, and a valuable four pages tell and picture how to use the body efficiently and safely, including the movers' straps, the tumpline and the two-person carry. Adkins is no dilettante; his aim is effect, and so he does not fail to remind the reader that "a big, powerful friend" is no mean ally and that sometimes the rollers will scratch the floor; sometimes too it is cheaper to call in the engines and be done with it. When the case is clear for moving by hand, however, the rigger's path to prowess is made clear with good sense and directness. (pp. 47-8)

> *Philip Morrison and Phylis Morrison, in a review of "Moving Heavy Things," in* Scientific American *(copyright © 1980 by Scientific American, Inc.; all rights reserved), Vol. 243, No. 6, December, 1980, pp. 47-8.*

An illustrated book about the use of simple machines to move heavy objects could be both fascinating and instructive. Unfortunately, this book seems to be more fascinating than instructive. It is, however, hard to believe that a book about this subject could be so thoroughly entertaining. But it may not be entertaining to a reader who does not already know the subject matter. Junior high school students who read it for me found the drawings to be interesting, but the text obscure. The introductory material seems to be too whimsical for some students and a bit too "cutesy" for others. This book is obviously not meant to replace a good science book about simple machines; yet, that is a large part of the subject. The author only says: ". . . here are some kindergarten basics, a primer of moving." Evaluating it as a science book, we must find it to be a poor one. Topics are treated unevenly, despite their relative merit. Certain concepts seem to be illustrated and explained in much greater detail than other concepts of equal or greater interest. For example, on pages 30 and 31, we are treated to an elaborate discussion of tension upon sling supports. Even a table of factors is included to further make the point. Yet, on page 39, a parallelogram of forces appears without the slightest explanation. The text does not even mention the parallelogram, despite its importance as a highly generalizable, useful concept. Although meant as a "primer of moving," it is doubtful that the uninitiated reader could learn enough from this book to safely go about moving heavy objects. Perhaps it is entirely beside the point to consider this book science or anything more than good entertainment. (pp. 8-9)

> *Clarence C. Truesdell, in a review of "Moving Heavy Things," in* Appraisal: Science Books for Young People *(copyright © 1981 by the Children's Science Book Review Committee), Vol. 14, No. 3, Fall, 1981, pp. 8-9.*

[The] representational drawings of Jan Adkins can explain almost anything. Imagine trying to explain in words alone the technique for tying a ring hitch, or how to operate a "luff," to say nothing of a "comealong," or the best way to move a piano. His clear illustrations in *Moving Heavy Things* . . . are

From Moving Heavy Things, *written and illustrated by Jan Adkins. Houghton Mifflin Company, 1980. Copyright © 1980 by Jan Adkins. Reprinted by permission of Houghton Mifflin Company.*

reinforced by equally clear verbal instructions, a combination that is hard to beat in nonfiction books for children. (p. 47)

> Jo Carr, *"Clarity in Science Writing," in* Beyond Fact: Nonfiction for Children and Young People, *edited by Jo Carr (copyright © 1982 by The American Library Association), American Library Association, 1982, pp. 43-53.**

HEAVY EQUIPMENT (1980)

Brief descriptions and clean sketchbook-like drawings of graders, backhoe/loaders, cranes, excavators, and other mobile construction giants. Adkins' early explanation of hydraulics is more abbreviated than elegant, and his general comments are flat; but his descriptions of individual machines should win some respect for the drivers and awe of the supergiants' stupendous dimensions.

> *A review of "Heavy Equipment," in* Kirkus Reviews *(copyright © 1981 The Kirkus Service, Inc.), Vol. XLIX, No. 1, January 1, 1981, p. 9.*

Jan Adkins has an infectious fascination with how things work, and a sure eye and hand for detail. Here he uses his pen and brush to give us clear, delicate drawings of the big earth-moving machines. . . . The drawings alone would be enough for most children, but there is also a quirky, interesting text.

> *Robert Wilson, in a review of "Heavy Equipment," in* Book World—The Washington Post *(© 1981, The Washington Post), January 11, 1981, p. 7.*

With a brief appealing text the book introduces younger readers to the equipment that "can clear off a forest for the lumber, lift off the soil to bring up ore and coal, fill a swamp to let a road pass." Compactors, excavators, loggers, and numerous other big machines lumber across the pages, each one depicted in detailed ink-and-wash drawings and described in an explicit text. Despite the mechanical nature of his subject, the author writes in a lucid manner, incorporating lively comparisons into the text to explain the machinery: The crawler drills, for instance, are "like loud insects" and "a good operator works a crawler delicately with his hands and feet, like a piano player." When particularly technical explanations become necessary to clarify such terms as *low ground pressure*, simple diagrams

supplement the larger illustrations. While the author stresses the power and diversity of road machinery, he warns against its abuse, ending on a cautionary note. . . .

> *Karen Jameyson, in a review of "Heavy Equipment," in* The Horn Book Magazine *(copyright © 1981 by The Horn Book, Inc., Boston), Vol. LVII, No. 1, February, 1981, p. 65.*

A page or two is devoted to each kind of machine, with a paragraph or two of text per page; most of the space (on some pages, all space) is taken up by Adkins's carefully detailed drawings, unfortunately not always provided with labels for parts. The text is written with adequate clarity for the most part, but occasionally there are explanations of how a machine works that are not adequate and that might be more comprehensible if labels for parts were included.

> *Zena Sutherland, in a review of "Heavy Equipment," in* Bulletin of the Center for Children's Books *(reprinted by permission of The University of Chicago Press; © 1981 by The University of Chicago), Vol. 34, No. 10, June, 1981, p. 185.*

Mr. Adkins' drawings of heavy equipment in action are a delight, and appear to be quite authentic as well. His text deals directly and simply with what these machines *do*, and whenever necessary he puts in detail about how something works—controls, crawler treads, footprint pressure, etc. I endorse his attempt to explain hydraulics, but in trying to explain both principle and application he got bogged down and did neither well. He also showed (and described) only a single-acting cylinder. A technical point, to be sure, but the machinery he shows simply will not work without double-acting cylinders, i.e., cylinders in which high-pressure oil can push on *either* side of the piston, producing his "enormous force" in either direction as needed.

Kids reading this book will probably wish it were longer than its 30 pages. I did.

> *Norman F. Smith, in a review of "Heavy Equipment," in* Appraisal: Science Books for Young People *(copyright © 1981 by the Children's Science Book Review Committee), Vol. 14, No. 3, Fall, 1981, p. 7.*

LETTERBOX: THE ART AND HISTORY OF LETTERS (1981)

This history of written communications covers the creation of pictographs and the development of alphabets and letter forms as well as the mechanical and electronic processes of today. The format and writing style are similar to other books by Adkins, such as **Toolchest: a Primer of Woodcraft**. . . . It is filled with interesting black-and-white pencil illustrations, samples of scripts, photographs and reproductions of letters and documents. These samples include the cartouches of Ptolemy and Cleopatra and letters of Elizabeth I and Nelson. This entertaining and imaginative work is an appreciation of letter and type styles, and also contains instruction on learning the italic hand. Cahn's *The Story of Writing* (Harvey, 1963) covers some of the same material, but Adkins' lively and enthusiastic approach is far more attractive and appealing. Suitable for beginning readers, **Letterbox** provides fresh material for older students and adults as well.

> *Lorraine Douglas, in a review of "Letterbox: The Art & History of Letters," in* School Library Journal *(reprinted from the August, 1981 issue of* School Library Journal, *published by R. R. Bowker Co./A Xerox Corporation; copyright © 1981), Vol. 27, No. 10, August, 1981, p. 61.*

The art and history of the written word is skillfully and elegantly unfolded in a handsomely designed book that will attract young calligraphers, researchers, and browsers. . . . The variety of typefaces in print, as well as the many kinds of hand-formed letters, are illustrated and commented upon with the author-artist's well-known precision, wit, and attentive style. An inspiring guide to perfection of penmanship. No index.

> *Barbara Elleman, in a review of "Letterbox: The Art and History of Letters," in* Booklist *(reprinted by permission of the American Library Association;*

copyright © 1981 by the American Library Association), Vol. 78, No. 1, September 1, 1981, p. 40.

[This] is another of Adkins' earnestly high-toned, craft-looking anomalies—if anything, less effective than usual because it's more ambitious. He's tracing writing (the letters of the alphabet), and type-faces, and communications over the ages (to electronic instruments); at the close, he appends some pointers on practicing calligraphy. There's lots of fine calligraphy in evidence, but that's all most youngsters will get out of this. Adkins has a penchant for throwing information together into a sort of cultural collage: "When Greek characters were developed over centuries they included vowels, new characters, and some attractive curves." The information is not infrequently esoteric: re calligraphy—"The *cancellaresca* evolved into the *ronde* (developed in the French financial ministry) and then to commercial hands we recognize today as scripts." The writing has a way of sounding impressive—and not quite making sense: "Do you also see the dangers and discomforts of a net of communication with a web so fine as to strain the simplest and most necessary human needs?" Given the number of books (on the juvenile, YA, and adult level) that cover the same material clearly and systematically, this can well be left to exhibits of creative enterprise. (pp. 1084-85)

> *A review of "Letterbox: The Art and History of Lettering," in* Kirkus Reviews *(copyright © 1981 The Kirkus Service, Inc.), Vol. XLIX, No. 17, September 1, 1981, pp. 1084-85.*

This review ought to be inscribed calligraphically on fine rag paper with a reed pen to properly capture the spirit of Jan Adkins's new book. The author says he has been fascinated by letters since high school, and his loving treatise on their art and history should intrigue similarly interested high school students and their elders. . . .

From Letterbox: The Art and History of Letters, *written, illustrated and designed by Jan Adkins. Walker and Company, 1981. Copyright © 1981 by Jan Adkins, confused but persistent. Used with permission from the publisher, Walker and Company.*

Mr. Adkins's enthusiasm for his subject is contagious. Sometimes, however, his expertise leads him to assume like knowledge on the part of his readers. A sharp editorial eye could have clarified textual ambiguities and assured that all basic definitions were present and precise.

What must be an overwhelming abundance of material has been well weeded and generously illustrated. The limits of such a survey do not permit going deep into any specific area. But there is much intriguing information that should lead the curious to further explorations on the subject of capital letters, for example, so named because they were chiseled into the capitals of columns. Or "boustrophedon" (literally "ox-turning"), the Greek method of writing one line left to right and the next right to left. And why not study more about eccentric antique typewriters such as the "Literary Piano," first touted by Scientific American in 1867 or the "Bennett," just two inches high with 84 characters or, in this corner, the aptly named "Megagraph" weighing in at 400 pounds and six feet high? Knock that off the desk and it might be wise to return to your nice reed pen. Mr. Adkins thinks so. He ends, as he began, with a heartfelt brief for the beauties of calligraphy. May he inspire many artistic heads and steady hands. (pp. 49-50)

> *Karla Kuskin, in a review of "Letterbox: The Art and History of Letters," in* The New York Times Book Review *(copyright © 1981 by The New York Times Company; reprinted by permission), September 13, 1981, pp. 49-50.*

This is simply a beautiful book! From prehistoric pictographs to complete communications technology of the eighties, the author traces the art and history of the written word and stirs readers of all ages to perceive writing and printing with new eyes, with appreciation and sensitivity, and with awareness of the distinctions between varying ages.

This book is handsomely produced: the graphic quality and the illustrations alone are worth its price.

> *David W. Baker, in a review of "Letterbox," in* School Arts *(copyright 1982 by Davis Publications, Inc.), Vol. 82, No. 2, October, 1982, p. 37.*

A STORM WITHOUT RAIN (1983)

Not wanting to give a speech at his grandfather's ninety-third birthday party, 15-year-old Jack sails away to an island near his Cape Cod home, where he is caught in an unnatural storm and finds himself transported back to 1904. There, a stranger in his own town, he is befriended by young John Swain, whom he realizes is his own grandfather. Though some suspense is introduced through Jack's dilemma and the despicable Higgins, who is out to get him, the story's thrust is the mystery of time and of people caught in its layers, which Adkins provocatively addresses. Vivid descriptions of the sights, sounds, and smells of the bay area in 1904 add atmosphere, and sailing buffs will know the author's love of sailing, which surfaces time and again in this intriguing tale.

> *Barbara Elleman, in a review of "A Storm without Rain," in* Booklist *(reprinted by permission of the American Library Association; copyright © 1983 by the American Library Association), Vol. 79, No. 16, April 15, 1983, p. 1089.*

This, Adkins's first novel, is superior fare, like his award-winning nonfiction *The Craft of Sail, The Art and Industry of Sandcastles,* et al. . . . The people [Jack] meets and the things he learns are story elements that will keep readers immersed in events that Adkins limns lyrically and convincingly.

> *A review of "A Storm without Rain," in* Publishers Weekly *(reprinted from the June 24, 1983 issue of* Publishers Weekly, *published by R. R. Bowker Company, a Xerox company; copyright © 1983 by Xerox Corporation), Vol. 223, No. 25, June 24, 1983, p. 58.*

[Jack's day on Penikese Island] changes not only his attitude but also his life, for it proves to be a portal, or a thin spot in time, through which he is transported to the year 1904, when Penikese was a leper colony and his grandfather a boy of fifteen. . . . The rapport between the two fifteen-year-olds leads to their working together to seek the means to return the time-traveler to his own era. The search introduces them to such personages as Mark Twain and the wood-carver Leander Allen Plummer, whose work hangs today in the New Bedford Public Library; it also gives them the opportunity to discuss the nature of time, thus adding credibility to the plot. Remarkable for its imagery, characterization, and sense of place, the novel defies classification. It can be considered fantasy, an excursion into history, or a moving study of the relationship between generations; but it is first of all an engrossing story, narrated in fluid, honed prose and drawn from a genuine love of the locale and its people. (pp. 448-49)

> *Mary M. Burns, in a review of "A Storm without Rain," in* The Horn Book Magazine *(copyright © 1983 by The Horn Book, Inc., Boston), Vol. LIX, No. 4, August, 1983, pp. 448-49.*

Arnold Adoff

1935-

American poet, biographer, and anthologist.

Using free verse and vivid sensory images, Adoff creates poems that express such diverse feelings as the security of family life *(Make a Circle, Keep Us In)*, the joy of black pride *(Big Sister Tells Me That I'm Black)*, the terror of a tornado *(Tornado!)*, and zest for good food *(Eats)*. He seeks to visually represent the literal meaning of words in a poem by including variations of line length, type size, and letter arrangement as well as syllable divisions in sometimes unconventional places; he rarely uses punctuation or capitals and sometimes employs black English. Adoff says, "I want words to sing and mean and be arranged into a form that can stand strong." His only biography, *Malcolm X*, presents its subject accurately and without sentimentality.

Concerned about social justice, Adoff taught high school in Harlem for many years. Acutely aware that the best black literature, especially poetry, was not readily available to his students, he compiled and edited numerous poetry anthologies *(Black Out Loud)* and prose collections by black authors *(Brothers and Sisters)*. Adoff married award-winning children's writer Virginia Hamilton; their two black-Jewish children provide the focus for several of Adoff's books for younger and middle-grade readers, including *Black Is Brown Is Tan*, the first picture book dealing with an interracial family.

Critcs praise Adoff for his striking word-pictures and lilting rhythm, as well as for the warmhearted emotions and sense of family which permeate his poetry. They consider his poems simple yet filled with meaning, but give his free verse form a mixed reception. Some find his word and line breaks to be more of a hindrance than a help in understanding the poem's meaning and reading it aloud. Despite some negative reaction to his style, Adoff continues to experiment and challenge his readers. He comments: "What I try to do with my work is open kids' heads—push out the limits and expand those elements called 'spirit' and 'soul.'" For his successful efforts, Adoff has earned a respected place among contemporary poets for children. The Jane Addams Peace Association awarded Adoff a special certificate in 1983 for *All the Colors of the Race*.

(See also *Something about the Author*, Vol. 5; *Contemporary Authors*, Vols. 41-44, rev. ed.; and *Authors in the News*, Vol. 1.)

AUTHOR'S COMMENTARY

[**Top of the News**]: Why do you write for children?

[**Arnold Adoff**]: All my anthologies, both all-black and integrated, have contained material written by adults, which I feel can be understood and appreciated by young people. My work has been as much directed at raising the literary level of all writing used in classrooms and libraries, as it has been to introduce the mass of black American literature neglected in this white mass-culture. *City in All Directions* was a collection of urban theme poems for teen-agers, and *Black Out Loud*, a book of black American poems for the grade school child. In both cases (and in all my books) the material selected must be

Photograph by Jill Gussow; courtesy of Arnold Adoff

the finest in literary terms as well as in content/message/racial vision. In the final analysis, my one hope left, is with the kids . . . my two, and their brothers and sisters across the country, and those a little older in the high schools and colleges. They must insist on the changes, on the truth. . . .

[TN]: Did any of your childhood reading leave a permanent mark?

[AA]: It taught me, in sum, how to walk a cultural tightrope: *Little Women* and Sholem Aleichem; *The Five Little Peppers* and *The Story of Chanukah*; Longfellow, Riley, and Peretz. . . .

[TN]: What did you read during your teen-age years?

[AA]: First, everything in the house, then all I could carry home each week from the libraries I could reach on Bronx buses. De Maupassant and Balzac and Shakespeare. Steinbeck and Dos Passos. The Golden Book Magazines of the thirties, along with Havelock Ellis and the deep eugenics manuals. Many books by Menninger and Horney, Steckel, and other psychologists. Poets and poets and poets.

[TN]: Who are your favorite poets?

[AA]: The poets who can sing and who can control their word-songs with all-important craft: Dylan Thomas and e. e. cum-

mings and Rilke . . . Marianne Moore and Gwendolyn Brooks; Robert Hayden, Clarence Major, Michael Harper.

[TN]: Contrast what you read as a child with books about black children today.

[AA]: Sambo and Uncle Remus (Africa and the American South) lead the parade. Movies and radio provided the rest; Aunt Jemima, Amos and Andy, Mantan Morland, and the other sick creations of a guilty and fearful nation. It was not until I was older, when Shirley Graham DuBois' superb biography of Frederick Douglass, *There Was Once a Slave,* was published, that I read of strong black men and women alive and breathing free. I went through Stuyvesant High School, City College, Columbia University Graduate School, etc., etc., all without studying, in any classroom, a single black American novelist, poet, or playwright.

Today, of course, books by and about black Americans are being published for young people, *but only in the minutest fraction of what publishing houses could produce* if there was total commitment to true cultural and literary equality in the industry and the nation as a whole. And the situation in textbooks for young people has changed little. For the vast majority of social studies and literature books, there is a long, long way to go, in recession and out, to bring the full and rich heritage of black American life and literature to black and to white kids. (pp. 153-55)

[TN]: Do you feel that a white writer can create an authentic portrait of a black man?

[AA]: Could John Updike write Malamud's *The Assistant;* Saul Bellow create O'Hara's Pottstown people; Pasternak be Moravia, and James Baldwin ride in the front of that *Streetcar Named Desire*? A fine writer leaps tall buildings (on Third Avenue) at a single bound . . . but there are limitations within the skin . . . limitations of language and music and the very depth of feelings that are never spoken, even to the closely loved. And who would dare say that this nation really *is* the fabled melting pot, and all peoples really live together and really know each other?

You may be married to a black woman for a dozen years, live within an extended and loving black family, and help raise two black (and white) kids of your own . . . but you never *become* black.

There is movement and understanding . . . deeper and more conscious living . . . there is much study and learning and the empathy of anger, frustration, and rage. But in this skin-sick country it is that thin layer which never changes . . . and carries with it all the cultural "genes" of long ago. To deny one's self is always the easy cop-out . . . always the easy denial of guilt, responsibility.

And in my small way, from the beginning of my publishing, I have laid down ground rules: always a black artist to illustrate a collection of black American literature I have assembled. (Or in the case of the *Malcolm X* picture book I wrote, John Wilson, a fine black artist from Boston to contribute his black vision to my vision of the man I loved and respected.) And I never do a critical essay or article on any aspect of black American literature or life. There are too many gifted, qualified, and intelligent black writers who could cut that kind of assignment as easy as cake. We don't need any more white "experts" on black Anything in this country. (pp. 155-56)

[TN]: Did your teaching experience or your experience with your own two children give you new concepts in terms of books for the very young or preschool children?

[AA]: Although I continue to do books for young adults and adults, I find myself being drawn to the younger age levels to try and make the change at the earliest exposure, to eliminate the very need for any "gap," to be a witness for the whole truth, if you will. . . . The opportunity to do the picture book *Malcolm X* was most welcome. I am now at work on . . . a collection of black American poems for the earliest grades and ages [*My Black Me: A Beginning Book of Black Poetry*]. Others will follow. You could say they were always for my own two children anyway. If I can lay Malcolm and DuBois on top of Sambo and Remus, will they finally die and disappear? And when you think you are making small dents in the consciousness . . . here come the old "Our Gang" comedies, still running Buckwheat and Farina, bless their beautiful heads. (p. 157)

[TN]: What was the intent, or purpose, behind the use of syllables or soundings in *MA nDA LA*?

[AA]: This book comes from experimentation in my own poetry, from my attempts to destroy the inherent meanings each word carries around with it (within its culture/medium), and to create new configurations, new words, new meanings. I realized that I had been this way before: when *I* first learned to read; that my children were learning to read in this same way . . . that it was the *music* that could make things *fun.* After a long time I made *MA nDA LA* from a longer poem I was working on. It really isn't a poem, but a word-song of "soundings" that tells only a minimal story. It is for the child to expand, through the use of imagination, from the music of the ma and da and the eventual ah. No words to tie him down. No set story beyond the outline of lovely and universal rural Africa as seen in the superb paintings of Emily McCully. It is an attempt to help free all children as they encounter a first book (remember they *are* free in their own unbook babble and experimentation until then). (p. 158)

[TN]: What advice do you have for future writers?

[AA]: You must learn to control: Yourself as a conscious individual; your craft, work habits, self-discipline; the very form of the poem or prose piece. You must believe you have the power. Always write, and study, with others and alone, the work of other writers that is relevant. Don't beat your head against doors. Use your fists! (p. 159)

Top of the News, *in an interview with Arnold Adoff, in* Top of the News *(reprinted by permission of the American Library Association), Vol. 28, No. 2, January, 1972, pp. 152-59.*

GENERAL COMMENTARY

X. J. KENNEDY

Girls who wear spikes and burn up tracks will identify with the speaker in Arnold Adoff's **"I Am the Running Girl"**. . . . Words are spaced out and wrenched about the page as in with-it open form poetry. In **"Eats"** . . . Mr. Adoff employs similar techniques to praise food . . .—but except for a few morsels, this one seems a banquet of diet soda. (p. 68)

X. J. Kennedy, "Rhythm and Rhyme," in The New York Times Book Review *(copyright © 1979 by The New York Times Company; reprinted by permission), November 11, 1979, pp. 53, 68.**

ALETHEA HELBIG

[In more serious poetry] lack of "substance"—what some might call poetic vision, or poetic integrity—and technical deficiencies become much more apparent since the element of humor is not present to divert one's attention from them. Take Arnold Adoff's recent [*Tornado, Eats,* and *I Am the Running Girl*], in all of which he very self-consciously sprinkles words about the page like the *avantgarde* poets, a technique which cannot magically turn them into poetry. Form alone cannot mask prosiness or make up for lack of imagery and music. (p. 41)

> *Alethea Helbig, "The State of Things: A Question of Substance," in* Children's Literature Association Quarterly, *Vol. 5, No. 2, Summer, 1980, pp. 38-45.**

BERNICE E. CULLINAN WITH MARY K. KARRER AND ARLENE M. PILLAR

Arnold Adoff writes song poems with rhythm and melody. *Big Sister Tells Me That I'm Black* . . . resounds with an exuberantly rhythmic chant: "we shout out loud / hip hip / hip hooray / hip hip / we Black today." *Black Is Brown Is Tan* . . . is a rhythmic story-poem about the beauty of the family that is all the colors of the human race. It is also a gentle celebration of the strength of family love, as is *Make a Circle, Keep Us In: Poems for a Good Day.* . . . The text here rambles all over the page in roughly circular fashion, underscoring the theme ideographically; the circle of love that makes a family is visible in text form. . . . (p. 285)

> *Bernice E. Cullinan with Mary K. Karrer and Arlene M. Pillar, "Poetry and Verse," in their* Literature and the Child *(copyright © 1981 by Harcourt Brace Jovanovich, Inc.; reprinted by permission of the publisher), Harcourt Brace Jovanovich, 1981, pp. 247-88.**

MALCOLM X **(1970)**

In effect a precis of *The Autobiography,* and as such potent. . . . As an aggregate, this is a fair—meaning just—representation of Malcolm's achievement and beliefs minus the substantiation and reflection of *The Autobiography.* And to that extent more polemical in effect, although it is hard to see, today, how else Malcolm could be presented, even to young children, without being emasculated.

> *A review of "Malcolm X," in* Kirkus Reviews *(copyright © 1970 The Kirkus Service, Inc.), Vol. XXXVIII, No. 8, April 15, 1970, p. 456.*

[*Malcolm X* is] one of the best books of the season. . . . Arnold Adoff's biography could be useful to would-be writers as a glowing example of *how* to write a biography. He tells Malcolm X's story straight, he doesn't omit the less admirable events in Malcolm X's life, but he presents him with admiration.

> *A review of "Malcolm X," in* Publishers Weekly *(reprinted from the April 20, 1970 issue of* Publishers Weekly, *published by R. R. Bowker Company, a Xerox company; copyright © 1970 by Xerox Corporation), Vol. 197, No. 16, April 20, 1970, p. 62.*

"**Malcolm X**" is the best of the [Crowell Biography series.] It never sentimentalizes or simplifies the complex motivations of its subject or the people in his life: his grim story emerges clearly. . . . This honest book introduces young readers to a remarkable man who articulated the emerging black consciousness.

> *Bernice Gross, "Five Men Above the Crowd," in* The New York Times Book Review, *Part II (copyright © 1970 by The New York Times Company; reprinted by permission), May 24, 1970, p. 39.**

Despite a clipped style this short forthright biography vividly outlines the events, both tragic and rewarding, which influenced the life and thought of Malcolm X from childhood to death and clearly evinces his significance as a black leader. The account describes the adverse effects of Malcolm's bitter childhood experiences, the changes which began during his incarceration in the Norfolk Prison Colony, his association with the Black Muslims and his later break with them, and the hostility of both black and white groups toward his Organization of Afro-American Unity. Although designed for young readers . . . , the book can be used with older reluctant readers.

> *A review of "Malcolm X," in* The Booklist *(reprinted by permission of the American Library Association; copyright © 1970 by the American Library Association), Vol. 66, No. 21, July 1, 1970, p. 1339.*

Mr. Adoff outlines many of the major events in Malcolm X's life, but gives little detail. The book can serve only as a simplified introduction to this black hero; but even as such it fills a gap since there are no other biographies of him for young children.

> *Merrilee Anderson, in a review of "Malcolm X," in* School Library Journal, *an appendix to* Library Journal *(reprinted from the September, 1970 issue of* School Library Journal, *published by R. R. Bowker Co./A Xerox Corporation; copyright © 1970), Vol. 17, No. 1, September, 1970, p. 98.*

A remarkably restrained biography for young readers in which hardly a sordid detail is spared in the life of the late, eloquent, and controversial black leader. Deceptively simple text and illustrations [by John Wilson] help to produce the picture of a vigorous character, without sensationalism.

> *Barbara Rollock, in a review of "Malcolm X," in* Top of the News *(reprinted by permission of the American Library Association), Vol. 27, No. 2, January, 1971, p. 208.*

MA NDA LA **(1971)**

Here is a charming game for children to play—a story poem to chant and shout and whisper. Strange words for lovingly familiar things (Ma is mother, Da is father) that an African family uses to celebrate the family circle and the cycle of life. Together, with words and pictures, Arnold Adoff and Emily McCully have created a poem of joy.

> *A review of "MA nDA LA," in* Publishers Weekly *(reprinted from the August 9, 1971 issue of* Publishers Weekly, *published by R. R. Bowker Company, a Xerox company; copyright © 1971 by Xerox Corporation), Vol. 200, No. 6, August 9, 1971, p. 47.*

A praise song to the earth, the African earth which produces corn for the family: planted by "MA" and ("n") "DA," . . . sighed for ("NA"), laughed at ("HA"), sung about ("LA"), cheered ("RA"), and inspiring happy feelings ("AH"). All this without words as such; rather, the song is sung in the abovementioned lilting sounds, the meaning conveyed by the sequence of sounds and by the stunning watercolor paintings. . . . This is a unique book to be shared intimately with

very young children, who will sing and interpret it as an experience never twice the same.

Gertrude B. Herman, in a review of "MA nDA LA," in School Library Journal, *an appendix to* Library Journal *(reprinted from the November, 1971 issue of* School Library Journal, *published by R. R. Bowker Co./A Xerox Corporation; copyright © 1971), Vol. 18, No. 3, November, 1971, p. 102.*

["**MA nDA LA**"] is a curious experiment with sound—seven monosyllables to be exact. Each of the syllables stands for a word or an idea . . . (although in what language, if any, we are never told), and Arnold Adoff has simply arranged and rearranged the monosyllables on each page. It is also never clear what relation [the illustrations] bear to the sing-song syllables. But maybe it would be fun to shout it all out.

Lisa Hammel, "A Sound Way of Learning," in The New York Times Book Review *(copyright © 1972 by The New York Times Company; reprinted by permission), January 23, 1972, p. 8.**

A beautiful but imperfect picture book which leaves a feeling of imbalance between text and [the almost self-sufficient] illustrations. . . . The recurring monosyllables of the text may sounded or sung, emphasized or accented in any way. . . . Now the adult scarcely requires the explanation—printed only on the dust jacket—but, for clarity, children might need to be told that "MA is mother; DA is father; LA is singing; HA is laughing." Again it is a note on the dust jacket, rather than in the book itself, that reveals the author's intent in his "story-poem that celebrates the circle of family and the cycle of life." For there is the obvious *double-entendre* in the title; since the word *mandala*, with its circular connotation, is a term used in psychology and art.

Ethel L. Heins, in a review of "MA nDA LA," in The Horn Book Magazine *(copyright © 1972 by The Horn Book, Inc., Boston), Vol. XLVIII, No. 1, February, 1972, p. 38.*

BLACK IS BROWN IS TAN (1973)

Black Is Brown Is Tan is warm is love is a beautiful picture of a family that has "all the colors of / the race." There is mom—"i am black / i am a brown sugar gown . . ." and dad—"I am white / i am light / with pinks and tiny tans." . . . There are two children and assorted relatives in assorted shades, all interacting with the unselfconscious harmony of colors in a rainbow. No strict divisions between sexes and colors are found here, but there is individuality and different styles. Both mom and dad cut wood, cook, read and sing to the children, kiss and hug, etc; and "chocolate cheeks and hands" also "darken in the summer sun." This book is a first in that it is about an interracial family; more important, however, is that it is an artistic achievement. Arnold Adoff's spare free verse combines familiar images in a startling original way (e.g., "hairbrush mornings / catching curls"). . . .

Marilyn R. Singer, in a review of "Black Is Brown Is Tan," in School Library Journal, *an appendix to* Library Journal *(reprinted from the September, 1973 issue of* School Library Journal, *published by R. R. Bowker Co./A Xerox Corporation; copyright © 1973), Vol. 20, No. 1, September, 1973, p. 54.*

Interracial families are more obvious in recent years and need more exposure to many children and adults. Arnold Adoff, in a first attempt on the subject, expresses in an easy poetic rhythm the feelings of being "black is brown is tan." . . . [The] text reads better if done aloud. Although this title is not the best, it deals fairly with the subject and serves as an important beginning in the field of easy books for children about different kinds of families.

Anne Wheeler, in a review of "Black Is Brown Is Tan," in Children's Book Review Service *(copyright © 1973 Children's Book Review Service Inc.), Vol. 2, No. 2, October, 1973, p. 9.*

Arnold Adoff has written a book of worth, mellowness and joy about himself and his family. . . . [They] are *real* people. This in itself is a major accomplishment since such couples (families) often meet with hostilities from each racial group. However, in his zeal to "humanize" this family (and other multiracial relationships) Mr. Adoff has, perhaps, painted too rosy a picture of family life. Neither parent "works" even though there is a typewriter in one of the drawings and there is no interaction with any one except other family members. Why? Why don't the children ever play with anyone other than their parents and relatives? It is true that the story has a country setting, but can they be that isolated? . . .

Quibbles aside, this book fills a definite need. It is all that we have to offer children about the multiracial family, and until something "perfect" comes along, my daughter *can* say, "That looks like us." The book also breaks down the traditional family role stereotypes—the mother is shown chopping pine wood as well as reading stories and cooking. The father is shown taking charge of cooking and bed preparation (baths, yelling, and all) at least part time. The parents are sharing! Mr Adoff tried hard. . . .

Ed Celina Marcus, in a review of "Black Is Brown Is Tan," in Interracial Books for Children *(reprinted by permission of* The Bulletin—Interracial books for Children, *1841 Broadway, New York, N.Y. 10023), Vol. 5, No. 4, 1974, p. 4.*

MAKE A CIRCLE, KEEP US IN: POEMS FOR A GOOD DAY (1975)

The circle of the title is made by Mommy . . . and Daddy . . . whose strong arms keep their two preschoolers secure and safe—even from a late night thunderstorm. As with any poetry collection, some verses are better than others, yet each is unique as Adoff experiments with line length, spacing, and type to make every poem a visual as well as a literary experience. Although the verse is well suited to young children, adults reading the poems aloud may have trouble adapting themselves to the freeness of form. Also, the poems are untitled with some complete on one page while others carry over to another which could be confusing. . . . [This] celebrates family strength in a way that is not sugar coated but very easy to take.

Carol Chatfield, in a review of "Make a Circle, Keep Us In: Poems for a Good Day," in School Library Journal *(reprinted from the May, 1975 issue of* School Library Journal, *published by R. R. Bowker Co./A Xerox Corporation; copyright © 1975), Vol. 21, No. 9, May, 1975, p. 45.*

Warm feelings overflow from Adoff's poetry, sometimes as a result but occasionally in spite of his experimental word ar-

rangements and syllable breakdowns, which create visual impressions and an awareness of letter sounds. Gadgety at first glance, the verses become more natural with rereading and unfold a child's-eye view of some normal indoor and outdoor activities throughout a rural family's day.

> *A review of "Make a Circle, Keep Us In: Poems for a Good Day," in* The Booklist *(reprinted by permission of the American Library Association; copyright © 1975 by the American Library Association), Vol. 71, No. 20, June 15, 1975, p. 1072.*

Here is a series of free form poems which use mundane experiences as subjects, but elicit a remarkable sense of warmth and intimacy. . . . However, the poems are so unstructured in the traditional sense that very careful reading is essential to make this a worthwhile experience for young children.

> *Arlene Stolzer, in a review of "Make a Circle Keep Us In: Poems for a Good Day," in* Children's Book Review Service *(copyright © 1975 Children's Book Review Service Inc.), Vol. 3, No. 13, July, 1975, p. 97.*

The author's poetic style is unusual for a children's book. Words are often arranged in a visual design, divided in surprising places (cri es) or have some letters above and below the plane. . . . Some words, like "broken" and "trip," are on a slant. This makes reading certain passages difficult, as the eye must move in uncustomary directions.

All of this seems to be aimed at making words look like what they mean. Letters in the word "broken" are split, "yells" and "loud" are larger than adjacent words and the final letters in "tall" get progressively larger. This is certainly an imaginative device, but one wonders how much it adds to the sentiments expressed.

Both mother and father express affection for their children . . . and jointly care for them. In the two instances when family harmony is broken, father yells and mother gives a "smack" in a "sneak attack."

For a change, father, not mother, is on a diet, and daughter wants to be a lawyer, a singer and a track star. The grandparents, however, maintain traditional sex roles: Grandpa farms and Grandma cooks and knits while telling tales of "marching women long ago with flags / and brave old songs." If this is a reference to the women's suffrage movement (rare in literature for young children) it deserved more explanation. (pp. 70-1)

> *"The Analyses: 'Make a Circle Keep Us In: Poems for a Good Day," in* Human—And Anti-Human— Values in Children's Books: A Content Rating Instrument for Educators and Concerned Parents, *edited by the Council on Interracial Books for Children, Inc. (copyright © 1976 by the Council on Interracial Books for Children, Inc.; reprinted by permission),* Racism and Sexism Resource Center for Educators, *1976, pp. 70-1.*

Hugs and scoldings, thunderstorms and spring days, are enhanced . . . by the shape and placement of the poems. . . . (p. 17)

In spite of the bad times—ripped pants and spilled milk—the message of the book is that the familiarity of home and the love of family produces a feeling of security in the child. . . .

With this backdrop, the child is prepared and strengthened for the world outside and the world ahead. (pp. 17-18)

> *A review of "Make a Circle Keep Us In," in* Curriculum Review *(© 1977 Curriculum Advisory Service; reprinted by permission of the Curriculum Advisory Service, Chicago, Illinois), Vol. 16, No. 1, February, 1977, pp. 17-18.*

BIG SISTER TELLS ME THAT I'M BLACK (1976)

Those who know the beauty of **Ma nDa La** . . . and the special comfiness of **Black Is Brown Is Tan** . . . will be sharply disappointed by . . . this superficial cheer for Blackness. The sentiments expressed are positive and positively predictable. . . . A dash of sexism is casually thrown in with the twice repeated line: "she says that black men must stand tall." (pp. 92-3)

> *Melina Schroeder, in a review of "Big Sister Tells Me That I'm Black," in* School Library Journal *(reprinted from the September, 1976 issue of* School Library Journal, *published by R. R. Bowker Co./A Xerox Corporation; copyright © 1976), Vol. 23, No. 1, September, 1976, pp. 92-3.*

These are really football cheers, but the game is growing up black and proud. The simple verses will work best chanted or danced with groups of preschoolers (or even younger ones bounced on a knee), who will pick up the exuberant rhythms of Adoff's patterned repetitions. . . . Fans of Adoff's **Black Is Brown Is Tan** . . . and **Make a Circle, Keep Us in; Poems for a Good Day** . . . will want this one, too.

> *Betsy Hearne, in a review of "Big Sister Tells Me That I'm Black," in* Booklist *(reprinted by permission of the American Library Association; copyright © 1976 by the American Library Association), Vol. 73, No. 1, September 1, 1976, p. 33.*

[This is a] celebration of blackness, as big sister tells her brother that they are smart and proud and strong, that they will grow and stand tall and be free. The illustrations [by Lorenzo Lynch] are bouncy, echoing the vigor of the poem but lacking its note of tenderness. This is reminiscent of other Adoff poems (**black is brown is tan, make a circle / keep us in**) both in its message and in its phrasing, but it has a more assertive tone.

> *Zena Sutherland, in a review of "Big Sister Tells Me That I'm Black," in* Bulletin of the Center for Children's Books *(reprinted by permission of The University of Chicago Press; © 1976 by The University of Chicago), Vol. 30, No. 3, November, 1976, p. 37.*

The syncopated beat as of a dance provides the rhythm behind this series of connected poems designed to instill pride and challenge in black youngsters. Unusual, different and yet much subtlety deeper than the literal lines written on each page.

> *James A. Norsworthy, Jr., in a review of "Big Sister Tells Me That I'm Black," in* Catholic Library World, *Vol. 48, No. 5, December, 1976, p. 233.*

TORNADO! POEMS (1977)

It is sharply remembered detail that most adds staying power to Adoff's story-poem of experiencing a tornado. . . . [Freely] spaced words and phrases zero in on rituals of preparation and

the range of emotions that go along with enduring these violent elements. Throughout, there's an eye and ear for revealing incident that speaks of close association; and, in fact, the destruction wrought in Xenia, Ohio, near the author's home inspired this commemoration. The immediacy is impelling, despite a sense that the free verse form sometimes seems to impede action flow where line breaks appear random rather than serving a special purpose. On the other hand many of the word arrangements give a sense of sound and sight that heightens the impact and creates arresting images that would otherwise have remained prosaically on the ground.

> *Denise M. Wilms, in a review of "Tornado! Poems,"*
> *in* Booklist *(reprinted by permission of the American*
> *Library Association; copyright © 1977 by the Amer-*
> *ican Library Association), Vol. 74, No. 2, September*
> *15, 1977, p. 158.*

In a short, self-conscious epilogue, Adoff says that these "poems" . . . were written to prove that people, with their capacity to rebuild, are stronger than any natural disaster. A comforting thought, but it was not necessary for the author to drive home a message when the story, as he tells it, speaks strongly—though not poetically—for itself. The only thing that makes this even look like poetry is the confusing layout of unpunctuated, uncapitalized words on the pages. . . . Too bad Adoff chose to strain so much rather than to give his straightforward, powerful tale in more easily comprehensible form.

> *Marjorie Lewis, in a review of "Tornado! Poems,"*
> *in* School Library Journal *(reprinted from the Oc-*
> *tober, 1977 issue of* School Library Journal, *pub-*
> *lished by R. R. Bowker Co./A Xerox Corporation;*
> *copyright © 1977), Vol. 24, No. 2, October, 1977,*
> *p. 98.*

[The illustrations by Ronald Himler] are as evocative and dramatic as Adoff's linked poems. . . . The poetry is direct, vivid, and immediate, yet it is colored throughout by the sense of comfort that those within a family give each other and by the sense of determined courage of those whose lives and property have been damaged. . . . An epilogue gives background information on tornadoes and on the Xenia tornado of the poems.

> *Zena Sutherland, in a review of "Tornado!" in* Bul-
> letin of the Center for Children's Books *(reprinted*
> *by permission of The University of Chicago Press;*
> *© 1977 by The University of Chicago), Vol. 31, No.*
> *3, November, 1977, p. 41.*

Tornado! poems will comfort and assure those youngsters who have been through the storm, the others who await this season's cyclones, and readers who experience such destruction only vicariously. Similar in structure to the works of e. e. cummings, this poetic description . . . builds up tension from the very beginning with definitions "from the dictionary" and "from the spanish." The rhythm of the words catches the fear, the preparations, the storm itself, and the unwinding through altering length of sentences, phrases, and physical appearance on the page. . . . Try this for choral reading, letting the book's design be the guide.

> *A review of "Tornado!" in* Language Arts *(copyright*
> *© 1978 by the National Council of Teachers of En-*
> *glish; reprinted by permission of the publisher), Vol.*
> *55, No. 4, April, 1978, p. 526.*

WHERE WILD WILLIE (1978)

Willie leaves the circle of her family's warmth for a while to explore the range of her own sensations. She becomes a shadow creature, walks the fence, crouches behind a wall. There is a mood of quiet expectation. Willie is not running away; she wants to be alone. . . . Home love makes her journey possible. . . . There is no doubt she will return. Choosing the third-person voice, Adoff keeps the parents present as a Greek chorus, sometimes warning "don't fall," sometimes expressing Willie's own ambivalence and fears. One and two syllable words drop in impressionistic patterns of rhyme and alliteration. . . . A poem of reassurance, for reading aloud to the very young.

> *Sharon Elswit, in a review of "Where Wild Willie,"*
> *in* School Library Journal *(reprinted from the Oc-*
> *tober, 1978 issue of* School Library Journal, *pub-*
> *lished by R. R. Bowker Co./A Xerox Corporation;*
> *copyright © 1978), Vol. 25, No. 2, October, 1978,*
> *p. 129.*

A mood poem recalling the free-form patterns of e. e. cummings's stanzas focuses on a universal childhood experience—the temporary escape from familial constraints. Through dexterous use of alliteration, rhythm, and the syntax of Black English, the text suggests a commentary between watchful, loving parents as they describe their daughter's exuberant adventure. . . . Although an essentially simple concept and one readily apparent to young children, the subtle sophistication of the text suggests that the book be read aloud for full appreciation.

> *Mary M. Burns, in a review of "Where Wild Willie,"*
> *in* The Horn Book Magazine *(copyright © 1979 by*
> *The Horn Book, Inc., Boston), Vol. LV, No. 1, Feb-*
> *ruary, 1979, p. 75.*

Willie could be a boy or a girl. . . . The poem describes with lilting fluency Willie's rambles and then the voices from home speak for themselves, an antiphonal arrangement in which the two draw closer until Willie comes home. The ending is especially warm, for there are no reprimands, no punishment. . . .

> *Zena Sutherland, in a review of "Where Wild Wil-*
> *lie," in* Bulletin of the Center for Children's Books
> *(reprinted by permission of The University of Chi-*
> *cago Press; © 1979 by The University of Chicago),*
> *Vol. 32, No. 7, March, 1979, p. 109.*

Young Willie's flight towards temporary freedom should excite responses from primary grade youngsters and preschoolers. The strong beat of the rhymed verses matches her forays down streets and alleys. . . . Adoff's paean to independence gains from its typographical structure, since its heroine is in constant action. The quality of writing and imagery do not equal Adoff's *Under the Early Morning Trees,* a book better directed toward middle-graders. . . . Compare both of Adoff's books to gain an insight into inner and outer-directed poetry and the means poets use to achieve different ends. (pp. 690-91)

> *Ruth M. Stein, in a review of "Where Wild Willie"*
> *(copyright © 1979 by the National Council of Teach-*
> *ers of English; reprinted by permission of the pub-*
> *lisher and the author), in* Language Arts, *Vol. 56,*
> *No. 6, September, 1979, pp. 690-91.*

UNDER THE EARLY MORNING TREES: POEMS (1978)

[This] is musical to read aloud as we follow a young girl in her solitary dawn foray, seeing, listening, feeling, sensing the early moments of the natural world and then returning to the family voices that call. . . . This is some of Adoff's best work; the inner rhyme is startling, as are the sensory images and the flashes of color contrast woven together or apart. There is a natural ring and flow to the verse arrangement that fits the core of meaning and word working. Almost a song, this could certainly be chanted—take the trouble to relate it to the child's personal experience.

> *Betsy Hearne, in a review of "Under the Early Morning Trees," in* Booklist *(reprinted by permission of the American Library Association; copyright © 1978 by the American Library Association), Vol. 75, No. 4, October 15, 1978, p. 370.*

The mood is quiet and appreciative. Despite the subtitle **"Poems,"** however, individual pages or spreads cannot really stand alone. . . . [Children] will need some familiarity with poetry patterns to read this book successfully. Altogether, it's a low-key offering that would be a pleasant, but not vital, addition to the poetry shelves.

> *Margaret A. Dorsey, in a review of "Under the Early Morning Trees: Poems," in* School Library Journal *(reprinted from the November 1978 issue of* School Library Journal, *published by R. R. Bowker Co./A Xerox Corporation; copyright © 1978), Vol. 25, No. 3, November, 1978, p. 54.*

[The verses are] arranged and spaced to intrigue the eye. The poems develop a simple, meditative pastoral. . . . Appropriately unpretentious in diction and quietly buoyant in rhythm, but unrhymed and uncapitalized, the lines celebrating rural life are natural without indulging in jargon or fashionable colloquialisms, it is regrettable that two grammatical errors mar the unaffected simplicity of the poetic sequences. (p. 649)

> *Paul Heins, in a review of "Under the Early Morning Trees: Poems," in* The Horn Book Magazine *(copyright © 1978 by The Horn Book, Inc., Boston), Vol. LIV, No. 6, December, 1978, pp. 648-49.*

Many of these poems are almost prose descriptions. The words are simple, well chosen but, I think, over-arranged on the page. The line is broken so often it makes for too staccato a reading. (p. 91)

> *Karla Kuskin, "Rhymes and Reasons," in* The New York Times Book Review *(copyright © 1978 by The New York Times Company; reprinted by permission), December 10, 1978, pp. 76, 90-1.**

I AM THE RUNNING GIRL (1979)

Like **Under the Early Morning Trees** . . . this free-verse prose-poem about a girl who runs neither goes astray nor stretches very far. Adoff makes a high spot of sorts of the running girl's winning her climactic, closing race. . . . But his early attempts to lift the prose are weak (running on the sidewalk before school in the morning, "in my head i am the panther on the plain"). And however valid, the feminist grievance he slips in [comparing her worn-out uniform with the new ones of the boys' team] is too perfunctory to rouse any but a knee-jerk response. Topical, yes.

> *A review of "I Am the Running Girl," in* Kirkus Reviews *(copyright © 1979 The Kirkus Service, Inc.), Vol. XLVII, No. 19, October 1, 1979, p. 1147.*

Adoff's poems flow from one to another, evocative and insistent in their rhythm, free in form; [Ronald] Himler's pencil sketches echo the concentration and the elation of the running girl through whom the poet speaks. The girl speaks of . . . her feeling of affinity for all the other girls who are running, of the joy of the long pull of muscles, the hard breaths, and the concentration of that last spurt that wins a race. Potent stuff.

> *Zena Sutherland, in a review of "I Am the Running Girl," in* Bulletin of the Center for Children's Books *(reprinted by permission of The University of Chicago Press; © 1980 by The University of Chicago), Vol. 33, No. 5, January, 1980, p. 85.*

Slight in size but huge in spirit is this book. . . . Adoff, in his effective free verse . . . [presents] a splendid young woman who is a competitive athlete, a good friend to other athletes of both sexes, a warm family member and—best of all—respectful of herself, her body and her strength. Multicultural cast. Feminist message. Fine merger of poetry, content and art. (pp. 27-8)

> *Lyla Hoffman, in a review of "I Am the Running Girl," in* Interracial Books for Children Bulletin *(reprinted by permission of* Interracial Books for Children Bulletin, *1841 Broadway, New York, NY 10023), Vol. II, Nos. 1 & 2, 1980, pp. 27-8.*

EATS: POEMS (1979)

This loving tribute to culinary consumption is an absolute joy: who could resist an ode to chocolate that claims "i / love / you so / i / want / to / marry / you." All the heavenly smells, tastes, and obsessive cravings—pizzas, burgers, ice cream, etc.—are evoked in poems and verse-recipes that range in tone from dreamy to passionate. Adoff presents the true essence of the compulsive eater. . . . Readers of all ages will relate to Adoff's blissful musings and fancies and occasional whimsy. . . .

> *Marilyn Kaye, in a review of "Eats: Poems," in* Booklist *(reprinted by permission of the American Library Association; copyright © 1979 by the American Library Association), Vol. 76, No. 6, November 15, 1979, p. 497.*

Delicious plain poems for a young audience that's always hungry. No gourmet menu, these paeons to eating are fun, and even if the "poetry" is made by mere cleverly spaced, pleasant prose on a page, these choice morsels will be enjoyed. . . . A few recipes are included for healthy fare such as bread and pie crusts. . . . This should be a fine stimulus for creative writing as well as independent reading and may attract older reluctant readers as well if the typographical patterns and lack of punctuation are not a deterrent.

> *Marjorie Lewis, in a review of "Eats," in* School Library Journal *(reprinted from the December, 1979 issue of* School Library Journal, *published by R. R. Bowker Co./A Xerox Corporation; copyright © 1979), Vol. 26, No. 4, December, 1979, p. 71.*

Adoff's latest batch of broken-line prose poems have a little more crunch than most of their predecessors. . . . Many of the entries are pleasantly playful ("Dinner Tonight / is hiding / in a mystery of steam / from / the bowl of / spaghetti . . . we /

must make our way through / oregano fogs . . . into a parmesan dream . . .''), some more whimsically so (a giant flying Twinkie with cake bombs lands on the White House lawn). For some of the more reverently eulogized dishes there are also recipes, in the same free-verse format. . . . (pp. 6-7)

> *A review of "Eats," in* Kirkus Reviews *(copyright © 1980 The Kirkus Service, Inc.), Vol. XLVIII, January 1, 1980, pp. 6-7.*

FRIEND DOG (1980)

[This is a] second-person story, set down in Adoff's usual free-verse prose, has a little girl reminding her dog of how she found the animal in the field with its ear chewed by wild dogs. . . . But instead of demonstrating the bond Adoff expresses faintly mushy sentiments in "poetic" lines that merely thicken the fog.

> *A review of "Friend Dog," in* Kirkus Reviews *(copyright © 1981 The Kirkus Service, Inc.), Vol. XLIX, No. 2, January 15, 1981, p. 71.*

This puzzling book is brilliantly illustrated [by Troy Howell]; the drawings, in fact, are more articulate than the verse, which tends to close in on itself. . . . *Friend Dog* is the girl's meditation on her dog; she is unsettlingly sober and curiously abstracted throughout the book. Her voice is old in ways that seem inappropriate: "there is time / to walk / across the morning / fields. . . .'' She sounds like an overly serene greeting card. Adoff's versification is very weak. The rhythms are eccentric, and interrupt rather than lend momentum. He has a penchant for visual tricks, such as splitting one-syllable words; his syntax is simply incorrect on occasion: "together / we can bark and howl ourselves / and shout." Straining for rhyme, he ends up being obtuse. (pp. 138-39)

> *Marguerite Feitlowitz, in a review of "Friend Dog," in* School Library Journal *(reprinted from the March, 1981 issue of* School Library Journal, *published by R. R. Bowker Co./A Xerox Corporation; copyright © 1981), Vol. 27, No. 7, March, 1981, pp. 138-39.*

[The text] is imbued with the deep sense of protective love and the joy of companionship that children feel for their pets; it has both depth and simplicity.

> *Zena Sutherland, in a review of "Friend Dog," in* Bulletin of the Center for Children's Books *(reprinted by permission of The University of Chicago Press; © 1981 by The University of Chicago), Vol. 34, No. 8, April, 1981, p. 145.*

TODAY WE ARE BROTHER AND SISTER (1981)

Typographically aspiring to be poetry, the story is partly the dialogue between, and partly a third-person narration about, a young brother and sister who sometimes argue with each other most plausibly, but more often are good pals roaming the beaches and snorkeling in the waters of Puerto Rico. . . . The bilingual English-Spanish dedication to Culebran children is baffling because the text following, which so easily could have been bilingual too, is not. Notwithstanding a certain sweetness and lyricism, this book seems curiously misconceived.

> *Peter Neumeyer, in a review of "Today We Are Brother and Sister," in* School Library Journal *(reprinted from the September, 1981 issue of* School Library

Journal, *published by R. R. Bowker Co./A Xerox Corporation; copyright © 1981), Vol. 28, No. 1, September, 1981, p. 118.*

[One] wonders, reading the title, what makes this day different from every other day. . . . Presented simply and straightforwardly, this would be pretty ordinary, slightly strained stuff (and pretty jog-trotty rhythm): "Today we are sister and brother. Today we are faster than run. Today we are brother and sister. Today we are closer than one." . . . [Sibling] frictions and bonds are depicted with far more spirit and immediacy elsewhere.

> *A review of "Today We Are Brother and Sister," in* Kirkus Reviews *(copyright © 1981 The Kirkus Service, Inc.), Vol. XLIX, No. 18, September 15, 1981, p. 1155.*

Adoff's celebration of seesawing sibling relationships keeps to simple, straightforward prose lines, only occasionally slipping into beguiling wordplay or rhythmic singsong to further the poem's word picture. A lighthearted, loving venture. . . .

> *Denise M. Wilms, in a review of "Today We Are Brother and Sister," in* Booklist *(reprinted by permission of the American Library Association; copyright © 1982 by the American Library Association), Vol. 78, No. 10, January 15, 1982, p. 646.*

OUTSIDE INSIDE POEMS (1981)

A cycle of poems having the look of one long work, this recreates one day in a boy's life from morning to night, with a large chunk in between for playing baseball. Rich in visual and verbal images, it requires of readers both imagination and patience; the lack of punctuation may cause difficulties for all but the most stalwart. Adoff is able to say much with little; in this case he speaks about the differences between appearance and actuality, the difficulty of being a child and the importance winning has in how we perceive ourselves. A book for older readers in picture-book format, this may be difficult to place upon the shelves to best advantage. Those readers who find it will be amply repaid.

> *Holly Sanhuber, in a review of "OUTside INside Poems," in* School Library Journal *(reprinted from the November, 1981 issue of* School Library Journal, *published by R. R. Bowker Co./A Xerox Corporation; copyright © 1981), Vol. 28, No. 3, November, 1981, p. 85.*

In a poem that has story elements although it is not a narrative poem, Adoff muses through the mind of a boy who loves to eat, loves to play baseball, and is torn between his feelings of youthful inadequacy and his feelings of ebullient confidence. Thus, in a measure, he speaks for all childhood. The poem [is] at times flowing and at other times angular. . . .

> *Zena Sutherland, in a review of "OUTside INside Poems," in* Bulletin of the Center for Children's Books *(reprinted by permission of The University of Chicago Press; © 1981 by The University of Chicago), Vol. 35, No. 4, December, 1981, p. 62.*

This is some of Adoff's best-integrated poetry, both for sound and for image. There are unexpected rhythmic echoes that slide into a smooth pattern of refrain and lend coherence to the irregular arrangement of lines on paper. . . . This is an ideal book for concentration in a poetry group. It's not a popular

item like *Eats* . . . , but with a teacher or librarian's enthusiastic work, it will come clear in a way it won't to casual browsers.

> *Betsy Hearne, in a review of "Outside/Inside Poems,"* in Booklist *(reprinted by permission of the American Library Association; copyright © 1981 by the American Library Association), Vol. 78, No. 8, December 15, 1981, p. 546.*

Without a jot of punctuation, this could be seen as one long poem or a series of related ones, all contrasting OUTside appearances and/or reality with the INside feelings and fantasies of one boy's day. . . . There is more stretching for poetic imagery here than in Adoff's previous broken-line prose-poems, but most attempts come off as forced, far-fetched comparisons. The book's first words: "OUTside / the rain is falling fast like the falling curtain / at the end of a school play." The fantasies—in which that secret inner signal system is controlled by a green octopus eating a peanut-butter-and-tuna sandwich, then "identical centipedes" eating peanut-butter-and-pickle sandwiches, and later a "family of detroit tigers" eating peanut-butter-and-chopped-liver sandwiches—are perhaps meant to be humorous, but it's all too contrived and self-conscious to engage. . . . The pictures [by John Steptoe] might work to reflect a mood, but Adoff doesn't create one.

> *A review of "OUTside/INside: Poems,"* in Kirkus Reviews *(copyright © 1981 The Kirkus Service, Inc.), Vol. XLIX, No. 24, December 15, 1981, p. 1521.*

ALL THE COLORS OF THE RACE: POEMS (1982)

The scope of this book is narrow in the sense that the poems are ostensibly about the feelings of a girl with a Black mother and a white father. But the themes of the poems (the impact of one's ancestry and personal history on one's present moments, the damage rigid labels inflict on people, the essentials that the races and sexes have in common) are universal, ones that any thoughtful child will be able to relate to. The 36 brief, free-verse poems speak to readers with simple language and a dignified, though never stuffy or didactic, tone. . . . Humor and playfulness are also evident. . . . The girl's Black heritage and her Jewish heritage are both seen as positive parts of her emerging personality. . . . [Both] the poems and [John Steptoe's] art here are a pleasure to know. (pp. 142-43)

> *Lauralyn Levesque, in a review of "All the Colors of the Race,"* in School Library Journal *(reprinted from the March, 1982 issue of* School Library Journal, *published by R. R. Bowker Co./A Xerox Corporation; copyright © 1982), Vol. 28, No. 7, March, 1982, pp. 142-43.*

A celebration of multiethnicity, Adoff's loose, free-verse poems . . . extend their theme of tolerance to all races. . . . Cast in the first person, the poems show a speaker who is alternately thoughtful (**"I Am Making a Circle"**), observant (**"A Song"**), playful (**"At the Meeting"**), or fearful (**"Bad Guys"**). There is reflection on black and Jewish ancestors and on the special problems of mixed parentage. . . . But mostly there is joy in all the richness such a heritage implies.

> *Denise M. Wilms, in a review of "All the Colors of the Race,"* in Booklist *(reprinted by permission of the American Library Association; copyright © 1982 by the American Library Association), Vol. 78, No. 14, March 15, 1982, p. 951.*

["**All the Colors of the Race**"] is sensitively and movingly written. However, with the exception of **"On My Applications"** and **"There Is So Much,"** I would have trouble calling the individual offerings poems. The book [written from the viewpoint of Adoff's daughter] is more a journal that could have been written by a juvenile genius. (p. 49)

> *Ardis Kimzey, "Verse First, Poetry Next," in* The New York Times Book Review *(copyright © 1982 by The New York Times Company; reprinted by permission), April 25, 1982, pp. 37, 49.**

Contemplative, jubilant, and questioning, the upbeat verses stress the young person's humanity in terms of gifts received from her forebears. Framed illustrations . . . complement the rhythm and grace of the writing. . . . For all adolescents. (pp. 483-84)

> *Ruth M. Stein, in a review of "All the Colors of the Race: Poems by Arnold Adoff" (copyright © 1983 by the National Council of Teachers of English; reprinted by permission of the publisher and the author), in* Language Arts, *Vol. 60, No. 4, April, 1983, pp. 483-84.*

BIRDS: POEMS (1982)

Arnold Adoff is one of the best anthologists in the world. With his taste and ear, it stands to reason that he should have turned to writing poetry himself, and done it well. His [**"Birds"**] . . . is an ambitious book, both satisfying and frustrating to me. I am frustrated that he does not identify all the birds he writes about. But it is satisfying to read some of the poems, with their verbal shifts like variations of light in certain seasons. . . .

In some cases, perhaps, there is too much movement of words and lines in the physical layout of the poetry. The design of a poem usually can't make it better than the words do. [The illustrations by Troy Howell], together with the poems, form a class act. (p. 37)

> *Ardis Kimzey, "Verse First, Poetry Next," in* The New York Times Book Review *(copyright © 1982 by The New York Times Company; reprinted by permission), April 25, 1982, pp. 37, 49.**

Adoff's new poetry collection is a lush mixture, blending imagination with his observations of the many kinds of birds around his country home. . . . [It] may be petty to remark that Adoff indulges in a format that could confuse readers. He uses no punctuation marks, which sometimes means that one turns a page with the expectation of finding more lines in a poem, only to discover a new poem. More disconcerting (and puzzling) is the placement of a single letter on a line . . . "melted snows / and the stubs / of last year / s / stalks."

> *A review of "Birds," in* Publishers Weekly *(reprinted from the April 30, 1982 issue of* Publishers Weekly, *published by R. R. Bowker Company, a Xerox company; copyright © 1982 by Xerox Corporation), Vol. 221, No. 18, April 30, 1982, p. 59.*

Thirty original poems dealing with the day-to-day existence of birds convey the fear, pride, wariness, and exuberance that seem to be felt by these creatures. The poet communicates such feelings not only by his choice of words but by the placement of the words on the page. We feel the rhythm of an egg falling from a tree, of birds hopping across the ground, and of an eagle gliding through the air. (pp. 420-21)

Nancy Sheridan, in a review of "Birds: Poems," in
The Horn Book Magazine *(copyright © 1982 by The*
Horn Book, Inc., Boston), Vol. LVIII, No. 4, August,
1982, pp. 420-21.

Following the cadence of birds' calls and songs, the words are bunched at times, and other times trail in ascending or descending scales, sometimes repeated as call notes. The birds' voices make word pictures of flight, territoriality, hunger, the fear of cats and the succulence of worms. It's the quintessential bird's-eye view.

Kay Webb O'Connell, in a review of "Birds," in
School Library Journal *(reprinted from the Septem-*
ber, 1982 issue of School Library Journal, *published*
by R. R. Bowker Co./A Xerox Corporation; copyright
© 1982), Vol. 29, No. 1, September, 1982, p. 102.

Dick Bruna

1927-

Dutch author/illustrator and illustrator of picture books.

Bruna is internationally recognized for introducing the youngest viewers to their first books, a focus that was relatively new when he began publishing in 1953. Designing his fantasies, wordless stories, and concept books on letters, numbers, colors, and words to reflect the interest and capabilities of his audience, he makes sure that toddlers and preschoolers are comfortable with the content and format of his books. Illustrations and texts are basic, often repeating characters and details to give security to the child, and the works are produced in sturdy child-sized squares. Bruna's pictures usually present large, full-faced characters on a plain white or single color background. His characters look straight at the viewer, creating the sense of being personally addressed. Critics commend Bruna for depicting emotion in a way the child can relate to, as when he portrays sadness by adding a huge tear or two on the characters' cheeks. Bruna also uses this format for adaptations of fairy tales.

At sixteen, Bruna produced his first book jacket for the A. W. Bruna publishing company, a firm founded by his great-grandfather. Besides book jackets, Bruna has designed posters (for which he has won many awards), murals for schools and hospitals, medical information booklets for young children, postcards honoring the handicapped child, and postage stamps. As an artist, Bruna admires Matisse, Picasso, and de Stijl, a Dutch group who used rectangular forms and primary colors as their basis. These influences are shown in Bruna's flat perspectives, large central figures, and limited colors. His early books lack tertiary colors, which he added reluctantly to meet the increasing complexity of his works.

Critics have divided reactions to the success of Bruna's techniques. Some see his use of a ''red'' Indian and a ''yellow'' Eskimo as a racial slight, not realizing that the colors are a result of working within the confines of artistic principle. Reviewers fault Bruna for taking simplification too far, creating bland stories and pictures and sometimes unrecognizable illustrations where object identification is important. Other critics, however, assert that Bruna's style is clear, straightforward, and well suited to young children. In the popular *Miffy* series, which depicts the adventures of a little rabbit, they approve of Bruna's uncomplicated text and light-hearted illustrations. They also note that it is important for children to be able to identify such a familiar, likeable character. Most critics commend Bruna for understanding his audience, who find pleasure in the simplicity and comfortable repetition he provides for them.

(See also *Something about the Author*, Vol. 30.)

AUTHOR'S COMMENTARY

I have often tried to draw a face from the side. I thought it would be rather fun to have a nose and all the other things you can see. But I always gave it up. There was a poster I did which was my first 'in profile' drawing but even then there was an eye looking at you. Even on my book covers I try to

get the direct look one way or another. It always comes down to directness, to get as direct an effect as possible. (p. 4)

Do you know what I have recently been finding most difficult? To go on working just as spontaneously as before. I go on re-doing things so much longer these days before I regard them as finished; I always feel now that I have to justify myself. Luckily I can always withdraw myself completely without being influenced by what people say about my work. It begins with the drawings; I already have the plot in my head by then. While I am working on the drawings texts occur to me, I make a brief note of them and work them out later. I make the first draft of a book like this; then I go over the other possibilities of almost all the drawings to see if there's better ones. So for a book of twelve pictures I make at least a hundred. The funny thing is that even after all this endless trying out, I frequently come back to the first draft after all. I go on writing texts endlessly too. I type pages and pages of them, much too much, and then suddenly see what's right. Here in my studio I read everything out loud and imagine that there's a child listening. There have been times when I've thought: it's all over now, there's nothing more to come. However I know that I have been working better in recent years than before. I have become more critical, more accurate. (pp. 4-5)

Blue is the colour which recedes. It is a cool colour and a colour which moves away from you. Red and green come

towards you. They are warm colours because there is yellow in them. I use blue when I want to make it cold. When Miffy is walking through the snow I put a clear blue sky above her. But when I draw children in a house I give them a red or yellow background because I want them to be warm there. (p. 5)

> *Dick Bruna, in an interview with Dolf Kohnstamm, in* The Extra in the Ordinary: ''Children's Books by Dick Bruna'' *by Dolf Kohnstamm (text © copyright Dolf Kohnstamm 1978; reprinted by permission of the author), revised edition, Merces Americanae n.v., 1979, pp. 4-5.*

GENERAL COMMENTARY

MARGERY FISHER

[*Tilly and Tessa* and *The Little Bird* are] for the two-year-old whose fascinated eyes go with destructive fingers—little books illustrated in bright primary colours in pictures very crisp and spirited, with tiny but adequate stories. . . . To recognise pig, chickens, house, glass of milk, hair ribbons on a page is a landmark in any child's life, and these are wonderful books to start with. (pp. 92-3)

> *Margery Fisher, in a review of ''Tilly and Tessa'' and ''The Little Bird,'' in her* Growing Point, *Vol. 1, No. 6, December, 1962, pp. 92-3.*

MARGERY FISHER

[*The Egg* and *The King*] are making a sure appeal, with their minute stories (each with a proper order and point) and the rich bold colours in which separate objects are shown on coloured pages. Ideal for helping infants to make their first two-dimensional identifications.

> *Margery Fisher, in a review of ''The Egg'' and ''The King,'' in her* Growing Point, *Vol. 3, No. 3, September, 1964, p. 373.*

THE TIMES LITERARY SUPPLEMENT

The Bruna books are the most exciting things to hit the smallest shelf in a long time. Visually brilliant, they combine two or three of the primary colours with a lot of white. The pictures, which take up the whole of each right-hand page, can be enjoyed on their own, while the text, on the left, is miles above the average provided for three and four-year-olds and not beneath the dignity of even six and seven-year-olds to read aloud.

> *''Pictures to the Point,'' in* The Times Literary Supplement *(© Times Newspapers Ltd. (London) 1965; reproduced from* The Times Literary Supplement *by permission), No. 3328, December 9, 1965, p. 1149.**

THE TIMES LITERARY SUPPLEMENT

Dick Bruna adds another four titles to his distinctive quiverful; irresistible as brightly wrapped presents, the only danger is that they may not live up to their gaudy promise. Best perhaps is *The School*, where Sally, Pip, Jane and their friends are encouraged by teacher to build, draw and sing, but *Pussy Nell*, a white kitten which rides on the back of a fish and meets Red Indians, *The Sailor* who steams away to find the Eskimoes. and *The Apple* that peers through the windows of a house from its perch on a weathercock's back are all gay and stimulating.

> *''All Things Bright and Beautiful,'' in* The Times Literary Supplement *(© Times Newspapers Ltd. (London) 1966; reproduced from* The Times Literary

Supplement *by permission), No. 3351, May 19, 1966, p. 440.**

JOHN COLEMAN

[Bruna's latest books] show signs of getting a bit fancy, which is a pity. The pictures are as thick-line and primary colour as ever—stained-glass for the tinies—but in *Pussy Nell* the green-eyed feline is discovered wanting to be a Red Indian and asking a big white daisy how to go about it and that eponymous Apple gets into an involved relationship with a Weathercock. *The Sailor* and *The School* steer clearer of whimsy. I suppose Mr Bruna's bored with her, but my younger one could do with more of the she-rabbit Miffy's unexigent adventures. One wants this series to keep up a high standard of content if only because of its superlative, dreadnought casing. (p. 743)

> *John Coleman, ''Square Deals,'' in* New Statesman *(© 1966 The Statesman & Nation Publishing Co. Ltd.), Vol. 71, No. 1836, May 20, 1966, pp. 742-43.**

MARGERY FISHER

The charm of [*Pussy Nell, The Apple, The School,* and *The Sailor*] comes partly from their reassuring solidity, partly from the brilliant, unrealistic primary colours in which pigs, houses and teacups are presented, and partly in the satisfying basis of most of the stories. . . . [These stories] whisk the reader away from routine. . . . There are now quite a number of Bruna books but I can see no signs of flagging in the author's dexterity with text or illustrations, nor any sign that his enjoyment is any the less because he knows so well what he is doing.

From The Apple, *written and illustrated by Dick Bruna. First published in the U.S.A. in 1984 by Dick Bruna Books Inc., New York. Illustration Dick Bruna copyright. Copyright Mercis b.v., Amsterdam © 1953. All rights reserved. Reprinted by permission of Price/Stern/Sloan Publishers Inc., Los Angeles.*

Margery Fisher, in a review of "Pussy Nell," "The Apple," "The School," and "The Sailor," in her Growing Point, *Vol. 5, No. 2, July, 1966, p. 735.*

MARGARET MEEK

[*The School, The Sailor, Pussy Nell,* and *The Apple*] are examples of a successful series; bold colours, simple drawings and text, exactly right for engendering the delight of turning the pages and stimulating the imagination which are the beginning of learning to read. Specially recommended for nursery schools and early birds who want a real book.

Margaret Meek, in a review of "The School," "The Sailor," "Pussy Nell," and "The Apple," in The School Librarian and School Library Review, *Vol. 14, No. 2, July, 1966, p. 254.*

J. H. DOHM

Earlier this year one reviewer prophecied 1967 might go down in picture book history as the year when Jaap Tol's work first appeared in England. . . . The historians will in any case note that this sudden emergence of successful picture-book makers of very diverse talents [Frans van Anrooy, Georgette Apol, Maryke Reesink, Céline Leopold] from a country which had produced no exportable books of this type for many decades, was heralded in England in 1962 by the first pair of Dick Bruna's little square books for the very youngest children. . . . [Dick Bruna can be hailed] as the inaugurator of the decade, as far as exportations are concerned. And as an innovator in the '50's, for his modest little books began appearing in Holland in 1953 and have proved some of the most durable in the rapidly proliferating group of better designed "very first" books. "Better designed" might be the slogan of the Bruna's; their creator is primarily a designer rather than an artist, but though it is an open question whether Dick Bruna can really draw, he shows real artistry in what he selects and shows on the page and in combining it with equally simple but satisfactory text to make each story a real book and not just a series of haphazard posters with random text. Elementary though they are, the books don't seem to take any sort of unfair advantage of tiny children's simplicity, and offer security without being sickening about it. Like the characters they portray, story and pictures are sturdy and factual and know just when to stop. The bits of fantasy are matter-of-fact as well, rooted in everyday affairs, so the apple who wants to see the world and gets a ride on the weathercock's back is satisfied with a glimpse through a kitchen window and when the little fish saves Susan from drowning by telling her to climb on his back no comment is made on their relative sizes. This knack of knowing how far to go may have some connection with Mr. Bruna's nationality or sex or maturity or history, but is most likely to be an inborn gift reinforced by observation of children; whatever the cause, there's no doubt of the rarity of the gift as any scrutiny of local bookshop shelves of "books for the tinies" will show. There are pleasantly old-fashioned, rather cosy books and exciting high-priced sophisticated books and a great deal of rubbish, but little that's so "just right" for the pre-Potter age as these gay little books from Holland. . . .

[Dick Bruna] claimed in a recent *Sunday Times* interview that he could design two picture books in a month, which conjures up visions of having too much of a good thing, except that the previous book seems to prove he's quite conscious of the dangers of excess. In his zeal to reduce all he treats to the minimum he has recently gone a bit astray according to some critics, for his series of folk-tales . . . removed a little too much of the flavour of the original. . . . They are indeed less successful than his original tales, and though sound as far as they go, probably do not go far enough. . . . The Bruna Christmas book is also fairly drastically simplified, but fills its purpose well, and last Christmas I saw some Christmas cards using these pictures which were most effective. And in Utrecht, at a small exhibition of Mr. Bruna's work, I was able to see quite a large sampling of the book covers he has designed since 1945 for the paper-back books issued by the Utrecht firm of Bruna & Son. . . . His posters for the firm's "Bear" series enliven the hoardings of Holland wherever you go. . . . Obviously a man so full of ideas for variations on the theme of Maigret—his Simenon jackets are especially good—for posters combining books and bears and publishing publicity in general is occasionally going to experiment a little with his picture books, but so far his best have been the little square tough-constructed books with solid colour backgrounds and the minimum of objects to a page. And so far he has avoided making them just "formula" books despite considerable repetition. It's all so simple it looks easy, but try it yourself and you see there's more to it than meets the eye. It's not pseudo-child-style—thank goodness, for a child enjoys his own drawing partly because he knows all he meant it to express, and can guess what another child means to a certain extent, but what is he to make of an adult's deliberate attempt to draw crudely when all the drawing means to express is "this is how a child would draw this"? Bruna's are not aimed at the adult who presents them, but direct at the child they are bought for—they aren't books to be kept on a "clean-hands" shelf, but books to be lived with and slept with, and, very likely, chewed at the owner's discretion. As an introduction to book ownership they probably can't be bettered.

It seems that Mr. Bruna is the forerunner of a revival of interest in picture book art in Holland, and it also seems possible that some of the new young artists experimenting in all sorts of ideas and techniques may come to find his books square in more senses than one. But they are no more square than dandelions and have much the same universal, perennial appeal for children, who need to see all sorts of flowers, wild and cultivated in their early years but are often, in the book world, handed the equivalent of plastic flowers instead. As Dick Bruna is probably tired by now of being called a Dutch uncle, he may not feel it much more of a compliment to be called a Dutch dandelion. But there is no doubt that if he chooses to make a book about a dandelion it will soon be translated from Dutch to Swedish, German, Spanish, Japanese and even American—for even if the dandelion has no nose at all, it can always have a tear in its eye, and if the rest is equally up to standard who can resist it? And it seems safe to predict the rest *will* be up to standard—dandelions, if you look at them closely, prove to be very carefully made. (pp. 225-28)

J. H. Dohm, "D is for Dutch—and Dick," in The Junior Bookshelf, *Vol. 31, No. 4, August, 1967, pp. 225-28.*

PUBLISHERS WEEKLY

I know; it's hot, it's humid, the air is so polluted walking is like pushing your way through cotton batting. . . . But here is news that will refresh you: four small books [*Miffy, Miffy at the Zoo, Miffy at the Seaside* and *Miffy in the Snow*] have just been published that will delight small children, four books in clean, bright colors with simple graphic pictures (by Dick

Bruna—and you already know how good his colors and designs are), pictures that illustrate four pleasantly easy-to-follow and/or easy-to-read stories.

> *A review of "Miffy," "Miffy at the Zoo," "Miffy at the Seaside," and "Miffy in the Snow," in* Publishers Weekly *(reprinted from the August 10, 1970 issue of* Publishers Weekly, *published by R. R. Bowker Company, a Xerox company; copyright © 1970 by Xerox Corporation), Vol. 198, No. 6, August 10, 1970, p. 56.*

SUSANNE GILLES

Four insipid titles [**Miffy, Miffy at the Seaside, Miffy at the Zoo,** and **Miffy in the Snow**] obviously aimed at the doting-relative trade, inexpensively priced and brightly colored. Miffy is a little-girl rabbit. In the first title, Mr. and Mrs. Rabbit wish for a child. "One night there was a tap on the window . . . Outside stood a little cherub . . . 'A baby rabbit is on her way to you.' . . . The baby was born soon afterwards."—in this day of sex education in nursery school? The other books are equally bland, pointless adventures. . . . Preschoolers may be attracted by the bright colors and simple lines of the pictures, but Miffy will never be a match for Peter Rabbit.

> *Susanne Gilles, in a review of "Miffy," "Miffy at the Seaside," "Miffy at the Zoo," and "Miffy in the Snow," in* School Library Journal, *an appendix to* Library Journal *(reprinted from the January, 1971 issue of* School Library Journal, *published by R. R. Bowker Co./A Xerox Corporation; copyright © 1971), Vol. 17, No. 5, January, 1971, p. 40.*

E. HUDSON

The quality and ability of an illustrator of children's books can sometimes be gauged by the number of copyists he has. Such a criterion would put Dick Bruna in a leading position today, for his work has been reproduced and copied in many countries of the world. His simple, always effective drawings in primary colours have made a large impact on the development of children's book illustration. The Bruna books, after a slow start in this country are now well established and new titles are eagerly sought by parents and infant teachers, who often derive as much enjoyment as the children from the short simple text and inspired illustrations. I repeat the word 'simple' for this is indeed Bruna's secret—the minimum of line detail with the maximum effect. He has the rare gift of being able to see animals and objects with the infant's eyes.

> *E. Hudson, in a review of "Miffy Goes Flying," and "Miffy's Birthday," in* Children's Book Review *(© 1971 by Five Owls Press Ltd.; all rights reserved), Vol. I, No. 2, April, 1971, p. 50.*

MARGERY FISHER

There is nothing unexpected in [**Miffy's Birthday** and **Miffy Goes Flying**]. Children who like the positive colours and outlines of the Bruna books—they will be mainly in the three to four age-range—will welcome further instalments of the adventures of Miffy, a rather wistful little rabbit who provides a female counterpart to the cheery little dog Snuffy. Miffy's flight in Uncle Bob's aeroplane, over castle and yachts, and the floral chair set ready for the birthday girl, offer to small children the simple pleasure of seeing dreams come true.

> *Margery Fisher, in a review of "Miffy's Birthday" and "Miffy Goes Flying," in her* Growing Point, *Vol. 10, No. 1, May, 1971, p. 1741.*

DAVID GENTLEMAN

Dick Bruna's Dutch look is admirably clear and straightforward: **Miffy's Birthday** and **Miffy Goes Flying** . . . have firmly outlined pictures with cheerful flat colours and much reassuring repetition; Miffy . . . reappears throughout in interesting situations but unchanging in expression. (p. 781)

> *David Gentleman, "Local Colour," in* New Statesman *(© 1971 The Statesman & Nation Publishing Co. Ltd.), Vol. 81, No. 2098, June 4, 1971, pp. 780-81.**

THE TIMES LITERARY SUPPLEMENT

At two plus or minus, when large pages tear readily and are turned with difficulty, ease of handling is quite as important a recommendation for a book as quality of story and pictures. Dick Bruna's picture books, often bland and characterless to the adult eye, have all the physical qualities that will endear them to the very young, together with a brief and uncomplicated text well suited to the needs of the child whose vocabulary is limited. The pictures, variously regarded as masterpieces of simplicity and as boring ideographs, have, from the child's point of view, the virtues of utter clarity and of a close adherence to the text. In **Miffy's Birthday** and **Miffy Goes Flying,** the heroine's expression remains deadpan and her reactions are predictable in the face of all kinds of excitements, but to the inexperienced two-year-old, whose chief pleasure in literature has always been the spotting and naming of objects he recognizes, the unchanging world of Miffy is stimulating stuff.

> *"Keeping It Small," in* The Times Literary Supplement *(© Times Newspapers Ltd. (London) 1971; reproduced from* The Times Literary Supplement *by permission), No. 3618, July 2, 1971, p. 771.**

LIAM HUDSON

How does one say anything about children's books that is not vacuously bland? Only, it seems, by letting off steam in a childish display of prejudice. Before I follow this second option let me declare my position. I have lurked in the background while my wife has brought up our four children to a point where they are beyond the reach of the kind of children's book I want to comment on here. I care about books in a generalized kind of way. And I care about painting and design more specifically. And shocking though it may seem to those who love him, Dick Bruna's name had not properly penetrated my consciousness until I picked up Dolf Kohnstamm's brief essay on him [an excerpt from the revised edition appears below].

I read Professor Kohnstamm's comments (in translation for the Dutch, I hasten to say), and looked through a number of Bruna's books. I realized as I did so that I had been aware of Bruna's work after all, but subliminally, rather in the way that one assimilates the music on Radio 2. A Bruna book, though, is in conspicuously good taste. It is economically drawn. And it is obviously well-suited to the three and four-year-olds who have enjoyed it in massive numbers. . . .

But truth must be told. I do not like Bruna's books. My instinct on opening one, I found, was to close it again; even to remove it from the room. Why? Although eminently skilled, they strike me as empty; and as conducting a discreet flirtation with the twee. After a few voyages into the world as Bruna re-creates it, I began to entertain an uncharacteristic desire for some grossly Victorian eruption. For a Doré monster, who would devour Bruna's tasteful little figures by the handful. And finish

with a belch. The craftsmanship of Bruna's drawings is real; but it is the craftsmanship of the tasteful gift wrapper, the decorated napkin you find beside your muesli or your glass of apple juice. It seems to me that he portrays the emotional life to children as parents in their cheaper moments would like to pretend it is: wholesome, nice. . . .

[The] most telling point Kohnstamm makes is Bruna's insistence on his characters facing straight out of the page, establishing direct eye-to-eye contact with the reader—as in the best television commercials. The frank eye-to-eye contact that sells stockings, and cigars, and motor cars, and signals trust.

Bruna is the son, the grandson and the great grandson of publishers: and A. W. Bruna is the family firm. It is evident that he knows in his bones how to sell books. The parallel drawn by Professor Kohnstamm with advertising is unwittingly apt. The books do not just express wholesomeness and good taste: they merchandise those qualities, and that is something rather different. Like successful commercials, the vision of the good life they portray smacks indelibly of the ersatz. The Good Life as it can be delivered by a skilled advertising agency, on the button.

It is this commercial savvy of Bruna's that makes Professor Kohnstamm's references to Mondrian so alienating. A painting like Mondrian's ''Broadway Boogie Woogie'' irradiates the Museum of Modern Art in which it now hangs: a work of severity which nonetheless trembles and sparkles at the intersections of its grid lines from the sheer tension of the composition that Mondrian has evolved. It is as remote from Bruna's little figures as a comet from a doughnut. . . .

All this, it may be protested, is a lot of fuss for a grown man to be making about some books for three and four-year-olds. That's true. But before I lose my nerve and collapse into self-parody, allow me one more paragraph of unbridled sententiousness. We are what we read; and to bring up our children on a pre-packed diet so slickly anodyne is to express our neglect of the depths of emotional response, pleasurable and painful, of which children ought to be capable. Advertently or inadvertently, we contribute to a structuring of the child's (and, eventually, the adult's) psychic life in which only nice and rational-seeming impulses can be consciously entertaining; and in which the darker, more peremptory sides of our nature must be repressed. But if we impose on ourselves a reign of niceness and good taste, the everyday life we grow up to lead may well turn out to be suffused with a sense of artifice, of inauthenticity. . . .

So rather than Bruna, give me Sendak or Desperate Dan, or Charlie Brown, or Ivor the Engine, or Wanda Gág, or Andy Capp, or Charles Addams, or Grimm—or anything in which there are some imaginative loose ends for children to hang on to; which addresses itself to the fantasies of adults as well as children, and in which the effects are not being calculated with such studious, and studiously commercial, care.

> *Liam Hudson, ''Ghastly Good Taste,'' in* The Times Literary Supplement *(© Times Newspapers Ltd. (London) 1976; reproduced from* The Times Literary Supplement *by permission), No. 3864, April 2, 1976, p. 385.*

SCHOOL LIBRARY JOURNAL

[Bruna's four new books] are among the season's most expendable easy readers. *I Can Count More* . . . obviously a sequel to *I Can Count* . . . covers the numbers 13 through 24. Each two-page spread consists of the digit on one side and the appropriate number of objects (drops of rain, window panes) on the other. *I Can Read More* . . . again a sequel—has a short simple sentence on one page . . . with a dull primer-style picture opposite. Two books about Miffy the Rabbit, *Miffy Goes Flying* . . . [and *Miffy's Birthday*], have slightly more difficult texts, but the story line in each of these books is so slight that the titles tell it all. The texts of all four books are so dull and insipid as to bore even the most avid new readers.

> *A review of ''I Can Count More,'' ''I Can Read More,'' ''Miffy Goes Flying,'' and ''Miffy's Birthday,'' in* School Library Journal *(reprinted from the December, 1976 issue of* School Library Journal, *published by R. R. Bowker Co./A Xerox Corporation; copyright © 1976), Vol. 23, No. 4, December, 1976, p. 65.*

SHARON HEALY

Another Story To Tell is a wordless picture book in which a youngster decides to take advantage of a good snow fall; the resulting romp will be good for many an impromptu tale. As always, the illustrations [here and in *I Can Dress Myself, I Can Read Difficult Words,* and *Miffy in the Hospital*] are uncluttered and colorful; the messages, straightforward.

> *Sharon Healy, in a review of ''Another Story to Tell,'' ''I Can Dress Myself,'' ''I Can Read Difficult Words,'' and ''Miffy in the Hospital,'' in* School Library Journal *(reprinted from the January, 1979 issue of* School Library Journal, *published by R. R. Bowker Co./A Xerox Corporation; copyright © 1979), Vol. 25, No. 5, January, 1979, p. 40.*

DOLF KOHNSTAMM

The first and by far the most important thing that must be said about Dick Bruna's pictures is that so little appears in them. In an enquiry into the complexity of pictures in children's books we found that in Dutch playgroups and day nurseries for children under four no other books have pictures of the same simplicity of structure and detail.

Although Bruna always seems to be searching for the minimum means with which he can illustrate something, he also often uses an apparently superfluous detail to produce an amusing effect or to direct attention to an essential aspect of the action or the object. But however much effect these details may have, the very great simplicity of the pictures is a paramount and universally recognized characteristic of his work. This simplicity in the representation of reality is necessarily linked with stylization and abstraction of what appears in three-dimensional reality or two-dimensional photographs of reality. Pictures like Bruna's have very little in common with reality. Yet the great attraction of his books remains. What is the reason? Is it because that little does still contain the essential characteristics of reality? Or are people really in search of simplifications, stylizations and idealizations of reality?

I shall not try to answer these difficult questions. It is easier to answer the following question: What objects do appear in these very simple pictures? People and animals are portrayed more frequently by Dick Bruna than lifeless objects. And yet by now there is a whole series of books consisting entirely of representations of objects: the counting books, the '**I can read**' series (apart from the first book) and the *Flower book*. But in all the other books characters predominate, whether people or

animals. *The King,* for instance, contains only one picture in which a house appears by itself, with no human figures, and in the fairy tales *Red Riding Hood* and *Cinderella* every picture portrays characters. The strength of Bruna's preference for the portrayal of children themselves is well demonstrated by the book called *My vest is white.*

Considering that the book does not tell a story about children or animals there was no necessity to have them in the pictures. Bruna could have linked the names of the colours and the colours themselves with almost anything besides the human figure. But what does he do? He makes a child dress itself, and gives the various garments one by one their name and a colour. And so in this book too the child's figure predominates.

A second important characteristic is that the figures are not usually set small against a background, but large, filling the page. Often the artist wants to emphasize his human figures still more, bring them still closer to the child observer, so he draws the head alone. (pp. 7-8)

Of the attributes which the humans receive, the clothing is the most notable. Bruna has never drawn the human figure completely naked in his books. The clothes give him the opportunities for colour denied him by human faces and limbs. These are practically without exception white or red. . . .

Another point is that Bruna's characters are far from always in action. They are often standing quite still, just looking. They may be extremely busy with something in the accompanying text, but in the picture they are standing as if in an old-time photograph: looking into the lens. I am inclined to think that this is the most outstanding characteristic of all in Bruna's work: *the characters look at the observer.* I have never seen this done as consistently as in Bruna's books. Whatever the characters are doing, whether they are talking to someone else or looking at something beside them in the picture, the face is never turned towards the other person but always towards the observer. There is not one face in profile among the human figures in all Bruna's children's books.

This does not apply to the animals. (p. 8)

In *Miffy goes flying* Uncle shows Miffy all the sorts of things which are actually portrayed under the aircraft in the picture.

What would have been more natural than for Miffy and her uncle to bend their heads a little and actually look towards the lower part of the page? Almost any other illustrator would have done this. But no, Miffy and Uncle are looking at the child who is looking at them and appear not to see the castle at all.

This direct look into your eyes is modified only now and again, when the eyes are closed.

Bruna makes great use of closed eyes to express sleep, sorrow, shyness or indulgence.

The open eyes are without exception vertical black ovals. It is remarkable that neither the shape of the head nor the shape of the eyes conforms to reality, and this applies as much to the human figures as to the humanized rabbits. The heads are horizontally flattened spheres, like a melon, whereas in reality the head is a vertical oval. The heads are also drawn much too big in relation to the rest of the body.

Now we know that young children and young animals have relatively much larger and rounder heads than adults, but Bruna

has very highly exaggerated this characteristic of early childhood.

The animal psychologist and ethologist Konrad Lorenz has proved by experiment that in human beings and animals there is a preference for heads which emphasize the infant schema referred to above. His studies also show that both children and adults found illustrations in which the infant characteristics were presented in an exaggerated manner more appealing than portrayals which were closer to nature. (p. 9)

In my opinion Bruna has adopted this rule unconsciously to a great extent, although he has selected a completely original form for it. Where Lorenz carried out his experiments with heads in profile, Bruna has drawn exclusively frontal views of faces. He uses the melon shape not only for young children but also for older children and even for grown-ups. There are only a few exceptions, of which the majority convincingly confirm the rule. Wherever a woman is meant to create an unsympathetic effect—there are no unsympathetic masculine characters in Bruna's work—as in the case of the thin green ladies in *The King* and the queen in the fairy tale of *Snow White,* the heads are drawn as vertical ovals. And anyone who cares to take the trouble can compare the shape of Cinderella's head with that of her two horrid sisters.

Only the school-mistress in *The School* also has a vertical oval head but as she is smiling at the same time the impression she makes is, fortunately, sympathetic.

Then there is the clown [in *The Circus*] with the roundest head of all, reinforced by a globular nose, a colossal grin and eyes set high in the circular head. (pp. 9-10)

Dick Bruna's eyes look at the child just as the faces on the covers of modern journals look at their public.

In the newspaper trade they know that a magazine cover on which a face, drawn big, is looking straight at the passing customer, sells better. Photographic models who are supposed to be directly recommending a product are told to look straight into the lens. The eyes, looking at us, attract our attention and create the illusion of person-to-person contact. (p. 10)

Dick Bruna applies this principle to the point of absurdity and I believe a great deal of the success of his books is due to this. From physiognomy we know that the frank, open look in which the eyelids conceal the eyes as little as possible is associated with a naïve, open, unbiased and childlike nature. The unobscured black ovals, which with the line of the mouth and dash for the nose are generally the only features in Bruna's faces, must strengthen the impression of frankness and childlike directness which has already been created by the shape of the head. That is why the expressiveness of the closed eye is so strong in his pictures, because the contrast is so great.

The mouth is just as important as the eyes in Bruna's pictures. Like so many other artists, he creates exaggerated impressions of the way that happy, neutral, sulky, sad or angry mouths really look by emphasizing the upturned corners of the mouth for happiness and the downturned for distress. Every child knows how the moon can be given a jolly or a mournful face by this means and the question is whether our pictorial culture has not developed a whole symbolism of its own for facial expression, which we spoonfeed to our children.

This symbolism is apparently understood and appreciated by children of many and varied nationalities and races, most prob-

ably because these abstract mouths relate well to what we really see. (p. 11)

Other visual means used by Bruna to convey the mood of his character are the tears and body positions referred to before. For him a tear is a large, fat white drop and there are never more than one or two of them.

Bruna's tear is of giant and impressive size and it may also be rolling out of the eye of an apple, a fish, a cat or a flower. For children and adults alike, the tear is convincing evidence of real distress. Dick Bruna seeks clarity above all and magnifies the symbol for this evidence.

The body positions and movements of Bruna's figures are worth a study on their own.

Let me mention a few striking examples: the little girl who is sitting on the ground when Snuffy finds her, the monkey on a branch in *Miffy at the zoo,* the tightrope dancer in *Circus,* Miffy's drowsily drooping head when she is tired, the file of children in *The School,* Miffy playing ball with her friends at her party, etc.

How it is possible to convey so much movement, so much tension and relaxation with so few lines will always remain a mystery. Of course these impressions are reinforced by the accompanying texts, but examples such as the drying up in *A story to tell* prove that they work even without the text. I could go through Bruna's illustrations for a long time.

Take sleep, for instance, depicted by closed eyes and the two lines of the turned-down sheet concealing the lower half of the face. How vividly the essence of the child lying in bed is

From Miffy in the Hospital, *written and illustrated by Dick Bruna. First published in the U.S.A. in 1984 by Dick Bruna Books Inc., New York. Illustration Dick Bruna copyright. Copyright Mercis b.v., Amsterdam © 1975. All rights reserved. Reprinted by permission of Price/Stern/Sloan Publishers Inc., Los Angeles.*

portrayed here! What adults who have tucked children in and kissed them goodnight will not be immediately reminded of those moments when children are at their most angelic and lovable?

What effect does Bruna achieve by making children and adults put their hands behind their back? And what effect does he produce by suddenly making them appear in the next picture?

That fingerless hand in which the thumb alone plays such a prominent part has become typical of his work. How can he draw a scarf so that you feel that it's knotted at the back, so that you can feel the knot itself without seeing it?

Perhaps this would be a good moment to mention that Dick Bruna has always and exclusively made his black lines and outlines—only the red of the clown's mouth in *Circus* is left without black outlines—with a paintbrush, not with a felt-tip pen as most people think. He began to draw them before there were any felt tips and he has remained faithful to himself and his technique. (pp. 12-13)

Since 1973 the Otto Maier Verlag in Ravensburg, Germany, has been publishing books consisting of five pieces of hard cardboard with one of Dick Bruna's pictures on either side. Plastification and a cloth back ensure maximum durability. A few words appear on the cover alone.

In each case there is a connection between two adjacent pictures—on the right hand and left hand pages—which is not set out in words. The books are obviously intended for one and two year-olds. Children of that age would not see any connection between the pictures for themselves.

Only if grown-ups or older children invent little stories to accompany the pictures will small children see more than the individual images. By this means these simplest of all books are an unspoken challenge to the activity and creativity of whoever is looking after the toddler.

It is in these little books (which, incidentally, are not square) that the power of Bruna's colours and lines finds its clearest expression.

Inescapable and fascinating. The irregularities in the thick black lines caused by Bruna's paintbrush give the image a capricious, lively quality.

They also convey a message: this line was drawn by a hand, by someone looking at what he was making. That is why Dick Bruna has always been so insistent that these irregularities must not be converted by printing techniques into regular, lifeless lines. This is why sticking to his paintbrush has been so important; it has something to do with the entirely different feelings and thoughts which can be evoked by the printed word and by hand-written letters.

Most of the books which contain a continuous story were originally written in a four-line verse form of 8-6-8-6 syllables, in which the last word of line four rhymes with the last word of line two.

The characteristic 8-6-8-6 rhythm has lodged itself like a tune in the minds of the Dutch-speaking parents, grandparents and child-minders who have endlessly read the Bruna books aloud. (pp. 13-15)

In his stories Bruna talks a lucid, child's language consisting of short sentences made up of simple, familiar words. One is

struck by the frequent use of the past tense of the verbs. The stories describe events which have already taken place: once upon a time there was . . .

This is an important fact because children of the age at which the Bruna books are most popular are generally still experiencing a lot of difficulty over producing for themselves the regular and irregular forms of the past tense of verbs.

The same applies to the past participles of which Bruna also makes considerable use. So I would assume that children to whom a lot of Bruna books are read aloud must be stimulated in their understanding and use of these forms of the verb. (p. 15)

Has Dick Bruna's use of language contributed to the success of his books? If I knew only the Dutch editions, my answer would be an unreserved affirmative: I think that the strictly maintained verse form 8-6-8-6 above all, has contributed appreciably to their popularity. Easy for adults to read aloud— even if they have not had much practice at it—and easy for children to follow and repeat to the same beat. The verse form and rhymes are a very good memory aid here. And the better the text is known by heart, the nicer it is to hear it all over again.

But since the foreign editions are also very successful, although not much of Bruna's original use of language has been preserved in them, I cannot provide a plain answer to this question after all.

What are the books about? They can be classified in all kinds of ways. One big difference is between the books which tell a continuous story and the books which simply consist of illustrations and names of separate objects.

First, something about this second group. It includes:

> the two *counting books*
> *B is for bear*
> the *I can read* series (four books)
> the *animal books* (two in the new small-format
> edition)
> *I am a clown*
> the colour book *My vest is white*
> the *Flower book*

In the two counting books and in the alphabet book *B is for bear* there is a link between the pages insofar as the sequence of the number series (from 1-10 and from 11-20) and the alphabet is adhered to. In all the other books in this series the sequence of pages is arbitrary and based purely on aesthetic grounds.

A feature of this group is that the texts consist only of the names of the objects illustrated. Bruna did not start on this group until 1967. The first was the alphabet book and the last (up to now) the *Flower book*.

These books are naturally often bought with the *intention* that children should learn something from them. They are even easier to read aloud than the story books, and, which is more important, they can be more easily 'read' by the child himself, because the child very quickly learns the complete text by heart.

The recognition and naming of various kinds of animals and the recognition and naming of other objects in daily life (as in the *I can read* series and in *B is for bear*) constitute the beginning of the development of a vocabulary. The two counting

books will probably only be given to children who have passed the first stage, that is, who can already speak in simple sentences and have a vocabulary of at least a couple of hundred words.

At the same time parents will also think it important for the names of *colours* to be learned. For most parents, on the contrary, knowing the names of various *flowers* is quite unimportant. Many adults, after all, do not know the names of the flowers illustrated in the flower book themselves. So I think this book is unlikely to go into as many impressions as the other books in this group.

The book *I am a clown* will probably be bought mostly for the charm of *dressing up* and because the child can learn to distinguish between different professions through it. For that matter, the 'let's pretend' game of *I am a clown* is of course equally present in the other books in this group; this can be seen most clearly on the final pages of the *I can read* series: look, I really can read! I believe that this is the key to the raison d'être of these books: not because children of this age really need to *learn* these things, but because the children are getting a book for themselves, of which they can learn to master the contents perfectly as *if* they knew all about it. Look, I really am big!

Most of Dick Bruna's books, on the other hand, consist of little stories. Only two of them are completely without words. (pp. 15-16)

Little girls predominate in *The school*, in *Tilly and Tessa*, in *I can read*, *My vest is white* and in the whole *Miffy* series. On the other hand, *The King*, *The sailor*, *I am a clown* and *Circus* are predominantly masculine, while in *Snuffy* the poor helpless creatures are females and in *Snuffy and the fire* the rescuers are male.

It looks as if Dick Bruna has striven for a balanced effect here as well: where his subject left him completely free to choose, as in *I can read*, *A story to tell* and *My vest is white* he chose a little girl the first time, a boy the second time and a girl again the third time.

In Bruna's books girls, women and female characters do always wear skirts or dresses and boys trousers. On the few occasions when bricks are played with boys are doing the playing.

Miffy's mother plays a subordinate role in the whole series, but this is offset by the fact that Miffy's father goes to the beach and the zoo with her. Balance again: since Miffy is female, the adults who have most to do with her must be male.

New to Dick Bruna's work is the main character in *Poppy Pig*. The first part, in which Poppy is introduced, must be a thorn in the flesh of the supporters of women's liberation. The little pig spends all day on domestic tasks and is extremely content to do so. But in the second part Poppy suddenly shows that she can be a first-class gardener who mows the grass, clips the hedge and runs a wheelbarrow. Poppy is certainly not in need of a man to do it! With *Poppy Pig* Dick Bruna wanted to create a new character who is capable of doing things for herself and others because of her own independence and who can also enter into a parent-child relationship, as she does with her little niece Gruntie in *Poppy Pig's garden*.

Whereas in the *Miffy* series Bruna's point of departure is the *child*, in the Poppy series (at least there is a chance that it will become a series!) his point of departure is the *adult*. Now of

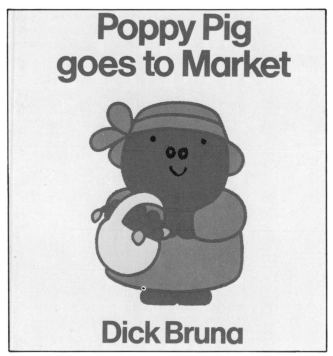

Poppy Pig goes to Market

Dick Bruna

From Poppy Pig Goes to Market, *written and illustrated by Dick Bruna. Methuen, 1981. Copyright © 1980 Dick Bruna. Illustrations Dick Bruna copyright © Mercis b.v. 1980. Reprinted by permission.*

course the great question is whether Miffy and Poppy will ever meet each other. (p. 17)

Dick Bruna uses colour in a way which has not been seen in children's books before. To begin with he used only black, white, red, green, blue and yellow, generally separated from each other by black outlines, and also always in the same shade, which may be self-evident for the first two, but not for the last four.

Although the colour may also be used to produce a small detail, such as grandpa's tie-pin in *I can read,* it is generally the large, uninterrupted colour surfaces which have become characteristic of the whole of Bruna's work. Another characteristic is the many pages which look as if coloured paper has been used: a single colour fills the entire background and people or objects stand out against it in a different colour. If the action takes place outdoors the background is often in two colours, with the horizon as the dividing line.

To begin with Bruna only used white as a background incidentally, when he wanted to put someone in the snow, such as *Miffy in the snow* and the eskimo in *The Sailor.*

Afterwards he used white as a background for whole books, for instance for the *I can read* and *I can read more* books. In the *Dick Bruna animal book* Bruna moved the coloured background over for the first time from the right-hand page with the picture to the left-hand page with the words. Bruna used brown for the first time in the two parts of *Snuffy* and afterwards in the fairy tales, the *Animal book* and *I can dress myself.*

As in so many other respects, the fairy tales and *Christmas* occupy quite a separate position in Bruna's work as regards colour as well. He wanted to use softer pastel colours in them

in order to distinguish their fairy tale character from the more realistic character of his other books.

He first designed *Christmas* in the same colour as his other books but when it was finished he found the result too hard and did it all over again in pastel colours.

He first used grey a year after the fairy tales in *A story to tell.*

You could say that Bruna stood out against brown and grey for a long time and only began to use these colours when he was forced to by his subjects. He put up a lengthy resistance—for instance, the haystack in *The little bird* still had red posts and the farmer in the same book smoked a green pipe. The evidence that in the end Dick Bruna was completely won over appears in the *Animal book,* in which not only a number of animals but also a number of left-hand pages of text are executed entirely in grey and brown. Again, we see the evidence of Bruna's strict and deliberate handling of colour in the fact that in this same book for the first time the colour blue is not used at all. Was this a limitation he imposed on himself because apart from grey and brown the author also had to use a kind of beige in this book for the lions and camels? Or was it because he had no blue animals to paint and would therefore have disturbed the balance by giving a text page a colour which was not also represented in one of the animals?

When asked why he seldom uses orange and never purple, Bruna says that he regards them as half or intermediate colours and would prefer to restrict himself to the colours from the beginnings of his work. But he also says that he knows his red has been gradually moving towards orange, which is most clearly demonstrated in a number of glossy covers such as those of *Pussy Nell, I can count more,* and *Miffy's birthday.* But it is actually in the colours on these covers that differences can easily arise from one edition to the next. Not until 1977 was genuine orange used, for the carrots prepared by *Poppy Pig.* So if Bruna has gradually accepted orange, he still completely rejects purple and says he doesn't believe he will ever be using that colour. (pp. 19-20)

Apart from the *Miffy* series, Bruna's attachment to the colours black, white, red, green, blue and yellow is shown in the book *My vest is white,* which he made specially to help children to learn the names of those colours. What lies behind Bruna's preference for these colours? He himself feels he is influenced by the use of colour of the De Stijl group, whose members included the painter Mondrian and the architect Rietveld. Dick Bruna says that even in his first books, to his regret, he had to admit green because he seemed to need that colour in everything he wanted to say.

The De Stijl group rejected green because it was not a primary colour. The group also rejected nature, in which green—certainly in the Netherlands—is such a dominant colour.

Black, white, red, yellow and blue were the only colours which the De Stijl group liked using. But how can anyone make books for children without using nature and therefore green?

That Bruna always gives the names of the colours he uses in his pictures in the texts of his books is well known. We also know that parents and teachers are generally very keen on getting their three and four year-olds to learn the names of the colours and although most children of that age can distinguish the colours perfectly well for themselves and often naturally know and use some colour names, they are not all that careful

about their correct application and call red things green and yellow things blue. Even in a country like Holland, with so many children's books and so many parents who want their children to give the colours their correct name, countless four and even five year-olds seem unable to connect the right name with the right colour. The Dick Bruna books therefore fulfil in this respect an important demand from parents and teachers of playgroups and infant schools: to teach children to apply the names of the colours correctly. (pp. 20-1)

> *Dolf Kohnstamm, in his* The Extra in the Ordinary: "Children's Books by Dick Bruna" *(text © copyright Dolf Kohnstamm 1978; reprinted by permission of the author), revised edition, Merces Americanae n.v., 1979, 33 p.*

BRENDA DURRIN MALONEY

The School, which must be a nursery school, seems like a fun place. Children sing, draw pictures, build with blocks, weave, share candy, and go back home. Rockwell's *My Nursery School* . . . offers a much more realistic picture of what school is like for young children.

In *The Sailor,* a seafarer with a brand new boat sets off to see the world. Soon he meets a whale who tells him the land of the Eskimos is near. Never donning warm clothing, he spends a night with the Eskimos (yellow faces) and then sails off again, promising to return.

Bruna's bold and vivid illustrations definitely appeal to one to two and a half year olds. His stories are marginal. Until better materials are available, Bruna's books do serve a purpose.

> *Brenda Durrin Maloney, in a review of "Miffy at the Beach," "Miffy at the Playground," "The Sailor," and "The School," in* School Library Journal *(reprinted from the April, 1980 issue of* School Library Journal, *published by R. R. Bowker Co./A Xerox Corporation; copyright © 1980), Vol. 26, No. 8, April, 1980, p. 90.*

JUDITH GOLDBERGER

Typical of the popular Bruna books for preschoolers, [*Miffy at the Beach, Miffy at the Playground, The Sailor,* and *The School*] have mild, benevolent stories with few words and primary-colored pictures. Bruna succeeds at his apparent goal: to produce eye-appealing, happy books uncomplicated by any over-the-head challenge for a listener.

> *Judith Goldberger, in a review of "Miffy at the Beach," "Miffy at the Playground," "The Sailor," and "The School," in* Booklist *(reprinted by permission of the American Library Association; copyright © 1980 by the American Library Association), Vol. 76, No. 16, April 15, 1980, p. 1200.*

RUTH M. STEIN

[In] all of his undersized books, the deservedly popular author/ artist uses sharp primary-colored pictures outlined in black, with four lines of text facing each illustration. Whether Bruna writes of Snuffy, or Miffy, or a day at school, his illustrated tales leave a clear impression of cheeriness with pre-schoolers. Bruna manages to say so much in so few words! (pp. 647-48)

> *Ruth M. Stein, in a review of "The School" (copyright © 1980 by the National Council of Teachers of English; reprinted by permission of the publisher and the author), in* Language Arts, *Vol. 57, No. 6, September, 1980, pp. 647-48.*

From The School, *written and illustrated by Dick Bruna. Methuen, 1981. Copyright © 1980 Dick Bruna. Illustrations Dick Bruna copyright © Mercis b.v. 1964, 1967, 1968, 1969, 1970, 1972, 1974, 1976, 1980. Reprinted by permission of Price/Stern/Sloan Publishers Inc., Los Angeles.*

MARGERY FISHER

[In *I Know about Numbers* and *When I Am Big*] Bruna's simple but positive images of ordinary things take infants at once away from the photographic representation while they satisfy the need for pictures that can be easily identified. Very simple addition is demonstrated with clear figures and grouped objects (scissors, toffees, mittens, keys, for instance) and the equally direct examples of activities (swimming, playing the violin, gardening, skating) end with the role-playing child asserting 'When I'm big, I'm going to do lots of things'. An engaging view of the ordinary.

> *Margery Fisher, in a review of "I Know about Numbers" and "When I Am Big," in her* Growing Point, *Vol. 20, No. 2, July, 1981, p. 3918.*

DENISE M. WILMS

Bruna's books are familiar bookstore items; sometimes they're the only "real" books on the shelf for the youngest reader/ viewer. Despite the shortcomings of his elementary, heavy-lined style, both of these latest offerings are successful in conveying their elementary concepts. . . . [*I Know about Numbers* and *When I'm Big* are] useful filler for the pre-preschool shelf. (pp. 101-02)

> *Denise M. Wilms, in a review of "I Know about Numbers" and "When I'm Big," in* Booklist *(reprinted by permission of the American Library Association; copyright © 1981 by the American Library Association), Vol. 78, No. 2, September 15, 1981, pp. 101-02.*

NICHOLAS TUCKER

[One] of the masters of the art of writing and illustrating for the very young is the Dutch artist Dick Bruna. In his books,

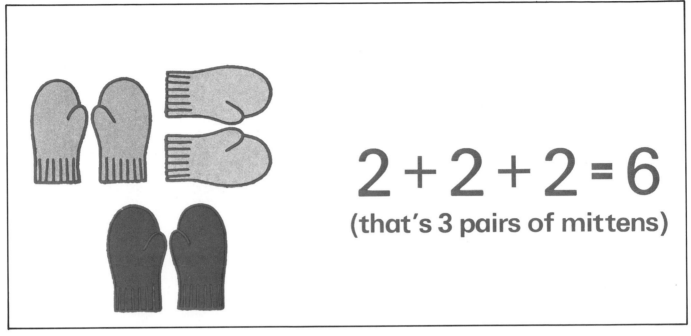

From I Know about Numbers, *written and illustrated by Dick Bruna. First published in the U.S.A. in 1984 by Dick Bruna Books Inc., New York. Illustration Dick Bruna copyright. Copyright Mercis b.v., Amsterdam © 1969. All rights reserved. Text copyright © Dick Bruna 1984. Reprinted by permission of Price/Stern/Sloan Publishers Inc., Los Angeles.*

figures always stand out flat and square against the clear, uninterrupted colour surface that makes up their background, and are drawn in thick, black contour lines which render their basic shapes impossible to miss—no danger of overlapping detail or confusing, common contours here. Elsewhere, essential detail is kept to a minimum: a child's grief, for example, is portrayed by a down-turned mouth, two round tears and hardly anything else. The texts, in turn, are usually as spare and easy to follow as the illustrations.

Popular as they are, however, a diet of picture-books that only consisted of titles by Dick Bruna and his imitators would be scant fare for a child, and even in his own country the Dutch librarians' association decided not to recommend his versions of *Hop o' my Thumb* and *Cinderella,* on the grounds that the brevity of the texts could not do justice to these rich, traditional tales. There is also a need at this age, therefore, for a different type of literature which extends the imagination and perceptual skills beyond their present confines. (p. 27)

> *Nicholas Tucker, "First Books (Ages 0-3)," in his* The Child and the Book: A Psychological and Literary Exploration *(© Cambridge University Press 1981), Cambridge University Press, 1981, pp. 23-45.**

BRENDA DURRIN MALONEY

[*Poppy Pig Goes to Market*] is the simple tale of Poppy, who rises early one morning and heads off to market. Poppy buys cherries and calls a friend to share them. . . . The simplicity of form and design are fine, but they do not save this uneventful tale. [*I Know More about Numbers*] is not a simple counting book, but an introduction to the skills involved in addition. The logic of the sequences is questionable. In a picture portraying "7 + 3 = 10," ten strawberries are shown in rows of three, four and three. Far more clear is "4 + 1 = 5," with

four blue shovels and one red shovel. This device carried throughout would have made the book much simpler and its purpose clearer. If the format of the book were not directed to preschoolers, criticisms could be overlooked because of the general appeal of Bruna's books.

> *Brenda Durrin Maloney, in a review of "I Know More about Numbers" and "Poppy Pig Goes to Market," in* School Library Journal *(reprinted from the September, 1982 issue of* School Library Journal, *published by R. R. Bowker Co./A Xerox Corporation; copyright © 1982), Vol. 29, No. 1, September, 1982, p. 104.*

***DE VIS** [THE FISH]* **(1962)**

The sturdy, simple images in their bright primary colours are perfect for infants learning to recognise pictures on a page. The little green fish in this tiny tale is especially emphatic, and his rescue of Susan, bringing the reward of two basketsful of bread, should please very small listeners.

> *Margery Fisher, in a review of "The Fish," in her* Growing Point, *Vol. 8, No. 8, March, 1970, p. 1492.*

***KERSTMIS** [THE CHRISTMAS BOOK]* **(1963)**

Here is the child's-eye view again, with figures like clay models interpreted in present day terms—Mary looks like a hospital sister in a maternity wing, the kings are clearly little boys dressed up. A friendly, spontaneous and direct picture-story for the youngest to look at.

> *Margery Fisher, in a review of "The Christmas Book," in her* Growing Point, *Vol. 6, No. 6, December, 1967, p. 1040.*

[Bruna's] version of the Nativity is so beguiling that it's hard to think of anyone passing it up, come the season for remembering a special child. Little ones and their parents should love the bright primary colors in the deceptively childlike representations of the star, the stable, shepherds, Magi and angels—to say nothing of a most unusual Jesus, Mary and Joseph; the text (faithful to the original) is as simple and effective as his pictures.

> *A review of "The Christmas Book," in* Publishers Weekly *(reprinted from the July 5, 1976 issue of* Publishers Weekly, *published by R. R. Bowker Company, a Xerox company; copyright © 1976 by Xerox Corporation), Vol. 210, No. 1, July 5, 1976, p. 91.*

For those just learning to read, Bruna's Christmas book has large print and a limited vocabulary but the heavily outlined illustrations are on the level of a coloring book. Cupid-style angels hover over wooly sheep, and a five-pointed bright yellow star guides the three wise men (one of whom looks like a Little Black Sambo) to the bare stable where the infant sleeps flanked by Mary and Joseph.

The poetic beauty and archetypal appeal of the Nativity story are still best captured by such artists as the Petershams, the Provensens, Charles Keeping, Celestino Piatti, and Felix Hoffmann.

> *Allene Stuart Phy, in a review of "The Christmas Book," in* School Library Journal *(reprinted from the March, 1977 issue of* School Library Journal, *published by R. R. Bowker Co./A Xerox Corporation; copyright © 1977), Vol. 23, No. 7, March, 1977, p. 129.*

Bruna retells the Christmas story in warm, easy-flowing phrases. Juxtaposed with the text are boldly colored illustrations that match the narrative with quiet simplicity to make this an appropriate presentation for the very young.

> *Barbara Elleman, in a review of "The Christmas Book," in* Booklist *(reprinted by permission of the American Library Association; copyright © 1977 by the American Library Association), Vol. 73, No. 13, March 1, 1977, p. 1010.*

DE MATROOS [THE SAILOR] (1964)

With their pared-down, childlike stories and pictures in the simplest shapes and bright primary colors, the little books by Dutch author-illustrator Bruna find few rivals in the world of tots too young for reading on their own. They will enjoy listening to the story and taking in scenes describing the first voyage of this book's hero.

> *A review of "The Sailor," in* Publishers Weekly *(reprinted from the February 1, 1980 issue of* Publishers Weekly, *published by R. R. Bowker Company, a Xerox company; copyright © 1980 by Xerox Corporation), Vol. 217, No. 4, February 1, 1980, p. 108.*

IK KAN LEZEN [I CAN READ] (1965)

An attractive, simple reading book, each page bearing a brief sentence with an illustrative picture in typical Bruna style. The first pages explain things close to a child—nose, mouth, brother, sister—while the second half introduces external things—house,

bed, chair. Not all the pictures are entirely self-explanatory. For instance, "A fish swims in water. A bird flies in the air" is illustrated by a fish and a bird, looking very like each other in shape and size, without conveying at all the ideas of "swim", "water" or "air". But it is hard to see how a child could resist reading both the words and the pictures and saying, with the child on the last page, "So you see I can read". The 28 pages are stapled together: how long they will stay that way, with the constant re-reading each book should get, I would hesitate to say.

> *V. A. Bradshaw, in a review of "I Can Read," in* Children's Book News *(copyright © 1968 by Baker Book Services Ltd.), Vol. 3, No. 3, May-June, 1968, p. 130.*

[A] first reading book that even the very young will memorise so as to have the illusion of reading. Bruna books are well designed and particularly appropriate for adults and children who find satisfaction in extremely simplified text and pictures. A book to look at with babies, too—they will enjoy the strong design.

> *A review of "I Can Read," in* Books for Your Children *(© Books for Your Children 1976), Vol. 12, No. 1, Winter, 1976.*

B IS EEN BEER [B IS FOR BEAR: AN ABC] (1967)

Among the simpler stuff, the alphabets, first readers, indestructibles and the like, Dick Bruna wins by several lengths. . . . [His **B is for Bear** unlike his fairy tale adaptations, is] an undoubted success. This is, most usefully, a *lower*case alphabet, simple as only real assurance and devotion can manage. . . . (p. 658)

> *John Fuller, "Colour and Bedtime" (© British Broadcasting Corp. 1967; reprinted by permission of John Fuller), in* The Listener, *Vol. LXXVII, No. 1990, May 18, 1967, pp. 658, 660.**

Dick Bruna is too well-known to need introduction. His abc is presented in his usual strikingly simple style, and many old friends—apple, sailor, rabbit—are instantly recognized. One lower case letter appears opposite each drawing; your reviewer would have liked to see the whole word written, instead.

> *"First Favourites," in* The Times Literary Supplement *(© Times Newspapers Ltd. (London) 1967; reproduced from* The Times Literary Supplement *by permission), No. 3404, May 25, 1967, p. 453.**

No one can simplify much more attractively than Dick Bruna and this larger-than-usual Bruna square book makes good use of his practice in making apples, fish, rabbits, etc., and includes a good owl and toadstool. The absence of colour backgrounds makes the book less gay than his earlier picture books, but on the whole this is vintage Bruna.

> *A review of "B Is for Bear," in* The Junior Bookshelf, *Vol. 31, No. 4, August, 1967, p. 234.*

By stripping his illustrations of inessential details, Bruna has left them with a flatness that tends to destroy the essential aids to object recognition for many small children. While this does not affect the attractiveness or comprehensibility of the many picture story books produced by Bruna that are so popular with children, it is more confusing in the case of an alphabet book,

where the objects should be easily recognisable, particularly when on the page facing the picture there is no clue to the name of the object, only the stark letter on the page. But like most Puzzle books, the answers have been obligingly placed at the end of the book.

> *Pat Garrett, in a review of "B Is for Bear," in* Children's Book Review *(© 1971 by Five Owls Press Ltd.; all rights reserved), Vol. I, No. 2, April, 1971, p. iv.*

[**B Is For Bear**] is too stark—all right for design-conscious grown-ups but dull and sterile for children despite its bright colours. I much prefer *The Toolbox* by Anne and Harlow Rockwell . . . , which has equally simple and well-designed pages but far more interestingly-drawn objects—these resemble and have the rich charm of the real things, where Bruna's are needlessly over-simplified and stark. (p. 665)

> *David Gentleman, "All Things Bright," in* New Statesman *(© 1971 The Statesman & Nation Publishing Co. Ltd.), Vol. 82, No. 2121, November 12, 1971, pp. 664-65.**

The illustrations have an appealing, toylike appearance in bright blues, greens, oranges, and yellows, outlined with bold, black lines. Though a few (j—jigsaw, t—toadstool, x—xylophone) may be difficult at first for youngest learners to grasp, most will be recognized instantaneously, with reinforcing gratification, again and again.

> *Barbara Elleman, in a review of "B Is for Bear: An ABC," in* Booklist *(reprinted by permission of the American Library Association; copyright © 1978 by the American Library Association), Vol. 74, No. 10, January 15, 1978, p. 810.*

BOEK ZONDER WOORDEN [A STORY TO TELL] (1968)

The book has a main character and a story concerned with everyday things, with the difference that the little boy finds on his morning walk, a doll or gnome which is crying by the wayside. The little boy puts the gnome under his arm and after that the gnome takes part in the boy's life. The story is as simple as it could possibly be: one person has a home in which he lives alone but not unhappily; he meets another person who is also alone, but homeless and unhappy as well; the first character takes pity on the second and brings him home.

It is important to know that on a number of occasions [Bruna] has referred to this book as his best, the one he himself is most fond of. But besides being a children's presentation of an old theme, this book is at the same time a private affair between the artist and the child. The child does not need any adult or older child to read the words and sentences in this book; looking at the pictures is enough. And the artist shows the child that he knows what a great thing it is to have a doll or a bear coming to share your life, someone sitting on a chair waiting for you when you have to wash yourself and someone to share your bed all night. (p. 13)

> *Dolf Kohnstamm, "Dick Bruna," in* Books for Your Children *(© Books for Your Children 1978), Vol. 13, No. 3, Summer, 1978, pp. 12-13.*

SNUFFIE [SNUFFY] (1969)

The gulf between quality and quantity yawns as wide as ever, and top marks in this year's baby stakes must again be given to Dutch Dick Bruna . . . for bridging it with the only books that make an immediate appeal to everyone, high or low, left or right, dim-witted or brainy. Bruna Books now number around twenty-five titles, and you might think Mr. Bruna would be hard put to it to find new heroes and new themes, limited as he is by the discipline of his strict rules of format; not a bit of it. *Snuffy*, the little dog, is as quickly stamped on the memory as all his other characters, and will be greatly loved.

> *"Nursery Worlds," in* The Times Literary Supplement *(© Times Newspapers Ltd. (London) 1970; reproduced from* The Times Literary Supplement *by permission), No. 3589, December 11, 1970, p. 1455.**

With a few thick black lines, the use of bold colours, a striking square shape and the final touch of artistry which shows itself in the simple effect of the drawing of eyes, nose and mouth, Dick Bruna introduced us to Miffy whom the young children adored. Now, instead of this famous little white rabbit, Mr. Bruna has given us a new character called Snuffy, who is "a small brown dog, with bright black eyes, floppy ears, and a nice cold nose". It is Snuffy's nice cold nose that enables him to restore a lost child to her mother, and it looks as though this nose will prove very useful in future stories of Snuffy, who will surely become a much-loved picture-book hero.

> *Berna Clark, in a review of "Snuffy," in* The Junior Bookshelf, *Vol. 35, No. 1, February, 1971, p. 20.*

TELBOEK NO. 2 [I CAN COUNT MORE] (1972)

This volume has been thoughtfully conceived with some interesting use of number patterns with the objects, rather than an incoherent jumble. I particularly liked the example for 20, which shows an abacus frame with the beads showing four different '5' patterns. The beads are also used for 21, this time on a string, with the twenty-first still on the needle, showing most effectively the concept of the one to be added to twenty that some children find quite difficult.

> *Pat Garrett, in a review of "I Can Count More," in* Children's Book Review *(© 1973 Five Owls Press Ltd.; all rights reserved), Vol. III, No. 5, October, 1973, p. 137.*

DIERENBOEK [DICK BRUNA'S ANIMAL BOOK] (1972)

This latest and larger-than-usual volume of this famous artist for very young children displays all the customary skill which we expect from him. The thick black lines and simple but so effective faces are with us as always. The children who are given this book to enjoy will recognise similar drawings in previous books, like the face of Snuffy, but some here of special appeal include the giraffe, the camel and the snail.

> *Berna Clark, in a review of "Animal Book," in* The Junior Bookshelf, *Vol. 38, No. 4, August, 1974, p. 200.*

Gentle humour rather than zoological accuracy is what characterizes Dick Bruna's book of animals. We have a snooty camel, conversational giraffes, a condescending kangaroo ("*my baby's bigger than yours*", she seems to be saying) and con-

fidential penguins (swapping secrets on the floor of the Stock Exchange, perhaps?) Bold drawings, coloured paper, animals' names printed in large type, and a solid binding make this square sturdy book an attractive prospect for nursery school use (and abuse).

> Elaine Moss, ''Picture Books: 'Dick Bruna's Animal Book','' in Children's Books of the Year: 1974, edited by Elaine Moss (© Elaine Moss 1975), Hamish Hamilton, 1975, p. 16.

IK BEN EEN CLOWN (1974; British edition as *I Am a Clown*)

As a first 'book with text', the latest Bruna book will be welcomed by reception class teachers. It starts 'I am . . .' and then on each page appears the text and illustration for a clown, a sailor, a doctor, etc. As are most books, this is strictly for the boys. Every occupation depicted is male, including 'cook', and unfortunately, again as in most early books, text is on the left, illustration on the right. As we are trying to encourage children to scan from left to right at this level and as they take their cue from the illustration in a caption book, this all too common layout does not help. However, we are very short of inexpensive quality hardbacks in this genre and must tolerate a few imperfections for the time being.

> Cliff Moon, in a review of ''I Am a Clown,'' in The School Librarian, Vol. 24, No. 4, December, 1976, p. 318.

NIJNTJE IN HET ZIEKENHUIS [MIFFY IN THE HOSPITAL] (1975; British edition as *Miffy in Hospital*)

Miffy, a little rabbit, has a sore throat, and the doctor says she must go to the hospital. . . . Once there, she is still frightened—until a nurse takes her by the hand, helps her undress and get into bed, and gives her an injection that "only hurt a little." Soon, Miffy falls asleep. When she awakens feeling rather strange, the nurse tells her that her throat will no longer hurt and she will soon feel better. As if to prove this, Miffy's parents appear with a present—a nurse doll—and Miffy decides that she no longer minds being in the hospital.

Some routine hospital experiences that might frighten a little child are ignored or treated superficially in this book. But this same light treatment makes it suitable as an introduction to hospitalization for just such a child. Simple line and color illustrations maintain the light tone.

> Sharon Spredemann Dreyer, in a review of ''Miffy in the Hospital,'' in her The Bookfinder: A Guide to Children's Literature about the Needs and Problems of Youth Aged 2-15: Annotations of Books Published 1975 through 1978, Vol. 2 (© 1981 American Guidance Service, Inc.), American Guidance Service, Inc., 1981, No. 90.

NIJNTJE'S DROOM [MIFFY'S DREAM] (1979)

Miffy's Dream, the ninth Miffy book for the very young, has a new balance between story and illustration. The brief text, describing how Miffy meets another rabbit with whom she invents games in a sky playground, is confined to page one. A lengthy sequence of rather similar pictures follows in illustration. Miffy is a white rabbit; her dream playmate is brown. But even a good moral needs an interesting context.

> Lesley Wood, ''Rude, Stamping Giant,'' in The Times Educational Supplement (© Times Newspapers Ltd. (London) 1979; reproduced from The Times Educational Supplement by permission), No. 3316, December 28, 1979, p. 19.*

The very best children's books are usually the most simple. Dick Bruna is a genius in capturing for small children the whole essence of a story, with love, serenity and above all, fun. Buy this book, without words, because it is worth every penny. Miffy tumbles about the story on a dream cloud playing with a new found friend—tentatively at first but with increasing joy until they fall asleep together—a sure and perfect touch with just a few expressive lines and colour.

> A review of ''Miffy's Dream,'' in Books for Your Children (© Books for Your Children 1980), Vol. 15, No. 4, Autumn-Winter, 1980, p. 35.

HEB JIJ EEN HOBBIE? [WHEN I'M BIG] (1980)

Bruna's books for toddlers are enormously popular and this small item epitomizes their allure. Shapes representing little children and things drawn with a minimum of lines and curves, are painted in poster-bold, primary colors. The text is equally reduced to simplicity, spoken by aspirants of two or three years who anticipate the performance of great feats. . . . The cute tykes with their solemn expressions appeal to grown-ups as well as to children.

> A review of ''When I'm Big,'' in Publishers Weekly (reprinted from the May 15, 1981 issue of Publishers Weekly, published by R. R. Bowker Company, a Xerox company; copyright © 1981 by Xerox Corporation), Vol. 219, No. 20, May 15, 1981, p. 62.

Initially a caption book for child and adult to share, later a book for independent reading by beginners, some possibilities for future accomplishments are depicted, ending '. . . And I'll read books.' There's a slight sexist bias (dancing for girls, judo for boys) and my perennial plea for left-right orientation in caption books (illustration left, text right) still hasn't sunk in. Nevertheless, a useful little book for starters.

> Cliff Moon, in a review of ''When I'm Big,'' in The School Librarian, Vol. 29, No. 3, September, 1981, p. 226.

BETJE BIG GAAT NAAR DE MARKT [POPPY PIG GOES TO MARKET] (1980)

Bruna's picture books disappear fast from bookstores and libraries because of their strong appeal to tykes. Children too young to read love to hear about the simple happenings, such as those recounted and illustrated here by pixieish characters and things painted in undiluted primary colors. Poppy Pig can't decide what to choose from the appetizing foods in the stalls at her town market. . . . Poppy opts for a basket of juicy cherries and, back home, calls her friend Grunty to share the feast. When they've eaten their fill, they tickle their audience by making snazzy earrings out of the leftovers.

> A review of ''Poppy Pig Goes to Market,'' in Publishers Weekly (reprinted from the September 18, 1981 issue of Publishers Weekly, published by R. R. Bowker Company, a Xerox company; copyright ©

1981 by Xerox Corporation), Vol. 220, No. 12, September 18, 1981, p. 154.

DICK BRUNA'S WORD BOOK (1982)

The latest of bestselling Bruna's books is a veritable treasure for his wee fans, a much bigger volume than usual and more generous with the illustrations that children twig to. The Dutch artist is often imitated, but no one approximates the childlike pictures he produces with the simplest shapes and undiluted primary colors.

A review of "Dick Bruna's Word Book," in Publishers Weekly *(reprinted from the July 30, 1982 issue of* Publishers Weekly, *published by R. R. Bowker Company, a Xerox company; copyright © 1982 by Xerox Corporation), Vol. 222, No. 5, July 30, 1982, p. 75.*

Many of the illustrations will be familiar to readers of Dick Bruna, but it is rather pleasant to find the well-known pictures from the artist's ideas of home, school, toys, the outdoors, people, the zoo and the farm all between the same covers. However much these drawings are looked at, they have a fresh appeal every time.

Berna Clark, in a review of "Word Book," in The Junior Bookshelf, *Vol. 46, No. 4, August, 1982, p. 130.*

GOOD MORNING (1983)

It is a lucky child whose very first book is **Good Morning.** There are no words to interfere with Dick Bruna's delightful pictures. Mummy can turn the pages and discuss the events which fill the morning of this little chap. . . . An attractive production of bright colours and explicit diagrammatic drawing.

Donald A. Young, in a review of "Good Morning," in The Junior Bookshelf, *Vol. 47, No. 5, October, 1983, p. 196.*

Donald Crews

1938-

Black American author/illustrator of picture books and illustrator.

Crews utilizes his expertise as an artist, designer, and photographer to create concept books distinguished by their poster-style graphics. Employing little or no text, he is noted for his striking pictorial presentations of such topics as transportation, light, the alphabet, and numbers. Crews visualizes movement and energy through his powerful use of color, scale, perspective, and photography. Children find his stylized, pop-art renditions exciting and invigorating, while critics praise the clarity, strength, and beauty of his designs.

Crews has been drawing since childhood. Following artistic training and work as a designer, he published *We Read: A to Z*, an alphabet book using a sophisticated multi-concept approach not found in his later works. Following the publication of the companion counting volume, *Ten Black Dots*, Crews spent ten years illustrating for other authors. He then capitalized on children's interests in trains, trucks, and ships by producing information books celebrated for their geometric shapes and flat, bold colors. *Freight Train*, inspired by yearly boyhood trips to his grandparents' farm in Florida, and *Truck*, a wordless journey by red semitrailer, merited national attention. *Light, Harbor, Carousel,* and *Parade* are further displays of Crews's artistic ability, bolstered by texts that define the illustrations and serve as springboards for them. Critical reception to his works is largely favorable, though some reviewers consider the texts too sketchy and the illustrations overly stylized or lacking in detail. However, Crews's ability to make everyday objects visually stimulating has earned him a dedicated following among children of all ages. Crews's awards include Caldecott Honor Book designations for *Freight Train* in 1979 and *Truck* in 1981.

(See also *Something about the Author*, Vols. 30, 32 and *Contemporary Authors*, Vol. 108.)

GENERAL COMMENTARY

MARJORIE REINWALD ROMANOFF

The Caldecott winners and Honor books of the past decade, not unlike previous decades, have included a variety of types of illustrations. However, Donald Crews . . . deserves singular recognition. (pp. 19-20)

[*Freight Train* provides] the child with a visual experience in the illustrations that both inform and move vibrantly across the page. Crews makes use of vivid red, orange, yellow, green, blue, and purple for the freight cars that are accented in black verticals, horizontals, circles, and squares. For contrast, the engine, tender, clouds of smoke, and tunnels are in black and grays. The forms and shapes created by color and line are arranged in compositions that focus attention and delight the eye. In addition, the track, a tan bar with small evenly-spaced squares acting as supports, continues from the title page to the end of the book and serves to direct the movement of the eye from left to right. In the beginning of this very attractive book, the reader views five white background pages of track as he/she waits for the train to pass. . . . For the youngster, these

five pages create [a] feeling of anticipation. Following are eight pages that describe each car accurately and concisely, in words as well as illustration. The author/illustrator continues to propel the reader along through the adventure of the train. . . . It is a joy for the young child who has—or has not—experienced an actual freight train to become involved in this magnificently illustrated book and thereby expand his/her horizons. . . .

Freight Train was my first choice [for the 1979 Caldecott Award], and I defended it on the basis of its imaginative, though accurate, illustrations; but more importantly, it rated number one in my mind because of the accuracy of the brief text. The train was not anthropomorphic, and it was not referred to as a "choo-choo." On the contrary, each freight car was correctly named. It was the first book of its kind that I had found in my search [for a book that accurately described freight trains], begun in 1951.

Two years after *Freight Train* was named an Honor Book, it came as no surprise to me that another Donald Crews' work, *Truck*, was also chosen as an Honor Book. A gifted artist, Crews appears to have been influenced by the Pop Art movement in the 1960s as well as by the Futurist movement that celebrated the creation of machinery and began in Italy prior to World War I. Not unlike the Futurist, Boccioni, Donald Crews has focused his attention on machines of the twentieth

century: the train and the truck. The medium that he employs is vivid color outlined in black. Drawing upon the apparent influence of Pop artists, in general, and Robert Indiana, in particular, Crews uses bright colors, graphic lettering, city signs, and diagonal lines in *Truck*. (p. 20)

With his tractor-trailer loaded with bicycles, going through the city, passing traffic, following signs, entering tunnels, passing diners and truck stops, going over bridges, passing cities and circling expressways in all kinds of weather, Donald Crews has transported the young reader from the narrow confines of his/her neighborhood and introduced a tool of our modern technological society as it operates in the world. In a true picture book, without any narrative, Crews makes use of the truck's primary-red shape and large lettering to provide a contrast to the variety of other brightly-colored vehicles in traffic. The falling snow and deep mist that appear on four pages produce a filmy cover and provide some variety, and almost relief, for the eye that is bombarded by the excitement of the color. Line, form, and shape come into play as the truck goes uphill and/ or down, and the eye is dazzled by the combination of shapes. In one spread, as traffic moves across the page, the buildings are muted against a fading mountainous backdrop, giving the reader the impression that the truck is truly travelling some distance. For the child who has had the experience of riding along an expressway, the sights will be familiar, and the large green direction signs with white lettering will surely be recognizable. For the child who has not travelled, all of these sights will be illuminating. In either case, there is opportunity for conversation and expanding vocabulary, which is one of the basic needs of childhood. (pp. 20-1)

Above all, books such as *Freight Train* or *Truck* allow the child to conjure up visual images, thereby offering him/her an enjoyable tumble into the abyss of literary imagination.

Donald Crews has started a trend that I hope will continue, because children's literature needs this addition to the variety that already exists. Simple, realistic, easily identifiable characters; fantastic, mythical beasts; or just a simple train or truck present infinite possibilities for stimulating the imagination through picture books, and *all* are needed in the education of a child. (p. 21)

> *Marjorie Reinwald Romanoff, "'Freight Train' and 'Truck': A New Trend in Children's Literature?" in* Children's Literature Association Quarterly, *Vol. 6, No. 3, Fall, 1981, pp. 19-21.*

WE READ: A TO Z (1967)

Here are the letters—*A, a;* here is the word—*almost;* here is the verbal meaning, the equivalent—*nearly;* here is the visual meaning, the concept—*nearly all red,* a double-page nine-tenths red (with a white strip running down the right-hand edge). And so it goes, each letter represented by a relational word, each word exemplified by the relationship of abstract forms in penetrating colors. (One regret: in two instances—*y, only; w, whole*—the letter is used unphonetically.) This is primary communication stunningly presented, with artistic antecedents from Mondrian and Malewitsch to Albers, and a bright future in introducing children to abstract concepts and aesthetic quality, in addition to letters and words. *We read, we see, we understand, we abzorb.*

> *A review of "We Read: A to Z," in* Kirkus Service *(copyright © 1967 Virginia Kirkus' Service, Inc.), Vol. XXXV, No. 3, February 1, 1967, p. 125.*

["We Read: A to Z"] is a new, fresh way to reveal an old, stale story, the ABC story. It's a different kind of ABC, different because A doesn't stand for Apple, different because the reader has to stop a minute to figure out the pattern of it. (If you hear a cry from some educator that its creator has presented too many concepts all at once, refer him to the age group indicated: "5-up.") But once the reader has caught the rhythm, the pattern reveals itself in direct words, direct, clean colors, direct, clean designs. **"We Read: A to Z"** is already on its way to a four-year-old I know who is bewitched by the Mondrians at the Museum of Modern Art. She'll be the first four-year-old to learn her ABC's from Donald Crews. But not the last—not if parents have the daring of the editor who published his book—as well as the perception of my four-year-old friend.

> *A review of "We Read: A to Z," in* Publishers Weekly *(reprinted from the February 27, 1967 issue of* Publishers Weekly, *published by R. R. Bowker Company; copyright © 1967 by R. R. Bowker Company), Vol. 191, No. 9, February 27, 1967, p. 103.*

A most unusual alphabet book that has some imaginative innovations but is difficult enough to need more adult participation than simply reading aloud. The author-artist uses color, design, location, and concepts of comparative sizes and shapes to illustrate the word used for each letter. No apples and xylophones here, but such words as "almost" and "zigzag." Typical format: A brilliant black and yellow checkerboard faces a page explaining, "Ee, equal: as many black as yellow." More difficult to understand is a page that is diagonally split into two triangles (yellow and orange). Facing page: "Kk, kind: same shape, different color." For the unusual child, a challenging book, but the combination of concepts is perhaps complicated for some children. Artistically, the book is quite stunning.

> *Zena Sutherland, in a review of "We Read: A to Z," in* Bulletin of the Center for Children's Books *(reprinted by permission of The University of Chicago Press; copyright 1967 by The University of Chicago), Vol. 20, No. 9, May, 1967, p. 137.*

See all the brilliant colors, patterns and geometric designs in Donald Crews's **"We Read: A to Z"**. . . . [It's an alphabet book;] "Ee" is for "equal: as many black as yellow" on the checkerboard pattern of eight yellow and eight black squares; and "Mm" for "middle: the center from any direction." If you can understand such concepts then you don't need an alphabet book. It's like having a set of storm warning signal flags: you don't know what they say, but they are flashily impressive.

> *George A. Woods, in a review of "We Read: A to Z," in* The New York Times Book Review *(copyright © 1967 by The New York Times Company; reprinted by permission), May 7, 1967, p. 52.*

The usual function of an ABC book is secondary here to the presentation of concepts of position, quantity, size, shape, etc. The result is interesting, but its success with small children will depend entirely on the adult who must interpret it. The simple basic shapes and the brilliant colors will appeal to young eyes, but the words used to illustrate the letters are not always obvious in the facing designs, e.g., . . . "Ee, equal: as many black as yellow" is demonstrated in a checkerboard arrangement, and "checkerboard" rather than "equal" would more

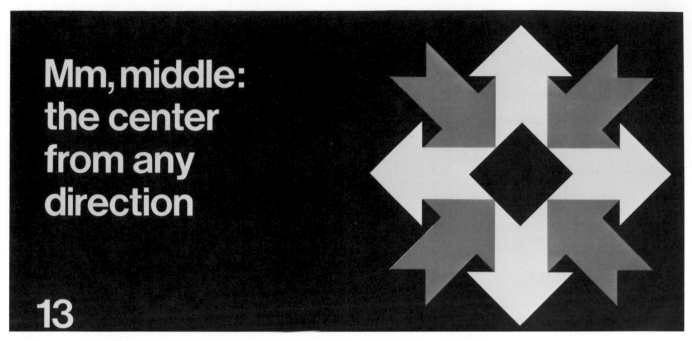

Mm, middle:
the center
from any
direction

13

From We Read: A to Z, *written and illustrated by Donald Crews. Greenwillow Books, 1984. Copyright © 1967 by Donald Crews. By permission of Greenwillow Books (A Division of William Morrow & Company, Inc.) and the author.*

likely occur to a child looking at the illustrations. A good book for group use in initiating discussions of the various concepts.

> *E. Louise Davis, in a review of "We Read: A to Z," in* School Library Journal, *an appendix to* Library Journal *(reprinted from the September, 1967 issue of* School Library Journal, *published by R. R. Bowker Co./A Xerox Corporation; copyright © 1967), Vol. 14, No. 1, September, 1967, p. 160.*

TEN BLACK DOTS (1968)

Mr. Crews made an auspicious entrance with *We Read: A to Z,* which did things with the alphabet that nobody'd done before; this does the same things with numbers that everybody's done before, and better. Counting black dots, one to ten, makes sense only when the dots themselves make sense—first as the objects named, then as elements in the composition, finally as representing a characteristic quantity. Here they're miscast as enormous seeds, misplaced as portholes on the upper decks of a boat and miscalculated (four) as knobs on a radio. . . . Count this one out.

> *A review of "Ten Black Dots," in* Kirkus Service *(copyright © 1968 Virginia Kirkus' Service, Inc.), Vol. XXXVI, No. 4, February 15, 1968, p. 178.*

Good primary-grade readers could enjoy by themselves this sturdy little counting book in which bold black dots represent objects for counting, such as buttons on a coat or wheels on a train, but the book's greatest appeal will probably be to the nursery-school age. The jolly rhyme is brief and to the point, and the clear, bright colors, enclosed in line drawings of geometric simplicity, set off objects familiar to most households. The size, 6½" square, is neither too large for small laps nor too small for library shelves, and the vitality and excellent design give an impact not often found in books for this young age. Mr. Crews, whose recent *We Read from A to Z* employed the alphabet book device to present some rather difficult language arts concepts, has produced another original picture book.

> *Della Thomas, in a review of "Ten Black Dots," in* Library Journal *(reprinted from* Library Journal, *April 15, 1968; published by R. R. Bowker Co. (a Xerox company); copyright © 1968 by Xerox Corporation), Vol. 93, No. 12, April 15, 1968, p. 1782.*

["**Ten Black Dots**"] is a good example of modern graphic design—uncluttered, stylized and austere. The question is posed, "What can you do with ten black dots?" Blobs are then used arbitrarily to suggest that "One dot can make a sun, or a moon, when that's done," seven can make a snake's spots, or stones turned up by a rake. Little rhymes which leave something to be desired in the scansion department accompany the artwork.

> *Nora L. Magid, "For Beginners: Things that Count," in* The New York Times Book Review *(copyright © 1968 by The New York Times Company; reprinted by permission), July 14, 1968, p. 26.**

FREIGHT TRAIN (1978)

As trains do, this one simply—splendidly simply—comes and goes. . . . Through tunnel and city and darkness and daylight moves the freight train, "Going, going—gone," leaving behind a trail of smoke and a strong, sharp impression. Clean, clear, brilliant design, with no drag.

> *A review of "Freight Train," in* Kirkus Reviews *(copyright © 1978 The Kirkus Service, Inc.), Vol. XLVI, No. 24, December 15, 1978, p. 1352.*

A superb, beautifully designed book by a new talent to the children's book scene. Strong shapes, strong colours. . . .

Everything here is integrated for a child to discover the feel of a good book as the train moves through the pages in light and darkness in perfect rhythm. . . .

> *A review of "Freight Train," in* Books for Your Children *(© Books for Your Children 1979), Vol. 14, No. 3, Summer, 1979, p. 3.*

While some adults may refer to this book as "slick graphics," children find it thoroughly delightful. Tucked away in every head is a love for and delight in those wonderful old steam locomotives. Crews has given them new life for new generations. Through color and bold design, each major component of trains is identified. Then in the final twelve pages this book literally vibrates as time, motion and the train burst into life. To be truly appreciated, this book must be used with children pre-school through grade 2. Highly recommended.

> *A review of "Freight Train," in* Catholic Library World, *Vol. 51, No. 2, September, 1979, p. 92.*

The extremely limited text helps accent and dramatize the effects of the illustrations, which depict cars in motion, their colors blending like smudged pastels.

The graphic qualities of the train and the stylized land- and cityscapes attract the eye to and focus attention on the illustrations; the horizontal format of the book and the motif of the speeding train and billowing smoke help emphasize the progression in the action of the text and locomotive as well.

The design of this book is attractive, and the visualization of movement is appropriately handled through the choice of technique and media. While the work capitalizes upon a familiar object of childhood experiences, it also provides a convenient tool for aiding color identification and developing spatial concepts so important in the growth of young children. (p. 370)

> *Linda Kauffman Peterson, "The Caldecott Medal and Honor Books, 1938-1981: 'Freight Train'," in* Newbery and Caldecott Medal and Honor Books: An Annotated Bibliography *by Linda Kauffman Peterson and Marilyn Leathers Solt (copyright © 1982 by Mar-*

ilyn Solt and Linda Peterson; reprinted with the permission of Twayne Publishers, a division of G. K. Hall & Co., Boston), G. K. Hall, 1982, pp. 369-70.

TRUCK (1980)

The only words in **"Truck"** are on traffic signs or identifications printed on big rigs, diners, gas pumps. But how much Crews tells in his flashing pictures of the "star," the enormous truck of glittering scarlet, speeding across the country with a load of brand-new bicycles. Readers will feel they are traveling the superhighways, fighting the traffic, handling the monster vehicle as their pulses leap with the excitement of the trip. The artist creates all this movement in a book without a single depiction of a human being. It's decidedly a rarity, comparable only to **"Freight Train,"** which won . . . devoted fans among children just beginning to investigate picture books. A winner.

> *A review of "Truck," in* Publishers Weekly *(reprinted from the February 15, 1980 issue of* Publishers Weekly, *published by R. R. Bowker Company, a Xerox company; copyright © 1980 by Xerox Corporation), Vol. 217, No. 6, February 15, 1980, p. 110.*

The art, meticulously prepared in four half-tone separations combined with black line drawings, features stark bright colors and close-up road signs that effectively simulate on-site observation. Placement of the truck, roads, and other details gives a sense of motion as the vehicle moves on and off the pages and across the country. Its entry and exit to and from the tunnel, for instance, are done with careful regard for perspective. Though a clock on the final page shows time of delivery, none was used at the starting point to indicate time involved, nor was a stop at a weighing station included that would have added dimension to this wordless journey; however, young children will experience an involvement here similar to the excitement they felt for Crews' *Freight Train*. . . . (p. 1055)

> *Barbara Elleman, in a review of "Truck," in* Booklist *(reprinted by permission of the American Library*

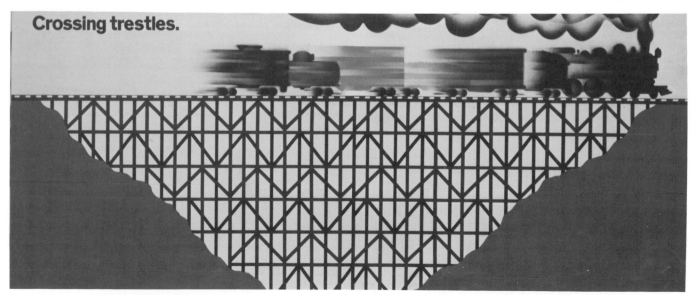

Crossing trestles.

From Freight Train, *written and illustrated by Donald Crews. Greenwillow Books, 1978. Copyright © 1978 by Donald Crews. By permission of Greenwillow Books (A Division of William Morrow & Company, Inc.).*

Association; copyright © 1980 by the American Library Association), Vol. 76, No. 14, March 15, 1980, pp. 1054-55.

["**Truck**"] uses bold geometric forms and aggressively bright colors to convey the power and hurly-burly of the outside world. . . . The violent noise and color of city streets filled with trucks, cars, vans, traffic lights, signs and billboards, the huge scale of superhighways, interchanges, tunnels, bridges, gas stations, seen by night and day, and in rain and fog, are all brilliantly conveyed in simple, almost two-dimensional shapes that have the impact and celebratory joy of 1940's travel posters seen by a post-pop artist. The variety of shapes and colors and the enormous energy of "**Truck**" put it miles ahead of Mr. Crews's recent "**Freight Train.**" "**Truck**" both mirrors the nursery school child's expansive fantasies of physical omnipotence and yet, most reassuringly, contains and orders them around objects of the real, material, even mechanical world. These trucks and cars are machines that can be controlled as well as enjoyed. They're exciting, not frightening.

Harold C. K. Rice, in a review of "Truck," in The New York Times Book Review (copyright © 1980 by The New York Times Company; reprinted by permission), April 27, 1980, p. 48.

In *Truck,* the artist works alone, tapping a well known obsession in children. He uses no text, yet he is not trying to package a collection of prints that have strayed from a picture gallery. There is a phase during a child's early years that includes much page turning with the sole intent of viewing cars and trucks. Donald Crews is capitalizing on that interest. He does it better than the illustrators who have traditionally supplied libraries with such redundant items as *The Great Big Car and Truck Book, The Big Book of Real Trucks,* or possibly, The Real-True-Honest-to-God Car and Truck Book!

There is a quality of power, speed, and movement in Crews' oversized vans. This is achieved by size differentiation, parallel arrangements of vehicles in traffic, changing perspective in terms of angle and distance, and some unusual diagonal patterns. Raw colors, as well as an ingenious composition of assorted traffic signs, add to the excitement.

A particularly interesting visual task for Crews was the incorporation of diesel engine emissions (fuzzy-edged and irregular in form) in an otherwise precise arrangement of shapes. He uses a sensitive spray of black over the upper roof surface of the trucks. It functions as smoke without detracting from the overall clean-edge technique. What a risk the artist took with this innovation. It required insight and control, and that is the distinguishing quality of the graphics as a whole.

Donnarae MacCann and Olga Richard, in a review of "Truck," in Wilson Library Bulletin (copyright © 1980 by the H. W. Wilson Company), Vol. 54, No. 10, June, 1980, p. 663.

First published in the USA, *Truck* is a non-event for this reviewer. Written presumably for children, it is a picture book about a truck travelling along an American road system. The illustrations are well produced, with bold designs and colours; but they are static and not easy to 'read' as the author-illustrator often reverses the perspective. They are also rather menacing: there's not a soul in sight, not even a driver. Only hope (unfulfilled alas) makes one turn the pages.

Michael Sayers-Lewry, in a review of "Truck," in The School Librarian, Vol. 30, No. 1, March, 1982, p. 25.

LIGHT (1981)

A striking picture book based on the concepts of illumination—and darkness. Dramatic full-color double-page spreads with a minimum of text show city and country, first as twilight falls and then as lights shine through the night: the incandescence of man-made lights as well as moonlight, lightning, and starlight. Although the pages are graphically exciting, sharp-eyed and literal-minded children may be distressed by two things: The clocks indicate that the city has grown darker by six o'clock than the country has by eight, and what is labeled the country looks more like pure suburbia.

Ethel L. Heins, in a review of "Light," in The Horn Book Magazine (copyright © 1981 by The Horn Book, Inc., Boston), Vol. LVII, No. 2, April, 1981, p. 180.

Lights—in city, in country, in nature—inspire Crews' smooth spreads of light-filled and shadowed scenes. There is no story line; this is really an album for looking, a kind of visual poem that translates an everyday phenomenon into something to be especially appreciated. Color is rich, particularly in the evening and twinkling night scenes that dominate the book. The sharp angles contrast with the low-lying horizons and peacefulness of country and suburban vistas, so some of the book's visual continuity is sacrificed to its intent to show up differences. This is slim, slightly uneven, but, like a well-designed poster, each expanse will hold you steady in its spell.

Denise M. Wilms, in a review of "Light," in Booklist (reprinted by permission of the American Library Association; copyright © 1981 by the American Library Association), Vol. 77, No. 15, April 1, 1981, p. 1097.

Children's publishing is a tough, speculative industry, particularly since the interest rate boom, and so it is surprising that Greenwillow chose to speculate on a word rather than a subject. *Light* may have been irresistible as the germ of a book idea, one of those schemes that promises thematic excitement and graphic punch, but logic should have outrun inspiration, here, and overtaken it before the contract was signed. Quite simply, there is not much in this book.

This is not to say that *Light* is not a handsome book. Half a dozen spreads in this slim oblong volume are striking graphic compositions that speak well for Donald Crews as a designer with a fine sense of color and form. As closely as I can figure, he has planned to show a progression from dusk to dawn, lights of many kinds punctuating the darkness. The minimal drawings are filled with carefully chosen flat tones. The book as a whole, however, is more a private essay, an indulgence, than a communication to young readers or pre-readers about light. Or even about design. The financial side of children's publishing may be tight but good editorial philosophy is even more binding: design itself is not enriching; design is a modifier, a tool, a way to amplify communication, and without a basic message the best design is empty.

In previous books, *Truck* and *Freight Train* . . . , Crews directed his considerable talents toward real goals: bold renderings of big forms that move across pages, across country; the excitement of motion, the confusion of the highway; the power

From Truck, *written and illustrated by Donald Crews. Greenwillow Books, 1980. Copyright © 1980 by Donald Crews. By permission of Greenwillow Books (A Division of William Morrow & Company, Inc.).*

of big haulers; the continuum of the route, the achievement of the delivery. His design had a lot to work with.

The nature of light, though, is not concrete. It changes and, like good design, is not an object in itself but a revealer of other things. The message *Light* has for its young readers is shadowy at best and should have had a lot more candlepower to make it plain. Some parts are confusing: the "Dark in the city" spread is actually brighter than its "Lights in the city" sequel; the spread on "Glimmering lights" doesn't glimmer, at least not enough to justify introducing the word "glimmer" to early readers. "Starlight" is confusing and inaccurate and a cliché and . . . okay, enough, I'll put down my venomous pen.

It's too easy to be angry with a talented man who doesn't deliver the goods, and it gets easier to be angry each time he produces a successful book: that is the increasing danger and vulnerability all good writers face. Donald Crews is good. But in *Light* he has fumbled in the dark, without sight of a goal. Let him find a theme and he will illuminate it with his excellent gifts for beauty.

> *Jan Adkins, "All through the Night," in* Book World— The Washington Post *(© 1981, The Washington Post), April 12, 1981, p. 8.*

[A recent volume] about night is unusually accomplished. Donald Crews's **"Light"** . . . is confirmation that he is a first-rate author/illustrator of children's books. Mr. Crews is already known for his 1979 Caldecott Honor Book **"Freight Train"** and for the even better volume **"Truck,"** a vividly colored pop-art celebration of the sound and power of 16-wheel diesel semis and the like. The contrast between that visually noisy book and the sumptuous quiet elegance of his new book attests to the range of his skills. In these days of tight production budgets, **"Light"** is rich with subtle nighttime colors and a sober minimal text.

On wide glossy pages that invite you to look long and slow, we see: "dark in the country" (all leafy green and gray), "dark in the city" (a brilliant geometric hodge-podge skyline), "lights in the country" (indigo sky and yellow twinklings), a spec-

tacular display of apartment-house "lights in the city," a wonderful soft twilight highway scene of "headlights and taillights," a noble gray and white suspension bridge of "glimmering lights," a warm, Milton Glaser-ish "moonlight" scene on a farm, a hushed city's "lights out" and a splendid blackish-purple country darkness.

Unfortunately Mr. Crews has not used a consistent time frame: Both the city and the country scenes have prominent clocks on the buildings, but the hour skips forward and backward as we go from page to page instead of calmly progressing toward morning. This weakens the coherence of the book and constitutes a missed narrative opportunity that would have given it greater depth and resonance. But as it stands, the book is unusually well-done—one of the best picture books I've seen this year. (pp. 51, 71)

> *Harold C. K. Rice, "The Subject Is Night," in* The New York Times Book Review *(copyright © 1981 by The New York Times Company; reprinted by permission), April 26, 1981, pp. 51, 71.**

Donald Crews is one of the most exciting of children's book artists, and in *Light* he has produced yet another gem. There is a minimum of words, only labels such as "Lights in the country" or "Headlights/Taillights" and the visual impact is allowed to do its own work; a hundred words could not have evoked the stillness of the night as Crews does in his picture of moonlight.

> *Kicki Moxon Browne, "First Encounters with Literature," in* The Times Literary Supplement *(© Times Newspapers Ltd. (London) 1981; reproduced from* The Times Literary Supplement *by permission), No. 4103, November 20, 1981, p. 1359.**

[*Light* is a] self-consciously artistic and purposeful book. To look at it mathematically, there are 33 words accompanying 15 double-spreads and two single pages. Night comes to city and country alike, and then the darkness is transformed by tungsten, neon and lightning. The strong stylized pictures are admirably done and will be greatly admired in, for example, colleges of art. I cannot think that they will have much to say

From Light, *written and illustrated by Donald Crews. Greenwillow Books, 1981. Copyright © 1981 by Donald Crews. By permission of Greenwillow Books (A Division of William Morrow & Company, Inc.).*

to the very young children attracted by the picture-book format; in this country the youngest readers will additionally be puzzled by essentially American details. (p. 14)

> *Marcus Crouch, in a review of "Light," in* The Junior Bookshelf, *Vol. 46, No. 1, February, 1982, pp. 13-14.*

HARBOR (1982; British edition as *Harbour*)

Crews again, doing what he does best: presenting one aspect of transportation in poster-simple drawings with clean lines, and blocks of clear, bright colors. Here he shows the many different kinds of boats and ships in a busy harbor, with all the docks, piers, wharves, and warehouses. The minimal text is descriptive, and although the text on a single page may say . . . "Liners, tankers, tugboats, barges, and freighters move in and out," without distinguishing one from the other, that's taken care of by a page at the end of the book, with small, labelled black and white pictures of "Ship Shapes."

> *Zena Sutherland, in a review of "Harbor," in* Bulletin of the Center for Children's Books *(reprinted by permission of The University of Chicago Press; © 1982 by The University of Chicago), Vol. 35, No. 7, March, 1982, p. 125.*

Crews has turned again to the contemporary scene, adding this crisply conceived picture book to his trio of earlier winners [*Freight Train, Truck,* and *Light*]. Simple planes of color serve as a foil for the more sharply defined shapes of ships and boats. The bright illustrations pan slowly upstream from the mouth of the harbor to the heart of a busy, big city port. Careful observers will find that at times a scene on one page is extended on the following pages and that shifting perspectives catch views seen earlier from another angle. Of the many types of vessels plying the waters, only the ferry, tug and fireboat are specifically identified in the body of the book; on the final page, however, each vessel is shown again in silhouette and identified by name. Visually, *Harbor* is far superior to that old standard, Alexander's *Boats and Ships from A to Z.* . . . The brief text is less successful, providing vocabulary without content since (with the three exceptions noted above) no clues are given to which items in the illustrations terms such as pier, wharf, warehouse, tanker or lighter refer to. The boats' functions are also left out. Well then, forget the text. *Harbor* is a picture book, and a great one at that. Every library will want it. (pp. 129-30)

> *Janet French, in a review of "Harbor," in* School Library Journal *(reprinted from the March, 1982 issue of* School Library Journal, *published by R. R. Bowker Co./A Xerox Corporation; copyright © 1982), Vol. 28, No. 7, March, 1982, pp. 129-30.*

Harbor has no story line, nor does it evoke the sense of mesmerizing movement that helped establish *Truck* . . . [or *Freight Train*]. It is, in fact, a lineup of posterlike displays of harbor ships and boats, with minimal comment. . . . As in previous works, design is Crews' special talent. Colors are flat and clean, with scenes trim and very carefully composed for a crisp, tidy appearance. Best experienced alone or in the course of one-on-one sharing.

> *Denise M. Wilms, in a review of "Harbor," in* Booklist *(reprinted by permission of the American Library Association; copyright © 1982 by the American Library Association), Vol. 78, No. 14, March 15, 1982, p. 956.*

Donald Crews is an engaging colorist whose poster-clear graphic style and evident delight in bodies-in-motion seem exactly suited to certain interests and needs of very young readers. In *Harbor* . . . , Crews builds his images from solid blocks of color venturing broadly from bright primaries to delicate pastels, with the sparing addition of simple black outline. It is a type of illustration that, by simplifying the objects depicted almost to the level of graphic symbols, closely corresponds to the basic language-function of naming. Children learning to talk make a game of repeating the names of any object that crosses their path; *Harbor* itself draws the reader into the game. The artist's modest text—more than identifying captions, less than a poem or story—does the tugboat-work of pointing and guiding from one illustration to another.

New York harbor as illustrated by Crews is a festive, robust, unfailingly active place from which all signs of dank water and garish urban desolation have providentially disappeared. It is an artist's dream. One would in any case like to see *this* artist put in charge of projects to repaint industrial land- and harbor-scapes everywhere.

Curiously, no human figures appear in these paintings, an absence that any inquisitive child is apt to question; some readers will seize the opportunity to place *themselves* on board the artist's passenger liners, fire boats, motor cruisers and tankers. *Harbor* can, one imagines, be enjoyed by readers of widely differing outlooks and temperaments. Little realists may picture for themselves future careers as merchant marines, barge operators or shipping magnates; they may learn to identify several types of seagoing vessel and to spell such useful words as "sanitation," "manufacturing," and "cement." It would be hard to find a book more likely to heighten a young child's awareness of the pure possibilities of color. For latterday Huck Finns, the artful means of escape are everywhere on these pages. (p. 17)

> Leonard S. Marcus, "Worlds without Words," in Book World—The Washington Post (© 1982, The Washington Post), May 9, 1982, pp. 17-18, 22.*

This definition-book clearly distinguishes between pleasure-boats and commercial vessels of all kinds, including police-launches, tugs and a fire-boat decked for a celebration. The pictures are firmly outlined and blocked out in strong, clear colour, and the artist gives them a personal air by composing each spread as a scene, crowded and dramatic, communicating all through the book a sense of busyness and demonstrating the intrinsic interest of boats and water. A book to catch the eye of the very young and their elders too.

> Margery Fisher, in a review of "Harbour," in her Growing Point, Vol. 21, No. 5, January, 1983, p. 4019.

CAROUSEL (1982)

Crews's new book is another triumph, a creation in his incomparable style that makes movement and sound visible and audible. The few words in the text are hardly necessary accompaniments to vividly colored paintings starting when the carousel is still, empty; the calliope, silent. Then people step onto the platform and choose their mounts. The majestic steeds begin to rise up and down and to follow the circuit as the music booms and toots. Gradually the pace quickens; the calliope's tune is louder and the colors begin to blur as the horses seem to race each other until all we see is a swirl of blended hues until time is up and the scenes slowly become still again. Undoubtedly Crews will have to make room for an addition to his awards. . . . (pp. 71-2)

> A review of "Carousel," in Publishers Weekly (reprinted from the August 20, 1982 issue of Publishers Weekly, published by R. R. Bowker Company, a Xerox company; copyright © 1982 by Xerox Corporation), Vol. 222, No. 8, August 20, 1982, pp. 71-2.

A simulated ride on a carousel—via the blurrrrr of a moving camera—in lieu of an exciting new perceptual experience, such as that afforded by *Truck*. True, at the first blurred "Horses off," there's a bit of a lift; otherwise, neither the interspersed *toot-boom, toot-boom* of the music, nor the increasing rush of the carousel, accomplishes anything but a picture-book approximation of the kind of special effects natural to film. And, impersonalized as the ride is, it's a whole lot less mesmerizing than watching the real thing.

> A review of "Carousel," in Kirkus Reviews (copyright © 1982 The Kirkus Service, Inc.), Vol. L, No. 17, September 1, 1982, p. 994.

Crews uses both color photography of words and paintings in Art Deco style of the carousel; a brief text describes the ride, from the horses waiting, silent and still, to the end of a whirling ride. The speeded blurred pictures of the carousel in motion and of the words (boom, toot) that signify the calliope sounds are very effective. Despite the lack of story line, this should appeal to children because of the brilliant color, the impression of speed, and the carousel itself.

> Zena Sutherland, in a review of "Carousel," in Bulletin of the Center for Children's Books (reprinted by permission of The University of Chicago Press; © 1982 by The University of Chicago), Vol. 36, No. 2, October, 1982, p. 24.

The author-artist celebrates the up-and-down, 'round-and-'round exhilaration of a merry-go-round ride in a narrative study of light, shape, and movement combining collage, graphics, and photography to reveal the inherent drama contained within the captive energy of the carousel itself. The resting state of the carousel is pictured with a bold frieze of colorful horses shown in stiff cut-outs. Children mount while the horses wait expectantly, heads held high. As the carousel turns, a moving camera sweeps across the page to simulate motion; the frieze softens, and shapes blur together while horse and rider, calliope and canopy merge under waves of color which wash over the stationary figures. Still, remnants of the original forms remain to serve as a subtle reminder of the ride's beginning and a promise of its end. Donald Crews continues to explore the dramatic and artistic possibilities offered by the functions of everyday objects, searching for and discovering the natural narrative structure endemic to both object and experience. (pp. 639-40)

> Amy L. Cohn, in a review of "Carousel," in The Horn Book Magazine (copyright © 1982 by The Horn Book, Inc., Boston), Vol. LVIII, No. 6, December, 1982, pp. 639-40.

[*Carousel*] rides along on a blend of crisp, flat color and a whirl of blurred images. The 33 words of text are more like cues to the pictures, which show the carousel empty and then full of children. Music and movement are implied in a picture sequence that contains fuzzy trains of onomatopoeic sounds and ever more blurred speeds of the carousel. As the ride slows, pictures become more distinct, ending with a simple "Ride's over." The disparity between clearly drawn scenes and those deliberately blurred by photographic technique disrupts the book's unity; very young children who will readily respond to the sharp, literal opening scenes may not readily understand the meaning of the carousel's indistinct phases. This is an interesting, colorful, but not entirely successful experiment in design. The sight of a beckoning merry-go-round will catch young eyes, but it will take some explaining to hold them.

> Denise M. Wilms, in a review of "Carousel," in Booklist (reprinted by permission of the American Library Association; copyright © 1982 by the American Library Association), Vol. 79, No. 7, December 1, 1982, p. 498.

Horses slowing.

From Carousel, *written and illustrated by Donald Crews. Greenwillow Books, 1982. Copyright © 1982 by Donald Crews. By permission of Greenwillow Books (A Division of William Morrow & Company, Inc.).*

PARADE (1983)

Visually, one of Crews' snazziest creations—and pretty terrific at capturing the many moods and shadings of a parade too. The book begins in the gray dawn with a sanitation truck sweeping the street; food and souvenir vendors get ready; knots of people gather; we see "A crowd. Waiting"—faceless, but each differentiated. (The two lines of watchers, on either side of the street, have the abstract crackle-and-pop of Crews' first picture books.) Then: "Here it comes!" The color guard (a sea of national flags—for the observant to recognize) and, for three openings, the marching band. . . . Next: floats—comical ballyhoo floats. . . . "And at the end of the parade"—with confetti flying—"the brand-new fire engine." Then the crowds disperse. . . . With less martial spirit than high-stepping, holiday hijinks—a parade to please even the dyspeptic.

> *A review of "Parade," in* Kirkus Reviews *(copyright © 1983 The Kirkus Service, Inc.), Vol. LI, No. 6, March 15, 1983, p. 303.*

The book is similar in bold design and format to others by Crews. Text is printed in gray block letters, the effect being emphasis on illustrations and a de-emphasis on the visual impact of the text. Vibrant illustrations include a great ethnic variety in the crowds of onlookers, but the featureless faces and stylistic design of each person results in the impression of sameness. (pp. 99-100)

> *Catherine Wood, in a review of "Parade," in* School Library Journal *(reprinted from the April, 1983 issue of* School Library Journal, *published by R. R. Bowker Co./A Xerox Corporation; copyright © 1983), Vol. 29, No. 8, April, 1983, pp. 99-100.*

All that's missing from Crews's new picture book are the festive sounds, the shouts from the excited crowd and the music from the marching bands in a dazzling parade. The prize-winning artist uses few words, but all the sights necessary are here, in the brightest colors, to vivify the people at the spectacle, the vendors of balloons and toys, the high-stepping paraders and the fancy floats that make up the gala celebration. With sly wit, Crews opens and closes the book with the ignored, unglamorous sanitation truck. . . .

> *A review of "Parade," in* Publishers Weekly *(reprinted from the April 22, 1983 issue of* Publishers Weekly, *published by R. R. Bowker Company, a Xerox company; copyright © 1983 by Xerox Corporation), Vol. 223, No. 16, April 22, 1983, p. 103.*

The best thing about this parade is the anticipation reflected in the many and various poses of bystanders waiting for it to begin. The watchers lack facial features, so the focus is on the participants, who have been endowed with eyes, nose and mouth.

Mr. Crews puts on a grand display through his poster-style art. The colors are overwhelming to an adult eye. But never mind; everyone's in step, flags fly, and people wave. The only thing missing is a Sousa tune.

> *George A. Woods, in a review of "Parade," in* The New York Times Book Review *(copyright © 1983 by The New York Times Company; reprinted by permission), April 24, 1983, p. 24.*

[*Parade*] more or less succeeds at what it sets out to do; but unfortunately, that is neither terribly significant nor engrossing. . . . [The parade is] not any particular parade, so it lacks the flavor of any real celebration, whether an Inaugural or a small-town Fourth of July. And the pictures, though pretty, don't serve child readers very well; they decorate more than they illustrate. They are vivid and highly sophisticated, but almost too stylized for a small child to make out or respond to. (p. 17)

> *Beryl Lieff Benderly, "This Is the Way the World Works," in* Book World—The Washington Post *(© 1983, The Washington Post), May 8, 1983, pp. 16-17.**

Roald Dahl

1916-

Welsh-born English author of fiction, short stories, picture books, and nonfiction, playwright, and screenwriter.

Witty, nauseating, ingenious, cynical, and hilarious are just a few of the adjectives used to describe Dahl's popular works for children. Although the levels of absurdity differ greatly from book to book depending on the maturity of their audiences, the theme that runs throughout the works is evil getting its just desserts. Every wicked child, domineering aunt, unmanageable neighbor, or pestering grandmother is done away with, meaningfully and justifiably, temporarily or permanently. *James and the Giant Peach, Charlie and the Chocolate Factory,* its sequel *Charlie and the Great Glass Elevator,* and *George's Marvelous Medicine* are the most graphic examples of this theme. *The Magic Finger,* in which duck-hunting neighbors are momentarily transformed into their feathered adversaries, *The Twits,* about a bizarre couple who are conveniently super-glued to their ceiling, and *The BFG,* in which Childchewer, Fleshlumpeater, and the rest of the Bad Crunching Giants are displayed in a pit for tourists, are milder examples. Dahl's works are skillfully crafted, with fast-paced plots, captivating detail, and onomatopoetic words that facilitate reading aloud.

Dahl's career as a writer came to him purely by accident in 1941. C. S. Forester asked him to jot down a few episodes of his life as an RAF pilot which the *Saturday Evening Post* accepted without changing a word; this convinced Dahl that writing certainly could be an easy way to make a living. His first work of fiction, *The Gremlins,* appeared in 1943 and was well received by children's literature critics. It was not until 1961, after several successful books for adults, that Dahl returned to a younger audience with *James and the Giant Peach.* Although *James* was praised by most critics, it did introduce the gruesomeness and stereotypes which were to be issues of critical concern in his later works.

Critical response to Dahl ranges from declaring him a genius and some of his works as classics to considering him racist and unethical. His most popular and controversial work is *Charlie and the Chocolate Factory,* the story of a poor, honest boy who wins the Willie Wonka Chocolate Factory through good moral fiber. Many critics discredit this book for its stereotyping and inhumanity. Prominent in the opposition is Eleanor Cameron, whose comments prompted debates on popularity versus quality and the appropriateness of violence in children's literature. Critics also accuse Dahl of racism for his portrayal of the Oompa-Loompas in the *Charlie* stories. In the original version of *Charlie and the Chocolate Factory,* the Oompa-Loompas are described as black pygmies from deepest, darkest Africa who sing and dance and work for nearly nothing. In a revised edition, Dahl changes their basic appearance and fictionalizes their birthplace. Dahl's supporters say that he follows the traditional fairy tale style, which includes extreme exaggeration and the swift and horrible destruction of evildoers. They conclude that children are not harmed by this literary approach. Indeed, Dahl's own *Roald Dahl's Revolting Rhymes*

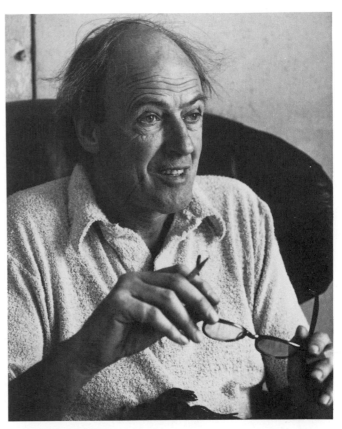

Photograph by Mark Gerson

parodies the old classics; he is merely more graphic and modern in his descriptions.

Dahl's ability to weave and tell a story, no matter how absurd, is considered exceptional. His contribution to children's literature is an acute sense of the natural appeal that the frightful and the bizarre have for children. In spite of adult disapproval, he aligns himself with the tastes and preferences of children to create works that delight and entertain them. Dahl won the Whitbread Literary Award in 1983 for *The Witches* and has received numerous child-selected awards.

(See also *CLR,* Vol. 1; *Contemporary Literary Criticism,* Vols. 1, 6, 18; *Something about the Author,* Vols. 1, 26; *Contemporary Authors New Revision Series,* Vol. 6; and *Contemporary Authors,* Vols. 1-4, rev. ed.)

GENERAL COMMENTARY

MARGERY FISHER

Stir up Swift, Maria Edgeworth, Belloc and Richard Hughes, add colouring, and you get some way towards Dahl's two children's stories [*James and the Giant Peach* and *Charlie and the Chocolate Factory*]. They are good-luck or cautionary tales, according to how you read them. In the first, an orphan escapes

from two really horrid aunts to fame and fortune in Central Park by way of a giant peripatetic fruit and a group of diverse and entrancing insects: in the second, a little Oliver wins fame and fortune in a sweet factory, his natural goodness saving him from the metamorphoses suffered by stout Augustus Gloop, nuthead Mike Teavee, spoilt Veruca Salt and gum-chewing Violet Beauregarde (and they are even more revolting than their names). It would be foolish to try to summarise the plot further, to describe the pyramids of bizzarre incident that make up these alarmingly sane excursions into nonsense. The particular dottiness of the stories is supported by miniature, delicate drawings which show that each illustrator—[Michael Simeon and Faith Jacques] has been drawn into this world of imagination. The author has style and uses it in a bewildering number of ways. (pp. 1046-47)

> *Margery Fisher, in a review of "James and the Giant Peach" and "Charlie and the Chocolate Factory," in her* Growing Point, *Vol. 6, No. 7, January, 1968, pp. 1046-47.*

THE JUNIOR BOOKSHELF

Roald Dahl has described the conception of [*Charlie and the Chocolate Factory* and *James and the Giant Peach*] as 'the usual way—it grew from being a bed-time story told to my children.' So have some of the greatest of all children's stories begun; so, as every harassed children's editor knows from bitterest experience, have some of the worst. These two books come somewhere between the two extremes.

Writing for children demands all the qualities of the good adult novelist and something more, in particular a special kind of integrity. This is what Mr. Dahl lacks. There is a casual character in his invention, and a shrill tone in the writing, which he would have detected and rejected at once in his adult books.

This is a pity because we could do with writers of Mr. Dahl's standing in the children's book world. There are good things in both books: attention to detail in the organization of the chocolate factory, lively dialogue with an ear for character in the 'peach' story, a kind of rough justice in both stories which suits children but may upset some grown-ups. Where they fail conspicuously is in their grotesque exaggeration. It is not necessary to underline everything as if the reader were half-witted; it is like shouting at a foreigner in the hope that he will understand English better that way. The repulsive children in *The Chocolate Factory* are horrible beyond all credibility. Their discomfiture would have been no less telling had they been drawn closer to the limits of the reader's belief. This exaggeration . . . plays for cheap laughs. . . . (pp. 36-7)

The laws of Wonderland are inflexible. The writer of fantasy, be he ever so famous in the great world outside, breaks them at his peril. (p. 37)

> *A review of "Charlie and the Chocolate Factory" and "James and the Giant Peach," in* The Junior Bookshelf, *Vol. 32, No. 1, February, 1968, pp. 36-7.*

J. S. JENKINS

Roald Dahl has a rare and rich gift, a kind of Heath Robinson inventiveness of mind [in **"Charlie and the Chocolate Factory"**]. Children laugh and gasp at his splendid fantasies—the waterfalls of chocolate, the everlasting gobstoppers, the chewing-gum machines. All words and sounds are grist to his mill, and the mixture of elan and nicety with which he uses them gives a zest to his writing which is all too seldom found in

children's books. **"James and the Giant Peach"** is less satisfying in construction, more brash in language. But both books will be snapped up by children if purists can be persuaded to throw their fearful scruples to the wind and let the children read. (p. 79)

> *J. S. Jenkins, in a review of "Charlie and the Chocolate Factory" and "James and the Giant Peach," in* Children's Book News *(copyright © 1968 by Baker Book Services Ltd.), Vol. 3, No. 2, March-April, 1968, pp. 77, 79.*

SAM LEATON SEBESTA AND WILLIAM J. IVERSON

All tall tales have wish-fulfillment at their centers. . . . The wishes implicit in Roald Dahl's *Charlie and the Chocolate Factory* . . . are more modern and perhaps more cynical. . . . Satisfaction of the taste buds dominates the whole value system in this story, although toward the end a new satisfaction is added: flying through the air in a glass elevator, a motif that Dahl develops in a sequel *Charlie and the Great Glass Elevator*. . . . (p. 198)

A multitude of readers and movie-goers profess to love Charlie and all that happens to him though it's hard to see that Charlie amounts to anything more than a passive appetite. Eleanor Cameron has attacked the first book at considerable length; the heated exchange between this critic and author Dahl [see excerpts below] ought to be read before you decide whether to include Charlie Bucket in your selection of good fanciful fare for intermediate-age children. (pp. 198-99)

> *Sam Leaton Sebesta and William J. Iverson, "Fanciful Fiction," in their* Literature for Thursday's Child *(© 1975, Science Research Associates, Inc.; reprinted by permission of the publisher), Science Research Associates, 1975, pp. 177-214.**

ELEANOR CAMERON

[One] can only conclude from the angry letters received by *The Horn Book* following the publication of Part I of 'McLuhan, Youth and Literature' [see excerpt below] in which I criticized *Charlie and the Chocolate Factory*—letters which continually referred to the book's enormous popularity—that it is widely taken for granted that children naturally have good taste, that they are born with it. But I have my doubts about children's innate good taste, while believing that they can be influenced toward a recognition of what is good and what is specious. (I am here using 'taste' according to the dictionary definition, concerning aesthetics, as 'the perception and enjoyment of what constitutes excellence' as it is recognized within a culture.) It would seem to me that children, *generally speaking*, in the early years, have no particular taste as the word is applied to aesthetics. . . . (p. 59)

Because children know what they like, it seems to follow in many minds that this means that children automatically know what is good, that they have some sort of sixth sense about goodness and authenticity. But . . . they are by no means always capable of separating by intuition the vapid, the vulgar, the banal, and the tastelessness from what is excellent.

Most children between the ages of 8 or 9 and 11 seem to put E B White's *Charlotte's Web* on a level with *Charlie;* I am coupling these two not because of my personal opinion about them but because they rank first in popularity with the children (or have in the past) and because they are at opposite poles in the nature of their appeal. One could say that if a story moves

quickly and has constant excitement and surprises and variety, children are apt to love it; however, as a matter of fact their catholicity of taste is more complex than this because *Charlotte's Web,* though it has surprises and variety, is not filled with constant movement and excitement, there being time for descriptive passages and a progressive revelation of character.

In an interview between Anthony Arthur of California State University at Northbridge and Clifton Fadiman, which appeared in the Summer 1975 number of *Children's literature in education,* Mr Fadiman says, 'White is of course sophisticated. Yet he retains a quality of shining innocence almost as William Blake did. It's a quality not easy to find these days; so many writers have replaced their innocence with toughness, because we live in a frightening world and we're scared.' Anthony Arthur then asks, 'Is this quality of toughness what Eleanor Cameron . . . was objecting to in Roald Dahl's books?' to which Mr Fadiman replied, 'Yes, I think it is, among other things. She's harder on Mr. Dahl than I would be, but it's true that Dahl appeals to an element of sadism in children. It's there—children are no nearer the angels than you or I, despite Wordsworth, and I respect Dahl for a certain honesty. But there's a difference between Dahl and someone like Sendak. Sendak is giving birth to a story out of his sensitivity to some deeply embedded emotional needs in himself which children respond to; Dahl is merely constructing stories.'

I agree with Mr Fadiman as far as this comparison is concerned. Sendak, in other words, is expressing his private vision through the books he writes, while it has struck me, when I consider certain facts, that rather than building on any private vision, Dahl is always revealing a kind of opportunism, as when he apparently took the criticism of his treatment of the Oompa Loompas into consideration and came up with what he may possibly have thought of as a palliative: producing, in *Charlie and the Great Glass Elevator,* long golden hair. How little he understands the blacks!

But I should like to set one point straight in that exchange between Clifton Fadiman and Anthony Arthur. Nowhere in my discussion of Roald Dahl and *Charlie* did I use the word 'tough', nor did I indicate in any way that what I objected to in the book is its so-called toughness. What I objected to throughout my criticism is the book's tastelessness, expressed through its phoniness, its hypocrisy, its getting laughs through violent punishment, the author's revealed contempt for the blacks in *taking for granted* that the Oompa Loompas could be used like squirrels for purposes of experimentation, the subject being discussed as though there is no reason why both author and reader should not approve of it. Dahl caters to the streak of sadism in children which they don't even realize is there because they are not fully self-aware and are not experienced enough to understand what sadism is.

As for respecting Dahl for 'a certain honesty', meaning, I assume, his honesty in recognizing that sadism in children *does* exist and that they enjoy stories containing sadism, might one just as well say that we can respect a businessman or a politician for his 'honesty' in recognizing exactly how greedy and perfidious human beings can be and then taking advantage of that greed and perfidy in order to get ahead?

Assuredly children are no nearer the angels than you or I. But children, unlike you or I, are fresh and new and malleable, capable of being influenced in any direction. When Mr Dahl writes his horror stories for adults in *Kiss, Kiss,* . . . adults can

take these stories or leave them. They are already set in their propensities. But if we desire to help children discriminate and agree that influencing *is* possible, it would seem that during school hours of reading aloud, we could choose books that bring them enlargements and illuminations woven through attention-holding stories. They are going to get to *Charlie* on their own in any case, so that we need hardly make a special effort to bring it to their attention. (pp. 59-61)

Eleanor Cameron, "A Question of Taste," in Children's literature in education *(© 1976, Agathon Press, Inc.; reprinted by permission of the publisher), No. 21, (Summer), 1976, pp. 59-63.**

MYRA POLLACK SADKER AND DAVID MILLER SADKER

Recently [*Charlie and the Chocolate Factory*] has come under fire because of its racist overtones. Were there greater sensitivity to mistreatment and misrepresentation of the elderly, it would have received criticism as an "ageist" book as well. At the book's conclusion Charlie arrives home in triumph in a glass elevator piloted by Willie Wonka himself. When the bedridden grandparents learn that they are to live out the rest of their days in the chocolate factory, they refuse to go and scream that they would rather die in their beds. Willie Wonka and Charlie, taking no notice whatsoever of their protests and screams, simply push the old people, beds and all, into the glass elevator. The message with which we close the book is that the needs and desires and opinions of old people are totally irrelevant and inconsequential.

Charlie and the Great Glass Elevator . . . picks up the elevator and ageism where *Charlie and the Chocolate Factory* put them down. Because of an error in timing, the elevator does not return to the chocolate factory but instead orbits Willy Wonka, Charlie, and his parents and grandparents into space. There follows a variety of space adventures as well as a potpourri of demeaning comments about being old. When astronauts spot the unique flying vehicle, they comment on its elderly inhabitants: "There's these three old birds in nightshirts floating around in this crazy glass box." The elevator's cantankerous elderly crew throws insults at one another in which the word *old* seems to be the main derogatory comment: "You miserable old mackerel." "My dear old dotty dumpling." "Be quiet you balmy old bat." (p. 82)

Some critics cite *Charlie and the Chocolate Factory* as racist, basing their criticisms on the characters Dahl calls the Oompa-Loompas.

On a visit to Africa Mr. Wonka crosses paths with a tribe of pygmies who live in trees, eat horrible green caterpillars, and manage to keep just one step ahead of starvation. Mr. Wonka strikes a deal with the chief of the tribe and promises to provide the tribe with chocolate in return for all 3000 of them agreeing to work in his chocolate factory. "They are wonderful workers. They all speak English now. They love dancing and music . . . I must warn you, though, that they are rather mischievous. They like jokes. . . .'' But Mr. Wonka accepts the humor and dancing of the Oompa-Loompas because they provide cheap labor, as well as ready subjects for the testing room. The testing room is the scene of Mr. Wonka's experimentation with new candies. One experiment attempts to create candy that will grow hair on bald boys and girls. Unfortunately, the candy is not yet perfected, as any of the now bearded Oompa-Loompas can attest. Another experiment involves gum that is supposed to taste like an entire meal, but it too has gone awry, turning

twenty Oompa-Loompas into blueberries, much to Mr. Wonka's annoyance.

This devastating portrayal is continued in Dahl's later book *Charlie and the Great Glass Elevator*. . . . [In] this tale also, the Oompa-Loompas act like a ludicrous Greek chorus. . . . [Devising] lyrics, dancing, making chocolate candies, and being used as subjects of experimentation comprise the major activities of the brown Oompa-Loompas in Dahl's books.

The negative portrayal of the Oompa-Loompas has been criticized in several reviews as stereotyping Negro characters as ignorant and musical. In addition, the Oompa-Loompas work for low wages in Mr. Wonka's factory, and this has been cited as a form of colonialism in miniature. Mr. Wonka's factory represents the industrialized societies, and the cheap labor of the Oompa-Loompas symbolizes the exploitation of the developing and usually nonwhite countries of the world. In addition to the exploitation symbolism, a new degree of injustice is introduced in the form of experimentation on the Oompa-Loompas. In bringing the Oompa-Loompas from Africa, Willie Wonka has used and abused them for his own ends.

Roald Dahl has defended his Oompa-Loompas in particular and his books in general because of their appeal to children. He asserts that the Oompa-Loompas are caricatures, not meant to be used as carrying deep significance. One need not question Mr. Dahl's intention to assume that some children may also derive negative images of blacks from Mr. Dahl's presentations. (pp. 148-49)

> *Myra Pollack Sadker and David Miller Sadker, "Growing Old in the Literature of the Young" and "The Black Experience in Children's Literature," in their* Now Upon a Time: A Contemporary View of Children's Literature *(copyright © 1977 by Myra Pollack Sadker and David Miller Sadker; reprinted by permission of Harper & Row, Publishers, Inc.), Harper & Row, 1977, pp. 71-97, 129-62.**

ALASDAIR CAMPBELL

Roald Dahl is certainly one of the more difficult authors to categorise, not only because he writes for all ages from infancy upwards, but also because his work reflects several contrasting moods and a willingness to experiment with literary methods. There is in fact very little that one can safely say about his work as a whole. Sometimes he writes purely to entertain, with a shameless disregard for conventional morality, but on other occasions a social or moral message is skilfully conveyed; sometimes all the interest hinges on a fast-moving plot, with the characters mere puppets, but elsewhere the pattern is reversed in favour of memorable heroes or villains; sometimes the language is so aggressively child-centred as to lapse into vulgarity or gibberish, yet in several books one is struck by Dahl's command of style and ability to conjure up the vividest picture in a few sentences. However, with just possibly one exception, I would say that all his books are marked by a powerful creative imagination and an instinctive understanding of the sort of themes and incidents that appeal to young readers. (p. 108)

As it happens, Dahl's four books for the youngest age range, say four- to eight-year-olds, seem to have largely escaped the attention of hostile critics—though one must admit that in all of them the shadows of greed, cruelty and revenge are variously present. If one wishes to avoid such ingredients altogether in books for young children, Dahl must be ruled out; but in my opinion that would be a perverse attitude, indefensible on either psychological or literary grounds. Normal children are bound to take some interest in the darker side of human nature, and books for them should be judged not by picking out separate elements but rather on the basis of their overall balance and effect. Each of these four books is ultimately satisfying, with the principles of justice clearly vindicated.

The most light-hearted of the four, and also the most pictorial, is *The enormous crocodile*. . . . There may be no great originality in this . . . picture book, but it can be heartily recommended for a captivating start, for non-stop action spiced with a gruesome sort of humour, and for the author's skill in enlivening a very simple text with occasional graphic phrases. The grotesque style of Quentin Blake's illustrations seems exactly right in this context; they might be less suitable for *The magic finger* . . . , which, although possibly quite within the reach of five- or six-year-olds, falls just outside the picture-book category and does contain a pretty clear message from the author. Here, as elsewhere, Dahl voices his dislike for Man's inhumanity to animals, though usually in the most matter-of-fact tone. . . . Incidentally, *The magic finger* should be to the liking of those adults who worry about sexism in literature—its narrator is a ruthlessly efficient eight-year-old girl.

Just a little more demanding and sophisticated are *The Twits* . . . [and *Fantastic Mr Fox*]. Both of these belong to the category of pure entertainment and both are notable for the unmitigated nastiness of their villains. The author is at his very best in presenting Mr and Mrs Twit for our shuddering disapproval, but I think the second half of this story is inclined to be disappointing—there ought to be rather more tension and surprise in the build-up to its climax. *Fantastic Mr Fox*, on the other hand, seems to me to have all the makings of a genuine children's classic. In six or seven thousand words, and without ever going beyond the likely limits of a six-year-old's imagination, Dahl here offers a constantly-evolving plot, a spectrum of incidents ranging from broad comedy to tingling suspense and, above all, a quiverful of truly memorable characters. The fact that most of these characters are deplorably greedy and given to carousing is not likely to make them any the less popular with children. (pp. 109-10)

[*James and the giant peach*] is Dahl's earliest surviving book for children, and is no doubt an established favourite in very many primary schools. Like most of Dahl's work it lends itself admirably to reading aloud, and its animal characters, including a spider, a glow-worm and a centipede . . . are most worthy additions to what one may call the *Alice in Wonderland* dynasty. This is not one of Dahl's more strongly-plotted books, but it does contain passages which surely disprove any suggestion that the author lacks descriptive power. . . .

It seems unlikely that many readers of this article will be hearing of *Charlie and the chocolate factory* for the first time. . . . I have yet to hear of any child or group of children in the middle-school range who do not respond to it with enthusiasm. However, the verdict of thoughtful adult critics has been far from unanimous. . . . (p. 110)

Personally, I find considerable merit in the book, and I think that the undeniable anger which it has aroused is due largely to a misunderstanding of its nature. I would see *Charlie* as an amoral fairy tale in modern idiom, belonging to a tradition in which violence and ruthless punishments are taken for granted, and where deliberate stereotyping is a valid technique. I would

expect child readers to realise instinctively that this is not the sort of book from which to learn about social attitudes, or in which to look for models for one's own future behaviour. What one does find in it is an abundance of pleasure, and, if more is needed, surely the young reader's literary education must be somewhat advanced by enjoying such a skilfully designed and constructed piece of fiction? I would agree that there are children's books, possibly including some of Enid Blyton's, which contain potentially harmful material; and however great their popular appeal, these must be out of place in a school library. But, with due respect to the obviously sincere concern of Eleanor Cameron and others, I do not believe that *Charlie and the chocolate factory* could be in any way harmful.

I think there is no need to say much about *Charlie and the great glass elevator,* because in my view it falls well below the author's normal standard—like so many attempted sequels. There are good things in it, certainly, especially in the early chapters, but the general impression is of a nightmare rather than a fairy tale. In that altered context I think the author is on dangerous ground with his portrayal of the Oompa-Loompa slave-workers. By literary standards the book would scarcely qualify for inclusion in a school library, nor would I expect it to be a particular favourite with children.

When we come to *Danny the champion of the world,* on the other hand, we are possibly back with what I have called the problem of deplorable popularity. *Danny* has the same sort of qualities that are found in *Fantastic Mr Fox,* but for an older age range—a powerful plot artfully developed, convincing technical details, incidents both dramatic and hilarious, and a small cast of clear-cut characters, including one of the author's most hateable villains. To some adult critics, however, the theme is unacceptable because the hero and his father are triumphant poachers; and if poaching can be presented as a heroic activity, what about shoplifting or any other kind of theft? In the fairy-tale tradition the crafty thief is of course by no means out of place, but this book is not exactly a fairy tale, since it has a realistic modern setting and no magic. Nevertheless in my opinion *Danny* is far enough into the world of make-believe for it to escape the charge of encouraging crime—although the author certainly does intend to promote a critical attitude towards land-owning and game-shooting. From a literary point of view it seems to me Dahl's best achievement up to now. I would recommend it for a slightly older age range, say nine to thirteen, than any of the titles previously mentioned, and I would be inclined to think it more suitable for private reading than for reading aloud. (pp. 111-12)

It is not just a matter of prejudice against best-seller status [that brings suspicion and hostility towards *Charlie and the chocolate factory*]; the suspicion does have a rational basis. For in order to achieve overwhelming success with young children it may well be that a writer has to exploit certain common juvenile tastes which to adults appear rather deplorable. For example, many children like to read about large expensive meals and similar luxuries; they enjoy violence and merciless punishment for wrong-doers; and they do not like puzzling situations and subtleties of character. But a book which appeals to these sort of tastes may be bad or good or even excellent. Great popularity indeed gives no proof of merit, but neither, in my opinion, does it imply an absence of quality. In the case of Roald Dahl I would be inclined to say that *Charlie and the great glass elevator* is a bad book, or at least a borderline case. Most of his other writings seem to me to be in the highly

commendable category; and at least two of them, *Fantastic Mr Fox* and *Danny the champion of the world,* I would describe as excellent. Roald Dahl's recent work has shown no real sign of declining inspiration, so we may hope that there is much excellence still to come. (p. 113)

> *Alasdair Campbell, "Children's Writers: Roald Dahl," in* The School Librarian, *Vol. 29, No. 2, June, 1981, pp. 108-14.*

GERALD HAIGH

[What Dahl] does in *Charlie* and in his other children's books is to home unerringly in on the very nub of childish delight, with brazen and glorious disregard for what is likely to furrow the adult brow. Dahl is the literary Clitheroe Kid—a grown man in short trousers, carrying a catapult and thumbing his nose through the schoolroom door before haring arthritically off with his young companions to look for earwigs. He declares himself unashamedly a subversive, beloved and accepted by the children whose world he inhabits and yet doomed to raise only doubtful chuckles from those adults whose inhibitions cannot allow them to see past the threatening ambiguity of a responsible adult story-teller who betrays a penchant for spit, worms and removable glass eyes.

That he is an adult story-teller there can never be any doubt. His books are far from being exercises in introspection to which the reader is permitted incidental access. Rather are they delivered consciously and calculatedly outwards to an audience which is surely clearly visualized. He is a benign mentor, firmly in control and evoking deliberately provoked cries of appreciation from the listeners who sit, roundeyed, at his feet. It is Dahl's effortless mastery of this storyteller's voice which is the key to his success. It also, incidentally, makes his books into natural fodder for reading aloud. *Fantastic Mr Fox,* and *Danny the Champion of the World,*—especially these two—are simply excellent tales superbly told, and a gift for the teacher who can do a few voices.

Once, in an interview, Dahl gave it as his opinion that English writers for children are slowed up by the influence of *Alice* and *The Wind in the Willows.* He even—surely, with his catapult showing—suggested that it would be "lovely to rewrite" the latter book. Apart from the sudden and hastily suppressed vision of Ratty and Mole encountering among the reeds a sewage outfall, one derives from this thought of Dahl's the notion that perhaps we really are bogged down by our reverence for the great leisurely and elegiac works of children's fiction.

Leisurely and elegiac are not words which are readily applied to Dahl's books. The distance between the riverbank and, say, the world of *The Twits* is so great as to be absurd. Put these books together on a shelf and you could light a block of flats on the energy released by their differing polarities. *The Twits* is, of course, Dahl at his most outrageous, up there pressed to the window, pulling his mouth sideways and crossing his eyes at the Carnegie Award panel assembled below trying not to look. It is the only children's book I have ever read which has literally made my gorge rise and my eyes water. That bit of decomposing sardine in Mr Twit's beard finally did it.

Dahl's latest is *The BFG.* . . .

The Palace adventure is a climactic moment in a full length fairy tale about a giant who snatches little Sophie from her bed and carries her off. This giant, happily, is benign—albeit a

little mischievous—and his main objective, with the help of Sophie, is to scupper those of his ilk whose ways are rather more malevolent. And you had better believe, friends, that when a Dahl giant is malevolent, then he is *pretty nasty.*

The story runs off—it never ambles or strolls—down many joyful byways. One stunningly imaginative sequence postulates dreams as semi-morphous objects confined in labelled jars. "Inside the jar Sophie could see the faint scarlet outline of something that looked like a mixture between a blob of gas and a bubble of jelly. It was moving violently, thrashing against the side of the jar and forever changing shape." Another tells of a beverage called frobscottle—which, of course, fizzes *downwards* and thus makes you do whizzpoppers.

Not least of the book's delights is the giant's turn of phrase: "Grown up human beans is not famous for their kindnesses. They is all squiffletrotters and grinksludgers." Not all human beans will like this of course, but then, they is all squiffletrotters. . . .

This book is simply a romp which entertains and delights. It is briskly paced and, make no mistake, professionally constructed for its task. . . .

I am convinced that the adult who would appreciate Dahl must continually and deliberately simplify his response to him. It is necessary to put aside those little clouds of doubt about cruelty and social attitudes, for they are irrelevances—mere hallucinatory bagatelles brought on by too much contact with those sad and intense folk who still believe the world to be a serious place. Perhaps it is all a matter of age. Both Roald Dahl and I have left adulthood behind and begun the slow and joyful decline into the lush prairies of irresponsibility which lie beyond middle age. Wait for me, Kids!

> Gerald Haigh, "For Non Squiffletrotters Only," in The Times Educational Supplement (© Times Newspapers Ltd. (London) 1982; reproduced from The Times Educational Supplement by permission), No. 3464, November 19, 1982, p. 35.

CANDIDA LYCETT GREEN

A hundred years after Edward Lear's nonsense songs and Hilaire Belloc's *Cautionary Tales,* Roald Dahl is still providing the fantasies and the shock horror treatment that children will always love. Though Dahl's verse is less refined than Belloc's and less elegant than Lear's, it is music to children's ears. . . .

> Candida Lycett Green, "Little Shockers," in The Times Literary Supplement (© Times Newspapers Ltd. (London) 1983; reproduced from The Times Literary Supplement by permission), No. 4190, July 22, 1983, p. 779.

THE GREMLINS (1943)

Gremlins have not hitherto appeared on this page because those I had found in books and newspapers were not only whimsy but synthetic whimsy. This book is different. It is the Real Thing. Preserve it as a firsthand source book on the origin of a genuine addition to folklore. That is, preserve it if the children in the family don't read it to bits. . . .

Flight Lieutenant Dahl, R.A.F., takes gremlins with the seriousness all magic deserves. They are funny, but also they have their grim aspects. . . .

You don't doubt the reason for the gremlin grudge against airplanes. But you follow with satisfaction the effort—finally successful—to educate them into being the friends instead of the enemies of pilots. The high spot of the process is when Pilot Gus's parachute falls into the Channel. There is a three hours' argument with Gremlin Gus, whom he has taken along. At last the little creature, who has been clinging to his hair, leans over and "wipes the salt water out of his master's eyes with a tiny little handkerchief." From then on it's a matter of training: the way the gremlins, fifinellas and widgets use their ingenuity to make Gus pass the medical exam that lets him fly again after a crash is not only ingenious but curiously moving. Walt Disney bases a motion picture on this story. He couldn't do better.

> May Lamberton Becker, in a review of "The Gremlins," in New York Herald Tribune Weekly Book Review (© I.H.T. Corporation; reprinted by permission), July 18, 1943, p. 8.

JAMES AND THE GIANT PEACH (1961; British edition as *James and the Giant Peach: A Children's Story*)

[This story has some] interesting and original elements, but the violent exaggeration of language and almost grotesque characterizations of the child's aunts impair the storytelling and destroy the illusion of reality and plausibility which any good fantasy must achieve.

> Ethel L. Heins, in a review of "James and the Giant Peach," in School Library Journal, an appendix to Library Journal (reprinted from the November, 1961 issue of School Library Journal, published by R. R. Bowker Co./A Xerox Corporation; copyright © 1961), Vol. 8, No. 3, November, 1961, p. 50.

This lively fantasy by an expert at chilling adult blood opens with a terrifying incident. Children, hardened to horrors by comics and television, or not subject to fears of losing their parents suddenly, will find the adventures of 7-year-old James Trotter and his surprising friends enthralling. A magic brew, concocted from absurdly nauseating ingredients, is the means by which the lonely orphan makes friends with a number of little creatures living inside a giant peach of a roving disposition. Soon they are all airborne over the ocean, as jolly a crew as can be, to their final destination in Central Park. The boy's cruel aunts are disposed of rapidly, and the perils confronting centipede, silkworm, spider, ladybug and others are overcome in short order.

There is never a dull moment, for when they are not all cooperating in emergencies, they are joining in rollicking song and dance. The choruses go with a swing, particularly when the theme is food. . . . The book contains many words too difficult for 8- to 10-year-olds to read, but when read aloud by an adult with a dramatic sense, it will be received with rapturous attention. Older children may also enjoy the story, relishing its humor without needing to accept its improbabilities. (pp. 35, 38)

> Aileen Pippett, "Between Perils, Song," in The New York Times Book Review (copyright © 1961 by The New York Times Company; reprinted by permission), November 12, 1961, pp. 35, 38.

Violence against children, and the attempted killing of children, is a basic ingredient of many legends, tales and stories. In the

typical opening of such tales it is the fate of the child to lose one or both parents. Failing that, the child may be made vulnerable by parental absence or be handicapped with a parent too weak to prevent the child's persecution or abduction or destruction. In these circumstances the wicked stepmother is frequently the first agent of attack. (p. 51)

Other relations are sometimes credited with the role of destructive 'stepmother'. In *James and the Giant Peach* . . . James' situation of loss is, despite the contemporary idiom and idiosyncratic humour, classic. His parents have been eaten up by 'an enormous angry rhinoceros', but worse is to follow. He is sent away to live in 'a queer ramshackle house' in the brutal custody of his two aunts. The book has a curiously dated quality about it and the aunts themselves resonate with echoes of Lewis Carroll, pantomime dames and the traditional ancestry of child-persecutors. (pp. 51-2)

The tradition is obviously alive. (p. 52)

> Michael Haines, "Witches, Wicked Queens and Mothers," in The Use of English (© Granada Publishing Limited 1979), Vol. 30, No. 2, Spring, 1979, pp. 51-7.*

CHARLIE AND THE CHOCOLATE FACTORY (1964)

AUTHOR'S COMMENTARY

[The first and third excerpts in this section are by critic Eleanor Cameron, the second a reply by Roald Dahl. They represent a classic debate on the value of Charlie and the Chocolate Factory. *See Cameron's "A Question of Taste" (*Children's literature in education, *1976) in* General Commentary *for a further expansion of the issue.]*

The more I think about Charlie and the character of Willy Wonka and his factory, the more I am reminded of McLuhan's coolness, the basic nature of his observations, and the kinds of things that excite him. [According to Cameron, Marshall McLuhan emphasizes the superiority of electronic media, the ear, and the senses over the reading eye and the reflective mind.] Certainly there are several interesting parallels between the point of view of *Charlie and the Chocolate Factory* and McLuhan's "theatrical view of experience as a production or stunt," as well as his enthusiastic conviction that every ill of mankind can easily be solved by subservience to the senses.

Both McLuhan's theories and the story about Charlie are enormously popular. *Charlie and the Chocolate Factory* (together with *Charlotte's Web* . . .) is probably the book most read aloud by those teachers who have no idea, apparently, what other books they might read to the children. *Charlie,* again along with *Charlotte's Web,* is always at the top of the best sellers among children's books, put there by fond aunts and grandmothers and parents buying it as the perfect gift, knowing no better. And I do think this a most curious coupling: on the one hand, one of the most tasteless books ever written for children; and on the other, one of the best. (p. 103)

Now, there are those who consider *Charlie* to be a satire and believe that Willy Wonka and the children are satiric portraits as in a cautionary tale. I am perfectly willing to admit that possibly Dahl wrote it as such: a book on two levels, one for adults and one for children. However, he chose to publish *Charlie* as a children's book, knowing quite well that children would react to one level only (if there *are* two), the level of

pure story. Being literarily unsophisticated, children can react only to this level; and as I am talking about children's books, it is this level I am about to explore.

Why does *Charlie* continually remind me of what is most specious in McLuhan's world of the production and the stunt? The book is like candy (the chief excitement and lure of *Charlie*) in that it is delectable and soothing while we are undergoing the brief sensory pleasure it affords but leaves us poorly nourished with our taste dulled for better fare. I think it will be admitted of the average TV show that goes on from week to week that there is no time, either from the point of view of production or the time allowed for showing, to work deeply at meaning or characterization. All interest depends upon the constant, unremitting excitement of the turns of plot. And if character or likelihood of action—that is, inevitability—must be wrenched to fit the necessities of plot, there is no time to be concerned about this either by the director or by the audience. Nor will the tuned-in, turned-on, keyed-up television watcher give the superficial quality of the show so much as a second thought. He has been temporarily amused; what is there to complain about? And like all those nursing at the electronic bosom in McLuhan's global village (as he likes to call it), so everybody in Willy Wonka's chocolate factory is enclosed in its intoxicating confines forever: all the workers, including the little Oompa-Loompas brought over from Africa and, by the end of the book, Charlie and his entire family.

To McLuhan, as Harold Rosenburg has pointed out, man appears to be a device employed by the television industry in *its* self-development. Just so does Charlie seem to be employed by his creator in a situation of phony poverty simply as a device to make more excruciatingly tantalizing the heavenly vision of being able to live eternally fed upon chocolate. This is Charlie's sole character and being. And just as in the average TV show, the protagonists of the book are types, extreme types: the nasty children who are ground up in the factory machinery because they're baddies and pathetic Charlie and his family, eternally yearning and poor and good. As for Willy Wonka himself, he is the perfect type of TV showman with his gags and screechings. The exclamation mark is the extent of his individuality.

But let us go a little deeper. Just as McLuhan preaches the medium as being the massage—the sensory turn-on—so *Charlie and the Chocolate Factory* gives us the ideal world as one in which a child would be forever concerned with candy and its manufacture, with the chance to live in it and on it and by it. And just as McLuhan seems to have lost sight of the individual and his preferences and uniquenesses, so Willy Wonka cares nothing for individual preferences in his enthusiasm for his own kind of global village. Just as McLuhan puts before us the question of leapfrogging Indonesia into whatever age we think best for it, so the question is asked why Mr. Wonka doesn't use the little African Oompa-Loompas instead of squirrels to complete certain of his processes. Brought directly from Africa, the Oompa-Loompas have never been given the opportunity of any life outside of the chocolate factory, so that it never occurs to them to protest the possibility of being used like squirrels. And at the end of the book we find the bedridden grandparents being snatched up in their beds and, though they say that they refuse to go and that they would rather die than go, they are crashed through the ruins of their house, willy-nilly, and swung over into the chocolate factory to live there for the rest of their lives whether they want to or not. (pp. 103-05)

If I ask myself whether children are harmed by reading *Charlie* or having it read to them, I can only say I don't know. Its influence would be subtle underneath the catering. Those adults who are either amused by the book or are positively devoted to it on the children's level probably call it a modern fairy tale. . . . What bothers me about it, aside from its tone, is the using of the Oompa-Loompas, and the final indifference to the wishes of the grandparents. Many adults see all this as humorous and delightful, and I am aware that most children, when they're young, aren't particularly aware of sadism as such, or see it differently from the way an adult sees it and so call *Charlie* "a funny book."

I believe it is a pity that considerable sums, taken out of tight library budgets, should be expended on sometimes as many as ten copies of *Charlie and the Chocolate Factory* . . . and that hard-won classroom time should be given over to the reading aloud of a book without quality or lasting content. (pp. 105-06)

> *Eleanor Cameron, "McLuhan, Youth, and Literature" (copyright © 1972, 1973 by Eleanor Cameron; reprinted by permission of the author), in* The Horn Book Magazine, *Vol. XLVIII, Nos. 5 & 6 and Vol. XLIX, No. 1, October, December, 1972 and February, 1973 (and reprinted as "At Critical Cross-Purposes: McLuhan, Youth, and Literature," in* Crosscurrents of Criticism: Horn Book Essays, 1968-1977, *edited by Paul Heins, The Horn Book, Incorporated, 1977, pp. 98-120).**

Mrs. Eleanor Cameron (I had not heard of her until now) has made some extraordinarily vicious comments upon my book *Charlie and The Chocolate Factory.* . . . That does not worry me at all. She is free to criticize the book itself for all she is worth, but I do object strongly when she oversteps the rules of literary criticism and starts insinuating nasty things about me personally and about the school teachers of America. (p. 121)

[She announces] that *Charlie* is "one of the most tasteless books ever written for children." She says a lot of other very nasty things about it, too, and the implication here has to be that I also am a tasteless and nasty person.

Well, although Mrs. Cameron has never met me, it would not have been difficult for her to check her facts. My wife, Patricia Neal, and I and our children have had a good deal written about us over the years, including a full-length biography called *Pat and Roald.* We have had some massive misfortunes and some terrific struggles, and we have emerged from these, I think, quite creditably. I deeply resent, therefore, the subtle insinuations that Mrs. Cameron makes about my character. I resent even more the patronizing attitude she adopts toward the teachers of America. She says, "*Charlie* . . . is probably the book most read aloud by those teachers who have no idea, apparently, what other books they might read to the children." She goes on to praise *Gulliver's Travels, Robinson Crusoe,* and *Little Women.*

I would dearly like to see Mrs. Cameron trying to read *Little Women,* or *Robinson Crusoe* for that matter, to a class of today's children. The lady is completely out of touch with reality. She would be howled out of the classroom. . . . The hundreds of letters I get every year from American teachers tell me that they are on the whole a marvelous lot of people with a wide knowledge of children's books. It is an enormous

conceit for Mrs. Cameron to think that her knowledge is greater than theirs or her taste more perfect.

Mrs. Cameron finally asks herself whether children are *harmed* by reading *Charlie and The Chocolate Factory.* She isn't quite sure, but she is clearly inclined to think that they are. Now this, to me, is the ultimate effrontery. The book is dedicated to my son Theo, now twelve years old. Theo was hit by a taxi in New York when a small child and was terribly injured. We fought a long battle to get him where he is today, and we all adore him. So the thought that I would write a book for him that might actually do him harm is too ghastly to contemplate. It is an insensitive and a monstrous implication. Moreover, I believe that I am a better judge than Mrs. Cameron of what stories are good or bad for children. We have had five children. And for the last fifteen years, almost without a break, I have told a bedtime story to them as they grew old enough to listen. That is 365 made-up stories a year, some 5,000 stories altogether. Our children are marvelous and gay and happy, and I like to think that all my storytelling has contributed a little bit to their happiness. The story they like best of all is *Charlie and The Chocolate Factory,* and Mrs. Cameron will stop them reading it only over my dead body. (pp. 121-22)

> *Roald Dahl, "At Critical Cross-Purposes: 'Charlie and the Chocolate Factory', A Reply" (originally published in* The Horn Book Magazine, *Vol. XLIX, No. 1, February, 1973), in* Crosscurrents of Criticism: Horn Book Essays, 1968-1977, *edited by Paul Heins (copyright © 1977 by The Horn Book, Inc.), Horn Book, 1977, pp. 121-22.*

Mr. Dahl states in his reply to my article "McLuhan, Youth, and Literature": Part I . . . that I have made a personal attack upon him. I had no intention of attacking Mr. Dahl personally. . . . I can only say that I find a certain point of view (or is it the *lack* of a point of view?) felt in *Charlie and the Chocolate Factory* . . . to be extremely regrettable when it comes to Willy Wonka's unfeeling attitude toward the Oompa-Loompas, their role as conveniences and devices to be used for Wonka's purposes, their being brought over from Africa for enforced servitude, and the fact that their situation is all a part of the fun and games. I find it regrettable, too, that Willy Wonka, through the cleverness of his advertising, can triumphantly convince Charlie that life lived forever inside the factory, enclosed in a prison, is the height of all possible bliss, with here again no word said, nothing expressed, that would question this idea.

The book is wish-fulfillment in caricature, and as caricature, it is removed from reality. This does not imply, however, that it lacks meaning (a depressing one, when you consider Wonka's power and coolness) any more than a fairy tale lacks meaning because, being fantastical, it is removed from reality. But the situation of the Oompa-Loompas *is* real; it could not be more so, and it is anything but funny.

Mr. Dahl doesn't touch on this point, but speaks instead of his personal difficulties. I am genuinely sorry to hear of them, and of the accident to Mr. Dahl's son. But had I known of the book *Pat and Roald,* which I did not, it wouldn't have occurred to me to read it as a necessary preface to thinking about the various ideas and attitudes that compose *Charlie.* Mr. Dahl's personal life has nothing whatever to do with those ideas and attitudes as far as criticism of the book is concerned.

Mr. Dahl accused me of "insinuating nasty things . . . about the school teachers of America" when I commented on the fact that *Charlie* and *Charlotte's Web* (Harper) are the two most read aloud books in the country by those teachers who haven't a wide enough awareness of what else they might read. I said that I wished more teachers had a real working knowledge of children's books which they could use to rich advantage in their classes. Mr. Dahl's exaggeration of these two statements into "insinuating nasty things . . . about the school teachers of America" is incredible. (pp. 123-24)

At no point in my article did I suggest that *Little Women* and *Gulliver's Travels* be read aloud in class. I spoke of them, along with *Pinocchio* and *Alice*, as books that have had a long life, and wondered how many books being written today would last as long.

As for Mr. Dahl's book, nobody is going to stop his son from reading it. Who would? This is preposterous. Thank God, both here and in the United Kingdom, we can read whatever books we like. Meanwhile, those who are involved with children's books and reading, those charged with making judgments, must bring all of their reflective powers to bear as well as a sense of aesthetics, because popularity and the literary value of a book are so often confused. Popularity in itself does not prove anything about a book's essential worth; there are all sorts of poor and mediocre creations which are enormously popular simply because they are wish-fulfilling.

Certainly, it is true that in the process of discriminating, some people may come to differing conclusions, as many of us have about *Charlie*. Still, those who are concerned with children's reading realize that they must think about a book as well as have feelings about it, even though criticism—indeed, *because* criticism—like poetry, begins with emotion. (pp. 124-25)

> *Eleanor Cameron, "At Critical Cross-Purposes: A Reply to Roald Dahl" (originally published in* The Horn Book Magazine, *Vol. XLIX, No. 2, April, 1973), in* Crosscurrents of Criticism: Horn Book Essays, 1968-1977, *edited by Paul Heins (copyright © 1977 by The Horn Book, Inc.),* Horn Book, *1977, pp. 123-25.*

Candy for life and a personally conducted tour of Mr. Willy Wonka's top-secret chocolate factory, that was the sensational prize for buying a candy bar that contained a Golden Ticket. As millions of these delicious morsels are gobbled up every day and there are only five tickets, the odds against finding one were enormous, and public interest was feverish. Here is the exciting, hilarious and, incidentally, moral story of the prizewinners' adventures. . . .

Roald Dahl, a writer of spine-chilling stories for adults, proved in **"James and the Giant Peach"** that he knew how to appeal to children. He has done it again, gloriously. Fertile in invention, rich in humor, acutely observant, he depicts fantastic characters who are recognizable as exaggerations of real types, and situations only slightly more absurd than those that happen daily, and he lets his imagination rip in fairyland.

The ta-ra in the press about the Golden Tickets, the fatuous remarks of the horrible children's parents, are wildly funny, while the break in starving Charlie's bad luck arouses a glow.

Jovial, nimble Mr. Willy Wonka, tireless searcher for ever more scrumptious candies, is a Dickensian delight, and his factory, with its laughing, singing, tiny Oompa-Loompa workers, is sheer joy. It would not be fair to tell more. His secrets shall be sacred; you must read about them for yourself.

> *Aileen Pippett, in a review of "Charlie and the Chocolate Factory," in* The New York Times Book Review *(copyright © 1964 by The New York Times Company; reprinted by permission), October 25, 1964, p. 36.*

In his second children's book Roald Dahl again proves his skill in writing and inventing wild original fantasy. . . . The swift exaggerated action and accumulating incidents will hold parents and children for a first reading. Unfortunately there is not much substance behind the plot surface. The long didactic poems that interrupt the action periodically in the manner of a Greek chorus make the book seem like a writing exercise. The author's facility with a pen is unquestioned. His taste and choice of language leave something to be desired.

> *Anne Izard, in a review of "Charlie and the Chocolate Factory," in* School Library Journal, *an appendix to* Library Journal *(reprinted from the December, 1964 issue of* School Library Journal, *published by R. R. Bowker Co./A Xerox Corporation; copyright © 1964), Vol. 11, No. 4, December, 1964, p. 54.*

This is an unashamed morality story. . . . Charlie (who is a bit too good to be true, really) is uncorrupted by the world, for he lives in great poverty in 'a small wooden house on the edge of a great town' (no doubt part of some organic community). Because of his virtue he is presented with the Chocolate Factory, and he and his family no doubt live happily ever after.

The squareness of the characters and of the moral judgments is somewhat redeemed by the author's inventiveness—children will be fascinated by the internal details of Willy Wonka's factory—and by the humour. Perhaps Mr. Dahl is poking fun at moral tales, but few children will feel they are being 'got at'.

> *Colin Field, in a review of "Charlie and the Chocolate Factory," in* The School Librarian and School Library Review, *Vol. 16, No. 1, March, 1968, p. 108.*

In this fantasy story, the owner of the chocolate factory, Mr. Willy Wonka, has to find factory workers who will not steal his candy-making secrets. He finds a tribe of "miniature pygmies" about the height of a man's knee in "the very deepest and darkest part of the African jungle where no white man has ever been before." It seems to me that the West has been treated to "dark Africa" too many times and that it is racism to perpetuate the myth and image of darkness. The people Wonka finds are called "Oompa-Loompas," a name that I find offensive because it tries to make fun of African language sounds. And they are incompetent in jungle living—they are "practically starving to death." Wonka (the Great White Father) saves the Oompa-Loompas by taking them back home and giving them work.

Wonka offers the Oompa-Loompas cacao beans for their meals and wages. The fact that the Oompa-Loompas are delighted and willing to accept the beans shows their childishness and

gullibility. But Wonka says about himself, "You don't think *I* live on cacao beans, do you?" Besides loving candy, the Oompa-Loompas are always laughing. Although they are spirited, they are presented as lacking dignity, as getting "drunk as lords" on butterscotch and soda and "whooping it up."

The Oompa-Loompas are musical. However, giving the Black characters the intelligence necessary to write songs hardly suffices to alleviate the stereotype. The American slaves, too, were musical, and jazz has long been acknowledged a cultural contribution without raising the whites' esteem for Blacks. The fact that the songs of the Oompa-Loompas contain the morals and messages of the book is on the credit side, though (and speaks against any charge that the author is being deliberately racist). It may not be to the point that I am made uneasy by the fierce moralism of the book as embodied in the songs, and that the Oompa-Loompas seem like Furies:

> Veruca Salt, the little brute,
> Has just gone down the garbage chute . . .
> We've polished off her parents, too.

Since I do not share an enthusiasm for dumping people down garbage chutes as punishment, I find the Oompa-Loompas rather like self-righteous children-Furies, little bogymen. The songs lessen the weight of the book's racism perhaps, but only momentarily, because after the songs, the Black characters recede again to childishness, dependency and dehumanization.

Parenthetically, I dislike these lines from one of the songs:

> . . . And cannibals crouching 'round the pot,
> Stirring away at something hot.
> (It smells so good, what can it be?
> Good gracious, it's Penelope.)

The name "Penelope" suggests a white girl; the term "cannibals" suggests Blacks. I find it unfortunate that the lines are there. Still another miscellaneous racist note is the fact that the rich girl and her father refer to an Oompa-Loompa character as "it" instead of "he." The author may have intended to disparage the father and daughter by their use of the neuter pronoun; however, leaving such a thing questionably in the air is, at best, insensitivity. (pp. 112-13)

It cannot be said that the Oompa-Loompas are treated any worse—in a satiric or caricature sense—than the white characters. The white children suffer fates, in my opinion, far worse than their vices deserve (the girl who chews gum turns purple and remains purple; the T.V. watcher is ten feet tall at the end). But the children's parents are concerned about their fates, and the children suffer individualized fates. But a Black man floats away to his death stupidly silent, and no one among his family or friends misses him, as far as the book is concerned. The Oompa-Loompas are still laughing.

The paternalism toward the Black workers is given a resounding finale. Says Mrs. Wonka: "*Someone's* got to keep it (the factory) going—if only for the sake of the Oompa-Loompas. . . ." It is this ending to the book that makes clear the racism present throughout. The entire plot is based on Wonka's quest for an heir—he has invited five children to his factory so that he can choose one. No Black child is a contender, although there are 3,000 Black people, many of them children, inside his factory. He searches the outside world for a child to become the owner. And although in the story he searches the "whole world," only preponderantly white-populated

countries—Russia and England—are mentioned by name. The children who find the golden admission tickets are never designated white in words, but the Oompa-Loompas are designated Black, and the illustrations show white children. . . . (If someone should say that the Oompa-Loompas are ruled out as heirs due to their size, not because of their color, I must answer that this is not what comes across.) I suspect, also, that in our cultural context of racism, the small size of the Black characters becomes a symbol of their implied inadequacies. (pp. 114-15)

Lois Kalb Bouchard, "A New Look at Old Favorites: 'Charlie and the Chocolate Factory'," in Interracial Books for Children *(reprinted by permission of* The Bulletin—Interracial Books for Children, *1841 Broadway, New York, N.Y. 10023), Vol. III, Nos. 2 & 3, 1970 (and reprinted in* The Black American in Books for Children: Readings in Racism, *edited by Donnarae MacCann and Gloria Woodard, The Scarecrow Press, Inc., 1972, pp. 112-15).*

Charlie and the Chocolate Factory is a thick rich glutinous candybar of a book. . . . It is fantasy of an almost literally nauseating kind. And there is an astonishing insensitivity about the creation, as late as the 1960s, of the comic little dark-skinned Oompa-Loompas who man the factory, and about the final carrying-off of Charlie's aged grandparents, against their will, to dwell among the sickly splendours of Mr. Wonka's candyland. (p. 255)

John Rowe Townsend, "Flying High," in his Written for Children: An Outline of English-Language Children's Literature *(copyright © 1965, 1974 by John Rowe Townsend; reprinted by permission of Harper & Row, Publishers, Inc.; in Canada by Kestrel Books), revised edition, J. B. Lippincott, Publishers, 1974, pp. 248-60.**

THE MAGIC FINGER (1966)

[*The Magic Finger* is] an unusual book that one cannot easily forget. . . . Great merriment here if this is allowed to crash the gates of the Establishment! I haven't been particularly attracted to Roald Dahl's books with their seemingly sadistic punishments, because I've never been attracted (at any age) by the barrel-of-nails type of retribution in stories. But *The Magic Finger* . . . , while eerie and strange, is not (as the publicity states) macabre. . . . [Its] story cannot but lead to discussion. . . . At the end we have the father of the family beating his guns into pieces. The story seems almost uncannily timely, with gun legislation coming up in Congress, and with everyone still bruised by the events in Austin, Texas. This book needs to be seen, and we need to find out what the children think of it. I hesitate to give any final opinion before the children have had a chance at it; their opinions may be wiser than ours. But I advise reading before buying. (p. 40)

Alice Dalgliesh, "That Pointing Finger," in Saturday Review *(© 1966 Saturday Review Magazine Co.; reprinted by permission), Vol. XLIX, No. 38, September 17, 1966, pp. 40-1.**

To see the name of Roald Dahl, as the author of this book is sufficient, even on such short acquaintance, to make one expect something unusually imaginative. He does not disappoint. Not that there is necessarily anything particularly unusual in the magic powers of a pointing finger, but in the fact that a young girl with a great sense of right and justice should find herself

endowed with such powers when she is very annoyed. Add to this that she should have a love of wild life and its preservation, including wild ducks, and the chase is on. A sprinkling of doing unto others as ye would it be done to you. . . . and the magic finger! It would be as manifestly wrong to give away the story as it would be to miss this modern fable.

A review of "The Magic Finger," in The Junior Bookshelf, *Vol. 33, No. 1, February, 1969, p. 24.*

FANTASTIC MR. FOX (1970)

Here is more cause for rejoicing: a new story by Roald Dahl. There has been too long a time since **"Charlie and the Chocolate Factory."** But **"Fantastic Mr. Fox"** is well worth waiting for, this story of Mr. Fox, a dauntless husband, father and citizen who rescues his wife and his children and all his friends who live underground from three of the most horrendous villains, three beastly men who are out to destroy him. Only one critical complaint: the illustrations [by Donald Chaffin] are dreary. And *nothing* dreary has a place anywhere near Mr. Dahl's sparkling words.

A review of "Fantastic Mr. Fox," in Publishers Weekly *(reprinted from the November 2, 1970 issue of* Publishers Weekly, *published by R. R. Bowker Company, a Xerox company; copyright © 1970 by Xerox Corporation), Vol. 198, No. 18, November 2, 1970, p. 53.*

Of somewhat riper vintage than earlier Roald Dahls. . . . [Mr. Fox] excuses his raids to the more conventionally moral Badger by the unpleasantness and greed of the humans who chase him. Their revolting personal habits, described with gusto, will appeal to small boys, even if their sisters and elders experience a faint tremor. The chapter division makes both for convenient bedtime reading and easier attack by early readers. (p. 35)

Mary Hobbs, in a review of "Fantastic Mr. Fox," in The Junior Bookshelf, *Vol. 35, No. 1, February, 1971, pp. 35-6.*

It is impossible not to sympathise with the fox in his vendetta against three farmers, for their personalities are as uneuphonious as their names—Boggis, Bunce and Bean. A worthy descendant of the medieval Renard, Mr. Fox enlists admiration for his defiant courage. . . . The climax of this robust tale of villainy sees Mr. Fox and his family entertaining badgers and other underground friends to a banquet while the frustrated farmers pause from their useless labours. [This is a] cheerfully amoral satire.

Margery Fisher, in a review of "Fantastic Mr. Fox," in her Growing Point, *Vol. 9, No. 9, April, 1971, p. 1716.*

CHARLIE AND THE GREAT GLASS ELEVATOR: THE FURTHER ADVENTURES OF CHARLIE BUCKET AND WILLY WONKA, CHOCOLATE-MAKER EXTRAORDINARY (1972; British edition as *Charlie and the Great Glass Elevator*, 1973)

These [adventures] are many and exciting although the author seems to be rivaling Dr. Seuss as he invents the terrible Vermicious Knids, Minusland, Gnoolies and other spaced-out creatures and places. It is all good fun and suspense, however,

and the British author's many fans will find the book entirely sane and entertaining.

A review of "Charlie and the Great Glass Elevator," in Publishers Weekly *(reprinted from the September 4, 1972 issue of* Publishers Weekly, *published by R. R. Bowker Company, a Xerox company; copyright © 1972 by Xerox Corporation), Vol. 202, No. 10, September 4, 1972, p. 51.*

In this unsuccessful sequel to **Charlie and the Chocolate Factory** . . . , Willie Wonka, Charlie Bucket, his parents, and his four unpleasantly eccentric grandparents orbit Earth in the vehicle of the title. Down in the White House, a frantic president entangles himself in the Hot Line to Russia and China while trying to save the threatened planet. He gives up because "'. . . every time you wing you get the wrong number.'" But it is Willie who saves Earth and then proceeds to rejuvenate three of Charlie's elderly relatives: an overdose of the pill regresses two of them to babyhood, the third to Minusland, where she is rescued by our heroes and overdosed in the opposite direction. To further complicate the plot there are the brown Oompa-Loompas who are talented in singing and dancing. They tell a story about unfortunate Goldie who ate her grandma's chocolate covered laxative which rearranged her innards, including her chromosomes, so that now she sits

> For seven hours every day
> Within the everlasting gloom
> Of what we call The Ladies Room.
> And there she sits and dreams of glory.
> Alone inside the lavatory.

Some children will get pleasure from the silly plot and mildly scatalogical humor, but the book, marred by overtones of racism, offers caricature without characterization, plot without theme, and cleverness without style.

Katherine Heylman, in a review of "Charlie and the Great Glass Elevator," in School Library Journal, *an appendix to* Library Journal *(reprinted from the December, 1972 issue of* School Library Journal, *published by R. R. Bowker Co./ A Xerox Corporation; copyright © 1972), Vol. 19, No. 4, December, 1972, p. 58.*

If you know that unusual child who has not read the first book about Charlie or **James and the Giant Peach** . . . put them in his hands. The momentum of those two wonderful and entertaining books will carry him happily through this new one until a better Dahl dawns. . . . Throughout the book clever ideas pop on and off like light bulbs, but Dahl seems to have mislaid his discrimination. Puns that cause severe pain cuddle up with genuinely charming nonsense. There is real wit, poor verse, and a kind of w. c. humor that children will probably enjoy but their parents probably will not.

Toward the end of the book Grandma Georgina achieves the overly ripe age of 358 from too much "Vita-Wonk." The antidote is 14 "Wonka-Vites." They are administered, and she falls into a stupor, snapping awake every so often to cry out something lively, then succumbing once more as she travels back to her original age. There is a similarity between her behavior and Dahl's. When he's awake, everything is engaging and lively, but there are arid stretches where he seems to have fallen off from sheer boredom.

Karla Kuskin, in a review of "Charlie and the Great Glass Elevator," in Saturday Review *(© 1973 Saturday Review Magazine Co.; reprinted by permission), Vol. 1, No. 3, March 10, 1973, p. 68.*

Children addicted to the Chocolate Factory will want this book and I hope they won't be baffled by the political satire which makes it conspicuously different from the first one. Taking up the story after Mr. Wonka and his guests have burst through the factory roof in the glass lift, the author lands them in a gigantic American Space Hotel, where they are watched through television scanners by the President, whose comments on the hot line to Moscow are thoroughly predictable. Apart from sundry loud and confusing confrontations in the Space Hotel, there is the matter of the Wonka-Vite pills, which do strange (indeed, decidedly nasty) things to the four grandparents who have gone along on the trip. Everyone to his taste. I prefer to stay with the more straightforward grue of the first book.

Margery Fisher, in a review of "Charlie and the Great Glass Elevator," in her Growing Point, *Vol. 12, No. 2, July, 1973, p. 2199.*

DANNY: THE CHAMPION OF THE WORLD (1975)

Here's a problem.

Roald Dahl has written an entertaining new book about a motherless boy named Danny who lives with his father, a filling station operator addicted to poaching pheasants. After four chapters on the super qualities of Father, Danny relates their magnificent discomfiture of an enemy, Victor Hazell, a fat *nouveau-riche* brewer-landowner with a face "pink as a ham, all soft and inflamed from drinking too much beer."

Father poaches with ingenious methods involving raisins, horsehair and sticky paper, all inherited from his own father Horace. But an inspired Danny invents a way of stuffing raisins with powder taken from sleeping-pills and sewing them up again to be fed to the pheasants, which can then be harvested as they fall, doped, from their roosts.

Together they bluff a suspicious keeper . . . and acquire 120 pheasants. This effectively wrecks Mr. Hazell's season-opening shoot—even though the drugged birds all finally escape, rising groggily out of the baby-carriage in which the obliging wife of the local vicar is transporting them.

The problem? It's this: how new should a new book be?

Fifteen years ago, in a marvelous collection called **"Kiss Kiss,"** Roald Dahl published a short story entitled **"The Champion of the World,"** which had previously appeared in The New Yorker. It was about two filling station operators, Gordon and Claud, who poach pheasants from one Victor Hazel, a fat brewer-landowner with only one "l" to his name but a face unmistakably "pink as a ham, all soft and inflamed from drinking too much beer."

So it goes echoing on, through the bluffing of the suspicious keeper . . . to the 120 groggy pheasants flying out of a baby carriage pushed by the vicar's wife.

Most of **"The Champion of the World"** is incorporated verbatim in **"Danny."** Naturally, much incident is added, to extend a tight 30-page story into a 198-page book, and there's some engaging revision: "poacher's arse," a rear-end scarred by buckshot, becomes for the children "poacher's bottom."

But the liveliest part of the plot of **"Danny"** is a straightforward, unacknowledged lift.

Is self-pirating unethical? I suppose we all repeat ourselves to some extent, though few writers achieve as much mileage as this from one idea. Composers have certainly done it, even Beethoven. And yet, and yet. . . .

My children love **"Charlie and the Chocolate Factory,"** and they aren't going to care whether **"Danny"** is an expansion of an old short story. Maybe shepherd's pie is as good as roast beef. Maybe there are no rules to the game. Maybe it's unreasonable that this bouncy book, from a hitherto highly inventive writer, should leave me feeling sad. Maybe.

Susan Cooper, in a review of "Danny: The Champion of the World," in The New York Times Book Review *(copyright © 1975 by The New York Times Company; reprinted by permission), October 26, 1975, p. 16.*

Half the time, in children's fiction, if Mother had been there, the adventure would never have happened. [In *Danny, The Champion of the World*] the eponymous hero's family is himself and his father, a widower. . . . Dad is not only emotionally very close to his boy, but he is a boy in all his interests. They come to share the same obsession: poaching. This is presented as the straightforward adventuring of small, daredevil goodies against huge, game-preserving baddies. Social morality and the feelings of the pheasants don't come into it. There is plenty of very careful and apparently realistic detail on poaching methods (on which much research must have been done); but the story as a whole disregards all likelihoods, and goes off into its adventures like a rocket. If readers accept this, they will certainly enjoy the zest and pace. When Dad fails to return from a night-mission to a distant wood, Danny resolves to find him. Legally, of course, he can't drive; but, in practice, he can. He borrows a car they have just repaired. The reprehensible story of a child driving a car at night with his eyes just topping the wheel and his toes just reaching the pedals is marvellously gripping.

Philippa Pearce, "Forbidden Pleasures," in The Times Literary Supplement *(© Times Newspapers Ltd. (London) 1975; reproduced from* The Times Literary Supplement *by permission), No. 3847, December 5, 1975, p. 1460.**

Roald Dahl, in *Danny, The Champion of the World,* is preoccupied with the power of love, more important in the story than social morality—for the basis of Danny's admiration for his father is that he is so much fun, and the fun, as the author sees it, comes from an entirely illicit and hilarious poaching episode. . . . The dénouement is positively Hibernian in its cumulative clatter and slapstick; the relationship of boy and man is a trifle lush; the conclusion is shrewd, if a little glib— "a stodgy parent is no fun at all. What a child wants and deserves is a parent who is sparky". An ingenious recast of a tale in *Kiss Kiss.*

Margery Fisher, in a review of "Danny, the Champion of the World," in her Growing Point, *Vol. 14, No. 7, January, 1976, p. 2799.*

Here is sentimental, escapist humor at its delicious best. Since mother died "suddenly" when Danny was four months old, "Father washed me and changed my diapers and did all the millions of other things a mother normally does for her child.

That is not an easy task for a man, especially when he has to earn his living at the same time by repairing automobile engines and serving customers with gasoline.''

Despite this sexist opening, the tale of Danny and his father is hilarious fun. Danny's pop is warm, imaginative and totally devoted to his son in a totally unrealistic way. Father tells great stories, builds marvelous toys, never leaves his son's side and teaches him how to take an automobile engine apart and put it together before he starts attending school. (p. 124)

Children will adore this idyllic parent-child relationship. They will adore the bravery and zaniness of Danny and Dad and can probably expect to soon see it on the wide screen as a ''G'' film with Fred MacMurray playing the father. If you are not turned on by this warm and joyous brand of escapism, then,—bah humbug! don't buy this book. (pp. 124-25)

> *"The Analyses," in* Human—and Anti-Human—Values in Children's Books: A Content Rating Instrument for Educators and Concerned Parents *(copyright © 1976 by the Council on Interracial Books for Children, Inc.; reprinted by permission),* Racism and Sexism Resource Center for Educators, *1976, pp. 85-174.**

Style is the term we use for the way a writer employs language to make his second self and his implied reader and to communicate his meaning. It is far too simplistic to suppose that this is just a matter of sentence structure and choice of vocabulary. It encompasses an author's use of image, his deliberate and unaware references, the assumptions he makes about what a reader will understand without explication or description, his attitude to beliefs, customs, characters in his narrative—all as revealed by the way he writes about them.

A simple example which allows a comparison between the style a writer employed when writing for adults and the alterations he made when rewriting the story for children, is provided by Roald Dahl. . . . The original version could hardly be called difficult in subject or language. A ten-year-old of average reading ability could manage it without too much bother, should any child want to. Both versions are told in the first person; the adult narrator of the original is in some respects highly ingenuous, a device Dahl employs (following *New Yorker*-Thurber tradition) as a foil for the narrator's friend Claud, a worldly wise, unfazable character, and an exaggeration into comic extravagance of the otherwise only mildly amusing events of a fairly plain tale.

Because the original is written in this first-person, easily read narrative, which is naive even in its emotional pitch, Dahl could transfer parts with minimal alterations straight from the original into the children's version. Yet even so, he made some interesting and significant changes. (pp. 67-8)

Dahl has simplified some of his sentences by chopping up the longer ones with full stops where commas are used in the adult version. And he does some cutting: he takes out the abstractions such as the comment about Hazel loathing people of humble station because he had once been one of them himself. Presumably Dahl felt children would not be able (or want) to cope either with the stylistic complexities of his first version or with the motivation ascribed to Hazel's behaviour. Whatever we may think about this, it certainly reveals Dahl's assumptions about his implied reader.

What he aims to achieve—and does—is a tone of voice which is clear, uncluttered, unobtrusive, not very demanding linguistically, and which sets up a sense of intimate, yet adult-controlled relationship between his second self and his implied child reader. It is a voice often heard in children's books of the kind deliberately written for them: it is the voice of speech rather than of interior monologue or no-holds-barred private confession. It is, in fact, the tone of a friendly adult storyteller who knows how to entertain children while at the same time keeping them in their place. Even when speaking outrageously about child-adult taboo subjects (theft by poaching in *Danny* and, in this extract, harsh words about a grown-up), the text evinces a kind of drawing-room politeness. (p. 69)

> *Aidan Chambers, "The Reader in the Book: Notes from Work in Progress" (copyright © 1977 Aidan Chambers; reprinted by permission of The Thimble Press, Lockwood Station Road, South Woodchester, Glos. GL5 5EQ, England), in* Signal, *No. 23, May, 1977, pp. 64-87.**

THE WONDERFUL STORY OF HENRY SUGAR AND SIX MORE (1977)

Odds and ends from a crack short-story craftsman, reprinted from *The Saturday Evening Post* and other magazines in a calculated bid for young readers. . . . Without the bite of Dahl's top adult fiction these slick stories crackle with old-fashioned entertainment value, but it takes all the good will they can build up to applaud the autobiographical success story **"Lucky Break"**—which accompanies a competent but typical WW II combat story, the last entry here but the first in Dahl's writing career. This ploy gives the whole collection a self-indulgent tinge.

> *A review of "The Wonderful Story of Henry Sugar and Six More," in* Kirkus Reviews *(copyright © 1977 The Kirkus Service, Inc.), Vol. XLV, No. 21, November 1, 1977, p. 1148.*

I think one should take Roald Dahl's note at the beginning of *The Wonderful Story of Henry Sugar*—'This book is dedicated with affection and sympathy to all young people . . . who are going through that long and difficult metamorphosis when they are no longer children and have not yet become adults'—in a slightly special sense. He means 'sympathy', since adults are for the most part so awful, and he has therefore no desire to speed up the process of entering the so-called real world. Instead he opts for aggressive magic, not only miracle twists of plot and stories within stories, but also an inside story of his own career, full of urgent propaganda about finding a vocation, which seems to be the only form of growing up he believes in. One of the shorter pieces, **'The Hitch-Hiker'** is a fair sample of his narrative ingenuity: the hitch-hiker longs to boast about his profession, but can't until he's got the driver on the wrong side of the law. Once they've been picked up for speeding (by a revoltingly 'meaty' traffic cop, a typical adult) he can admit that he's a superlative 'fingersmith'. He removes the narrator's belt, shoelace, watch and so on to prove it, and only then reveals that he removed the policeman's notebook too. 'The secret of life', he says 'is to become very very good at somethin' that's very very 'ard to do.'

An amoral tale, you might think, but not really, from Dahl's point of view, since the narrator starts off infatuated with his expensive car ('terrific acceleration . . . genuine soft leather')

and ends up awed by his passenger's discipline and dexterity. Likewise in the title story, wealthy parasitic Henry studies the disciplines of yoga in the hope of being able to see through playing-cards, and succeeds, only to find that the fun has gone out of gambling; it takes immense cunning (disguises, Swiss bank accounts) to get the fun back by giving all his winnings away. It's the Dahl version of Scrooge, this one, with cards and stocks replacing the ledgers and money boxes that Marley's ghost used to clank around in, and the delight of mental concentration instead of Tiny Tim. Dahl's account of how he became a writer turns out to have a similar twist: the misery of prep school and Repton, the excitement of working for Shell in East Africa, and even his narrow escape from death as a fighter-pilot, are almost incidental compared with the moment he put pen to paper in 1942: 'For the first time in my life, I became totally absorbed in what I was doing . . .' He reprints that story here and insists that the real vividness was in the telling, not—as you might expect—in the frying alive.

It's a collection with an obsession but, except in the animal stories (where the humans are too obviously monsters), that does little harm. What he would most like to do, though, and can't, is to hand over directly to his readers (threatened with adulthood) a sense of vocation and personal magic that will set them apart from the ordinary life-sized world he regards with such profound dislike. (pp. 626-27)

Lorna Sage, "Sympathy for the Devil," in New Statesman *(© 1977 The Statesman & Nation Publishing Co. Ltd.), Vol. 94, No. 2433, November 4, 1977, pp. 626-27.*

In [the admittedly awkward age Dahl refers to in his introduction] most juveniles have problems—of self-identity, of dealing with mood and impulse—that are perhaps not well served by indulgence in unbridled fantasy. They are curious about the actual world and about their own future in it. Accordingly, Dahl has made certain adjustments in meeting the admittedly somewhat unclear and complex needs of this audience.

"The Mildenhall Treasure," published originally in The Saturday Evening Post 30 years ago, and **"Lucky Break: How I Became a Writer,"** are the first true accounts Dahl has ever published; they are responses to the curiosity of the young as to how things come about in the real world and, especially, how people get started in careers. Both are beautiful, bare narratives; the first about the discovery of a hoard of Roman silver in a Suffolk field during World War II. . . .

I suppose there is a touch of East versus West allegory [in the title story], and the Indian part is as flavorful as Kipling, but the orphanage business may raise an eyebrow or two. Could Roald Dahl actually not know that few parentless children are put away in such institutions nowadays?

[There] are two slightly morbid stories in which wild creatures, a giant sea turtle and a swan, are tormented by dismal people. Rather disappointingly, no girls are given leading parts in any of the stories. How interesting it might have been if the person who could read playing cards through their backs had been Henrietta Sugar, ex-debutante. She might have laid out her ill-gotten gains more tellingly than Henry.

Dahl's gift for fantasy is universally appreciated. What is emphasized less, perhaps, is his ability at straight narrative, his skill of embedding convincing detail in a context of appropriate

incident and of moving us through a crafted plot at just the right pace. Given half a chance, the young keenly appreciate fine technique—witness the young audiences for Nadia Comaneci or the American Ballet Theatre. They will appreciate a similarly fine technique in the best parts of this book.

Julian Moynahan, "Unusual Powers," in The New York Times Book Review *(copyright © 1977 by The New York Times Company; reprinted by permission), December 25, 1977, p. 6.*

Dahl's collection of short stories is a gem. It is a sophisticated work, enhanced by simple (but not simplistic) plots and language. This unusual merger of style and planning permits the reader to be both observer and participant—very much akin to listening to a master storyteller. Whether the reader is a young person or an adult matters little, as the stories prove to be neither above nor below those respective audiences.

Entertainment is still a reputable purpose for reading. One is assured of that value upon completion of the seven stories in this volume. . . . Children or adults are the central characters, but Mr. Dahl's subtle themes make one ask if the roles are indeed reversed. Though every story is nothing less than first-class, two deserve special mention. . . .

["**Lucky Break**"] is not replete with the trauma and frustration many writers seem to convey about their humble origins. Instead, it is an honest appraisal of his goals. This story is the second to last, but readers would do well to read "**Lucky Break**" first; it gives the reader an insight into the author's talent and sets the scope for this entire collection. "**The Swan**" has a theme like that of *Lord of the Flies*. "**The Swan**" might influence more people, though, because of its brevity and all-too-realistic situation. For all its cruelty, the story is told brilliantly.

These neat, compact stories will be appreciated even more after a second reading. Consider the book an investment.

Tony Siaulys, in a review of "The Wonderful Story of Henry Sugar and Six More," in Best Sellers *(copyright © 1978 Helen Dwight Reid Educational Foundation), Vol. 37, No. 10, January, 1978, p. 334.*

The fact that two of the stories have child characters may have suggested a juvenile audience for the book. Although the writing varies in quality, Dahl's strengths as a short story writer are evident. A compelling feeling for the uncanny and for the venality—even viciousness—of human nature, gives his writing a powerful effect. (p. 53)

Charlotte W. Draper, in a review of "The Wonderful Story of Henry Sugar and Six More," in The Horn Book Magazine *(copyright © 1978 by The Horn Book, Inc., Boston), Vol LIV, No. 1, February, 1978, pp. 52-3.*

Some bachelor uncle will no doubt discover Roald Dahl's new collection of stories in a bookstore, on the shelf marked Juvenile, and intend to give it to his favorite nephew for Christmas. He'll remember *Charlie and the Chocolate Factory, James and the Giant Peach*, and, seeing *The Wonderful World of Henry Sugar and Six More*, think it in quite the same grotesque and amusing tradition. Dahl, after all, is ever grotesque and amusing.

If the uncle pauses a moment to leaf through the book, however, his nephew may have to do without. Only parts of *Henry Sugar* are for children.

These are what literary journals like to call fugitive pieces, which is to say pieces that never found a home in other collections. Each is marvelous, in its perverse way, with magically sinister twists that fascinate like a not-quite nightmare. And, then, three of the pieces are true. . . .

[The] two bits of autobiography that conclude the book are Dahl at his most inventive and most grotesque.

The stories are neatly arranged, luring the reader on. Unlike most collections, *Henry Sugar* is hard to put down. The first tale, **"The Boy Who Talked With Animals,"** is what one might expect from Dahl—boy meets sea turtle, boy falls in love with sea turtle, boy goes to sea with turtle. . . .

"The Mildenhall Treasure" is a bit of "new journalism" written before the term was invented (there seems to be an awful lot of that around). . . .

Well, by now the book has got you. And it takes a turn. **"The Swan"** details the unparalleled viciousness of stupid young boys, with images as sadistic as a reader is likely to encounter.

The title story lightens things up again. . . . (p. E1)

Dahl's first bit of writing, put on paper at Forester's request then forwarded untouched to The Saturday Evening Post, is an eerily understated account of being shot down over Egypt and nearly burned alive. **"A Piece of Cake,"** it's called.

> My face hurt most. There was something wrong
> with my face. Something had happened to it.
> Slowly I put up a hand to feel it. It was sticky.
> My nose didn't seem to be there.

This, certainly, is grimmer than Grimm. Not for a child, barely endurable for an adult.

But after our bachelor uncle has stood enthralled near the juvenile shelf for a couple of hours, he will probably decide to buy the book anyway. He can read **"The Boy Who Talked With Animals"** and **"Henry Sugar"** aloud to his nephew. He can keep the rest for himself. (p. E4)

Christopher Dickey, "A Dahl for All Seasons," in Book World—The Washington Post *(© 1978, The Washington Post), November 13, 1978, pp. E1, E4.*

THE ENORMOUS CROCODILE (1978)

The Crocodile is a crafty, hungry beast:

> The sort of things I'm going to eat
> Have fingers, toenails, arms and legs and feet.

Roald Dahl's snapping verses do not scan but they do scare. He tells how the Crocodile's determination . . . to eat at least three juicy little children is foiled by the scandalized birds and beasts of the jungle; but not before Crocodile has had fun pretending to be a date tree, a see-saw, a roundabout animal. Roald Dahl's verbal relish in cruelty-to-come is both matched and made bearable by Quentin Blake's pictures. . . . The end is never in doubt, yet the story will be asked for again and again because the vicarious thrill of *almost* being eaten by a crocodile is infinitely desirable.

Elaine Moss, "Going to the Pictures," in The Times Literary Supplement *(© Times Newspapers Ltd. (London) 1978; reproduced from* The Times Literary Supplement *by permission), No. 3991, September 29, 1978, p. 1087.**

This is a good racy adventure written by somebody who has the idiom for it. Mr. Dahl also understands the symmetry of story-telling that young children *do* like—a kind of near predictability saved from being boring by good, ingenious invention. . . . A sure-fire success for anybody under ten, and possibly older. (p. 591)

Elizabeth Jane Howard, in "Salad Days," New Statesman *(© 1978 The Statesman & Nation Publishing Co. Ltd.), Vol. 96, No. 2485, November 3, 1978, pp. 591-92.**

[The crocodile] embarks on a number of secret plans and clever tricks, bringing him to the very brink of success. After Clever Trick Number Four he says, "They (the children) will come and sit on my back and I will swizzle my head around quickly, and after that it'll be *squish crunch gollop*." Not only is the word "swizzle" chosen with a poet's care for language, but Mr. Dahl's speciality is his exquisite choice of eating words throughout. . . . This book will become a classic. (pp. 1023-24)

John Horder, in a review of "The Enormous Crocodile," in Punch *(© 1978 by Punch Publications Ltd.; all rights reserved; may not be reprinted without permission), Vol. 275, No. 7209, December 6, 1978, pp. 1023-24.*

It's an uninspired plot, right up to the typically Dahl retribution—Trunky sends the croc flying through the air until he crashes into the hot hot sun and is "sizzled up like a sausage." It's also played out with typical Dahl gusto. . . . In all, a basic, teeth-baring rendition of the old *yum-yum-squish-crunch* number. (p. 3)

A review of "The Enormous Crocodile," in Kirkus Reviews *(copyright © 1979 The Kirkus Service, Inc.), Vol. XLVII, No. 1, January 1, 1979, pp. 2-3.*

COMPLETE ADVENTURES OF CHARLIE AND MR. WILLY WONKA (1978)

[It] is the sheer drive of Roald Dahl's fantasies that gives them their special appeal. *Charlie and the Chocolate Factory* and *Charlie and the Great Glass Elevator* in one volume offer us 280 pages of Mr Wonka in a single gulp, and he keeps his fizz and flavour all the way through. The secret lies in the style, which is that of a very intelligent second-former with a little magic added. The books rocket along with schoolboyish inventiveness—awful puns, dotty incidents, enthusiasm, far too many exclamation marks, uneven English, and appalling quantities of sweets—and with that steady eye on simple moral truths which is more characteristic of childhood than adults like to remember.

With the two stories together, one can see that the first is tidier but less original, with its bad children out of Belloc and its overdose of (sometimes accurate) words like "fantastic". The second keeps Charlie and his odd family more firmly at its centre, yet it ranges more widely—from space to the White House to Chaos. Taking the Elevator into the underworld is

ambitious, but no epic is complete until its hero has been there; the visit, made by Charlie and Mr Wonka alone, is deftly handled and puzzling. Who is this magician who is greeted with cries of "alleluia" by his people and who can descend into the shadow world?

The moral of the first book is clear enough. Gluttony, covetousness, pride and sloth are punished, while the poor but honest Charlie is rewarded. The ending of the second story is more complicated. We are given a rare insight into Mr Wonka's thoughts and find him sighing over fallen humanity. The three bedridden grandparents are given the chance to become much younger; after some disagreeable confusions, they learn to accept their true ages. But then Mr Wonka works his last miracle, this time with no magic at all: the old people get out of their bed and walk. He has given away his factory and not taken his own elixir; like Prospero, he has taught people to find themselves and now he lays aside his art.

Dominic Hibberd, "Magical Morals," in The Times Literary Supplement *(© Times Newspapers Ltd. (London) 1978; reproduced from* The Times Literary Supplement *by permission), No. 4000, December 1, 1978, p. 1398.*

THE TWITS (1980)

The Twits is a disgusting book. But that is not a criticism. Roald Dahl has deliberately set out to create, in Mr and Mrs Twit, the most repellent couple in children's fiction. They are physically foul—there is a memorable description of Mr Twit's beard, full of decaying cornflakes and old Stilton cheese—and wholly malevolent. They get pleasure from tormenting each other, putting frogs in the bed and worms in the spaghetti. This repulsiveness . . . is the real point of the book. The story proper does not start until page 36, which is nearly half way through, and by any ordinary standards the narrative structure is sloppy. But it is effective, because the reader is being given ample opportunity to wallow vicariously in the evil practical jokes of the Twits before being satisfied that they meet a (literally) sticky end. Many adults prefer to ignore this kind of crude delight in the disgusting, but most children share it at some time and all but the very squeamish will revel in finding it recognized in *The Twits*.

Gillian Cross, "Foul but Funny," in The Times Literary Supplement *(© Times Newspapers Ltd. (London) 1980; reproduced from* The Times Literary Supplement *by permission), No. 4051, November 21, 1980, p. 1330.**

Everybody knows that Mr. Dahl is a renowned writer for adults and children. For the latter he has written a few wonderfully funny and imaginative books. **"The Twits"** is not one of them. The movement of the plot is capricious. And the humor dwells on rather elementary physical jokes, only a few of which are funny. Basically this reads like a story reeled out at bedtime by a talented but distracted uncle who wants to pack the children off quickly. It needs pruning, paring, sharpening and some bolting down in order to go public and add luster to the already lustrous, and funny, name of Roald Dahl.

Karla Kuskin, in a review of "The Twits," in The New York Times Book Review *(copyright © 1981 by The New York Times Company; reprinted by permission), March 29, 1981, p. 38.*

As he did in *The Magic Finger* . . . , Dahl uses the hoist-by-your-own-petard device to achieve retribution for the mistreatment of animals. Here the monkeys and birds that have been mistreated by the Twits, an unbelievably unpleasant couple, play a very nasty trick that eventually results in the slow disintegration of both Twits. The story is weakened by the rather sharp break after the first chapters. . . . [Perhaps] Dahl meant to so firmly establish the Twits as repulsive that the reader would sympathize when the animals trap them and leave them to die. Perhaps the ebullience of Dahl's exaggeration will carry the story for some readers, and certainly the vigor and humor of Blake's pictures help—but this isn't quite as well constructed as some of Dahl's earlier books nor quite as funny. Readers may find objectionable Dahl's statement that ". . . these were English birds and they couldn't understand the weird African language the monkeys spoke."

Zena Sutherland, in a review of "The Twits," in Bulletin of the Center for Children's Books *(reprinted by permission of The University of Chicago Press; © 1981 by The University of Chicago), Vol. 34, No. 8, April, 1981, p. 149.*

The effect of [this story] on the reader is, I suggest, to confront him or her with the limits of the possible in the physical world. First, the reader is taken to the limits by the comic. It is, after all, possible to put glass eyes at the bottom of beer glasses. Then the reader is taken beyond the limits by the fantastic. It is quite impossible that birds and monkeys should be able to stick the entire contents of a living room to the ceiling. . . .

Dahl says, Here are the facts: what is the most unconventional sum you can make of them? And of course Dahl's mentioning of the unmentionable clearly relates to this aspect of his work. The contents of beards, naked bottoms, nasty people, are things not generally talked about in polite—i.e., adult in front of the children—conversation. This exposure of adult hypocrisy has ideological implications. . . . (p. 160)

In *The Twits* we are not introduced to the goodies until halfway through the book, when we meet the monkeys and the birds. And even then it is not at all clear that they are going to be the agents of retribution until they actually start on their plan of revenge.

Reversal of power can thus be seen as the other major theme of the book. Indeed, once the central plot reversal has occurred, it becomes obvious that the revenge motivation that causes Mr and Mrs Twit to play practical jokes on each other is the initial exposition of this reversal-of-power theme. . . . [It] is incorporated at every stage into the action.

Dahl also incorporates his predilection for sensual detail into the revenge theme. Glass eyes, frogs in the bed, worms in the spaghetti, being stretched, being eaten, all details designed to revolt or otherwise engage the senses of the reader, also are an integral part of what the Twits do to each other in their pursuit of revenge. Eating too is thus also part of the action rather than being introduced at points of rest. Shrinking and growing have obvious phallocentric Freudian connotations, but also would seem to have direct relevance to children, for whom relative size must be of absorbing interest, exemplifying as it does so clearly the power imbalance in our society between adult and child. . . .

Dahl opens with an out-and-out attack on hairy people. He makes it plain whose side he is on:

Things *cling* to hairs, especially food. Things like gravy go right in among the hairs and stay there. You and I can wipe our smooth faces with a flannel and we quickly look more or less all right again, but the hairy man cannot do that.

An analysis of plot development shows the politics of the book in an even more unfavourable light. Dahl chooses an element in society, holds it up to ridicule and vilification, and then proceeds to annihilate it. Even though co-operative action is required for that annihilation, the group that takes the action is seen as incapable of helping itself: it is dependent first upon the arrival of a *deus ex machina*—in the form of the Roly-Poly bird—to solve its communication problems, and even then needs a charismatic leader who brooks no opposition, Muggle-Wump, to tell it what to do. '"Never mind why!" shouted Muggle-Wump. "Just do as you're told and don't argue!"' (p. 161)

Since the reversal of power is such a major theme of the book, the politics of that reversal become a central issue for me. But I am an adult reader with my political antennae fairly well developed. For the child reader other issues may be more important.

First, for all that the Twits are plainly set up by Dahl as public enemy number one, a very important element of their nastiness is their arbitrary exercise of authority. In their relationship with the monkeys and the birds, indeed, it is the dominant element. And, as already pointed out, the central plot development involves the overthrow of that arbitrary authority by the persecuted underdogs.

Second, in a number of ways, Dahl clearly lines up with the child reader. Again, as already pointed out, he mentions the unmentionable, he explores the limits of the *child's* world: most adults are not particularly interested in mashed worms, shrinking, or in fantasizing about the potentialities of super-glue. The tricks that the Twits play on each other are tricks that *children* would like to play on each other, or they are tricks that *children* report as having been played by friends of friends.

In other words, in subject matter and content the book is plainly part of the culture of childhood. And not only that, it explores themes and interests that many adults would rather not know about. In that sense it is part of an oppositional culture.

So we find that on the one hand Dahl presents us with a fascist world in which certain elements of society become scapegoats and ripe for destruction. In that same world the mass of ordinary people are incapable of helping themselves but are dependent instead upon the emergence of a charismatic leader who tells them what to do and whom they are to follow without question. On the other hand he presents us with a world where arbitrary authority can be overthrown by co-operative group action and where that overthrow is achieved by challenging the 'commonsense' view of things and insisting upon other possible orderings of the world. And he insists on the legitimacy of childhood concerns in the face of adult euphemism and hypocrisy.

Thus in untangling the ideological implications of the book the picture is nowhere as clear-cut as might at first appear. Even if I have correctly outlined the picture I have still not touched on the effect of the book on a reader. Some will argue that the lessons that we don't know we are learning are the most dan-

gerous ones and that children will unconsciously pick up the underlying fascist message, but how you prove such a contention I am not sure. My own contention, equally unproven, would be that many children would see the Twits as a nasty arbitrary authority and would thus rejoice at their overthrow. They may also, however, envy the authority of Muggle-Wump in getting everything done that he wants done. Alternatively the fact that the Twits are overthrown by co-operative group action may be salient for them. Whatever the result there, I am pretty certain that they will regard Dahl as being on their side against adult hypocrisy.

Dahl does not appear to be so overtly sexist [as does Enid Blyton in *Shock for the Secret Seven*]. Mr and Mrs Twit are equally unpleasant characters, but as the book develops Mr Twit becomes the main representative of their unpleasantness. He is going to shoot the birds, he is going to put them into a pie. His opponents, both the Roly-Poly Bird and Muggle-Wump, are male, and so the action comes to be male dominated and male led. The class background of the characters is difficult to pin down. The Twits had been monkey trainers in the circus but they are shown as having minimum contact with the human world now. All that is clear is that the monkeys and the birds represent an oppressed group. Whether they are read as children, or as working class, seems to me to depend upon the reader.

Before we go on to look at what are, ostensibly, more technical matters, I should like to sum up here. It is clear that [*The Twits* and *Shock for the Secret Seven*] are ideologically equivocal. Dahl's incipient fascism and Blyton's feudalistic paternalism will give many adults responsible for introducing books to children pause for thought. They certainly give me pause for thought. However, within the ideological messages are carried elements of their own contradiction. This occurs primarily because both authors wish the largest possible readership for their books. In a wider sense, by the themes they develop and the subject matter they include, both authors introduce themselves firmly into the world of the nine-year-old reader, tackling issues of great interest to the growing child. (pp. 162-63)

Dahl introduces subject matter which is either frowned on by adults or has been outgrown by most of them. In addition, both authors present morally absolutist worlds. The liberal humanist amongst us may complain that the world is not like that. But at the time of writing miners have occupied the South Wales Area office in protest about a pit closure and the whole of South Wales is out on strike. For many of us the world is like that. And so it is for many children.

It is, I suspect, a feature of popular literature for all ages that character is defined in terms of function within the plot. It is certainly a feature of folk tale, it is certainly a feature of the Hollywood film. These two books are no exception. There is minimum internal psychology: when characters do think things or wonder things, what they think or wonder has direct implication for their future action. (pp. 163-64)

In *The Twits* character is . . . firmly rooted in action. The Twits are nasty people because they do nasty things; Muggle-Wump develops into a leader when he has the opportunity to lead. Dahl . . . includes lengthy description of external appearance and habits. He even goes so far as to begin the book with a general dissertation on hairy people before he actually introduces Mr Twit as an exemplar.

Characters can thus be seen as functions of plot rather than vice versa. To characterize people in terms of their actions and their social role rather than in terms of their presumed internal motivation is not without implications in a world where we ourselves are equivocal about such distinctions. . . . [For] many children, parents and teachers may well be parents and teachers first, and individuals with personal histories second. To argue that as adults we should be teaching children that people are individuals first and social beings second is an ideological and moral judgement about which there is room for disagreement.

It has been suggested that the shaping of experience and feeling is crucially important in the creation of a novel. In books where character is subservient to plot we are going to need to look for that shaping in terms of plot structure: the building and resolution of climax, the incorporation and resolution of themes, and where it occurs, the development of character. (pp. 164-65)

[Dahl] unites the two main themes in the climax to *The Twits*. The monkeys reorder the world by sticking the contents of the Twits' living room to the ceiling, and thus at the same time wreak their revenge. Character development is hardly an issue here since there is so little of it, but the climax does see the emergence of Muggle-Wump into his full role as leader. (p. 165)

The first thirteen sections of the book concern the practical jokes, with the climax towards the end. The central three sections include the story of the boys and the superglue, and the remaining thirteen sections concern the turning of the tables on the Twits, climaxing towards the end in their final defeat. If Dahl appears to delay the first climax rather a long time, he gets away with it by introducing minor climaxes earlier on. Each joke is actually a little story in itself, getting longer and longer as the book progresses.

I know of no criteria by which we can say that such and such a plot structure is more effective than any alternative. Certainly some principle of balance and symmetry would seem to be operating here in the pacing of climax. . . . Whether the satisfactions of this sort of pattern are culturally derived, or whether they have deeper psychological roots, would be a matter for further investigation. However, I am convinced that plot structure is a crucial element in the popular success of [*The Twits*]. (pp. 165-66)

There is nothing Dahl does that doesn't have its equivalent in the earlier author. What Dahl does do is to use one or two techniques in a much more daring way, and at greater length than does Blyton. Most noticeable is his willingness to suspend the action for descriptive purposes. The first four sections of *The Twits* are totally static in that respect. We are always told that young children cannot tolerate description, yet if what is being described interests them enough, they can tolerate it very well.

Two other techniques result from this descriptive process of Dahl's. One is that his narrator continually moves from the present tense of direct address to the past tense of traditional storytelling, and back again. And the other is that he tells us once about events that occur more than once: 'Mr Twit didn't even bother to open his mouth wide when he ate.' . . . The point being, of course, that every time that Mr Twit ate he didn't bother to open his mouth—an occurrence that must have happened repeatedly yet we are told about it only once. (pp. 168-69)

Dahl uses one device for which no parallel can be found in Blyton, and that is to tell three separate stories without at all making their relationship in time clear. We realize, of course, that the last one happened last, but we don't know how long after the other two it happened, nor do we know the order of the other two.

The point I am making here is that, between them, both authors have used virtually every trick of the trade in their handling of time. Also, their young readers are clearly able to cope with all the various shifts and changes that are offered. They will meet little in modern adult fiction, so far as the techniques of handling time go, that they will not have met in embryo form here. . . .

The traditional 'straightforward' stance is frequently assumed to be that of the omniscient third-person narrator. . . . Dahl's narrator moves continually from the position of knowing only what the characters know, to a position where he is omniscient, and back again. (p. 169)

In detailed description of action, or in the recounting of direct speech, the function of the narrator is simply to show what the characters are doing or saying. As soon as the narrator starts to summarize, the narrative function moves from 'showing' towards 'telling'. Such a move conceals a much greater selectiveness on the narrator's part as to what is going to be told. (pp. 169-70)

As I suggested at the beginning, subject matter, themes, the shaping of plot, cultural and ideological considerations, and the development of character in action rather than in terms of internal psychology—these are the factors that matter. Children will tolerate any amount of description if it is description of something they are interested in. Children can manage quite complicated time shifts, changes in narratorial stance and function, so long as these techniques move the story on, developing the themes that they are interested in, generating suspense about the outcome and resolution of those concerns. What I am saying, in essence, is that children are remarkably competent at handling all sorts of technical devices of storytelling provided that the story is clearly of their culture, for them. (p. 170)

Charles Sarland, "The Secret Seven vs The Twits: Cultural Clash or Cosy Combination?" in Signal *(copyright © 1983 The Thimble Press; reprinted by permission of The Thimble Press, Lockwood Station Road, South Woodchester, Glos. GL5 5EQ, England), No. 42, September, 1983, pp. 155-71.**

GEORGE'S MARVELOUS MEDICINE (1981; British edition as *George's Marvellous Medicine*)

For some time now Roald Dahl has been the most popular living novelist that we have for children, despite, or sometimes possibly because of, lapses in taste that have not always found equal favour among adult readers. His latest offering, *George's Marvellous Medicine,* is a good example of this ability he has to entertain the young often at the cost of offending many of the other sort. It is about a small boy who declares war against his disagreeable grandmother, described variously as "a skinny old hag", or a "grizzly old grunion" with "a small, puckered up mouth like a dog's bottom."

Such a picture may well reflect quite graphically small children's occasional resentment of the elderly, plain and frequently querulous. Yet since the days of Dickens and W. S.

Gilbert, and their pitiless humour at the expense of old age, it has been customary, especially in children's books, not to encourage such attitudes. Instead, there have been reams of admittedly often rather anodyne books about witches who are merely lonely or misunderstood rather than evil, and if grumpy old ladies still survive in other stories, they are usually portrayed with compassion rather than cruelty. Not Mr Dahl, however; not only does his young hero George think murderous thoughts about his grandmother right through to the end, he also actually administers some "medicine" to her made up from the bathroom (nail varnish), the kitchen (shoe polish) and the garden shed (antifreeze and engine oil.)

At this point, what could seem like a blue-print for a new type of granny-bashing turns into outright fantasy, with the old lady first floating like a balloon and then growing as high as a crane. . . . In fact, I am sure that most children will read the whole of this otherwise lively and inventive story as something purely fantastic, and old ladies still sheltering in household corners will probably be quite safe to stay where they are, rather than make for the nearest Old People's home double quick. And yet, as with the marvellous medicine itself, a slightly nasty taste does persist after consumption, despite much else in the tale that is both fast and funny.

> *Nicholas Tucker, "Inventing for Fun," in* The Times Literary Supplement *(© Times Newspapers Ltd. (London) 1981; reproduced from* The Times Literary Supplement *by permission), No. 4086, July 24, 1981, p. 839.**

Roald Dahl has already proved himself to be a very gifted storywriter for adults and children. But if literary agents were what they are not, *George's Marvellous Medicine* . . . should have been thrown on to the rubbish heap. It would be bad enough if a children's writer were advocating mercy-killing for ailing members of the family. In his desire to be excruciating and so terribly odd and inventive, Roald Dahl seems actually to advocate murdering the more irritating members of the family and to make it sound acceptable. . . . The reader is led to believe that the nasty ingredients [George] is pouring in might miraculously turn into a panacea for all [grandmother's] ills and that her cure will be the usual Dahl anti-climax. Oh no. The grandmother is neatly disposed of with the approval of George's parents. . . . If there is a moral here about how horrid families can be, Roald Dahl's own advanced sense of horror, gone berserk on this occasion, has successfully obscured it.

> *"For Immediate Disposal," in* The Economist *(© The Economist Newspaper Limited, 1981), Vol. 281, Nos. 7217 & 7218, December 26, 1981, p. 108.*

No more palatable than Dahl's unsavory **"The Twits."** . . . Fun is fun; this isn't. One wonders what has possessed the author of dandy stories like **"Charlie and the Chocolate Factory," "James and the Giant Peach,"** and others, that he offers such trash.

> *A review of "George's Marvelous Medicine," in* Publishers Weekly *(reprinted from the January 22, 1982 issue of* Publishers Weekly, *published by R. R. Bowker Company, a Xerox company; copyright © 1982 by Xerox Corporation), Vol. 221, No. 4, January 22, 1982, p. 65.*

[The] story really bogs down. It does, of course, treat Grandma in wholly cavalier fashion, but the literary weakness may prove as boring as the treatment of Grandma; Dahl has a wild imagination which usually works to his advantage as a writer of fantasy, but here he has floundered in ramification of one concept. Any situation, no matter how amusing, becomes tedious when overdone, and here the idea of the shape-changing magic potion is run into the ground.

> *Zena Sutherland, in a review of "George's Marvelous Medicine," in* Bulletin of the Center for Children's Books *(reprinted by permission of The University of Chicago Press; © 1982 by The University of Chicago), Vol. 35, No. 9, May, 1982, p. 166.*

ROALD DAHL'S REVOLTING RHYMES (1982)

Roald Dahl and Quentin Blake push their satirical talents to the extreme. Six of the best known nursery tales are retold in lolloping rhymed couplets, each one with a new ending that will shock or amuse, according to taste. To give an example, Snow White, who has found a job with seven ex-jockeys, finding she can't cure their gambling fever, steals her stepmother's magic mirror to put their bets on a secure basis, 'which shows that gambling's not a sin, Provided that you always win.' The rest of the tales are given summary treatment likewise and there is an ingenious link between *Red Riding Hood* and *The Three Pigs* with a sharp stroke in the final couplet. This kind of joke will only succeed if it is superlatively well done, as it is here. Roald Dahl's thoroughly nasty version of the well-worn tales allow him opportunities for sprightly false-rhymes—'You are the only one to charm us, Queen, you are the cat's pyjamas'—and for the shock of incongruity:

> "The Wolf stood there, his eyes ablaze
> And yellowish, like mayonnaise.
> His teeth were sharp, his gums were raw,
> And spit was dripping from his jaw." . . .

[The] only characters one could enjoy meeting are the animal victims of human villainy like the Three Bears and the Three Pigs. There is a moral here somewhere.

> *Margery Fisher, in a review of "Roald Dahl's Revolting Rhymes," in her* Growing Point, *Vol. 21, No. 2, July, 1982, p. 3923.*

Revolting Rhymes is not a title to seduce the more pernickety of parents who police their children's cultural intake. Nor will Roald Dahl's verse mutations of classic fairytales please the purists who like their Grimm, Jacobs and Perrault unadulterated, still less sent up, turned inside out and brought down to the earthy in couplets. And those who are not particularly partial to having their noses rubbed in doggerel might well wince at the pedestrian irritant to bear snouts with which young Goldilocks decorates Ursa Minor's bunk:

> Worse still, upon the heel of one
> Was something that a dog had done.
> I say once more, what *would* you think
> If all this horrid dirt and stink
> Was smeared upon your eiderdown
> By this revolting little clown?

These rhymes, though, are rarely really revolting, in the playground-sniggering sense of the word. They toy with tradition rather than muscle their way beyond the bounds of decency.

"**Cinderella**" offers a rich diet of blood and guts . . . but it is hardly strong meat compared with what now passes for (and succeeds as) entertainment for children. A few people get their heads chopped off by the decapitatingly inclined prince whom Cinders ditches for a jam-maker. . . . Prurience is also muted. Cinders, when the prince grabs her dress as midnight strikes, is reduced to her underwear. Little Red Riding Hood "whips a pistol from her knickers" to blast her lupine aggressor into a wolfskin coat, then repeats the trick when making a guest appearance in Dahl's revamped version of "**The Three Little Pigs**", only this time the trigger-happy heroine bags a pigskin travelling case as well as more big bad winter wear. And far from adding dirt to "**Jack and the Beanstalk**", this curious tale, . . . which tells how a burgeoning mountain of uneaten agricultural produce can be turned into gold, now becomes a veritable parable of the life-preserving qualities of cleanliness. Jack, realizing that the giant's ability to distinguish our national corpuscular aroma has lethal consequences . . . scrubs all essence of England from his pores. The giant deprived of all whiff of humanity can only mutter "FE FI FO FUM / RIGHT NOW I CAN'T SMELL ANYONE." "A bath", remarks the enriched Jack, "does seem to pay / I'm going to have one every day."

And as for "**Goldilocks**", Dahl is positively a missionary in advocating a need for moral revision of the old version mouthed down to us through the years by mother.

Far from allowing his Goldilocks to get off scot-free, Dahl ends his tale with Big Bear telling Baby Bear that if he wishes to eat his porridge he will have to consume the purloining hussy as well for there lies his breakfast.

Revolting Rhymes is in fact pure pleasure. Raucous, irreverent, inventive, richly colloquial in its language, never afraid to press-gang the inappropriate into its service, it delights with its teasing turns of phrase and twists of plot. . . .

But is it *for* children? The gulf between language *for* children and language *of* children, the prescriptive and the descriptive, remains, despite old-school grammar caned into young minds or deep-structured grammar encoded into them, mercifully wide. Children do not speak as they are spoken *to* by adults. They speak as they speak *with* each other. But they are quite capable of making magpie forays into parental patter seizing a word or phrase which they might not fully understand and playing with it. (Indeed, some grown-up phatic utterances can only be rendered pleasurable when not understood.) Many authors who convert literature for children, particularly classics which were originally written for them, make the mistake of producing, in the name of comprehension, anodyne, simplified texts devoid of the joys of both adult and juvenile linguistic play. There are some neutered versions of fairytales which are reduced to bare accounts of their curious neurotic plots. Dahl, however, has chosen, like the best of children's authors to enjoy himself and the young will find his zest contagious and his rhymes hilarious even if they do not pick up every comic nuance.

> Andrew Hislop, "*Earthy Couplets*," *in* The Times Literary Supplement (© *Times Newspapers Ltd. (London) 1982; reproduced from* The Times Literary Supplement *by permission*), No. 4138, July 23, 1982, p. 793.

No matter if an elderly reviewer finds these rhymes indeed 'revolting' as well as clumsy doggerel. I have first-hand evi-

dence that they can be a smash hit with teenagers, for whose hearty and irreverent tastes they are presumably well suited. . . .

I find most of the jokes unfunny and in doubtful taste, the verse limp and padded with slightly outdated slang. . . .

But let's face it. Children are going to love the book.

> Marcus Crouch, in a review of "Roald Dahl's Revolting Rhymes," in The Junior Bookshelf, *Vol. 46, No. 4, August, 1982, p. 140.*

Dahl's *Revolting Rhymes* seeks to appeal to the same hunger children have for parodies of their official culture, and many children will surely relish Dahl's basic ploy of recasting classic fairy tales in current slang (albeit British slang—American kids may need a glossary for "half a tick," "do a bunk," and "going round the twist"). It's not a new idea but not necessarily a bad one. However, Dahl's execution is spotty. Grading the six separate verse-tales with a factor for "works up to ability," Dahl scores from C-minus to, at best, a B. His doggerel couplets have a numbing one-and-two-and-now-we're-through monotony that has the bumpy effect, over long stretches, of riding an octagonal-wheeled bicycle.

The book's larger problem is that Dahl hasn't managed to come up with many new wrinkles to the six tales he's burlesquing. Cinderella, after seeing the Prince decapitate her two ugly sisters (Grimm disposes of them much more grimly), decides not to marry above her station and settles for a "simple jam-maker by trade who sold good homemade marmalade." I know that Britain is going through a period of scaled-down expectations, but Dahl seems to have a prejudice against princes, for Snow White likewise ends up in a rather grubby *ménage à huit* with the Seven Dwarfs.

Most children, however, who are young enough to crack up over the idea of, forgive the expression, underwear will readily overlook the book's thumping doggerel and lack of narrative fizz for the sake of its giggles. (pp. 13-14)

Quentin Blake's slapdash cartoons and the *Revolting Rhymes* they accompany are as forgettable as popcorn. (p. 14)

> Thomas M. Disch, "Beyond Mother Goose: Poetry for Children," in Book World—The Washington Post (© 1983, *The Washington Post*), May 8, 1983, pp. 13-14.*

THE BFG (1982)

BFG are the initials of the Big Friendly Giant, who is different from others of his race, who are even bigger and so unfriendly that they eat human "beans" when they go on foraging missions every night. When Sophie, a young English orphan, catches the BFG blowing a silent trumpet into the bedroom of some neighbor children one night, the giant steals her away to his homeland, where he reveals to her the horrors of his race. . . . Together with the present Queen of England, the British Navy and the Royal Air Force, Sophie and the BFG successfully capture the offending giants and put them in a deep pit as a tourist attraction in England. Sophie receives the world's undying gratitude, and the BFG a good British education. One wonders how interesting he will be after he is so thoroughly educated, for it is his malapropisms that are part and parcel of the book's interest. His only source of study has been *Nicholas Nickleby* by Charles Dickens, whom the BFG refers to as "Dahl's

Chickens.'' By the time that helicopters are transformed into ''bellypoppers'' and the highest pleasures are described in adjectives like '''phizzwhizzing''' and '''flushbunking,''' readers are sure that they are in the presence of genius.

> *Ruth K. MacDonald, in a review of ''The BFG,'' in* School Library Journal *(reprinted from the December, 1982 issue of* School Library Journal, *published by R. R. Bowker Co./A Xerox Corporation; copyright © 1982), Vol. 29, No. 4, December, 1982, p. 48.*

Children are always quick to notice with a proper contempt when 'grown-ups' clump along on the leaden feet of whimsy. That way they can never catch the butterflies of authentic childish fantasy.

Roald Dahl comes uncharacteristically close to the sort of error I mean when he invents a special cute language for the hero of *The BFG*. . . . 'Every human bean is diddly and different,' Dahl has the giant saying. 'Some is scrumdiddlyumptious and some is uckyslush.' That's the sort of stuff that made Dorothy Parker confess that Tonstant Weader fwew up. (p. 25)

> *Patrick Skene Catling, ''Wild Things,'' in* The Spectator *(© 1982 by* The Spectator; *reprinted by permission of* The Spectator*), Vol. 249, No. 8056, December 4, 1982, pp. 24-5.**

[*The BFG*] is a winner. It is very funny and exciting, and moves at a cracking pace. There are also some satisfyingly rude jokes, and all in all I would say that it would make an ideal Christmas present for anyone of five upwards. BFG stands for Big Friendly Giant. . . . He and nice, sensible Sophie, aged eight, with the help of the Queen of England . . . manage to defeat the other giants and immobilise them. . . . When it is all over, Sophie encourages her large friend to learn to use English properly and to write up his account of the operation. The Queen reads it aloud to her grandchildren, and every parent and grandparent ought to do the same.

> *Gillian Avery, in a review of ''The BFG,'' in* The Spectator *(© 1982 by* The Spectator; *reprinted by permission of* The Spectator*), Vol. 249, No. 8056, December 4, 1982, p. 26.*

Roald Dahl and Quentin Blake are uncanny in their understanding of what children like to read and see. Thus some adults will be intensely offended. . . .

Mr. Dahl offers just what many children like: humorous yet chilling descriptions of the giants and their evil doings. . . .

The BFG has taken upon himself the delivery of ''Lovely golden dreams'' to earth's children. These dreams and nightmares will appeal to the ''dreams of glory'' syndrome of children. Youngsters will delight in visions of power over adults; the author knows that children are essentially anarchistic and revolutionary. . . .

Children will enjoy this book. Many adults will dislike it. Thus, **''The BFG''** is a success since it allows children a recognition of the habits, dreams and humor that they alone possess. Mr. Dahl appeals to a child's sense of justice, morbidity and humor. An occasional humorous finger poked at the establishment habits of the world should harm no one and delight many.

> *Ruth I. Gordon, in a review of ''The BFG,'' in* The New York Times Book Review *(copyright © 1983 by The New York Times Company; reprinted by permission), January 9, 1983, p. 32.*

Everything about the BFG is fascinating and unusual: For example, he eats nothing but '''the repulsant snozzcumber''' and is shocked that human beans kill other human beans; but the giant's speech is a tour de force in itself. . . . In the flamboyant and fast-moving fantasy the ridiculous situations, the indelicate allusions, and the wickedly funny speech of the giant . . . will undoubtedly provoke unseemly gales of merriment.

> *Ann A. Flowers, in a review of ''The BFG,'' in* The Horn Book Magazine *(copyright © 1983 by The Horn Book, Inc., Boston), Vol. LIX, No. 2, April, 1983, p. 165.*

Our perceptions of children's fiction and nonfiction have made us uneasy about clear distinctions between fact and fancy, and we must be most so in looking at stories for [the] intermediate age group. Here the magic and the ordinary inevitably intertwine: indeed the ordinary *is* magical and we are helped to perceive that. . . .

The BFG is a book of such richness that it is hard to know where to begin. The theme, the outwitting of evil by good, is simple; the plot line clear just because its twists and turns are so much under control; the suspense is maintained to the end. The characters are familiar—brave little Sophie, Big Friendly Giant, Bad Crunching Giants (we can guess what Bettelheim would make of them)—though no cardboard cutouts, but the liveliest lot assembled in Dahl's work. Yet the whole far exceeds the sum of the parts. Dahl must have enjoyed writing this book, which leaves us with a vision of a more liberated, generous way of life, just within our reach. And determined to be a bit more trusting, admitting the justice of BFG's admonition.

> *Peggy Heeks, in a review of ''The BFG,'' in* The Signal Review 1: A Selective Guide to Children's Books 1982, *edited by Nancy Chambers (copyright © 1983 The Thimble Press; reprinted by permission of The Thimble Press, Lockwood Station Road, South Woodchester, Glos. GL5 5EQ, England), Thimble Press, 1983, p. 28.*

THE WITCHES (1983)

Roald Dahl knows every bit as well as Bruno Bettelheim that children love the macabre, the terrifying, the mythic. In his latest book, **''The Witches,''** a 7-year-old orphan boy, cared for by his Norwegian grandmother, discovers the true nature of witches and then has the misfortune to be transformed into a mouse by the Grand High Witch of All the World—a horrifying creature with a bride-of-Frankenstein face concealed behind the mask of a pretty young woman. In this book, witches are characterized as figures of horror—baldheaded, claw-fingered, toeless women, their deformities hidden beneath pretty masks, fancy wigs, white gloves and pointy shoes.

Although I have written a book arguing for the rehabilitation of the witch as a descendant of the great mother goddess of the ancient world, I can certainly see what Roald Dahl is up to here. His witches must be horrifying creatures to underline his hero's heroism. For **''The Witches''** is a heroic tale. A schoolboy is transformed into a tiny mouse (with, however, the mind and language of a very bright child), and through his extraordinary bravery, he manages to save all the children of England from the same fate.

Under the surface of this deceptively simple tale, which whizzes along and is great fun to read, lurks an interesting metaphor. This is the equation of childhood with mousedom. A child may be smaller than all the witchy, horrifying adults, but he can certainly outwit them. He is tiny and crushable, but he is also fast and well-nigh invisible. With the assistance of his benevolent Grandmamma (who hoists him up to things he can't reach, secretes him in her handbag, feeds and cuddles him), he is able to outsmart nearly the whole adult world.

"**The Witches**" is also, in its way, a parable about the fear of death as separation and a child's mourning for the loss of his parents. Mr. Dahl's hero is happy when he is turned into a mouse—not only because of his speed and dexterity (and because he doesn't have to go to school) but also because his short life span now means that he will never have to be parted from his beloved grandmother as he has been from his parents. Already well into her 80's, she has only a few years to live, and he as a mouse-person is granted the same few years. Rather than bemoaning this, both grandmother and grandson rejoice that they can now count on living and dying together.

The boy doesn't mind being a mouse, he says, because "It doesn't matter who you are or what you look like so long as somebody loves you." And, indeed, the hero of this tale is loved. Whether as a boy or a mouse, he experiences the most extraordinary and unqualified approval from his grandmother—the sort of unconditional love adults and children alike crave.

"**The Witches**" is finally a love story—the story of a little boy who loves his grandmother so utterly (and she him) that they are looking forward to spending their last few years exterminating the witches of the world together. It is a curious sort of tale but an honest one, which deals with matters of crucial importance to children: smallness, the existence of evil in the world, mourning, separation, death. The witches I've written about are far more benevolent figures, yet perhaps that is the point of witches—they are projections of the human unconscious and so can have many incarnations.

Erica Jong, "The Boy Who Became a Mouse," in The New York Times Book Review *(copyright © 1983 by The New York Times Company; reprinted by permission), November 13, 1983, p. 45.*

Dahl has created a fast-moving, well-paced adventure that many children will love; some adults may find it too grizzly and the bathroom humor offensive. The witches, always female, are purely evil and intent on the extermination of all children. The inclusion of sex-role stereotyping is unfortunate: woman teachers will be afraid of mice; girls don't keep pet mice; a woman couldn't be the head of the Norwegian police. However, the author has crafted a special relationship between grandmother and grandson, one which will thrive even when one of the pair is a mouse-person. This message of love and acceptance comes through clearly. Children will appreciate Dahl's honest way of dealing with death and separation.

Ellen Fader, in a review of "The Witches," in School Library Journal *(reprinted from the January, 1984 issue of* School Library Journal, *published by R. R. Bowker Co./A Xerox Corporation; copyright © 1984), Vol. 30, No. 5, January, 1984, p. 74.*

Genevieve (Stump) Foster

1893-1979

American author/illustrator of nonfiction.

Foster is acclaimed for her unique approach to history and biography. She generally profiled prominent American figures and times, paralleling their histories with concurrent events and personalities throughout the world. This technique broadens the perspectives of young readers by allowing them to view history as a cohesive whole rather than a series of isolated occurrences. Foster's books include her own charts, maps, and illustrations, which critics consider outstanding accompaniments to the texts. Her books are well researched and often feature overlooked historical figures such as Christopher Columbus's son, Ferdinand, and Richard Trevithick, inventor of the "horseless carriage."

After vicariously living history amid the antiques and memorabilia which filled the house she shared with her mother, aunt, and grandmother, Foster found the narrow and limited delivery of history uninteresting and complex. In an effort to make history more enjoyable for young readers, Foster approached its retelling in various ways. Her "World" books—*George Washington's World, Abraham Lincoln's World, Augustus Caesar's World, The World of Captain John Smith, The World of Columbus and Sons,* and *The World of William Penn*—are written for middle school-age children. They are seen as a successful blend of biography and history—informal, yet clearly written and illustrated. Urged to create works for even younger readers, Foster developed an "Initial Biography" series, in which Washington, Lincoln, Andrew Jackson, and Theodore Roosevelt are presented from childhood through adulthood. Foster contends that children will be more apt to read about and accept historical figures by realizing they were once children like themselves. Still another series revolves around specific years, such as *Year of the Pilgrims, 1620, Year of Independence, 1776,* and *Year of Lincoln, 1861.* A two-volume set, *Birthdays of Freedom,* receives mixed reviews for containing a vast amount of information and history in very few pages. On the one hand, readers are exposed to many different historical situations; on the other, they may be misled by the books' occasional broad generalities. Critics applaud Foster's works for their informal, understandable illustrations and language. They are regarded as excellent learning tools which succeed in making history interesting and universal. Several of Foster's books have been chosen as Newbery Honor Books: *George Washington's World,* 1942; *Abraham Lincoln's World,* 1945; *George Washington: An Initial Biography,* 1950; and *Birthdays of Freedom, Vol. 1,* 1953. Foster was awarded the Friends of Literature Award for Distinguished Service to Literature for Young Readers in 1959.

(See also *Something about the Author,* Vols. 2, 23 [obituary]; *Contemporary Authors New Revision Series,* Vol. 4 and *Contemporary Authors,* Vols. 5-8, rev. ed., Vols. 89-92 [obituary].)

AUTHOR'S COMMENTARY

Nothing is more necessary, I believe, than that children growing up in these critical, explosive days should be given an

Courtesy of Joanna Foster

understanding of American history as a part of the history of the world. Every year this grows more urgent, as increasingly rapid communication integrates world events more closely and the impact of foreign affairs on our own lives becomes more serious and immediate.

It was my own need for a better historical background against which to view the world of today that led me to write my first book. Of all the history courses which I had taken in high school and college, none had given me the perspective that I needed. There must have been teachers who saw the story as a whole, but none happened my way. History was sliced vertically instead of horizontally. The history of each nation, isolated from the others, was presented from beginning to end, with but the barest reference to what was taking place in the rest of the world.

The result was as lifeless and confusing to me as a play in the theater might be if only one character appeared upon the stage at a time, while the others mumbled their lines behind the scenes. History is drama, with men and nations as the actors. Why should it not be presented with all the players who belonged together on the stage at once?

Why not write a history showing what was going on, not only in the United States, but all over the world and how events in

various nations were related? The idea possessed me. I determined to try it.

I visualized it as a multiple biography, one in which scientists, artists, musicians, writers, explorers—all would be included, as well as kings, presidents, and generals. I would show how their lives fitted together and what part each one played in the great adventure story. To set the stage, I planned to use charts, maps, illustrations, whatever means I could command to make it vivid and colorful.

Children of Grades VI-VIII were the audience I had in mind, believing that they were of the age to get the most value from this kind of world picture. If, just before entering high school, they could have an orderly pattern or framework on which to fit all the facts that they would later learn in more formal textbooks, I felt sure that they would be spared the confusion I had suffered. An orderly pattern—that, too, I wanted the book to be, as well as a warm, human drama and an exciting adventure story.

That was my aim. But how to go about it? How handle the time element and yet keep the pages from bristling with dates? After much round-about thinking, I hit upon a very simple answer, as so often happens.

It is natural, I thought, for all of us to correlate world events in point of time with events in our own lives. The nearest approximation to this, in an age gone by, would be to take some well-known, historical figure, and relate what events were contemporary with various periods in his life.

George Washington's life, which spanned the years from 1732 to 1799, made a perfect measuring stick for that fascinating period which included the French Revolution, the beginnings of the British Empire, as well as our own War for Independence. Then, keyed to the life of Abraham Lincoln, who was born but nine years after Washington died, the world story is continued without interruption to the end of our war between the states. So those two books, *George Washington's World* and *Abraham Lincoln's World,* present American history with a world background from 1732 through 1865. (pp. 53-5)

In the text, as many as possible of the principal characters are introduced as children, so that later on, when they play their parts in public affairs, they may be more than mere names. Each will seem like a childhood friend, whose manners and actions are familiar. Fat, little John Adams, red-faced and curly-headed, tugging impatiently at a weed to get out the root down to the very end, will show the same impatient determination when he rises in Congress to propose making George Washington commander of the army and be done with the "shilly-shallying." This technique helps young readers, I believe, to realize that history is just the story of what people have done—people who were once boys and girls very like the ones to be met every day in school or on the playground.

The amount of space devoted to each character is necessarily brief, merely an appetizer that will lead, I hope, to the reading of longer biographies. (p. 55)

To stay within the young reader's span of interest, the sections are short, and illustrations tell part of the story. I try never to show in a drawing what I have described in words, because of limited space, for one thing, and because of the truth of the old saying that one drawing is worth a thousand words. More important is the fact that no illustration can ever quite coincide

with the picture that each reader forms in his own mind. To interfere with the image created by the words is to destroy part of the joy of reading. . . .

The little **"Initial Biographies,"** *George Washington, Abraham Lincoln,* and *Andrew Jackson,* are what the name implies, beginning biographies. (p. 56)

The series is an outgrowth of the **"World"** books. They are the answer to requests that I write brief but equally serious biographies for younger children. At first, the idea did not appeal to me. Then the very size intrigued me. The thought of condensing the entire story of a man's life into 112 pages, without reducing it to a bare synopsis, presented a fascinating problem.

For it was to be a complete story. Even though a biography be short for very young readers, I feel that it should tell the entire life. Otherwise, the relation of cause and effect that gives it meaning and value is lost. What qualities did this child have that helped him to succeed? What handicaps or faults did he have to overcome or correct? What was the result of the choices he made? All this must be seen if a biography is to be what it can be—a powerful medium in character-building. The slighting of the adult years for fear that they will not be of interest to a child is a mistake. The arbitrary line between children and adults is more imaginary than real. My old grandmother made me see this many years ago in words that a very small girl could understand. "Growing old, my dear," said she "is mostly on the outside. I know that this house I live in looks very old and wrinkled to you. But inside I am just the same person that I always was."

That is the key. If a character feels and acts and seems like the same person, the child will grow along with him in sympathy and understanding. About the only change I make is to use a more simple sentence structure in writing for the younger readers, who have not acquired the reading skill of their older brothers and sisters. Comprehension of basic human relationships is quite within their ability, since this is not so much an intellectual achievement as a matter of intuition.

Needless to say, these short, condensed biographies demand as much research as do much longer ones, and, in fact, require a more thorough digesting of the material in order to reduce it to its essentials. I am constantly reminded, as I condense and cut and rewrite, of the motion picture of the Curies which showed them reducing a carload of pitchblende until only the merest film of radium remained in a tiny white crucible.

The actual writing demands meticulous care. Every word has to carry its full weight, as if in a giant telegram. Every transition must move the action forward without seeming to hurry it, and must often bridge great gaps in time. Vowel sounds must be considered, as in poetry, to establish atmosphere and set a mood. Tempo and rhythm are used to suggest the temperament and dominant characteristics.

Of the three, the pace of the Lincoln biography is the slowest. That of Andrew Jackson is the fastest and most tempestuous. The Washington biography is the most orderly and formal. It also has the fewest direct quotations, since he was a man of few words.

The illustrations play as distinctive a part in these small books as in the large ones. The life-story may be read from beginning to end in the pictures alone. Each is a more or less composite

picture. My thought was that children too young to read might enjoy picking out various places, people, and objects in the story as the mother talked about it.

The age range has also been extended upward; for, while designed for elementary grades, the biographies are proving useful, I'm told, in junior high school. And on a trip east last fall, I heard two librarians say that they were giving them to adults of foreign birth who still needed simple English. That delights me. The wider the age range a book has, the more pleased I am.

But the concern of one who writes biography and history, as I see it, should be not so much that the book be scaled to fit some chronological age as that it have the vital quality that will give it universal appeal. It is something of the vigor and directness of the old sagas and hero tales that we should strive for—their accent upon primary emotions and fundamental relationships. Then we can hope to have more books that will be enjoyed by both old and young, read aloud perhaps by parents, and so help children to grow toward maturity in a most simple and natural way. (pp. 56-7)

> Genevieve Foster, *"Biography and History for Today's World,"* in Supplementary Educational Monographs *(reprinted by permission of The University of Chicago Press; copyright 1951, and renewed 1979, by The University of Chicago), Vol. XIII, No. 74, November, 1951, pp. 53-7.*

GENERAL COMMENTARY

ANNE CARROLL MOORE

[Genevieve Foster's *Abraham Lincoln*] is even better than her *George Washington*. In these **"Initial Biographies,"** as in her books for older children, *George Washington's World* and *Abraham Lincoln's World,* Mrs. Foster is rendering unique service to the field of children's books. In her text and drawings she respects the intelligence of her audience as well as the stature of the character she has chosen to write about. (p. 457)

> Anne Carroll Moore, in an extract from *"The Three Owl's Notebook,"* in The Horn Book Magazine *(copyrighted, 1950, renewed 1977, by The Horn Book, Inc., Boston), Vol. XXVI, No. 6, November-December, 1950, pp. 455-57.*

MITCHELL DAWSON

It was a crisp October evening in the year 1938. Genevieve Foster sat in her attic studio in a big house in Evanston, Illinois. Her husband was working in his shop in the basement three floors below. Their children, Tony and Joanna, were, or should have been, in bed. A red gold hunter's moon hung high over Lake Michigan a block away. It was visible through the tall windows of Mrs. Foster's studio, but she didn't see it. She was obsessed with an idea that had been nagging her for months. She wanted to write a history book for children, a new kind of history in words and pictures. She should have been finishing a set of illustrations for a children's story. The deadline was only three days away, but she couldn't get the history out of her mind.

Boom! The house rocked with the sound of an explosion. She didn't hear it. She sat there under the bluish light of a fluorescent lamp, completely absorbed. On the drawing-board before her was the layout for the opening pages of a book. To her right stood a paint-stand and on her left a typewriter. The floor was littered with stacks of books.

The telephone began to ring. It rang and rang and finally brought Mrs. Foster back to here and now. It was Tony calling from the kitchen on the "inter-com" line.

"It's all right, Mother," he said. "Dad says to tell you there's no harm done."

"Wh-what's all right?" asked Mrs. Foster.

"Why, the explosion. Didn't you hear it?"

"Explosion? No! What happened?"

"Nothing much," laughed Tony. "But Dad looks awfully funny without his eyebrows."

This is just the sort of thing that was continually happening in the four-ring circus of the Foster household. Mr. Foster was an engineer. He loved to work in his basement laboratory, where his experiments sometimes produced startling reactions. But Mrs. Foster didn't mind. She loved to experiment herself. This time she was trying to figure out an experiment in multiple biography. She was going to write history in the terms of the lives of the people who made it. (p. 190)

By telling the story of [George Washington's] life and the lives of other important people of his time, she could tell the story of the beginnings of the United States and its principles of government in relation to the rest of the world.

It was going to be a tough job. She would have to do an immense amount of reading, note-taking, sorting, selecting and correlating. She would have to recast this material into a clear, realistic and interesting narrative within the space of some three hundred pages, including illustrations. Fortunately she was endowed with a highly developed but well-controlled imagination which enabled her to project herself into the past in the role of a reporter who could see, hear, feel, taste and smell what had gone on and retell it in vivid words and pictures. She also had a superb sense of values, abounding energy, great strength of purpose and a family who backed her project fully and enthusiastically. Knowing they were with her, she used them as sounding boards—the children to give her the feel of the audience she hoped to reach and her husband as a test of the more critical adult response. He had high standards of clarity, precision and readability. When she read a passage of the book to him, he could tell her unerringly whether or not it hit the mark. After his death in 1945, it was hard for her to go on, but she got much comfort from trying always to apply the high standards he set for her.

She read and read; she wrote and drew. Text and pictures grew together. When I asked her which came first, she was baffled. It would have been impossible for her to write such a book and then sit down and illustrate it. The relationship between text and pictures was complementary. Together they told the story. Neither would have been effective alone.

She divided *George Washington's World* into six sections, each covering a period of his life. A two-page spread of pictures at the beginning of each section introduces the reader to the Very Important People who were living during that particular period. The first presents **"People Who Were Living When George Washington Was a Boy."** There they are: Daniel Boone, James Watt, Ch'ien Lung, Louis XV, Junipero Serra, Maria Theresa

and a dozen others with a brief identification under each. She thus achieves a cross-section of the time that would be impossible to accomplish with words alone. Each of these double-spreads is a sort of curtain-raising presentation of the cast of characters before each act of the play begins.

It took three years of painstaking work to finish *George Washington's World,* but the result justified the pains. The book caught on almost at once. Here was history streamlined, dramatic and full of suspense. The past came to life in swift, vivid narrative. . . . (pp. 191-92)

Mrs. Foster's method of beginning with the childhood of her protagonist and his contemporaries . . . proved to be a "natural." It piques the interest of youngsters to realize that the people who made history were once just boys and girls very like themselves. (p. 193)

George Washington's World covers the period from 1732 to 1799. It was inevitable that *Abraham Lincoln's World* should follow and thus bring history down to the year 1865 in terms of the lives of America's two top heroes. The Lincoln book was done with the same fine skill as was its predecessor, and it evoked the same warm response, encouraging Mrs. Foster to dream of new worlds to conquer. So far, she had kept pretty close to history and biography in terms of action. She wanted her next book to have wider scope.

As she rode the time-machine of her imagination back and forth through history, she kept returning with fascination to one particular era—the period in which Jesus was born. It offered a magnificent opportunity as well as a terrific challenge. Augustus Caesar was then at the height of his fame and power. His life span (from 44 B.C. to 14 A.D.) would make an excellent yardstick. She would tell not only what people did in those momentous times, but also what they thought and believed as expressed in mythology, philosophy and religion.

Mrs. Foster set to work on this new project with her usual gusto. *Augustus Caesar's World* slowly emerged, telling, as do her earlier books, the story of the period, and including also the myths and beliefs of different peoples throughout the world— the Greek and Roman concept of a hierarchy of gods and goddesses; the Japanese worship of a sun-goddess; the cult of the mysterious Mayan hero-god; the teachings of Confucius, Buddha, Ahkenaton, the Hebrew prophets, the Greek philosophers and the Persian Magi. Excerpts from the sacred writings of various religions are also included to show the basic similarity in the precepts of the world's great spiritual leaders.

With each new **World** book Mrs. Foster's audience expanded. It was much broader than the sixth, seventh and eighth grade age levels she originally had in mind. High school teachers of history and social studies prescribed her books as collateral reading for their students. Latin teachers found *Augustus Caesar's World* a great help in creating a realistic historical background for the study of such writers as Cicero and Virgil. Mrs. Foster began to acquire a group of "fans" who took a proprietary interest in her and her work. She belonged to them and they wanted to know what sort of a book she was planning to do next. Some of them wrote to her publisher, saying it was all very well to write history for the sixth grade and up, but what about the fourth and fifth graders? They were old enough to take a lively interest in history, at least in the history of their own country. Why didn't Mrs. Foster prepare some shorter biographies for that age level?

Mrs. Foster was not too keen about the idea at first. She didn't want to do lower-age versions of the Lincoln and Washington books, but as she mulled the matter over she realized that wasn't necessary. With the material all at her finger tips she would do a series of entirely new short biographies of great Americans that would cover the entire span of United States history. She would call them "**Initial Biographies**" because they were for beginners and also because she would put the initials of the subject of each biography on the cover of the book as a kind of trademark to make it easy for children to identify and remember the series. (pp. 193-94)

[The **Initial Biographies**] are not just boiled-down versions of the **World** books. Vocabulary and sentence structure are a bit simpler, but there is no skimping in quality or scope. The illustrations are in color and gayer in style. The whole life— not just the childhood and youth—is told and in a way that brings out the relation of cause and effect without moralizing. What handicaps did the protagonist face? And how did he overcome them? What were his special abilities and what use did he make of them? What were the consequences of his major decisions? The **Initial Biographies** answer questions like these and in so doing become character-building experiences for young readers. (pp. 194-95)

One cannot help wishing that Genevieve Foster's books—especially the **World** books—in appropriate translations could be distributed by the million to the children of all countries, for the worlds of Genevieve Foster are young, eager, fresh worlds. They are worlds of struggle, fighting and tragedy; but tragedy, terror and despair are not the dominant notes. Her books show that ours is a world worth saving, a world where there is still hope. (p. 195)

> *Mitchell Dawson, "Genevieve Foster's Worlds," in* The Horn Book Magazine *(copyrighted, 1952, renewed 1980, by The Horn Books, Inc., Boston), Vol. XXVIII, No. 3, June, 1952, pp. 190-95.*

SARA INNIS FENWICK

Young people today have had contemporary history made alive to them in a most exciting way through the developments in news reporting by radio and television. A horizontal view of history in the making in today's current events is a part of every day's experience for children. They know what is going on in Indo-China, in Germany, in Africa, in the world of science, the world of sport, of drama, music, and art, as well as in those less desirable portions of the current scene in police court and under-world. Children still need, however, as desperately as any generation has ever needed, a similarly broad view of what has happened in the past in order to develop the perspective which will help them to form value judgments. Genevieve Foster, in her "**World**" books, has provided materials upon which such understandings can be nourished.

George Washington's World, Abraham Lincoln's World, Augustus Caesar's World were not planned as merely supplementary materials for an area of social studies. To use them thus is to limit their usefulness. Mrs. Foster designed them each as an introduction to a period of history, as basic to an understanding that lives of outstanding men who punctuate all history were not lived in isolation, but, while they were exerting qualities of leadership in one country, other men and women were at various stages of their careers in other national scenes. (p. 316)

It is the wealth of material to appeal to so many varied interests of young people, while exploring history, that is the source of one of the great values of Mrs. Foster's writings. Materials from the fields of science, music, painting, archeology, are all included, and open up many new fields of interests. (p. 317)

Abraham Lincoln's World was the most difficult to write [of the "**World**" books], Mrs. Foster acknowledged, even as it is the most difficult for children to read. This is understandable when one considers the many upheavals in nationalistic spirit and economics and social change that were breaking the surface of the stream of world history in the period marked by the life of Abraham Lincoln.

Possessing the profound respect for order and accuracy which is a prime requisite for a historian, Genevieve Foster laid the groundwork for each of the three "**World**" books in a series of chronological charts, wonderfully fascinating and exciting outlines of what was happening around the world, and how, where, and why each event touched the life of the character from whose point of view this particular segment of time is being considered. Having this great wealth of interesting material spread and organized, the author recreated the life of her main character, pulling in the strands of contemporary lives and events in Europe, Asia, South America, Africa, and weaving them precisely, with a style reflecting her originality and vision. Thus she produced a panoramic tapestry of the worlds of George Washington, Abraham Lincoln, and Augustus Caesar. There is excitement, humor, and great fascination in Genevieve Foster's writing.

It is the good fortune of younger readers than the eleven to fifteen-year-old group who form the best audience for the "**World**" books, that Mrs. Foster's publishers persuaded her to use her research and skill to fill one of the great gaps in children's literature—the well-written, simple biography. . . .

Mrs. Foster has written the four Initial biographies as introductions to the characters and careers of the four men whose life spans encompassed most our country's history: George Washington [, Andrew Jackson, Abraham Lincoln, and Theodore Roosevelt]. (pp. 318-19)

Since the text of each brief biography had to be so distilled to the essential facts, it seemed important that every facet of the presentation should add something to the reader's conception of the character and his life story. The style of writing, sentence length, dialogue, and vocabulary all were viewed as tools by the author, to be used in the telling of the story. Thus, she chose to write of George Washington in a quiet style, with little dialogue, because he was a quiet man. The style of *Abraham Lincoln* mirrors something of the slow tempo of the period, and of the deliberate quality of its hero. *Andrew Jackson* is written in a staccato style, characteristic of the explosive character of "Old Hickory." (pp. 319-20)

In setting the style for *Theodore Roosevelt,* Mrs. Foster had in mind the tremendous drive and vigor of the man.

With guidance, children reading these biographies can be made aware of qualities of style in writing, and can be helped to appreciate the different ways of writing description and telling a story. (p. 320)

[A] factor which is a carrier of information in these brief biographies is that of illustration. Mrs. Foster has made the pictures always supplementary to the textual descriptions. Her aim has been to produce pictures which would give an idea of the life of the subject to a child looking at the book, even if he could not read a word. Teachers and librarians will always be grateful to Mrs. Foster for the double-page illustration in *George Washington* which shows a cross-section of the home at Mt. Vernon, giving the arrangement of rooms in the great plantation home.

The illustrations and the design of the books of Genevieve Foster are never an after-thought to the next, because Mrs. Foster is artist as well as writer. She sees each page in its completeness of text, illustration, and design. The illustrations and the page layout are conceived as the text is growing, and Mrs. Foster produces the entire design for each of her volumes, doing the color separation for each illustration herself.

International recognition has been awarded Mrs. Foster for the important contribution she has made to literature for children in the fields of biography and history, and for the interpretation of American history in its relation to world history. *Abraham Lincoln's World* was chosen to go into the CARE packages of books to be sent to schools and libraries abroad. Translations of the "**World**" books and of the Initial biographies have been made into many foreign languages. . . . In a world beset with misunderstandings between nations, it is encouraging to know that new generations will have these excellent writings about America, produced by a craftsman with sincerity and integrity, to interpret our country. (p. 321)

> Sara Innis Fenwick, "Exploring History with Genevieve Foster" (copyright © 1954 by the National Council of Teachers of English; reprinted by permission of the publisher and the author), in Elementary English, Vol. XXXI, No. 10, October, 1954, pp. 315-21.

DOROTHY M. BRODERICK

Genevieve Foster's *George Washington's World* and its companion volumes are excellent examples of the merging of theme and research. These books would be valuable if judged solely on the basis of the information they impart. But because their author also imbues them with her belief that men and nations are irrevocably intertwined, their worth is vastly increased. Through her technique of roaming over the world and interrelating the causes and effects of widely separated but connected events, she makes history a living force for junior high school children. Her works represent a landmark in the children's book world. (pp. 36-7)

Few authors in the children's field can surpass Genevieve Foster in knowledge of American history. Because she knows the subject so well, she is able to make her biographies *George Washington, Abraham Lincoln, Andrew Jackson,* and *Theodore Roosevelt* simple enough for the fourth grader without resorting to distortion or imaginary scenes and conversation. (p. 112)

> Dorothy M. Broderick, "Book Selection Criteria" and "Nonfiction Books," in her An Introduction to Children's Work in Public Libraries (copyright © 1965 by Dorothy M. Broderick), The H. W. Wilson Company, 1965, pp. 25-40, 106-17.*

KIRKUS REVIEWS

[*The Year of Columbus* and *The Year of the Pilgrims* are] brief books (of 64 pages), with rather crude but really useful drawings and decorations and labels; except for the sophistication of the content, the whole could pass for a school project. Half

From George Washington, *written and illustrated by Genevieve Foster. Charles Scribner's Sons, 1949.*
Copyright 1949 by Genevieve Foster. Reproduced by permission of Joanna Foster.

is devoted to the focal story, half to sketchy profiles of outstanding contemporaries and glimpses of contemporary civilizations outside Europe; worked in are historic lessons of larger import. . . . On the one hand the effort to broaden the child's perspective and deepen his understanding is admirable, on the other it is a great deal of thinly connected information for a young child to take in all at once. *The Year of the Pilgrims* is the more successful of the two: by its very nature the subject is less personal and anecdotal, more immediately connected to the substance of history; the **"Artists and Scientists"** are more diverse and interesting; there is one fewer **"Around the World"** sequence, so that it is easier to keep them straight. The books would benefit enormously by passing through the hands of a resourceful teacher; on his own it's hard to imagine an eight-year-old cheering *go, go Grotius.* (pp. 1198-99)

> *A review of "The Year of Columbus" and "The Year of the Pilgrims," in* Kirkus Reviews *(copyright © 1969 The Kirkus Service, Inc.), Vol. XXXVII, No. 22, November 15, 1969, pp. 1198-99.*

MAY HILL ARBUTHNOT

[A] notable writer-artist with an original approach to history is Genevieve Foster with her books *George Washington's World, Abraham Lincoln's World, The World of Captain John Smith, Augustus Caesar's World, The World of Columbus and Sons.* In each of these five books, the author takes a horizontal look across and around the world to tell what was happening of

importance when the hero was born, during his childhood, in his youth and early manhood, and so throughout his life. In this world's-eye view of countries, periods, and people, young readers see movements rise and culminate or disappear, men who turn the tide of history in one direction or another leaving the world markedly better or worse for their presence. The effect is curiously impressive and gives children a rounded sense of history that their textbooks rarely suggest. Only an author-artist with a remarkable sense of design could integrate her text and illustrations as Mrs. Foster does. One or more of these books is fascinating to own as a reference. What was China doing in those days? What impact did Napoleon make on world history? The answers to these and similar questions may be found in these books. (p. 303)

> *May Hill Arbuthnot, "Informational Books," in her* Children's Reading in the Home *(copyright © 1969 by Scott, Foresman and Company; reprinted by permission), Scott, Foresman, 1969, pp. 279-308.**

FRANCES CLARKE SAYERS

With all the inventive, fresh ways of presenting history to children, the chronological approach still holds an appeal for young readers. Genevieve Foster, gifted writer and artist, has experimented with time in her unusual books which combine history and biography. Her *George Washington's World* . . . and *Augustus Caesar's World* . . . present the contemporary world as background for the life span of the subject of her

biography, and include accounts of the arts, science, and politics of the time in which her subjects lived. These richly documented, horizontal views of history are infinitely varied and interesting. This approach adds a new dimension of reality to facts which had not been formerly related to each other, and it comprises a singularly original presentation of history for children. (pp. 1104-05)

> *Frances Clarke Sayers, "Travel and History: Introduction," in* Anthology of Children's Literature *by Edna Johnson, Evelyn R. Sickels and Frances Clarke Sayers (copyright © 1970 by Houghton Mifflin Company). Reprinted by permission of Houghton Mifflin Company), fourth edition, Houghton Mifflin, 1970, pp. 1103-06.*

AMY KELLMAN

[In *1492, Year of Columbus, 1620, Year of the Pilgrims, 1776, Year of Independence,* and *1861, Year of Lincoln*] Mrs. Foster looks at a crucial year in American history by describing what led up to that year and what the results were that followed; who were a few of the important people living at the time; and what was happening at the same time in other parts of the world. The result is a greater feeling for the period, as well as a firmer grasp of the facts. As adults, we soon learn that one country's history rarely occurs in isolation, but is affected by and changes what is happening in other places. These books go a long way to help children understand this complicated process. Mrs. Foster's drawings and maps are useful and attractive additions to the text. . . .

> *Amy Kellman, in a review of "1492, Year of Columbus," "1620, Year of the Pilgrims," "1776, Year of Independence," and "1861, Year of Lincoln," in* Grade Teacher *(copyright © 1971 Macmillan Professional Magazines; used by permission of The Instructor Publications, Inc.), Vol. 88, No. 6, February, 1971, p. 139.*

GEORGE WASHINGTON'S WORLD (1941)

Such a readable presentation of world affairs during the years 1732-1799 should serve to show school children that the events of history never take place in compartments but are, of necessity, related to one another. . . . Many older persons, as well as children, will have their historical sense quickened when they realize that Catherine the Great of Russia and Marie Antoinette were reigning, that James Watt was discovering the possibilities of steam, and the secrets of ancient records were being revealed by the Rosetta Stone during the period. Numerous illustrations and an excellent index add to the value of an unusual book.

> *Alice M. Jordan, in a review of "George Washington's World," in* The Horn Book Magazine *(copyrighted, 1941, renewed 1969, by The Horn Book, Inc., Boston), Vol. XVII, No. 5, September-October, 1941, p. 364.*

Something that badly needed doing has been done, in this portly and fascinating book, extremely well. Look back on your own study of American history as a child and later in your education, on the study of European history; it will come back country by country, without connection one with another. You once knew what was going on in America in a given year, but this did not bring up an echo of what was going on anywhere else. If you needed to know, you had to make a chart for yourself:

I did in high school. Now Mrs. Foster . . . makes for this age, as well as for that a trifle younger, something more convincing than a chart.

It begins with George Washington's boyhood, and sketches that briefly. When he was twelve Daniel Boone was nine; you see him in an environment different from George's, or from that of John Adams, who was nine also in Braintree, with his schoolmate John Hancock, or from that of Benjamin West in Philadelphia. England and Spain were facing each other in the New World; Fray Junipero Serra came limping into Mexico City in 1750; and when Washington was eight, "a keen young prince by the name of Frederick became King of Prussia and sprung his first surprise on an unsuspecting world." In that year the child who was to be Catherine the Great was eleven, and "old Bach" had developed the king's theme so he might play it on the flute. Pierre Caron, James Cook, James Watt, were starting on their life-adventures. In fifty-eight pages, with lively drawings, we have gone round young George's world. The process is repeated when he was a soldier, a farmer, a commander, a plain citizen, and the President. For each of these periods a double page drawing assembles the world's leading characters at the age they were then.

It is safe to say that children will not be the only ones to read this book. It is easier to start reading it than to stop.

> *May Lamberton Becker, in a review of "George Washington's World," in* New York Herald Tribune Books, *September 14, 1941, p. 6.*

The book shows evidence of much research and thought. The illustrations are clever and descriptive, the style of writing and vocabulary clear—although at times sentences are long and involved. Two indexes, one of people and the other of places and events. Would appeal to children from the sixth grade up. . . . Recommended for both public and school libraries as a very fine piece of work.

> *Mary R. Lucas, in a review of "George Washington's World," in* Library Journal, *Vol. 66, No. 16, September 15, 1941, p. 798.*

The correlation of world events at a given period in history is a feat to stump the average adult, let alone a schoolchild, yet as the world shrinks through transportation and communication this visualization of historical events as a whole becomes increasingly important to an understanding of past and present. Working with and originally for her own children, Genevieve Foster has created a book to develop this lateral viewpoint in history without sacrificing the sense of its forward flow.

She has selected one of the most significant periods in world history, the years spanned by George Washington's life, and, using him as the focal point, she has brought into relation the outstanding personalities and events which shaped the course of the years. . . . [In] brief chapters arranged according to six phases in the life of Washington are traced the most important movements of the period. Portrait sketches, revealing anecdotes, pithy sayings of the founding fathers, details of living, round out the picture in an account as readable as it is instructive. Many pictures, which leave something to be desired in the way of beauty, but which are suggestive and interesting, serve their purpose of helping to visualize the pattern of the world. This is an ambitious project, brilliantly executed.

ABRAHAM LINCOLN'S WORLD (1944)

I liked this better than *George Washington's World*—it seems
better keyed to the age group, and without being simplified,
it manages to create a better integrated picture of what is going
on in the world during Lincoln's lifetime than was achieved
in the earlier book. . . . Graphic writing—history in the way
it should be taught—this blends world history and biography
into a vigorous whole.

Once more Genevieve Foster performs an important service to
our children's sense of history: as in an earlier volume she
gave them, in a close-woven narrative with many drawings, a
good idea of what was going on all over the world at various
stages of George Washington's career, she now reveals—it
will be a revelation to many young people—what made the
period of Abraham Lincoln vitally interesting in so many parts
of the world at once. Many of us learned in high school days
that the liveliest way to get a bird's-eye view of history was
to make a chart for a century's decades and note on it significant
dates in every country—but we had to make our own charts.
Miss Foster gets the same effect by a method much harder to
do and much more successful when done: continuous narrative
into which events and characters of Europe and America are
woven, taking a fresh start with each period of Lincoln's life,
carrying the same leading figures and constantly introducing
minor ones.

This checking-up is accompanied by drawings like that showing
"what other people were doing when A. Lincoln was a law-
yer." . . . What the picture summarizes the lively narrative
tells; nobody gets much space but everybody seems to have a
chance. Profound treatment is in such a survey neither possible
nor desirable: the book gives young people literally the once-
over, on a time crackling with importance.

It makes better reading than her first book because Lincoln
makes better reading than Washington and because his time
comes nearer our own.

"Abraham Lincoln's World," following by two years Mrs.
Foster's distinguished and original **"George Washington's
World,"** brings her readers a step nearer to the "One World"
so poignantly in our minds at this moment. . . .

From Abraham Lincoln's World, *written and illustrated by Genevieve Foster. Charles Scribner's Sons,
1944. Copyright, 1944 by Genevieve Foster. Reproduced by permission of Joanna Foster.*

Lincoln himself would have found this book absorbing reading; more of its facts would have been completely new to him than will be new to the high school age readers for whom this volume will still offer an exciting experience. He would have recognized his own life story as singularly true to the spirit of himself; he would have been familiar with all that Mrs. Foster has to say in her swift, informal, at times humorous and at times grave and moving prose concerning the United States, for he was an untiring student of his own country. But Abraham Lincoln was in the main ignorant of what this book has to tell us of concurrent events within the other nations of the world. Isolated through no fault of his own, he was unknowing of much of the picture now painted here with such color and skill, in its entirety.

The remarkable resemblances achieved by Mrs. Foster's pen-and-ink drawings possess a Brady-like fidelity to feature and expression. In both text and pictures one is made aware of the author's belief that through the determination of men striving to accomplish—and accomplishing—the impossible—"the great cause of the world will go forward."

> *Dorothy Kunhardt, "A. Lincoln," in* The New York Times Book Review *(copyright © 1944 by The New York Times Company; reprinted by permission), November 12, 1944, p. 20.*

[In "**Abraham Lincoln's World**"] Genevieve Foster continues the same informal, vivid sort of historical chronicle which she developed so successfully in "**George Washington's World.**" It is a panorama of the events which happen during the years of one man's life, and gives a sense of the interweaving of history and the knowledge that the fortunes of each nation are important to other races and people far away. . . .

There is a clear pattern to the book, and every picture and anecdote has been chosen with care. Through all the narrative we follow the gaunt figure of Lincoln himself, railsplitter; lawyer; president, until he steps into the carriage that drove him to Ford's Theatre. . . . The book has an excellent index.

> *Frances C. Darling, "In Lincoln's Time," in* The Christian Science Monitor, *December 14, 1944, p. 10.*

AUGUSTUS CAESAR'S WORLD, A STORY OF IDEAS AND EVENTS FROM B.C. 44 to 14 A.D. (1947)

This book is more than a history of the Roman world. It contains accounts of life among the wild Germanic tribes, of life in Persia, India and China, in Britain and in the Western Hemisphere. These, in addition to maps and charts, give the book an unusual inclusiveness. (p. 5)

> *Ralph Adams Brown, "Living Past: 'Augustus Caesar's World'," in* The New York Times Book Review *(copyright © 1947 by The New York Times Company; reprinted by permission), November 16, 1947, pp. 4-5.*

Miss Foster's splendid history with its abundant line drawings, symbolical and historical, and many instructive maps, pictures the great Augustan Age and shows what the world was like under Roman law. The canvas is a large one but it is skillfully covered. What people thought and believed, what reforms Augustus instituted, what great buildings he inspired, have a place in a book which introduces also the arresting figures who lived under his rule, Cicero, Vergil, Hillel, the famous rabbi in Jerusalem, the Boy of Nazareth. It makes fascinating reading for any age. (pp. 46-7)

> *Alice M. Jordan, in a review of "Augustus Caesar's World," in* The Horn Book Magazine *(copyrighted, 1948, renewed 1975, by The Horn Book, Inc., Boston), Vol. XXIV, No. 1, January-February, 1948, pp. 46-7.*

Augustus was eighteen years old when, in 44 B.C., his uncle Julius Caesar was murdered. The next half century was to see world-shaking events. The boy Augustus became Emperor, ruler of the Western world. Significant changes took place in ways of living and of thinking. In a manger in Bethlehem was born a child who was to affect the whole course of world history. Miss Foster . . . has told in interesting detail the story of this complex period, so filled with unusual personalities.

In her story we can learn how people traveled, what food they ate, the clothes they wore, their thoughts, their faiths, the laws by which they were governed—all the aspects of life as it was lived two thousand years ago. Nor is it only the Roman world that is reviewed. China, India, Britain, Germany, France, and the Americas—civilization in all of these is weighed and considered. But it is the personalities that will stand out to young readers. . . . [They] parade across these pages, often in brief but always in unforgettable characterizations. The maps, charts, and drawings are careful in design, generous in quantity, suggestive in character. This is, in every way, a beautiful and valuable book. It is a book to own, to "grow up with." (p. 32)

> *Mary Gould Davis, "Important People," in* The Saturday Review of Literature *(© 1948, renewed 1976, Saturday Review Magazine Co.; reprinted by permission), Vol. XXXI, No. 7, February 14, 1948, pp. 32-3.**

"**Augustus Caesar's World 44 B.C. to A.D. 14**" becomes seething with significant events and intrigue when described and pictured by the modern historian, Genevieve Foster. . . .

[Her] verbal and pictorial method of presenting the glories and infamies of the past is such a dramatic and effective one that this reader wishes that future historians would follow her pattern. Her book can be enthusiastically recommended for classroom and home use.

> *Harriet Ford Griswold, "Of Old Roman Days," in* The Christian Science Monitor *(reprinted by permission from* The Christian Science Monitor; *© 1948, renewed 1975, The Christian Science Publishing Society; all rights reserved), April 29, 1948, p. 17.*

GEORGE WASHINGTON (1949)

Mrs. Foster's distinguished writing has again enriched our historical literature for children. No ordinary skill could create in such a brief volume, in such simple language, a thrilling new biography of George Washington. Scores of books about him are, of course, available for the various age groups. Yet this one fills a marked need and recognizes an important audience.

It is addressed to children old enough to read genuine biography, but too young for the author's much longer "**George Washington's World.**" Let it be recorded, to the immense credit of Genevieve Foster, that the intelligence of these younger

From Augustus Caesar's World: A Story of Ideas and Events from B.C. 44 to 14 A.D., *written and illustrated by Genevieve Foster. Charles Scribner's Sons, 1947. Copyright, 1947, by Genevieve Foster. Reproduced by permission of Joanna Foster.*

readers (of 8 to 12) has been respected. The story of Washington's life is told with finished style, keen historical judgment and absorbing drama. It is not rewritten from the earlier work but is a wholly new **"Initial Biography"** which will find its own permanent place. The book's design is in full accord with its value and interest.

> *Irene Smith, "The Story of Washington," in* The New York Times Book Review *(copyright © 1949 by The New York Times Company; reprinted by permission), August 14, 1949, p. 18.*

Story of Washington's entire life, told simply and briefly for young readers. Historical background and customs are so cleverly woven into the story that the colonial period of our history becomes very real. Excellent format and beautiful illustrations should make this the most popular life of Washington for ten- and 11-year-old readers as well as providing a valuable aid for introductory material in social studies. Authentic. Recommended.

> *Harriet Morrison, in a review of, "George Washington," in* Library Journal *(reprinted from* Library Journal, *September 1, 1949; published by R. R. Bowker Co. (a Xerox company); copyright © 1949 by Xerox Corporation), Vol. 74, No. 15, September 1, 1949, p. 1207.*

This author is well known for three remarkable books for young people: **"George Washington's World," "Abraham Lincoln's World"** and **"Augustus Caesar's World."** . . .

Now she has done another brilliant job: told the whole story of Washington in a biography brief yet dignified, easy reading yet fully informative. Intended for younger children yet of interest to any one. She makes his childhood and youth particularly vivid, gives intelligent short summaries of the French and Indian wars and the Revolution, covers the laying out of Washington, which George always called "Federal City," and leaves us with a remarkably rich sense of this great man in spite of the few pages. Her charming pictures include many interesting details, especially the double-page spreads of Mount Vernon. Any one who is to visit that historic shrine for the first time could do no better than to remind himself of its past with this little book. Chiefly, however, it fulfills its aim as an "initial biography" for young readers.

> *Louise S. Bechtel, in a review of "George Washington," in* New York Herald Tribune Book Review, *November 6, 1949, p. 16.*

An expert biography that manages, with a minimum of fictionalization, to be stirring and authoritative reading for seven- to ten-year-olds. Washington's boyhood and youth are so felicitously handled that by the time the young reader arrives at the skillfully telescoped sections dealing with the Revolution and the military campaigns, the first President has already become a definite personality, rather than the usual hallowed prig. (pp. 184-85)

> *Katharine T. Kinkead, in a review of "George Washington," in* The New Yorker *(© 1949, 1977 by The New Yorker Magazine, Inc.), Vol. XXV, No. 41, December 3, 1949, pp. 184-85.*

ABRAHAM LINCOLN (1950)

A beautiful and simple biography . . . with an artistic and compact format. Avoiding sentimental clichés, the author tells the story with a sincere and quiet pleasure in the telling. There is an easy informality of style without leaning too heavily on regional speech. . . . Each two-color illustration by the author has a rugged solidity and vibrant charm beautifully adapted to the subject.

> *A review of "Abraham Lincoln," in* Virginia Kirkus' Bookshop Service, *Vol. XVIII, No. 17, September 1, 1950, p. 516.*

The wide acclaim won by Genevieve Foster's Initial Biography, **"George Washington,"** is further justified by the excellence of this volume on Lincoln. Here again is the prose style that makes easy reading for younger children, and the sense of humanity which reaches and satisfies older readers. Many a biography three times as long reveals less truth and understanding of Lincoln.

This is the great American story, told by a master of its entire historical background. Proof of her mastery is to be found in her much longer work, **"Abraham Lincoln's World."** The need for these briefer but equally serious biographies assures a grateful response from librarians, teachers, and children.

> *Irene Smith, "Portrait of Lincoln," in* The New York Times Book Review *(copyright © 1950 by The New*

York Times Company; reprinted by permission), September 3, 1950, p. 13.

[In] the same simple, direct style [as **"George Washington,"**] with eloquent illustrations playing the same important role, she tells here the life of another President, Lincoln, whose story, so often given, never fails to thrill and move all of us. Readers of Mrs. Foster's larger work, **"Abraham Lincoln's World,"** are well aware of her mastery of her subject. In this little book she makes the great story shine for readers, young and old, in a smaller but equally brilliant setting.

> *Polly Goodwin, in a review of "Abraham Lincoln," in* Chicago Tribune *(© 1950 Chicago Tribune), October 1, 1950, p. 12.*

The appeal here, for eight to ten year olds, is instantaneous, for this baby is born where there might be bears or Indians. Soon we see little Abe . . . beginning to learn to read, but mostly sharing the hard work of a pioneer life. How he grew up, his various homes and jobs, the surprising way he became a lawyer and entered politics, all is told with a warmth and richness of detail surprisingly possible on such brief pages. The summaries of the Civil War also are well done, in their concise choice of the vital points. And the quotations chosen are those we want every American child to remember.

The decorative pictures in two colors add to the appeal of a well conceived, distinguished little book.

> *Margaret C. Scoggin, in a review of "Abraham Lincoln," in* New York Herald Tribune Book Review, *November 12, 1950, p. 20.*

ANDREW JACKSON (1951)

In these younger biographies the author always manages a firm, light tone, without those deadly excursions into the archives which discourage many young readers of biography. The narrative is centered around brief, important events in the life of the red-thatched adventurer and Man of the People, yet the sense of time and history is skillfully evolved through unobtrusive details of speech and background. . . . Beautifully illustrated in whirling, joyous line by the author, and the blue-inked typography is a welcome complement to the blue and orange colors of the double-spread pictures.

> *A review of "Andrew Jackson," in* Virginia Kirkus' Bookshop Service, *Vol. XIX, No. 20, October 15, 1951, p. 618.*

Young readers will be charmed at once by finding Jackson, a poor farm boy, chosen "public reader" at nine years old, to read the Declaration of Independence aloud to the Wraxhaw settlement. Soon after Andy and one of his brothers were imprisoned by the British. The rest of his life continues this exciting beginning, the author choosing her details well, both for historic importance and to interest younger children. She divides the stages of Jackson's career by pictures or picture maps on double pages. They add much to the lively feeling of Jackson as one knowing well and caring about a great part of his country. The book covers a period and a hero seldom before made vivid for this age reader.

> *Louise S. Bechtel, "A Pageant of American Heroes in Fine Biographies for All Ages," in* New York

Herald Tribune Book Review, *Part II, November 11, 1951, p. 3.**

Mrs. Foster has captured much of the romance and excitement of Jackson's life. . . . The sentence structure often violates all rules and the casual conversation between Jackson and various individuals is created at will by the author. Young readers won't mind this, however, for the book provides abundant excitement.

> *Marian Rayburn Brown, "For Ages 9-12, Big Men and Big Events in History: Colorful President," in* The New York Times Book Review, *Part II (copyright © 1951 by The New York Times Company; reprinted by permission), November 11, 1951, p. 36.*

Though written in a rather pepped-up style, in an attempt to convey its subject's intensity of feeling and informality of manner, this is a superior biography for eight- to twelve-year-olds, soundly factual yet lively, giving the reader a sense of nearness to the times and setting forth both the strengths and the weaknesses of Jackson's personality.

> *Katharine T. Kinkead, in a review of "Andrew Jackson," in* The New Yorker *(© 1951, 1979 by The New Yorker Magazine, Inc.), Vol. XXVII, No. 42, December 1, 1951, p. 185.*

[This] gives a warm and intimate picture of Jackson. . . . Some readers may wonder at the author's complete omission of any mention of Lafitte in the account of the Battle of New Orleans. Otherwise the story is well told and will be read with equal interest by elementary and secondary school readers.

> *A review of "Andrew Jackson," in* Bulletin of the Children's Book Center *(reprinted by permission of The University of Chicago Press), Vol. 5, No. 6, February, 1952, p. 44.*

BIRTHDAYS OF FREEDOM: AMERICA'S HERITAGE FROM THE ANCIENT WORLD (1952)

"The idea of freedom lives on forever in the minds of men." It has never died. But, thru the ages and thruout the world it has been lost and reborn many times. To trace the rise and fall of this precious possession, which Americans have taken for granted since their own Birthday of Freedom in 1776, was the author's aim in writing this remarkable book. . . .

Step by step the author takes the reader from early man's discovery of fire and the free choice it held for good or bad thru the fall of the Roman Empire to the barbarians in 476 A.D., when freedom ended for the ancient world. Supplementing the text are stunning illustrations, maps, and a brilliantly conceived two-page chart which follows the River of Time from 4236 B.C., the earliest date on the Egyptian calendar, to 1776.

Along its course appear the old civilizations, nations and empires set in their proper periods, the barbarian peoples who overran them, the great leaders and teachers. Sargon of Sumer, Hammurabi of Babylon, Ikhnaton of Egypt. Moses and David and Jesus of Nazareth. Buddha, Laotze, and Confucius. Darius and Zoroaster of Persia. The Greek philosophers and the Roman emperors.

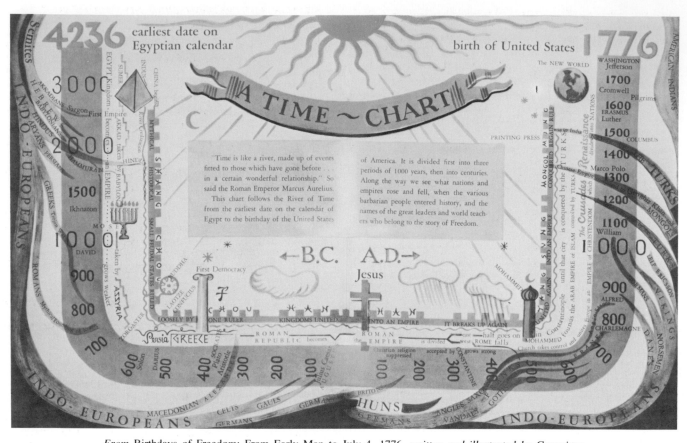

From Birthdays of Freedom: From Early Man to July 4, 1776, *written and illustrated by Genevieve Foster. Charles Scribner's Sons, 1973. Copyright © 1952, 1957, 1973 Genevieve Foster. Reprinted with permission of Charles Scribner's Sons.*

This is a tremendous sweep of history to encompass in 60 pages. It is a tribute to Mrs. Foster's genius for selection and for relating world movements to one another so that they make history understandable to young people that she succeeds so well.

> Polly Goodwin, "The Rise and Fall of Freedom,"
> in Chicago Tribune (© 1952, renewed 1980, Chicago Tribune), December 7, 1952, p. 40.

The page layouts are unfortunately over-elaborate and confusing. The text is printed in three different type sizes ranging from extra-large, caption size to extremely small size. On some pages the large type captions are an integral part of the text and must be read in proper sequence in order for the text to make sense. On other pages the captions bear little relation to the accompanying text. The author has done an interesting job of selecting examples of progress from the many events that took place between the days of early Egypt and the fall of Rome. However, space limitations have made it impossible for her to elaborate on single events, with the result that the reader needs a good background in world history to be able to follow the text and relate the individual events to the overall idea of man's growth toward freedom. The material is well-written and interesting but the book will be limited, because of the confusing format and difficult style, to use by high school students or by teachers in the elementary grades who would interpret it for their students.

> A review of "Birthdays of Freedom: America's Heritage from the Ancient World," in Bulletin of the Children's Book Center (reprinted by permission of The University of Chicago Press), Vol. 6, No. 6, February, 1953, p. 44.

It must have been a tremendous task to decide what to highlight in so brief a space and then to present each significant event in its relation to others as Mrs. Foster does. Obviously much creative thought has gone into the text, the illustrations and the strikingly designed pages. And creative thought should go into the use of the book if it is to be thoroughly appreciated. It is not a book to be taken hastily but rather one to be shared by adults and children as a background for discussion of the many ideas it contains.

> Jennie D. Lindquist, in a review of "Birthdays of Freedom," in The Horn Book Magazine (copyrighted, 1953, renewed 1981, by The Horn Book, Inc., Boston), Vol. XXXIX, No. 1, February, 1953, p. 60.

Mrs. Foster tells this story in pictures as well as in words. The double-page chart that shows the "River of Time" from the earliest Egyptian records to the American Declaration of Independence is worthy of long study by adults as well as by the children. On every page Mrs. Foster pictures the men who led their people out of slavery into freedom and who believed in the dignity and worth of individual man. . . . It is by pictures

that she brings out the progress of democracy through Greece and the Fall of Rome to Philadelphia in the New World 1,300 years later, where the Liberty Bell rang out a new freedom. It is a book that has value for a very varied age, from the children who learn largely through pictures to the mature mind that will find much of it a challenge. (pp. 62-3)

> *Merrit P. Allen, "Heroes: 'Birthdays of Freedom',"*
> *in* The Saturday Review, *New York, Vol. XXXVI,*
> *No. 7, February 14, 1953, pp. 62-3.*

Told with restraint, dignity, and deep reverence, the isolated historical events seem to fuse into a natural, living whole which will fire the pride and imagination of children as a matter-of-fact textbook may never do. Illustrations by the author, lavishly spread out on every page, are in perfect harmony with the text. The whole forms a distinguished book for children.

> *A review of "Birthdays of Freedom: America's Her-*
> *itage from the Ancient World,"* in The United States
> Quarterly Book Review *(reprinted by permission of*
> *Rutgers University Press for the Library of Congress,*
> *Washington, D.C.), Vol. 9, No. 1, March, 1953, p.*
> *42.*

THEODORE ROOSEVELT, AN INITIAL BIOGRAPHY (1954)

[*Theodore Roosevelt*] is a competent, companionable introduction to the beloved rough rider,—a straight run-through from the boy as an asthmatic seven year old, challenged with the importance of hardening himself, until at fifty five, he had weathered the storms of fortune and become a robust South American explorer. The incidents of his life take on firm vitality and the facets of a turbulent political career are set in firm relief against the balance of an eventful life.

> *A review of "Theodore Roosevelt," in* Virginia Kir-
> kus' Bookshop Service, *Vol. XXII, No. 10, May 15,*
> *1954, p. 312.*

Mrs. Foster gives a remarkably well-rounded picture of this dynamic, many faceted American patriot; as a child, as a western rancher, politician and statesman, traveler and explorer—and especially as a wonderful husband and father. Her own attractive drawings add interest for young readers.

> *Polly Goodwin, "T. R.'s Story," in* Chicago Tribune
> *(© 1954, renewed 1982, Chicago Tribune), June 6,*
> *1954, p. 5.*

The adventurousness and ebullience of Theodore Roosevelt make a lively, enjoyable story. He was a frail, delicate boy, determined to grow into a healthy man. His dynamic energies made him a military hero, public leader, President, big game hunter and world figure. But the reader of this brief, uncomplicated biography will remember T. R. most vividly as a devoted father, the center always of a warm, fascinating family.

Genevieve Foster has created a worth-while volume, one that gives children the essential characterization of a famous leader in terms both easily understood and meaningful.

> *Irene Smith, "T. R.," in* The New York Times Book
> Review *(copyright © 1954 by The New York Times*
> *Company; reprinted by permission), July 11, 1954,*
> *p. 20.*

BIRTHDAYS OF FREEDOM: FROM THE FALL OF ROME TO JULY 4, 1776, BOOK TWO (1957)

Genevieve Foster's **"Birthdays of Freedom,"** like the first book of the same name dealing with the same subject in ancient times, is for everybody, for schools and homes. Because of its attractive format, each page wreathed with decorative pictures in rosy red and greenish gold, it can be enjoyed by quite young children, by those who just want to dip into the past as well as by those over eleven who have a real interest in history.

Here are the highlights of medieval and early modern history that affect the growth of liberty, the German tribes, the Arabs, Charlemagne, feudalism, the church of the Middle Ages, the Reformation on the continent and in England, the ferment of ideas from the thirteenth to the sixteenth centuries and such "birthdays of freedom" as Magna Carta, the revolt of William the Silent, Lord Calvert's declaration of religious freedom in Maryland, and this one we celebrate this week. Mrs. Foster has found a fresh approach to these thousand years of history, half chart, half picture-history, unified by tracing the growth of democracy.

> *Margaret Sherwood Libby, in a review of "Birthdays*
> *of Freedom: Book II," in* New York Herald Tribune
> Book Review *(© I.H.T. Corporation; reprinted by*
> *permission), June 30, 1957, p. 8.*

As striking in format, as exciting in subject matter, as creative in its approach to history as Book I of **"Birthdays of Freedom,"** Book II now makes its welcome appearance. . . .

Briefly—but vividly—the author outlines and relates one to the other the shifting periods and movements of history, marking men and events which have influenced the course of freedom. . . As in the first volume, decorative illustrations, lavishly used, are an important part of this distinguished book.

> *Polly Goodwin, in a review of "Birthdays of Free-*
> *dom, Book II," in* Chicago Tribune *(© 1957 Chicago*
> *Tribune), August 18, 1957, p. 7.*

[Book One] traced the course of freedom from the time when man learned to use fire to the Fall of Rome. This begins "on that small remote Roman colony of Britain and brings us thirteen centuries later to the shores of the new United States of America." It does not, however, confine itself to the history of Britain but covers also related events in other parts of the world. Although Mrs. Foster has done all this in a mere sixty-four pages she has nevertheless succeeded—through concise text and many illustrations—in giving children some idea of man's growth in the search for democracy. In most cases children will depend on adults to use the book with them, and one could make an interesting reading list of historical stories to help point up the high lights along the way.

> *Jennie D. Lindquist, in a review of "Birthdays of*
> *Freedom: Book Two," in* The Horn Book Magazine
> *(copyrighted, 1957, by The Horn Book, Inc., Bos-*
> *ton), Vol. XXXIII, No. 5, October, 1957, p. 410.*

The book presupposes an interest in history and sufficient background to enable the reader to cope with the rather fragmentary style in which the material is presented. However, in the hands of a skillful adult it can be used to stimulate interest and to lead to fuller accounts of the events included. The pictures are informative as well as decorative and add greatly to the book's

appeal. Readers from 10 to 14 will find much here to enliven their study of history, though the reference value of both books is limited by lack of index and table of contents.

> *Elizabeth Hodges, "For 9-12, Men and Events of the World's Past: Milestones," in* The New York Times Book Review *(copyright © 1957 by The New York Times Company; reprinted by permission), November 17, 1957, p. 40.*

As in the first book, the high spots only are touched, and there are frequent over-simplifications that could prove misleading for readers who do not already possess a sound background of knowledge of the events.

> *Zena Sutherland, in a review of "Birthdays of Freedom: From the Fall of Rome to July 4, 1776," in* Bulletin of the Children's Book Center *(reprinted by permission of The University of Chicago Press), Vol. 11, No. 7, March, 1958, p. 69.*

THE WORLD OF CAPTAIN JOHN SMITH, 1580-1631 (1959)

Here, the world into which John Smith was born is described in fascinating detail. There are but brief references to Smith through his childhood years, and the author stresses the events of the Elizabethan world; there is an increasing amount of material about him as the book progresses, and the scene broadens to include events in America as well as in England and on the continent. Impressive in scope and execution, this is fascinating to read and, as with the other Foster books, unusual in the way the historical material is synthesized. The index increases the value of the book.

> *Zena Sutherland, in a review of "The World of Captain John Smith: 1580-1631," in* Bulletin of the Center for Children's Books *(reprinted by permission of The University of Chicago Press), Vol. 13, No. 5, January, 1960, pp. 80-1.*

Like **"George Washington's World"** and its successors, Genevieve Foster's new book is a beautifully planned portrait of a man and his era. "A slice of history" she calls it, "measured by the lifetime of John Smith" and a generous, plummy slice it is. During that half-century, 1580 to 1631, man's world expanded enormously, culturally as well as geographically. The first two permanent English colonies were established in North America, due in great part to the doughty John Smith; Canada was founded; the Thirty Years War began; Shakespeare wrote his plays; grand opera was originated; Galileo discovered new planets. Young people often learn of these events in bits and pieces; it is Mrs. Foster's special contribution that she brings them all together and introduces also lesser-known events which had far-reaching effects, such as the rise of the Romanoffs in Russia, the briefly opened door of Japan; the Manchu seizure of China.

Straight down those mighty years goes Mrs. Foster, shuttling from continent to continent, integrating these and many other events to give the reader a sense of the continuity and the unity of history.

> *Ellen Lewis Buell, "Half-Century of History," in* The New York Times Book Review *(copyright © 1960 by The New York Times Company; reprinted by permission), January 24, 1960, p. 38.*

Reading ["**The World of Captain John Smith, 1580-1631**"] we are lost in admiration at the skill with which the complexities of world history in a brilliant era are woven together with plenty of colorful detail yet without any sense of mere dull recounting of "facts." Here are the brilliant, devious policies of Queen Elizabeth dueling with Philip, the war of the three Henrys in France and the Thirty Year War, Akbar in India, Boris Godunov in Russia. Here are Spenser and Shakespeare, Bacon and Tycho Brahe, Galileo and the first violins, Velasquez and Drake, Raleigh and the first colonies of the New World. At first we are startled at having John Smith the figure around which all this turned. He hardly seemed at the stature of Augustus, Washington or Lincoln, Mrs. Foster's other fixed stars, but as we read we realize what a perfect thread his life (as he reported it at any rate) was on which to string these many-faceted beads and help young Americans, woefully lacking in the European background of their history, to a broader understanding of the great movements in history.

> *Margaret Sherwood Libby, in a review of "The World of Captain John Smith, 1580-1631," in* New York Herald Tribune Book Review *(© I.H.T. Corporation; reprinted by permission), February 7, 1960, p. 9.*

No writer for young people today can bring history as excitingly alive as Genevieve Foster. Not content to concentrate on one aspect of it at a time, she takes on the whole world. To her three previous "world" books she now adds a magnificent fourth, which she calls a "slice of history measured by the lifetime of Captain John Smith". . . . And what a rich slice it is, covering a period of tremendous intellectual growth and geographical expansion. . . .

Brilliantly organized, written in lively style, and generously illustrated by the author, this handsome book belongs in every home library.

> *Polly Goodwin, in a review of "The World of Captain John Smith," in* Chicago Tribune *(© 1960 Chicago Tribune), February 14, 1960, p. 9.*

THE WORLD OF COLUMBUS AND SONS (1965)

The new book in the remarkable series of "horizontal views of history" by Genevieve Foster is most stimulating. She has attempted the astounding task of describing events in Europe, Asia, Africa and the Americas during the 88-year period from the birth of Columbus in 1451 until the death of his son Ferdinand in 1539—not only the European explorations but the Golden Horde, African kingdoms, Aldus Manutius in Venice and William Caxton in England. . . .

Mrs. Foster seems to be triumphantly successful on the whole in her use of the interrelationships of outstanding personalities as connecting threads of the narrative, although there are places where her interest in dynastic complexities entices her into giving rather more details of royal interrelationships than most young readers can take (especially in her treatment of the Wars of the Roses and of Ferdinand and Isabella's descendants in Spain).

It is hard to see how all this could have been told more effectively or more dramatically and clearly for those without any historical background.

"*A Wide Swath of History,*" in Book Week—The Sunday Herald Tribune (© 1965, The Washington Post), May 9, 1965, p. 20.

[Genevieve Foster] here gives a skillful survey of Columbus' world which is entertaining and useful. Memorable episodes—Luther's defiance at Worms, Savonarola on the scaffold—are superbly woven together and offset the complexities of court intrigue which might overwhelm the reader.

Regrettably, Columbus himself is somewhat obscured in the panoply of events. His death occurs when nearly a fourth of the book remains, preventing his full realization as a multi-dimensional figure—dignified and stubbornly persistent, yet mystical, vain, bungling and incredibly cruel. The book is a colorful panorama of European society poised at the brink of those fateful voyages of discovery signaling "the expansion of Europe" onto a New World frontier.

William J. Jacobs, in a review of "The World of Columbus and Sons," in The New York Times Book Review *(copyright © 1965 by The New York Times Company; reprinted by permission), June 27, 1965, p. 26.*

The extraordinary assemblage of people who influenced [the years from 1451 to 1539] is shown in a series of dramatic accounts, and as each brief story ends, the reader wishes to know more. This is not an easy presentation of history; although the fitting together of the pieces is skillfully done, following the pattern demands attention, while it constantly inspires interest. Teachers who have not combined the use of Mrs. Foster's parallel treatments of history with the more conventional books have missed an unusual opportunity to bring history to life.

Ruth Hill Viguers, in a review of "The World of Columbus and Sons," in The Horn Book Magazine *(copyright © 1965, by The Horn Book, Inc., Boston), Vol. XLI, No. 4, August, 1965, p. 400.*

The author gives, in vignettes of varying length and unvarying brilliance, a series of concentrated and detailed episodes that give a broad picture of the important events and people of those complicated years. The result is a sort of tapestry in prose: a huge canvas in which one can see only a few details at a time or can see the whole intricate effect of the total. Wonderfully lively and informative. An extensive index is appended.

Zena Sutherland, in a review of "The World of Columbus and Sons," in Bulletin of the Center for Children's Books *(reprinted by permission of The University of Chicago Press; copyright 1965 by The University of Chicago), Vol. 19, No. 1, September, 1965, p. 8.*

With her usual careful research, thoughtful interpretation, colorful writing, and effective illustration [Foster] presents personalities and events throughout the world during this important period showing their interaction and revealing their contributions or effect on civilization. A stimulating and eminently readable history.

"*History, Geography, Travel, Social Life and Customs: 'The World of Columbus and Sons','*" in Books for Children: 1960-1965 *(copyright © 1960, 1961, 1962, 1963, 1964, 1965 by The American Library*

Association), American Library Association, 1966, p. 168.

YEAR OF COLUMBUS, 1492 (1969)

As young readers will discover in this well written overview, 1492 was notable, not for Columbus' achievement alone, but for being part of a period in which considerable progress was made by countries undergoing, or being influenced by, the Renaissance. The impetus to travel and exploration was one aspect of this cultural, intellectual, and geographical reaching out. Mrs. Foster presents the discovery of America in this context—not as the isolated incident which is circled in red on every schoolroom calendar, but as the outgrowth of many interacting people, ideas, and influences. In a manner calculated to whet the reading appetites of middle graders, she also includes a bird's-eye view of artists and scientists of the Renaissance period (Copernicus, da Vinci, and Michelangelo), and interesting tidbits about the contemporary, highly developed civilizations of China, Japan, the Incas, and the Aztecs. Illustrations are plentiful, and include carefully researched maps and charts. Wider in scope than most books bearing on the subject for this age group (e.g., Dalgliesh's more straightforwardly biographical *The Columbus Story*, Scribners, 1955), this is for children too young for the author's excellent, longer and more difficult **The World of Columbus and Sons**. . . .

Pat Byars, in a review of "Year of Columbus, 1492," in School Library Journal, *an appendix to* Library Journal *(reprinted from the March, 1970 issue of* School Library Journal, *published by R. R. Bowker Co./A Xerox Corporation; copyright © 1970), Vol. 16, No. 7, March, 1970, p. 128.*

YEAR OF THE PILGRIMS, 1620 (1969)

In regard to the Pilgrim story particularly, this [horizontal approach to history] is helpful for American children, who have likely heard the tale out of context ever since they can remember. So, in addition to discussing the *Mayflower*, beliefs of the Puritans, and such people as Brewster, Bradford, Massasoit, and Squanto, the author talks about the Thirty Years' War, Grotius, Shakespeare, Rembrandt, Harvey, Galileo, and rulers and happenings in Africa, India, China, and Japan. The text is written simply, but is not oversimplified; maps, diagrams, and pictures accompany it. The book is good for either reference or pleasure reading and will therefore have the same wide appeal.

Carolyn K. Jenks, in a review of "Year of the Pilgrims, 1620," in School Library Journal, *an appendix to* Library Journal *(reprinted from the May, 1970 issue of* School Library Journal, *published by R. R. Bowker Co./A Xerox Corporation; copyright © 1970), Vol. 16, No. 9, May, 1970, p. 72.*

YEAR OF INDEPENDENCE, 1776 (1970)

Of what use the Declaration of Independence and the Revolution simplified to the point of distortion (in a scant seventeen pages of printed matter) in conjunction with profiles of Montgolfier, Lavoisier, Voltaire and Mozart . . . and with accounts of Cook's voyages, introducing King Kamehameha in Hawaii, of Father Junipero in California and Emperor Ch'ien Lung in China (the last third, intended to represent developments

"Around the World"). Of the Declaration one hears that Jefferson "had worked hard on it for two weeks. He had done his best. What fault would they find with it today?" One does not learn what fault they found, nor why approval was granted "today," July 4th. Similarly, the French alliance eventuates from the wearing down of Louis XVI with "so many reasons" (none specified) that he "finally gave in," when the very least an ostensible world view should take in are Spain and Saratoga. In this case, even more than in *The Year of Columbus* and *The Year of the Pilgrims* . . . , a dilution of the familiar ill accords with attention to the obscure.

> *A review of "1776: Year of Independence," in* Kirkus Reviews *(copyright © 1970 The Kirkus Service, Inc.), Vol. XXXVIII, No. 6, March 15, 1970, p. 324.*

YEAR OF LINCOLN, 1861 (1970)

The problem of reconciling reach and grasp, fundamental to the [*Years*] series, is complicated by the increasing complexity of events in the mid-19th century and their tenuous relation to one another; the steps leading to the American Civil War do not lead on to Victoria in England or Tzu Hsi's misrule of China or the Meiji transformation of Japan (not initially the doing of the fifteen-year-old Emperor credited here). Even the detailed reprise of the extension-of-slavery issue sandwiched between Lincoln's departure from Springfield and his arrival in Washington . . . is a lot to ask children to absorb in ten pages. Differently confounding is the sanguine view of British imperialism: "But whatever land England acquired, another nation or tribe of people had to lose. That is the way, since the beginning of history, all empires have been created." This is not the whole truth (neither, incidentally, is the profile of Frederick Douglass) but it's what comes of making too little of too much.

> *A review of "Year of Lincoln: 1861," in* Kirkus Reviews *(copyright © 1970 The Kirkus Service, Inc.), Vol. XXXVIII, No. 20, October 15, 1970, p. 1153.*

[Although this book gives] some information about other events and people during a segment of history, it has neither the breadth of coverage nor the format that showed simultaneous events. This is, rather, a description of the Civil War, with some background and a brief focus on 1861; it moves from 1830 to 1865. The second part of the book deals separately with contemporary figures: Darwin, Twain, Douglass, Dickens, Queen Victoria, the Empress Tzu Hsi, and the Emperor Mutsuhito; again, the span for these quick historical sketches embraces but does not focus on the title year. Useful but not unusual in the coverage of American history; the second half of the book has some interesting material, but each section seems isolated.

> *Zena Sutherland, in a review of "Year of Lincoln: 1861," in* Bulletin of the Center for Children's Books *(reprinted by permission of The University of Chicago Press; © 1971 by The University of Chicago), Vol. 25, No. 3, November, 1971, p. 42.*

THE WORLD OF WILLIAM PENN (1973)

Introducing: young William Penn (described by Samuel Pepys as "a most modish person"), the "Merry Monarch" Charles II the Sun King, Sir Isaac Newton, Shah Jahan and his con-

quering son Aurangzeb, Peter the Great and the Manchu Emperor K'ang-Hsi—all contemporaries in the world of the late 17th-century. Foster draws her leading characters with a few bold stokes, and her precise, amateurish drawings of people, floor plans and family trees will be the envy of any notebook-keeping fourth grader. This method often borders on caricature. . . . Still, the popularity of previous *Worlds* shows that despite generous simplifications, these "horizontal histories" manage to combine an international perspective seldom gained from primary school texts with entertaining glimpses of historical personalities, scaled to a child's eye view.

> *A review of "The World of William Penn," in* Kirkus Reviews *(copyright © 1973 The Kirkus Service, Inc.), Vol. XLI, No. 7, April 1, 1973, p. 389.*

The clear textual treatment brings to life the backgrounds and activities of the second half of the seventeenth and the first quarter of the eighteenth century—in the arts and sciences, and in war and peace. Portraits, scenes, diagrams, and pictorial maps clarify and enliven the text. The broad compass of the book permits paths to cross, as when William Penn meets with Peter the Great. An enlightened approach to the study of world history.

> *Virginia Haviland, in a review of "The World of William Penn," in* The Horn Book Magazine *(copy-*

From The World of William Penn, *written and illustrated by Genevieve Foster. Charles Scribner's Sons, 1973. Copyright © 1973 Genevieve Foster. Reprinted with permission of Charles Scribner's Sons.*

right © 1973 by The Horn Book, Inc., Boston), Vol. XLIX, No. 4, August, 1973, p. 389.

The familiar story of William Penn and his colony is here smoothly interwoven with other events of his time. . . . The account is smoothly written, and has a plentiful number of charts, maps, and sketches. Although the text is briefer and less comprehensive than the other titles in this series and Penn is covered in many other sources, this will supply good supplementary material on the period.

Elizabeth Gillis, in a review of "The World of William Penn," in School Library Journal, *an appendix to* Library Journal *(reprinted from the September, 1973 issue of* School Library Journal, *published by R. R. Bowker Co./A Xerox Corporation; copyright © 1973), Vol. 20, No. 1, September, 1973, p. 125.*

This is not a full biography, although the last pages summarize the events of Penn's declining years, but a broad view of happenings throughout the civilized world in the year in which he was most active as a Quaker and was establishing the settlements of Pennsylvania. Like other Foster books, this **"World"** moves, shuttle-fashion, from episodes in Penn's life to events in England and the Continent, the Far East and colonial America. Like the others, it is engrossing as a broad view of history; unlike the earlier books, it is not oversize and therefore a bit easier to handle.

Zena Sutherland, in a review of "The World of William Penn," in Bulletin of the Center for Children's Books *(reprinted by permission of The University of Chicago Press; © 1973 by The University of Chicago), Vol. 27, No. 3, November, 1973, p. 42.*

THE YEAR OF THE HORSELESS CARRIAGE, 1801 (1975)

Does the name Richard Trevithick mean anything to you? Well he's the inventor of the "horseless carriage" (actually the ancestor of the locomotive, not the automobile) and Foster places him in the forefront of her simultaneous history, up there with Napoleon, Jefferson, Toussaint L'Ouverture and Beethoven. Foster's narrative has both the charms and the drawbacks of the elementary school project notebook—hand-drawn maps and portraits that would be the envy of any fourth grader and an unfortunate tendency towards arbitrary lists. . . . Yet her choice of showcased individuals is not frivolous; all are related to the career of Napoleon—even Trevithick. . . . As always a highly dramatized lesson, but amusing and original.

A review of "The Year of the Horseless Carriage, 1801," in Kirkus Reviews *(copyright © 1975 The Kirkus Service, Inc.), Vol. XLIII, No. 10, May 15, 1975, p. 570.*

If you want to present history as relationships and in broad perspective, not as a series of facts, note **The Year of the Horseless Carriage**. . . .

The text has many facts and information. The lively style of presentation and the relationship between events and people make the story dynamic and vital. The short vignettes, that focus on key people, interrelate events (that constitute chapters), and provide sufficient information to sustain interest. Since the breadth is so broad, innumerable takeoff points for further investigation are apparent.

The uniqueness of this volume is its approach of dealing with events throughout the world during a specific time period. The result is a better feeling for the events and people of a time period by stressing interrelationships. This volume proves history can be fun, exciting, and alive.

John G. Herlihy, in a review of "The Year of the Horseless Carriage: 1801" (copyright © 1975 by the Instructor Publications, Inc.; reprinted by permission of the author), in Instructor, *Vol. LXXXV, No. 2, October, 1975, p. 192.*

While Richard Trevithick did indeed make his first run in a steam-propelled horseless carriage in 1801, the title of this book is somewhat of a misnomer, since the text actually covers the years 1801-1821. A chart that precedes the text shows events of importance in chosen years. . . . This across-the-board approach to history is, as it is in other Foster books, a stimulating one; the writing is direct and brisk, the illustrations interesting if not always informative.

Zena Sutherland, in a review of "The Year of the Horseless Carriage," in Bulletin of the Center for Children's Books *(reprinted by permission of The University of Chicago Press; © 1975 by The University of Chicago), Vol. 29, No. 3, November, 1975, p. 43.*

Rachel Isadora
1953(?)-

American author/illustrator and illustrator of fiction.

Isadora uses her experience as a performing artist and long-term New York City resident to create books with theatrical and urban backgrounds, fresh artistic styles, vital characters, historical and contemporary settings, and themes on the importance of individuality and mutual support. Her works are often praised for their dramatic illustrations, which convey emotion through body placement and facial expression and create moods through a variety of techniques and page designs. Isadora's books are also recognized for their multiethnic, nonsexist approach, showing both sexes and many cultures working and playing together.

At eleven, Isadora was a professional ballerina; she began drawing to relieve the tensions of her career, and developed her self-taught artistic talents into a new profession when she retired from dancing. Her first book, *Max*, is about a boy who discovers the usefulness of ballet as a preparation for baseball. Critics appreciate it for its graceful, humorous pictures and natural view of childhood. This is also a characteristic of *Willaby*, which successfully depicts a girl who loves to draw. Most critics say that the story and the pictures are sensitive and capture the child and the classroom atmosphere accurately. Perhaps Isadora's most noteworthy book is *Ben's Trumpet*, which shows a boy growing up in the Jazz Age with ambitions of becoming a trumpeter. This book exemplifies her dancer's feel for expressing movement and mood as she skillfully presents this era in a lively Art Deco style. Critics commend her vigorous black and white illustrations for bringing the sounds and bodies to life. They generally observe that Ben's character is well defined and that children will identify with the boy and his yearnings. Fairly new to children's literature, Isadora brings a unique and powerful illustrative style and varied cultural view which adds new dimensions to picture books for children. *Max* was an ALA Notable Book selection and a Classroom Choice of the International Reading Association in 1976; *Ben's Trumpet* was selected for the Boston Globe-Horn Book Honor in 1979 and was a Caldecott Honor Book selection in 1980.

(See also *Something about the Author*, Vol. 23.)

MAX (1976)

Baseballer Max, who walks his sister to her Saturday ballet lesson on his way to the park, stops in one morning and, before he leaves, has joined the little girls in their exercises. Not much of a story, but we like to think it's enough to hold together Isadora's drawings of poised but fetchingly unpolished ballerinas—and, at the end, Max's scruffy, disgruntled gang waiting for him at the ball park. As the pictures are the attention holders and Isadora never does show the whole class together, we wish we could follow individual dancers through the frames. (In one case the same girl seems to show up variously black and white and in short and long sleeves.) But that's a small frustration compared to the charm of the performers.

Courtesy of William Morrow & Company, Inc.

A review of "Max," in Kirkus Reviews *(copyright © 1976 The Kirkus Service, Inc.), Vol. XLIV, No. 14, July 15, 1976, p. 791.*

Rachel Isadora's debut as an author-illustrator calls for a 21-gun salute. . . . The pictures are an ebullient combination of grace and comedy, with the leggy students dipping and soaring, in contrast to Max in his uniform. The story is certainly one of the nicest examples of nonsexist fare in many a moon.

A review of "Max," in Publishers Weekly *(reprinted from the August 2, 1976 issue of* Publishers Weekly, *published by R. R. Bowker Company, a Xerox company; copyright © 1976 by Xerox Corporation), Vol. 210, No. 5, August 2, 1976, p. 114.*

The soft black-and-white pencil illustrations, framed in beige, are full of motion and life whether the scene is the barre or the ballfield. The message is clear—dance is for everyone—and the medium is warm and winning.

Amy Kellman, in a review of "Max," in School Library Journal *(reprinted from the December, 1977 issue of* School Library Journal, *published by R. R. Bowker Co./A Xerox Corporation; copyright © 1977), Vol. 24, No. 4, December, 1977, p. 35.*

[*Max*] is less successful at countering male sex stereotyping [than *King Nonn the Wiser*]. . . . This idea that traditionally 'female' arts—ballet, skipping etc—are acceptable for males but only as a warm-up for 'real' male activities—baseball, boxing etc—is reinforced by the fact that the baseball team is all male. This cop-out is a pity as Isadora's multi-racial black and white illustrations of young dancers are well executed. (p. 15)

> *Rosemary Stones, "Non-Sexist Males," in* Children's Book Bulletin, *No. 6, Summer, 1981, pp. 14-15.**

THE POTTERS' KITCHEN (1977)

The happy Potter family's busy country kitchen is an old-fashioned one, not only in the iron cook stove, wooden furniture, and ruffled valances that fill it but also, you'll note, in the division of labor that prevails. . . . [The mother and girls are in the kitchen and the father and boys are outside in the garden. When the family moves to a city apartment they make an] unusually quick adjustment, but the easygoing Potters might win over a hardened urbanite heart at that. And Isadora makes the drawings work expressively for the story—from the inviting old kitchen the Potters leave to the squashed, frenetic city neighborhood and the hollow-feeling apartment they enter. Let's just hope that the move exposes Samantha and Jonathan to some more flexible role models.

> *A review of "The Potters' Kitchen," in* Kirkus Reviews *(copyright © 1977 The Kirkus Service, Inc.), Vol. XLV, No. 4, February 15, 1977, p. 162.*

Though the somewhat pallid story may dispel moving fears, artist Isadora's knack for capturing children's actions, positions, and expressions . . . is what really gives the book its appeal. The black speckles and lines are enhanced with gold pencil splashes, while panoramic endpapers depicting the country kitchen add a homey touch. (pp. 1266-67)

> *Barbara Elleman, in a review of "The Potters' Kitchen," in* Booklist *(reprinted by permission of the American Library Association; copyright © 1977 by the American Library Association), Vol. 73, No. 16, April 15, 1977, pp. 1266-67.*

Isadora's drawings have a casual, rumpled look, with perspective observed primarily in the breach, lopsided buildings and furniture, and slightly scruffy characters. The book offers an antidote to the frequent anti-urban stories in which a family finds happiness by moving from city to country, and it demonstrates family affection and neighborliness, but it is weak in plot. . . .

> *Zena Sutherland, in a review of "The Potters' Kitchen," in* Bulletin of the Center for Children's Books *(reprinted by permission of The University of Chicago Press; © 1977 by The University of Chicago), Vol. 31, No. 1, September, 1977, p. 17.*

Isadora's gray-and-gold illustrations are as whimsical and appealing as those in *Max* . . . but her story falls short. While it may be of some small comfort to kids having to make similar adjustments, there just isn't much to it.

> *Helen Gregory, in a review of "The Potters' Kitchen," in* School Library Journal *(reprinted from the September, 1977 issue of* School Library Journal, *published by R. R. Bowker Co./A Xerox Corporation;*

copyright © 1977), Vol. 24, No. 1, September, 1977, p. 110.

WILLABY (1977)

[Isadora] infuses her stories and pictures with warmth and gentle humor, an unbeatable combination eminently present in this adventure of a small black scholar.

> *A review of "Willaby," in* Publishers Weekly *(reprinted from the June 27, 1977 issue of* Publishers Weekly, *published by R. R. Bowker Company, a Xerox company; copyright © 1977 by Xerox Corporation), Vol. 211, No. 26, June 27, 1977, p. 110.*

Like countless others who will recognize the syndrome, Willaby likes to draw and does so everywhere. . . . It's a disappointingly unimaginative treatment of a situation that promised more, and the last several pages (of close-ups and inactivity) drag. Still Willaby, an expressively sketched little black girl with three tiny tight braids, invites identification, and Isadora's easygoing drawings of the class—from above as they nap at their desks, in separate frames as they work on Miss Finney's get-well cards, or in action at recess—are as fetching as ever.

> *A review of "Willaby," in* Kirkus Reviews *(copyright © 1977 The Kirkus Service, Inc.), Vol. 45, No. 13, July 1, 1977, p. 667.*

[Isadora] brightens her black-and-white speckled art work with soft reds in Willaby's clothing and drawings. The uncoordinated stances and unlikely but natural positions of children are amusingly captured in this real-life reflection.

> *Barbara Elleman, in a review of "Willaby," in* Booklist *(reprinted by permission of the American Library Association; copyright © 1977 by the American Library Association), Vol. 74, No. 2, September 15, 1977, p. 195.*

Lighthearted charcoal sketches portray Willaby's predicament—of having a gift that is sometimes a blessing and sometimes an embarrassment—with humor and tenderness and provide an engaging view of a happy classroom setting.

> *Judith S. Kronick, in a review of "Willaby," in* School Library Journal *(reprinted from the October, 1977 issue of* School Library Journal, *published by R. R. Bowker Co./A Xerox Corporation; copyright © 1977), Vol. 24, No. 2, October, 1977, p. 104.*

Would that all teachers were as loving as this one who knows that a picture of a fire truck is as good as any "get well" card, even when it isn't signed. Miss Isadora has produced a touching as well as an integrated book—with black and white students, and an easy-to-read text to match warm pencil drawings.

> *David Anable, "Shirley Battles Pirates in Deep-Sea Daydreams," in* The Christian Science Monitor *(reprinted by permission from* The Christian Science Monitor; *© 1977 The Christian Science Publishing Society; all rights reserved), November 2, 1977, p. B2.**

A lovable and loving character, Willaby thoroughly enjoys her experiences as a first-grader. . . . [Her problem of sending an unsigned drawing as a get-well card] is satisfactorily and logically resolved through the combination of a simple, understated text and cleanly limned, expressive drawings. The use

When the other children are playing, Willaby is drawing.

From Willaby, *written and illustrated by Rachel Isadora. Macmillan Publishing Co., Inc., 1977. Reprinted with permission of Macmillan Publishing Company. Copyright © 1977 Rachel Isadora.*

of shifting perspective and varied page design conveys a sense of movement and vitality.

> *Mary M. Burns, in a review of "Willaby," in* The Horn Book Magazine *(copyright © 1978 by The Horn Book, Inc., Boston), Vol. LIV, No. 1, February, 1978, p. 35.*

BACKSTAGE (with Robert Maiorano, 1978)

Backstage at the ballet—a *Nutcracker* in preparation, to be specific, as revealed via little Olivia's progress from her father's car on [through a backdoor route to get her mother, who is a ballerina.]

Perhaps an appended floor plan would help to orient readers who've never heard the word proscenium or even orchestra pit; but anyone can enjoy the paper-moon magic of the property department, the workmen's nitty-gritty preparations on stage, the awesome view through the curtains of the empty house, and all the authentic rest. Isadora's inside views are refreshingly unglamorized, and her grave and skinny very young dancers are as fetching as those in *Max*. . . . Of course this is even less of a story.

> *A review of "Backstage," in* Kirkus Reviews *(copyright © 1978 The Kirkus Service, Inc.), Vol. XLVI, No. 3, February 1, 1978, p. 104.*

[An] informative and amusing insider's view of life backstage. . . . The brief text tells that Olivia's errand takes her where the "fly," "catwalk," "proscenium" and other things are. The authors can be thanked for being no more condescending to the young than Beatrix Potter, who trusted her readers to understand lovely words like "soporific." Here, the terms are perfectly understandable in Isadora's beautifully precise and humorous drawings of people, things and activities connected with preparations for the ballet.

> *A review of "Backstage," in* Publishers Weekly *(reprinted from the February 27, 1978 issue of Publishers Weekly, published by R. R. Bowker Company, a Xerox company; copyright © 1978 by Xerox*

Corporation), Vol. 213, No. 9, February 27, 1978, p. 157.

When I saw a pre-publication release on this title, I thought, "Ah, this is *the* book for all those kids who are just a bit too little for Krementz's *A Very Young Dancer*." Well, it isn't. . . . There is virtually no text, the information being given through a series of detailed, slightly grotesque, drawings. There is no sense either of the magic of the final production or the hard work involved in the creation of it. A disappointing book from two dancers.

> *Cynthia Herbert, in a review of "Backstage," in* Children's Book Review Service *(copyright © 1978 Children's Book Review Service Inc.), Vol. 6, No. 11, June, 1978, p. 102.*

There's really no story in this view of backstage life, but it has two strong appeals: the glamor of theater, and the idea—rare in books for children—of having a mother who is a ballet dancer. It also has two weaknesses: Olivia takes an improbable route when looking for her mother, and there is no explanation (as there is on the jacket flap) of the fact that a rehearsal of "Nutcracker" is going on. However, the long, circuitous route makes it possible for the pictures to reveal many aspects of the theater and the company. . . .

> *Zena Sutherland, in a review of "Backstage," in* Bulletin of the Center for Children's Books *(reprinted by permission of The University of Chicago Press; © 1978 by The University of Chicago), Vol. 31, No. 10, July, 1978, p. 181.*

BEN'S TRUMPET (1979)

The irony of the Jazz-Age was that the pleasure that turned a whole generation into hedonists was supplied by musicians in dusty, desperate ghettos. In this poignant, spare story of Ben, a boy whose dream is to be a jazz trumpeter but who is too poor to own an instrument until a real musician, remembering his own dreams, puts one into the boy's hands, Isadora has caught that irony perfectly. The bittersweet quality of the music

set against the tawdry neon-lit night and the soft sadness of the daytime scenes is captured in black-and-white illustrations of varying techniques—all coming together in a remarkable whole that seems, like a trumpet sound, piercingly sweet, both hot and cool. Though middle-grade readers may resist the deceptively simple story, this should definitely be introduced to older kids.

> *Marjorie Lewis, in a review of "Ben's Trumpet," in* School Library Journal *(reprinted from the February, 1979 issue of* School Library Journal, *published by R. R. Bowker Co./A Xerox Corporation; copyright © 1979), Vol. 25, No. 6, February, 1979, p. 43.*

[Isadora] embraces her 1920s setting in a style that matches the rhythm and mood. Her masterful ability to show body motion is again evidenced in this outstanding depiction of musicians at work, whether it be in black or white silhouettes, outline drawings, or closely marked cross-hatching. The beat vibrates through the pianist's poised hands, the saxophonist's straining face, the drummer's swaying body, and the trumpeter's gyrating movements; yet the artist also captures subtle emotions in her characters' faces. The one full page of intricate art deco design may leave children cold, but they will feel the pulse of this perceptively illustrated story and be easily caught up in Ben's dream.

> *Barbara Elleman, in a review of "Ben's Trumpet," in* Booklist *(reprinted by permission of the American Library Association; copyright © 1979 by the American Library Association), Vol. 75, No. 12, February 15, 1979, p. 934.*

The most surprising and original picture book of the season . . . [is **"Ben's Trumpet."** Both] the illustrations and the text are resolutely realistic. . . . The art is astonishingly varied in its brilliant re-creation—in the margins, in the urban backgrounds—of the commercial art of the 20's and 30's. . . . The author succeeds in her evident ambition to make us see the music of a jazz trumpet, but she accomplishes this while capturing the realistic tenament world and family and friends of a black city child in a checked poor-boy cap. A first-rate picture book.

> *Harold C. K. Rice, in a review of "Ben's Trumpet," in* The New York Times Book Review *(copyright © 1979 by The New York Times Company; reprinted by permission), April 29, 1979, p. 47.*

It is highly unlikely that any child will enjoy this book, illustrated as it is with an art deco style. It is an adult picture book, for they are the ones who will appreciate the art and be able to relate to the period of its setting. The black jazz musician is portrayed in a vague, stereotyped way, and the locale is a typical urban, poor ghetto. Too hip and taking the reader nowhere, it verges on the brink of being racist.

> *James S. Haskins, in a review of "Ben's Trumpet," in* Children's Book Review Service *(copyright © 1979 Children's Book Review Service Inc.), Vol. 7, No. 10, May, 1979, p. 92.*

Jazz rhythms visually interpreted in black and white fairly explode across pages of exciting graphic designs against which the realistic figures of the principal characters stand out in striking contrast. The straightforward text describes the frustrated musical ambitions of Ben. . . . Told in the present tense, the book, from the silvery art deco jacket to the black end papers slashed with vibrating jagged white lines, draws the reader into the atmosphere of the twenties through a rich variety of perspectives and patterns. Meticulously detailed cityscapes, silhouettes, portraits, and collage effects are combined into a coherent work; the diversity elicits excitement and avoids monotony. Although Ben's story is accessible to younger audiences, the book can be introduced to older children as well because of its sophisticated design and the current enthusiasm for traditional jazz. A reminder that black and white, imaginatively used, can be as vibrant as color. (pp. 293-94)

> *Mary M. Burns, in a review of "Ben's Trumpet," in* The Horn Book Magazine *(copyright © 1979 by The Horn Book, Inc., Boston), Vol. LV, No. 3, June, 1979, pp. 293-94.*

The swinging, throbbing beat of Isadora's illustrations accurately reflect the pulsating rhythm of the jazz sounds that permeate Ben's world. The black and white illustrations are full of a variety of styles which change as quickly as the turn of the page. Hatched and cross-hatched lines create a parquet effect on the pages on which this technique is utilized.

Contour drawings and silhouettes on other pages create only a momentary impression of the Jazz Club musicians as they produce their sounds. The art deco of the 1920s surfaces in the decorative designs, which become integral parts of the compositions, integral only for their visual impact, whether it be to mimic the sway of the trumpeter's walk or to visualize the aural effects of the music on Ben. Compositions interspersed with zig zag lines of sound waves and nearly vertical lines of the music's beat also appear throughout the book.

The music of Ben's trumpet reverberates in the visual images of this Honor Book; the diversity of styles creates a disjointed effect, not unlike the musical patterns of jazz itself, but at times the pages seem overwhelming, often outweighing the points they are meant to communicate. (p. 372)

> *Linda Kauffman Peterson, "The Caldecott Medal and Honor Books, 1938-1981: 'Ben's Trumpet'," in* Newbery and Caldecott Medal and Honor Books: An Annotated Bibliography *by Linda Kauffman Peterson and Marilyn Leathers Solt (copyright © 1982 by Marilyn Solt and Linda Peterson; reprinted with the permission of Twayne Publishers, a division of G. K. Hall & Co., Boston), G. K. Hall, 1982, p. 372.*

MY BALLET CLASS (1980)

Graceful eloquence are two words that leap to mind when leafing through Isadora's rendition of a young girl's ballet class. The simple procedures of donning tights and shoes, greeting friends, limbering up at the barre, practicing relevé and passé, and bowing a révérence to the teacher at the lesson's close take on the aura of a dream performed in rhythmical slow motion. Carefully placed lines, subtle speckling, and hints of delicate pink and blue color combine to form the figures that bend, leap, and move with fluid agility. Yet Isadora achieves a personal tone, too, with glimpses of friends sharing giggles, littered dressing rooms and, in the final page, the aspiring ballerina dressed again in street clothes, eagerly greeting her waiting father. There's no hard work suggested, but facial expressions and body movements are surely and thoughtfully captured, encouraging children to linger long over the pictures.

> *Barbara Elleman, in a review of "My Ballet Class," in* Booklist *(reprinted by permission of the American Library Association; copyright © 1980 by the Amer-*

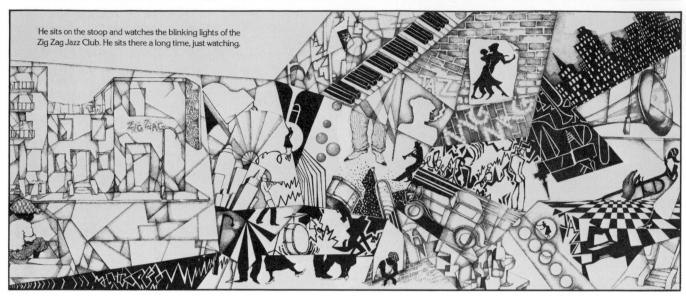

He sits on the stoop and watches the blinking lights of the Zig Zag Jazz Club. He sits there a long time, just watching.

From Ben's Trumpet, *written and illustrated by Rachel Isadora. Greenwillow Books, 1979. Copyright © 1979 by Rachel Isadora. By permission of Greenwillow Books (A Division of William Morrow & Company, Inc.).*

ican Library Association), Vol. 76, No. 10, January 15, 1980, p. 720.

Nicely textured drawings, lightly tinted, are effectively used on pages with no background distraction, so that the basic ballet positions demonstrated by the figures in a class of young dancers are very clear. . . . On only one page is the text confusing: it reads "We do portes de bras. I bend forward and try to touch my nose to my knees." Unless the readers already know what "Portes de bras" means, the figure of a child bending down may make them think that the second statement is an explanation of the first. Otherwise the book is excellent: simply written, nicely illustrated, and introducing ballet basics not only in a way that is clear but also in a tone that suggests ballet lessons are enjoyable.

> *Zena Sutherland, in a review of "My Ballet Class,"*
> *in* Bulletin of the Center for Children's Books *(reprinted by permission of The University of Chicago Press; © 1980 by The University of Chicago), Vol. 33, No. 6, February, 1980, p. 111.*

A gentle, inviting picture-book look at a ballet class, international and interracial. The weak point is the "easy" text—a young girl's straightforward description of the class in choppy sentences. . . . Possibly this is meant to be an easy-to-read book; but the French ballet terms in the text are sure stumbling blocks for beginning readers. The lack of incidents that could fuse into a plot make it less than great as a read aloud to younger age groups. Line and pastel wash drawings of the same leggy tykes we've seen in *Max* . . . and *Willaby* . . . are very pleasant to look at, but the whole is a bit off the mark for whichever audience was intended.

> *Jane Bickel, in a review of "My Ballet Class," in*
> School Library Journal *(reprinted from the February, 1980 issue of* School Library Journal, *published by R. R. Bowker Co./A Xerox Corporation; copyright © 1980), Vol. 26, No. 6, February, 1980, p. 46.*

The artist employs a freer style than the one she used in the pictures for *Backstage* and *Ben's Trumpet*—a style similar to

that of *Seeing Is Believing*. . . . Variety in design and layout is displayed, with both full-page illustrations and double-page spreads; the latter are usually more effective. Although the text seems essentially a vehicle for the illustrations, the book, nevertheless, is notable for its graphic effect.

> *Karen M. Klockner, in a review of "My Ballet Class,"*
> *in* The Horn Book Magazine *(copyright © 1980 by The Horn Book, Inc., Boston), Vol. LVI, No. 2, April, 1980, p. 164.*

[*My Ballet Class*] is a distinguished and imaginative picture book. Isadora, a former ballet dancer, has captured perfectly the atmosphere and training of the studio. Her drawings are delicate, sensitive and original. She has a remarkable eye. Highly recommended.

> *Moira Hodgson, "Poised at the Barre," in* Book
> World—The Washington Post *(© 1980, The Washington Post), May 11, 1980, p. 18.***

[Rachel Isadora] has created a charming volume. . . . With simplicity and directness, the author highlights a young girl's twice-weekly ballet class. . . . There are some amusing "asides" among the students, and the art of dancing is discussed with a respectful, matter-of-fact attitude which should help instill in young hopefuls a realistic approach to learning ballet.

> *Margaret Pierpont, in a review of "My Ballet Class,"*
> *in* Dance Magazine *(copyright 1980 by Danad Publishing Company, Inc.; reprinted with permission of Dance Magazine, Inc.), Vol. LIV, No. 9, September, 1980, p. 112.*

NO, AGATHA! (1980)

The storyline is very disjointed, the plot . . . what plot? The only saving grace of this book is the beautiful illustrations. A fantasy-loving adult might appreciate this book, but it is not suitable for children.

> *Marilyn E. Mize, in a review of "No Agatha!" in*
> Children's Book Review Service *(copyright © 1980*

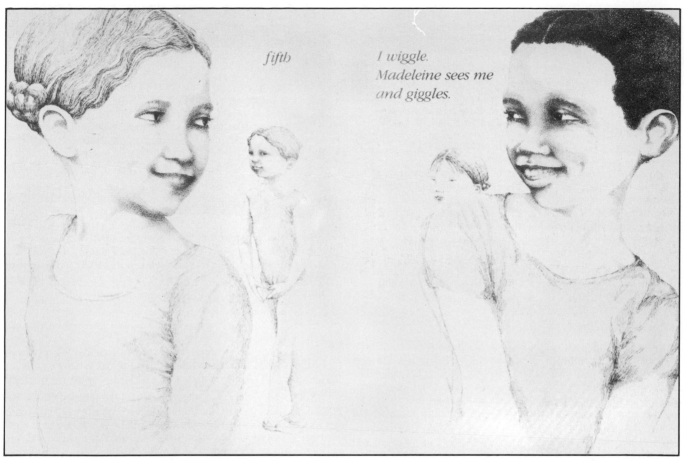

From My Ballet Class, *written and illustrated by Rachel Isadora. Greenwillow Books, 1980. Copyright © 1980 by Rachel Isadora. By permission of Greenwillow Books (A Division of William Morrow & Company, Inc.).*

Children's Book Review Service Inc.), Vol. 9, No. 1, September, 1980, p. 2.

This book starts out with an interesting idea—a transatlantic cruise made at the turn of the century by a young American girl. In fact, the photograph of an ocean liner on the end papers prepares one for a photographic Edwardian reminiscence. However, the text is plain and the plot disappointing; there seems to be no reason for Agatha's wandering around the ship, except that she escapes the constraints her very proper parents place upon her in her dream at the end of the book. The illustrations are even more disappointing, for they are not the expected photographs but are instead impressionistic pen-and-ink drawings that are alternately either too dark or so indistinct as to be difficult to interpret. In any case, they are too vague to provide the detailing necessary to convey either a feeling for the historical period or for the plot. At one point, Agatha is ordered to change from her favorite dress into a party dress; from the pictures, it is difficult to see why she should do so, since both dresses look alike.

> *Ruth K. MacDonald, in a review of "No Agatha!" in* School Library Journal *(reprinted from the September, 1980 issue of* School Library Journal, *published by R. R. Bowker Co./A Xerox Corporation; copyright © 1980), Vol. 27, No. 1, September, 1980, p. 60.*

Eager to experience all the excitement of the voyage, Agatha is inhibited at every turn by stern grown-ups who have unar-guable rules for young ladies' behavior. . . . But readers discover that the gritty girl has ways of keeping her zest alive, in the glittering finale of Isadora's new book. The text conveys depths of meaning and, as for the illustrations, they are simply astonishing, topping the award-winning scenes in **"Ben's Trumpet," "Max"** and the artist's other books.

> *A review of "No Agatha!" in* Publishers Weekly *(reprinted from the September 19, 1980 issue of* Publishers Weekly, *published by R. R. Bowker Company, a Xerox company; copyright © 1980 by Xerox Corporation), Vol. 218, No. 12, September 19, 1980, p. 160.*

Though the text reads more like individual captions than a smoothly integrated narration, the illustrations are evocative and need little elaboration to carry the story. Framed in thin, white mats against an ecru background, the intricate line work gracefully reflects the Edwardian time, catches the feel of spray and wind, and especially captures the vitality of a very real little girl.

> *Barbara Elleman, in a review of "No Agatha!" in* Booklist *(reprinted by permission of the American Library Association; copyright © 1980 by the American Library Association), Vol. 77, No. 3, October 1, 1980, p. 253.*

Isadora's finely etched black and white drawings . . . are handsome and evocative, although the read-aloud audience may not

appreciate the niceties of Edwardian dress and customs. . . . The book has nostalgic charm, but it lacks a story line and the ending seems to have little to do with the rest of the story, shifting from Agatha-the-happy-hoyden to Agatha-the-romantic; not that a child can't be both, but that here there is no connection between the two. (pp. 55-6)

> *Zena Sutherland, in a review of "No Agatha!" in* Bulletin of the Center for Children's Books *(reprinted by permission of The University of Chicago Press; © 1980 by The University of Chicago), Vol. 34, No. 3, November, 1980, pp. 55-6.*

[This is] a splendidly attractive book, with an almost non-existent dramatic line. . . . This seems a waste of Isadora's substantial talent, for it was she who was responsible for the compelling *Ben's Trumpet.* So evocative are these sepia-toned drawings that it might be worth it to buy the book and make up another story to go with the pictures. (pp. 14-15)

> *Michele Slung, "The Artful Menagerie," in* Book World—The Washington Post *(© 1980, The Washington Post), November 9, 1980, pp. 14-15.**

JESSE AND ABE (1981)

The story of this picture book is slight. Jesse is a young boy who visits his grandfather, Abe, doorman at Brown's Variety Theater, during the 1920s. The illustrations are not up to Isadora's usually high standard. They are vague black-and-white or black-and-yellow watercolor washes mostly on two-page spreads, but occasionally the two pages illustrate separate actions. There is a fair representation of on-stage vaudeville, but children will not be attracted to the dull, hazy pictures.

> *Beth Doyle, in a review of "Jesse and Abe," in* Children's Book Review Service *(copyright © 1981 Children's Book Review Service Inc.), Vol. 9, No. 7, February, 1981, p. 52.*

Isadora is at her best depicting stage life, and her black-and-white renderings, occasionally washed with gold for effect, suit her time frame (the 30s again) very well. Despite the success of *Ben's Trumpet* . . . , she hasn't frozen her style, and these softer ink washes, particularly effective in the street scenes, suit the nostalgia. The golden glow of onstage scenes gives just the right amount of variation. The story itself is simply told, with characters sketched in a few, well-chosen strokes, touching, yet never maudlin. (pp. 132-33)

> *Helen Gregory, in a review of "Jesse and Abe," in* School Library Journal *(reprinted from the March, 1981 issue of* School Library Journal, *published by R. R. Bowker Co./A Xerox Corporation; copyright © 1981), Vol. 27, No. 7, March, 1981, pp. 132-33.*

One night, Abe doesn't show up until curtain time and everyone feels lost. . . . Abe's reason for being late (a broken axle) is anticlimactic after the tension that has built up, which results in a thin plot line. However, as a mood piece on intergenerational relationships, the story features a strong and pleasing bond. Isadora's evocative illustrations capture the scene of 1920s vaudeville in black-and-white watercolors, which are accented with gold to create the glow of stage lights. Silent, shadowy figures backstage and energetic action onstage reflect the rhythm of the theater in the artist's graceful style, but it's the changing and genuine expressions of feeling that provide the holding power. (pp. 964-65)

> *Barbara Elleman, in a review of "Jesse & Abe," in* Booklist *(reprinted by permission of the American Library Association; copyright © 1981 by the American Library Association), Vol. 77, No. 13, March 1, 1981, pp. 964-65.*

A backstage view of show biz in the '20s, in shimmering, smudgy, impressionistic black and white. . . . The warmth is too deliberately laid on to enfold readers, and the story is deficient in action. But as usual Isadora succeeds in projecting an atmosphere around the stage, and as usual this speaks to the eye in its own way, not as a repeat or variation of a past success.

> *A review of "Jesse and Abe," in* Kirkus Reviews *(copyright © 1981 The Kirkus Service, Inc.), Vol. XLIX, No. 5, March 1, 1981, p. 280.*

Ostensibly this story is about [Jesse's and Abe's] devotion to each other. In fact the subject is the artist-author's devotion to a pastime of times past: vaudeville in the 1920's. Her efforts to capture the look and flavor of that setting dominate the slim thread of the story. . . .

Jesse sums up his feelings with, "I'm glad we're friends, Grandpa," and the book ends. This sentiment, like that depicted on the cover illustration, must be taken on faith. Jesse and his grandfather are a sweet looking pair but the emphasis of the book is scarcely on them. They remain shadowy figures both literally and as personalities.

Miss Isadora's prime concern is paying homage to images of another era. Her dark, brightly highlighted washes contain many visual echoes; the light struck canvases of Jules Pascin, the Jewish melancholy of the Soyers, some Reginald Marsh old movie stills. The appeal of much of this work is in a kind of graphic nostalgia.

But how much of that alone is interesting to children who are neither nostalgic nor art directors? Humor, tension, the devices a storyteller uses to draw an audience on to unfamiliar ground have been passed over. There are pages that sparkle, a number of poignant portraits of Jesse, a feeling for the night city, but what may have begun as a personal reminiscence has become an exercise in style.

> *Karla Kuskin, in a review of "Jesse & Abe," in* The New York Times Book Review *(copyright © 1981 by The New York Times Company; reprinted by permission), March 1, 1981, p. 24.*

CITY SEEN FROM A TO Z (1983)

In Isadora's urban alphabet, "Art" is pictured as an outdoor brick-wall mural of the UNICEF-card school. . . . [Most] of the entries are actual street scenes—from the obvious Roller Skates (on a black kid in a hip cap) . . . to the less expected interpretations of Entrance (down to a subway station). Music (a kid's big black box), Lion (pictured on the back of a boy's shirt), and Zoo (two boys' chalk drawings on the sidewalk). In general, though, Isadora sacrifices the buzzing vitality of city life for solitary, resting, sitting, pensive figures, and there are some still shots (Kitten, Snowman) with no human presence. The quiet moments she favors might be more effective as rests between more active or dynamic scenes. Still, there are those small jolts of recognition as in Music, and Isadora always has a nice feel for the easy postures of kids just hanging out. . . .

A review of "City Seen from A to Z," in Kirkus Reviews *(copyright © 1983 The Kirkus Service, Inc.), Vol. LI, No. 4, February 15, 1983, p. 181.*

[*City Seen from A to Z* is] successful in evoking an emotional response to its subject, a child's-eye-view of everyday Manhattan. This is not a sophisticate's New York, but the city of fire-hydrant showers on the August-hot pavement and grandparents with Old-Country ways. Indeed, this is one of very few children's books in which old people play a natural, pervasive role. Grandparents take young children for walks, stand with them on the beach, buy them ice-cream cones. Ostensibly a simple A-B-C, the book has a wit and sensitivity that transcends the form. Isadora's elegant, perceptive pictures capture small realities of city life. . . . It's too bad that most children in these parts lack the experiences that will make this fine book ring true. But it's a rich introduction to city life, and for any child (or ex-child) who knows New York, it has the real flavor of home. (pp. 16-17)

Beryl Lieff Benderly, "This Is the Way the World Works," in Book World—The Washington Post *(© 1983, The Washington Post), May 8, 1983, pp. 16-17.**

Some of the objects illustrated will be confusing to children just learning the alphabet. . . . "P" is for "Pigeon", but the pigeon seems incidental in the full-page illustration of a child and an adult going for a walk. An ABC book should be attractive and straightforward and include easily identifiable objects. This title is none of these.

Lelia Davenport Pettyjohn, in a review of "City Seen from A to Z," in Children's Book Review Service *(copyright © 1983 Children's Book Review Service Inc.), Vol. II, No. II, June, 1983, p. 108.*

[Isadora] uses the framework of an alphabet book to parade a panorama of city scenes beautifully captured in black, gray, and white. Each letter has its own picture full of the busy, humorous, and lonely moments of city life. Orientals, blacks, and whites—including a skullcapped Jewish man—share the city experience with quiet dignity and fill the pictures with the resonance of their own personalities. The book shows city life at its best, to be sure, for the artist sees beauty in a subway entrance, textural warmth in bricks and concrete, and handsome patterns in the zigzag of fire escapes or in a clutter of trash cans.

Ethel R. Twichell, in a review of "City Seen from A to Z," in The Horn Book Magazine *(copyright © 1983 by The Horn Book, Inc., Boston), Vol. LIX, No. 3, June, 1983, p. 292.*

Twenty-six beautifully detailed pencil drawings illustrate words that typify life in a large city. Some of the words are the typical picture book vocabulary; *ball, doll, kitten.* Some are surprises: *quiet, jazz, window box.* Yet each illustration has some element of surprise. *Lion,* a staple of ABC's, is a fierce iron-on transfer roaring from the back of a black youth's T-shirt. An Oriental toddler walking through Chinatown with her grandfather is frightened by an urban *pigeon.* A would-be ballerina in *tutu,* knee socks and sneakers is comical, while naively graceful. . . . The illustrations have a special value for their perceptive, detailed reflection, their ethnicity and amplification of city life. However, many of the cultural entries are beyond the experience and knowledge of most preschoolers.

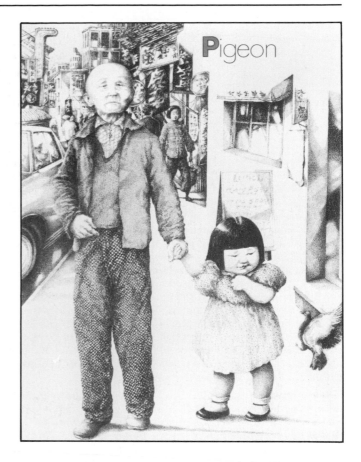

From City Seen from A to Z, *written and illustrated by Rachel Isadora. Greenwillow Books, 1983. Copyright © 1983 by Rachel Isadora. By permission of Greenwillow Books (A Division of William Morrow & Company, Inc.).*

Dana Whitney Pinizzotto, in a review of "City Seen from A to Z," in School Library Journal *(reprinted from the August, 1983 issue of* School Library Journal, *published by R. R. Bowker Co./A Xerox Corporation; copyright © 1983), Vol. 29, No. 10, August, 1983, p. 52.*

A new way to view life on the sidewalks of a city! The initial simplicity of this alphabet book is deceptive but the reader soon discovers the unexpected nature of each drawing. One word is frequently all that describes a letter; however, each contains a diversity of concepts relating to urban living. There are simply so many stories behind each shared glimpse.

New York's colorful rhythm, ethnic diversity, humanness and humor are uniquely presented. . . . [This is a] sensitive portrayal of life in the city.

City dwellers will more readily appreciate alphabet concepts such as: . . . Gallery, Quiet as in the park, Roller skates or Window box. The ultimate delight of the text is the view of two youngsters creating their own Zoo on the sidewalk! What a great idea to make an alphabetical city collage.

Ronald A. Jobe, in a review of "City Seen from A to Z" (copyright © 1983 by the National Council of Teachers of English; reprinted by permission of the publisher and the author), in Language Arts, *Vol. 60, No. 7, October, 1983, p. 897.*

Selma (Ottiliana Lovisa) Lagerlöf
1858-1940

Swedish author of fiction, autobiographer, poet, and dramatist.

One of Sweden's greatest novelists, Lagerlöf's adult works incorporate the land and lore of her native Värmland, a belief in the fairy world, and trust in humanity's essential goodness. These elements also appear in her two works for children, *The Wonderful Adventures of Nils* and *The Further Adventures of Nils*, considered distinguished contributions to fairy tale literature. Written as geography textbooks, these tales use an appealing fantasy framework to describe the natural features, history, and legends of her homeland. Lagerlöf presented these facts by centering on Nils Holgersson, a malicious boy reduced to elfin size as punishment for taunting an elf. Able to comprehend the language of animals, Nils travels around Sweden on the back of a gander and learns not only about his country but how to love and respect others. Educators and critics immediately acclaimed Lagerlöf's innovative approach to learning in *The Wonderful Adventures*, but it was not until the children asked for a sequel that she felt successful.

Inspired by her grandmother's retellings of local legends and tales, Lagerlöf retained a lifelong interest in Swedish folklore. She was an avid reader, due partly to an early attack of infantile paralysis which made sustained play impossible. While teaching school for ten years, she completed *Gösta Berling's Saga,* perhaps her most important novel. Because of her reputation as Sweden's best living writer, Lagerlöf was asked by her country's National Teachers' Association to write a geography book for the middle elementary grades. She gathered data for three years while pondering how to integrate fact, folklore, and the human world. A visit to Mårbacka, her ancestral home, led to the creation of Nils, one of Lagerlöf's most enduring characters.

Reviewers applaud the *Nils* books for their charm, clarity, accuracy, and clever mixture of reality and fantasy. They commend Lagerlöf's insightful characterizations of Nils and Mother Akka, the leader of the geese. Critics of her day likened Lagerlöf's storytelling ability to that of Hans Christian Andersen, and the books were soon translated throughout Europe. Today, the length of the two volumes and their relatively slow pace and local interest deter many readers. Nevertheless, Lagerlöf stands as a preeminent example of Sweden's legacy to children's literature. It is in tribute to her that Sweden's annual children's book prize is named the Nils Holgersson Award. Lagerlöf earned the Nobel Prize in 1909 and the added distinction of being the first woman to receive that honor. Five years later, she became the first female member of the prestigious Swedish Academy.

(See also *Twentieth Century Literary Criticism*, **Vol. 4** and *Something about the Author*, **Vol. 15.**)

NILS HOLGERSSONS UNDERBARA RESA GENOM SVERIGE [*THE WONDERFUL ADVENTURES OF NILS; THE FURTHER ADVENTURES OF NILS*] (1906-07)

[*The Wonderful Adventures of Nils* contains] much information about Sweden, the country, flowers, birds, animals, and some-

thing of history. Will interest children who like George MacDonald's fairy tales and the like; will make a place for itself but not be popular.

A review of "The Wonderful Adventures of Nils," in The Booklist *(reprinted by permission of the American Library Association; copyright © 1908 by the American Library Association), Vol. 4, No. 1, January, 1908, p. 22.*

Nothing since the days of Hans Christian Andersen has so stirred the children of not only Scandinavia but of Europe as Selma Lagerlöf's **"Wonderful Adventures of Nils."** This delightful and original fairy story tells of many wonderful adventures that happened to the boy Nils, of battles between rats, of talking cows, wicked foxes, etc. . . . So accurate is the author's knowledge of animal life, and so stimulating her description of the habits of animate nature, that the book has been adopted in the public schools of Sweden as equal to a textbook in natural history. (p. 249)

Edwin Björkman, "Selma Lagerlöf, a Writer of Modern Fairy Tales" (copyright 1910 by Review of Reviews, Co.; reprinted by permission of the Literary Estate of Edwin Björkman), in The American Review of Reviews, *Vol. XLI, No. 2, February, 1910, pp. 247-50.*

[Here] is a beautiful new fairy story, which we might rather call an animal story, by Selma Lagerlöf, **"Further Adventures of Nils."** . . . This is a masterpiece of mellifluous simplicity. Miss Lagerlöf's writing is as clear as a Bible narrative.

> *A review of "Further Adventures of Nils," in The American Review of Reviews, Vol. XLIV, No. 6, December, 1911, p. 764.*

[Following Miss Lagerlöf's **"Christ Legends"**] came the book that more than any other one has made friends for her in [America]—**"The Adventures of Nils."** . . . It is a book for children . . . but I have not yet found the grown-up reader of it who was unwilling to be counted a child again while the reading of it lasted. (pp. 152-53)

> *Edwin Björkman, "The Story of Selma Lagerlöf," in his* Voices of To-Morrow: Critical Studies of the New Spirit in Literature *(copyright 1913 by Mitchell Kennerley; reprinted by permission of the Literary Estate of Edwin Björkman), Mitchell Kennerley, 1913, pp. 139-53.*

That there is an ever widening circle of American admirers of Selma Lagerlöf is probably to be explained by the coming to maturity of the children who have read *The Adventures of Nils.*

Miss Lagerlöf's cultural medium is thoroughly saturated with the anthropomorphic conceptions that still compose the most attractive material for stories for children. . . . [*The Adventures of Nils* and *The Further Adventures of Nils*] proved to be two of the most entrancing children's books in literature. Middle-class America, with its offspring not quite fitted into the scheme of things, had been eagerly scanning the horizon for something new to entertain little children and instruct them as well. Selma Lagerlöf was destined to become a household idol. (p. 7)

> *Alvin Johnson, "Selma Lagerlöf," in* The New Republic, *Vol. X, No. 129, April 21, 1917, pp. 6-7.*

[*The Wonderful Adventures of Nils* and *Further Adventures of Nils*], so widely read in schools and homes in every civilized country to-day, are worthy a place on the shelves beside *Alice in Wonderland* of the past and *Doctor Dolittle* of the present type of juveniles. The boy, Nils Holgersson, and his "goosey-gander," with companions on the earth and in the air, appeal to the imagination of all ages, while the information about Sweden's outlines and landmarks is both accurate and entertaining. (pp. 116-17)

> *Annie Russell Marble, "Selma Lagerlöf—Swedish Realist and Idealist (1909)," in her* The Nobel Prize Winners in Literature, *D. Appleton and Company, 1925, pp. 104-23.*

If aught were needed to secure forever the place of [Miss Lagerlöf] in the hearts of her countrymen, [**"The Wonderful Adventures of Nils"** and **"The Further Adventures of Nils"**] accomplished the purpose. (p. 53)

Little Nils Holgersson, Morten Goosey Gander, the flock of wild geese and the other characters met there are now as much a part of the web and woof of story tradition in the American child mind as Andersen, Grimm, and Aesop. Although these books were Miss Lagerlöf's first work for children they showed her perfectly at home before a juvenile audience. Indeed, by many, Nils is considered the author's crowning achievement. (p. 54)

> *Harry E. Maule, in his* Selma Lagerlöf: The Woman, Her Work, Her Message *(copyright ©1917, 1926 by Doubleday, Page & Company, and renewed 1944 by Harry E. Maule), Doubleday, Doran & Company, Inc., 1926, 89 p.*

Within eleven years Selma Lagerlöf had published two major works depicting stirring episodes in the history of Värmland and Dalecarlia, wrestled with the problem of Socialism in an Italian story, and produced also a short novel and two volumes of stories all concerned with the deepest problems of human life. She must have turned with unspeakable relief to subjects in which her poetic imagination could have unfettered play. (p. 57)

The most successful book of this imaginative period [1904-07] is undoubtedly **'Nils Holgersson,'** which was written at the request of the National Teachers' Association to serve as a geographical reader on Sweden. It may seem strange that such a work should have at once become the most popular book of the year, but . . . national commissions stimulated rather than hampered the author's imagination, whose powers were always eagerly devoted to her country's service. Moreover, the task set her in **'Nils Holgersson'** was a singularly attractive one, affording unique opportunities to express her intimate knowledge of and love for her fatherland, and also allowing full rein to her delightful imagination and love of children. (pp. 62-3)

The result was something more than a children's story. **'Nils Holgersson'** gives the reader such a vivid impression of the land and its people, that it is an excellent preparation for a visit to Sweden. The adventurous flight of the bewitched peasant lad begins in the very south of Scone, and after he has reached Lapland by way of the eastern provinces, he returns to the south by a more westerly route. The long journey affords countless opportunities for describing both isolated scenes and broad landscapes in words which remain naturally in the memory. Happy comparisons and ingenious stories sharpen the impressions, and forestall any risk of didactic dullness. (p. 63)

[The] major part of the book is devoted to the Sweden of to-day, its lakes and rivers, woods and mountains, villages and towns, deserts and outlying islands, its landowners, farmers and workmen, its industries, agriculture and sport. This wealth of information would be wearisome, were it not a setting for the endless variety of adventures which befall Nils Holgersson on his journey, and if nature were not so frequently pictured in its most stirring moods. Sea-storm and river-flood, forest-fire and breaking ice add vigour to the action and the scene.

Nils Holgersson is a Swedish Mowgli, for a substantial proportion of the book is taken up with his varied, and often dramatic experiences among the animals, yet it is in no way an imitation of 'The Jungle Book.' Nils is very definitely a Swedish boy with human standards of conduct, and a fair knowledge of the world; he comes among the animals as a grown lad and learns to hold his own among them, and he is not, like Mowgli, more animal than human in his feelings. In the intimate pictures of natural lore it unfolds, the Swedish book can fairly claim a place beside Rudyard Kipling's masterpiece. The whole fauna of the country plays its part there. . . . But the wealth of human figures woven into the story give it a different tone from that of 'The Jungle Book.' Two of the most charming episodes are devoted to the relations between animals and men: the first is a tender plea for the protection of wild birds, and the second for a kindlier attitude towards worn-out horses—in both the plea is so implicit in the story,

that it needs no direct expression. Perhaps **'Nils Holgersson'** is often spoilt for Swedish children by its use as a school-book, but in other countries it is a source of inexhaustible pleasure to children of seven and over, and to all who love nature or have not lost the power of imagination.

The story is held together by the character of Nils, whose release from elf-dom is achieved after many trials. A number of birds and animals follow him throughout and help make the chain of adventures into a novel. . . . The leader of the wild geese, Akka of Kebnekaise, is a commanding character, and she has a wide circle of friends who play a part in the drama— the story Ermenrich, the Raven Bataki and the Eagle Gorgo are outstanding among them. . . . Wild creatures play a bigger part in the story than do human beings, for Akka and her friends form a kind of masonic lodge, to which Nils is initiated, and as a result of their training he gradually develops into a fine little man. . . . The change in his character takes place naturally in the course of the story, as he wins his way into the heart of the reader, whether child or adult. (pp. 64-6)

In many ways **'Nils Holgersson'** is the most successful of Selma Lagerlöf's longer books. The long chain of adventures is most happily forged into organic unity, and the dedication of the book to children leaves the reader free to enter whole heartedly into the magic world of the author's phantasy. A great love for childhood, for all the forms of nature, for every part of this far-flung Fatherland has found its full artistic expression in **'Nils Holgersson,'** making it a unique book, not to be compared with any collection of folk tales, or any book of travel. . . . Selma Lagerlöf had achieved the highest possible expression of her unique gifts. . . . (pp. 66-7)

> *Walter A. Berendsohn, in his* Selma Lagerlöf: Her Life and Work, *translated by George F. Timpson (originally published as* Selma Lagerlöf: Heimat und Leben, Künstlerschaft, Werke, Wirkung und Wert, *A. Langen, 1927), I. Nicholson & Watson Ltd., 1931 (and reprinted by Kennikat Press, Inc., 1968), 136 p.*

Selma Lagerlöf's imagination and her inventiveness were made to serve a pedagogical purpose when, under the title *The Wonderful Adventures of Nils (Nils Holgerssons underbara resa . . .),* she wrote a masterly popular fairy tale book about Sweden's scenic beauty and her memories of the past. The book is characteristic, too, of her moral optimism, which comes strongly to the fore after *Gösta Berling's Saga* and which aims to teach men goodness and love, charity and compassion. Her faith is often warm and deep, but at times it strikes one as rather cheap and uncritical. (pp. 175-76)

> *H. G. Topsöe-Jensen, "Neo-Romanticism and Symbolism: Sweden," in his* Scandinavian Literature: From Brandes to Our Day, *translated by Isaac Anderson (copyright, 1929, renewed 1947, by The American-Scandinavian Foundation), The American-Scandinavian Foundation—W. W. Norton & Company, 1929, pp. 162-86.*

[There runs throughout Dr Selma Lagerlöf's] work that love of high adventure and of the open air which pulses in the characters of the Scottish novelist [Sir Walter Scott].

Nowhere is this more apparent than in the great children's epic **'Nils Holgersson's Wonderful Ride through Sweden,'** a book which by its very nature is destined to a permanent place in the world's literature. . . . The whole book is instinct with the life of the open air; its countless scenes from wild life can never grow old, and there is a circumstance which will com-

mend it more and more to coming generations—Nils sees Sweden from the air, and though he rides on the back of a migrating gander, he prefigures the knight-errant of the future, for he has the mobility and at times the problems of the aeronaut. There breathes through the book also that sense of comradeship between man and the wild creatures which is already dawning, and is one of the brightest hopes of coming days. (pp. xv-xvi)

> *George F. Timpson, "Introduction to the English Edition" (1930), in* Selma Lagerlöf: Her Life and Work *by Walter A. Berendsohn, translated by George F. Timpson, I. Nicholson & Watson Ltd., 1931 (and reprinted by Kennikat Press, Inc., 1968), pp. xv-xx.*

Selma Lagerlöf's greatest non-fiction work . . . [is] the two books about Nils Holgersson and his journey through Sweden, written as a school reader. (pp. 69-70)

Miss Lagerlöf decided to confine herself practically to a description of nature and animal life. Human beings figure only slightly in the book, but the local legends which tell how the mountains and lakes, the rivers and plains and forests first took shape are cleverly utilized. She spent the better part of three years familiarizing herself with the material, for she was deeply impressed with the responsibility of writing an account that should be absolutely veracious. This does not mean that the fairy-tale element was excluded, however. In fact she needed a creature that should be a link between the animal and the human world. By a stroke of genius she created the boy who was changed into an elf and rode all over Sweden on the back of a goose. (pp. 70-1)

He who never in his former life felt affection for anyone, not even for his parents, now learns to love the goosey-gander and Akka, the venerable leader of the wild geese. And this ability to love and to feel for others does not leave him when he again regains human shape. Artfully and without a single "thus we see," Selma Lagerlöf leads her young readers first to see what pleasure they can enjoy in the companionship of animals and then to understand the broader principle that no one can be happy without feeling affection for others.

As the wild geese fly from southern Skåne to northern Lapland and back again with many excursions to the east and west, almost the whole country is spread out before the readers, and in telling all the adventures that befell Nils the author has an opportunity to introduce the children to almost all the wild birds and animals of Sweden. First and foremost there is the leader goose, Akka from Kebnekaise, ice-gray and venerable, reputed to be more than a hundred years old. Akka is quite a pedagogue. To the young goslings flying around her for the first time, Akka calls out the names of places they fly over. "This is Portsokjokko, this is Särjaktjokko, this is Sulitelma." At this the goslings shriek in heart-rending tones, "Akka, Akka, Akka! We haven't room in our heads for any more of those dreadful names!" "The more you put into your heads the more you can get into them," retorts the leader goose and continues to call the names. One can imagine the twinkle in her eye with which the ex-teacher Miss Lagerlöf wrote this rejoinder. Other outstanding "personalities" are Smirre the Fox, Gorgo the Eagle, Bataki the Raven, Herr Ermenrich the Stork, and many others. . . . (pp. 71-2)

[*Nils Holgerssons underbara resa genom Sverige*] has no doubt done more than any other book to acquaint both children and grown-ups with Sweden. (p. 72)

> *Hanna Astrup Larsen, in her* Selma Lagerlöf, *Doubleday, Doran & Company, Inc., 1936, 117 p.*

A fine story which has stood the test of many years is *The Wonderful Adventures of Nils*. . . . Its use in the schools has made it familiar to children in Sweden, but it has been taken to the hearts of boys and girls in many other countries with no less enthusiasm. There is need for a better English translation than any we have yet had, but even in a translation that is sometimes stilted, this story . . . is full of charm. The adventures with Smirre Fox, with the gray and black rats in their lonely turreted castle; the assembly of all the animals according to their kind for the great crane dance at Kullaberg; the changing panorama of forest, mountain, and lake, hold the reader's interest and, as always when Selma Lagerlöf writes about the out-of-doors, she brings to us scents and sounds of forest and meadow that almost convince us of their reality. (p. 105)

> Anne Thaxter Eaton, "Unicorns and Common Creatures," in her Reading with Children *(copyright 1940 by Anne Thaxter Eaton, renewed © 1967 by Anne Thaxter Eaton; reprinted by permission of Viking Penguin Inc.),* Viking Press, 1940, pp. 97-118.*

The Wonderful Adventures of Nils [is] a little classic that touches with magic the life of the farm and the air.

[A] reason for Miss Lagerlöf's success with the imagination and the use of magic is that she naturalizes them by homely little touches or by tying them down to what is closest to them in life and by making them amenable to reason and to the moral law. . . . On the first night when [Nils] and his gander come to rest on the ice of Vomb lake and prepare to sleep there, some of the magic of the experience begins to fade. He wonders how he can ever go to sleep on that frozen lake. Then the gander lifts his wing and tucks the little boy into the soft down, where he goes to sleep as cozily as in his own bed. The strangeness of the situation has been reconciled to the experience of every day. (p. 102)

> N. Elizabeth Monroe, "Provincial Art in Selma Lagerlöf" *(originally published in* The Scandinavian Review, *Summer, 1940), in her* The Novel and Society: A Critical Study of the Modern Novel *(copyright, 1941, by the University of North Carolina Press, and renewed 1969 by David R. Monroe),* University of North Carolina Press, 1941, pp. 88-110.

[*The Wonderful Adventures of Nils*] is legend, fairy story and adventure all rolled into one and I can still remember how utterly amazed I was when my father told me that the book was used as a geography in the schools in Sweden. I was studying geography myself at the time and thought of a geography in the terms of our American textbooks. Yet, here was one with chapters like this: "**The Wonderful Journey of Nils**," "**Glimminge Castle**," "**The Great Crane Dance on Kullaberg**," "**The Big Butterfly**," "**The Legend of Småland**."

I had by this time read it myself both in English and in Swedish but in neither language did it seem like a geography! Still Father told me that he had read that the National Teachers' Association of Sweden had decided that only the greatest creative writers were good enough to interpret their native land to children. And so they had asked Selma Lagerlöf to write of the country for children from nine to eleven.

They could not, of course, have found a better writer for the task. Selma Lagerlöf loved Sweden; she had heard and read its history and legends; she had by this time traveled over much of it. She had had experience in teaching and was vitally interested in the methods of education. (p. 119)

I may have studied Sweden in an ordinary geography but I have no recollection of doing so. I do not know the population of the cities, nor the height of the mountains, nor the exact dates in the history; but if I were put down now in any part of the land through which Nils traveled, I should feel at home at once, not only with the place and people, but with the animals, flowers and legends that belong there. So well did Selma Lagerlöf carry out the commission of the National Teachers' Association. (p. 121)

> Jennie D. Lindquist, "Selma Lagerlöf," in The Horn Book Magazine *(copyrighted, 1944, renewed 1971, by The Horn Book, Inc., Boston), Vol. XX, No. 2, March-April, 1944, pp. 115-22.*

English children of to-day are not likely to know Nils, since there has been no edition [of *The Wonderful Adventures of Nils*] readily available in this country for some years. One can imagine that the story would quickly become a classic for Swedish boys and girls of the early part of the century . . . , for there are lovely descriptions of the Swedish countryside, its birds and beasts, and old folk legends. Selma Lagerlöf has been called a "creative listener" rather than a creative writer, since even in her work for adults, she lets her fancy roam among the peasant stories told to her as a child, and becomes the medium by which they are brought to readers to-day. She is remembered for this rather than for any outstanding characters she has brought to life. The story of the bad boy Nils . . . is little more than a background against which the countryside life of Sweden is delicately painted. Modern children will probably find it too long and slow-moving; the exciting incidents are few and far between, and the ending is inconclusive, but those who read patiently will find here beauty and a tale of quiet courage. (pp. 58-9)

> A review of "The Wonderful Adventures of Nils," in The Junior Bookshelf, *Vol. 15, No. 2, March, 1951, pp. 58-9.*

[*The Further Adventures of Nils* is] a work of lasting value. . . . Karr the dog, Greyskin the Elk, and Helpless the grass-snake are amongst the animals whose characters and personalities stand out sharply against a well coloured background, each one lending thought to the story and wisdom to Nils. . . . Each incident has something of the eternal folk tale character, a haunting echoing note, and is stamped with the true story teller's art. (p. 197)

> A review of "The Further Adventures of Nils," in The Junior Bookshelf, *Vol. 17, No. 4, October, 1953, pp. 197-98.*

One might say that *The Wonderful Adventures of Nils* has done more in giving foreigners an impression and conception of Sweden than any other work. . . . Surprised as many educators were by [Selma Lagerlöf's] method of conveying a knowledge of their country to children, there was no question that the interest of the children could be and was captured; and as they would read the book with enthusiasm they even learned a great deal about the landscape and conditions of their own country. The strange and unusual fate of this school-book was that it became one of the world's best known and loved of all children's books. (p. 245)

> Frederic Fleisher, "Selma Lagerlöf: A Centennial Tribute," in The American Scandinavian Review *(copyright 1958 by the American-Scandinavian Foundation; reprinted by permission of* Scandinavian

Review*), Vol. XLVI, No. 3, September, 1958, pp. 241-45.*

One of his many wonderful adventures in Selma Lagerlöf's *Nils Holgerssons underbara resa* . . . takes Nils to Karlskrona, Sweden's naval port. The wild geese arrive there on a moonlit night, and the little fellow immediately sets out to explore the city. When he gets to the city square he finds it deserted: No human being about, only, high on a pedestal, the bronze statue of King Charles XI, founder of city and port, and of Sweden's naval power. As Nils gazes at the big, brawny man with the forbidding countenance, he is overcome by a feeling of his own smallness, and insignificance. To cheer himself up a bit, he utters a pert "Vad har den där Långläppen här att göra?" and walks off. Before long he hears someone walking behind him, stamping on the stone pavement with heavy footsteps, and pounding the ground with a hard stick: The bronze man. Little Nils runs and runs, as the heavy steps come nearer and nearer. When there seems to be no escape, he is miraculously rescued by the wooden "Rosenbom," another of Karlskrona's landmarks, who hides him under his hat. There he stays as the bronze king and the wooden boatswain walk over to the harbor, in pursuit of the culprit. As they do, they look over the docks and arsenals, the smithies and carpenter shops, the big new men-of-war, and the proud galley models of Charles' own day. King, boatswain, and little boy alike are filled with great pride and patriotic ardor, and Rosenbom, who—like the king himself—has forgotten why they had set out upon this inspection tour, lifts his wooden hat, shouting: "Jag lyfter hatten för den, som utvalde hamnen och grundade varvet och nyskapade flottan, för den kung, som har väckt allt detta till liv." And the king replies: "Tack, Rosenbom! Det var bra sagt. Rosenbom är en präktig karl. Men vad är nu detta, Rosenbom?" For there, right on top of Rosenbom's bald pate, stands Nils Holgersson, not a bit afraid any longer, but he, too, raises his hat, and shouts: "Hurra för dig, Långläpp!" The king strikes the ground hard with his big stick, but this very moment the sun rises, and bronze and wooden man alike vanish.

This episode is, in its basic theme as well as in several details, strongly reminiscent of Pushkin's poem, *The Bronze Horseman*. I have found no direct evidence to the effect that Selma Lagerlöf had actually read Pushkin's poem when she wrote her story. (pp. 150-51)

[It] is not the object of this paper to determine how much—if at all—Selma Lagerlöf is indebted to the Russian poet. (p. 151)

But then again, I feel that the parallel is so close that a comparison of the ways in which these two artists handle the same motive may enrich our understanding of both works. It may be suggested that they are not really comparable: After all, Selma Lagerlöf wrote her book for Swedish schoolchildren, whereas Pushkin's poem is a sophisticated work of art, with deep philosophical, social, and political implications. However, nobody will dispute the great *poetic* merit of this particular scene in Selma Lagerlöf's story, and this is, of course, what counts.

Pushkin's poem has been interpreted in many different ways, and most scholars today believe that at least several of these interpretations are equally, and simultaneously correct. The encounter of *man and demon* is, however, the main theme of *The Bronze Horseman*, and the uneven clash between the titanic figure of the monarch and the sorry hero, young Evgeny, certainly has a symbolic meaning. . . . He is no more than an empty shell of his former self when he turns to the bronze

statue of the czar with a feeble gesture of protest, of reproach rather than of mutiny. It is a wretched madman, a miserable beggar whom the bronze horseman pursues. On the other hand, Peter is the real hero of the poem, and its most beautiful passages are devoted to his apotheosis.

Selma Lagerlof's version of the encounter between the bronze statue of a mighty monarch and an insignificant little man has other qualities. Whereas the many, true or apparent contradictions in Pushkin's poem account for much of its poetic tension and appeal, Selma Lagerlöf's scene has the qualities of unity, balance, and simplicity. Its symbolism is direct and simple: We witness an encounter between a typical Swedish boy of rough peasant stock with a symbol of his country's glorious past, a demonstration of the solidarity between the plain Swedish people and Sweden's dynasty.

Nils Holgersson meets Charles XI under a spell of enchantment, but acts much as he would have acted in real life. Evgeny meets Peter the Great because he is mad. (pp. 151-52)

Selma Lagerlöf's episode tells the Swedish youth of a glorious past, of the energy and vigor of the man who made his nation great and strong once again, but also of the men who helped him in his prodigious effort. Even little Nils, a naughty, lazy, and ignorant boy in real life, will certainly become, or rather already is a most loyal subject of His Majesty the King. There is genuine affection between the king and his people. Pushkin's Peter the Great is a lonely, almost inhuman titan. Petersburg . . . is Peter's *idea*. Karlskrona is the *work* of Charles XI and of his people. (pp. 152-53)

Both scenes occur on a moonlit night, but entirely opposite aspects of what the Germans call "Mondscheinstimmung" are brought out by the Swedish story-teller and the Russian poet. Selma Lagerlöf's scene is all *andante*, Pushkin's is *allegro*. The slow, deliberate steps of the king, as he makes his round of Karlskrona harbor. The thunderous, frenzied galloping of the imperial horseman. The quick little taps of a little boy-turned-elf's wooden shoes. The panting of a wretched *real* man. The midget eludes the bronze man, who vanishes at the first ray of the morning sun. Little Nils cheerfully continues his flight across Sweden. Evgeny's ordeal also ends in the morning, but the fear of the galloping horseman keeps haunting him ever after.

In Selma Lagerlöf's story, the harsh, unpleasant traits of the monarch appear early. The statue shows him with a heavy stick in his hand, and he "såg ut, som om han skulle kunna göra bruk av den också." The way he handles his obedient subject Rosenbom leaves no doubt as to the correctness of such an assumption. But as the tale turns to the king's great achievements, as the city, the port, the navy which he built are shown to us, we forget about these traits, and, together with Rosenbom and Nils Holgersson, we hail the founder of the city, the builder of a great navy, the father of a nation.

Altogether different is the arrangement of essentially the same elements in Pushkin's poem. . . . There is a positively shattering contrast between the enthusiastic optimism of the introduction and the sad story of poor Evgeny. . . . (pp. 153-54)

The moral, if we may so call it, of the Swedish story is, in effect, that a king, even if he may appear to be a harsh, and hard, and perhaps a petty man, is still a father of his people—and that this is what counts. The moral of the Russian poem would be, accordingly, that a czar, while he may be a great ruler and his ideas among the loftiest, is still a brutal, vengeful

tyrant to the individual subject of his rule—and that this is what counts. (p. 154)

Victor Terras, "Two Bronze Monarchs" (reprinted by permission of the publisher and the author), in Scandinavian Studies, *Vol. 33, No. 3, August, 1961, pp. 150-54.**

The universal and timeless classics among children's books do not lie thick on the ground. Twenty years after *Treasure Island* and *Huckleberry Finn* there appeared in Sweden a book produced for the educational authorities which could hold its own with these other two in fame and in the pleasures which it has given. This was *Nils Holgerssons underbara resa genom Sverige (Nils Holgersson's wonderful travels round Sweden)*. . . .

The writer of this beautiful book was Selma Lagerlöf who was born in 1858 on an estate in central Sweden. Both the place and the country of her birth were important in this case for rarely has a writer looked at his homeland with so much affection and so much curiosity. Next to her most famous novel, *Gösta Berling's saga,* which is set deep in her home country, *Nils Holgersson* is the biggest and best example of a truly creative patriotism. . . .

Running to five hundred pages, the work is exceptionally long for a children's book but its main elements are brought together most successfully in a way that keeps the reader constantly amused. Information becomes part of the story and the exciting events also serve to show how a life in the wild can be a great moulder of character. Above all, there is the superb creation of Mother Akka, the leader of the wild geese, who, with her great wisdom, is one of the unforgettable characters of children's literature. The book's departures into history or legend or natural descriptions are the sort of thing which children normally skip or reject altogether, but here they are built into the story in so masterly a fashion that the reader's patience with them is never extended. Admittedly there is some doubt as to how far a modern city child will put up with them and it is quite likely that he would have to be encouraged by a sympathetic mother or teacher who would read and explain the less easily understandable passages of the story. (p. 260)

Bettina Hürlimann, "Men of Letters Write for Children," in her Three Centuries of Children's Books in Europe, *edited and translated by Brian W. Alderson (© Oxford University Press 1967; reprinted by permission; originally published as* Europäische Kinderbücher in drei Jahrhunderten, *Atlantis Verlag, 1959), Oxford University Press, Oxford, 1967, pp. 256-66.**

["**The Wonderful Adventures of Nils**"] was not the cut-and-dried textbook that might have been anticipated. It was a wonderful story touched with the magic of fairy tales and steeped in the lore of natural history. . . .

At the heart of the wide-ranging fantasy and flow of absorbing incident is essentially the story of a boy growing up. It can be read on many levels, and is a book for all ages, certainly one to read aloud in the family.

Several generations of children have read it with delight. Many children, however, intimidated by its bulk, shy from it.

Maria Cimino, in a review of "The Wonderful Adventures of Nils," in The New York Times Book Review *(copyright © 1968 by The New York Times Company; reprinted by permission), March 3, 1968, p. 30.*

[Selma Lagerlöf] was one of Sweden's greatest novelists, a member of the Swedish Academy, and winner of the Nobel Prize for literature. In view of these facts, it is noteworthy that many consider *The Wonderful Adventures of Nils* . . . to be one of her finest works. [While gathering information for this book] she pondered the form which the book would finally take. Finally, on a visit to her old home, the idea came to her of changing a boy into a tiny creature, who would fly on a gander's back with the wild geese over Sweden. For this visit, and the idea which came of it, the world should be grateful, since the result is a fantasy of sustained imaginative quality, which gives a vivid impression of a land and its people, written in a style remarkable for its unselfconscious purity. (pp. 343-44)

[Lagerlöf's skill] completely integrates aspects of the land and its people with the story. . . . As Nils travels from the south to the north, and back to the south, the varying beauty of the Swedish landscape unfolds like a panorama, fields and mountains and forests and water. . . . Written to achieve a realistic purpose, still the book is animate with the lovely spirit so prevalent in fantasy. (p. 344)

It is little wonder that this book, so intensely national in the sense that folk literature and folk music are national, is also universal. (p. 345)

Elizabeth Nesbitt, "A Rightful Heritage, 1890-1920: Extensions of Reality," in A Critical History of Children's Literature *by Cornelia Meigs, Anne Thaxter Eaton, Elizabeth Nesbitt, and Ruth Hill Viguers, edited by Cornelia Meigs (reprinted with permission of Macmillan Publishing Company; copyright © 1953, 1969 by Macmillan Publishing Company), revised edition, Macmillan, 1969, pp. 338-48.**

[Selma Lagerlöf's geography] is a timeless book in which folklore and the grand old stories and superstitions of the countryside hold their proportionate place. To dip into *The Wonderful Adventures of Nils,* to read and reread it, is always to discover some new refreshment of spirit. Read, for example, "**The Great Crane Dance at Kullaberg,**" one of the memorable chapters. . . . How it sticks in the mind, becoming a permanent part of one's cherished heritage. It could come only from the imagination of a great poet and storyteller. (p. 608)

Edna Johnson, Evelyn R. Sickels, and Frances Clarke Sayers, "Fantasy: Introduction," in their Anthology of Children's Literature *(Copyright © 1970 by Houghton Mifflin Company. Copyright © 1959 by Edna Johnson, Evelyn R. Sickels, and Frances Clarke Sayers. Copyright, 1948, by Edna Johnson and Evelyn R. Sickels. Copyright, 1935, by Edna Johnson and Carrie E. Scott. Reprinted by permission of Houghton Mifflin Company), fourth edition, Houghton Mifflin, 1970, pp. 607-12.**

The geographical aspect of [the two volumes in *Nils Holgersson's Wonderful Travels round Sweden*] is balanced by the theme of a naughty boy changed by experience. No book could better inculcate an intelligent love of animals than this tale of a natural, lively, noisy boy who converses with them in their own language and, while changing his attitude to life for the better, at the same time enjoys his multifarious adventures with engaging high spirits. (p. 258)

Margery Fisher, "Who's Who in Children's Books: Nils Holgersson," in her Who's Who in Children's Books: A Treasury of the Familiar Characters of Childhood *(copyright © 1975 by Margery Fisher;*

reprinted by permission), Holt, Rinehart and Winston, 1975, Weidenfeld and Nicolson, 1975, pp. 258-59.

[*The Wonderful Adventures of Nils* opens, like Randall Jarrell's] *The Animal Family,* with quiet realism. Nils is an adolescent Swedish lad who, since he has refused to attend church with his parents, is told by them to read the Sunday morning service at home. He promises, but it is a lovely early spring day, and he has no intention of more than halfheartedly keeping his promise. He starts to read the service, falls asleep, and wakes to discover that some thief has apparently left open the lid of his mother's chest:

> While he sat there and waited for the thief to make his appearance, he began to wonder what the dark shadow was which fell across the edge of the chest. He looked and looked—and did not want to believe his eyes. But the thing, which at first seemed shadowy, became more and more clear to him; and soon he saw that it was something real. It was no less a thing than an elf who sat there—astride the edge of the chest!

Already the story has taken a turn, Lagerlöf has made a choice. It might well have been a human thief that ransacked Nils's mother's chest, as could happen in Robert Louis Stevenson or Stephen Meader. But instead, "it was no less a thing than an elf."

Elves are less precisely literary figures than mermaids. They appear in various folk literatures, though, so far as I know, in this century only Tolkien has ever taken elves seriously. Knowing this, we might quickly check the date of *Nils,* which is 1907, to see what we might expect to be Lagerlöf's attitude toward elves. Since elves belong to an older world than ours, most latter-day authors tend to be a little cute or self-conscious about them. The more a writer believes in elves the easier that writer will find it to bring them into a realistically described world, while the writer who uses elves as an admitted contrivance is more likely to transport the story to an alternative world of the magical, where elves can safely exist. Lagerlöf settles the matter very quickly: "To be sure, the boy had heard stories about elves, but he had never dreamed they were such tiny creatures." In other words, Nils had heard about elves as he might have heard about Stockholm, as a matter of lore, other people's knowledge. But the lore is not to be doubted. From what he had been told Nils had wrongly imagined the size of elves, just as, from what he had been told, he might have wrongly imagined the height of the tall buildings in Stockholm. But he does not doubt the existence of either. "It was no less a thing than an elf" means that, tiny though they are, elves are important.

But Nils is not awed, or respectful, or even curious about the elf. He catches it in a butterfly net, and the elf pleads with Nils for its freedom, offering "an old coin, a silver spoon, and a gold penny" in return. Small and captive though it is, Nils is rather frightened of the elf and quickly agrees to the bargain: "He felt he had entered into an agreement with something weird and uncanny; something which did not belong to his world, and he was only too glad to get rid of the horrid thing." Again, Lagerlöf has made a choice, turning her story one way so it will not go another. E. Nesbit's Londoner Bastables see the Psammead, of whom they have never even heard, and they brightly start asking it questions. Nils is a darkly and narrowly

raised country boy, uncertain of his world and its limits. With a "weird and uncanny" elf, "the horrid thing," Nils is almost certainly not going to find any wet magic, or a trip on a magic carpet, or a road to Oz.

Nils quickly regrets his bargain when he thinks he might well have asked for more than the elf offered, and he tries to re-capture the elf. Suddenly he is hit on the head, sent reeling from wall to wall until he falls senseless on the floor. Again, we might read this as a cue to transport the lad away to an elfin world, rather as the cyclone does Dorothy Gale. But again Lagerlöf chooses to keep her Swedish country world intact: "When he awoke, he was alone in the cottage," and still with the Sunday service to read too. As he makes his way back to his book, however, Nils discovers he has been transformed into the size of an elf. Imagine the possibilities once again, remembering we are on page 17 of a book of over five hundred pages. Lagerlöf could still transport Nils out of Sweden, but everything she has done thus far shows she accepts elves and their magic powers as part of Sweden. Yet, accepting of elves or no, the more Swedenlike she keeps her world, the less elflike it must be. To have Nils now become part of a community of elves, running around the house of his parents, perhaps, might work for a little joking, like the invisible Faustus and Me-phistophilis at the papal court in Marlowe's play, or for a little doing good, as in *The Tailor of Gloucester*. Such stories must be short, though, since their narrative possibilities dwindle quickly. If Nils isn't going to go visit elves, what is Lagerlöf's point in changing his size?

The answer comes quickly: to make him smaller than animals. The elf has disappeared, Nils is alone, and he goes into the barnyard only to learn he has long been despised as a bully there:

> Instantly, both the geese and the chickens turned and stared at the boy; and then they set up a fearful cackling. "Cock-el-i-coo," crowed the rooster, "good enough for him! Cock-el-i-coo, he has pulled my comb!" "Ka, ka, kada, serves him right!" cried the hens; and with that they set up a continuous cackle.

This is a wonderful passage for showing the suppleness of the metaphor of the talking animal when used by a good author. Lagerlöf on the one hand goes out of her way to insist she is a close observer of real roosters and knows the sound of their crowing is not the standard "cock-a-doodle-doo." On the other hand, "good enough for him" and "he has pulled my comb" are the words of a standard talking animal. The effect of this is to make us ask what real roosters, "cock-el-i-coo" roosters, say to each other, or to us, could we hear them rightly. A child is apt to wonder about such questions, but so too is anyone who has spent slow, careful time looking at and listening to roosters. The answers are potentially frightening, and Lagerlöf's turning of her story as she has implies that if we were the size of elves we could hear what roosters say; and we would also be powerless to alter whatever judgment they might levy against us.

By this point we can be fairly sure this is not an elf story. The elf has been useful to clarify Nils's character, and to make him small, but it looks now as though his adventures are to be as a tiny Nils, in Sweden. Finding it unbearable to be told he might now be punished for past wickedness, Nils hurls a rock at the birds, who charge at him. A house cat appears, the barnyard birds disperse, and Nils is momentarily saved:

Immediately the boy ran up to the cat. "You dear pussy!" said he, "You must know all the corners and hiding places about here? You'll be a good little kitty and tell me where I can find the elf."

The cat did not reply at once. He seated himself, curled his tail into a graceful ring around his paws—and stared at the boy. It was a large black cat with one white spot on his chest.

Like *The Animal Family,* this keeps combining the talking animal with careful descriptions of the real, and for the sake of such careful descriptions. But the effect is very different, and nothing in Jarrell's book could be as ominous as this. Nils assumes the cat can talk since the barnyard birds can talk, but he forgets he can assume this because he himself is very small, much too small to be patronizingly jolly to a cat. This creature is no monster, but it is a real cat, not a "dear pussy":

> "I know well enough where the elf lives," he said in a soft voice, "but that doesn't say I'm going to tell *you* about it."

> "Dear pussy, you must tell me where the elf lives!" said the boy. "Can't you see how he has bewitched me?"

> The cat opened his eyes a little, so that the green wickedness began to shine forth. He spun round and purred with satisfaction before he replied. "Shall I perhaps help you because you have so often grabbed me by the tail?" he said at last.

> Then the boy was furious and forgot entirely how little and helpless he was now. "Oh, I can pull your tail again, I can," said he, and ran toward the cat.

Compare this with another difficult moment for a child magically reduced in size, Alice's "Conversation with a Caterpillar." Lewis Carroll describes his caterpillar as three inches high, and he will eventually become a butterfly, but essentially his conversation with Alice is between a schoolmaster and a pupil. By comparison, Lagerlöf's cat is frightening not because it acts like a figure of human authority, but because it acts like a real cat, its green wickedness shining forth from its eyes, able to talk, but only to remind Nils what any abused cat might say to any bullying child.

Then Lagerlöf reaps her first important reward for having adhered so closely to realism in her tale of elves and talking animals: "Then the cat made one spring and landed right on the boy; knocked him down and stood over him—his forepaws on his chest, and his jaws wide apart—over his throat." This is unimaginable in Wonderland, or in a fully realistic story, or in *The Animal Family.* Anyone who has looked inside a cat's mouth, or seen a cat play with a captive mouse or bird, or seen a child grab a cat and call it "dear pussy," knows the horror of this moment. How much, Lagerlöf asks us to see, does mere size and strength determine the order of creation; how casual we are, too, in using our strength; how awful for Nils, whose punishment is juster than nightmare: " 'There!' he said. 'That will do now. I'll let you go this time, for my mistress' sake. I only wanted you to know which one of us has the power now.' " The cat that can remember the unkindness of one person can remember the kindness of another, and his dismissal

of Nils shines forth, like his own green wickedness, as a gesture of sinister contempt.

Alice, when she is made small, is frustrated and irritated; Gulliver, in the country of the giant Brobdingnags, is disgusted; Nils here is plain scared, because Lagerlöf has made his world so coherent with the one he left when he first saw the elf. In going the direction she has gone thus far, Lagerlöf seems now in some danger of making her story into a lecture to Nils for his past sins, such as one finds in Carlo Collodi's *Pinocchio.* One of the laws of Kipling's jungle is that punishment must not be followed by recrimination, and clearly Lagerlöf must not break that law. We are not going on with the elf, the barnyard animals, or the cat, but we are going on with Nils's wonderful adventures, and Lagerlöf has gone as far as she can go in teaching her hero humility. Fortunately Lagerlöf has pondered her materials slowly and patiently, so she doesn't go Collodi's way. What she has pondered, we know, is Sweden, and especially, it soon becomes clear, the life of its wild animals. Nils goes back to the yard and watches a flock of geese fly over, calling to the tame geese on the ground to join them. One eager young gander agrees to leave. Nils climbs up on his back, and soon both have joined the flock in the air; for the first time, Nils's reduced size is a benefit for him. First, Nils learns the wild geese don't expect the gander to be able to keep up and have invited it along in order to watch it fail, and fall. Second, Nils is told the wild geese shun human beings because all people, large and small, are cruel to other animals. So we have abandoned the simpler sorts of didacticism. The wild geese are in their way as bullying as Nils, but they are grand, too, and not in the least in need of being punished. Likewise, if Nils has behaved badly, he has been no worse than most people tend to be. We are in open air, free to ponder such bracing grimness, and by comparison with these wild geese, Randall Jarrell's animals seem tame, human-oriented.

Some time later Nils is able to help one of the wild geese, and in return the leader of the flock, Akka, goes back to Nils's house and secures the elf's promise to return Nils to human size again:

> But the boy was thinking of the carefree days and the banter; and of adventure and freedom and travel, high above the earth, that he should miss, and he actually bawled with grief. "I don't want to be human," said he. "I want to go with you to Lapland."

"I don't want to be human" might be Gulliver denouncing a race of odious vermin, or Peter Pan wishing no one would ever grow up. But anyone might want to pursue adventure and freedom and travel, when it is not with Kenneth Grahame's Mr. Toad but with this stern, wild old goose. We may seem here to be edging toward satire, judgment against human ways, but Lagerlöf is still pondering:

> It was a strange thing about that boy—as long as he had lived he had never cared for anyone. He had not cared for his father or mother; nor for his schoolteacher; nor for his school mates; nor for the boys in the neighbourhood. All that they had wished to have him do—whether it had been work or play—he had only thought tiresome. Therefore there was no one whom he missed or longed for.

This passage is perhaps the greatest triumph of Lagerlöf's way with people and animals. "He had never cared for anyone" is

offered simply as a fact. It does not make Nils a freak, though it helps explain his past cruelty to animals. The very quietness with which the discovery is made serves to authenticate it, as though anyone might make such a discovery, as though we should not be surprised or aghast should we discover it about ourselves even without riding on the back of a wild goose. In their very grimness, such sentences offer bracing assurance.

Each time Lagerlöf has chosen how to place Nils within her shifting context of speaking animals, she has insisted, we can now see, on making a point about strength and power. There is the wrong kind of harsh strength, as we see when Nils's parents leave for church, when we learn about Nils's past behavior with animals, when the wild geese mock and tempt the tame ones. All these seem ugly and nasty. There is also a right kind of harsh strength, as we see in the cat and the geese handling Nils, as we see especially in Lagerlöf's handling of Nils. All these seem beautiful. Nils thinks of "adventure and freedom and travel" when he thinks of the geese, but it has been hard adventuring, not so much liberating as invigorating. The discipline of the birds is genuine, worthy, anything but tiresome, although very tiring. Slow and pondering though she is, Lagerlöf has actually moved rather quickly toward this cleansing moment when Nils discovers he does not want to be human again, and it is hard to see how she could have done this without the talking animals and the magical changes in Nils's size.

Each choice a storyteller makes works to deny other possible choices. Having kept her story in Sweden, she cannot move it much farther away than Lapland. Having stressed the fierce discipline of the geese, Lagerlöf cannot make them warm, nice, or very pleasant companions. Having chosen to use talking animals to reveal the nature of real animals, she has deprived herself of any large or enveloping plot, because the real life of wild animals can yield only episodes, and the long story of survival. As a result, after the moment I have just described, *The Wonderful Adventures of Nils* becomes more plainly episodic than it has been thus far, since Nils's essential choices have been reduced to two: stay with the geese or leave them. The driving narrative impulse which is sustained as long as Lagerlöf is shifting her contexts and our way of seeing Nils has been spent and, after this, can be recaptured only within episodes, and cannot be generated through the book as a whole. The book has become "adventures." (pp. 90-7)

Roger Sale, "Animals," in his Fairy Tales and After: From Snow White to E. B. White *(copyright © 1978 by the President and Fellows of Harvard College; excerpted by permission), Cambridge, Mass.: Harvard University Press, 1978, pp. 77-100.**

Leo(nard) Lionni

1910-

Dutch-born American author/illustrator, editor, journalist, and author of nonfiction.

A recognized master of art and design, Lionni creates fables which focus on individuality, self-reliance, and esthetic values. In keeping with the fable tradition, he uses non-human characters to represent humanity; mice, fish, pebbles, rabbits, frogs, lizards, and splotches of color are involved in adventures which teach them about life. As an artist, Lionni is praised for the variety of his techniques and his creative use of mixed media, especially in his collages. His illustrations are noted for their expression of mood and character and for portraying nature in vivid abstract forms. Critics appreciate Lionni's ability to make his viewers more aware of the natural world through his illustrations and the thoughtfulness and subtlety of his texts, while children usually relate to Lionni's cut-outs, finger paintings, construction paper scraps, and other media for their similarity to kindergarten art.

Lionni spent his first twelve years exploring Amsterdam's finest art museums. Confident that he would become an artist, he began painting seriously as a child. He was also an avid naturalist and drew pictures of plants, shells, stones, and animals. While working towards his degree in economics, Lionni taught himself to be an artist. He is revered as a pioneer in advertising art and design, and has had many international one-man shows. He became involved with children's literature when he created *Little Blue and Little Yellow* as a source of entertainment for his grandchildren on a long train trip across Europe. It was immediately successful and is now considered a classic. Critics attribute its popularity to the liveliness of Lionni's blue and yellow splotches and a story which is both a basic lesson in color mixing and an insightful look at integration, individuality, family acceptance, and the personal changes friendship brings. Lionni has said, "Like any work of art, children's books exist on many levels." This holds true for all his works—the messages are there for those mature enough to understand them but the ideas of sharing, color recognition, loneliness, and cooperation are subjects which hold the interest of the very young. Occasionally critics wonder if a Lionni theme is meant for children or adults, but most find that his stories are suitable for the very young reader.

Critics praise Lionni's successful construction of his stories as fables that are not overly didactic; *The Alphabet Book* is the only book out of Lionni's numerous works to receive negative reviews for its heavily moralistic theme. Early in his career critics frequently noted that, although the stories were usually above average, the supreme quality of a Lionni book was in its illustrations. Some critics say that his later fables are dull and that his pictures are becoming formulated. However, most of Lionni's works are praised for his expert presentation of the fable in words, ideas, and pictures at a level which young children can enjoy. Lionni says that he seeks "a coherence between form and content" as an author/illustrator. It is clear from the responses of children and critics that he has found it. Lionni received Caldecott Honor Book selections for *Inch By Inch* in 1961, *Swimmy* in 1964, *Frederick* in 1968, and *Alexander and the Wind-up Mouse* in 1970; he received the

Lewis Carroll Shelf Award in 1962 and the Children's Book Prize in Germany in 1963, both for *Inch By Inch; Swimmy* also won the Golden Apple Award at Bratislava First Biennial in 1967; *Alexander and the Wind-up Mouse* was selected for the first Christopher Award in the Children's Book Category in 1969; *Little Blue and Little Yellow* was added to the permanent collection in the Brooklyn Art Books for Children in 1975. Lionni was also given the George G. Stone Center for Children's Books Recognition of Merit Award for his body of work in 1976.

(See also *Something about the Author,* Vol. 8 and *Contemporary Authors,* Vols. 53-56.)

AUTHOR'S COMMENTARY

Among the many varied things I have done in my life few have given me more and greater satisfactions than my children's books. For an artist, to work for others means compromises which, however reasonable they may be, often leave the initial idea marred, transformed, devitalized.

That is why I have chosen, for my children's books, to collaborate with no one, but rather to invent, write and illustrate my own stories. I know that there are better writers and better illustrators, but I hope to achieve a coherence between form

and content which even the closest, most intimate co-operation between different people cannot reach. (p. 302)

When a story takes shape in my imagination, it does so in sentences and images. Sometimes the words trail the pictures and often it is the other way around, but the give and take between the two happens almost simultaneously in the privacy of my own mind. And so the form expresses the content in a direct, convincing manner. (p. 302)

When I have a story in mind I am not conscious of the average age of my potential readers. I believe, in fact, that a good children's book should appeal to all people who have not completely lost their original joy and wonder in life. When I am asked the embarrassing question of what do I know about children, their psychology, and their needs, I must confess my total ignorance. I know no more about children than the average parent or grandparent. I like to watch them, and when they are exceptionally sweet I like to hold them on my knee. But often I have not much patience for them. This is childish of me, perhaps, since children have very little patience with other children. The fact is that I really don't make books for children at all. I make them for that part of us, of myself and of my friends, which has never changed, which is still child. (p. 303)

A criticism that has often been made of my books and of my work in general is the absence of a consistent personal style. Most illustrators evolve a manner, which identifies them instantly, even if their signature is absent from their work. This technique, this comfortable form, is used no matter what the content is and no matter how it changes from story to story.

This preoccupation with style often derives from the artist's desire to have a personality which differentiates him from his colleagues. Often it is simply laziness. But sometimes it is an overwhelming urge to forge things into a personal mold. Many of my colleagues are neither artificially constructed personalities, nor lazy exploiters of a few easy mannerisms. They sincerely and almost unknowingly repeat the same attitudes and gestures. They see all colors through their particular prism and use the lines and shapes that are congenial to them over and over again.

It just happens that I do not aspire to that sort of style. I find greater joy and satisfaction in developing a form for each idea. Style, the way I see it, is deeper, more subtle and therefore more difficult to detect. Style is more than a technical mannerism, more than a consistent way to apply colors or to wiggle a line. It is a method of going directly to the heart of each situation and seeing and depicting it in its own specific term; it is participating in each particular mood and finding the proper technique for expressing it; it is presenting clearly, without detours and unnecessary frills, what is talked about; it is understanding and feeling about characters and environments the way we feel about ourselves and our world. A formal, independent style does not allow such complete identification; it does not permit each story, each character to live its own life. It dresses the actors with the same costumes, over and over again, no matter what their play is and no matter what their roles are.

You may have asked yourselves, when you saw my books: birds, worms, fish, flowers, pebbles . . . what about people? Of course my books, like all fables, are about people. Worms don't measure, torn paper doesn't go to school, little fish don't organize, birds don't engage in philanthropy, and pebbles don't make words. My characters are humans in disguise and their little problems and situations are human problems, human sit-

uations. The game of identifying, of finding ourselves in the things around us is as old as history. We understand things only in terms of ourselves and in reference to ourselves.

The child must be able to identify with the characters in my books, otherwise my stories will remain outside of him, to be looked at, at the most, as a thing not needed. Our capacity to identify, to feel pain and joy that is not our own, is our greatest gift. When it fails us, we become cruel and dangerous to others and to ourselves. It is important that children be encouraged to identify, to find themselves in others.

And then there is another aspect of the allegory as a storytelling technique. It is easier to isolate situations, to bring them to a clean, uncluttered, symbolic pitch *outside* of ourselves. What a ponderous, complex story *Swimmy* would have been if some cruel dictator had slaughtered a whole village and only a little boy had been able to escape. One would have had to describe a plausible historical background and justify the characters in all the intricacies of human terms. Of course one can write such stories. Tolstoy could, Hemingway could. But I am not a novelist. To tell and illustrate such an epic in 30 pages for small children would be an absurd task.

The protagonist of my books is often an individual who is, because of special circumstances, an outcast, a rebel, a victim, or a hero. His story ends happily because of his intelligence (the inchworm), his vitality and resourcefulness (Swimmy), his goodness (Tico), or simply because his will and patience turn the law of averages to his advantage. Often he has to learn through suffering (Little Blue, Swimmy, Tico), but it is always his own vitality, his discovery that life is a positive, exciting fact, that makes him come out on top.

I have no programs for my books, no conscious direction which I force myself to follow. The world which excites me, like Swimmy's world, is too vast and too varied for that. I must confess that the moment a story is formed in my mind, I always have a moment of panic in which I ask myself: is there another story just as good? Will this be the last one?

But this insecurity which so often accompanies the termination of works of fiction is irrational. The world in which we move is an ever-changing spectacle, revealing around each corner new adventures, new beauty and, of course, new problems. This infinite stream of experiences will never run dry. It is in the realities around me, in fact, that I find the assurance that my work will continue, for it is there that I will always find the stuff for my stories.

I like to write about birds because I have birds at home: parrots, pigeons, chickens, and finches. I like to write about fish because I used to have an aquarium and I cannot pass a bridge without stopping to search the stream for its mysterious inhabitants. I like to draw plants because at home we have an olive grove and a vineyard and in the spring the soil bursts with wild flowers that no one planted or planned. And I like to draw pebbles because there are really many pebbles on my beach. I am always looking for a perfectly round one, although I know that I can only find one on a billiard table.

I want my stories to have a beginning, a development, and an end. No matter how modest they are, they must have the ingredients of the classical drama: suspense and resolution. They should also have a moral. In some of my stories, the moral is quite simple and obvious; in others it may be more difficult to articulate. Their intent is not always a warning that could be summed up in a few words. More often my stories are meant

to stimulate the mind, to create an awareness, to destroy a prejudice. In that sense, they may not have a moral, but in their intentions, at least, they *are* moral.

I have often been asked about hidden meanings. Is *Little Blue and Little Yellow* a book about racial segregation? Does *Swimmy* have Marxist implications? Does *Inch by Inch* deal with space and time? Is *Tico* . . . a Freudian fable of love and hate?

To all these questions I must, of course, answer, No. I do not set out with such programmatic notions in mind. Yet all works of art, no matter how simple in scope, must have more than one level of meaning. Children's books are no exception. Meanings that are veiled and implied often take a more permanent place in one's heart and mind than the ones that are too explicitly hammered into one's consciousness. Children, especially, tend to resist overt pressure of authority by forgetting. To help them search and discover for themselves a value system that will be personally and socially useful is, I believe, a more promising endeavor.

The kind of care that is taken in printing books is, I believe, very important. Children must grow up with a sense of quality, of excellence. To have little respect for our materials and for the things we make means to have little respect for the people for whom these things are meant. Shoddy workmanship makes for a shoddy environment for Man. There are perhaps more dramatic roles for the artist in our industrial society, but I feel that one of our major responsibilities is to measure the standards of the mass-produced objects we design with the same exacting yardstick we use for our own artifacts. Children, especially, will have to learn, through our example, the satisfactions of quality.

I remember that when I was a child I admired the way my uncle drew. He was an architect but he drew portraits of all of us. I was fascinated by his cross-hatching, by the way he patiently built up the shadows in his drawings. Those memories disappeared in the turmoil of my adult life only to come back in a more tangible form: the quest for quality which I want to transmit in turn to the children who read my books. (pp. 303-06)

> *Leo Lionni, "My Books for Children," in* Wilson Library Bulletin *(copyright © 1964 by the H. W. Wilson Company; reprinted by permission from the October 1964 issue of* Wilson Library Bulletin*), Vol. 39, No. 2, October, 1964 (and reprinted in* Authors and Illustrators of Children's Books: Writings on Their Lives and Works, *edited by Miriam Hoffman and Eva Samuels, R. R. Bowker Company, 1972, pp. 302-06).*

GENERAL COMMENTARY

MARCIA BROWN

Leo Lionni is one of the most imaginative artists of collage, so skillful that one thinks first of the picture and only later of the means he used. In his *Inch by Inch* there is a scaffold of very lively drawing. The motif of the blades of grass recurs as the inchworm moves along through the book. Each component texture extends the expressiveness of the drawing; the artist confines himself to only those textures and colors needed to carry the inch worm along. In *Swimmy* he stamps, blots, superimposes prints of lace on his blotted watercolor washes. The blotted wet pictures suggest the beautiful, vague, and mysterious world under the sea, where menace and fear are precise

if the definitions of that world are not. The technique here always serves the idea.

Simplicity is not always strength, nor does an apparently naive technique reveal simplicity of spirit. At its best, simplicity is a matured richness distilled to its essence, the end of the progress of a creative idea, not the beginning.

With circles and strips of torn paper, the simplest possible means, Lionni made *little blue and little yellow.* It is a profound little book, gay enough to make a child laugh aloud but wise about color mixtures, about judging by appearances, about recognizing the changes brought about by friendship and love. Lionni uses collage with poetic economy. (p. 16)

> *Marcia Brown, "One Wonders," in* Illustrators of Children's Books: 1957-1966, *Lee Kingman, Joanna Foster, Ruth Giles Lontoft, eds. (copyright © 1968 by The Horn Book, Inc.), Horn Book, 1968, pp. 2-26.**

SELMA G. LANES

The illustrations of Leo Lionni, [a] sophisticated craftsman, could well stand alone, but his magical world of collage and color gains its richest meaning in the context of the simple stories he weaves around them, his "fables of search for identity and recognition." For a city child who has never observed nature close at hand—or for those children who seem able to walk through a paradise with unseeing eyes—Lionni's graphics are the next best thing to discovering the wonder of a blade of grass or a woodland fern all for oneself. No child should miss Lionni at his best—*Inch by Inch, Frederick* or *The Biggest House in the World.* (pp. 61, 63)

> *Selma G. Lanes, "Blow-Up: The Picture-Book Explosion," in her* Down the Rabbit Hole: Adventures and Misadventures in the Realm of Children's Literature *(copyright © 1971 by Selma G. Lanes; reprinted with the permission of Atheneum Publishers, New York), Atheneum, 1972, pp. 45-66.**

DONNARAE MacCANN AND OLGA RICHARD

Lionni's main involvement in illustration seems to be with the surface appearance of forms and with the arrangement of these textured forms on the picture page.

In *Inch by Inch* . . . he varies nature's surfaces and shapes, and carefully assigns a specific surface color and texture to each blade of grass, leaf, tree trunk, bird, flower—to everything he uses in his pictures. The only object that is immune to this treatment is the inchworm, which remains a solid color without texture. Since the inchworm is very small, this contrast enables one to find him, usually after a search. Some of the surface treatment is based on the natural object, while other surfaces borrow from sources outside nature. For example, the robin's texture is quite frankly a textile design pattern which has been most successfully and ingeniously appropriated. Each page has high visual interest, not only because of the clean-edged, cut-out look and consistent treatment of the objects, but also because of the page layouts. His designs are dramatic, as in one illustration of a heron, with legs zipping out of the page with a strong vertical and head swinging back into the page at the right. His color sense adds to the vivid quality of the book.

Lionni's preoccupation with the surface qualities of forms comes very close to the nonobjective in *Swimmy.* . . . He seems interested in the textures he invents for their own sake, rather than their relationship to any real object. If it were not for the occasional fish stereotype which he uses on the title page, the

forms, shapes, sizes, and colors would have no particular underwater connotation. The page would be suggestive of nature, but not of specific areas of nature; rather, nature in a generic sense in contrast to the man-made world. Every page is an experiment in surface texturing: sponge in paint, paint dripped, brayer rolling, doily painting, and so on. Young children are familiar with these experimental techniques since *gadget painting* is part of their art curriculum. Part of the great charm of this book to children lies in their own interest in surface explorations. Lionni has engaged in some of these same gadget painting experiments, but always with the controlled talent of a mature artist.

In contrast to the richly diversified surface treatments in *Swimmy*, Lionni's simple fish stereotype is stamped repeatedly, with no color variation, over the entire picture page. The result is somewhat monotonous. Another fish, a large black tuna, is diversified in textural treatment and is more successful visually. Interest is also maintained on a page with a colorfully surfaced lobster. Sometimes his sense of page design suffers because of his involvement with special effects, as in his preoccupation with the imprint made by a paper doily.

Alexander and the Wind-Up Mouse . . . sustains visual interest, but it is also a little too stagy. Lionni uses all his gifts (and he has an abundance) but this becomes more than the book needs. *Frederick* . . . is more sensitive throughout because it maintains the mood suggested at the beginning; it is a synthesis from cover to cover, the same song. Lionni arranges, in collage fashion, shape assortments of mice and rocks in a soft, quiet range of grays. The varied shapes reside so comfortably within the picture plane that Lionni makes his visual task seem effortless. All the shapes, except the mice, have clean edges and textured interiors. The illusion of furriness on the mice is created by the torn edges of the dark gray paper used for their bodies. This furriness contrasts simply with the clean edges of their ears, legs, and tails. (pp. 58-9)

> *Donnarae MacCann and Olga Richard, "Outstanding Contemporary Illustrators: Leo Lionni (1910-)," in their* The Child's First Books: A Critical Study of Pictures and Texts *(copyright © 1973 by Donnarae MacCann and Olga Richard; reprinted by permission of The H. W. Wilson Company), Wilson, 1973, pp. 58-9.*

ANNABELLE SIMON CAHN

[Lionni's children's books] are didactic both in word and image, and the cumulative corpus makes a significant statement about Lionni's thought.

His work retains some of the characteristic visual qualities of the 1950's, a design image he influenced and fostered. He continues to have his texts set in *Century*, a turn-of-the-century font which he revived. His illustrations tend toward flat, poster-like layouts affected by Klee, Matisse, Miro, and Jean Arp. Snippits of printed paper incorporated into complex collages are the artistic mainstay of his books. . . . Many papers are monoprints of his own fabrication. All share a visual uniformity of repeated surface decoration. Wrapping papers, wall papers, printed Japanese paper (sometimes ornamenting imported goods), marble papers (better known on bookbindings), William Morris designs, doilied, stenciled, potato-printed, flour-pasted, crayoned, watercolored, pastelled, inked, roughly torn or just left alone, they are combined in a rich admixture of flat, simple, chunky forms laid down as a series of interrelated patterned surfaces to achieve a limited, lateral, diorama-like sense of space. Contrasting artistic techniques and mixed media are frequently used in conjunction with these small-patterned papers to lend emphasis to contrasting ideas or states of mind. There is a recurring interplay between opaque and transparent effects, marrying crayon or mat tempera paint with transparent inks, or pen and ink with opulent papers.

Lionni's interest in Surrealism influenced his books. *On My Beach There Are Many Pebbles* . . . is devoted to the zoomorphic and anthropomorphic possibilities of striations and faults in pebbles worn by the sea. *The Biggest House* . . . , concerning the foolish aspirations and ultimate demise of a snail, exploits inconsistencies of scale to distort the natural optical relationship of reader to object. His involvement with the principles of Surrealism is also evident in the recent paintings of "moon-flowers" (metallic plants with amorphous, sometimes flat backgrounds), sculptural collages of branches cast in a Lionni-devised variant of the lost-wax process (using the casting metal to burn out and replace the wooden limbs), and elegant drawings and lithographs of imaginative and imaginary plants (resembling vegetation in its diseased or deformed state in the lineage of seventeenth and eighteenth century botanical drawings). (pp. 123-24)

Not only are Lionni's books visually stimulating, but the texts are thoughtful and philosophical: the succinct prose is colorful, sometimes whimsical, sometimes poetic, and always didactic. The stories are essentially contemporary parables. In the best fabulist tradition, most of Lionni's tales center around animal heroes—an age-old device used to make the critical message or moral more palatable to a potentially resistent readership. . . .

By electing the vehicle of illustrated stories, Lionni, perhaps unconsciously, takes advantage of notions concerning the function of children's books prevalent in late nineteenth-century England. A number of writers and artists of the Arts and Crafts movement voiced the belief that the most expedient way to influence or reform the direction of society was to present one's ideas to children, thought to be inherently brighter, more creative and open than their parents, and as yet unblemished or repressed by education. This appeal to youth, as much a sentimental hearkening after responses of simplicity and fresh wonderment as a desire to institute change, was thought to be most effective if the impact was through the presentation of well-designed topical books at an early age. (p. 124)

His first book, *little yellow, little blue* . . . , is now a well-established classic. In the torn-paper collages of the illustrations, Lionni applied bold torn color forms (not unlike the 1940's collages of Jean Arp) to a story reminiscent of El Lissitzsky's *Two Squares*, but centered in two shapes, yellow and blue. . . . They are shown as dear friends playing together, and their love for one another leads them to melt together into green. The story reads not only as a very simple lesson in color theory—what happens when blue and yellow mix—but also as a parable concerning integration, identity, and social acceptance. Now, green, the result of the fused shapes, each original color loses its own properties and characteristics, and neither blue or yellow is recognized nor wanted by his family. In keeping with the cultural optimism of the early 1960's, the work was initially viewed as a strong plea for integration; but the perspective of years makes this less clear, for the story also pleads for the retention of individual differences.

As in most fables, Lionni's heroes are found in situations of distress, but they are not outwitted by their adversaries and resolve their difficulties in a multitude of ways. For example,

a resourceful inchworm, working as a useful member of society to advance practical knowledge by measuring the length of various birds (*Inch by Inch* . . .) is called upon to measure the song of a nightingale or be eaten for breakfast, and "inches out of sight." *Swimmy* . . . , a stereotype of the hero distinguished by his deeds as well as his physique, is a small black fish whose leadership and intelligence lead him to organize a school which teaches red fish to compensate for their small size by swimming together in formation to imitate the shape of the larger fish who harass them.

In this latter book, Lionni touches on several issues to which he has returned periodically—individual and group relations, the singularity of each individual and the place of each individual in society. (pp. 125, 127)

[In *Fish is Fish,* Lionni] turned to the old Platonic dilemma concerning the essential nature of things. A tadpole and a minnow, inseparable friends in infancy, come to argue as the tadpole begins to take on his adult characteristics. . . . When, upon maturity, the frog quits the pond and does not return for many weeks and then only to tell his old friend of the wonders of the world, the fish completely misinterprets the significance of the frog's adventures. As in Medieval Bestiaries where creatures frequently take on vain pursuits and come to be castigated for ill-conceived plans, the fish tries to quit his home, and only after an almost fatal mishap does he realize his own essential properties and limitations as well as the beauty of his own aquatic world. Visually, there is a brilliant contrast between the pen-and-ink renderings of the fish's imagination and the softer-edged crayoning of his actual surroundings.

In the past few years, Lionni has begun to use the mouse as his hero or anti-hero, as the case would be, and with each new fable the swift-footed rodent has become the personification of certain ideas.

For instance, Lionni has conjured up a poetic mouse *Frederick* . . . , who, unlike the unfortunate cicada who sang all summer in LaFontaine's fable, does not suffer the consequences of a summer think-and-song fest. While he does not materially contribute to the family efforts to store goods for the winter, he is ultimately recognized as a stimulating member of this small community. Frederick, basically a flower child—a sleepy-eyed mouse holding what looks surprisingly like a poppy—is a fine example of the contemplative and creative *Melancholia,* one of the Four Humours. Frederick's poetry, iconoclastically animistic, depends on an ordered, almost encyclopedic, universe. (p. 127)

[*Theodore and the Talking Mushroom*] is concerned with false messiahs and the giving of religious power. Without the expanded prose of Jonathan Swift's *Tale of a Tub* or Anatole France's *Penguin Island,* Lionni has encapsulated the pseudo-religious experience. . . .

The whole story reads like refracted Near Eastern or Indian myth. Earth-toned papers are used for the bulk of the collages and stand in stark contrast to the acid blue mushroom head, the crisp outlines of the garlands of flowers, and the pen-and-inked undeserved crown. (p. 128)

The germinal ideas for the *Alphabet Tree* . . . , which shows individual letters learning to join together to make words and sentences owes something to Judeo-Christian myth and medieval legends about naming letters and animals. Medieval genealogical tables like the Tree of Jesse, or alphabet charts, such as *Abecedaria,* used well into the nineteenth century, lent some visual inspiration to the pictorial format. The world of medieval literature provided Lionni with other inspiration: bestiaries and Gothic encyclopedias are reflected in such parables as *Fish is Fish* and *The Biggest House.* . . .

Lionni explores the full range of artistic alternatives in any given phase of his work. When he works on his books, the idea and the text are first polished, which is surprising for a man of such visual orientation. Noting the prominence he gives to puns and word-play, however, the textual priority seems inevitable. His texts seem to reflect the verbal clarity and succinctness which comes from the practiced use of English as a second language and, perhaps, from the conciseness inherent in advertising. Once the text has been refined, the illustrations are considered and quickly follow, bringing the work into focus.

Lionni has returned to Italy, where he spent his university days as a student of economics (he holds a doctorate in the subject). He divides his time between a house of his own design overlooking the Bay of Genoa and a farmhouse in the Chianti hills which contains carefully collected, jewel-like *mementi* of numerous travels. Embroidered cloths and hammered brass trunks from his days as crafts advisor to India, Indonesian *wayang* puppets, and African sculpture are carefully though casually arranged against the white walls.

The house inspires reflection upon the recommendation in *The Biggest House* . . . to keep one's possessions light enough to be free at all times to go out into the world. For as one looks at Lionni's physical surroundings, the artistic souvenirs of a life which has been filled with interesting alternatives, one recognizes the value of the messages built into Lionni's texts—well-considered and lived truisms useful to us all. (p. 129)

> *Annabelle Simon Cahn, "Leo Lionni, Artist and Philosopher," in* Children's Literature: Annual of the Modern Language Association Seminar on Children's Literature and The Children's Literature Association, Vol. 2, *edited by Francelia Butler (© 1973 by Francelia Butler; reprinted by permission of Francelia Butler), Temple University Press, 1973, pp. 123-29.*

JOHN ROWE TOWNSEND

Leo Lionni has ingenious, offbeat ideas: the inchworm asked by the nightingale to 'measure my song' in *Inch by Inch* . . . ; the little fish that teaches other little fishes to swim in formation in the shape of a big fish (*Swimmy* . . .); the artist fieldmouse who stores up sun-rays and colours against the winter (*Frederick* . . .). Yet the effect is often one of flimsiness; an offbeat bright idea is not always strong enough to sustain a book. Lionni's first book for children, *Little Blue and Little Yellow* . . . was admittedly the most offbeat of all; it was however truly original and stimulating. Here the 'characters' are mere blobs of colour: abstract, but engagingly human in their associations. (pp. 316-17)

> *John Rowe Townsend, "Picture Books in Bloom: U.S.A.," in his* Written for Children: An Outline of English-Language Children's Literature *(copyright © 1965, 1974 by John Rowe Townsend; reprinted by permission of Harper & Row, Publishers, Inc.; in Canada by Kestrel Books), revised edition, J. B. Lippincott, Publishers, 1974, pp. 308-20.**

KARLA KUSKIN

Using the well remembered flora and fauna of his childhood Lionni furnishes his books with small stages and matching

personae. The discontented chameleon in **"A Color of His Own"** . . . has clearly wandered out of this past. Lionni, who is best known as an artist and designer, also has a knack for beginning a story with ease. He pares down sentences in much the same way that he simplifies his drawing and page design. So the story begins "Parrots are green . . . pigs are pink. All animals have a color of their own except for chameleons." This chameleon peers at us with the quietly desperate look of Charlie Brown in a lizard suit. His expression is unchanging no matter how brilliantly colored he becomes by standing on a lemon or in heather or upon a tiger's tail. Then he meets his mirror image, another chameleon, and a flicker of hope touches his gloomy green countenance (he is standing in grass at the moment). "Why don't we stay together?" suggests one to two, ". . . you and I will always be alike." Depending on where they go they proceed to turn purple and yellow and red with white polka dots, together. Let color be a synonym for mood and this becomes an idyllic romance. Lionni, who is always experimenting with new textures and techniques, combines painting and print making to render the stylized lizard set against soft, watered colors.

In **"In the Rabbitgarden"** . . . the mixture of mediums: crayon, pastel and collage, does not wed as successfully. The scale often overwhelms the story and the thick colors lack the meticulous clarity of much of Lionni's art. The story too has its opaque moments.

Two young rabbits are left by their mentor, the old rabbit, after he warns them against the fox. The two spy a beautiful carrot hanging from a tree. It turns out to be the tail of a serpent and he turns out to be an extremely nice snake who plies them with delicious apples, plays with them and eventually hides them from the fox by swallowing them whole. For a moment one may doubt the reptile's motives but when the fox flees the little rabbits reappear. Although they must have been regurgitated that key scene is missing and no mention of it is made. At last the old rabbit returns and the serpent befriends him with an apple too. "Maybe apples are just big, round shiny carrots that hang from carrot trees," is the big bunny's thought as he devours it. At which point the story doesn't end as much as it just stops. The reader may stop also to wonder, among other things, why the apples are carrot colored?

In **"Pezzettino"** . . . the Lionni compound of crayon and collage against pure white backdrops is handsome and effective. . . . Pezzettino, as his name implies, is a "little piece" of color who looks like an orange charm. "He was small and surely must be a little piece of somebody else." One day deciding to find out just who it is he belongs to he sets off on a journey across a landscape of marbled papers and over a beautifully patterned similar sea. The creatures he meets are abstract beasts constructed of many small squares. Pezzettino is sure he is a chip off one of these mosaic blocks until he trips and shatters realizing that he, like the others, is made of yet smaller pieces. "I am myself" he rejoices, pulling himself back together. Little as he is, he is a complete individual. It is an apt discovery to set before the very young.

Lionni selects from his store of remembered images with a carefully trained eye which peels away excess and sentiment and eccentricity. Contrasting patterns, shapes, a torn edge against flat color are basic to his graphic vocabulary. Pages are as patiently arranged as still lifes. Whether in the elementary collages of **"Little Blue and Little Yellow,"** the realistic, at times surrealistic, drawings of **"The Biggest House in the World"**

From Pezzettino, *written and illustrated by Leo Lionni. Pantheon, 1975. Copyright © 1975 by Leo Lionni. Reprinted by permission of Pantheon Books, a Division of Random House, Inc.*

or the mixed mediums of his most recent books his style is marked by a blend of glowing color and cool precision.

An early book, **"Frederick,"** tells about a family of mice who spend their nights and days gathering food for the winter. Not Frederick. He sits quietly gathering summer words and colors in his head. In the dead of the pale, wordless winter Frederick recalls and shares the summer memories he had stored away. Leo Lionni is such a collector, sharing his memories with affection and restraint. (pp. 28, 30)

Karla Kuskin, *"Three by Lionni," in* The New York Times Book Review *(copyright © 1976 by The New York Times Company; reprinted by permission), May 2, 1976, pp. 28, 30.*

LINDA ARNOLD

[The stories of Leo Lionni] are traditional fables in that animal characters and inanimate objects speak to certain moral considerations. Lionni as a fabulist certainly entertains his readers with tales succinct enough to fit the fable definition and enhanced with lively characters and unusual illustrations.

Fables have endured over the centuries because their underlying truths are meaningful to us today; however, the fabulists of each age of a necessity have written with their own particular societal considerations. Aesop, for example, is said to have adapted the ancient beast tale to fit the needs of tyrannous Greece. Leo Lionni may be considered a modern fabulist be-

cause he constructs many of his tales around the most crucial problem facing man today: survival. How can we get along in an increasingly hostile environment, one in which resources are constantly diminishing and power struggles are played for higher and higher stakes?

One way, Lionni's tales tell us, is by recognizing and using our talents. [*Inch by Inch* and *Swimmy* are examples of this]. (pp. 704-05)

The inchworm makes intelligent and creative use of his physical capabilities for his own survival; Swimmy's intelligent and creative thinking combined with courage leads to the preservation of himself and his school of fish. Indeed, it behooves the more mentally capable members of society to be the "eyes" for others.

Like the inchworm and Swimmy, Frederick, in the book of the same name, has something to contribute. Frederick's field mice companions busily gather food for the winter. They reproach Frederick when it appears he is idle, but he assures them that he, too, is working for the cold months ahead, gathering "sun rays for the cold dark winter days . . . colors . . . for winter is gray . . . and words."

In the midst of winter hibernation, when all the food supplies are exhausted, Frederick's friends call upon him. His suggestions of sun rays warm the mice, his reminders of blue periwinkles and yellow wheat take their minds off their empty stomachs, and his poetry recitation brings enthusiastic applause. Thus it seems that the contributions of the poet and therefore of all artists are as necessary for our spiritual survival as are the efforts of people who take care of our physical well-being.

In the process of learning to define and use our talents to survive we must also learn to recognize and accept the limitations imposed upon us by nature. An unwillingness to accept these limitations can sometimes lead to disaster, as is seen in *Fish is Fish*. (pp. 705-06)

Another fable that teaches us to live according to and in harmony with nature is *Biggest House in the World*. (p. 706)

Theodore, the mouse in *Theodore and the Talking Mushroom*, does not see his limitations in the proper perspective. Because he cannot grow a new tail like the lizard, swim under water like the frog, or "close like a box" like the turtle, he discounts his own ability to run. When he discovers a strange blue mushroom that utters, "Quirp!" he tells his friends that it is the Mushroom of Truth, the only one of its kind, and that what it says means that "the mouse should be venerated above all other animals." Believing him, his friends treat him in a kingly fashion until one day when they stumble upon an entire valley filled with blue mushrooms all chorusing, "Quirp!" When his angry friends turn on him, shouting, "Liar! Cheat! Charlatan!" he runs away and is never seen again. Thus Theodore's unwillingness to put his ability on a par with others leads to his eventual downfall and isolation.

A third way to survive is to know ourselves. In our increasingly complex society, in which man is faced with an overwhelming number of choices in so many situations, there is hardly time to contemplate Who am I? and What do I really want? Yet, an understanding of ourselves, an experiencing of ourselves as thinking, feeling human beings is crucial to intelligent decision-making. The better we understand who we are the more efficiently we will be able to order and enjoy life.

Three of Lionni's fables deal with this search-for-identity theme. *Tico and the Golden Wings* teaches us to be aware of and appreciate our uniqueness. Based on an old Hindu folktale, Tico is the story of a bird born without wings. When his wish for golden wings is granted his friends shun him for his opulent difference. He presents his feathers one by one to people in need, finding that as each golden one is plucked a real feather appears in its place. Even though now accepted by his friends for his apparent sameness, he observes, "We are all different. Each for his own memories, and his own invisible, golden dreams."

The fable of *Pezzittino* is perhaps the least imaginative of Lionni's search-for-identity stories. . . . Pezzittino's realization of his commonality is as important to his self-awareness as is Tico's discovery of his inner uniqueness.

As Tico's and Pezzittino's interaction with others helps them discover truths about themselves, so do Little Blue's and Little Yellow's experiences contribute to their self-understanding. . . . [Our] relationships and experiences with others do change us, but do not result in the loss of our own separate identities.

In addition to finding out who we are, another way to survive is to make sure we remain human beings who think for ourselves, no matter what the consequences. *Alexander and the Windup Mouse* illustrates this point. Alexander the mouse feels unloved because he is chased and screamed at by the people of the house. He would much rather be Willy, the mechanical mouse, who professes to be loved and cuddled. Alexander seeks out a lizard with magic powers who will make him like Willy, but he changes his mind when he finds Willy cast aside because new toys have been bought and his usefulness is over. Even though Alexander cannot be loved by his natural enemy, it is better at least to be alive, thinking for himself and loved by a few, than to be mechanical and cast off at someone else's whim.

More drastic results of being fooled by false prophets and of not thinking for ourselves occur in *The Greentail Mouse*. A community of field mice lives in bucolic harmony until a city mouse tells them about Mardi Gras. The country mice, deciding to hold a similar celebration, decorate the woods and masquerade as ferocious animals. During the revelry they forget they are harmless field mice and believe they really are ferocious animals. The community becomes filled with hate and suspicion until another visiting mouse tells the field mice to take off their masks and again be what they really are. If we behave long enough contrary to our real natures we will lose our identities.

Leo Lionni, then, is a successful fabulist of the modern age. His stories, while dealing with the serious theme of man's survival, offer the brevity, charm and entertainment that have made the fable an important and enduring literary genre. (pp. 706-08)

Linda Arnold, "Leo Lionni: Modern Fabulist" in Language Arts *(copyright © 1976 by the National Council of Teachers of English; reprinted by permission of the publisher), Vol. 53, No. 6, September, 1976, pp. 704-08.*

BARBARA BADER

"This is little blue," *Little Blue and Little Yellow* begins, showing us a true-blue blob. "Here he is at home with papa and mama blue. Little blue has many friends, but his best friend

"And how about the colors, Frederick?"
they asked anxiously. "Close your eyes again,"
Frederick said. And when he told them
of the blue periwinkles,
the red poppies in the yellow wheat,
and the green leaves
of the berry bush,
they saw the colors as clearly
as if they had been painted
in their minds.

From Frederick, *written and illustrated by Leo Lionni. Pantheon, 1967. Copyright © 1967 by Leo Lionni.*
Reprinted by permission of Pantheon Books, a Division of Random House, Inc.

is little yellow who lives across the street.'' At the second opening we understand . . . ; it is a new language, and we have the vocabulary and the key; just as one can, given a particular child, his family and his friends Jane and Tim and Mark, devise a multiplicity of plots, so one could, with sufficient imagination, carry on with the life of little blue. But children are enthralled from the words ''This is little blue'' much as they are from the opening of *Umbrella*. . . . (p. 525)

Lionni of course has in mind a plot intrinsic to his form—to his language of form and color. After pages of playing hide-and-seek (black streaks separate the patches one from another) and Ring-a-Ring o' Roses (the patches in a circle), of going to school (''in neat rows'' in a black rectangle) and letting loose after school (just imagine), little blue, left alone one day—and told to ''stay home''—goes looking for little yellow; but ''Alas! The house across the street was empty.'' He looks here (on a white page) and there (on a black page) ''and everywhere . . . until suddenly [the page is red], around a corner''—turn quickly—''there was little yellow!'' They hug each other and hug each other ''until they were green'': one solid light green. (p. 526)

The fascination in seeing *how* all these marvelous things happen—not only how little blue and little yellow become green but how they play in the park, run through a tunnel—is akin to that of seeing how Crockett Johnson's Harold, frightened, his pencil-hand shaking, falls into the ocean. It is tangible but not literal: the sense, the feel of the experience—and isolated

in Lionni's case, more immediate, more acute than the reality: the experience symbolized.

So, too, does the story have symbolic meaning—as individual or as general as one chooses. He was not writing about racial segregation, Lionni has said; but, quite evidently, it was as natural for him to be thinking about it then as for the question to be raised. In allegorical form, he portrayed human problems and human situations. . . . (pp. 526-27)

Nor would the conclusions, thinking particularly of *Little Blue and Little Yellow,* be as inescapable or, on the other hand, as admissible: to introduce circumstance is immediately to allow of exception, whether in the story or in oneself. We are at one with little blue and little yellow—as we were at one with [H. A. and Margret Rey's] *Spotty*—because we feel for them, but the significance of their plight is not forced upon us: it is because we feel it as a plight, see its source and understand its irrationality, that we can grasp its significance. And to the extent that the behavior in *Spotty* is indeed silly, it may be easier to dissociate ourselves from it than from the purely visual analogy that *Little Blue and Little Yellow* presents. ''This is little blue''; and by the power we possess to abstract and identify, it is you and me.

To find spreads the equal of these in sheer visual force we have to go back to Charles Shaw, to *It Looked Like Spilt Milk*. . . . Of further picturebooks that, on the other hand, engage us with abstract universals I can think offhand of only one, and that

not for children, Norton Juster's tongue-in-cheek romance of *The Dot and the Line*. Lionni isn't joking but *Little Blue and Little Yellow* is inherently funny: it *is* funny, an order of Nonsense, for a blue blob and a yellow blob to be best friends, for them to merge into a patch of green, for the green to emit blue and yellow tears. Lear would have appreciated it. . . . Except for want of a better word, one has in actuality no business calling little blue a blob; he is no more to be considered nondescript than a Charles Shaw cloud, the one that is "just a Cloud in the Sky." Ultimately it is the artist in both Lionni and Shaw that gives their books character, and Lionni's art that gives his conviction. . . . For his next book, *Inch by Inch*, he used collage in the more particular sense of preprinted or otherwise prepared paper—paper which by its own nature contributes to the image—and for equally evident reason. (pp. 527-28)

As an imaginative construct, it has the simplicity and inevitability of a poem; and with its sharply quizzical, block-patterned robin, its brilliantly crayoned head of a toucan, its sinuous neck of a flamingo, its elegantly elongated heron—all silhouetted against stark white paper—it is a breathtaking thing to look at. I tend to think of it as Lionni's Italian book and to associate it with Bruno Munari. . . . It is not just that Munari too is fond of flamingos, it is the cleanness and sharpness of the white page, and the vivid clarity of the forms.

But what was seen was less the composure than the textured and patterned paper; and with collage in the air (following Matisse's *papiers découpés,* Rand's bits and pieces) and full-color reproduction, requisite for full collage, becoming more feasible, it directed artists into paper jungles that are with us still. Lionni's grasses, silhouetted cut-paper forms, exist to be measured by the inchworm; stretching across the spread, they form a clear-cut yardstick by which, as he measures away, to gauge his progress. At the same time they have the interest, across an expanse, of independent and related visual forms; and, pictorially, they evoke what they represent. Where collage has appeared since, it has seldom appeared to such advantage.

Swimmy . . . is a more questionable quantity altogether; the situation, too, has not the tight rightness of *Little Blue and Little Yellow* or *Inch by Inch*. (pp. 528-29)

Objections can be raised on every hand. For a lone little fish-child, happiness is not 'a medusa made of rainbow jelly,' nor would a sea anemone look to him like 'palm trees swaying in the wind.' In union there may be strength, sometimes, but the composite fish remains a lot of little fishes: the visual illusion is visibly illusory. . . . But if *Swimmy* does not cohere, if we are conscious, always, of Lionni pulling the strings, it is ravishing to look at in turn—a wet-wash wonderland that set up waves of its own.

It is impossible to see—at all—and not recognize the beauty of Lionni's books; or, indeed, to feel and not acknowledge the sincerity of his purpose. But of subsequent titles *The Biggest House in the World* . . . seems to me to most nearly come together—the pictures to be most closely expressive of the parable, and that a pictorial one. A small snail says to his father, "When I grow up I want to have the biggest house in the world"; and his father tells him a story of a little snail, *"just like you,"* who made his house grow and grow . . . until it was as big as a melon . . . sprouted pointed bulges . . . acquired beautiful bright designs . . . and was taken by a swarm of butterflies for a cathedral (or a circus). But, unable to move on for more food, the little snail *"slowly faded away";* and

in time his house too crumbled *"until nothing remained at all."* The small listener has learned his lesson—as, from the vision of Rome-in-ruins, have we all; and he goes off happily through a wordless spread of giant ferns and budding stems, cracked, weather-worn bark, stones of all shapes and sizes, flowers, grasses, moss—as wonderful and, enlarged, as amazing as the enormous shell. One stone is as brilliantly spotted. (p. 530)

> Barbara Bader, *"Away from Words," in her* American Picture Books from Noah's Ark to the Beast Within *(reprinted with permission of Macmillan Publishing Company; copyright © 1976 by Barbara Bader),* Macmillan, 1976, pp. 525-43.*

CAROL STEVENS

In many ways, Lionni's picture books seem the most fulfilling outlet for his talents. They allow him to play with words and give vent to his effervescent stream of ideas. [Cipe] Pineles observes, "They pull out of him every bit of whimsy, laughter and humor." They also, in his search for the proper technique to express his ideas, give him an opportunity to experiment with an unlimited variety of media, from torn and cut paper, collage and rubber-eraser printing to watercolor, crayon and tight 6-H pencil drawings. (pp. 41, 93)

> Carol Stevens, *"Bursting Through Boundaries: Leo Lionni's Life with Design," in* Print, Special Issue: Leo Lionni *(copyright 1980 by RC Publications, Inc., 355 Lexington Ave., New York, NY 10017), Vol. XXXIV, No. III, May-June, 1980, pp. 35-41, 93.*

LITTLE BLUE AND LITTLE YELLOW: A STORY FOR PIPPO AND ANN AND OTHER CHILDREN (1959)

Lately it has seemed as if grown-ups were divided into three groups. The first, generally artists, are those who think Leo Lionni's **"Little Blue and Little Yellow"** wonderfully clever and handsome. The second group sees it mainly as a haphazard collection of color blobs and the third, which at first included this reader, admired its ingenuity but wondered if it weren't a sophisticated tour de force, too subtle for children. The latter—at least several groups ranging from 3 to 7—had no such reservations, possibly because children are unselfconscious artists themselves and love to play with color. They were fascinated by the idea that solid color-forms could be characters. They thought it very funny when Little Blue and Little Yellow played hide-and-seek with the other colors, and when the two hugged each other, turning green, to the confusion of their parents. The listeners and viewers promptly demanded colored papers, tore them into shapes and made up their own characters and stories. What better tribute? That they had just had an elementary lesson in color recognition and mixing was incidental—they were having fun.

> Ellen Lewis Buell, *"Colors and Shapes," in* The New York Times Book Review *(copyright © 1959 by The New York Times Company; reprinted by permission), October 25, 1959, p. 68.*

This overwhelmingly simple picture book is so charming and clever that we wonder no one has thought of doing one like it before. . . . The difficulty [Little Blue and Little Yellow's parents have in recognizing their children], and the way the difficulty is remedied make an excellent color lesson for very small children and an imaginative story. So well are the dots handled on the pages that Little Blue and Little Yellow and

their parents seem to have real personalities. It should inspire interesting color play and is a very original picture book by an artist.

> Margaret Sherwood Libby, "Guiding Young Eyes to Art: 'Little Blue and Little Yellow'," in New York Herald Tribune Book Review (© I.H.T. Corporation; reprinted by permission), November 1, 1959, p. 24.

[This is an] off-beat fantasy for the 3-6's. . . . The child may learn something about colors when Little Blue and Little Yellow hug each other and turn green. But to judge from the responses of one almost three, they will be more interested in the childish plight of a Little Yellow who comes home as another color. In Mr. Lionni's skilled abstractions, the colors weep so that a child knows what is going on. If his parents don't try to find too specific meanings, they may also have fun following these artfully designed pages.

> [Rod Nordell], in a review of "Little Blue and Little Yellow," in The Christian Science Monitor (reprinted by permission from The Christian Science Monitor; © 1959 The Christian Science Publishing Society; all rights reserved), November 5, 1959, p. 5B.

[In *Little Blue and Little Yellow*] you see how imagination can make of two children playing together a lesson and a delight. In this eccentric little book the characters (in fact, the only things on the page) are irregular blobs of paint, but I defy any child not to see them as lively images of themselves as they jump about the page and neatly illustrate the fact that blue and yellow make green.

> Margery Fisher, in a review of "Little Blue and Little Yellow," in her Growing Point, Vol. 1, No. 5, November, 1962, p. 75.

Told entirely in terms of blobs of color, the gaily amusing account of what happens to Little Blue and Little Yellow because of their close friendship is imaginative and original. As they delight in the adventures of the two friendly blobs of color, young children also gain a deeper understanding of harmony.

> Constantine Georgiou, "Picture Books and Picture Storybooks: 'Little Blue and Little Yellow'," in his Children and Their Literature (© 1969 by Prentice-Hall, Inc.; all rights reserved; reprinted by permission of the author), Prentice-Hall, Inc., 1969, p. 97.

[*Little Blue and Little Yellow*] is as simple, on the surface, as a picturebook could be. . . . [All] ends happily with a multi-coloured (multi-racial?) society. Mendelian geneticists may quibble at the scientific simplifications, but the message is clear.

> Elaine Moss, "Solace for Spring," in The Times Literary Supplement (© Times Newspapers Ltd. (London) 1977; reproduced from The Times Literary Supplement by permission), No. 3915, March 25, 1977, p. 355.*

INCH BY INCH (1960)

Leo Lionni, who last year gave us that rather startlingly abstract book, **"Little Blue and Little Yellow"**—which many children loved—has turned now to a somewhat more conventional form, although [**"Inch by Inch"**] would never be considered aca-

demic in its realism. . . . Thin as the story is, this is a book to look at again and again. The semi-abstract forms are sharply defined, clean and strong, the colors subtle and glowing, and the grassy world of the inchworm is a special place of enchantment.

> Ellen Lewis Buell, "Measure for Measure," in The New York Times Book Review (copyright © 1960 by The New York Times Company; reprinted by permission), November 6, 1960, p. 44.

With the same feeling for the beauty of great white spaces on a page and the same originality in using familiar forms in a striking and satisfying manner as Bruno Munari, Leo Lionni gives us a handsome and humorous picture book. As art it does not seem to us as distinguished as "Bruno Munari's ABC," partly because the artist prefers small precisely patterned designs on many of his big areas of color and partly because the choice of colors seems less beautiful. However, it is an outstanding picture book, and its tiny story is delightful. . . .

> Margaret Sherwood Libby, in a review of "Inch by Inch," in Lively Arts and Book Review (© I.H.T. Corporation; reprinted by permission), November 27, 1960, p. 35.

An enchanting picture book. . . . The illustrations are exquisite: beautiful clear colors, a unity of theme that combines with a variety of techniques, bold yet simple layout with a refreshing use of white space, and an imaginative interpretation of the text. It is regrettable that the illustrations extend to the end papers.

> A review of "Inch by Inch," in Good Books for Children: A Selection of Outstanding Children's Books Published 1950-65, edited by Mary K. Eakin (reprinted by permission of The University of Chicago Press; © 1959, 1962, and 1966 by The University of Chicago), third edition, University of Chicago Press, 1966, p. 213.

Inch by Inch grows from a very small idea, that the green caterpillar is just an inch long, but the artist makes the most of it, stringing it out through 32 pages of brilliantly coloured cut-paper designs. Undeniably clever, strong in personality, this is nevertheless a book which adult collectors will prize more than children.

> A review of "Inch by Inch," in The Junior Bookshelf, Vol. 31, No. 2, April, 1967, p. 107.

Essentially a book of pictures, which could exist perfectly well (or pretty well) without words. Perhaps we do need to be told that the nightingale has asked the caterpillar (or inch-worm) to measure her song, for this precipitates the climax of the story: but we can see for ourselves when and how measurements are taken of flamingo's neck, toucan's beak and heron's legs, and the greatest pleasure for a small child will probably be to follow with a finger the inches as they are crept along. This is a delightful and most original book with superb pictures in smooth, subtle colour.

> Margery Fisher, in a review of "Inch by Inch," in her Growing Point, Vol. 6, No. 1, May, 1967, p. 922.

As the little green worm travels across the pages of this book, his ingenuity and that of the artist become more and more apparent. The design of the compositions is creative and strik-

ing, and it becomes a challenge to locate the little green figure on each page. Cut shapes, torn shapes, corrugated cardboard, crayon and patterned paper give rise to a style and technique for which Lionni remains well known. The stark white backgrounds provide a perfect contrast for his creative designs. The curving neck of the flamingo loops across two pages, the beak of the bird curving back toward the inchworm, completing the composition.

The long legs of the heron lift the bird's body out of sight so that all that can be seen on the right is the graceful curve of the bird's neck, again leading the eye back toward the main character. As the worm inches across the pages at the close of the book, his progression through the tall blades of grass contrasts with his small size and emphasizes the triumph of the tiny crawler over his natural predator. (p. 320)

> *Linda Kauffman Peterson, "The Caldecott Medal and Honor Books, 1938-1981: 'Inch by Inch'," in* Newbery and Caldecott Medal and Honor Books: An Annotated Bibliography *by Linda Kauffman Peterson and Marilyn Leathers Solt (copyright © 1982 by Marilyn Solt and Linda Peterson; reprinted with the permission of Twayne Publishers, a division of G. K. Hall & Co., Boston), G. K. Hall, 1982, pp. 319-20.*

SWIMMY (1963)

An exquisite picture book which truly reflects the ethereal quality of underwater life. The illustrations demonstrate an-other technique by this artist: watercolor with pressing (other colors are pressed on the watercolor background with various materials such as rubber sponge, etc.). The story is slight. . . . The text won't bear constant repetition, but the pictures will evoke continuing awe from artistic, perceptive children.

> *Patricia H. Allen, in a review of "Swimmy," in* Library Journal *(reprinted from* Library Journal, *June 15, 1963; published by R. R. Bowker Co. (a Xerox company); copyright © 1963 by Xerox Corporation), Vol. 88, No. 12, June 15, 1963, p. 2547.*

What matters here is not the story but the masterly—and on the whole lovely—rendering of the underwater world, with its softness and lack of definition. A most thoughtful book, which may prove rather too indeterminate for the very small children to whom it seems to be directed. An artist's book.

> *A review of "Swimmy," in* The Junior Bookshelf, *Vol. 30, No. 3, June, 1966, p. 169.*

The pictures are original and very beautiful, with washes of pale but important colour giving the very feel of a watery world. The humour of Swimmy's campaign is evident in text as in pictures.

> *Margery Fisher, in a review of "Swimmy," in her* Growing Point, *Vol. 5, No. 5, November, 1966, p. 802.*

the legs of the heron...

From Inch by Inch, *written and illustrated by Leo Lionni. Ivan Obolensky, Inc., 1960. © 1960 by Leo Lionni. Reprinted by permission of Astor-Honor, Inc., New York, NY 10017.*

A child cannot own Swimmy or love Swimmy or fish for Swimmy because he is a symbol. However this brilliant tour de force of collage and color succeeds because Lionni makes this symbol a hero in a world of adventures and puzzles. It is far better to accept the fact that the artist fuses cool, muted sea-color with technique into meaningful painted fantasy rather than to list and explain his methods like a chemical analysis.

> *Diana Klemin, in a review of "Swimmy," in her* The Art of Art for Children's Books: A Contemporary Survey *(copyright © 1966, by Diana Klemin; reprinted by permission of The Murton Press), Clarkson N. Potter, Inc., 1966 (and reprinted by Murton Press, 1982).*

Individual differences can be very beneficial, as Lionni has demonstrated in word and pictures. His own individual, creative style brings the tale of Swimmy to life. Watery blues, grays, greens, and violets combine with repeated patterns and texture to create Swimmy's underwater home. The repetition of the figures in the school of fish gives the effect of block prints, and the patterned doily motif appears throughout the book and provides some unity.

When Swimmy's mood is lonely, sad, or troubled, the gray tones of the water dominate the page. When his spirits are high, the vibrant colors of the ocean floor predominate. Size remains an important element in this Honor Book, where a tiny being triumphs over larger, more dangerous foes. Physically, too, Swimmy remains a small black shape in contrast to the large pages of colorful underwater inhabitants.

Though Lionni's text is simple and direct, the economy of words makes the illustrations highly important in extending and embellishing the story. The artist's inventive style remains a popular one within the realm of picture books, and the underlying themes have a relevancy that wears well with time. (p. 327)

> *Linda Kauffman Peterson, "The Caldecott Medal and Honor Books, 1938-1981: 'Swimmy'," in* Newbery and Caldecott Medal and Honor Books: An Annotated Bibliography *by Linda Kauffman Peterson and Marilyn Leathers Solt (copyright © 1982 by Marilyn Solt and Linda Peterson; reprinted with the permission of Twayne Publishers, a division of G. K. Hall & Co., Boston), G. K. Hall, 1982, pp. 326-27.*

TICO AND THE GOLDEN WINGS (1964)

This is that rarity among picture story books—a strong story line to match the artistic strength of the illustrations. An exotic suggestion of Indian fable and art is present in the pictures and the text.

The implications of the story and its emotional undertones are universal. The oriental setting of the illustrations lends a timeless aura. The superbly crafted pictures display the simple, one-dimensional profile figures typical of the Far East backed up by a rich tapestry of delicately detailed leaves. The somber but variegated hues of the forest are illuminated by a subtle underlay of gold. This should fly at least as high as Mr. Lionni's *Swimmy* swam in 1963.

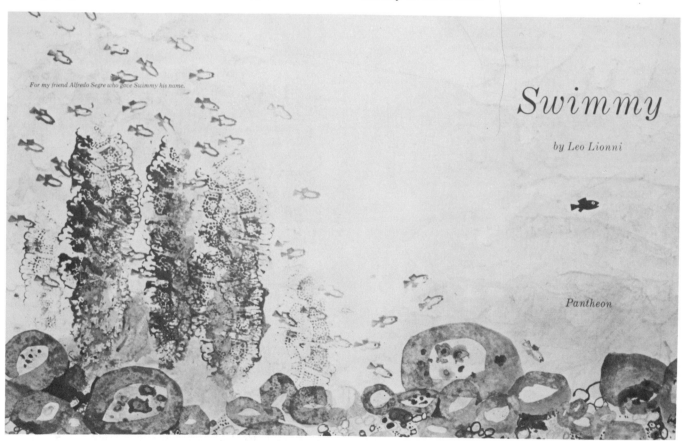

For my friend Alfredo Segre who gave Swimmy his name.

Swimmy

by Leo Lionni

Pantheon

From Swimmy, *written and illustrated by Leo Lionni. Pantheon, 1963. © copyright 1963 by Leo Lionni. Reprinted by permission of Pantheon Books, a Division of Random House, Inc.*

> *A review of "Tico and the Golden Wings," in* Virginia Kirkus' Service, *Vol. XXXII, No. 20, October 15, 1964, p. 1042.*

A picture book with richly detailed illustrations, stylized in adaptation of the ornate richness of Indian Art, and—with few exceptions—restrained in the use of space. The pictures have a dignity achieved by dark, plummy colors and a static quality: very handsome and quite different from the bright, childlike appeal of *Inch by Inch.*

> *Zena Sutherland, in a review of "Tico and the Golden Wings," in* Bulletin of the Center for Children's Books *(reprinted by permission of The University of Chicago Press; copyright 1965 by The University of Chicago), Vol. 18, No. 5, January, 1965, p. 76.*

Leo Lionni, who did the marvelously decorative pictures touched with gilt, wholly original but suggestive of Persian or medieval miniatures, or of tapestry designs, is an artist, like Frasconi and Munari, who can offer our young children a wonderful experience of beauty. We almost wish he had omitted the story entirely because it is trite, weak and confused, a very brief variant of the well-worn theme of enriching yourself by giving to others, mingled with rather puzzling comments on what constitutes being "different."

> *Margaret Sherwood Libby, "Putting Us in the Picture," in* Book Week—The Sunday Herald Tribune *(© 1965, The Washington Post), January 17, 1965, p. 19.**

Words and pictures of a strikingly unusual book have been directly inspired by the author-artist's recent travels in India. In a tender apologue Tico, a little bird born without wings, tells his story. . . . With traditional coloristic effects, Mr. Lionni has treated conventionalized Indian subjects and designs in an individualistic manner, revealing their patterns and emphasizing their textures.

> *Ethel L. Heins, in a review of "Tico and the Golden Wings," in* The Horn Book Magazine *(copyright © 1965, by The Horn Book, Inc., Boston), Vol. XLI, No. 1, February, 1965, p. 42.*

This is not a run-of-the-mill picture book at all. In fact it may not appeal to many 5-8's. The story is a rather dull fable. . . . But if the text is weak, the illustrations have a Far Eastern richness. Parents who point out the exotic designs, the exact patterns, the variegated colors with flashes of gold that give the effect of tapestry, can give their children a flavor of Indian art.

> *Patience M. Daltry, "The Cold That Came In with the Spy," in* The Christian Science Monitor *(reprinted by permission from* The Christian Science Monitor; *© 1965 The Christian Science Publishing Society; all rights reserved), February 25, 1965, p. C7.**

FREDERICK (1967)

What begins as a charming fable degenerates at the climax into ungrammatical doggerel. The distinguished illustrations, too, lapse into banality. They are effective, however, in conveying seasonal changes in the old stone wall, and the little field mice are immediately endearing. Perhaps the finished picture book will more nearly fulfill the promise of the beginning pages as seen in a prepublication state.

> *Priscilla L. Moulton, in a review of "Frederick," in* The Horn Book Magazine *(copyright © 1967, by The Horn Book, Inc., Boston), Vol. XLIII, No. 2, April, 1967, p. 196.*

Who wants to read about winter now? Why, anyone with an eye for beauty and, as in the case of **"Frederick,"** a taste for wisdom as well. . . .

This is only Leo Lionni's sixth book in nearly 10 years, but each one has been unique, varied in artistic expression. Here he uses a paper-collage technique to produce another outstanding volume. As Frederick's friends tell him, "You are a poet"; so is Lionni—with a palette.

> *George A. Woods, in a review of "Frederick," in* The New York Times Book Review *(copyright © 1967 by The New York Times Company; reprinted by permission), June 11, 1967, p. 32.*

This anti-Aesop fable does not take itself too seriously while proving that mice and men do not live by bread alone; the story ends in a shy little rhyming joke that very young children can recognize as one of their own. The collage drawings show stylized mice against a backdrop of bright scenery resembling stage settings. This is a splendid achievement in pure design that will enhance the natural taste of young readers while entertaining them.

> *Jean C. Thomson, in a review of "Frederick," in* Library Journal *(reprinted from* Library Journal, *June 15, 1967; published by R. R. Bowker Co. (a Xerox company); copyright © 1967 by Xerox Corporation), Vol. 92, No. 12, June 15, 1967, p. 2445.*

Frederick, a picture story illustrated by a type of collage of paper-cut-outs, interprets in an amusing yet far-reaching manner the tension between the artist as an outsider and the rest of the world around him—the whole thing disguised as a mouse story. The plot contrasts the meditative person with the realistic-materialistic character, and, at the same time, the imaginative simplicity and charm of the story do not fail to recognize the seriousness of the situation. *Effect on the child:* In his relationship with the pictures and the story he will come into dialogue on another, broader plane with his peers and with adults. Children are aware that there are social tensions and individual personal problems; children learn that people with different natures, different ways of thinking and different feelings should be treated with tolerance and respect. This learning process ensues with the assistance of artistic-literary aids. (p. 68)

> *Horst Künnemann, "A + B and then What?" in* Bookbird, *Vol. VIII, No. 2 (June 15, 1970), pp. 65-70.**

A plea for excusing the artists and poets of this world from the drudgery of everyday chores, told for four-year-olds in prose interspersed with second-rate, ungrammatical verse, is lifted above the general run of picture books by the superb illustrations. The artist uses a liberal mixture of cut-outs and tear-outs and exploits the varied textures of his papers to produce charming double spreads in subtle colouring of the exploits of his five little fieldmice. . . . The only criticism is that no one in his senses could have excused Frederick from sharing in the work for the sort of verse he produces. It is perhaps captious to quibble because nobody would grudge doing the washing up for Lionni the artist, whose pictures invite the finger as well as the eye to trace the shapes and patterns. Good books, however, must be judged by the highest standards.

C. Martin, in a review of "Frederick," in The Junior Bookshelf, *Vol. 35, No. 5, October, 1971, p. 229.*

The torn paper shapes of the bodies of the mice, the patterned foreground and background shapes, and the corrugated look of stalks of wheat are all indicative of the variety of media Lionni employs to bring his simple, yet meaningful, texts to life. Textures and patterns abound in the compositions created by the rounded, secure shapes of the stones of the mouse hideout.

Because there is little detail in the compositions, slight variations in the shapes and positions of the eyes of the mice become very important reflections of the moods of the characters. Frederick is distinguished by his half-closed eyes, giving him a detached, remote gaze.

Lionni's subtle themes continue to find expression in his lovable creatures of the animal world, and their small size makes them endearing heroes to their faithful audiences.

Linda Kauffman Peterson, "The Caldecott Medal and Honor Books, 1938-1981: 'Frederick'," in Newbery and Caldecott Medal and Honor Books: An Annotated Bibliography *by Linda Kauffman Peterson and Marilyn Leathers Solt (copyright © 1982 by Marilyn Solt and Linda Peterson; reprinted with the permission of Twayne Publishers, a division of G. K. Hall & Co., Boston), G. K. Hall, 1982, p. 337.*

THE BIGGEST HOUSE IN THE WORLD (1968)

Leo Lionni's books could always be considered fables in our time—his newest is no exception. It is a fable in which he suggests that the biggest is not always the best. He doesn't just suggest it—with his handsome pictures of snails, the houses they carry and the green world they live in, he proves it.

A review of "The Biggest House in the World," in Publishers Weekly *(reprinted from the April 1, 1968 issue of* Publishers Weekly, *published by R. R. Bowker Company, a Xerox company; copyright © 1968 by Xerox Corporation), Vol. 193, No. 14, April 1, 1968, p. 39.*

In the style of fine picture books, the illustrations extend the story so the reader experiences both the wonder and excitement of watching the enormous shell grow, and later the relief and joy of the small snail as he explores his own world. The translucent color of the pictures and the simplicity of the text make a perfect combination.

Anne Izard, in a review of "The Biggest House in the World," in Book World—The Washington Post *(© 1968 Postrib Corp.; reprinted by permission of* Chicago Tribune *and* The Washington Post), *May 5, 1968, p. 4.*

If the picture book is a new visual art form in our time, Leo Lionni is certain to be judged a master of the genre. His books stretch the sensibilities and make us, adult and child, more aware of the world beneath our feet and just beyond the garden fence. **"The Biggest House in the World"** . . . zooms in on the snail's small, cabbage-leaf habitat with a naturalist's delight. At midpoint, Mr. Lionni fabricates a multi-turreted giant shell for his snail with hubris that fills our wondering eyes with a new vision of fairyland. A thoughtful child will return to his graphic magic again and again.

Selma G. Lanes, in a review of "The Biggest House in the World," in The New York Times Book Review

(copyright © 1968 by The New York Times Company; reprinted by permission), May 5, 1968, p. 54.

A child could hardly do better than take the snail as a life-model. . . . The snail builds its own silver path to crawl upon. And the snail is always at home; it carries around with it a house of just the right size and protective coloring. Leo Lionni's story, illustrated in bold line and color, zeroes in on this last virtue of the snail. Any child will be better—and happier—for having met his wise little house-owner.

Peter J. Henniker-Heaton, in a review of "The Biggest House in the World," in The Christian Science Monitor *(reprinted by permission from* The Christian Science Monitor; *© 1968 The Christian Science Publishing Society; all rights reserved), July 3, 1968, p. 11.*

Lionni always has something different to offer, in theme and technique. For this tale of a snail suffering from a misconceived ambition he adopts a narrow environment. Almost all the action takes place on cabbage leaves. It is a severe test of the artist's strength and resourcefulness, but he comes through triumphantly. The predominating greens are always interesting and varied, and he uses the rare moments of strong colour with the skill of a dramatist.

Marcus Crouch, in a review of "The Biggest House in the World," in The Junior Bookshelf, *Vol. 43, No. 2, April, 1979, p. 96.*

From The Biggest House in the World, *written and illustrated by Leo Lionni. Pantheon, 1968. © copyright 1968 by Leo Lionni. Reprinted by permission of Pantheon Books, a Division of Random House, Inc.*

THE ALPHABET TREE (1968)

Leo Lionni is a moralist. And that's fine because he's an honest moralist—he tells a moral tale, makes his moral point straight out and makes it with dash and style, as in his **"Little Blue and Little Yellow"** and in **"Swimmy"** (your reviewer's favorite). The moral tale here is in **"The Alphabet Tree."** But where is the dash and style? The Lionni touch seems heavy-handed, this time around.

> *A review of "The Alphabet Tree," in* Publishers Weekly *(reprinted from the November 11, 1968 issue of* Publishers Weekly, *published by R. R. Bowker Company, a Xerox company; copyright © 1968 by Xerox Corporation), Vol. 194, No. 20, November 11, 1968, p. 49.*

Children are sure to be fascinated with letters of the alphabet living in the trees and rocking in the gentle breeze of spring. As always with Lionni, his illustrations are a glorious visual feast.

> *Rose H. Agree, in a review of "The Alphabet Tree," in* Instructor *(copyright © 1969 by The Instructor Publications, Inc.; used by permission), Vol. LXXVIII, No. 6, February, 1969, p. 180.*

A weak, sententious text is not redeemed by the distinguished artist's striking full-color illustrations. What begins as a dull but acceptable lesson on letters, words and sentences finishes as a contemporary fable on pacifism and the social utility of language. The acid political overtones of the topical punch line are more likely to hold attraction and meaning for political hip-to-yip adults rather than for the young children the format and illustrations suggest. The Alphabet Tree shelters letters until a gale blows some of them away and frightens the rest. A helpful word-bug convinces those remaining that they are stronger when combined into words, and a purple caterpillar teaches them to form sentences, chiding them to say something important like "peace on earth and goodwill toward all men." Loading the letters—marshalled into this slogan—onto his back, the caterpillar begins climbing down the tree. " 'But where are you taking us?' they asked anxiously." The caterpillar, pictured in a double page-spread with only the word "peace" showing on his fast disappearing posterior, replies, " 'To the President.' " Mr. Lionni's captioning texts, since the effective understatement of *Little Blue and Little Yellow* . . . show a steadily increased tendency on his part to spell out moral messages, and this time it's close to what Jules Feiffer does better for an adult audience better prepared to receive it.

> *Elva Harmon, in a review of "The Alphabet Tree," in* School Library Journal, *an appendix to* Library Journal *(reprinted from the February, 1969 issue of* School Library Journal, *published by R. R. Bowker Co./A Xerox Corporation; copyright © 1969), Vol. 15, No. 6, February, 1969, p. 67.*

Too complicated in concepts for the youngest, and slight in plot, the story doesn't have enough about words to please the word-lover, and the fantasy of sentient letters is lost in the message at the ending. The illustrations are lovely, but page after page of lovely leaves begins to pall.

> *Zena Sutherland, in a review of "The Alphabet Tree," in* Bulletin of the Center for Children's Books *(reprinted by permission of The University of Chicago Press; copyright 1969 by The University of Chicago), Vol. 22, No. 7, March, 1969, p. 115.*

ALEXANDER AND THE WIND-UP MOUSE (1969)

It's the turn this very ordinary plot takes that makes all the difference [Alexander discovers that being a real mouse is better than being a toy mouse like Willy]. . . . It's a happy solution but not one of Mr. Lionni's most felicitous picturizations: the two mice pale against textures and patterns that have nothing to do with their situation, the modest domestic drama being diminished rather than enhanced by the decor. Still, a little of Alexander and Willy is better than none.

> *A review of "Alexander and the Wind-Up Mouse," in* Kirkus Reviews *(copyright © 1969 The Kirkus Service, Inc.), Vol. XXXVII, No. 22, November 15, 1969, p. 1251.*

Domestic Alexander looks exactly like Frederick, a country cousin in an earlier book. His story, like Frederick's, is a simple one with an obvious message; the pictures, apart from the overly whimsical mice, are worked in beautiful, imaginative collage.

> *Ethel L. Heins, in a review of "Alexander and the Wind-Up Mouse," in* The Horn Book Magazine *(copyright © 1970 by The Horn Book, Inc., Boston), Vol. XLVI, No. 2, April, 1970, p. 153.*

Alexander's story lacks the depth and resonance of Lionni's previous mouse fable, **Frederick** . . . , but the illustrations employ the same imaginative collage techniques—less subtly, perhaps, but with even richer and more spectacular effects. Tissue-paper, marbelized and patterned papers, newspaper, Japanese rice paper are some of the surfaces used to provide a brilliant background for the endearing little grey mouse who looks a lot like Frederick but has a personality all his own.

> *Sada Fretz, in a review of "Alexander and the Wind-Up Mouse," in* School Library Journal, *an appendix to* Library Journal *(reprinted from the May, 1970 issue of* School Library Journal, *published by R. R. Bowker Co./A Xerox Corporation; copyright © 1970), Vol. 16, No. 9, May, 1970, p. 60.*

The coloured illustrations of this book are quite outstanding. The bright print designs and marbled textures give the effect of collage, on which the clean colours of the stylised grey mouse Alexander and his clockwork friend Willy, against white and black backgrounds, are deeply satisfying. The charming story has a neat twist. . . . This deserves to become a classic among picture books.

> *Mary Hobbs, in a review of "Alexander and the Wind-Up Mouse," in* The Junior Bookshelf, *Vol. 35, No. 6, December, 1971, p. 364.*

FISH IS FISH (1970)

Entirely refreshing . . . is Leo Lionni's graphic flight, via crayon and pencil, into the world of nature in **"Fish Is Fish."** . . . With his accustomed subtle interplay of graphic wit, clear language and plain thinking, he wisely proves that a minnow's grasp should not exceed his oxygen supply—i.e., that there's lots to be said for the life of even a small fish in a small pond.

> *Selma G. Lanes, in a review of "Fish Is Fish," in* The New York Times Book Review *(copyright © 1970 by The New York Times Company; reprinted by permission), November 8, 1970, p. 53.*

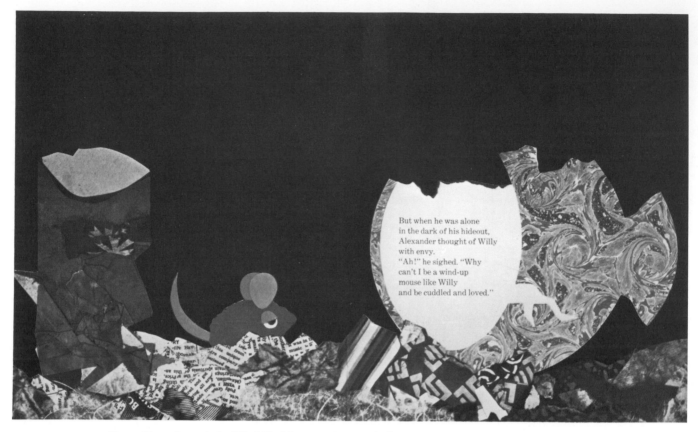

From Alexander and the Wind-Up Mouse, *written and illustrated by Leo Lionni. Pantheon, 1969. Copyright © 1969 by Leo Lionni. Reprinted by permission of Pantheon Books, a Division of Random House, Inc.*

Once again, Lionni has created a superior picture book, simple but eye-catching. The colorful crayon drawings, with their especially amusing—and logical—depiction of the way in which the fish visualizes people, cows, etc., will delight any young audience.

> *Joan M. Eaton, in a review of "Fish Is Fish," in* School Library Journal, *an appendix to* Library Journal *(reprinted from the January, 1971 issue of* School Library Journal, *published by R. R. Bowker Co./A Xerox Corporation; copyright © 1971), Vol. 17, No. 5, January, 1971, p. 43.*

A companion to **Swimmy,** with an all-too-familiar message urging contentment with one's own station. It is through his art, however, that the author-illustrator has avoided triteness. The simplicity and economy of the text . . . will suit the young picture-book age. But it is the large, full-color animations that delight: the swaying green water weeds; the swimming companions in the deep where the fish refuses to believe that the tadpole is becoming a frog ("'Frogs are frogs and fish is fish and that's that!'"); the flying birds, horned cow with her "pink" bag of milk, the dressed-up human family—all with amusing fish-shaped bodies.

> *Virginia Haviland, in a review of "Fish Is Fish," in* The Horn Book Magazine *(copyright © 1971 by The Horn Book, Inc., Boston), Vol. XLVII, No. 1, February, 1971, p. 43.*

Leo Lionni's **Fish is Fish** is a delightful book that seeks neither to preach nor to inform. . . . Mr Lionni does not spread the marvels of the underwater world before our wondering gaze (or rather, he does so only incidentally, in his pictures): instead, he invites us to contemplate the way a fish might imagine the creatures, including ourselves, that live on dry land. His luscious pastel drawings give graphic life to the images created in the mind of a minnow by the stories a frog tells him about life on land. We see feathered fish flying, four-legged fish with horns and udders and two-legged fish with clothes on; there is material here for unending speculation about the basic concepts on which our imaginations build.

> *"Celebrating Nature," in* The Times Literary Supplement *(© Times Newspapers Ltd. (London) 1972; reproduced from* The Times Literary Supplement *by permission), No. 3661, April 28, 1972, p. 488.**

This simple picture book is completely spoilt by the garish illustrations in the middle of the book, where humanised and bovine fish entirely reject the good design and colour which are a feature of the rest of the book. They seem to be a travesty of the gay wit and humour which could have accompanied such an imaginative story. Small children love to watch tadpoles, for they are one of few creatures which their impatient minds can actually see develop. It is a pity that the balance of this otherwise delightful book should be so spoilt.

> *Jean Russell, in a review of "Fish Is Fish," in* The Junior Bookshelf, *Vol. 36, No. 3, June, 1972, p. 155.*

From Fish Is Fish, *written and illustrated by Leo Lionni. Pantheon, 1970. Copyright © 1970 by Leo Lionni. Reprinted by permission of Pantheon Books, a Division of Random House, Inc.*

THEODORE AND THE TALKING MUSHROOM (1971)

Theodore is just too appealing for either his self-promotion or his disappearance to be taken with equanimity, but we have to admit that his fate fits the crime. Lionni's collages in earthy browns and greens (except for the mushrooms) are more restrained than his backgrounds for *Alexander and the Wind-up Mouse* . . . and subtler in their interplay of artifice and nature.

> *A review of "Theodore and the Talking Mushroom," in* Kirkus Reviews *(copyright © 1971 The Kirkus Service, Inc.), Vol. XXXIX, No. 22, November 15, 1971, p. 1210.*

Happy news for Leo Lionni fans! He is back again with a new mouse character, very reminiscent of Frederick and Alexander. . . . After several days of pomp and circumstance, Theodore gets his comeuppance in a most satisfying manner. Mr. Lionni's collages with their bright, earthy colors and defined shapes are suitably set against large areas of white background. A real charmer.

> *A review of "Theodore and the Talking Mushroom," in* Publishers Weekly *(reprinted from the December 6, 1971 issue of* Publishers Weekly, *published by R. R. Bowker Company, a Xerox company; copyright © 1971 by Xerox Corporation), Vol. 200, No. 23, December 6, 1971, p. 53.*

Leo Lionni's gentle animal fables occupy a very special place in the hearts of children. The hero in his newest is a mouse, but Theodore does not come of the same stock as that poet-philosopher, Frederick. Yet, mouselike though he may appear, he is full of recognizable frailties which make him endearing in his own right. Color and design are dramatically interwoven to create the visual feast which characterizes the superb artistry of Lionni's work.

> *Rose H. Agree, in a review of "Theodore and the Talking Mushroom," in* Instructor *(copyright © 1972 by The Instructor Publications, Inc.; used by permission), Vol. LXXXI, No. 8, April, 1972, p. 142.*

Lionni's illustrations are as captivating as in his previous books; however, while his protagonists usually reach satisfying solutions to their problems, Theodore's fate seems unduly harsh. After all, his hubris is not an uncommon one, that of enlarging upon the truth to enhance self-esteem. Banishment seems a steep price for a valley of "Quirping" mushrooms. On balance, then, Lionni's pictures cannot overcome the depressing conclusion to Theodore's adventures.

> *Barbara Gibson, in a review of "Theodore and the Talking Mushroom," in* Library Journal *(reprinted from* Library Journal, *July, 1972; published by R. R. Bowker Co. (a Xerox company); copyright © 1972 by Xerox Corporation), Vol. 97, No. 13, July, 1972, p. 2478.*

THE GREENTAIL MOUSE (1973; British edition as *The Greentailed Mouse*)

In Lionni's fourth mouse fable his familiar little gray rodent is set against still a fourth distinctive background—this one not collage but double-page textured paintings in orange-browns and blues, subdued to match the "quietest corner of the Willshire woods" where "a community of field mice lived a peace-

ful life.'' . . . Even though *Frederick* the poet remains the Lionni mouse with the sharpest message and most appealing personality, *The Greentail Mouse* has a simple, satisfying plot, some nicely modulated mood changes, and pictures that reflect and serve the story more organically than some of Lionni's more spectacular collages.

> *A review of ''The Greentail Mouse,'' in* Kirkus Reviews *(copyright © 1973 The Kirkus Service, Inc.), Vol. XLI, No. 20, October 15, 1973, p. 1154.*

Lionni's fatly formless, big-eared, popeyed mice in richly colored collages are familiar from the more successful picturebooks in which they've appeared. . . . As always, the mice are static and undifferentiated. They need an unmistakable yet subtle storyline to lend the action and/or reveal the point of their activities. They don't get it in this title. . . . In preaching about the complexities and pitfalls of early childhood's easy entries and often difficult exits from ''let's pretend,'' Lionni treads too heavily where only the lightest adult step is bearable for this audience.

> *Lillian N. Gerhardt, in a review of ''The Greentail Mouse,'' in* School Library Journal, *an appendix to* Library Journal *(reprinted from the November, 1973 issue of* School Library Journal, *published by R. R. Bowker Co./A Xerox Corporation; copyright © 1973), Vol. 20, No. 3, November, 1973, p. 41.*

The psychological concepts of masks, identity crises, appearance-versus-reality, and acceptance-of-self seem manipulated to state a message rather than tell a story, and the narrative sinks under the weight of pseudo-psychology. The illustrations make use of pleasing bright colors and bold shapes (the mice look like wind-up toys); the doublespreads of the mice cavorting in their masks are reminiscent of the wild dance sequence in Sendak's *Where the Wild Things Are*. . . .

> *Sidney D. Long, in a review of ''The Greentail Mouse,'' in* The Horn Book Magazine *(copyright © 1974 by The Horn Book, Inc., Boston), Vol. L, No. 2, April, 1974, p. 141.*

[In *The Green Tailed Mouse*] the mice are equally transparent symbols for our own frailties, and the best of the pictures have a considerable self-explanatory symbolic force. . . . There are good big double-spreads (without words) of mask-making and carnival, though in the end the mice are so simply drawn that their faces get a little boring. (p. 739)

> *David Gentlemen, ''Dog Days,'' in* New Statesman *(© 1974 The Statesman & Nation Publishing Co. Ltd.), Vol. 87, No. 2253, May 24, 1974, pp. 739-40.**

Growing up is akin to being a grown-up in that both states share the harrowing frustrations of daily life. The ability to cope is what determines how a person will provide for his survival. Children are instinctively interested in this aspect of life because they know that a mastery of it is essential to their own development.

The field mice in *The Greentail Mouse* live in a visually stimulating world created for them by Lionni's imaginative use of gouache. Inspired by a city mouse's description of Mardi Gras the field mice decide with the spontaneity of children to have their own Mardi Gras. The ingredients for the festivities are streamers and confetti along with music, dance and big scary masks. The mice are so involved in their celebration that their

ability to distinguish between reality and fantasy is diminished. They are lost in a world dominated by the ferocity that their masks invoked. Lionni magnifies this terror by the use of a double page spread with a dark murky background. Not wanting to be mean, he soon relents and brings on a strange mouse who is capable of relieving the mice of their torment.

Blue skies and soft clouds cushion the return of the field mice to reality. The horrors of their fantasy are neatly burned into oblivion with the masks. Greentail, however, is left with a constant reminder of that awful celebration. (p. 227)

People have wonderful ways of dealing with bad memories. Rather than regarding her tail as a scar or talking about her painful experience Greentail chooses to tell other mice that her green tail is the result of a festive occasion. Although this may not be the best way to cope with painful thoughts, it is what many people do.

But, when writing for children, I feel the author has an obligation to show them how to deal constructively with problems or fears that are raised in his story. Lionni takes the easy way out by allowing Greentail to hide her fear behind bright colors and cheerful words. Greentail merely exchanges a scary mask for one with an artificial smile, and the attractiveness of the new mask has the potential of fooling children into believing that prettiness and happiness are interchangeable.

It is a shame that a beautiful book was compromised for a slick ending. (p. 228)

> *Iris Finkelbrand, '''The Greentail Mouse', written and illus. by Leo Lionni,'' in* Children's Literature: Annual of the Modern Language Association Seminar on Children's Literature and The Children's Literature Association, Vol. 3, *edited by Francelia Butler (© 1974 by Francelia Butler; reprinted by permission of Francelia Butler), Temple University Press, 1974, pp. 227-28.*

IN THE RABBITGARDEN (1975)

The unique artistry of the author-illustrator makes him a great favorite not only with critics but with adults and children. Here are his bunnies again, in a sly spoof at the Adam and Eve myth. . . . They are tempted to disobey by a sage serpent, with funny and happy results instead of doom and gloom. And this book is all one needs to chase the glooms on the darkest day.

> *A review of ''In the Rabbitgarden,'' in* Publishers Weekly *(reprinted from the May 5, 1975 issue of* Publishers Weekly, *published by R. R. Bowker Company, a Xerox company; copyright © 1975 by Xerox Corporation), Vol. 207, No. 18, May 5, 1975, p. 96.*

No moral is cited, but there's a definite note of never-too-old-to-learn. The collage illustrations are bold in composition, excellent for group showing because of their scale, and the use of color is restrained and effective. The story line isn't strong, but it is firm, and the message that adults aren't always right will surely please the read-aloud audience.

> *Zena Sutherland, in a review of ''In the Rabbitgarden,'' in* Bulletin of the Center for Children's Books *(reprinted by permission of The University of Chicago Press; © 1975 by The University of Chicago), Vol. 29, No. 1, September, 1975, p. 14.*

A silly story serves as vehicle for a lot of bold, bright, child-like illustrations. . . . Shades of *Peter Rabbit,* the Garden of Eden, and Harper's *The Gunniwolf* . . .—but nowhere near as good a story as any of them—or as good as anything else by Lionni.

> *Marjorie Lewis, in a review of "In the Rabbitgar-den," in* School Library Journal *(reprinted from the September, 1975 issue of* School Library Journal, *published by R. R. Bowker Co./A Xerox Corporation; copyright © 1975), Vol. 22, No. 1, September, 1975, p. 86.*

Lionni is one of the world's masters of the picture book. Even in his lighter moods, as shown here, he is never less than impressive.

The rabbitgarden is a kind of Eden, in which a pair of rabbits have the run of all the food—but not the apples. One suspects allegory, but no; the serpent turns out to be both tempter and protector. Even the old rabbit, suspicious at first, relents and eats up the juiciest apple of all. Gorgeous colours and strong designs match the words beautifully.

> *Marcus Crouch, in a review of "In the Rabbitgar-den," in* The Junior Bookshelf, *Vol. 40, No. 5, Oc-tober, 1976, p. 266.*

A COLOR OF HIS OWN (1975; British edition as *A Colour of His Own*)

I suppose chameleons must have problems of identity. Leo Lionni's certainly has and like so many other problems the solution is love. What does it matter if you keep changing your colour if you have a companion who does the same? The colours are gorgeous and children just beginning to read will treasure this tale to look at over and over again.

> *Donald Young, in a review of "A Colour of His Own," in* The Junior Bookshelf, *Vol. 39, No. 4, August, 1975, p. 241.*

The point of *A colour of his own* is a biological one, and the book is really a study in colour, an example of what a picture-book can effectively do beyond merely interpreting or sup-porting words. . . . Wash and stipple effects carried out in lively colour illustrate the animal's special attribute and the point is made so readily that the book could almost dispense with words. (pp. 2713-14)

> *Margery Fisher, in a review of "A Colour of His Own," in her* Growing Point, *Vol. 14, No. 4, Oc-tober, 1975, pp. 2713-14.*

A slight fable. . . . The book is fun, the illustrations are smash-ing, and Lionni is up to his usual high standards in his use of vivid color and unusual printing effects. The mood expressing eyeballs of the frustrated chameleon are an especially charming Lionni touch. Visually rewarding, if you don't mind perpet-uating the myth of the red and white polka dotted chameleon. (pp. 51-2)

> *Merrie Lou Cohen, in a review of "A Color of His Own," in* School Library Journal *(reprinted from the May, 1976 issue of* School Library Journal, *published by R. R. Bowker Co./A Xerox Corporation; copyright © 1976), Vol. 22, No. 9, May, 1976, pp. 51-2.*

PEZZETTINO (1975)

"Pezzettino" is a simplistically silly story about a "thing" which is so small it thinks it is part of something else. The illustrations, artistically outrageous, suggest modern linoleum. Since small children live close to the linoleum they may ap-preciate this offbeat quality enough to make the book a success.

Parents who are Educators, with masters degrees in child psy-chology, may also see **"Pezzettino"** designed as a professional remedy for small fry schizoids. But never mind, the youngster will probably be able to identify with the mixed-up microcosm and think it is a fun thing.

As it turns out the little 'thing' discovers he is all himself and not part of something else. Presumably this is a happy ending; both for children and whatchamacallits.

> *Guernsey LePelley, "Gnats Swarm to the Rescue in Knotty Pine Tale," in* The Christian Science Monitor *(reprinted by permission from* The Christian Science Monitor; *© 1975 The Christian Science Publishing Society; all rights reserved), November 5, 1975, p. B8.**

The illustrations on heavy, glossy paper with clear color re-production are effective (especially the swirling, many shaded ocean that almost moves on the page), and their simplicity of line complements the straightforward story.

> *Carolyn Johnson, in a review of "Pezzettino," in* School Library Journal *(reprinted from the Decem-ber, 1975 issue of* School Library Journal, *published by R. R. Bowker Co./A Xerox Corporation; copyright © 1975), Vol. 22, No. 4, December, 1975, p. 47.*

Pezzettino is a small orange square who wonders who he is, suspecting he might be a piece (the name means "little piece") of somebody else. . . . The colors of the squares are bright (although not as forceful as the Wildsmith palette) and true, the figures have a primitive look, and the textures of the collage backgrounds are intriguing. The story is, despite its message, not substantial and not highly original, since there are many books about creatures that are happy to be themselves after an identity search. Two points may be confusing: one, Pezzettino, when he breaks into smaller pieces, thinks, "The wise-one had been right," whereas the wise-one says nothing about who or what Pezzettino is; two, all the other creatures are multicolor so that they seem different kinds of entities. (pp. 113-14)

> *Zena Sutherland, in a review of "Pezzettino," in* Bulletin of the Center for Children's Books *(re-printed by permission of The University of Chicago Press; © 1976 by The University of Chicago), Vol. 29, No. 7, March, 1976, pp. 113-14.*

A psychological aspect of atomic theory, illustrated with a diverting use of contrasting colour and form; the book has something of the perception and wit of the classic **"Little Blue and Little Yellow"**.

> *Margery Fisher, in a review of "Pezzettino," in her* Growing Point, *Vol. 16, No. 2, July, 1977, p. 3151.*

I WANT TO STAY HERE! I WANT TO GO THERE! A FLEA STORY (1977)

[Leo Lionni] has created another of his inimitable picture books. Readers never see the leading players in Lionni's story, just their conversation in balloons on each page. The flea with the

wanderlust has its speech encircled in blue while the flea home-body's is in red. What we do see and marvel at are the color collages where the insects argue. At first, they're at home in the woolly brown coat of a poodle. The compulsive traveler coaxes its friend to hop onto a turtle, and they are off together until the reluctant one heads back home while the adventurer pushes on. The book is grand comedy, sumptuous art and another subtle affirmation of Lionni's philosophy: Be yourself.

> *A review of "I Want to Stay Here! I Want to Go There! A Flea Story," in* Publishers Weekly *(reprinted from the July 11, 1977 issue of* Publishers Weekly, *published by R. R. Bowker Company, a Xerox company; copyright © 1977 by Xerox Corporation), Vol. 212, No. 2, July 11, 1977, p. 81.*

One must tread lightly where Lionni is concerned, for he is one of our most artistically accomplished picture-book creators, and many of his books have been widely acclaimed. But they are sophisticated fare, and I simply don't know how genuinely they appeal to small children. . . .

It's all well-meant but a little too thin—considering the protagonists—to rise above the level of an experiment with color and texture. I should confess, however, that as a dog-owner, I find it hard to say anything good about fleas.

> *Natalie Babbitt, "I Want to Stay Here! I Want to Go There! A Flea Story," in* The New York Times Book Review *(copyright © 1977 by The New York Times Company; reprinted by permission), September 25, 1977, p. 36.*

Lionni's language is crisp as celery, even when dealing with subjects as difficult for small children as relativity of size: a hero-flea, flying through the air on a blackbird's back, observes that "From here everything is almost as small as we are. A cow is no bigger than a bumblebee, and the woods are like flocks of sheep, huddled together in meadows." In a market flooded with derivative art, Lionni, who strikes out in bold directions, should be encouraged like an endangered species. But the obscurity of the characters in this book may make its reception lukewarm. (p. E2)

> *Ann S. Haskell, "Picture Books: The Eyes Have It," in* Book World—The Washington Post *(© 1977, The Washington Post), November 13, 1977, pp. E1-E2.**

Leo Lionni's wit is expressed in primarily visual terms in his latest book, *A Flea Story.* Two cantankerous fleas reveal their differences in character, as they hop from dog to chicken to porcupine to mole, etc. While one describes every new scene rapturously, the other gripes about its discomfort.

The trouble with this narrative is the sudden interruption of the tale at the climactic moment: The footloose flea speculates on whether words alone will be sufficient when the time comes to talk about its next adventure. This digression is given no preparation, and consequently, it disrupts the book's coherence. It is also too abstract an idea for the group the book is generally aimed at: five-year-olds.

Despite this defect children find it easy to empathize with the staid flea and feel admiration for the adventurer. Although the tiny fleas are never depicted, their presence is made known through blue and red conversation balloons that pinpoint their location on each animal they visit. Other creatures in the book are shown with alert expressions, as if eavesdropping on the fleas' conversation.

In a 1970 interview Lionni stated that in each of his books "the style flows out of the content and is never predetermined." But although he uses a bulkier scale than usual in *A Flea Story,* the basic formula is similar to that employed in *Alexander and the Wind-Up Mouse, Pezzettino,* and in some degree, *Inch by Inch* and *Frederick.* He is cutting up the same textured papers and arranging them the same ways, and although he still achieves some visual excitement, there is an apparent lack of involvement. Stories about out-of-door excursions readily lend themselves to the technique Lionni uses. It would appear that he has lost interest in the technique, for this book lacks visual fascination. A comparison of his earlier works with *A Flea Story* points this up—there is an inordinate amount of panache and style combined with increasing carelessness. (pp. 338-39)

> *Donnarae MacCann and Olga Richard, in a review of "A Flea Story," in* Wilson Library Bulletin *(copyright © 1977 by the H. W. Wilson Company), Vol. 52, No. 4, December, 1977, pp. 338-39.*

Leo Lionni has always been the most individual and unpredictable of artists. In *A Flea Story* his text consists of the bubbles which arise from his bold collages. . . . It might be sub-titled 'From dog to dog in eight moves.' The whole has a simplicity which comes only from much thought and fine craftsmanship. The textures of each opening are especially delightful. A few sensitive mamas may be distressed, but children will surely love the humour as much as the bold draughtsmanship. (pp. 134-35)

> *Marcus Crouch, in a review of "A Flea Story," in* The Junior Bookshelf, *Vol. 42, No. 3, June, 1978, pp. 134-35.*

GERALDINE, THE MUSIC MOUSE (1979; also published as *Geraldine, Music Mouse*)

Geraldine, a mouse of delicate perceptions, finds a large hunk of cheese and, nibbling away, sees that she is releasing a statue buried within. The figure is playing a flute and introduces Geraldine to the beauty of music, which she has never heard. Geraldine is entranced and defends her statue from her starving friends, who need it for food. Only when she finds that she, too, is able to create music can the cheese statue be eaten—for "'now the music is in me.'" The illustrator has not used his characteristic collages, but the creatures are clearly recognizable as Lionni mice. Geraldine, as a defender of the arts, is a worthy successor to the well-known Frederick, who recalled sunlight for the wintertime, and to Alexander, who gave life to a toy mouse.

> *Ann A. Flowers, in a review of "Geraldine, the Music Mouse," in* The Horn Book Magazine *(copyright © 1979 by The Horn Book, Inc., Boston), Vol. LV, No. 5, October, 1979, p. 526.*

Oversize pages afford ample space for the large-scale crayon pictures, handsome in composition and soft in mood. . . . Simple, imaginative, and tender, the story should appeal both because of its originality and because of its structure: it poses a problem, it offers a solution, and it ends with a satisfying flourish.

> *Zena Sutherland, in a review of "Geraldine, the Music Mouse," in* Bulletin of the Center for Children's Books *(reprinted by permission of The University of*

Chicago Press; © 1980 by The University of Chicago), Vol. 33, No. 5, January, 1980, p. 99.

Every book by this master is an event, even when he is less than his most inventive. Geraldine the mouse is at least as much sculptor as musician. . . . To say that Mr. Lionni's lithographs are brilliant is to state the obvious. The theme keeps him within bounds, however, and his range is less enterprising than is usual with this most talented and resourceful of artists.

Marcus Crouch, in a review of "Geraldine the Music Mouse," in The Junior Bookshelf, *Vol. 44, No. 4, August, 1980, p. 169.*

MOUSE DAYS: A BOOK OF SEASONS (1981)

Lionni's soft, colorful illustrations are as good as ever, but there's not much more to this book. Each month of the year is described in a few sentences, while the facing page shows fat little mice gleefully engaged in some activity suitable to the time of year. Still, there are ways in which the book can be put to good use. Pictures and format are suitable for three-year-olds' story hours; with older story-hour participants, the text could be used to elicit responses about their activities during different seasons; and *Mouse Days* just might be a lifesaver for the desperate parent looking for that elusive creature, the *short* book for bedtime.

Ilene Cooper, in a review of "Mouse Days: A Book of Seasons," in Booklist *(reprinted by permission of the American Library Association; copyright © 1981 by the American Library Association), Vol. 78, No. 4, October 15, 1981, p. 307.*

The mice tykes that have played roles in Lionni's honored picture books are gathered here as celebrants of nature's bounty throughout the year. Beautiful paintings in color are detailed portrayals of the quaint "children," spending blissful times from January through December. Solomon's gentle narrative can convince readers that the mice are telling how they observe the occasion and "wish the year a happy birthday" with songs and streamers.

A review of "Mouse Days: A Book of Seasons," in Publishers Weekly *(reprinted from the October 23, 1981 issue of* Publishers Weekly, *published by R. R. Bowker Company, a Xerox company; copyright © 1981 by Xerox Corporation), Vol. 220, No. 17, October 23, 1981, p. 63.*

The same 12 lighthearted crayon illustrations that decorate Lionni's *Mouse Days Calendar 1981* . . . are the basis for this "book of seasons." But this recycled artwork does not succeed in book form. Each picture is accompanied by a short, insipid commentary that strains to tie together the month and the scene depicted; April, for example, whimsically shows mice as well as chicks hatching from colored eggs, and the entire text states: "April begins to feel like spring. We shake off winter's chill and put on our new spring clothes to greet our friends. Hello, chicks!" For a book of months, turn to Sendak's *Chicken Soup with Rice* in the Nutshell Library. . . .

Sally Holmes Holtze, in a review of "Mouse Days: A Book of Seasons," in School Library Journal *(reprinted from the November, 1981 issue of* School Library Journal, *published by R. R. Bowker Co./A Xerox Corporation; copyright © 1981), Vol. 28, No. 3, November, 1981, p. 82.*

LET'S MAKE RABBITS: A FABLE (1982)

A mite of a fable, this time, about a rabbit drawn by a pencil and a rabbit cut out of scraps of patterned paper by a pair of scissors. . . . The book will probably satisfy, even delight, very small children; but the illustrations are, for Lionni, mundane—while the text is so perfunctory as to induce less emotional involvement than the situation allows for. (This is not, in short, another *Little Blue and Little Yellow*.)

A review of "Let's Make Rabbits," in Kirkus Reviews *(copyright © 1982 The Kirkus Service, Inc.), Vol. L, No. 7, April 1, 1982, p. 415.*

In *Let's Make Rabbits*, Leo Lionni, a modernist with a light touch, has taken the page itself as the field of his story's action and made characters of artist's tools and materials. A pair of scissors and a pencil meet and decide to "make rabbits." Pencil's rabbit doodle appears on the following page beside Scissors' work, a rabbit cut-out fashioned from scraps of decorative paper brightly rendered in color by the artist.

Now the rabbits come to life and, distinctly different from each other as they are—in graphic terms—get acquainted and set out on a journey of self-discovery that ends all too soon and on a "philosophic" note that, if not overly abstract to engage the imaginative sympathies of 3-, 4-, or 5-year-olds, is in any case ponderous.

Long an innovator in children's book illustrations (as in virtually every aspect of commercial art and design), Lionni has in *Let's Make Rabbits* taken the picture book form firmly in hand and with as much graphic inventiveness and joy-in-making as he showed, for instance, in *Inch by Inch,* which is a touchstone of the genre. The more unfortunate, then, that he has not supplied his characters with a more involving text. Lionni's rabbits leap expectantly from the page only to escape the storyteller's grasp. (p. 22)

Leonard S. Marcus, "Worlds without Words," in Book World—The Washington Post *(© 1982, The Washington Post), May 9, 1982, pp. 17-18, 22.**

The very youngest, for whom this book is eminently suitable, will be taken with the big, attractive artwork, with its interplay among lines, patterns, and shadows. While some perceptive older children might key into the question, What is life/what is art?, even those who find the philosophy over their heads will enjoy a brief tale that lends itself to story hours and activities. (p. 1315)

Ilene Cooper, in a review of "Let's Make Rabbits: A Fable," in Booklist *(reprinted by permission of the American Library Association; copyright © 1982 by the American Library Association), Vol. 78, No. 19, June 1, 1982, pp. 1314-15.*

Lionni has again created a simple tale—not a how-to (as the title might indicate), but rather an invitation to use the creative imagination. . . . A wonderful combination of collage and pencil drawings colorfully set against large white pages provide a lesson in art appreciation as well as a tribute to the joy of an imaginative reality, so readily available to the young.

Brenda Durrin Maloney, in a review of "Let's Make Rabbits," in School Library Journal *(reprinted from the August, 1982 issue of* School Library Journal, *published by R. R. Bowker Co./A Xerox Corporation;*

copyright © 1982), Vol. 28, No. 10, August, 1982, p. 101.

[**Let's Make Rabbits**] is suitable for the very young. . . . On every page are large clearly drawn, expressive illustrations, most in bright primary colours. The few complementary lines of text are easy to understand, with simple dialogue that gives vitality to these attractive creatures.

> *Alice Thatcher, in a review of "Let's Make Rabbits," in The Junior Bookshelf, Vol. 47, No. 1, February, 1983, p. 15.*

A small philosophical fable or a study in artistic method—which is more important in this radiantly simple picture-book . . . ? Humanised only by the placing of eyes and the tilt of heads, the rabbits make a statement about imagination in the neatest possible way.

> *Margery Fisher, in a review of "Let's Make Rabbits," in her Growing Point, Vol. 21, No. 6, March, 1983, p. 4047.*

CORNELIUS (1983)

Although the title page refers to the story as a fable, this does not follow traditional fabular structure. The collage pictures are used to full advantage on the oversize pages, somewhat repetitive, but distinctive in their color and composition. The story is slight: Cornelius is an alligator who walks upright from the time of his birth, learns to stand on his head and swing by his tail with the help of a friendly monkey, and shows off to the other crocodiles, who say "So what?" but try to do the same as soon as Cornelius has turned his back. That's the end of the story—mildly amusing, visually effective, with no moral for the "Fable."

> *Zena Sutherland, in a review of "Cornelius," in Bulletin of the Center for Children's Books (reprinted by permission of The University of Chicago Press; © 1983 by The University of Chicago), Vol. 36, No. 8, April, 1983, p. 155.*

Lionni endearingly captures the spirit of the seeker, the thinker and those who are born to be different. . . . Cornelius inhabits a lush green jungle with the artist's familiar use of marbleizing for tree trunks, ground and flowing river. Lionni's collages are wonderfully spare, yet rich and colorful against a white and pale blue background, perfectly setting the stage for a tale children will enjoy.

> *Brenda Durrin Maloney, in a review of "Cornelius," in School Library Journal (reprinted from the April, 1983 issue of School Library Journal, published by R. R. Bowker Co./A Xerox Corporation; copyright © 1983), Vol. 29, No. 8, April, 1983, p. 103.*

The reader too is tempted to add, "So what?" The trials and triumphs of leadership (an original, if peculiar, notion to share with egocentric preschoolers) are reduced by the fable form to a static smugness. It's impossible to like Cornelius better than his narrow-minded peers or to see of what use his superiority is, even to himself. The usual bold beauty of the Caldecott medalist Leo Lionni's jungle-colored collages simply illustrates the unattractiveness of excellence without spirit.

> *Janice Prindle, in a review of "Cornelius: A Fable," in The New York Times Book Review (copyright © 1983 by The New York Times Company; reprinted by permission), May 29, 1983, p. 18.*

Sct forth in simple language, the tale is appealing in its directness. The collage technique is used effectively to suggest a tropical backdrop: Lush green leaves hang down to a mottled jungle floor, each shape a carefully placed element in the design. Strolling among the greenery, with his smiling face and unblinking eyes, Cornelius has the dreamy look of a true visionary.

> *Kate M. Flanagan, in a review of "Cornelius," in The Horn Book Magazine (copyright © 1983 by The Horn Book, Inc., Boston), Vol. LIX, No. 3, June, 1983, p. 293.*

Lionni accompanies his wise and funny story with pictures full of his customary strength and vitality. He uses a cut-paper technique with amazing effect. Nowhere else will you find such assurance, technique and vision going confidently hand-in-hand.

> *Marcus Crouch, in a review of "Cornelius," in The Junior Bookshelf, Vol. 47, No. 4, August, 1983, p. 155.*

Penelope (Margaret) Lively

1933-

English author of fiction, nonfiction, and drama and critic.

Lively's literary career reflects her thorough interest in the function of memory. Her works underscore the concept that we are joined to the past by personal and collective memory, a connection she feels helps us deal with the present when we perceive ourselves as part of history. The pervasive theme of Lively's books is the continuity of time, the thread that ties the past to the present and future. Stimulated by the physical and imaginative links of setting and locale (which Lively calls "landscape") with the continuity of time, she sets her books in England, a country where history and modern culture exist simultaneously. Her young, contemporary protagonists are influenced by contacts with the past which affect their reactions, decisions, and perspectives. Lively notes that learning about ancestry is a step toward maturity for a child, a pull towards acknowledging the existence of others. Often using fantasy to frame her stories, she structures them as adventure, reminiscence, and satire. In addition to fiction, Lively has written a history of English landscape for children as well as novels and short stories for adults.

Born in Egypt, Lively began making historical connections as a child. She moved to England at twelve, developing an enthusiasm for the country and its history while adjusting to her new environment. After receiving a degree in modern history from Oxford, Lively explored the land around the school and researched local history and folklore, activities which prompted her first books. *Astercote, The Whispering Knights, The Wild Hunt of Hagworthy,* and *The Driftway* introduce Lively's fascination with the permanence of place and the continuity of time. They blend history and legend to demonstrate what happens when past and present collide. Lively was soon regarded as a promising author with original, thought-provoking ideas and a talent for pacing, atmosphere, and characterization. Some critics, however, find the books unconvincing narratives that lack credible dialogue and immediacy. With *The Ghost of Thomas Kempe,* Lively's strengths became obvious. Perhaps her most popular book, it uses the technique of a humorous ghost story to depict a child's awakening to the concept of memory and the possibilities of real evil. Critics mark it as the first book in which Lively is confident as a writer. They admire her successful union of the natural and supernatural, and acclaim the authenticity of her dialogue and character development. Lively's flair for comedy, which lightens the serious themes, contributes to making *Thomas Kempe* among her most accessible works.

Lively's post-*Kempe* books show her ability to vary literary styles while presenting consistent themes. In *The House in Norham Gardens* and *A Stitch in Time,* Lively is praised equally for her descriptions of daily life and parent/child relationships and her many-layered shifts in space and time. Inspired by memories of her grandmother's house in Somerset, *Going Back* uses selective memory to describe the lives of a brother and sister during World War II. Both this work and Lively's *Fanny* series, which is written for younger children and set in Victorian England, are commended for the accuracy of their social observations and view of childhood. With *The Voyage of QV*

66, Lively changes her focus to the future. She gently satirizes society's weaknesses in this allegorical fantasy about a group of animals who journey through an England vacated by humanity. Critics judge the humorous and suspenseful *QV 66* as one of Lively's most successful works. She returns to familiar themes with *The Revenge of Samuel Stokes,* a ghost story similar to *Thomas Kempe* but lighter in tone. Reviewers applaud *Samuel Stokes* for its polish and comic effect, but generally consider *Thomas Kempe* the more memorable work.

Despite the youth of her audience, Lively refuses to abandon the subjects that intrigue her. Often deemed a demanding writer, she hopes children will benefit from her adult experiences and imagination by observing the workings of memory in their own lives. Recognized as an author whose skill with narrative, language, and theme increases with each book, Lively is among the most respected contemporary writers for children. Readers and critics view her works, whether haunting or hilarious, as good stories as well as reminders of the constant presence of the past. Lively was awarded the Carnegie Medal in 1973 for *The Ghost of Thomas Kempe,* which was also selected for the Hans Christian Andersen Honor List the same year. She won the Whitbread Literary Award in 1976 for *A Stitch in Time,* and has been given several notable book citations and child-selected awards.

(See also *Something about the Author*, Vol. 7; *Contemporary Authors*, Vols. 41-44, rev. ed.; and *Dictionary of Literary Biography*, Vol. 14.)

AUTHOR'S COMMENTARY

[Writing] for children should not be taken too solemnly. I say solemnly instead of seriously with some deliberation—because I do think it should be taken seriously. . . . Children, as far as I am concerned, are very unsolemn creatures, and those of us who are being so presumptuous as to intrude upon their imaginative world shouldn't be solemn either.

It is only fairly recently that we managed to shake off the yoke of nineteenth-century didacticism in children's literature, the notion that books for children exist in order to teach them how to be virtuous, how to live in harmony with their parents or their brothers and sisters, how not to be unkind to animals or to those less fortunate than themselves, and so on and so forth. We do actually believe now that children's books need to be fun and nothing else, and we have got quite good over the last twenty years at producing distinguished fun. Now, then, let's not slip into another trap. Children's books are important— very important; but we should not start thinking of them again as vehicles for instructing children about anything except the simple fact that to extract the maximum possible enjoyment out of life, books are going to be indispensable. As a children's writer, I am only saying to children, "Here—let me tell you a story," and because most of them have as natural a hunger for stories as for food or drink, they are probably going to listen. The rest is up to me.

And that—let me hasten to say—leaves me properly apprehensive. Because I do think those of us who have taken up this job have to treat it seriously. What we are doing is providing children with an imaginative landscape. We are introducing them to language and to imagery and to narrative—and if we don't do it skillfully, we may do quite a number of undesirable things: We may simply switch children off altogether, so that they decide books and reading really aren't worth bothering with; we may offend by committing one of those crimes I was referring to just now, offering moral instruction— or any other kind of instruction—thinly disguised as fiction (and children are not so crass, usually, that they are not going to spot that and feel, quite rightly, got at); or we may fail to provide something that extends their imaginations at all.

Now of course one hopes and assumes that most children are going to be exposed to a good many books, so if one book falls into any of these traps, others will not. But in some ways, you have to set out, in writing each book, with some kind of dreadful pessimistic assumption that you are writing for a solitary child on a desert island who has no other book to read. You are the Ancient Mariner, and the poor child is the Wedding Guest; your job is not only to tell him a tale but to convince him of the value of tales in the first place—which is what the Ancient Mariner was so bad at. I shouldn't be clutching the child by the arm; I should have him sitting silent at my feet, waiting for what comes next.

And that can be done only by treating children's books seriously—by which I mean putting the book before the child. This is my responsibility as a children's writer. Anything else is patronage—patronage is the other historical pitfall of children's literature, the one that succeeded didacticism. No sooner was the idea abandoned that children's books are the vehicles for instruction than it was followed by the notion that, as a result, they didn't really matter all that much, and anything would do so long as it kept children quiet. And that, of course is patronage—it is saying to the child, "You are only a second-class person at the moment and therefore you need only second-class books; when you are older and wiser like me and able to appreciate it you can have the real thing." (pp. 17-19)

[My] loyalty, as a writer, must be to the book before the child. I am writing books, not conforming to some kind of preconceived notion of what children like to read or of what makes a good children's book. I have no idea, frankly, about either of those things. I'm not a child, and I don't expect I remember any more distinctly than most people what it was like to be one. I can't clear my head of all the intellectual and imaginative equipment and experience of thirty years—I can't go back to childhood, but what I can do is offer the child a product of all this equipment and experience. And in this sense it seems to me that the writer for children must invite children to come to him or her rather than go to them. I am writing for children as an adult, and I am quite clear that I am writing for children; if I weren't, I would do it differently. But I don't mean that I would do it differently in the sense of diluting language or content. That is patronage again. I am writing the book I want to write—the one that satisfies me creatively—but in such a way that I offer it to children or invite them to come and share the fun with me. I am not abandoning my own adult preoccupations because the book I am writing is for children.

My particular preoccupation, as a writer, is with memory. Both with memory in the wide historical sense and memory in the personal sense—that it is what we are all either enriched by or encumbered with; I am never sure which. I find memory a very complicated and ambiguous thing; I don't understand its function in our lives and I try to explore this function by writing novels which are concerned in one way or another with the operation of memory. *The Ghost of Thomas Kempe* . . . , which is intended to be, and I hope is, an entirely light-hearted book, is concerned at one level with a child's growing awareness of the layers of memory of which people are composed—that an old woman is also the child she once was. This, to us as adults, is self-evident, though I suspect not as evident as it should be; we underestimate the force of memory in our lives. I think children often are not aware of memory—they simply haven't been here long enough yet to have had time to observe its effects—but it naturally arouses their curiosity. Here is a landscape littered with objects which have been there a great deal longer than people—historical memory. Adults are always recalling the past. Why? What does it matter? Does it matter? We all need a sense of time and a sense of continuity. We all change and will change again. The moment when a child begins to realize this—begins to be able to project himself both backward and forward in time—is the beginning of maturity. And if childhood is anything, it is the process whereby we acquire maturity and, with any luck, a full and responsible maturity. Immaturity is dangerous. Childish adults are not attractive people.

In this sense, I suppose, I am not being entirely open with my reader. I am keeping something back, I am trying to construct a story for children like an iceberg. Only the tip is showing— the other seven-eighths is invisible, but without it the whole thing would sink or capsize. Because if the visible tip of it is the story—the narrative that I hope is going to keep you, or the child, turning the pages over—the other seven-eighths is the substance, the product of all that adult experience and preoccupation that I am trying to share with the child without his ever being aware of it. A child reading a satisfying book

should come away feeling that there is something he can't quite put his finger on—some sense of mystery, some intangible that he can't isolate or describe. And the mystery is the presence of the adult—the way in which I have tried not to patronize but have invited the child to join me. If this is detectable, however, the book has failed. I could not have written **Thomas Kempe** if I had not been reading, in the year or two before I wrote it, a lot of important and very serious recent historical writing on the nature of popular superstitition and belief in the seventeenth century; but if I had allowed that to show, the book would have been a history book instead of the entertainment that I intended it to be. I could have written a history book, but I thought I could say more about memory and continuity to children through a story than through some instruction about how people lived and felt in the seventeenth century. [Similarly, *A Stitch in Time*] was rooted in an interest in Darwin and the *Origin of Species* and the Victorian debate about natural selection; but all this, I hope, is well concealed underneath a story about a girl spending a summer holiday at Lyme Regis and fantasizing about what may have happened to the Victorian child who made a sampler that she sees. It's another kind of ghost story. The ghost, in one form or another, is a most useful literary device for those of us concerned with memory and illusion.

So I am deceiving the reader, in a sense, but for the best possible motive. It is not that I am sugaring the pill or disguising instruction as something else but simply that I am refusing to abandon the things that interest me on the grounds that they may be too complex or demanding for someone of ten or twelve. Children have the same pains and pleasures to cope with as we do; by and large, our concerns are theirs. Not quite, of course. We have had experiences that they have not had, as yet, and I would feel a certain wariness in writing of them in a children's book. But children experience the range of emotions that we do; they know what it is to feel betrayed, desolate, frightened, contented, ecstatic, enraged. And they ought to be immersed in the process of exploring their own imaginations—having some curiosity about what it is like to be someone else, having some desire to escape from the trap of personal preoccupation. We are all locked inside our own heads; lack of imagination is the inability to escape from this jail. And literature is the principal door. We read to find out what it is like to be a human being. Now this begins to sound solemn—which I don't intend to be—but the fact is that a response to literature starts with the child sitting wrapped up in a book for the first time. He has accepted an offer to be told how things are for someone else and has taken the first important step out of his own self-preoccupation. And we have to understand ourselves through understanding other people. (pp. 20-3)

· · · · ·

I've spoken of the way in which I hope to make a book work on more than one level by concealing—for the best possible reasons—the adult sources of inspiration and the adult preoccupations that produced it. In doing this I am in one sense abiding by the rules of those traditional ancestors of children's literature—the fairy tale and the folklore that precedes it. (p. 197)

I don't write fairy tales, but I've tried to learn from them, and I write for children with something of the same intention—to use fantasy as a form which allows a story to work on two levels, the narrative and something else over and beyond. A good children's book always seems to me like a very subtle and ambitious soup: Most of the ingredients will be obvious, the bits of leek and carrot, the shreds of meat, the hint of lemon and herb. But there should also be some indefinable flavor— a taste you can't quite put a name to—that lifts the soup out of the area of food for the sake of nourishment and into that of food for the sake of enjoyment. Now sometimes the flavor may, in fact, be definable to the adult reader, but I don't think it should be to the child. . . . We each take out something different—something that we find or that we need.

And this is perhaps the most vital function of the author: To provide plunder for the reader's imagination—and I mean just that. Plunder. Books, if they work at all, should be robbed by the reader—they should provide something to take away and mull over on his own and maybe develop and enlarge and breed from. And I don't see how they can provide this unless a lot has gone into them, unless the author has been prodigal with his or her own intellectual and imaginative sources. This is where I must return to the point I have already made about writing for children as an adult and retaining all the concerns and preoccupations of an adult in the process. My preoccupation is with memory and the mystery of its function in our lives. I don't imagine that I am ever going to find an answer to the questions prompted by the workings of memory; all I can do is pose these questions in fictional form and see what happens. And so far it has seemed tempting to do this in the form of fantasy, because it seems to me that memory itself is a kind of fantasy. (pp. 198-99)

"The art of memory" is not just an empty phrase that sounds quite nice as the title for an essay. It has an actual historical meaning. The art of memory, as developed in the classical world and revived in the Renaissance, was the art practiced by orators and lawyers for the retention of the sequence of an argument or the presentation of a case. . . . In the classical practice of the art, visual and verbal punning seems to have been used a lot—a picture of a fish to prompt a reference to the soul, for instance, and plays on words with sound associations—as well as the then common symbolisms, the short-hand of medieval imagery which appears all over the stained glass of English churches and is incomprehensible to the modern eye but which, for contemporaries, set off a whole chain of associated stories and ideas. In other words, the visual imagery of a non-literate society, which for people like us, conditioned by the written word, is almost irretrievable. (pp. 199-200)

But the classical art of memory is not, of course, what I really am talking about. I bring it in because I find the imagery of it fascinating—remembering by means of pictures in the mind. Because that is what memory seems to me to be. One kind of memory. A random, sometimes inexplicable series of pictures that we all carry around in our heads, a personal set, unsharable with anyone, incommunicable and bewildering. (p. 200)

I have an orderly, chronological image of English history—it goes on in a nice straight line without any gaps—but European history, for me, is a rather sporadic business with areas of illumination and a great many dark ages. It is more like personal memory. And I am uncomfortable with it; I like to know where I am.

This is what comes of having been trained to think—to some extent—in a historical way, and I am extremely grateful for it. I need a past—a collective one as well as a personal one— and I like it explained. I want to know why the town I live in is as it is, why the buildings are as they are and where they are, and why the people do what they do, and how long they

have been doing it and why. And I don't think I'm particularly unusual in this. I have had a bit more luck than some people in having been trained to ask historical questions and taught how to find the answers. I can be businesslike about the past. But concern with the past—however muddled a concern—is perhaps more evident now than ever before. Stately homes vie with each other in pushing up their numbers of visitors every year. Stonehenge is being worn away by the tread of feet on the turf. Estate agents use period features and historical associations as selling points in property dealing. We are prepared to shell out a lot of money for the past, even if we're often not too clear to what end. We must need it, then. I wonder why?

That's not quite such an ingenuous question as it sounds. I think history is important; I think a sense of the past is important. And by that I mean not just a vaguely nostalgic and sentimental feeling about old things or old places but a much more matter-of-fact response to the past as something that actually happened and not necessarily as something particularly pleasant. By and large, the past is pretty unpleasant. What interests and puzzles me about our concern with the past, both a historical and a personal past, is that I think we have a great talent for distorting it. We hang eighteenth- and nineteenth-century agricultural implements on our walls because we like the shape of them, but we probably don't know their precise function. We salvage beams, bread ovens, and inglenooks and make them features of twentieth-century living, tastefully lit and decorated. We take the children to Stonehenge or wherever, but we'd probably shrink from exposing them to a candid account of Bronze Age beliefs and practices. We like the past gutted and nicely cleaned up; then we know where we are with it.

This attitude is in some ways an extension of what we do with our own pasts. We select what pleases, to some extent, and keep it bright and shiny and in good repair. The obsessions that most people—of whatever age—have about their parents is perhaps the most interesting aspect of this combined search for, and rejection of, our own pasts. We want to get rid of them, hang on to them, blame them for all that went wrong and attribute to them all that went well. It's fascinating. I'm as perplexed as to what it's all about as anyone else; but as a novelist, I can at least try to explore the process a bit and without presuming to come up with any answers, point things out. At the moment I'm interested in pointing out the element of fantasy in our treatment of the past—that, to a great extent, we make it up. The classical art of memory is concerned with an exact retention of facts; most people's art of memory is a random retention of fact and fantasy. We rearrange things to suit ourselves: I can't possibly have behaved as badly as that, of course; I was a victim of society, my parents, the economic situation. But just when we've got it as we feel sure it really was, the uncomfortable visual image of what happened pops up, the picture in the mind. We can only fix the past so far. And the historical past is recalcitrant too—it will keep changing. No sooner have we got used to one set of explanations for something than the historians get to work and come up with something else. We are not at all safe with the past—it has a habit of turning round and betraying us.

And for a writer it's an inexhaustible subject: aspects of memory, different ways of expressing concern for the past, memory as truth, and memory as fantasy. When I started writing for children, the fantasy aspect of historical memory interested me very much—legend and folklore. People make attempts to meet the imaginative challenge of the landscape itself—the age-old response to the amazing fact that the world we live in is older than we are ourselves, that other people have been here before us. I haven't much time for mysticism—for cavorting around Glastonbury or attributing psychic energy to bits of Somerset or Wiltshire or wherever. Ghosts and the occult are useful literary devices, as far as I'm concerned, and that's all. But I do have a great sympathy with the ancient desire to pay tribute to the landscape's role as a shrine to the past, the consciousness which has been around since prehistory that we only pass through the world, make a faint mark on it, and then hand it on to someone else. This may be a form of the pathetic fallacy, of course—hills and rivers and buildings don't remember; they simply are, and that's all there is to it. But *we* need to remember, whether in the form of fact or fantasy. Making up stories about a place seems to me a very powerful and evocative aspect of the hunt for the past; the ubiquity and repetitiveness of folklore throughout the world is one of its most interesting aspects. I don't think that as a writer I have anything more to take from it, but I still find myself turning to *The Golden Bough* as a piece of favorite reading or to the inexhaustible treasure-house of Dr. Katherine Briggs.

I can't imagine ever ceasing to draw on the landscape itself. It seems to me to have this extraordinary dual presence. It functions in layers, rather as I like a book to function, the obvious and explicable shrouding the less obvious and accessible. There is the place—town, village, field, or hillside—looking uplifting or depressing or what you will; and suggested but invincible are the explanations of why it is as it is, who made it like that or used it for what purpose, and when and why. And then as a product of the explanations—of what we know about places if you like—there is something else which I can only describe as emotional, a charge, even, though not the mystical kind of charge of which I am so wary. We ourselves give attributes to places—whether in the form of stories or just the feelings they arouse in us—because of what we know or imagine they represent. It may be romanticism, just the pathetic fallacy, but it doesn't seem to me all that unhealthy; and even if it breeds strange and often irrational ambiguities in the way we express what we feel about the past and our own memories, I think it should be respected.

To return to the children who seem to have been rather left out for the last few pages—what does this have to do with them? Just what I said earlier: that memory is as relevant and bewildering to them as it is to us, and the sooner they come to grips with it the better. Not because it will solve personal problems or help children come to terms with life or perform any of the functions that people keep assigning to books nowadays. I write seriously—though I hope not solemnly—for children and so try to share with them my own adult interests and concerns. I want to introduce children to the art of memory so that they can observe its possibilities and effects and wonder about them, as I do myself. (pp. 200-03)

Penelope Lively, "Children and the Art of Memory: Part I" and "Children and the Art of Memory: Part II" (a revision of a speech originally given at the University of Loughborough in 1976), in The Horn Book Magazine *(copyright © 1978 by The Horn Book, Inc., Boston), Vol. LIV, Nos. 1 and 2, February and April, 1978, pp. 17-23; 197-203.*

GENERAL COMMENTARY

JOHN ROWE TOWNSEND

Penelope Lively published an introduction to the history of landscape under the title *The Presence of the Past*. . . . That

title indicates the preoccupation underlying almost all her fiction for children, as well as her adult novel *The Road to Lich-field*. She is not a historical novelist; her books are primarily about present-day people in present-day surroundings. But she is concerned with continuity: concerned to show that people and places as they are now incorporate the past, and that to see them without this dimension would be to see them 'flat', lacking perspective.

Mrs Lively's perspectives can be long ones, and she can work on more than one time-scale at once. Her award-winning children's book *A Stitch in Time* . . . illustrates this characteristic. The events in the foreground of this story are those which take place during the brief period in which a girl called Maria is on holiday at Lyme Regis. Behind them lies Maria's personal history as the diffident only child of quiet, reserved parents. But the present for Maria is also affected by her imaginative involvement with a little girl called Harriet who lived in the same house more than a century before and who failed to finish her sampler. And Maria becomes fascinated by the fossils she finds in the blue lias of the cliffs and which she goes to see, in vastly greater variety, in the local museum: the creatures from 'forty million years ago, a hundred and eighty million, four hundred million', all of which have 'stepped out of the rock of which the place is made, the bones of it, those blue cliffs with which England ends'. There are, one might say, three orders of time past. There is the immediate past of living memory. Behind that is the historical past, extending over a few hundred or at the outside a few thousand years; and behind that again lie the immensities of prehistory, reaching back through spans of time that defeat the imagination. Events on all three time-scales have gone into the making of people and places as they are today: especially, in *A Stitch in Time* and Mrs Lively's other books, the people and landscape of England, for which she has deep feeling.

Penelope Lively sees a sense of continuity as essential to the life of the imagination. In an article in the *Horn Book* for August, 1973, she regretted that modern children were in danger of losing the personal memory that came from contact with the old ('the grandmother at the fireside'), and suggested that 'it may be that books attending to memory, both historical and personal, are more important to children than ever before'. (pp. 125-26)

There must always, I think, be an element of rationalization in a writer's discussion of his or her own work; a book is there and its author, like anyone else, is interested and looks for explanations. The real ones may not be obvious. But when Penelope Lively writes of the importance of memory, of the continued life of the past in the present, there can be no doubt that she is talking about the sources of her inspiration, as well as about what she seeks to offer to children. Places stimulate her, and as she says in the article already referred to, 'certain places are possessed of a historical charge that sets the imagination flaring'.

In her early books, this historical 'charge' is very evident, and strikes one as being not only the inspiration but the motive force throughout; the concern with the personal evolution of the individual is not yet developed very far. Astercote, in the book of that title, . . . is based on Hampton Gay, an Oxfordshire village which died in the Black Death. The Whispering Knights who give their name to Mrs Lively's second book . . . are the Rollright Stones, on the border between Oxfordshire and Warwickshire; the stretch of road which features in *The Driftway* . . . is now 'a perfectly ordinary road, B4525 from Banbury to Northampton', but is very ancient and was once a drovers' road along which herds were driven from Wales for sale in southern England. *The Wild Hunt of Hagworthy* . . . is also firmly rooted in a place—West Somerset—but this story was probably inspired even more by what the author has called 'the widespread, ancient and powerful legend of the ghostly hunt'.

None of these books, to my mind, quite reaches the front rank of recent children's fiction. The story of *Astercote* hinges on the disappearance of a chalice—saved from the ruined church of the lost village—which people in the surviving village near by think keeps the plague from coming back. When the chalice's disappearance is followed by a case of mumps, with symptoms similar to the early signs of plague, there is a panic which turns into ugly xenophobia. It is an interesting idea, but the development is curiously oblique; the fear of the returning plague soon ceases to be the villagers' motivation, and when they plan to barricade themselves against strangers we learn that 'nobody once mentioned the chalice, or the Black Death, or any of that. It was as though they'd forgotten what it had all been about in the first place.' The author seems to have lacked confidence in her own idea, and partly as a result of this the book fails to establish its probabilities and carry the reader across the unlikelihood of the story. Peter and Mair, the children from whose viewpoint events are seen, are just such a brother and sister as might appear in any standard adventure story, and the outcome—they recover the chalice from the young motorbiking hoodlum who'd stolen it, and all is well—is commonplace and anticlimactic.

Nevertheless, given that it was a first book and bore marks of being prentice work, *Astercote* looked very promising. Its successor, *The Whispering Knights,* was a disappointment. Martha, William and Susie concoct a witches' brew (*Macbeth* recipe, with modifications) and raise the malevolent spirit of Morgan le Fay, who represents 'the bad side of things' and is always turning up in various places and guises. It's the familiar running battle of Light against Dark; and the Dark of course is defeated, at least for the time being, with the aid of those mysterious stones and of the white witch Miss Hepplewhite. This, to be frank, is a bad book, parts of which read almost like a parody of early Garner. *The Wild Hunt of Hagworthy,* which came out in the same year, was quite strikingly better. In a Somerset village, the Vicar's idea of reviving the Horn Dance as a tourist attraction at the annual fête has implications that he is unaware of. The dance goes back to older beliefs than Christianity; it is really a hunt; it seeks an odd-person-out as its victim and has dehumanizing effects on its participants; and behind it lies the Wild Hunt of legend, which the Horn Dance may start up again by mimetic magic.

Lucy is a girl staying in the village; Kester, the bright but socially isolated boy with whom she forms a friendship, is identified, and identifies himself, as the victim of the hunt, driven into playing this role by something beyond his control. The menace grows steadily along the way to a powerful climax, and for the first time in Penelope Lively's work the human relationships are interesting. And her sense of landscape is beautifully worked into her account of Lucy's and Kester's friendship. (pp. 127-29)

The Driftway is another book built on an attractive notion: an ancient road along which significant incidents from the past still linger. Sometimes in everybody's life, says the old man who gives Paul and Sandra a lift in his cart,

there's a time when a whole lot of living gets crammed into a few minutes, or an hour or two, and it may be good or bad, but it's brighter and sharper than all the rest put together. And it may be so sharp it can leave a shadow on a place—if the place is a special place—and at the right time other people can pick up that shadow. Like a message, see?

Paul picks up a series of such messages on a momentous, tormented day of his own life. But the story does not quite jell. Curiously, the effectiveness of the realistic opening—Paul hating his stepmother, dropping something into his pocket while preoccupied in the big store, and running away from trouble with his small sister in tow—works against the rest of the book. One wants badly to know what is going to happen to Paul and Sandra; and the incidents from the past that lie along the Driftway are not gripping enough to appear as other than traffic holdups in the progress of the story. And one doesn't quite believe in kind, informative old Bill, who comes along so providentially in his cart and understands so much, or in the way the experience so neatly and edifyingly unties the knots of Paul's hatred.

When these four books (of which the best, to my mind, is *The Wild Hunt of Hagworthy*) had appeared, it could have been said that Penelope Lively's talent was undoubted but did not seem outstanding in a field which had grown much more crowded over the preceding decade. The book that made her name was the next one, *The Ghost of Thomas Kempe*. . . . This is a blessedly funny book, and infinitely welcome, since in children's as in adult fiction the gap for comedy of quality is always open. Thomas Kempe is an apothecary from the reign of King James I who has re-emerged in our own day as a poltergeist, after being bottled up in a wall in an ancient house. Like other poltergeists he is heard but not seen; but he can write. He leaves notices around in a crabbed, antique hand, advertising his services in sorcerie, astrologie, alchemie and physique, and he wants to make the small hero, James Harrison, aged ten, his apprentice. James, who reminds one a little of Tom Sawyer but rather more of Richmal Crompton's William, gets the blame for Thomas Kempe's activities. . . . This is bad enough, but it soon becomes clear that Thomas Kempe is an unpleasant character: self-important, opinionated, malevolent. When he starts chalking libellous graffiti on walls and doors, it's too much, and James has to consult Bert Ellison, builder, decorator and part-time exorcist. He tells Bert there's a ghost in the house. 'Bert poured himself another cup of tea, and began to roll a cigarette. He stuck it in the corner of his mouth, lit it, and said, "Just the one?"' But not even Bert can get rid of Thomas Kempe until he grows weary of modern ways and in the end seeks help in finding his resting-place. Besides the humour of the story there is a pleasant, relaxed exploration of Mrs Lively's usual themes of time, memory, continuity; and an additional time-scale is introduced by James's discovery of the diary of a Victorian spinster lady whose nephew Arnold was staying with her when Thomas Kempe made a previous return to life. The nephew, appearing in the diary as a small boy who would have been a kindred spirit to James, is remembered by an old lady living nearby as a dignified elderly gentleman who visited the village school during her childhood: a detail which links the past with living memory and recalls Penelope Lively's remark . . . that 'the span of a lifetime is something to be wondered at and thought about'.

The title of *The House in Norham Gardens* . . . correctly identifies the true centre of the story, even though the plot has its origins far away and long ago in New Guinea, and though each chapter opens with a passage describing the way of life of a New Guinea tribe in the last years before the twentieth century overtakes it. Clare, aged fourteen, lives with her ancient great-aunts in their huge, ugly Victorian house in North Oxford. The house belonged, years ago, to her anthropologist great-grandfather; and in the attic is a shield painted with strange patterns, which he brought back from New Guinea, not realizing its magical significance to the tribesmen. Clare, in what seem to be dreams, becomes aware of brown men who desperately want it back; but in a final dream or vision which she has in hospital after a road accident she takes it back to them and they don't want it any more. They don't understand or even recognize it. The time has passed.

Though in a sense this is the matter of the story, the setting is Oxford, not New Guinea, and the main substance of the book is located away from the storyline. Once again this is a book about time and memory and continuity, about the four-dimensional wholeness of life, about the sadness yet inevitability of change; yet above all, and most simply, it is about the rambling impossible old house and the people who live in it. The affection between Clare and the aged academic aunts, feeble of body yet sharp and clear of mind, is beautifully and sensitively drawn. This is a novel of great human warmth, written with the calm authority of an author who by now is fully in command of her style and material.

Going Back . . . is an evocation of wartime childhood in a country house in Somerset, as remembered by the grown woman who goes back to look at the place many years afterwards. Disciplinarian Father, to the general relief, is away at the war, and the house and grounds—which the children love, though he doesn't—are in the easygoing care of the tiny remaining staff. It's a happy life in the main, until Father insists on sending sensitive brother Edward away to boarding school; and the distancing through memory is performed with admirable skill, so that some events are recalled in clear bright detail, others through shifting mists, while some are totally lost. As in life, there are beginnings and endings, apparently random, sometimes poignant. Mike, the conscientious objector doing farm work, is a great friend of the children, and when at the end the prospect of Edward's imminent return to school drives them to run away, it is Mike whom they seek and find at the farm he has moved to, several miles away. Mike does what has to be done, and they last glimpse him on that very day, at the farm gate, waving good-bye. 'We never saw him again,' says the narrator. 'And I do not know what became of him.'

To a grown-up reader, *Going Back* is a pleasing and satisfying book; but it is about childhood as recalled in adult life, and it is arguable that its proper place is on the adult list, alongside *The Road to Lichfield*. This latter book cannot be discussed in the limited space of the present essay, but a few points of difference from the children's books may be briefly mentioned, and may be of interest since the underlying concern with past and present is in many ways similar. An obvious one is the adult viewpoint, the absence of a young eye at the centre; another is the inclusion of sexual and other material which is likely to be outside most children's range of knowledge and interest. A third is the introduction of a rather sophisticated concept which does not, I think, appear in any of Mrs Lively's children's books: the concept of the past as something that has a shifting nature in relation to the present. It doesn't stay put; and when narrator Anne finds that her dying father's life included a major area that she knew nothing about, the landscape

of her own life is subtly changed. A fourth, and for the present purpose the last, difference is one that I cannot help seeing as a restriction on the adult novel. In the essay already quoted, Penelope Lively remarked that 'if a novel for adults concerns itself with memory, it will probably consider it in the context of a lifetime rather than in the context of history'; and this indeed *The Road to Lichfield* does. But as a result the writer has given herself far less imaginative scope than she had in, say, *The Driftway* or *A Stitch in Time*. The children's books are at an advantage in the size of the territory they can open up.

Mrs Lively has also written three stories, of short book length, for young children of perhaps seven or eight to ten. The most pleasing of these is *Fanny's Sister* . . . , which has a Victorian setting. Fanny prays to God for cherry tart and clotted cream for dinner; she also requests Him to take back the new baby she hadn't asked for. And when cherry tart and clotted cream are duly brought to the table the dreadful fear sweeps Fanny that the Almighty might well intend to answer her other prayer as well. She runs away. That is not a new idea in children's fiction, but the events that follow are both unexpected and intriguing. It all adds up to an engaging and happily-concluded story which comes well within a youngish child's comprehension. (pp. 129-34)

[*The Voyage of QV66* is] a humorous story in a totally different vein from her previous work. There's been another Flood, and all the people (it seems) have been evacuated to Mars, leaving only animals behind. The crew of QV66, a flat-bottomed boat, PROPERTY OF THE PORT OF LONDON AUTHORITY RETURN TO DEPOT 3, consists of Ned, a horse; Freda, a cow; Pal, a dog, the narrator (he can read, and he knows his name because he saw it with a picture of himself on a dog-food tin); Pansy, a kitten; Offa, a pigeon; and Stanley. Stanley has hands and feet, and although pictures of people give him the shivers he feels 'kind of connected to them'. Nobody's seen an animal like Stanley before, and the purpose of the voyage is to get to the London Zoo and find out what he is. He's the brains of the outfit, and he's also the one with imagination. (p. 134)

Stanley—vain, excitable, clever, silly, endlessly curious—is the central figure of the story. He is of course a monkey (and a person), and alone among the animals he is fully characterized; the rest are drawn with a few broad strokes. It is an episodic story, not in the least realistic—carefully avoiding, for instance, any of the unpleasant things you might expect to see when floods go down—but with a good deal of sly satire. When the animals get to the Zoo they find that the monkeys there are carrying on a parody of human society and organization; Stanley discovers *what* he is but realizes that the point is *who* he is; and the friends return to QV 66 to carry on exploring. To travel hopefully, it's clear, is a better thing than to arrive. There is a good deal of what might be called reversible humour: the animals' comments on what people did and how they used things make one think the animals are funny—until one changes sides, looks at people from a non-people viewpoint, and perceives that people themselves are funny, or on occasion unfunny, for instance in devising 'sharp sticks for killing each other with'. *The Voyage of QV 66* seems as I write (before publication) to have the qualities required for great popularity; and it looks a natural for an animated film.

I feel sure, however, that Penelope Lively will return, and very likely keep on returning, to the group of themes that have underlain the main body of her work. She is not likely to exhaust them. Continuity of course does not stop short at the present moment; it runs from the past through the present and on into the future. Mrs Lively has not so far engaged in any serious speculation on the future, and perhaps would have to be a different kind of writer in order to do so. She takes the matter no farther than the remaining lifespan of people now alive, but she does occasionally show children becoming aware of their own future, contemplating the (to them surprising) possibility of changing, becoming adult, growing old. Maria in *A Stitch in Time* ponders the prospect of growing into someone different, and into her head comes the idea of 'mysterious and interesting future Marias, larger and older, doing things one could barely picture'. Clare in *The House in Norham Gardens* similarly tries to project herself forward in time to meet the unknown future woman with her own name and face; but 'she walked away, the woman, a stranger, familiar and yet unreachable. The only thing you could know about her for certain was that all this would be part of her: this room, this conversation, the aunts.'

The longest and most splendid projection into the future however is Clare's birthday present to Aunt Susan. It is a copper beech tree that will take fifty years to grow and will last another two or three hundred years after that. What could be more suitable for an old lady of eighty-one? There's continuity for you. Aunt Susan is delighted. (pp. 134-36)

John Rowe Townsend, "Penelope Lively," in his A Sounding of Storytellers: New and Revised Essays on Contemporary Writers for Children *(copyright © 1971, 1979 by John Rowe Townsend; reprinted by permission of Harper & Row, Publishers, Inc.; in Canada by Penguin Books Ltd.), J. B. Lippincott, 1979, pp. 125-38.*

DAVID REES

Penelope Lively would have to write only slightly differently to find herself labeled by those people who need to pigeonhole books into categories as an historical novelist for children and to find herself compared with Rosemary Sutcliff, Henry Treece, or other writers of that genre. After all, her interests seem to be historical—the Black Death, Morgan le Fay, seventeenth-century ghosts, ancient ritual dances of the Exmoor area. None of her books, of course, is set in the period of any of these; they are set firmly in the twentieth century; and the reader is constantly made aware of this fact by references to supermarkets, plans for building motorways, rows of council houses. . . . In her concern for what is happening now and how the past helps to shape the present, Penelope Lively differs from the historical novelist who is more interested, perhaps exclusively interested, in what happened "then." She is nearer to the writer of fantasy, the writer who uses parallel stories of past and present—such as Lucy Boston in *The Children of Green Knowe* or, less obviously perhaps, John Christopher, who, in *The White Mountains* and *The Guardians,* uses a real past and a fantasy future to meditate on the problems of the present—as she does herself in *The Voyage of QV 66.*

But these comparisons are inexact; though there is a similar feeling, as in Lucy Boston's work, of the influence of place and history in shaping the lives of those who people her books, there is not the sense of displacement, of disorientation, that so interests Lucy Boston. . . . Much luckier, much more capable of enrichment, are the children in Penelope Lively's novels. Even if those children come originally from other places and their middle-class backgrounds mean some loss of roots, their own lives are firmly involved in the community: the large sprawling Midlands villages with their sense of the past—

ancient field-patterns and parish registers—and with their thriving present—new housing estates and traffic problems. And unlike John Christopher, Penelope Lively is not asking what kind of society do we wish to live in, how do we wish to develop; society to her evolves from a slow, natural growth and is not capable of violent change, nor does it need such change. The past is never made to seem worse than the present, nor better—Chipping Ledbury must cope with the problems caused by motorway planners that threaten to destroy it, just as Astercote had to cope with the Black Death. The Harrison family, in *The Ghost of Thomas Kempe,* has all the advantages of the comforts of modern living combined with a rewarding sense of the past; but not so for Betsy Tranter, in *Astercote,* who has all the disadvantages of such a combination.

Comparisons with other authors lead nowhere when writing about Penelope Lively. There may be a hint of Virginia Woolf, even of Philippa Pearce, in *The House in Norham Gardens,* only because of a slight similarity in language; there may be a hint of Penelope Farmer in *The Wild Hunt of the Ghost Hounds,* but only because of a likeness in landscape. What Penelope Lively has achieved in her novels is something unique, a kind of book that is neither history nor fantasy but has something of both, and that cannot be labeled conveniently—a book where the power of place is a stronger force than most of the characters, where "history is now."

How has she managed to achieve such an individual niche in the very cluttered world of children's books, where works of fantasy and history come ten a penny? It is obvious from her first novel *Astercote* that, despite its faults, here is a writer who is capable of putting together an exciting narrative, one in which the pace is exactly right and which, if nothing else, will keep the reader turning the pages to see what happens. This is no achievement to be scorned; unfolding a story bit by bit is to most writers a much more difficult task than composing a poetic piece about a sunset. *Astercote* seems immediately different from most other books. Goacher, one feels, is a character who could have been conceived by no other writer; and who else would posit a suggestion—one that the reader is made to take seriously—that the theft of Astercote's chalice could actually lead to a possibility of an outbreak of bubonic plague? . . . There are faults in the writing: Some of the characterization, particularly that of the district nurse, is thin and unconvincing; and there seems to be a curious infirmity of purpose at one important point in the novel, as if the author had not really made up her mind which way the book was going to develop—will the plague *really* return? The reader is a little disappointed that it does not: He is left with a feeling that the author has avoided that possibility because it was, at that point, beyond her power to deal with.

Most of these awkwardnesses are ironed out in the next two books, *The Whispering Knights* and *The Wild Hunt of the Ghost Hounds.* Both deal with similar themes and are structurally similar to *Astercote.* The children, however, are much more sharply individualized in *The Whispering Knights* than in *Astercote;* and the minor characters in *The Wild Hunt of the Ghost Hounds* are treated ironically—a very successful excursion into satirical social observation and a way of looking at character that Penelope Lively does not use again until *A Stitch in Time.* . . . Irony would have improved *Astercote.*

In *The Whispering Knights* Morgan le Fay affects the lives of Susie, Martha, and William; and in *The Wild Hunt* the revival of the horn dance affects Lucy and Kester more than the stolen chalice affects Mair and Peter in *Astercote.* The difference

between these two books and *Astercote* is that the evil caused by a silly meddling with the past is a real evil, not an imaginary one. As a result, there is no slackening of the narrative tension in the last stages of *The Wild Hunt* or *The Whispering Knights;* on the contrary, the concluding chapters contain the most exciting writing of the books—where the struggle between good and evil reaches its climax. . . . In *The Whispering Knights,* there are hints in the character of Martha that Penelope Lively is beginning to be interested in children who are not wholly uncomplicated and nice. And in *The Wild Hunt* there is a very odd and unusual, but sympathetic character, Kester: a child who deliberately invites persecution; in Kester there is something more complex than what she had achieved before—a convincing mixture of contradictions.

If the first three novels are similar in theme and structure, their successors are not only very different, but different from each other in these respects, though the preoccupations with "places . . . are now but also then" and with how it was for the people "then" remain. . . . The road actually becomes the central character of [*The Driftway*] rather than the boy, Paul, who is traveling on it, and it is used to hang somewhat loosely together various self-contained stories set in the past: the adventures, for example, of an eighteenth-century highwayman and a soldier escaping from a battle in the Civil War. It is probably the least successful of Penelope Lively's books, the only one which readers consistently say is dull. There is no loss in the quality of her writing ability; indeed there are passages, notably of landscape description, that are finer than anything she had previously done. . . . But the book is shapeless. It seems to be the length it is because that is the standard length required by publishers. It could have been longer (a few more historical episodes inserted would not seem out of place), or shorter (a few of these episodes less and the reader would not notice anything missing). Old Bill, the cart-driver, is a totally unconvincing rustic, made of sentimental clichés about rural characters. The predicament of the central figure, Paul—who is running away from home because he cannot face up to the implications of his father's second marriage—remains curiously unfelt. The reader is never allowed to come fully to terms with the situation: Paul's father and stepmother remain outside the narrative and are only present in Paul's thoughts. So the reader is asked to share a vague emotive identification with Paul without enough information to go on.

Why does *The Driftway* fail so badly? Largely because the author has abandoned the technique she had mastered so ably—telling in a tight, exciting manner a highly readable narrative that has a beginning, a middle, and an end—and has substituted an experimental, impressionistic framework she does not know how to handle. In *The Ghost of Thomas Kempe* . . . she returned, fortunately, to the business of telling a story—with triumphant success. . . . *The Wild Hunt of the Ghost Hounds* had shown how well Penelope Lively could write, if only fleetingly, in a comic vein; *Thomas Kempe* is a comedy from beginning to end and has a lightness of touch that never fails. Not only is the poor poltergeist a figure of fun, but Aunt Fanny's journal is a magnificent pastiche of a Victorian diary-writer. (One grumble: Would such a masterpiece have ever been thrown out onto a bonfire?) . . . And James, the central character—a sound, solid, boylike boy—is just a bit larger than life, not exaggerated enough to be a caricature, but a little like Tom Sawyer. He fits perfectly into the world of this novel. Parents play a larger part in this book than in the previous three; quite correctly, for the absence of parents in many children's books is often self-indulgence on the writer's part. Who,

if not parents, play the largest role in a child's life? So here are Mr. and Mrs. Harrison, amusing and uncomprehending, so busily engaged in the tasks of earning a living or doing the housework that they cannot possibly begin to understand the fantastic or the supernatural, cannot even allow that they may exist. Poor James has to battle with Thomas Kempe alone.

The Ghost of Thomas Kempe is perhaps the first of Penelope Lively's novels in which the reader feels that the author is completely sure of her own abilities, and the writing has a positiveness that derives from the author's pleasure in her awareness of these abilities. Certainly it was her finest book so far, and armed with this new-found authority, she went on to deal with a more complex analysis, in *The House in Norham Gardens,* of the same themes that have always preoccupied her. The prose has a poetic, luminous quality that is a sheer delight; like Philippa Pearce's *The Children of the House,* it is a prose poem from beginning to end. . . . This is a far cry from the prose of *Astercote,* which was competent but flat, unmemorable.

Adults become even more important in *Norham Gardens* than in *Thomas Kempe.* Aunt Anne and Aunt Susan are observed by both Clare and the author: difficult, eccentric, very old, wrapped in a way of life that has long since ceased to exist, only vaguely aware of the hardships they cause Clare, yet credible and sympathetic. . . . The emphasis in *Norham Gardens* lies not so much on "places . . . are now but also then" but on people who are now but also then. Not that place is neglected. The decaying Victorian suburbs of Oxford—with their grandiose houses that are symbols of an age of greater certainties than ours, crumbling or split up into flats, their gardens filled with weeds and students' bicycles—are created with great lovingness and care. But Aunt Anne and Aunt Susan are *people* from history and also of now, and this theme beguiles both the reader and Clare into an awareness that the hardships of her existence are mitigated by imaginative rewards denied to most children. (pp. 185-93)

The house is now and then; so are the aunts; and so, as a result, the element of fantasy in this novel is less strong than in any other of Penelope Lively's previous books, except perhaps for *Astercote.* Indeed it might have been dispensed with altogether; not that one wishes it were not there—for the fusion of the theme with the quest of the brown men of New Guinea for their lost shield is highly successful. In fact, the fantasy element shows another perspective of history and memory and their relationship to the present—not only are people and places of now and then, but also objects, even when they are torn out of their environment and taken into other, incongruous situations where they apparently have no meaning.

After *The House in Norham Gardens,* the complete absence of fantasy in *Going Back* comes as no surprise; and in its successor, *A Stitch in Time,* it is firmly established as the product of a lonely child's overactive imagination, not as a force to be reckoned with in its own right. Both books are still concerned, however, with past and present; in *Going Back* Jane's comfortable married middle age is compared with her childhood in the Second World War, and in *A Stitch in Time,* Maria, on holiday in Lyme Regis in an old house that has hardly changed in a hundred years, becomes so involved with thinking about a Victorian girl who lived there that she imagines she is going to suffer the same supposed fate, death in a landslide. *Going Back* is not entirely satisfactory. Its opening chapter—Jane revisiting the village in Somerset where she was brought up—attempts a similar kind of poetic prose-style to that of *The*

House in Norham Gardens, but it doesn't work so well: the place hasn't fired the writer's imagination quite so vividly. The children's father is an unconvincing figure: one could understand his being heavy-handed and insensitive, but he is so repellent, so totally nasty, that the reader cannot believe in him as a probability. The other characters, however, are excellent, and the narrative, after an unusually slow start, holds the reader in its spell. The strange new aspects of life in wartime, both pleasant and unpleasant, are emphasized in detail, and particularly good is the initial lack of comprehension with which Jane and her brother greet things entirely out of the ordinary. . . . And, most interestingly, in *Going Back,* there are signs that Penelope Lively has growing doubts about the kind of material she has, since *Astercote,* chosen to use:

> People's lives tell a story, I thought once: and then, and next, and then . . . But they don't. Nothing so simple. If it's a story at all, then there are two of them, running side by side. What actually happened, and what we remember. Which is more important, I wonder?

A Stitch in Time is a perfect illustration of those doubts, distinguishing between what actually happened to Harriet (nothing very much) and what Maria imagines happened to her (a melodramatic death). Yet the influence of the past on the present is seen as enormous, even though the author seems to be saying that we can never exactly realize what it was like to be living in a bygone age. This is well conveyed in the person of the landlady, Mrs. Shand, who was a child in late Victorian times, and, surrounded as she is by relics of the past, she is not the girl she was then; she's a rather sharp-tongued old woman with a faulty understanding of children, and her interest in the past is little more than a sentimental wish to keep family mementoes. Maria looks in her face "for the shadow of this other person she must once have been, and could not find it." *A Stitch in Time* is probably Penelope Lively's most important and memorable book. Not only is its exploration of the significance of history and memory more profound than in any other of her novels, but the unfolding of the story is very fine, and the power of place has rarely been better done in a children's novel. Lyme Regis is a town soaked in history, and along with its unpredictable landslides it is famous for its fossils and pre-history; but it's also a modern seaside resort: she manages to suggest that like people it has layers, now and then. The book also shows Penelope Lively's gifts as a humorist—the social comedy, contrasting two completely different families, one noisy, slapdash, and chaotic, the other so organized that all spontaneous life has been crushed out of it, is extremely well handled. She has little good to say about the stultifying Fosters. . . . Their interest in the past is shallow and frivolous. . . . No wonder Maria, their only child, is so bored and lonely that she is given to talking aloud to cats and petrol-pumps and clocks. But she's a girl of spirit, if somewhat repressed, and has some moments of splendid indignation. (pp. 193-96)

The change in Penelope Lively's attitude to the past is an important development. Mrs. Shand says:

> "Things always could have been otherwise. The fact of the matter is that they are not. What has been, has been. What is, is." She stabbed the needle confidently into the brown canvas.
>
> "I suppose so," said Maria. "But it's a very difficult thing to get used to."

"One does eventually," said Mrs Shand, "there being no other choice."

She chose to set her most recent novel, *The Voyage of QV 66,* in the future, which, after the questions raised in *A Stitch in Time,* is quite logical; she clearly felt a strong need to take a very different look at the themes that have preoccupied her until now. So this story is all fantasy and no history. . . . It's a very amusing tale, but it's cautious and experimental, its characters too predictable, incapable of giving the reader any sense of surprise. It was reviewed almost ecstatically in England, but it doesn't begin to measure up to *A Stitch in Time.* No matter; an author making such a radical change of direction as Penelope Lively does here is unlikely to write a masterpiece at once. Or is it a dead end? It's not easy to predict her next move. Yet there are some absorbing passages in *The Voyage of QV 66,* particularly when the animals are meditating on the nature of men and their achievements. Its conclusions are somber: man was a pretty nasty piece of work on the whole, and there is a danger that his mistakes will be repeated. Already the dogs are beginning to organize themselves into fascist-like packs, and the monkeys are, in an extremely primitive way, inventing machines. Good, too, is the author's liberal attitude to outsiders and misfits—the book expresses a sense of outrage that nonconformists must automatically be persecuted or eliminated.

Children "can't yet place themselves in a wider framework of time and space than *today* and *here,*" Penelope Lively wrote in "Children and Memory": "But they have to, if they are not to grow up enclosed in their own personalities. Perhaps books can help, just a little" [see excerpt above]. Her most recent work seems to be suggesting that it is a very hard task indeed. Maria's experiences in *A Stitch in Time* may have prevented her from being enclosed in *her* own personality, but no such optimism pervades *The Voyage of QV 66.* Penelope Lively's next novel—if in fact she hasn't written herself out as far as children's books are concerned—will be different again. One awaits it eagerly; she's undoubtedly the most interesting author of children's fiction to have emerged in the nineteen-seventies. (pp. 196-98)

> *David Rees, "Time Present and Time Past: Penelope Lively" (originally published in a slightly different form in* The Horn Book Magazine, *Vol. LI, No. 1, February, 1975), in his* The Marble in the Water: Essays on Contemporary Writers of Fiction for Children and Young Adults *(copyright © 1979, 1980 by David Rees), The Horn Book, Inc., 1980, pp. 185-98.*

SHEILA A. EGOFF

[Lively's] fascination with human memory can be seen in several of her books, among them *A Stitch in Time* and *The Ghost of Thomas Kempe.* She is fast becoming the Proust of children's writers with such passages as Jane's adult musings in *Going Back*:

> Remembering is like that. There's what you know happened, and what you think happened. And then there's the business that what you know happened isn't always what you remember. Things are fudged by time: years fuse together. . . . There is time past, and time to come, and time that is continuous, in the head forever.

Lively also has an uncannily accurate and honest recall of what it is like to be a child in a world made for adults. She uses the clear, perceptive eye of childhood observation with its chilling remorselessness, patient detection, and striking sensuality to uncover the difficult, confusing truths and half-truths that typify the relationships between adults and children. This she accomplishes by blending the passionate immediacy of a child's experience with the bittersweet, ironic understanding of that experience from the vantage point of adult memory. All this Lively combines with adept portrayal of sympathetic and very real characters, intricate dialogue, and a poetic prose style. As she struggles with her personal view of memory and time, as she works through the eternal "you can't go home again" to discover her own truths, she provides the reader with unusual rewards in a kind of realistic fiction that is highly subtle and almost unique.

Subtlety is hardly a staple of children's literature and, whatever its authenticity, *Going Back* does raise the suspicion that many modern writers for children are writing for the adult in themselves rather than, as in former times, for the child within the adult. In a very real sense this approach matches society's current view of childhood, which seems to be that it is somehow injurious or at least condescending to children to treat them as children. It may be, also, that modern writers found their own childhood reading to be inconsistent with the reality they observed about them or remember. In either case, the conclusion derived is that contemporary children's books should deal with serious matters in a serious manner. (p. 41)

> *Sheila A. Egoff, "Realistic Fiction," in her* Thursday's Child: Trends and Patterns in Contemporary Children's Literature *(copyright © 1981 by the American Library Association), American Library Association, 1981, pp. 31-65.**

KATHERINE DUNCAN-JONES

[*Fanny's Sister, Fanny and the Monsters* and *Fanny and the Battle of Potter's Piece*] are now gathered into one volume [titled after the second story]. They are set in the Bad Old Days of the 1860s, when fathers were heavy, Sunday was given over to church-going and improving reading, and Science was not part of the curriculum in the family school-room. Fanny, the eldest of eight children in an upper middle-class Oxfordshire family, is surprisingly detached in her outlook on these things, rejecting religion, longing to be a palaeontologist, and discovering that the way to achieve contentment in a large family is by democratic process. . . . Could she perhaps, like the children in some of Penelope Lively's other books, have wandered back from a *Guardian*-reading family of the mid-twentieth century? The 1860s are depicted condescendingly as a period of bigotry and barbarism—though Fanny's father, in the title story, shows brief glimmerings of approval for her when her observant eye for fossils wins the admiration of a young scientist from the British Museum.

By far the best story is the first, which deals with Fanny's theological and emotional upsets after a supplicatory prayer for cherry pie at Sunday lunch has been answered. Appended to the prayer for cherry pie was a wish that the latest Stanton baby might be removed (not killed) by divine intervention. . . . After a rather unconvincing episode in which she runs away from home and spends half an hour pretending to be a kitchenmaid at the vicarage, she comes back, fast friends with the myopic but understanding vicar, and subsequently develops a particular affection for the baby. The narrative is fast moving, events are well described, and social observations, such as

Fanny's momentary reflection that the real kitchen-maid employed by the Stanton family is little older than herself, are lightly delivered.

The second story shows Fanny pursuing her interest in fossils and prehistoric monsters in the face of strong discouragement from her Aunt Caroline, her father, and her stereotypical governess, Miss Purser. The third describes the battle of the Stantons over a piece of waste ground with an almost equally numerous family newly arrived next door. It is here that the softness of Mrs Lively's imagination is most damaging: the idea that fourteen children from two separate families can sort out their territorial differences and achieve joint decisions without rancour would be hard to credit even if the story had been set amid group-sharing schoolchildren in the 1980s. Mrs Ewing's story "Our Field", 1889, on a similar theme, did full justice to the insistent individuality of children: here the ideals of the Adventure Playground seem too hopefully projected into a supposedly repressive environment. . . .

It is a pity that the stories were not revised and edited a little before being brought together. It is at the end of the second story, rather than the last one, that we learn what happened to Fanny when she grew up; we are told three times over about the composition of the family and the fact that only the older children enjoy the privilege of a nice big Sunday lunch with their parents. Nine-year-old readers may not object to the ideological anachronisms, but they will find these repetitions tedious.

Katherine Duncan-Jones, "The Olden Days," in The Times Literary Supplement *(© Times Newspapers Ltd. (London) 1983; reproduced from* The Times Literary Supplement *by permission), No. 4190, July 22, 1983, p. 777.*

ASTERCOTE (1970)

Astercote is a medieval village, lost not under the sea, but under the tangle of a thick wood: the bells of its ruined church ring for those who can hear them, and the sounds of its people, its animals, its life, well up sometimes into the consciousness of the sympathetic listener. Such a girl is Mair, the new schoolmaster's daughter who ventures into the wood with her brother rather against the will of the farmer whose land lies round it, and meets an uncouth, strange young man with two fierce dogs, apparently living there. Astercote in fact was wiped out by the plague and the present day village retains a residual memory of horror. . . .

This is an evocative idea, particularly when we are seeing it through the eyes of Mair, who is the most developed of the characters. She suffers a

> dreamy, detached feeling . . . the sensation of being no longer Mair now, but Mair then, a watcher Mair in some other time, passive recipient of sounds and smells that were real, and yet, unreal . . .

It is in the description of Mair's feeling about the place, her sense of the extreme poignancy and mystery of ruined habitations, the atmosphere of the lingering past, that the writing most often achieves some distinction (and, in a way, it is only this that distinguishes Mair). It is a fresh eye, all the same, that sees the dog's prints in the dew as black pennies.

The country people are quite adequately filled in, particularly the farmer's daughter, and her subnormal brother, and the young district nurse who is the children's source of information about this odd village. And the villagers' total lethargy when the babbling television reporter walks backwards into their pond is a pleasing, if doubtful, idea.

None the less, it is difficult to believe that such an hysteria could really happen; that an old belief, that what's hidden in the wood is a safeguard against the return of plague, could be in the first place still current in such precise detail; and, then, believed in to the point of causing communal action like barricading the road and preparing to take up arms against inquisitive strangers. Moreover, if they all really trust in the efficacy of [the chalice], would they leave it to the sole care of poor, simple Goacher? (Who cannot, surely, exist on hawk-caught rabbits, but who does not come home for days on end.) And who, as one might expect, fails to save the thing from a predatory motor-cycle lout who has wormed its whereabouts out of him. It is the knowledge of the loss of it that fans the hysteria, the recovery of it that returns all to normal.

The recovery is certainly undertaken with courage and sublety by Mair, her brother and the nurse, and makes a fast, exciting piece of action, with a most dramatic coup as climax (whose likelihood only a falconer could assess). But it is an ingenious idea. Indeed, the possibilities inherent in the whole book are perhaps rather greater than the performance. All the same, this is an enjoyable story, by a new author with a sense of history, which in itself has caused her perhaps over-romantic treatment of a poetical idea, and which is much to be preferred to *no* sense of history.

"Pull of the Past," in The Times Literary Supplement *(© Times Newspapers Ltd. (London) 1970; reproduced from* The Times Literary Supplement *by permission), No. 3555, April 16, 1970, p. 421.*

[*Astercote* is] a literate, enjoyable story. . . . Ancient and modern interweave and one's sympathies, like the young heroine's, are pulled both ways: rural hysteria on the one hand, townish patronage on the other. The villagers' attitude hardens into the kind that turns a demonstration into a riot, its initial object forgotten: a protest against everything, an anti-Them campaign. A good ear for talk and a pleasant swinging style do plenty for a plot as dense and many-layered as this one.

Isabel Quigly, "Dream Days," in The Spectator *(© 1970 by* The Spectator; *reprinted by permission of* The Spectator*), Vol. 224, No. 7402, May 9, 1970, p. 623.**

The plot is neatly constructed and the characters well-delineated—both the practical Peter and his sensitive sister Mair with their bickering comradeship and those of the villagers. Their suspicion of new-comers and superstitious reactions to disturbing events in contrast to the scepticism of officials and outsiders are wholly acceptable. Only Luke the ton-up boy is unconvincing.

After an awkward introduction to the children, the narrative flows naturally, despite a few minor inconsistencies. The scenes and personality of the area are deftly conveyed. An engrossing read for ten to thirteen-year-olds.

J. Aldridge, in a review of "Astercote," in Children's Book News *(copyright © 1970 by Baker Book Services Ltd.), Vol. 5, No. 3, May-June, 1970, p. 131.*

Such a happening [as a revived superstition and a corresponding epidemic of mumps] seems an incredible hypothesis in the twentieth century, but the author . . . has used it to make a readable story with a considerable build-up of atmosphere. The weak points in the plot and in the drawing of character in some instances will be forgiven by children in the interest of the story. (pp. 170-71)

> A review of "Astercote," in The Junior Bookshelf, Vol. 34, No. 3, June, 1970, pp. 170-71.

Fresh, intelligent, with a strong sense of place and of history and not the least hint of condescension—these are the outstanding virtues of Penelope Lively's first book for children. They are qualities which readers of *Books For Your Children* will already have noted in her articles. And indeed, writing in the Winter issue about the world of Green Knowe (and at the same time showing her veneration of Lucy Boston), she used a phrase which aptly describes her own book: "full of reverence for the past and the sanctity of a place, but at the same time lively, full of . . . interest".

Astercote was, or is—the ambivalence is important—a Cotswold village destroyed in the 14th century by the Black Death. . . . [The theft of a relic chalice] reveals how powerfully the shape of the past moves on the action of the present. . . .

An assortment of villagers, police and media-people comprises the background to the story; but the focus is mostly, and most successfully, on the two children and Astercote itself. Indeed, though Peter and Mair are important agents in the recovery of the chalice, they are not at the imaginative heart of the book. They are vehicles more than they are individuals. The one distinctive presence in these pages is Astercote: the village, its bells, its setting, and its spirit. This impression is fortified by Antony Maitland's drawings, which strongly evoke the various places important in the story (wood, church, farm, summerhouse), but which do not seem to me to render human figures convincingly living and moving.

And, I am afraid, this is at present Mrs. Lively's weakness too. Her writing has clear virtues: it is crisp; strikingly visual in description; organised in paragraphs which have shape and chapters which end cliff-hangingly. The chase which occupies the bulk of Chapter Ten is very exciting, as the children's campaign to recover the chalice nears its end. But these are *intellectual* virtues (I do not mean to undervalue them), and they are insufficient to bring fictional characters to life. They serve a critic well, but they let a novelist down. For example: Peter is said to be 14; for the sake of his part in the plot he needs to be; but there is nothing early-teens about either his behaviour or his speech: "Bother Mair! Oh, bother her and bother her and worse things than that." The dialogue generally just doesn't have that ring of truth that readers immediately recognise, and so the people in the story never fully come alive. They are not differentiated in their talk, except that some use dialect—and even that seems to me more Zummerzet than Cotswold. And the retarded Goacher doesn't *sound* retarded when he speaks: "I were afraid to tell 'un. I were scared—scared of what they'd say and scared of what was to happen. I knows what 'ud happen if it were to leave Astercote."

This failure to render speech convincingly isn't, I think, just a failure of ear; it's a failure to penetrate imaginatively into the mind of the speaker. It can be seen, too, in Mrs. Lively's tendency to *summarise what happened* rather than to *describe it as it occurs;* and to tell it from the standpoint of a disembodied narrator rather than through the experience of a participant in the scene.

> Gordon Dennis, in a review of "Astercote," in Books for Your Children (© Books for Your Children 1970), Vol. 5, No. 4, Summer, 1970, p. 20.

The idea of a shadowy, not necessarily impenetrable division between the Then and Now of time has always fascinated writers and their mystery-minded readers. It often appears, in a particularly happy fashion, in current juvenile fiction.

Such a book is **"Astercote"**. . . .

This is a book marked by excellent narration and atmosphere, with well drawn characters. On the debit side, the unnatural lack of parental curiosity as to what their children are up to creates a credibility gap which the adult reviewer must wish had been bridged more plausibly. It will not, of course, bother the 9-12-year-olds to whom the story is slanted.

> Silence Buck Bellows, "Green Hair, Anyone?" in The Christian Science Monitor (reprinted by permission from The Christian Science Monitor; © 1971 The Christian Science Publishing Society; all rights reserved), May 6, 1971, p. B6.*

THE WHISPERING KNIGHTS (1971)

'Morgan le Fay rides again!' you groan—but [*The Whispering Knights*] will please even those who are tired of Arthurian survivals. . . . [The] story is suspenseful and serious, sometimes frightening. . . . The time shift is handled economically—like the dragon episode, where the children never do use the word 'dragon'. The dialogue is mostly convincing, the prose is effortless. . . . This is a book to buy and an author to watch.

> Maureen F. Crago, in a review of "The Whispering Knights," in Children's Book Review (© 1971 by Five Owls Press Ltd.; all rights reserved), Vol. I, No. 3, June, 1971, p. 90.

The author's first book, *Astercote,* was promising. Her second one fulfils that promise to some degree. It is set once more in the Cotswolds of which the author gives the reader vivid and nostalgic glimpses.

The whole story hinges on the unexpected result of a witches' brew which children make up for fun. It calls forth Morgan le Fay, the enchantress, and her power for evil grows with the progress of the story. . . .

The three children involved so closely are well drawn, particularly Susie, the sturdy, sensible daughter of the owner of the general shop in the village. Martha, perceptive and imaginative, is a natural prey for the enchantress.

A witty and amusing story builds up to a climax as the driverless Rolls Royce with the enchantress as a passenger pursues the children relentlessly, an episode rather reminiscent of the film *1001 Dalmations* and Miss Cruella de Vil. The terrifying battle between the "Knights" and Morgan le Fay is all the more impressive because it is only felt and heard, not seen. A mysterious and possibly legendary figure, Miss Heppelwhite, gives the children support.

Throughout the story the past impinges on the present to show that there is a recurring pattern of good and evil in life.

Eileen Colwell, in a review of "The Whispering Knights," in The Junior Bookshelf, *Vol. 35, No. 3, June, 1971, p. 184.*

[*The Whispering Knights*] is outstandingly good. . . . This book beautifully contains the different characters of the three children, the gossiping, self-contained atmosphere of village life, and the threat of bad magic, personified in the figure of Morgan le Fay. There's no whimsy here, but true feeling: not a book any publisher could have commissioned, but springing direct from the author's genius.

Catherine Storr, "The Virtue of Surprise," in New Statesman *(© 1971 The Statesman & Nation Publishing Co. Ltd.), Vol. 81, No. 2098, June 4, 1971, p. 777.*

The secret of successful fantasy, it has been said by innumerable pontificating critics, from Aristotle onwards, lies in the plausible impossibility. You take a normal everyday world and inject into it one alien element, then proceed to whatever complications logically ensue. . . .

It is never quite impossible that the terrifying events which follow [the creation of a witches' brew] could be all coincidence and imagination, but the progress into a world of sorcery where the siting of a motorway becomes a struggle between the primal forces of good and evil is so gradual as to be utterly convincing. Miss Lively is learning to twist the threads of reality and unreality in her plot into a fabric of increasing strength and tension. You could bounce hard on this one and it would not let you down.

"A Pinch of Madness," in The Times Literary Supplement *(© Times Newspapers Ltd. (London) 1971; reproduced from* The Times Literary Supplement *by permission), No. 3618, July 2, 1971, p. 774.**

There are some scary moments before the Stonehengelike rocks known as the Whispering Knights come to life and rout the witch, but finally it all seems a trifle silly, and the characters are highly forgettable.

Karen B. Andersen, "'Tis the Season for Fantasies," in The National Observer *(reprinted by permission of* The National Observer; *© Dow Jones & Company, Inc. 1976; all rights reserved), December 25, 1976, p. 14.**

In a time-displacement fantasy—a particularly successful genre in British juveniles—that is easy reading but requires some thought, Penelope Lively has written another fast-paced children's adventure, related in 10 lively chapters. The British expressions, such as telly and motorway, seem so clear and familiar because of the author's flowing style and command of dialogue that children will quickly grasp the meanings. Boys and girls from 9 to 13, as well as younger readers, will appreciate it. (p. 208)

Being able to identify easily the abstract theme of good versus evil is satisfying to many readers as they confront their own moral development. . . . Further, an equally important theme, but one requiring the more difficult step of thought abstraction, is the author's portrayal of what may be the 3 elements in any individual in the character of 3 young children: Susie, outgoing and practical; Martha, sensitive and dreamy; and William, actively curious about the real and the imaginary. The plot's resolution parallels the hero's resolving of the two other elements into a transcendent, harmonious whole in a healthy personality. This level of abstraction at this age is possible for only a few. For everyone, however, it is a rousing tale of adventure among the commonplace. (p. 210)

Diana L. Spirt, "Appreciating Books: 'The Whispering Knights'," in her Introducing More Books: A Guide for the Middle Grades *(copyright © 1978 by Diana L. Spirt; reprinted by permission of the author), R. R. Bowker Company, 1978, pp. 208-11.*

THE WILD HUNT OF HAGWORTHY (1971; U.S. edition as *The Wild Hunt of the Ghost Hounds*)

Woven into [this sensible examination of mob violence] is the West Country legend of the Wild Hunters. The well-meaning vicar [who decides to revive the Horn Dance of Hagworthy as an interesting piece of folklore using the village boys as the Horn Dancers] raises not only the passions of the mob but the Ghost Pack. This is the theme that really engrosses the reader—the behaviour of the Horn Dancers has been predictable from the start. Tension is built up under the sultry, thundery skies. There are shadows, footprints, eerie portents. We are all ready for an episode of Tolkienian dimensions. And inevitably we feel let down. Only the best ghost stories succeed in making us really feel we have been in contact with supernatural happenings: more often they seem merely stagey. Penelope Lively is hindered, besides, by relegating her supernatural to the role of a sub-plot. But it is a readable book, clearly and crisply written, with a real feeling for the Somerset country.

"Dangerous Spirits," in The Times Literary Supplement *(© Times Newspapers Ltd. (London) 1971; reproduced from* The Times Literary Supplement *by permission), No. 3640, December 3, 1971, p. 1516.**

The wild hunt of Hagworthy follows the pattern of Penelope Lively's two earlier books in its bold mingling of old beliefs with present-day events, and in the skilful managing of a long crescendo from a simple opening movement. . . . The story is briskly told but the simple point is firmly made within a proper novelist's framework of recognisable characters, delicately drawn settings and a nice judgement of village words and ways.

Margery Fisher, in a review of "The Wild Hunt of Hagworthy," in her Growing Point, *Vol. 10, No. 7, January, 1972, p. 1864.*

The influence that old superstitions may still exert on contemporary society is a phenomenon that evidently intrigues Penelope Lively, for in different ways she has explored the theme in each of her three interesting books. *The Wild Hunt of Hagworthy* owes its inspiration to a fragment of Somerset folklore, itself probably a survival of an even earlier rural tradition; it owes its credibility to the author's skill in sustaining a sense of impending disaster without revealing too much, too soon. . . .

The story is compact, enjoyable and thought-provoking on several counts to anyone over ten or eleven. I was infuriated by the Vicar and the horse-mad Norton-Smiths because they lacked conviction and yet were not quite funny enough as caricatures for it not to matter; but they were necessary foils to the more satisfying characters in the book, as well as providing light relief.

Nina Danischewsky, in a review of "The Wild Hunt of Hagworthy," in Children's Book Review *(© 1972 by Five Owls Press Ltd.; all rights reserved), Vol. II, No. 1, February, 1972, p. 13.*

The descriptive complexity of the style captures the lush, rural quality of the background of the story, and the characterization brings to life the types of people generally associated with English villages; but the power of the story resides in the ancient legend of the hunter and the hunted. This legend is effectually combined with the psychology of the situation—with Lucy as outsider, Kester as tentative sceptic, and Mr. Hancock as traditionalist; and the reader becomes caught up in the ritual reenactment of whispered folklore. (p. 377)

> *Paul Heins, in a review of "The Wild Hunt of the Ghost Hounds," in* The Horn Book Magazine *(copyright © 1972 by The Horn Book, Inc., Boston), Vol. XLVIII, No. 4, August, 1972, pp. 376-77.*

THE DRIFTWAY (1972)

The journey in **The Driftway** is slow and extremely local; indeed, as I read the book I felt I was really moving at horse-and-cart speed along the road between Banbury and Northampton and I would guess that the most important idea in the author's mind is expressed by the old travelling-man as he inveighs against the motor car:

> "Real travelling's crawling your way over the country like a fly on the wall, hedge by hedge and hill by hill and village by village. That way you feel the bones of the place, see? You see the way the land goes, and why they grow corn here and why they graze cattle there, and why there's cities where there are, and why there's a lot of people in one place and not so many in another . . ."

There is certainly a human problem in the book, the unhappy situation of Paul and his little sister. They are running away to Gran at Cold Higham, ostensibly to escape the consequences of entirely accidental shop-lifting but really, in Paul's case at least, to escape the young stepmother who he resents but whose affection he secretly longs to accept. A change of heart comes slowly to Paul, in part as he listens to the old man who is helping them on their way but far more because he receives "messages" from the past, visions of events that have taken place on the ancient drovers' road along which they are travelling. . . . [Every] interlude reflects part of Paul's situation and brings him a step nearer to understanding himself and his family. The organisation of the book is very formal and deliberate. The feeling of travel, of an actual road with its verges and hedge-trees and occasional cottages, gives it emotional and visual unity, and an elegant precise prose creates the pattern of the landscape as the horse plods slowly through it. Though this is less obviously exciting than Penelope Lively's earlier books, I believe she has touched a new dimension of writing in it. (pp. 1965-66)

> *Margery Fisher, in a review of "The Driftway," in her* Growing Point, *Vol. 11, No. 2, July, 1972, pp. 1965-66.*

Penelope Lively's book is vividly imagined and written, and she re-creates the style of different periods confidently and knowledgeably—the Anglo-Saxon and eighteenth-century episodes are particularly good in this respect. Ultimately, however, the book is weakened by the lack of detailed correspondence between the messages and their recipient, apart from the obvious element of shared troubles; this strongly limits the possibilities of interaction between Paul and what he hears.

The Driftway is written in the tradition of Kipling's Puck stories, E. Nesbit's *Harding's Luck*, and more recently, Noel Streatfeild's *The Fearless Treasure*; it is a worthy successor.

> *"Ghosts," in* The Times Literary Supplement *(© Times Newspapers Ltd. (London) 1972; reproduced from* The Times Literary Supplement *by permission), No. 3672, July 14, 1972, p. 812.**

For Paul, the Driftway is peopled with presences which at intervals he sees clearly while he lapses into a fey condition. . . . At the same time Bill and his own acquaintances on the route are interesting enough in themselves. You might wonder, sometimes, how a boy who behaves so perversely in the face of what seems to the reader like obvious kindness should be granted the grace of communication with the ambience of the past. Sandra, being only seven, has no option but to tag along. There it is. Miss Lively writes well, exceeding by far the style and effect of **The Wild Hunt of Hagworthy**.

> *Aneurin R. Williams, in a review of "The Driftway," in* The Junior Bookshelf, *Vol. 36, No. 4, August, 1972, p. 252.*

Penelope Lively's preoccupation with the past has been used in this book to help a young boy come to terms with changes in his life that he has found upsetting. . . . The interweaving of the old stories with the things that happen to Paul and his sister on their way is nicely done and the children are real, especially Sandra with her annoying and endearing ways, which Paul is so well able to anticipate in the way of any young boy forced by circumstances to be responsible for a much younger child. For readers of eleven to thirteen if it must be arranged, but worthy of a much wider audience.

> *Sylvia Mogg, in a review of "The Driftway," in* Children's Book Review *(© 1972 by Five Owls Press Ltd.; all rights reserved), Vol. II, No. 4, September, 1972, p. 115.*

It is not often that the elements of realism, fantasy, and history are given equal stress in a single story. . . . The general narrative movement of the novel is leisurely but absorbing; the interpolated stories are vivid and are varied in style to suit the historic background. And the realism of present events and the significance of past are given full verisimilitude. The weakest of the three elements in the story, however, is the unaccountable way in which Paul communicates with former travelers along the road—unless one assumes that an introspective child is, by nature, not only more open to occult influences but actually influenced by them. (pp. 271-72)

> *Paul Heins, in a review of "The Driftway," in* The Horn Book Magazine *(copyright © 1973 by The Horn Book, Inc., Boston), Vol. XLIX, No. 3, June, 1973, pp. 271-72.*

THE GHOST OF THOMAS KEMPE (1973)

AUTHOR'S COMMENTARY

Fictional ghosts have a long and respectable ancestry, from Hamlet's father to Quint and Miss Jessel. Indeed the ghost is a most handy literary device, adaptable and disposable to a far more convenient degree than most fictional characters, and to be used as a vehicle for anything from good clean horror to a stern moral message. It's the moral position of ghosts that has always intrigued me—the ghost story as fable, including a layer

other than the merely narrative, just like the fairy story, and I think it was with this in mind that I wanted to write a children's book in which the hero—or the secondary hero—was a ghost. Thomas Kempe is not a moral figure, and the story is intended as a light-hearted one, but I wanted to give it an invisible substance, a content beyond the story, and Thomas Kempe is the vehicle for that. (p. 143)

Ghost stories are moral tales: they are warnings about how people ought to behave, for societies where the arm of the law is not very long and crime frequently does pay. Ghosts do not appear at random: they appear to draw attention to their own murder, to clear up unresolved financial matters, to reveal undetected crimes, to persuade the listener that retribution pursues the guilty even beyond the grave. No wonder they lose their potency in the well-policed modern world. No wonder Thomas Kempe, bewildered by the rational efficiency of the twentieth century village, retreated back to his tomb. (pp. 143-44)

Thomas Kempe, and his background of a place—house and village—which have lasted considerably longer than the people who live there now, is a device for me to explore a personal preoccupation with memory. The memory of places, and the memory of people, and the curious business that we are all of us not just what we are now but what we have been. To grown-ups this is—or ought to be—self-evident. We know that we are sustained by our memories. Children, on the other hand, it seems to me, are barely aware of this: they simply haven't been here long enough yet to have found out. But at the same time they are fascinated by the implications of it all. No child seriously believes that it is going to grow up. They may talk airily of ambitions and intentions, but at the same time—unless childhood has become a much more sophisticated business than it was in my day—they do not really conceive of themselves as grown-ups. And yet here are parents and others claiming once to have been children, and furthermore producing photographs and other evidence in support of the claim. It must be true, and yet it is unimaginable. The point at which children extend this unimaginable truth towards other people, and recognise the layers of time and memory in adults, seems to me to be an important moment in the growing-up process—a liberation from seeing people, and themselves, as fixed and static. We have all changed and will change again: so will they.

The Ghost of Thomas Kempe is intended to be a story—and a light-hearted one—but tethered to something more serious. Serious but not solemn, because I do not think children can be doing with solemnity, and neither can I. It is tethered also to a good deal of respectable historical fact about the kind of person that Thomas Kempe was, and could not have been written without drawing upon some recent most important historical writing on the nature and extent of seventeenth century popular superstitious belief. Thomas Kempe—he is my invention, but his type is not—was a cunning man, or sorcerer. These were local magicians of Tudor and Stuart England, concerned with a wide variety of wizardry from healing to the detection of crime, much consulted, we now know, and fulfilling, in a primitive peasant society, the functions of doctor and policeman but above all, perhaps, in a hazardous and uncertain world, offering explanations for misfortune other than the sheer malevolence of fate.

All Thomas Kempe's beliefs and preoccupations are historically correct, I hope—my only deliberate piece of cheating lay in making him much more literate than the average village cunning man would have been. And if he writes in the style

of John Aubrey, that I am afraid is because I was avidly reading John Aubrey while I was writing the book and have an uncomfortable tendency to absorb style like blotting-paper. But once that had happened it seemed perhaps no bad thing, and led me to the letters of Jane Welsh Carlyle when I was wondering how Aunt Fanny would write her diary. . . . All of which goes to show the odd and random ancestry that a story can have, and perhaps says something more about the pervasive nature of memory. (pp. 144-45)

> *Penelope Lively, "The Ghost of Thomas Kempe," in* The Junior Bookshelf, *Vol. 38, No. 3, June, 1974, pp. 143-45.*

The trouble with the Harrison parents in Penelope Lively's wholly delightful story is that they can't see what is right under their noses. Helen, another regrettably perfect sister, is half inclined to believe the evidence of her senses. Only James, at ten, accepts the inescapable fact that their house is haunted. . . .

[The] story gains its conviction from the setting and the characters. Thomas is loose in a world of telly, primary school and the National Health. It is a difficult world for a ghost, difficult too for James. . . . The resolution of James's and Thomas's difficulty is acceptable and strangely moving. Out of the experience James has gained a reputation for breaking things and a formative kinship with another boy who, nearly a century earlier, had also been the target of Thomas Kempe's malice. The gaiety and high spirits of Penelope Lively's story do not disguise its essentially sober wisdom.

> *"Unquiet Spirits," in* The Times Literary Supplement *(© Times Newspapers Ltd. (London) 1973; reproduced from* The Times Literary Supplement *by permission), No. 3709, April 6, 1973, p. 380.**

This expert blend of humour and historical imagination is at once more mature and more skilful than anything Penelope Lively has so far written. The two schoolboys, James and his friend Simon, are superbly drawn, with all the casual knowledge, the surprising ignorances, the protective self-justification of their age; slightly in the background, older sister, parents, vicar, village gossip, schoolmaster have their moments of total, entertaining reality. Wise in the course of village life, the author is wise too about the development of children. James—eager, opportunist, essentially good-hearted—profits by the discovery that getting to know people is rather like peeling onions layer by layer. It is a discovery children who read this sharp, amusing fantasy will make also. (pp. 2200-01)

> *Margery Fisher, in a review of "The Ghost of Thomas Kempe," in her* Growing Point, *Vol. 12, No. 2, July, 1973, pp. 2200-01.*

Penelope Lively is an expert at summoning up from the historical basis of the present aspects of the mysterious and supernatural, and stage-managing an evocative *danse macabre* that makes compelling reading. Never for one moment do we feel that creaky, spooky literary furniture has been dragged out to bedeck and pad out the imaginative core of the story. (p. 81)

> *C. S. Hannabuss, in a review of "The Ghost of Thomas Kempe," in* Children's Book Review *(© 1973 Five Owls Press Ltd.; all rights reserved), Vol. III, No. 3, June, 1973, pp. 81-2.*

One of the things I want from any book for children is a sense of firstness. If the quality of the imagination and the excitement of the writing can't match in some part a child's own wonder at the world about him, then the author is a cheat or a hack, an adult spoiler belittling new childhoods because he's lost touch with the richness of his own.

Being young means being surprised. No one knows this better than Penelope Lively, whose *The Ghost of Thomas Kempe* kept me on the edge of my chair until the last page. . . .

The struggle between the ghost, Thomas, and the boy, James, affords a good deal of fun, and in an unpretentious manner Mrs. Lively manages to convey a pervasive feeling of mystery—of a supernatural world that penetrates nature at its thinner points. This is a book to give to your more poetic nephew, or to that changeling niece.

> *Robert Nye, "Being Young Means Being Surprised,"*
> *in* The Christian Science Monitor *(reprinted by permission from* The Christian Science Monitor; © *1973*
> *The Christian Science Publishing Society; all rights*
> *reserved), November 7, 1973, p. B4.**

Penelope Lively originally intended to write social history, but turned to stories for children as a convenient way of exploring her own particular interests. The settings for her books are usually firmly in the present, but in more than one instance contacts are made with the past, which influence the characters and their reactions to the situations in which they find themselves. *The Ghost of Thomas Kempe* opens innocently enough with the discovery by workmen renovating an old cottage of a small green bottle which is dropped, broken, and forgotten. . . . There is much humour in the book, but the author is in earnest in her treatment of the supernatural, and there is potential tragedy when Kempe accuses a harmless old lady of being a witch and causes a fire in her cottage. Various attempts are made to be rid of the nuisance, but in the end Kempe himself shows the means by which his restless spirit may be at peace.

James is a very ordinary boy who is always hungry, not over fond of water, and full of curiosity, and his sheer normality contrasts with the strange experiences he undergoes. As he becomes convinced of the existence of Kempe, the balance is kept by the healthy scepticism of his friend Simon. This book is aeons away from the type of fiction, familiar to all, where the characters are only too eager to believe in and become involved with the supernatural. The author has the ability to sum up situations and describe the village, the countryside, and the weather in a succinct phrase or sentence. She vividly evokes the village where the same families have lived for generations, and she understands young people. There must be many would-be writers for children who would sell their souls to possess the literary gifts of Penelope Lively. (pp. 167-68)

> *Alec Ellis, "'The Ghost of Thomas Kempe,' by Penelope Lively," in* Chosen for Children: An Account of the Books Which Have Been Awarded the Library Association Carnegie Medal, 1936-1975, *edited by Marcus Crouch and Alec Ellis (© Marcus Crouch and Alec Ellis, 1977), third edition, The Library Association, 1977, pp. 167-68.*

[Most] intriguing is the kind of ghost that comes not from remote strata of time past, but from remote depths of a person's own mind—so remote indeed that it may scarcely be recognised as belonging to the character. The use of conditional and past conditional tenses to which one frequently has to resort in discussing the nature of these fictional ghosts presupposes that one is dealing with a particular kind of time-slip convention. It is that which is concerned with different aspects of the same person, the person he might have been, or might still become, had he not encountered the ghost of his potential self. The most obvious example of the latter is the Ghost of Christmas-Yet-to-Come in Dickens's *A Christmas Carol.* And I think this is also, though far more subtly, the nature of the ghost in Penelope Lively's *The Ghost of Thomas Kempe.* (p. 60)

James, at first, does not believe in ghosts. He is compelled gradually to acknowledge Thomas Kempe's reality only because he gets blamed for all the ghost's misdeeds. They are exactly the kinds of things he might have done himself. (p. 61)

His reluctance to recognise Thomas Kempe paces the disbelief we all share in our own potential for evil. It is as though the ghost has been conjured out of the very depths of James's own mind. He is the embodiment of all the mischievous and, finally, all the wicked potentialities in James's own character—a kind of nightmare shadow of himself, the side he usually represses in the name of reasonable behaviour, self control, and consideration for others, decencies strengthened by an understanding headmaster, and a shrewd and forthright father who delivers a lecture on vandalism when he feels the occasion warrants it.

Not that James is in the least a problem child or in the least likely to become a vandal. The implications of the tale are all the wider just because James is such a normal boy. He is a boy who gets into trouble for ordinary small misdemeanors—breaking windows, slamming doors, and so on. As Thomas Kempe's activities become more serious, change from the merely irritating to the hurtful (painting "Widdow Veritie Is a Wytche" along the fence), and finally to the criminal (setting fire to the cottage) James is increasingly anxious to repudiate all connection with him, not only because Thomas Kempe manages to implicate him in every prank, not only to escape blame for what he has not done, but because he learns through the ghost what wickedness really is, and he is appalled. The book is not about justice and injustice—James's being blamed for things he has not done—but about moral education. James learns about the nature of evil from the inside and rejects it. He wants to be kind and considerate finally, not because the mores of society (in the shape of father, headmaster, policeman) tell him to be so, but because he has learned from facing his own potential wickedness how to cope with it. Then the ghost of Thomas Kempe can be laid finally to rest in the crypt under the church. . . .

His materialisation as a ghost is the author's rhetorical device for exploring in dramatic, rather than theoretical, terms the amazing variety of character that may coexist within a single personality.

James's friend Simon remains sceptical throughout the book about the real existence of Thomas Kempe. At the primary level of story he is mistaken: there certainly is a ghost, a particularly effective and destructive one; but at another level of interpretation, Simon is right: the ghost is only a part of James, and to another person, indistinguishable from him. It is difficult for an outsider to perceive the different potentialities within another's personality. Penelope Lively has used the tradition of the sceptic within the story to illuminate this fact.

> "Nobody believes in him except me," said
> James. "And I wouldn't if I didn't have to."

"Perhaps," said Simon thoughtfully, "he's only there for you."

"What do you mean?"

"Perhaps he's a kind of personal ghost. I mean, maybe he's real alright, but only for you."

James considered this. It was possible.

Thomas Kempe personalises the phenomenon of the "might-have-been." His existence is a way of exploring the eternally conditional—what could be, but never will be, forever. The convention of this ghost therefore enlarges by means of rhetorical technique possibilities for discussion far removed from the usual past tense of narration—possibilities for parallel lives in the future that will never be, as much as in the past that never was. And this discussion is carried alive to the understanding, or rather to a level of comprehension below conscious understanding, because the argument is in terms of characters in a story, a story that belongs to a particular convention, and is not therefore merely theoretical. The ghost had lived once as an ordinary man, had died, and reappeared again, twice, to haunt the living—once before to Arnold, and now to James, who are thus linked together through time, living in duplicate. So the past in two stages (Thomas Kempe's time and Arnold's), the present, and the future-conditional (what James might have become, and what Arnold could have been), all interpenetrate each other, and in a sense are one and eternal. The time is growing-up time for everyone.

It is one of the book's major satisfactions at an interpretive level that we are concerned with James's reaction to Thomas Kempe, and not with Arnold's, for Arnold in his lifetime only managed to exorcise the ghost by a trick, luring him into the green-stoppered bottle and shutting him in the attic. Therefore, Arnold's moral education is not so complete as James's; he stayed short of facing fully his own potentialities for evil. James exhausts the evil within when Thomas Kempe, exhausted himself, begs for release. . . . (pp. 61-2)

In a sense, James inherits the responsibility from Arnold, and could not have got so far had Arnold not had his turn. They are allies. James will always be able to call on Arnold's friendship. Through the agency of Thomas Kempe, Arnold is as real to him as though he were living now. He is another kind of ghost within. . . . (p. 63)

The common conventions of the ghost story provide, because of their familiarity, a reliable structure which can be used as grounding for all kinds of variants with differing degrees of sophistication. Take, for example, the conventional narrative pattern in which the ghost appears, reappears probably several times, and finally disappears. Conventions only become so because they have been found to be, throughout the history of storying, both satisfying and fruitful. The satisfactory nature of this particular pattern may be because the successive repetition of the appearances of the ghost parallels our psychological feeling/thought pattern, in that during periods of stress, we call to mind repeatedly the elements of the situation, at first in grief or disbelief, appalled, and then again to wonder at and familiarise ourselves with them. By then the situation has been ritualised and the elements so often repeated have formed a kind of incantation, whose rhythm comforts. Characters become dependent on visitations from their ghost, of whom they were at first deeply fearful and mistrustful.

We repeat things in order to remember them; equally we repeat things in order to forget them. The process of grieving, for example, is aimed at forgetting; if not entirely, at least the immediacy of painful detail. This is achieved by constantly calling to mind all aspects of the person who has gone, so often that finally the emotions are exhausted and refuse to be summoned. And thus we are at least partially reconciled. We can only bear to live with our memories when they have lost their sting. In fiction, something decisive then happens; the character needs the ghost no longer, and he is exorcised, or merely melts away. Maybe the protagonist has simply grown up. In this way, the reappearances of Thomas Kempe catalogue the stages of James's maturation. Growing up is a painful business: Thomas Kempe's activities cause pain. So this pattern of successive haunting is in life the process of the making of identity, and in fiction the rhetorical pattern which expresses and confirms that identity for each of us as we read.

Thomas Kempe is James grown old without growing up. His meddlesomeness is a small boy's curiosity aged into a combination of arrogance and irascibility, selfish and without pity. He is not fully human because he is not humane, nor is he capable of change. In this he is typical of most fictional ghosts, who are personified essences rather than rounded characters, and who represent a single idea or bundle of related ideas, such as "violated innocence," "victim of injustice," "outraged father" and so on. The effect of the ghost is powerful, therefore, because he opposes the fixity and simplicity of a being from an unfragmented world against the malleability and uncertainty of a person here and now who is changing and being changed all the time. It is no wonder that James, being faced with the persistent malice of Thomas Kempe, feels hopelessly at a loss, for James's world of uncertainties does not make easy standing against the thrust of a fixed idea. So it is again that the pattern of the ghost story, setting as it does the fluidity of the present against the fixity of the past, is the counterpart in the rhetoric of fiction of the psychological experience, in which we are forever contrasting the intactness of our past selves with the complexity of our current self. (pp. 63-4)

We tell ourselves stories about our own past, about the kind of children we were, and believe them. Tales of our own past become personal myths, and in thinking them over, retelling them perhaps to our own children, the myth is personified and we find that we are haunted by the ghosts of our former selves. Children's writers often say they are writing for the child they once were, or the child they might have been, or the child they still are deep down, so that in any of these three cases, books are written for children by the ghost of the child within. But we die to each other and to ourselves daily, and in that sense we are every day the ghost of our former selves. And thus we grow, unable to escape the legacy of every passing minute that made us what we are. The simplicities of our past selves personified as ghosts are the pointers that indicate how much we have developed.

Successive moments, like successive generations, are related to each other through a line of descent which can be both enriching and constricting. . . . The personalised ghosts of the ghost story proper, in making it possible to mix up those successive moments, can establish a community among people even when the illusion of the eternal present has faded. Penelope Lively often uses animals to symbolise this community. For example, the dog Tim in *The Ghost of Thomas Kempe* is "squat, square and mongrel . . . independent and unobliging," the successor to Palmerston of Arnold's time. He is a survivor, "a dog with a long complicated and mysterious past," inex-

haustively adaptable. Everyone who meets him thinks he has seen him somewhere before.

The sense of community of which Tim is the symbol is dramatized in the relationship between James and Arnold.

> James told Arnold a joke about two flies on a
> ceiling that he had heard at school and Arnold,
> a hundred years away, laughed and shouted and
> swung on the branch on an apple tree.

At the end, having put Thomas Kempe to rest, James walks home feeling the warmth of Arnold's friendship. . . . The themes of generation and inheritance, memory and the nature of time absorb Penelope Lively in all her books, but in no other so far have they been embedded so effortlessly, effectively, and wittily in the narrative, and this is I think because the ghost story convention as she uses it here sets us from the beginning halfway along the path: we know something of what to expect. It is thanks to the same convention that James can be an ordinary boy, and not the sensitive, deprived or sick child usually vouchsafed special entry into other worlds by virtue of his disabilities. In the latter case half the reader's sympathy is used up before the story starts, and he feels he is reading about a special case. A ghost as robust as Thomas Kempe involved with a boy as universal as James ensures that the book will have the widest possible acceptance, not only because there are numerically more "ordinary" readers than "special" ones, but because it appeals to that which is at the centre in everyone. (pp. 64-5)

In children's fiction these are the themes that underlie the work of many current writers of whom Penelope Lively is among the most distinguished—themes that are concerned with the time/growth relationship, with the past feeding the present, and with the nature of its heritage for each generation. Many of them use the convention of the ghost story to revitalise those sedimentary layers, celebrate the possibilities of parallel lives; exploring what-might-have-been as well as what has been, by means of a rhetorical technique which, to paraphrase Emily Dickinson, allows instinct to pick up the key dropped by memory. (p. 66)

> *Judith Armstrong, "Ghosts As Rhetorical Devices in Children's Fiction," in* Children's literature in education *(© 1978, Agathon Press, Inc.; reprinted by permission of the publisher), Vol. 9, No. 2 (Summer), 1978, pp. 59-66.*

THE HOUSE IN NORHAM GARDENS (1974)

Everything in this subtle, rich, compelling story is part of the pattern but there is nothing forced about the pattern; it seems entirely natural. Clare (a thinking, listening girl) and her aunts (early graduates, still interested in Africa and art though not in gutters or new pence) are entirely convincing—people one is glad to get to know. . . . Mrs Lively has certainly written more exciting books, but it is a considerable achievement to write so honestly about the long Sunday afternoons, the creeping clocks, the boredom of being fourteen, without ever being boring. Her relaxed, flexible style copes equally well with visits to the butcher and the brisk, useless doctor, and with "the shadows of another world and another time". *The House in Norham Gardens* is full of delights.

> *"Haunted Houses," in* The Times Literary Supplement *(© Times Newspapers Ltd. (London) 1974; reproduced from* The Times Literary Supplement *by permission), No. 3774, July 5, 1974, p. 717.*

Penelope Lively goes from strength to strength. Her skill in marshalling selected details to bring a particular setting before our eyes has never been better shown than in *The house in Norham Gardens.* The realities of North Oxford have been transmuted in this book. The author has chosen details most selectively to establish the personality of Clare so that we can believe completely in the way she comes to investigate, to reconstruct, to feel her way to that long-distant year when her great-grandfather, an archaeologist, persuaded New Guinea tribesmen to let him take away one of their most sacred ceremonial shields. Using a variety of narrative devices, direct and indirect, eking out her clues so that the reader feels his way along with Clare towards the whole truth, Penelope Lively constructs her mosaic piece by piece. Scenes which could have been incidental prove to be properly relevant, though never laboriously so, to plot and theme. When Clare and her new friend John . . . visit the London Zoo, their conversation consolidates their friendship and at the same time Clare's thoughts are still obliquely on her strange dream-experience. . . . This new book should satisfy the expectations, constantly increasing, of Penelope Lively's readers.

> *Margery Fisher, in a review of "The House in Norham Gardens," in her* Growing Point, *Vol. 13, No. 3, September, 1974, p. 2452.*

After a well-deserved prize, Mrs Lively shows that she has many more shots in her locker of historical imaginings. The simple-seeming framework, a large Victorian house in a well-known part of Oxford, serves to contain a series of mirror illusions. . . . By unravelling the plot one does scant justice to the author's appreciation of 'the illusion of life in the form of a virtual past' and her deep understanding of the idea that stories are what we continually tell ourselves. The secondary characters are well intended, but compared with the heroine, are seen from the outside. Girls will appreciate the subtlety and the sympathy; the socially conscious reader will say 'just like Oxford' and the rest of us will admire the mastery and skill of the writing.

> *Margaret Meek, in a review of "The House in Norham Gardens," in* The School Librarian, *Vol. 22, No. 3, September, 1974, p. 253.*

For her latest book, Penelope Lively has moved right away from British fantasy, but she has retained her outstanding originality and craftsmanship. This is a personal portrait of adolescence, with the emphasis on a *place* such as we find in Mayne's Yorkshire or Garner's Cheshire. . . .

Both real-life and fantasy episodes are brilliantly written and contrasted. The insight and sensitivity shown by the writer make this book stand far above the usual romantic slush recommended to our teenage girls. A book for many readings.

> *Jessica Kemball-Cook, in a review of "The House in Norham Gardens," in* Children's Book Review *(© 1974 Five Owls Press Ltd.; all rights reserved), Vol. IV, No. 3, Autumn, 1974, p. 106.*

[*The House in Norham Gardens*], beautifully written (but in unfortunately small print), has two themes: Clare's concern for her beloved aunts and her recurrent lapses into another time and place, New Guinea, a bond created by her interest in a shield she's found in the attic. These dream-episodes are nicely integrated into the realistic story; the occasional passages in italics that narrate directly, incident by incident, the story of the shield, are less smoothly handled.

Zena Sutherland, in a review of "The House in Norham Gardens," in Bulletin of the Center for Children's Books *(reprinted by permission of The University of Chicago Press; © 1975 by The University of Chicago), Vol. 28, No. 6, February, 1975, p. 96.*

It is not often that three staples of young readers' fiction—realism, fantasy, and history—are so well-combined as in this novel. . . . Against the obbligato of its introductory paragraph, each chapter deploys the various elements of the narrative unobtrusively but skillfully: Clare's relationship with her aunts, with Mrs. Hedges the household helper, and with two lodgers . . . ; Clare's awareness of the social and intellectual activities of her forebears; and her realization that her memory would become the final storehouse of her experiences. Reality and dream, everyday world and bygone world are finely fused to make the telling of the story identical with the evolution of its chief character. (pp. 55-6)

Paul Heins, in a review of "The House in Norham Gardens," in The Horn Book Magazine *(copyright © 1975 by The Horn Book, Inc., Boston), Vol. LI, No. 1, February, 1975, pp. 55-6.*

GOING BACK (1975)

Penelope Lively has employed her concept of selective memory in *Going back.* "There's what you remember, and then there are the things that have never stopped happening, because they are there always in your head." . . . Penelope Lively's perspicuous prose and the relative shortness of this book might suggest it is a slight work. Certainly it is conceived in a different form from *The house in Norham Gardens.* Its merit lies in its brevity, in its free lyrical tone and the glancing, allusive way in which characters are drawn through their speech, and still more through the physical details of daily life which affect them most. Quick (but not light), vivid (but not heavily descriptive), the book has something of the quality of H. E. Bates's country stories. Like Bates, Penelope Lively allows a hint of the pathetic fallacy in her narrative, and this gives it a particular colour. Young readers—perhaps no younger than ten—may recognise in the book the wavering, accidental quality of their own way of remembering their childhood past.

Margery Fisher, in a review of "Going Back," in her Growing Point, *Vol. 14, No. 1, May, 1975, p. 2633.*

[*Going Back*] regresses frankly and gracefully to focus on the long, long playtime of a brother and sister blissfully neglected in a West Country village during the last war. Because those years are finished, there's time for leisure and exactitude in evoking them, almost as though the present narrator had died and was in limbo—as though all of life was crowded in them . . . and now there's only the memory of taste and smell and touch. It's the authentic note of the writer obsessed with childhood. . . . (p. 693)

Lorna Sage, "This Side of Paradise," in New Statesman *(© 1975 The Statesman & Nation Publishing Co. Ltd.), Vol. 89, No. 2305, May 23, 1975, pp. 693-94.**

Soon there will have to be an examination of writers who write books for themselves but hope that the young will read them. This is a piece of beautiful recreation of the war period as two children felt it. The 'going back' is of the same order as Nina Bawden's in *Carrie's War,* although here the narrative is sec-

ond to the interweaving of characters to whom the reader responds. It is coterie writing. Adults will enjoy it very much and forgive its self-indulgence. As for the young, they will doubtless be preoccupied with their own problems of the same order, which might commend the book to them, or it might not.

Margaret Meek, in a review of "Going Back," in The School Librarian, *Vol. 23, No. 2, June, 1975, p. 148.*

The story, with its somewhat inconclusive ending, is . . . notable for the sights, sounds, and smells of a vividly realized childhood and for magnificent descriptions of the English countryside. Despite an introspective, nostalgic quality, there is great immediacy of feeling throughout the narrative.

Ann A. Flowers, in a review of "Going Back," in The Horn Book Magazine *(copyright © 1976 by The Horn Book, Inc., Boston), Vol. LII, No. 1, February, 1976, p. 51.*

[In *Going Back,*] Jane remembers causing some fish to die: "the emotion came rushing back, like a bad taste. It is called guilt: at six, knowing it for the first time, I felt as though clutched by some disease". The gap between the adult's and the child's words for things is neither ignored nor fussily highlighted: you won't read about "girlish talk" or "boyish ways" here. . . . [The story is] told by the adult Jane, entering vividly and freshly into her childhood feelings but with an active awareness of subsequent layers of time. The result is an unforced solution to the dilemma of all adult writers of children's books: how to achieve a child's perspective without resorting to a falsifying childspeak or a self-conscious avuncularity. Memory plays honest broker in an elaborate traffic between past and present, handled with great delicacy. This is a classic English orphan idyll of genteel rural growing up, made poignant by a muffled awareness of war and by a sense of later sadness. It is a book for children and adults: those in-between creatures called children-of-all-ages won't make much of it.

Claude Rawson, "Choosing a Modern Classic: 'Going Back'," in The Times Literary Supplement *(© Times Newspapers Ltd. (London) 1983; reproduced from* The Times Literary Supplement *by permission), No. 4208, November 25, 1983, p. 1311.*

BOY WITHOUT A NAME (1975)

The situation in *Boy without a name* is readily recognisable even though the situation of an illegitimate orphan of Charles I's time is not factually comparable with those of a boy similarly placed today. The search for an identity and a place in the world is one which most children will appreciate. . . . Penelope Lively has related the boy to his period mainly through topographical detail. The solution to his problem, apprenticeship to a stonemason, is historically apt and takes account also of the boy's personal talent. A moment of humour, when Thomas wins the friendship of the village lads by walking on his hands, lightens a tale of effort and doubt which has an air of historical reality about it. (pp. 2818-19)

Margery Fisher, in a review of "Boy without a Name," in her Growing Point, *Vol. 14, No. 8, March, 1976, pp. 2818-19.*

A quiet, graceful story. . . . The delicately detailed illustrations [by Ann Dalton] correspond nicely to the chiseled subtlety

of Lively's style, grave and direct, and the story has a timeless quality in its perception of a child's emotional needs.

> *Zena Sutherland, in a review of "Boy without a Name," in* Bulletin of the Center for Children's Books *(reprinted by permission of The University of Chicago Press; © 1976 by The University of Chicago), Vol. 29, No. 8, April, 1976, p. 127.*

A STITCH IN TIME (1976)

Even such a super-craftsman as Pinero wasn't above easing his plot along with flagitious letters found underneath the floorboards. A largish book-batch, the majority historical-fantastical, reveals today's writers to be quite as obsessed with yesterday's secrets. . . .

Only one sample of this past-intuitive genre survived into my final pool, but it's a peach. The passage to the past in Penelope Lively's *A Stitch in Time* . . . leads through the communing mind of Maria, introspective only child of a turgid couple who rent an unfurbished Victorian house in Lyme Regis for the summer hols. The restlessly imaginative Maria (she converses with everything in sight, including petrol pumps, portraits and a singularly sardonic cat) is intrigued by a sampler worked by Harriet, a girl of her own age, in 1865. Soon, she is hearing a swing squeaking—only there isn't a swing; a dog barking—but there isn't a dog. . . . This latest Lively is a bit light on story-line and the final twist of the thread is not unforeseen. Any suspicion of narrative inertia is masked, though, by descriptive energy. The pages sparkle with jokes, perceptions and neat felicities. Maria herself, a sophisticated child with a well-nigh Murdochian concern for contingency, is a little triumph. (p. 686)

> *Martin Fagg, "In Search of Lost Time," in* New Statesman *(© 1976 The Statesman & Nation Publishing Co. Ltd.), Vol. 91, No. 2357, May 21, 1976, pp. 686-87.*

A quiet, solitary child has her life changed by the past in *A Stitch in Time.* I find this particular change all the more plausible because it is followed through with humour and with a marked shrewdness in the depiction of childhood. Maria is a splendidly individual child. . . . It is partly because Penelope Lively never exaggerates her points that they are so clear. She could so easily have made Maria into one of those sensitive, psychologically aware children who are dramatically changed by irruptions from the past in so many fantasies of this kind. How much more believable, and artistically valid, the dryly humorous approach shown in this passage about Mrs. Fosters's beautiful, slowly created needlework:

> "Maria, when she was younger, had sometimes felt jealous of the patchwork quilt and once she had taken some of the pieces of material that her mother was collecting for it and put them in the bottom of the dustbin under tea-leaves and potato peelings. No one had ever known. It was quite the worst thing she had ever done and she still went hot and cold at the thought of it. Nowadays she no longer had any emotions of any kind about the quilt but it did sometimes occur to her that it was taking her mother almost as long to make it as it had taken to make her, Maria, and that people often showed more interest in the quilt."

There is a different kind of sidelong wit, too, in the use of Lyme Regis as setting for a story in which fossils and a Victorian sampler both help in the construction of a pattern of past and present. As in all Penelope Lively's stories, historical associations are here for the noticing but as a background for the cumulative revelation of personality in parents and children of more than one period.

One of Penelope Lively's virtues as a novelist is that she leaves the reader free to follow clues, find meanings, learn about the people she has created for himself. (pp. 2933-34)

> *Margery Fisher, in a review of "A Stitch in Time," in her* Growing Point, *Vol. 15, No. 3, September, 1976, pp. 2933-34.*

Creaking noises, glimpses into a past of a hundred years ago, and a sampler stitched by a little girl in 1865 all combine to create a sense of mystery. Unfortunately this book promises much in suspense but does not deliver. The ending, while resolving the mystery, is anticlimactic.

> *Anne Devereaux Jordan, in a review of "A Stitch in Time," in* Children's Book Review Service *(copyright © 1977 Children's Book Review Service, Inc.), Vol. 5, No. 7, February, 1977, p. 70.*

A gifted writer again builds a story creatively from elements of the past which are part of the present. . . . Like the reflective Maria herself, the story grows in liveliness as she explores and begins to enjoy the area with neighboring Martin and his noisy family, chattering excitedly with them to the amazement of her stuffy father and often unperceptive mother. . . . As the story gathers in pace and atmosphere, Maria, a brilliantly realized character, dominates the work, and her individuality highlights the depiction of the others. (pp. 52-3)

> *Virginia Haviland, in a review of "A Stitch in Time," in* The Horn Book Magazine *(copyright © 1977 by The Horn Book, Inc., Boston), Vol. LIII, No. 1, February, 1977, pp. 52-3.*

Delicate, subtle, and completely convincing, this book is a delight. Though it may perhaps be too finely drawn for the robust average child, there are after all many odd and only children in the world, to whom it will speak clear.

> *Jill Paton Walsh, "Legend-Smiths Spin Tales of Hobgoblins and Fossils," in* The Christian Science Monitor *(reprinted by permission from* The Christian Science Monitor; *© 1977 The Christian Science Publishing Society; all rights reserved), May 4, 1977, p. B2.*

"Things always could have been otherwise. The fact of the matter is that they are not." This solid, commonsense advice from the solid owner of the nineteenth century house in which Maria Foster is spending her summer holiday finally ends Maria's "vague imaginings" and completes one part of her education. Penelope Lively, like John Fowles in *The French Lieutenant's Woman,* builds her novel around that education, far from the classroom, which enables one to start to come to terms with life. Both novelists place their characters in the Lyme Regis of now and a hundred years ago; a landscape which is at once genteel and primeval; a place full of memories. There the similarities end, for Mrs. Lively's novel is relatively straightforward with a clear-cut conclusion. Maria, the small, pale, rather introverted only child of slightly old-fashioned parents finds in her holiday home links with a Victorian ten-

year-old and a mystery, possibly even a tragedy. She sees a sampler, a picture of the house, started but not completed by Harriet Polstead; that Harriet of whom there aren't any photographs as an adult in the Polstead family album. It is an intriguing situation in which the reader is led, with Maria, into an exploration of the past. Maria's "imaginings" of that past time are set against the reality of her holiday in Lyme, the common sense of the boisterous boy on holiday next door, the near chaos of an amateur Medieval Joust. She is able to escape from her everyday world through her conversations with cats and petrol pumps: is the reader then to believe that Maria hears the creaking of a ghostly swing or is it the noise of a gate which needs oiling? Mrs. Lively provides the solution to this and to the other "mystery" in a narrative which unfolds slowly but satisfyingly. There has been a tragedy, though only a minor one; there is a link with Harriet. Maria's world does, metaphorically, slip around her like the Lyme cliffs. She leaves the Regency house determined to acquire "some new wisdom about the way things are." She grows, and the reader grows with her. (pp. 124-25)

> *Terry Jones, in a review of "A Stitch in Time," in* Children's literature in education *(© 1981, Agathon Press, Inc.; reprinted by permission of the publisher), Vol. 12, No. 3 (Autumn), 1981, pp. 124-25.*

THE STAINED GLASS WINDOW (1976)

The information contained in historical novels for the middle years may reach young readers in very different ways. They might respond to *The Stained Glass Window* first because of the way a story is hidden in a picture. During a church service, when the thoughts of the congregation wander this way and that, Jane wonders about the different landscapes in the window beside her, the one as hot and barren as the other is lush and green, and about the knight and the lady depicted in them. From that point a deliberate, grave narrative takes its course, describing the arranged marriage of a young couple, the unexpected love that grows between them and the agony of separation when the knight is summoned by his lord to go on a Crusade; the climax is reached when, wounded to death, the knight seems to hear his lady calling him home and discovers later that she had seen him clearly in the alien surroundings of a Crusader castle. As the child watches the window, she thinks for a moment that the two figures move together past the barriers of metal and glass. This simplest of tales conveys a sense of the past through the use of carefully selected words, images and suggestions of action, words that are simple enough but with the weight of associations behind them. . . . Transferred from the author's speculation to Jane's reflections, the comment on one aspect of the Crusades is pertinent and easy to follow. (pp. 2909-10)

> *Margery Fisher, in a review of "The Stained Glass Window," in her* Growing Point, *Vol. 15, No. 7, July, 1976, pp. 2909-10.*

Why is it so notoriously difficult to satisfy the needs of that voracious band of readers, the eights, nines and tens? . . . The reason can only be the discrepancy between the mental appetite of a young reader and his technical skill in dealing with words. At this stage he wants something short, straightforward and easy on the eye. These simple requirements appear to inhibit most writers to the point of sterility—or worse, banality.

Not so, thank goodness, Penelope Lively. Her latest book, *The Stained Glass Window,* is an object lesson in how to commu-

nicate something of real value to a child of only minimal reading skills. . . . The slender story is a miracle of simplicity and artistry. . . . It is difficult, if not impossible, to convey the purity of this book. It shines through the writing, which is totally without affectation and which reflects the love of the knight and the lady (who, significantly, are never named). This has about it the timeless quality of the great epics and puts the book into a class of its own.

> *Ann Evans, "Crusading Spirit," in* The Times Literary Supplement *(© Times Newspapers Ltd. (London) 1976; reproduced from* The Times Literary Supplement *by permission), No. 3879, July 16, 1976, p. 880.**

[*The Stained Glass Window*] is a simple story, told in calm, measured prose, but it seems an odd choice for inclusion in [the Grasshoppers] series which sets out to provide entertaining fiction for younger readers. Haunting though the story is, it is unlikely to hold the attention of most eight-year-olds and the book deserves a wider, older readership than it will achieve within the limits of this series.

> *Lance E. Salway, in a review of "The Stained Glass Window," in* Children's Book Review *(© 1976 Five Owls Press Ltd.; all rights reserved), Vol. VI, October, 1976, p. 24.*

This is a fictional story but it reads like one of the duller history books. Never once does the author become part of the story or allow the reader to do so. It is a romantic story set in one of the most colourful periods of our history and though like the stained glass window it is two dimensional, and flat, unlike the stained glass window, it is colourless. Only at the end of the story when a modern young girl is sitting in the church, looking at the stained glass windows of the Knight and his Lady does the story begin to perk up, but by then it is too late.

> *G. L. Hughes, in a review of "The Stained Glass Window," in* The Junior Bookshelf, *Vol. 41, No. 1, February, 1977, p. 22.*

FANNY'S SISTER (1977)

Victorian conventions are strongly present in both characters and setting: Papa is aloof and formal; two nannies manage the children; a cook and kitchen maid keep meals in order. In fact the times dictate Fanny's response to her guilt. . . . The whole tale has an air of absolute gentility that makes it almost a curio. Lively's seemingly inexhaustible eye for nuance nicely authenticates Fanny's naiveté, which may be an unfamiliar quantity to many of today's readers.

> *Denise M. Wilms, in a review of "Fanny's Sister," in* Booklist *(reprinted by permission of the American Library Association; copyright © 1980 by the American Library Association), Vol. 76, No. 19, June 1, 1980, p. 1425.*

With humor, perception, and deft description, the author brings Fanny and her family to life. Fanny chafes against her lot as an older child and a girl and longs for the days when she had the coveted place on Nurse's lap. But although her world is strictly governed, it is also warm and loving; adults laugh as well as reprimand. . . . Together, text and pictures [by Anita Lobel] re-create a past era and introduce an enormously likable heroine. (p. 409)

Christine McDonnell, in a review of "Fanny's Sister," in The Horn Book Magazine *(copyright © 1980 by The Horn Book, Inc., Boston), Vol. LVI, No. 4, August, 1980, pp. 408-09.*

A small gem, this Victorian story that takes place in just a day, sees into a child's mind, captures the essence of family life in England's middle class, and is beguiling without being saccharine. The writing is polished, with overtones of humor. . . . [Fanny] has an encounter with the Vicar that is quietly hilarious and touching. This may be too restrained a story for some children, but it is highly probable that those who enjoy it will enjoy it with a passion.

Zena Sutherland, in a review of "Fanny's Sister," in Bulletin of the Center for Children's Books *(reprinted by permission of The University of Chicago Press; © 1980 by The University of Chicago), Vol. 34, No. 1, September, 1980, p. 15.*

The focus is not really the new baby sister, but Fanny herself, a child who is learning to cope with the changes every new year brings. . . . Another year gone, she is even more excluded from the world of the Young Children (who are cuddled on laps and go for donkey-cart outings) and is progressing through the world of the Old Children (who struggle with lessons and must go to church). . . . The vicar is a magnificently realized character: His patience in letting Fanny work her own way through her dilemma until the proper moment for him to intervene is the best message of the book.

Fanny grows more and more endearing and her world more and more captivating as the story unfolds. The language is absolutely delightful, with natural but rich imagery and the perfectly chosen expression. . . . **"Fanny's Sister"** bears further witness to its already-distinguished author. . . .

Dana G. Clinton, "Is Baby Sister Necessary?" (© 1980 The Christian Science Publishing Society; all rights reserved; reprinted by permission of the author), in The Christian Science Monitor, *October 15, 1980, p. B8.*

THE VOYAGE OF QV 66 (1978)

It is difficult not to feel a little surprised at Penelope Lively's latest book, **The Voyage of QV66**, even though such a reaction reveals limiting preconceptions about her work. Until now her imagination has been most deeply engaged by the relationship between the present and the past. Here she is concerned with an impossible future, an after-the-holocaust adventure in which the only survivors of a drowned world are the beasts, men having been evacuated to Mars. A small group of animals, mainly domestic, set out in a flat-bottomed boat from Carlisle to London to find out what sort of creature Stanley, the most inventive and man-like of them, is. . . .

The voyagers cast a conventionally cold eye on the ugliness and shoddiness of the people's abandoned world, with its wanton destruction of so much natural beauty. Decency and common sense, apparently, are the prevailing norms of the animal kingdom, and there is scarcely any reference to the violence and rapacity of its carnivores and killer dogs, for this is pastoral. Sick of ourselves we turn to live with the animals, believing them innocent because they cannot feel guilt. Yet the golden world must eventually decay, and there is more than one echo of William Golding, an author obsessed with its loss; Stanley's creative headaches recall Lok in *The Inheritors*, and

the birth of irrational fear that culminates in a blood sacrifice at Stonehenge is also reminiscent. This intensely dramatic climax somehow fails to achieve its full effect, partly because elsewhere the book is often light and humorous in tone, and the change of mood is unexpected. Such tonal shifts—and there are several—might have been easier to accept in a more familiar context. Here they sometimes sound like uncertainties, and the total impression is one of fanciful invention rather than of true imagination. But there is much to please all but the most literal-minded readers—action, adventure, jokes, as well as some charmingly English dismissals of bureaucracy and gang behaviour in favour of independent initiative.

Julia Briggs, "After the Deluge," in The Times Literary Supplement *(© Times Newspapers Ltd. (London) 1978; reproduced from* The Times Literary Supplement *by permission), No. 3966, April 7, 1978, p. 377.*

The Voyage of QV66 is neither an Orwellian satire nor a sermon against Man's complacency. Penelope Lively has provided against this by using a good-hearted, simple-minded dog as her narrator. This is animal fable, elegant and witty. In the manner of fable, each animal has a type-character. Freda the cow is a mother-nannie figure; she believes in Instant Creation, a flat earth and the *status quo*. Ned has the dignity of a thoroughbred but his speech is coloured by racecourse slang. Offa the pigeon, hatched on Lichfield Cathedral, speaks largely in biblical tags. All this is neatly and easily achieved in the course of a narrative steered as unerringly as the barge is steered on its dog-leg course towards the open ending of the book. The various stopping-places, cunningly selected, provide a geographically exact pattern as a frame for irrational events. The tone is light, teasing, allusive; the traditional source is confirmed as if by accident by Stanley, when he makes up a story about some "Nice People . . . not like the rest of them" who sail off to find high ground in a Flood, taking two of each kind of animal. This irresistible comedy is published in a children's list. Reversing the process by which the young have long ago laid claim to *Gulliver's Travels* and *Animal Farm*, their elders should certainly claim a share in it. (p. 3319)

Margery Fisher, in a review of "The Voyage of QV66," in her Growing Point, *Vol. 17, No. 1, May, 1978, pp. 3318-19.*

Here is not just another cosy animal story but one packed with wit, quite hilarious and marvellously conceived comedy, pathos, suspense, fantasy, satire and sheer entertainment of such a high order that one reaches the end with genuine regret. The characterisation is pure delight; of the other creatures they encounter none is more memorable than a parrot, once a regimental mascot, who introduces himself as Major Trumpington-Smith and who rambles on about Omdurman and Ladysmith and the Khyber Pass. . . . This outstanding novel should not be confined to children's libraries; it has a great deal to offer adults, and is one of the best things I have met in many a long day. It deserves a whole string of awards.

Robert Bell, in a review of "The Voyage of QV66," in The School Librarian, *Vol. 26, No. 4, December, 1978, p. 357.*

Innocuous events and frightening ones mark [the animals'] passage. Most startling is their encounter with the priestly crows at Stonehenge, who conduct animal sacrifices. Throughout, the travelers display both their indigenous virtues and foibles and many human traits. Lively clearly enjoyed, and so

will the reader, exploring museums, libraries and factories from the viewpoint of inquiring, but blessedly ignorant, minds. The book founders, though, as the animals' intelligence arbitrarily waxes and wanes to fit the convenience of the plot. Then, too, the distinctly British tone and physical references obscure much of the intended wit. Anyone who likes allegorical tales will probably enjoy the book despite these flaws, but others will likely jump ship before the voyage is done.

Stephen Krensky, "Animals Aweigh" (© 1979 The Christian Science Publishing Society; all rights reserved; reprinted by permission of the author), in The Christian Science Monitor, *May 14, 1979, p. B7.*

[*The Voyage of QV66* is] a delightful odyssey filled with adventure, warm friendship, and quick, embarrassingly on-target pokes at human foibles. By the time they reach London, the reader knows all seven friends and their post-flood un-People'd England so well that the memory will remain an imprinted smile on the mind and prick of the conscience. Penelope Lively has more than done it again.

Sara Miller, in a review of "The Voyage of QV66," in School Library Journal (*reprinted from the October, 1979 issue of* School Library Journal, *published by R. R. Bowker Co./A Xerox Corporation; copyright © 1979), Vol. 26, No. 2, October, 1979, p. 152.*

FANNY AND THE BATTLE OF POTTER'S PIECE (1980)

Potter's Piece is a plot of wasteland which Fanny Stanton and her siblings regard as their own. One day it is invaded by strange children, immediately identified as the enemy, the Robinson children. . . . [Battle commences] in open warfare in Potter's Piece.

When, after a few wonderful days of combat, the Robinsons are gated for a week because of the post-battle state of their clothing, the Stantons realise that having Potter's Piece to themselves again is not so much fun. When battle is rejoined both sides realize that joint activities like damming the stream could also be fun. Peace prevails.

The book is enjoyable, though a little over collusive in its "children-against-adults" aspect and predictable in its characterization. No doubt Fanny fans will love it.

Sophie Last, "A Sharp Slap from Her Grandmother," in The Times Educational Supplement (© *Times Newspapers Ltd. (London) 1980; reproduced from* The Times Educational Supplement *by permission), No. 723, August 22, 1980, p. 20.**

Like William Mayne, but unlike most other masters of the full-length novel, Penelope Lively can adapt her talents to the small-scale work with no loss of quality. Her 'Long-Ago' tales of Fanny, the little Victorian girl, have just those merits of historical integrity and psychological understanding which have made her novels so outstanding in their field. . . .

Mrs. Lively 'frets not at her narrow cell'. On the contrary she writes on a small scale but quite uninhibitedly, with no nonsense about an artificial restraint of vocabulary. In less than fifty pages she tells us a great deal about the Victorian age and about her varied, numerous and individual characters. Here she shows us, by the clearest example, just how it can be done!

Marcus Crouch, in a review of "Fanny and the Battle of Potter's Piece," in The Junior Bookshelf, *Vol. 44, No. 5, October, 1980, p. 241.*

THE REVENGE OF SAMUEL STOKES (1981)

[*The Revenge of Samuel Stokes*] is light and without menace. Character development is lacking; no player seems more than a collection of mannerisms. Humorous as Grandpa's fondness for cooking outré meals may be, it does not seem wise to build an entire character upon that peculiarity. More seasoned readers familiar with the ghost stories of Eileen Dunlop and L. M. Boston as well as earlier Lively books may be disappointed at the lack of dramatic confrontation between the forces of good and evil, but newcomers to the genre may well be entranced.

Holly Sanhuber, in a review of "The Revenge of Samuel Stokes," in School Library Journal (*reprinted from the October, 1981 issue of* School Library Journal, *published by R. R. Bowker Co./A Xerox Corporation; copyright © 1981), Vol. 28, No. 2, October, 1981, p. 144.*

Memory—how it affects our lives and the places around us—is a central theme in most of Penelope Lively's books. . . .

It is predictable then that the memory theme would recur in her latest novel; however, the close parallels to the author's highly successful *Ghost of Thomas Kempe* provoke an analysis. What results is admiration for Lively's ability to provide a fresh, inventive story around her familiar theme without re-running old material or recasting used characters in different chains of events.

Similarities are most certainly there. Both stories have at their core an appealing, thoughtful, down-to-earth protagonist, a sidekick who helps move the action forward, no-nonsense parents who are caring but inflexible in their skepticism of "other beings," an adult eccentric who does believe in the supernatural, and a bad-mannered, ill-tempered ghost from the past who stirs up a lot of trouble.

The positioning of characters as well as the basic ingredients may be similar, but the superb portrayals are distinctive and finely etched with shades of individuality. In addition, the subtle, constantly flowing humor, convincing use of fantasy, and imaginative descriptive phrases give sheen to a polished tale.

Though *Revenge* has a first-person narrator, which *Thomas Kempe* does not, and opens with some tantalizing musings about cooking smells that come from a washing machine, mysterious tobacco smoke, and a flood from water that does not exist, the first scene in both books concerns workmen discovering a remnant from the past, which becomes central to the plot line. . . .

The poltergeist in *Thomas Kempe,* who gets James in constant trouble, may evoke more laughter, but the old gardener's earth-moving antics and the resulting situation have their own humorous momentum, especially when linked with the narrator's wry supposition about Stokes' future—"whether he will ever be well and truly laid to rest is another matter." Some readers may wish for a more sensational exorcising ceremony, but Lively's solution is clever and entirely within the context of Stokes' behavior and personality.

Other characters are equally well portrayed. Although all three are open to the idea of ghosts, Grandpa, a vegetable grower

and lover of "inventive, prolonged, and unpredictable" meals, is completely different from either the nosey Mrs. Verity or the matter-of-fact Bert Ellison in *Thomas Kempe*. Tim, who partakes of Grandpa's idiosyncrasies, cements an early friendship with Jane, another newcomer to Charstock, when she shows an appreciation of Grandpa's concoctions. Given a larger role than was James' friend Simon in *Thomas Kempe,* Jane is expertly presented. . . .

It is Tim who shows the greatest character growth, in understanding of both himself and the world, as he contemplates the weird, implausible happenings around him. It is through his thoughts that Lively skillfully and quietly inserts her theme. . . .

The only jarring moment in the story is the unlikely mixture of eighteenth-century ghost and twentieth-century technology. Whereas Thomas Kempe sneered at "evil machines" such as television and handwrote his notes to James in ornate script, Stokes uses both the telephone and television to communicate with Tim, which detracts from the believability of the story.

The descriptions of Stokes' follies, however, are evocative and amusing, especially when he stubbornly floods the entire area, and the subtle portrayal of human foibles adds dimension to the story.

Sure to be a favorite as a ghostly read-alone or read-aloud, this also offers a rich experience for perceptive children who may be stimulated to investigate their own historical landscape or simply to ponder the yesterdays and tomorrows of the places where they live.

> *Barbara Elleman, "Focus: The Revenge of Samuel Stokes," in* Booklist *(reprinted by permission of the American Library Association; copyright © 1976 by the American Library Association), Vol. 78, No. 8, December 15, 1981, p. 549.*

Thomas Kempe proves to be as difficult to reincarnate as he was to exorcise, even for a writer of such consummate skill. In a new confrontation of the past with the present, reminiscent in theme, plot, and character of the author's light-hearted and memorable *The Ghost of Thomas Kempe* . . . , the eighteenth-century landscape gardener Samuel Stokes plays much the same troublemaking role as did the seventeenth-century sorcerer Kempe. Stokes and his masterpiece, the Charstock House gardens and park, reassert themselves upon the land and life of a contemporary English village. Families in the newly built Charstock Estate development experience "'up-sidence,'" not subsidence. Old brick walls rise from nowhere and march across newly planted lawns; an elegant eighteenth-century garden gazebo replaces a cedar frame greenhouse; and a formerly drained lake inundates the modern shopping center and many of the houses. While residents rail at builders and politicians, only eleven-year-old Tim, his friend Jane, and his grandfather—who "'think flexibly,'" not just "'in straight lines'"—recognize the reemergence as Samuel Stokes's work. And not even these free thinkers can stop Stokes until the town has been flooded for thirteen days. The plot is at times equally frustrating to the characters and to the reader, for the author veers away from developing the intriguing idea of a landscape reasserting itself. On the other hand, Stokes, expanded to unbelievable proportions and given uncomfortably godlike powers, fails to carry the heavy burden of establishing the credibility of the story. Diversion substitutes for resolution; we are left with Grandpa's advice: "'[D]on't go asking for sense where no sense ought to be expected.'" Self-conscious authorial asides intrude, such as "we shall get on with the story," and the

action, when it comes, seems almost as anticlimactic as the wet dishcloth and small clod of dirt that the mob of angry townspeople throw at the foot-dragging authorities. The writing cannot be faulted, but the story does not satisfy. (pp. 44-5)

> *Nancy C. Hammond, in a review of "The Revenge of Samuel Stokes," in* The Horn Book Magazine *(copyright © 1982 by The Horn Book, Inc., Boston), Vol. LVIII, No. 1, February, 1982, pp. 44-5.*

This is a book about time and history, about the interdependence of past and present and the constructive power of memory. . . . The choice of the central figures in the story—Tim, Jane and Grandpa—ensures that the extraordinary events compel belief; because the three enjoy the manifestations so much, because their minds are open to the inexplicable, the theme of time can be carried through and the fantastic happenings established in gaiety and humour. Penelope Lively develops her proposition in a plain, purposeful, documentary style. Above the narrative you hear from time to time a persuasive, slightly ironic voice, as of an historian looking at odd events in a detached way. This voice speaks out in the opening sentences— 'You may well ask how a smell of roast venison could come out of Mrs. Thornton's washing machine'—and then allows children, householders, officials, to make their several reactions felt. An old-fashioned authorial technique is brilliantly used to establish the authenticity of the Charstock affair, in something like the way Stevenson or Scott imposed fiction on their readers as historical truth. The plot of the book recalls the plot of Penelope Lively's first book, *Astercote,* in which another small community drew together in the face of mysterious emanations from the past. Here, in this latest story, she has used a similar idea with greater economy and with a beautifully managed comic impetus. . . . The latest addition to a notable body of work for young readers . . . is as generous as any forerunners in its provision of mystery, fun and ingenuity. (pp. 4018-19)

> *Margery Fisher, in a review of "The Revenge of Samuel Stokes," in her* Growing Point, *Vol. 20, No. 6, March, 1982, pp. 4018-19.*

"'A place is bound to have its feelings, just like a person does!'" Thus Grandpa sums up neatly the thesis of Penelope Lively's new and delightful story. She has hit upon her best idea since *Thomas Kempe,* and, if the performance does not quite live up to the original concept, here nevertheless is a most entertaining, provocative and readable novel. (p. 106)

[Samuel Stokes's pranks are] very good stuff, and so is Miss Lively's evocation of the unfortunate residents, especially Tim, the central character, his accident-prone friend Jane—when the developer sees Jane on one of her better days 'an expression of horror and disbelief' crosses his face—and that sage and master cook Grandpa. Miss Lively makes her main point, that very forceful people and very distinctive places have 'the power to keep on bobbing up for ever,' very effectively. I just have reservations about Samuel Stokes himself. As a shadowy presence, surrounded with tobacco smoke, on the television screen, he is fine. His more material manifestations test the reader's credulity hard. It is the author's fault if we take her frolic too seriously. She has done it so well that we may be loading her light-hearted jest with altogether too much significance. (p. 107)

> *Marcus Crouch, in a review of "The Revenge of Samuel Stokes," in* The Junior Bookshelf, *Vol. 46, No. 3, June, 1982, pp. 106-07.*

Myra Cohn Livingston

1926-

American author of poetry, picture books, and nonfiction, anthologist, and critic.

A noted expert on children's poetry, Livingston uses a variety of techniques to express the wonders and realities of the child's everyday world. Structured as haiku, cinquain, free verse, and rhythmic prose, her works concern such subjects as nature, routine activities (playing, eating, taking a bath), emotions, surroundings, holidays, and social problems in clear, modern language that Livingston flavors with humor and suggestions of spontaneity. She is recognized for creating books that appeal to a wide range of children, including those who cannot usually relate to poetry.

Livingston was read to a great deal by her mother, who taught her to be aware of the wonders of nature. She began to write stories and poems as soon as she could read and was encouraged by her mother to write simply about the things she knew best, advice which Livingston still applies to her work and passes on to children as a creative writing teacher. She vacillated between a career in music or writing, deciding on the latter when she went to college. *Whispers and Other Poems*, a collection of traditional poetry for preschool to grade two, was written at this time but not published for twelve years. Most critics say it delightfully captures the joys of childhood. Of this and her other poetry for children Livingston says, "*Whispers . . .* is a reflection of my own childhood, and although my recent poetry encompasses a more contemporary view of childhood, I feel I have never departed from the child I was: the child I know best. I am not consciously aware of writing *for* children: my poetry seems to be born of the genre of childhood."

Livingston's picture books are usually composed as stories in verse. These books, which include *I'm Hiding, See What I Found,* and *Come Away,* receive mixed reviews. While some critics consider them dull and condescending, others concur that the repetition and focus on universal themes make these books ideal for the preschool audience. Her works for older children are diverse in topic and poetic style. Most notable are *The Malibu and Other Poems,* a mixture of nature appreciation, current events, and daily observations; *No Way of Knowing: Dallas Poems,* which describes the political and social life of Texas during the 60s using black English; and *Circle of Seasons,* which presents thoughts about the changing seasons in unusual metaphors. As with her picture books, the recurring complaint about her books for older children is that they lack imagination and focus on the mundane. Although Livingston's works are occasionally thought to be trite and forced, critics commend her contemporary approach to poetry, which presents ideas and topics important to young children and preteens while retaining accepted rhyme, meter, and form. She tells her poetry students to be aware of their sensitivities and to give new ideas or old ones a fresh view. It is clear from the success of her poetry that she applies this technique to her own works as well. *The Way Things Are and Other Poems* was selected for a Golden Kite Honor Award in 1974. Livingston

received the National Council of Teachers of English Achievement Award for Poetry for Children in 1980.

(See also *Something about the Author*, Vol. 5 and *Contemporary Authors*, Vols. 1-4, rev. ed.)

AUTHOR'S COMMENTARY

Sharing poetry with children, whether in the library, in the classroom, or at home, is a joy immeasurable for many. It is, in essence, what Robert Frost spoke of as the "delight to wisdom" implicit in the poem itself. But today, how many librarians and teachers must create a case for poetry, must explain the need for it in the child's world: perhaps to parents who have long since found poetry so much unnecessary baggage in their workaday and social worlds; perhaps to the child who has had no taste of it at home and is even a stranger to Mother Goose; perhaps to adult friends who dismiss the love of poetry as an idiosyncrasy.

It is difficult to define why poetry is important to the individual. Poetry is, after all, a personal thing; its meaning to each human being is private. It invades the innermost thoughts; it clings to and bolsters the inner life. It is not a something to be rationalized or explained; it is not an abstract principle; it is not part of an All-About book which arms with facts; it is not a piece

of logic with which to startle others or to alter the course of scientific knowledge. It is not something to be classified. It cannot be proved.

Yet, could the very lack of dependence on fact be the dimension that makes poetry so important? Might one suggest to skeptical friends, to the parents caught in their business and social worlds, that the very lack of utility, gain, profit makes poetry more meaningful? Might one even suggest that, instead of buying pills to quiet, to exhilarate, to induce sleep, they spend money for poems? For poetry will provide the stillness, the jubilance men and women find so necessary in their lives.

At the symposium on Excellence in Children's Literature, . . . at the University of California last summer, the poet Harry Behn spoke. Reminiscing about his own life with poetry, its meaning to him, he cited his early love for William Blake. Perhaps, he mused, the very beginnings of long-remembered poems, whether "Oh rose" or "Ah, sunflower," explain more than he realized as a child. Is it not the "ahs" and "ohs" of poetry that satisfy man, quiet him, elate him? (pp. 174-75)

Such is the beauty of poetry: how it speaks to man, why it is so necessary to him; the everlasting longing for he knows not what, the very stillness, the absolute "now of it," as Mr. Behn would say. It is not the past, not the future, not the gain or the profit, but the essential religious-like awe; the satisfaction the individual feels in discovery, the nearest he can come, not to fact or abstract knowledge—there is another place for that in his life—but to achieving intuitive knowledge. This is a renewing knowledge, one affirming joy in the universe. It is self-affirmation, the discovery that he is at one with his world. Rather than grapple with utilitarianism or with the mode of society as it exists, man places himself in the midst of great beauty and harmony.

In short, man affirms poetry. He knows and clings to it for the increasing dimension and awareness it gives to his life. When I tell my Creative Writing students that I demand two things of their writing, I realize how much I am asking. I tell them: When you write a poem, either tell me something I have never heard before or tell me in a new way something I have heard before.

A new way! I am asking them for fresh imagery. I am asking them to develop their own sensitivities, to use their own imaginations. I am even asking them to discover something they may not have known they possessed. For without imagination, man is dead. And the world of imagination is as real as the world of Chavez Ravine, Cape Kennedy, or the bones and eating habits of the Tyrannosaurus rex.

Granted, then, that there is a place for poetry in the individual's life, that he is richer for it: what sort of poetry shall be shared with children? If, in Eleanor Farjeon's words, poetry is "not the rose but the scent of the rose," how can the right scent be detected?

There are two schools of thought on the sort of poetry children should read. One decries poetry written especially for children. The other upholds it. And something can be said for either side. If, however, one school had its way, we should have to reject Stevenson, Rossetti, and the others, writing from the child's point of view, who followed—Milne, Farjeon, de la Mare, Roberts, Behn, and the like. I have often suspected that those who challenge poetry written especially for children are

a bit too far away from the young child's mind and imagination. Much depends, of course, on the child, his background, and on whether or not his parents have read to him from an early age. (One can tell from a child's writing, in minutes, if he has had this advantage.)

One must throw out the "cute" poetry for children and try to establish criteria for judging the excellence of poetry, bearing in mind that certain criteria applied to fantasy, realistic fiction, and other forms of literature, apply to poetry as well.

Again, Robert Frost's words, "a poem goes from delight to wisdom." . . . Delight is of prime importance, and the poem must reach the child if delight is to be met. Always will the wisdom follow, whether it is the stretching of the imagination, the discovery of self and the self's intuitive knowledge, the essential stillness of the soul, or its unbounded joy and happiness. And the wisdom must vary from child to child. What will add dimensions to one person's life will not necessarily affect another's.

The degree to which the reader is provoked to find the part, the fraction that is missing or not understood, is another measure of a poem's worth. It may be the simplest image, the fewest words. I cannot forget the delight on the face of a fourth grader in our class the day we read Marie Louise Allen's poem of winter, where "bushes look like popcorn balls." Of course, she seemed to say, I knew it all along, but I never heard it said. Now I shall see bushes differently in the winter. Imagine the offshoots of the discovery, the "finding," should the child look at bushes in summer, in fall, and let her imagination run free. Perhaps she will even extend the comparisons, the imaginings and findings to trees, to flowers. She has found something meaningful to her.

A third criterion, the one most important to me, is applied to all types of literature, but it is least understood in poetry. It is best stated by the postulate, Let the Reader Make the Ultimate Judgment. For something as personal, as emotional as poetry, this sounds rather like a political declaration, a philosophical statement. Yet how often does the poet, completely captivated by his own visions, leave no room for the reader's imagination. In stanza after stanza, the writer must make his point, must hammer it in, superimposing his adult vision so that the child's is all but stifled. (pp. 175-77)

[One] should never make the mistake of coercing children into poetry because it is good for them. Children can be presented with poetry; they can be guided to it. But they should never be forced to read it. Poetry is not facts with which to pass a test. It is not a feat of memory with which to astound parents and friends.

Poetry is not the rose with a name, a color—a spot in the garden, an arrangement in a vase; not the food the rose is fed nor the dust with which it is sprayed to keep bugs away. It is the scent. And no amount of explanation, no amount of cajoling or discussion or teaching can equal the joy a child will find, should he stoop to smell the rose himself. (p. 180)

Myra Cohn Livingston, " 'Not the Rose . . .' " (originally published in The Horn Book Magazine, *August, 1964), in* Horn Book Reflections: On Children's Books and Reading, *edited by Elinor Whitney Field (copyright © 1969 by The Horn Book, Inc., Boston), Horn Book, 1969, pp. 174-80.**

GENERAL COMMENTARY

CHARLOTTE S. HUCK AND DORIS YOUNG KUHN

Myra Cohn Livingston is a comparative newcomer to the scene of young children's poetry, and she brings a charm and freshness that is delightful. Her book, *Whispers and Other Poems*, is filled with laughter, curiosity, gaiety, and tenderness. Some of the imagery is as delicate as her title poem. . . . *I'm Hiding, See What I Found, I'm Not Me, Happy Birthday,* and *I'm Waiting* are written in simple rhythmic prose that approaches poetic form. (pp. 418-19)

> *Charlotte S. Huck and Doris Young Kuhn, "Poetry: Poets and Their Books," in their* Children's Literature in the Elementary School *(copyright © 1961, 1968 by Holt, Rinehart and Winston, Inc.; reprinted by permission of Holt, Rinehart and Winston, Publishers, CBS College Publishing), second edition, Holt, Rinehart and Winston, 1968, pp. 416-25.*

JEANNE McLAIN HARMS AND LUCILLE J. LETTOW

In *4-Way Stop,* Myra Cohn Livingston deals with many topics and emotions that interest children—coping with fear of the dark at bedtime, the fun of blowing bubble gum, the loss of a pet, and the feeling of not being appreciated. Livingston also has two other recent volumes, *O Sliver of Liver* and *The Malibu and Other Poems.* The latter, for older children and youth, addresses some of the issues and incongruities of contemporary life as well as giving a keener awareness of human relationships. (p. 377)

[Livingston] has delightful holiday poems in *O Sliver of Liver,* with several perspectives of valentines. **"Conversation with Washington"** is fun for children. (p. 378)

Livingston uses haiku, cinquain, triolets, concrete poetry, and limericks. Both *4-Way Stop* and *O Sliver of Liver* reflect her ability to use diverse forms. (p. 380)

> *Jeanne McLain Harms and Lucille J. Lettow, "Poetry for Children Has Never Been Better!" (copyright 1983 by the International Reading Association, Inc.; reprinted with permission of the International Reading Association), in* The Reading Teacher, *Vol. 36, No. 4, January, 1983, pp. 376-81.*

WHISPERS AND OTHER POEMS　(1958)

[Poetry] about winter and summer, balloons, merry-go-rounds, trains, sand and buildings. . . . The verses are little chants about everyday experiences—not the stuff on which classics are made. The expression is not particularly original nor melodious.

> *A review of "Whispers and Other Poems," in* Virginia Kirkus' Service, *Vol. XXVI, No. 23, February 1, 1958, p. 74.*

The poems in this delightful volume for the very young make adventure out of ordinary events. In writing such poems, it is hard not to seem imitative of Robert Louis Stevenson or A. A. Milne, especially when rhyme and meter are in the traditional groove. Miss Livingston has managed to avoid this to a large degree; and when she doesn't quite avoid it, she is still individual, and contrives to make us glad that someone is carrying on so fine a tradition.

> *Silence Buck Bellows, "Time to Rhyme," in* The Christian Science Monitor *(reprinted by permission from* The Christian Science Monitor; *© 1958 The Christian Science Publishing Society; all rights reserved), May 8, 1958, p. 16.*

Here is an utterly delightful little book of verses for the youngest child, one to be enjoyed right along with Mother Goose and the "Child's Garden of Verses." . . .

The author has a true ear, a quick perception of the things that delight four- or five-year-olds and no "cuteness" whatever. Deceptively simple, we suspect that these brief verses, all expressing a little child's feelings, were difficult to write. Most are about quite ordinary things. . . . One or two demand a little more of the child. . . .

> *Margaret Sherwood Libby, in a review of "Whispers and Other Poems," in* New York Herald Tribune Book Review *(© I.H.T. Corporation; reprinted by permission), May 11, 1958, p. 3.*

A beguiling collection of poems, illustrated [by Jacqueline Chwast] with sympathy and a humor that reflects the poetry. The author captures the spontaneity of fleeting emotions and of the small events in a child's life that evoke imaginative thoughts. Good for reading aloud.

> *Zena Sutherland, in a review of "Whispers and Other Poems," in* Bulletin of the Children's Book Center *(reprinted by permission of The University of Chicago Press), Vol. 11, No. 10, June, 1958, p. 111.*

In the mind of the young child there is no barrier between reality and imagination. In **"Whispers"** Myra Cohn Livingston expresses the children's own ephemeral fantasies, but her rhymes are more whimsical than memorable. Jacqueline Chwast's charming drawings of children are really the most creative part of this book.

> *Anzia Yezierska, in a review of "Whispers and Other Poems," in* The New York Times Book Review *(copyright © 1958 by The New York Times Company; reprinted by permission), June 1, 1958, p. 18.*

Once whispers were merely audible, but never again, because **"Whispers"** by Myra Cohn Livingston captures other sensory qualities. Notice, too, the pleasant connotations of the many sensory appeals. . . . Whispers will never be the same, because not only do we hear them, but we feel whispers when they "tickle," "blow," and are "soft as skin"; we see them as the "words curl in." Because of the connotative meanings of the words, we delight in whispers, feeling their tender softness and seeing their spiral curl headed for listening ears. (p. 171)

> *Rebecca J. Lukens, "From Rhyme to Poetry," in her* A Critical Handbook of Children's Literature *(copyright © 1976 by Scott, Foresman and Company; reprinted by permission), Scott, Foresman, 1976, pp. 153-80.*

WIDE AWAKE AND OTHER POEMS　(1959)

A delightful collection of little poems for "little" moments. The author shows an insight and imagination for even the smallest private things that little children can do. This measures up to her previous collection of similar poems called **"Whis-**

pers.'' A little girl's book, it will be cherished by young children in kindergarten-grade 3. . . . Highly recommended.

> *Lynn Sudell, in a review of ''Wide Awake and Other Poems,'' in* Junior Libraries, *an appendix to* Library Journal *(reprinted from the March, 1959 issue of* Junior Libraries, *published by R. R. Bowker Co./A Xerox Corporation, copyright © 1959), Vol. 5, No. 7, March, 1959, p. 135.*

Again we have a sheaf of small poems, the thoughts of a moment quickly expressed, by the author of **''Whispers,''** and again Jacqueline Chwast has made tiny black and white sketches of children to embody the gayety and spontaneity of these brief verses. While perhaps not so original as the first collection, there is the effortless singing, the same avoidance of all straining for rhyme and the same reflection of the quaint, odd thoughts that flash through a small child's mind. . . . Many indeed would be fun to quote at the appropriate moment when you see your own small child in similar situations, just as you do with nursery rhymes.

> *Margaret Sherwood Libby, in a review of ''Wide Awake and Other Poems,'' in* New York Herald Tribune Book Review *(© I.H.T. Corporation; reprinted by permission), July 12, 1959, p. 6.*

A certain charm pervades this small volume of verses projecting a child's moods and delights. There is little that is memorable here, but a number of subjects will please. . . . However, the expression lacks the melody, rhythm, and fun with words and topics which distinguish some of the best recent poetry for younger children.

> *Virginia Haviland, in a review of ''Wide Awake and Other Poems,'' in* The Horn Book Magazine *(copyright, 1959, by The Horn Book, Inc., Boston), Vol. XXXV, No. 4, August, 1959, p. 302.*

I'M HIDING (1961)

This is poetry for the youngest listeners with almost tactile imagery that cries for personal listener's participation. . . . Children will adore feeling their smallness as an advantage as they discover their own special hiding places.

> *A review of ''I'm Hiding,'' in* Virginia Kirkus' Service, *Vol. XXIX, No. 2, January 15, 1961, p. 52.*

Written in the first person, the verse is free, flowing and simple; the images are evocative and the whole effect muted in a manner that is admirably suited to the topic. This, on the other hand, gives a sameness to the pages, so that the book has a repetitive and static quality.

> *Zena Sutherland, in a review of ''I'm Hiding,'' in* Bulletin of the Center for Children's Books *(reprinted by permission of The University of Chicago Press; copyright 1961 by The University of Chicago), Vol. 14, No. 9, May, 1961, p. 146.*

In keeping with Myra Cohn Livingston's interest in expressing in light, gay rhymes the amusing thoughts and fancies of small children (**''Whispers''** and **''Wide Awake''**), she now has written one long poem which tells of absorbing games of hide-and-seek in fourteen verses. It is not a new idea but it is perennially popular and Mrs. Livingston . . . has found some satisfying hiding places. . . . A book that could be used to

turn a small child's energies away from a real overstimulating game of hiding at bedtime to thoughts of imaginary hiding places.

> *Margaret Sherwood Libby, ''Art in Stirring Ballads, Gay Rhymes and Famous Pictures,'' in* Lively Arts and Book Review *(© I.H.T. Corporation; reprinted by permission), May 14, 1961, p. 18.**

SEE WHAT I FOUND (1962)

Small familiar objects—a feather, a rubber band, an acorn, a key—have infinite uses and meanings for the child collector. Myra Cohn Livingston . . . has tried to convey these possibilities through a series of poetic prose sketches linked by the recurring phrase, ''See what I found. . . .'' When read at one sitting, the book (similar in format and feeling to her recent **''I'm Hiding''**) seems repetitive and uneven. However, the more perceptive children will enjoy choosing a few evocative and rhythmic favorites, skipping those sections which are forced and unimaginative. Erik Blegvad's sensitive and charming line drawings are more effective than the text in creating a mood which invites children to browse for some quiet moments in the gentle world reflected in these pages.

> *Alice Low, in a review of ''See What I Found,'' in* The New York Times Book Review *(copyright © 1962 by The New York Times Company; reprinted by permission), April 1, 1962, p. 38.*

[This small read-aloud book is written in] flowing and rhythmic prose. . . . The writing is gentle and evocative; it has a static quality that is partly due to the fact that there is little variation in the treatment.

> *Zena Sutherland, in a review of ''See What I Found,'' in* Bulletin of the Center for Children's Books *(reprinted by permission of The University of Chicago Press; copyright 1962 by The University of Chicago), Vol. 15, No. 9, May, 1962, p. 145.*

Delights of childhood, delicious to experience, are recalled affectionately in Mrs. Livingston's writings, both in verse and in rhythmic prose. In her latest little book she lists a dozen treasures, and enlarges on the joys each can bring. . . . Those who select this kind of book to read aloud to very young children will be enchanted with this reflection of the child's mind. . . . They are reminded of their child selves and are eager to share their memories with small children of today, sure of a response that childhood pleasures do not change. The children will oblige. They will nod appreciatively, and the more imaginative ones will immediately suggest other treasures and other uses for those mentioned. **''See What I Found''** is a perennial cry, perhaps with all of us, but most unselfconsciously with those under eight.

> *Margaret Sherwood Libby, in a review of ''See What I Found,'' in* Books *(© I.H.T. Corporation; reprinted by permission), June 17, 1962, p. 9.*

THE MOON AND A STAR AND OTHER POEMS (1965)

Myra Cohn Livingston has a gift for expressing musically and simply the thoughts of very small children and their comments on life. Small listeners will enjoy having these verses read to them, sensing thus anew their feelings about roller skating,

about riding a tricycle, playing with clay, or observing the oddities and delights of life around them.

> *A review of "The Moon and a Star," in* Book Week—The Sunday Herald Tribune *(© 1965, The Washington Post), May 9, 1965, p. 24.*

Forty little poems make up Mrs. Livingston's latest collection, and they are similar to her others in **Whispers** and **Wide Awake**. The rhythms are all different, and so are the subjects and moods. They range from surprise, when the gray "stone" turns out to be a toad, to the poignant **"For a Bird"**. . . . Mrs. Livingston writes about . . . [many] things close to the heart of childhood. City things (cranes and girders, roller skates, empty lots) and country things (barnyards, cows) and suburban things (peeking through the fence at the neighbors' backyard party)—all are here. The poems are easy to read, easy to remember, and fun to say.

> *Phyllis Cohen, in a review of "The Moon and a Star and Other Poems," in* Young Readers Review *(copyright © 1965 Young Readers Review), Vol. I, No. 10, June, 1965, p. 15.*

This little book of poems children will immediately recognize as especially for them. The author, perceptive and discerning, expresses with delight and understanding a child's sense of wonder, enjoyment, and humor. Not didactic or condescending, the poems are appealing because of their simplicity, directness, and sense of sharing a special moment.

> *Helen Neavitt, in a review of "The Moon and a Star and Other Poems," in* School Library Journal, *an appendix to* Library Journal *(reprinted from the September, 1965 issue of* School Library Journal, *published by R. R. Bowker Co./A Xerox Corporation; copyright © 1965), Vol. 12, No. 1, September, 1965, p. 3121.*

I'M WAITING (1966)

It's a collection of free verse tidbits about a little girl who coyly reveals her eager anticipation of all the events of the day, including getting up in the morning . . . , mealtimes, naptime, playtime, bathtime, and bedtime. Not much to keep any young child on tenterhooks. The most appealing aspects of the book are the [illustrations by Erik Blegvad]. . . .

> *A review of "I'm Waiting," in* Virginia Kirkus' Service *(copyright © 1966 Virginia Kirkus' Service, Inc.), Vol. XXXIV, No. 8, April 15, 1966, p. 417.*

[Myra Cohn Livingston] has once again processed the routine suburban cant about childhood into her tasteless cheese-spread (tasteless in every sense: the quality of life implied in this child's day and play is as vulgar as it is bland, unflavored by imagination or challenge of any sort, and certainly not by risk). . . . [The child is] perpetually "waiting," in these catalogues of cute vacuity, for the world to come and *do* something to her. The phrases are set up on the page as a set of versicles, but if poetry is ever a revelation of what it is like, or what it means, to be alive, these moribund metaphors ("I'm waiting / to jump in the big ocean of the bathtub") are an insult not only to the Muse but to the "amusable" audience the author so readily patronizes. (p. 16)

> *Richard Howard, "Varieties of Verse," in* Book Week—The Washington Post *(© 1966, The Washington Post), September 11, 1966, pp. 16-17.*

OLD MRS. TWINDLYTART AND OTHER RHYMES (1967)

No pretensions to poesy here, no titles to make us stop, look and concentrate—just a flow of fun, sometimes nonsensical, sometimes tied to the vagaries of animals and men (or even the moon), sometimes gentle satire of nursery rhymes and nursery tales. . . . Ensconced in each narrow page is a poem and a picture [by Enrico Arno], easy to listen to, easy to like (and easy to slip into picture book collections).

> *A review of "Old Mrs. Twindlytart and Other Rhymes," in* Kirkus Service *(copyright © 1967 Virginia Kirkus' Service, Inc.), Vol. XXXV, No. 5, March 1, 1967, p. 272.*

Mrs. Livingston has written long enough—and brightly enough—in the poetic idiom to be able to laugh in rhyme over the wonders and the absurdities of the world. The children whom she delighted with her earlier books will shout, "Thank goodness," when they find out in her newest that she is still laughing—and is still writing in rhymes.

> *A review of "Old Mrs. Twindlytart and Other Rhymes," in* Publishers Weekly *(reprinted from the May 8, 1967 issue of* Publishers Weekly, *published by R. R. Bowker Company; copyright © 1967 by R. R. Bowker Company), Vol. 191, No. 19, May 8, 1967, p. 62.*

A CRAZY FLIGHT AND OTHER POEMS (1969)

Feelings and responses to the world are the natural resources of the poet and are the subject of these poems. The best involvements are with images—and some of the best make the jump from words to the tactile. Example: pine cones are "little heads of brown that / tumble down / all sticky." Now, that sticks, like a jujube.

The language is not precocious—but often has the honesty of the proverb, incantation, or adage. . . .

I do miss poems of the preposterous skitter and peppermint fogs of childhood, and the space-travel poems seem too programmed. (Even poets' rockets occasionally misfire.) An innovative frankness, however, distinguishes **"A Crazy Flight."**

> *Ramona Weeks, "Said in Verse: 'A Crazy Flight and Other Poems'," in* The New York Times Book Review, *Part II (copyright © 1969 by The New York Times Company; reprinted by permission), May 4, 1969, p. 47.*

Though uneven in quality, the 42 poems in this engaging collection . . . generally give a sense of awareness and timeliness. The author's observations on seasons, animals, growing up, space, etc., have a highly personal quality; the vocabulary is of today, and the verse forms have a sophistication usually found in poetry for older readers. This collection will make middle graders aware that poetry doesn't always have to rhyme, that the arrangement on the page is part of the poem itself, and that poetry can be about anything; it will also appeal to reluctant poetry readers, turned off by most juvenile poetry but not ready for more mature verse.

Marjorie Lewis, in a review of "A Crazy Flight and Other Poems," in School Library Journal, *an appendix to* Library Journal *(reprinted from the September, 1969 issue of* School Library Journal, *published by R. R. Bowker Co./A Xerox Corporation; copyright © 1969), Vol. 16, No. 1, September, 1969, p. 1575.*

THE MALIBU AND OTHER POEMS (1972)

Forty short, reasonably proficient rhymes about familiar things and feelings. . . . Some of the verses might be described as second-rate Swenson in their arrangement, cadence, and internal rhyme ("Smooth it feels / wheels / in the groove of the gray / roadway / speedway / freeway / / long along the in and out / of gray car / red car / blue car"); others offer prosaic observations (of a "little kid" trying to roller skate) or commonplace sentiments (the "purple mountains" *really are*). Many of the latter are more like preliminary notes than finished poems and few have the transforming sharpness and surprise we keep hoping for, but the modesty of tone and specificity of subject are commendable. (pp. 726-27)

A review of "The Malibu and Other Poems," in Kirkus Reviews *(copyright © 1972 The Kirkus Service, Inc.), Vol. XL, No. 13, July 1, 1972, pp. 726-27.*

From the everyday **"Time to Practice"** to the imaginative **"Goldfish Whisper"** these poems each say something particular with meaning for the older elementary child. Very much "now." The poet exposes her total involvement in her own children—(they speak the same language)—and the wide spectrum of her moods and interests.

A review of "The Malibu and Other Poems," in Children's Book Review Service *(copyright © 1972 Children's Book Review Service Inc.), Vol. 1, No. 2, October, 1972, p. 14.*

Contemporary, short, direct and occasionally humorous, these 40 new poems reach Livingston's usual high level of quality. Most of the poems are observations on everyday life, nature, pollution, peace, people, animals, books. The young person's viewpoint is well maintained throughout, and this . . . title is a good addition to juvenile poetry collections. (pp. 111-12)

Margaret A. Dorsey, in a review of "The Malibu and Other Poems," in School Library Journal, *an appendix to* Library Journal *(reprinted from the October, 1972 issue of* School Library Journal, *published by R. R. Bowker Co./A Xerox Corporation; copyright © 1972), Vol. 19, No. 2, October, 1972, pp. 111-12.*

Mrs. Livingston writes with such strength, insight, and beautiful control that one might be moved to cheer her and the handful of others who care enough to produce real books of poetry for the [young].

Georgess McHargue, "How Now, Poetry Lovers?" in The New York Times Book Review *(copyright © 1972 by The New York Times Company; reprinted by permission), November 5, 1972, p. 32.**

Serious poetry lurks in **"The Malibu and Other Poems."** . . . The 40 selections included here, in free verse and formal, are attuned to the speech of eight-, nine-, and ten-year-olds.

Youngsters will recognize their own feelings here: in school, on the freeway, watching raindrops, wanting (or not wanting) to be alone.

Neil Millar, "A Good Season for Poetry: About the Moon and Other Secrets," in The Christian Science Monitor *(reprinted by permission from* The Christian Science Monitor; *© 1972 The Christian Science Publishing Society; all rights reserved), November 8, 1972, p. B2.**

While she is in command of the tools of structured poetry, Myra Cohn Livingston, one of the major contemporary writers of poetry for children, does not need to depend on them; she writes with a free-flowing rhythm and an effect of spontaneity. Themes and mood vary, some of the selections light and humorous, others thoughtful. There is a sharp awareness of ecological disruption, a perceptive capturing of mood or a suddenly sharpened vision of natural beauty, and many of the poems reflect the child's view of self. Although this book is recommended for a particular reading-level span, there are no boundaries for good poetry—adults may enjoy this, and it can be read aloud to younger children.

Zena Sutherland, in a review of "The Malibu and Other Poems," in Bulletin of the Center for Children's Books *(reprinted by permission of The University of Chicago Press; © 1973 by The University of Chicago), Vol. 26, No. 5, January, 1973, p. 79.*

COME AWAY (1974)

A true marriage of art and story results in a superior book, all about a boy and girl who leave their homes in a crowded city. . . . The friends spend an afternoon of exploration and delight as they meet birds, snails, flowers, a shimmering brook and other wonders of the natural and imaginative world. When they go home, they are refreshed—and so is the reader of a book which shows that the poet's voice is also heard in prose.

A review of "Come Away," in Publishers Weekly, *(reprinted from the February 25, 1974 issue of* Publishers Weekly, *published by R. R. Bowker Company, a Xerox company; copyright © 1974 by Xerox Corporation), Vol. 205, No. 8, February 25, 1974, p. 114.*

Mark finds a snail. Alice does not tell him it is a snail. Alice finds a bird, while staring directly into the sun. Mark does not tell her it is a bird. For some reason, both children practically break each other's hearts over this misunderstanding. **"Come Away"** . . . is poetically conceived . . . , but it is burdened with misleading pronouns and adult symbolism.

Rosemary Wells, "To Read and Look At," in The New York Times Book Review *(copyright © 1974 by The New York Times Company; reprinted by permission), September 22, 1974, p. 8.**

[Although] Livingston's writing is accomplished, this is still an overly precious picture book account of two children's dreamlike sojourn in a natural wonderland. . . . The theme of rapt self-involvement with nature is overstated and inappropriate for the picture book set. . . . [This] will tempt few primary graders.

Corinne Camarata, in a review of "Come Away," in School Library Journal, *an appendix to* Library

Journal *(reprinted from the October, 1974 issue of* School Library Journal, *published by R. R. Bowker Co./A Xerox Corporation; copyright © 1974), Vol. 21, No. 2, October, 1974, p. 106.*

[Sober and introspective] children will probably get most pleasure from **"Come Away."** The title is from a verse in a poem of W. B. Yeats, printed before the text of the book begins. This is an early clue to the approach of Myra Cohn Livingston and [illustrator] Irene Haas. Their aim is to share with others the romantic images conjured up in a child's thinking on encountering for the first time, away from the city, such creatures as a snail, a bird or a frog in their unspoilt surroundings. But as my two young friends said, it doesn't make you laugh. What (I asked) does it make you do? And the answer was: Dream.

Geoffrey Godsell, "Nature Books to Make You Laugh or Dream," in The Christian Science Monitor *(reprinted by permission from* The Christian Science Monitor; *© 1975 The Christian Science Publishing Society; all rights reserved), November 5, 1975, p. B3.**

THE WAY THINGS ARE AND OTHER POEMS　(1974)

These short poems speak to young readers where they live, in language they use, about sorrows and joys they experience. One poem agrees that it's better to keep things you need in a hurry under the bed; another marvels at the trivial conversations of old people; still another comments wryly on the soft life of the **"New Baby."** . . . Ms. Livingston writes with empathy for the young. The book should have a wide audience.

A review of "The Way Things Are and Other Poems," in Publishers Weekly *(reprinted from the July 8, 1974 issue of* Publishers Weekly, *published by R. R. Bowker Company, a Xerox company; copyright © 1974 by Xerox Corporation), Vol. 206, No. 2, July 8, 1974, p. 75.*

It's hard to take exception to verse as modest and unassuming as "walking along / munching potato chips, / me and potato chips / lunching along." Poetry teacher Livingston certainly earns high marks for avoiding both coyness and cant; nevertheless these short, everyday poems are severely limited in both form and content. When Livingston does attempt "style," she sometimes sounds like an Emily Dickinson parody . . . Too often Livingston merely lists and observes and her failure to make anything at all of what she notices seems to be laziness rather than restraint, and—except when she adopts youthful slang—her diction is so poverty stricken that one feels she is apologizing directly to her audience in **"I'm Sorry"**. . . . On occasion Livingston does come up with lines that have a modicum of personality—notably in **"Beach," "Abstract Picture,"** and **"Tolkien on the Subway."** But throughout, Livingston seems to have two big problems: first, she tries too hard to assume the viewpoint of the child she is not; second, she seems too busy avoiding allusion to be really spontaneous. In all, the collection—and particularly the down to earth contemporaneous subject matter—will be refreshing to children who have been overexposed to "classics." But others, notably Valerie Worth and Lilian Moore, handle the same sort of mundane themes more imaginatively.

A review of "The Way Things Are: And Other Poems," in Kirkus Reviews *(copyright © 1974 The Kirkus*

Service, Inc.), Vol. XLII, No. 14, July 15, 1974, p. 747.

Thirty-eight short poems that will serve as good introductory material, since their natural language offers easy access to the verses' uncomplicated messages. The poet chooses informal subjects common to children's everyday living—friends, school, bathing, museums. Most of the poems are loose in rhythm and easy-going in tone. In her better efforts like **"Dinosaurs"** and **"Swimming Pool"** Livingston contains originality and music within simple words; other poems like **"Poor"** and **"Friends"** oversimplify language and thought to the point of condescension.

A review of "The Way Things Are and Other Poems," in The Booklist *(reprinted by permission of the American Library Association; copyright © 1974 by the American Library Association), Vol. 71, No. 1, September 1, 1974, p. 44.*

The mechanical washing of a car, a messy room with Hershey bars and *Mad* magazines, the inconsequential talk of adults— all presented from a child's point of view—are crystallized in carefully wrought verses that resonate with occasional rhymes. The diction is generally direct and simple; the phraseology is often current. . . . Everyday mechanical devices are taken for granted: Scotch tape, Porsche, cassette; but never catering to the commonplace, each poem is the acknowledgment of a child's awareness of things seen and felt. The last stanza of **"Poor"** triumphantly combines simplicity with profundity. . . .

Paul Heins, in a review of "The Way Things Are and Other Poems," in The Horn Book Magazine *(copyright © 1974 by The Horn Book, Inc., Boston), Vol. L, No. 5, October, 1974, p. 146.*

Ordinary and lackluster, none of these compositions . . . is likely to stay with readers. In poems such as **"Old People," "Swimming Pool," "My Box,"** and **"Car Wash"** Livingston is unable to match her own previous (and excellent) *The Moon and a Star and Other Poems* . . . which ranks with the best of this genre.

Daisy Kouzel, in a review of "The Way Things Are and Other Poems," in School Library Journal, *an appendix to* Library Journal *(reprinted from the October, 1974 issue of* School Library Journal, *published by R. R. Bowker Co./A Xerox Corporation; copyright © 1974), Vol. 21, No. 2, October, 1974, p. 106.*

Myra Cohn Livingston, in about half the poems in *The Way Things Are and Other Poems,* tries to do without meter and rhyme, and in some of them without humor also. Well, why not write free verse on serious themes for children?

Unfortunately, Ms. Livingston's poems arc so flat and diffuse that they do not provide a fair test for this question. In her title poem she undertakes the forbidding challenge of telling children **"The Way Things Are"**:

> It's today,
> This road,
> This knowing the road is there.
> A few brambles,
> A few tangles,
> A few scratches,
> A rough stone against your toe,

But still, you've got to go
And take it.
Fast, sometimes,
Or slow,
But go—
 everywhere.
 anywhere
 You need
 to go.

The main problem with this poem, aside from its sententiousness, is that once the hackneyed metaphor of the road of life in introduced, everything else follows predictably. "A few brambles" leads inevitably to "A few tangles"; "Fast, sometimes," to "Or slow"; "everywhere" to "anywhere." Secondly, the poem lacks that vital coalescence of what is said with the way it is said that should justify its being presented as poetry at all. For instance, the necessity that the child should push on despite brambles and tangles is never made concrete, but instead comes across in a series of lifeless lines such as "But still you've got to go." Free verse, in surrendering rhyme and stanza as even the weakest excuses for a line's existence, incurs the obligation to make every line and every word in it self-justifying. It cannot admit a line of conjunctions, flabby verbs, and spiritless qualifiers that fail to exploit either the imagistic, connotative, or polysemantic potentialities of language. The Imagists and other early proponents of free verse realized that the only point in abandoning traditional rhythms was to allow the poem to discover its own: "A new cadence means a new idea." They discovered early that except in the long line of Whitman or Ginsburg, free verse rhythms were deadened by the steady coincidence between line and syntactic unit that characterizes Ms. Livingston's poems.

The fact that Ms. Livingston cannot write effective free verse suitable for children does not prove that it cannot be done; indeed, William Carlos Williams' well known "Poem" ("As the cat . . .") is a conclusive counterexample. Yet the task poses difficulties. For one thing, while verse strongly measured, accented, and rhymed is an aural form, with its lines and stanzas perceptible to the ear alone, free verse is a visual form. (pp. 168-69)

Ms. Livingston's **"New Baby"** has less psychological insight [than Marci Ridlon's "My Brother"], the child's basis for resentment now being the baby's freedom from responsibility. In her short lines, where compression is essential and where the surprise level must be maintained, we have only a humorless and unimaginative catalogue of the most obvious obligations of the older child:

Whoever's the new baby around here has it o.k.
Just crying and eating and sleeping all day.
No schoolwork.
No chores.
No trash to empty.
No slamming doors.
No nothing to do but lie around and play.

From the second line on, this poem, like the title poem quoted earlier, is completely predictable. After "schoolwork" we expect "chores"; after "chores," emptying the trash. True, the line "No slamming doors" is a surprise, but only because it makes no sense in context. How is a baby free of "slamming doors" in a way that the older sibling is not? I am forced to

conclude that in a poem where the rhyme is obscured by chaotic rhythms anyhow, Ms. Livingston has managed to trap herself into a rhyme-forced line. (pp. 171-72)

A. Harris Fairbanks, "Children's Verse: Four Styles," in Children's Literature: Annual of the Modern Language Association Seminar on Children's Literature and The Children's Literature Association, Vol. 4, *edited by Francelia Butler (© 1975 by Francelia Butler; reprinted by permission of Francelia Butler),* Temple University Press, 1975, pp. 165-72.*

4-WAY STOP AND OTHER POEMS (1976)

With limericks and haiku, dialogue and visual forms, and, simply, more longer, meaty-looking poems, this promises to be a good deal more substantial than Livingston's previous books of verse. Unfortunately, in the midst of this new expansiveness, Livingston's ideas are as relentlessly banal as ever. . . . Livingston relies overmuch on our willingness to share her egocentric perspective—as when . . . a petulant litany ends with the supposedly empathic "The trouble is *no one* appreciates me." The trouble is, there just isn't much to appreciate . . . not one really good or memorable poem out of the whole thirty-eight. (pp. 477-78)

A review of "4-Way Stop and Other Poems," in Kirkus Reviews *(copyright © 1976 The Kirkus Service, Inc.), Vol. XLIV, No. 8, April 15, 1976, pp. 477-78.*

As an anthologist and critic [Myra Cohn Livingston's] standards are high and she has a feeling for simple, direct and uncluttered speech. The kind of verbal play of which she is capable . . . [is] unfortunately not found nearly enough in her new volume, **"4-Way Stop And Other Poems."** . . . (p. 42)

William Jay Smith, "Sounds of Wind, Sea and Rain," in The New York Times Book Review *(copyright © 1976 by The New York Times Company; reprinted by permission), May 2, 1976, pp. 23-4, 42.*

As Mrs. Livingston is writing for somewhat older children in **"4-Way Stop"**—say, 10's and over—her language is slightly grown up, the subjects varied as the human condition. . . . **"4-Way Stop"** diversifies its forms from limericks to the freest of free verse.

A few poems are mildly astringent, but they are good of their kind, and real children could relate to them.

Neil Millar, "'Bubblegum' and Other Sweet Verse— With Lyric Rhymes to Stall Bedtimes," in The Christian Science Monitor *(reprinted by permission from The Christian Science Monitor; © 1976 The Christian Science Publishing Society; all rights reserved), May 12, 1976, p. 25.*

[Myra Livingston] displays a welcome unpretentiousness. She is brave enough to write about Paul Revere, George Washington, the Fourth of July, the first Thanksgiving, and even the Statue of Liberty; but her statements are fresh and new. She considers matters of perpetual concern to children: the death of a beloved pet, the eeriness of Halloween, the beauty of trees and clouds and animals. And she links herself firmly with modern life.

Ethel L. Heins, in a review of "4-Way Stop and Other Poems," in The Horn Book Magazine (copyright © 1976 by The Horn Book, Inc., Boston), Vol. LII, No. 4, August, 1976, p. 418.

From one of the best contemporary children's poets, this new collection offers variety of mood, subject, and form, with a consistently high quality. Livingston is equally proficient at writing a lyric poem like **"October,"** a humorous piece like **"Revenge"** (a declaration of vengeance against whoever took the last cooky in the jar), or a sharp comment on current concerns like **"Pollution."**

Zena Sutherland, in a review of "4-Way Stop and Other Poems," in Bulletin of the Center for Children's Books (reprinted by permission of The University of Chicago Press; © 1976 by The University of Chicago), Vol. 30, No. 1, September, 1976, p. 13.

Myra Cohn Livingston's poems are traditional, but not completely effective. Ideally, a child's poem should create an intense reaction, a feeling of recognition in as simple as possible a manner. However, the poems of Ms. Livingston often degenerate into verbal exercises, full of unwarranted complexity, leading up to a punchline that is disappointingly inane.

Granted, some of the poems are better than others. . . .

Perhaps the problem with this collection is that there is just too much diversity in tone and style. Or perhaps the poems just are not very good.

A review of "4-Way Stop and Other Poems," in Curriculum Review (© 1977 Curriculum Advisory Service; reprinted by permission of the Curriculum Advisory Service, Chicago, Illinois), Vol. 16, No. 1, February, 1977, p. 47.

A LOLLYGAG OF LIMERICKS (1978)

It is not necessary to be familiar with the English settings to be delighted by Livingston's limericks. The old man of Needles-on-Stoor and the confectioner from Skittle vie with the forgetful young woman of Tring and other characters to transform arrant nonsense into a semblance of reasonable discourse. Not only the meter but the words roll off the tongue: fleeting, propitious, roostery, bevy, erudite.

Charlotte W. Draper, in a review of "A Lollygag of Limericks," in The Horn Book Magazine (copyright © 1978 by The Horn Book, Inc., Boston), Vol. LIV, No. 4, August, 1978, p. 408.

Livingston's limericks people sonorous English locales with 32 ridiculous adult and animal figures and their paraphernalia. . . . There are none you'd care to meet in the flesh; they're an arrogant, crusty, greedy, lazy bunch of complaining snobs and fools. Meter and rhyme fit with gymnastic grace and tongue-twisters stay within defined bounds. . . . Though technically correct, not all of the verses have a point, and they do lollygag, sometimes depending on proper names for punch instead of on characters. But for the most part, this gallery of misfits . . . is amusing. (pp. 146-47)

Sharon Elswit, in a review of "A Lollygag of Limericks," in School Library Journal (reprinted from the October, 1978 issue of School Library Journal,

published by R. R. Bowker Co./A Xerox Corporation; copyright © 1978), Vol. 25, No. 2, October, 1978, pp. 146-47.

The fact that each first line ends with an English place name is the only apparent link among the limericks in this collection. . . . The familiarity of the limerick form and the nonsense of many of the selections should appeal to readers, but some of the selections seem contrived.

Zena Sutherland, in a review of "A Lollygag of Limericks," in Bulletin of the Center for Children's Books (reprinted by permission of The University of Chicago Press; © 1978 by The University of Chicago), Vol. 32, No. 3, November, 1978, p. 47.

O SLIVER OF LIVER: TOGETHER WITH OTHER TRIOLETS, CINQUAINS, HAIKU, VERSES, AND A DASH OF POEMS (1979)

Once again the poet has expressed her exuberant and sometimes petulant attitudes about life and love. . . . Her moods range from tenderness and quiet reflection to outrage and anger. They are expressed in a variety of forms, including some shaped poems. . . . Thoughts on everyday sights and sounds, memories of people and moments, exclamations of wonder and delight are all touched with the poet's playful, light-hearted tone. (pp. 315-16)

Karen M. Klockner, in a review of "O Sliver of Liver: Together with Other Triolets, Cinquains, Haiku, Verses, and a Dash of Poems," in The Horn Book Magazine (copyright © 1979 by The Horn Book, Inc., Boston), Vol. LV, No. 3, June, 1979, pp. 315-16.

Livingston offers 40 or so small, evanescent poems, a few incorporating visual elements, a few extending to a full page projecting her impressions of a view; but once more she fails to make much of her initial small thoughts and observations. Some of the poems address their subjects with fatuous questions: Which of us, she asks the bee, "has the better right to smell the first summer rose". . . . There are banal thoughts on friendship—every flower should have one—and three Valentine poems, all of which end flatly with repeated lines. Inoffensive, but unrewarding.

A review of "O Sliver of Liver and Other Poems," in Kirkus Review (copyright © 1979 The Kirkus Service, Inc.), Vol. XLVII, No. 12, June 15, 1979, p. 688.

Poetry for children must be as true, as surprising, as intelligent, and as sound-effective as poetry for adults. Often, works without these qualities try to pass for poetry, but are really verse, doggerel, or prose in disguise. For example, in **O Sliver of Liver and Other Poems,** too many of the selections are trite, banal, without the sound or sense of true poetry. Take one-third of the poems in this book; . . . then you'll have a book of children's poetry.

A review of "O Sliver of Liver and Other Poems," in Curriculum Review (© 1979 Curriculum Advisory Service; reprinted by permission of the Curriculum Advisory Service, Chicago, Illinois), Vol. 18, No. 3, August, 1979, p. 210.

[The] poems in this slim anthology speak simply and feelingly about a variety of things. . . . The moods vary from funny to sad. . . . The poetry is pleasing if not great, and in its deceptive easiness, will stretch young imaginations to see with more perception and read with more pleasure. . . .

> *Marjorie Lewis, in a review of "O Sliver of Liver,"* in School Library Journal *(reprinted from the October, 1979 issue of* School Library Journal, *published by R. R. Bowker Co./A Xerox Corporation; copyright © 1979), Vol. 26, No. 2, October, 1979, p. 143.*

NO WAY OF KNOWING: DALLAS POEMS (1980)

[Several] new fall books address kids who can stand the tartness of real poetry—not cotton-candy verse, but stuff that demands a little thoughtful chewing. One is Myra Cohn Livingston's **"No Way of Knowing: Dallas Poems"**. . . . Set in a Texas black working community in the years 1952-64, these brief dramatic lyrics express, in Black English, the feelings of actual people the author knows, whose voices form a kind of "Spoon River Anthology." That Mrs. Livingston herself is white may inspire distrust: How can she know enough to do more than sympathize? But if her venture runs high risks, as speech it persuades and as poetry it comes over beautifully. . . . In **"Arthur Thinks on Kennedy,"** there's the sorrow of dreams suddenly taken away, like the protective bubble removed from the President's car before that fateful Dallas parade. In **"Minnie,"** a young man praises his dancing partner:

> No question she the spider.
> No question I the fly.
> No way I gonna miss that web
> When Minnie spin on by—

In this poem, the lovely, punning word, *spin*, works in two directions. While all the poems are in plain diction, and many should easily reach young listeners, some—on themes of courtship, old age and loneliness—may call for at least teen-age understanding. In all, this seems quite the most touching and impressive work so far by a poet who, in writing for the young, hasn't stopped deepening and growing. (pp. 50-1)

> *X. J. Kennedy, "The Poets Speak," in* The New York Times Book Review *(copyright © 1980 by The New York Times Company; reprinted by permission), November 9, 1980, pp. 50-1, 62.**

A primary feature of this collection, in which Livingston seeks to "speak about all that has changed and all that will never change," is her rendering of local speech patterns and idioms. Unfortunately, the poet's overly rich and rigid-seeming rhyme scheme works against her objectives. Livingston tries to capture the "voices" of the Black community in Dallas, but what we hear are voices reciting, not speaking. Too much attention is given to the surface of the poetry here; very few verses actually penetrate the persona, the milieu or the moment. In **"Arthur Thinks on Kennedy,"** Arthur concludes, "And I got bubbles, / I got dreams, / So I know what / That killing means." What *does* it mean to him? That, I think, should be the stuff of poetry. The more successful poems are those which express uncertainty or bewilderment: e.g., **"Bea: In Mineral Wells,"** in which Bea, caught between old times and new, is relieved of her job. In it, Livingston doesn't force a conclusion; wisely, she doesn't strive for poignancy when being plain will do. The

book should only be purchased for large collections with an already strong section on Afro-American poetry.

> *Marguerite Feitlowitz, in a review of "No Way of Knowing: Dallas Poems," in* School Library Journal *(reprinted from the January, 1981 issue of* School Library Journal, *published by R. R. Bowker Co./A Xerox Corporation; copyright © 1981), Vol. 27, No. 5, January, 1981, p. 63.*

With a poet's sensitivity to words and a musician's instinct for nuances of pitch and intonation, the author introduces a remarkable, vital Black community. . . . The lyric impulse—as C. Day Lewis described it—is manifested in a series of remarkable vignettes, each unique yet each part of a larger mosaic. While not exclusively about children nor even particularly for them, the poems are accessible to young readers and deserve to be introduced to as wide an audience as possible. Deceptively simple in vocabulary and form, the verses are particularly effective in suggesting the personae of the speakers. Also notable is the poet's ability to manipulate words, exploring their potential for allusion and symbolism to intensify emotion. The description of Minnie in a lace dress sweeping alluringly past her admirer is a delicate and precise example of imagery. . . . Fresh and haunting contemporary poetry, perhaps the versatile author's best work to date.

> *Mary M. Burns, in a review of "No Way of Knowing: Dallas Poems," in* The Horn Book Magazine *(copyright © 1981 by The Horn Book, Inc., Boston), Vol. LVII, No. 1, February, 1981, p. 63.*

A CIRCLE OF SEASONS (1982)

It's saying a great deal to say that neither the poet nor the painter [Leonard Everett Fisher] has ever done better—although each has done equally distinctive work—than in this lovely book. Livingston's poems move through the year, each quatrain followed by a brief three lines that are as evocative as the imagery they follow. . . . Nice to read alone or aloud. . . .

> *Zena Sutherland, in a review of "A Circle of Seasons," in* Bulletin of the Center for Children's Books *(reprinted by permission of The University of Chicago Press; © 1982 by The University of Chicago), Vol. 35, No. 11, July-August, 1982, p. 211.*

[This is] a splendid adventure in seeing and feeling. Livingston's sensuous, musical poem in 13 stanzas calls up thoughts and feelings on the atmosphere each season produces, beginning and ending with spring, the symbol of continually renewed life. The poetry is remarkable for inventiveness, whether it reflects on quiet joys or compares autumn to a football player who plays a tough game. . . .

> *A review of "A Circle of Seasons," in* Publishers Weekly *(reprinted from the August 20, 1982 issue of* Publishers Weekly, *published by R. R. Bowker Company, a Xerox company; copyright © 1982 by Xerox Corporation), Vol. 222, No. 8, August 20, 1982, p. 72.*

[The] poet has employed both description and invocation to give her stanzas a dynamic pattern. . . . Using three rhymed lines and one unrhymed line for each descriptive quatrain, and a couplet printed in three lines for each incantatory verse, the thirteen sections of the poem reflect the iterative nature of the

seasons. Thus, the last stanza of the poem is identical with the first, suggesting a new beginning for an anticipated cycle. . . . As in the imagery of the verses, the carefully disciplined use of color and form is intense rather than startling; words and pictures taken together create a surprising combination of exaltation and serenity. (pp. 526-27)

Paul Heins, in a review of "A Circle of Seasons," in The Horn Book Magazine *(copyright © 1982 by The Horn Book, Inc., Boston), Vol. LVIII, No. 5, October, 1982, pp. 526-27.*

Mrs. Livingston's poems are lyric, rhyming, physical evocations that use a mixture of nature, sports, and technological imagery. . . . My favorite poem/painting spread begins: "Summer fattens melons up. . . ." Here there is no laziness of word choice, no flatness of rhyme—all lines are succulent and crisp. This book needs an adult guide for the young set; sensitive twelves-and-up will enjoy it on their own.

Leigh Dean, in a review of "A Circle of Seasons," in Children's Book Review Service *(copyright © 1982*

Children's Book Review Service Inc.), Vol. 11, No. 3, November, 1982, p. 29.

Livingston's fanciful-poetical verses . . . conjure up personified Seasons, beginning with **"Spring"**. . . . [A] strained metaphor has Spring swing her baseball bat, pitch bulbs and blossoms, catch violets, slide to meadowsweet, bunt a breeze, and tag the trees with buds. . . . Proceeding, we see a vibrant red sun as "Summer blasts off fireworks" which come back to earth as flowers; next, in a heap of fairy-tale clichés, Summer trips about playing with mermaids, a frog prince, hidden gold, and castle-clouds. With Autumn we see more sport in a round of football images that don't connect, and then Winter comes raging and etching windowpanes and doing all the things that winter does in little poems. It's the kind of poetry that seems to derive from a sanctimonious idea of poetry, the kind you'd expect a good creative writing teacher to squelch. (pp. 1193-94)

A review of "A Circle of Seasons," in Kirkus Reviews *(copyright © 1982 The Kirkus Service, Inc.), Vol. L, No. 21, November 1, 1982, pp. 1193-94.*

Margaret (May) Mahy

1936-

New Zealand author of picture books, short stories, fiction, and nonfiction, poet, and scriptwriter.

Mahy is considered an original and versatile writer. Her books combine realism and fantasy in plots that range from the serene and philosophical to the exciting and humorous. She creates stories with a strong but understated sense of morality (*Mrs. Discombobulous, Raging Robots and Unruly Uncles*), crafts witty exposés of adult conventions (*Ultra-Violet Catastrophe!*, *The Man Whose Mother Was a Pirate*), and explores family and other relationships (*Stepmother, The Bus under the Leaves*). Although Mahy has written since the age of seven, her commercial success came quite suddenly in 1968 when Helen Hoke Watts of the Franklin Watts publishing house purchased nearly all her existing work. Mahy's writing is noted for its imaginativeness, exuberant style, and rich syntax. While composing a new book, she expresses aloud the voices she hears in her head and transcribes them when the words sound right. Mahy's attention to the cadence of language, evident in her choice of colorful, sometimes poetic prose and her use of difficult words to enhance the sound of a sentence, makes her books especially effective when read aloud. Children find her engaging characters and comical situations appealing, while critics cite her shrewd understanding of humanity as well as the respect she shows her audience.

Most critics appreciate Mahy's distinctive blend of the real and the magical, especially in *The Haunting*, her first novel for children. They applaud her ability to be lively but sensitive, and commend her insightful portrayals of characters and their relationships whether her stories concern the mysterious or the everyday. *Ultra-Violet Catastrophe!* is particularly praised for its thoughtful presentation of the problem of freedom as shared by the elderly and the young. Mahy's four collections of short stories and poems, containing both the reflective and the nonsensical, are uniformly praised for the variety of their mood and subject matter. Despite occasional occurrences of wordiness, self-indulgence, and thin plots, critics enjoy Mahy's books and recommend them for young readers. Known for the excellence and confidence of her prose, Mahy is recognized as a master teller of stories. She received the New Zealand Library Association's Esther Glen Award in 1970 for *A Lion in the Meadow* and in 1973 for *The First Margaret Mahy Story Book: Stories and Poems*. *The Haunting* was awarded the 1982 Carnegie Medal.

(See also *Something about the Author*, Vol. 14 and *Contemporary Authors*, Vols. 69-72.)

AUTHOR'S COMMENTARY

[The following excerpt is from an interview with Mahy.]

As a writer, and as a person, Margaret Mahy isn't easy to categorise. She both loves and resists her New Zealandiness; she wards off all attempts to turn her into a moralist yet fiercely defends the significance of the craft she practices; she's a fantasist who claims 'I always write about real life'; she has a

"The Press," Christchurch, New Zealand

zest and flair that can bring her a bullseye where many other authors don't even recognise there's a target . . . and at the same time she can't offer any guarantees that a new book of hers won't misfire completely. In short, she's a writer who takes risks, who's always changing, always capable of growth.

But then, the last person to be impressed by the writing of Margaret Mahy is Margaret Mahy herself. 'I always start writing a story with a lot of optimism; that this time I have a really good idea. Then towards the end I start to lose confidence. The minute I had posted *The Haunting* I thought it was dreadful. Then they wrote and said they liked it so I thought it must be good after all.' . . . Yet so inventive and unpredictable is this New-Zealand-based, internationally-known author that at least two other books have a claim to being her best, *The Boy Who Was Followed Home*, which gave illustrator Steven Kellogg as perfect a picture-book text as he's ever likely to get; and *The Great Piratical Rumbustification*—a wonderful spoof that's a sure-fire winner with all youngsters old enough to get the measure of a babysitter. . . . In the case of Mr Clinker, to name only one splendid Mahy character, it's hard to agree with his creator that no matter how well she writes a book it's never as good as the idea she had in the first place—'with the translations of the idea on to a page, it somehow loses energy.' Really? Then the energy of Margaret Mahy herself must be a

sight to behold as she works off any looming writer's block: 'I go for a walk around the edge of Lyttleton harbour where I live and I talk aloud because often when I'm writing and certainly when I'm reading, I do hear the story as a voice speaking . . . and what I try to do then is take the voice out of my head and put it in the outside world and hear what the words sound like. And so I walk around the coast talking to myself, watching carefully ahead to see if anyone's coming because I don't wish to seem too bizarre.' Much the same method was used by William Wordsworth, you may recall. . . . One big difference, though, is that Margaret Mahy takes herself much less seriously. As a solo parent with daughters Penny (22) and Bridget (18) she has her sharpest critics living on the premises. Bridget especially 'makes various comments—she feels obliged to be critical having read so many times how honest children are! For instance, of the next book I wrote she said "the beginning's too much like *The Haunting*" and in actual fact this is what the editor said too . . . I'm very influenced by what people say.' Yet it's not surprising she was tempted to repeat her successful formula in *The Haunting*. . . . Who would've expected such a triumph from her first attempt at a full-length novel for older children? Well, any admirer of Margaret Mahy's possibly. In a couple of dozen books she'd already testified to her conviction that 'a fairy tale is often the truest way of talking about real life . . . that humour has a more spiritual function than people are prepared to admit.' (p. 12)

'I write the kind of book that reflects the European middle-class family I came from. . . . [For] years I could not conceal that my natural writing landscape was not Whakatane and the Bay of Plenty, which I love dearly, but another mongrel country where the Wild West and forests of wolves and lions melted into each other.' In fact she'd still recommend *The Adventures of Tom Sawyer* and *Treasure Island* as books to grow up with 're-reading them over and over again.' Her own first stories were written 'from the time I was seven onwards . . . in a spirit of implacable plagiarism because, reading widely as I did, I rapidly came to feel that everything worthwhile had already been written. I do believe now that the games I acted out, talking aloud as I did so, were the *real* stories I was inventing.' . . .

[If] she were an illustrator she'd like 'to be Edward Gorey who said that all his books are about real life, and I believe him.' But then, real life for Margaret Mahy includes 'more emotional and intuitive components than is commonly acknowledged' and the relationship between her books and reality has always been negotiable. Take the latest one to be published in Britain. *The Pirates' Mixed-Up Voyage*. . . . For her model here she went to The Goon Show, Monty Python and The Hitchhiker's Guide to the Galaxy which she listened to on tape 'over and over again while I did the dishes. There's something about the pace that I liked and I suppose what I was trying to do was to make that pace indigenous to myself in some way.' The result is a riotous and anarchic knockabout comedy which seems guaranteed to grate on the nerves of anyone beguiled by *The Haunting* . . . among adults, that is. Children, as Margaret Mahy well knows, tend to be more catholic, and flexible, in their tastes. 'In books, as with love, we are always astonished at other people's choices.' . . .

One advantage she [has in the job of being a writer] is a very clear idea of what she's about. Her books don't, for example, make moral points 'perhaps because I am not as sure about

these as other people. I try to tell an exciting story, something which children enjoy reading. For older children I try to suggest the world is not a rigidly defined place, that they can allow their imaginations to move and have a lot of freedom . . . children who are most articulate and deal most enthusiastically and capably with language are those exposed to a lot of conversation in the home, or who have had stories read to them. They have an expectation that they will be able to use and enjoy language.' Hence her deliberate use of complicated words, sometimes for their sound, sometimes because the story makes their meaning clear. How many other writers for young children would call a character Mrs Discombobulous—and let context explain the word's meaning? Not that this prolific enchanter of children is by any means satisfied with her previous work. 'Many of my books I don't like at all now.' Nor is she satisfied with herself. 'I am becoming less and less capable of giving a simple answer to anything, and try to justify this by maintaining that there are no simple answers, and there may not even be any real answers, only points where people agree not to argue.' For all her uncertainties, however, she's careful to preserve the twinkle in her eye and sums herself up with the declaration that 'I am forty-six, untidy with things (not people) and entertained all the time. I am slowly disintegrating but I don't mind, and would quite like to turn into a tree some day, but not immediately.'

Even at her jokiest and most slapstick, as with *The Pirates' Mixed-Up Voyage*, Margaret Mahy insists her theme is the infinite retreat of ideal life . . . that as you catch up with it, it's turned into something different.' In one respect for sure she does have a resemblance to the Wordsworth of *The Prelude*, her constant attempt to 'negotiate the interface of my current state of being an adult and the stage of childhood which everybody shares'. But the instant she says this she laughs. (p. 13)

"Authorgraph No. 24: Margaret Mahy," in Books for Keeps (© School Bookshop Association 1984), No. 24, January, 1984, pp. 12-13.

GENERAL COMMENTARY

THE TIMES LITERARY SUPPLEMENT

Miss Mahy's two offerings both concern magic in an everyday context. In [*The Dragon of an Ordinary Family*], a family buys a dragon, a predictably unpredictable pet; in [*Mrs. Discombobulous*], a "fierce and thistley wife" is sucked into the washing-machine and emerges in a gypsy encampment. . . . Both stories are altogether too facile, and both abuse rather than use the relationship of ordinary to extraordinary. *Mrs. Discombobulous* is, however, told with tremendous vigour and verbal high-jinks. . . .

"Shaggy-Dog Story," in The Times Literary Supplement (© Times Newspapers Ltd. (London) 1969; reproduced from The Times Literary Supplement by permission), No. 3536, December 4, 1969, p. 1387.*

PUBLISHERS WEEKLY

"The Dragon of an Ordinary Family" is destined to be as popular with the dragon crowd as Lyle is with the crocodile one.

And **"The Procession"** . . . is one of the most joyful "dances around the world" in search of a king that any child is likely to join.

A review of "The Dragon of an Ordinary Family," in Publishers Weekly (reprinted from the December 29, 1969 issue of Publishers Weekly, published by R. R. Bowker Company, a Xerox company; copyright © 1969 by Xerox Corporation), Vol. 196, No. 25, December 29, 1969, p. 67.

THE JUNIOR BOOKSHELF

[*The Dragon of An Ordinary Family*] is for slightly older children [than *A Lion in the Meadow*] and is longer, although both stories are told with economy of words. . . .

Both stories show originality and an understanding of children. Their appeal is primarily for children but adults will enjoy reading them aloud for their undertones.

A review of "The Lion in the Meadow" and "The Dragon of an Ordinary Family," in The Junior Bookshelf, Vol. 34, No. 1, February, 1970, p. 21.

Margaret Mahy's publisher does her no great kindness in making such extravagant claims for their 'discovery'. It does little good to a new writer to have to survive a build-up of this kind; after the flourish of trumpets has died away, any right-minded critic is on the alert to find the goods not up to the advertisement.

In the event, Miss Mahy turns out to be not at all bad. She seems happier with the earthy humours of *Mrs. Discombobulous* than the frail fantasy of *The Procession,* although the former is not too well organised for picture-book treatment. . . . [In *Mrs. Discombobulous*] the author does best with her dialogue—more strictly monologue—which reads well aloud, as a picture-book text should. (pp. 21-2)

[*The Procession*] is one of those pseudo-poetical fantasies which some adults like. Children may feel that it is all much ado about less than nothing. (p. 22)

A review of "Mrs. Discombobulous" and "The Procession," in The Junior Bookshelf, Vol. 34, No. 1, February, 1970, pp. 21-2.

DAVID REES

Clancy's Cabin and *The Bus Under the Leaves,* are for the same age group [as *The Changeling* by Rosemary Sutcliff and *The Sugar Trail* by Jean Wills] and will probably prove popular, though they are not so well written. Do people's mouths really "fall open with surprise" so often as the Harrington children's; does Dad really laugh so much or so often as Mr Harrington; do children "dance a stamping war dance of joy" when they are pleased? It seems more like fantasy than real life. The setting of the books—summer in New Zealand—reinforces the impression given by a great deal of children's fiction from Australia and New Zealand that life there is an eternal summer outdoors. . . .

David Rees, "Reading for Pleasure," in The Times Literary Supplement (© Times Newspapers Ltd. (London) 1975; reproduced from The Times Literary Supplement by permission), No. 3813, April 4, 1975, p. 372.*

ELSIE LOCKE

[Margaret Mahy] has simply stepped out of the local scene into a universal one. She peoples her fantasies with pirates and witches and kings and clowns who could be anywhere, and

that suits our children because their fantasy world is everywhere and anywhere. And she has the most delicious language. (p. 98)

Personally I do see a light-hearted commentary on New Zealand in Margaret Mahy's fondness for juxtaposition of the ordinary and the respectable with the delightfully incredible. (p. 99)

These are books inspired by books, words inspired by words, sometimes words that children, in practice, may find difficult and daunting but helped along by lavish illustrations since Margaret Mahy was "discovered" by an American publisher, Franklin-Watts. (p. 100)

Elsie Locke, "Book Trails in a Small Country—New Zealand," in One Ocean Touching, edited by Sheila A. Egoff (copyright © 1979 by Sheila A. Egoff; originally a series of papers delivered at the University of British Columbia, May 10-15, 1976), The Scarecrow Press, Inc., 1979, pp. 93-109.*

EILEEN COLWELL

[*The Chewing-Gum Rescue and Other Stories*] is a collection of comically whimsical stories for children, a mixture of modernity and fantasy, the product of a lively imagination. They range from a story of a real child who climbs to the top of the tallest tree in town and experiences the ecstasy of seeing her whole world spread out below her, to the extraordinary adventures of a family who have a giant's bath in their home and get sucked down the drain. . . . As usual there is an entertaining selection of stories with something for every taste.

[*Raging Robots and Unruly Uncles*] is far better than its clumsy title suggests. It is a sustained story of two brothers—one villainous, the other of blameless character—the first with seven sons, the other with one daughter. The boys in spite of being brought up to dishonesty and bad behaviour would rather be good; the girl taught to be painfully good is a rebel and a tomboy. . . .

Meanwhile their respective fathers are plagued by robots—a wicked, thieving rogue for the bad father, a simpering 'do-gooder' for his brother. Although these creatures are replicas of their own natures, the two men are driven nearly mad by them. Very generously the children rescue their distracted parents from ruin. The whole situation is utterly impossible but most entertaining!

Eileen Colwell, in a review of "The Chewing-Gum Rescue and Other Stories" and "Raging Robots and Unruly Uncles," in The Junior Bookshelf, Vol. 46, No. 3, June, 1982, p. 99.

A LION IN THE MEADOW (1969)

The writing style is almost staccato but is an effective foil for a story about imaginative play. . . . The story begins, "The little boy said, 'Mother, there is a lion in the meadow.' The mother said, 'Nonsense, little boy.'" Mother says firmly that this is a made-up story; she gives the child a match box, telling him that there is a tiny dragon there that will grow huge when it is let free in the meadow, and that it will chase the lion away. . . . The idea of a parent coping with an imaginary situation isn't wholly new in picture books, but the theme is nicely handled and the ending should please and amuse young listeners.

Zena Sutherland, in a review of "A Lion in the Meadow," in Bulletin of the Center for Children's Books *(reprinted by permission of The University of Chicago Press; © 1969 by The University of Chicago), Vol. 23, No. 3, November, 1969, p. 49.*

It is pleasant to see a miniature reprint of that fine fable of imagination, *A lion in the meadow.* I still think in some ways it is Margaret Mahy's best story so far—crisp, lucid and superbly reflecting the humour in a parent-child relationship.

Margery Fisher, in a review of "A Lion in the Meadow," in her Growing Point, *Vol. 11, No. 1, May, 1972, p. 1941.*

[*A Lion in the Meadow* is] out of the ordinary. It has fewer than 400 words, but is to be lingered over again and again, not rushed through while the potatoes are cooking and returned to the library.

Ann Maxwell, "Stimulants," in New Statesman *(© 1972 The Statesman & Nation Publishing Co. Ltd.), Vol. 83, No. 2150, June 2, 1972, p. 763.**

THE DRAGON OF AN ORDINARY FAMILY (1969)

This very believable addition to the animal kingdom makes a useful link between the ordinary family whose suburban house and yard he quickly overflows and the Isles of Magic where he takes them for a holiday that satisfies their dreams. . . . [This] young New Zealand writer, reported to be prolific, manipulates words, sentences and story line with confidence and zest and *must* be more widely known in England.

Margery Fisher, in a review of "The Dragon of an Ordinary Family," in her Growing Point, *Vol. 8, No. 5, November, 1969, p. 1410.*

[The] story, unusually long, is as fascinating and as witty as [Helen Oxenbury's] illustrations. By her unexpected nonending, New Zealander Margaret Mahy manages to keep the story still going on in our imaginations.

Pamela Marsh, "Dragons and Other Sights," in The Christian Science Monitor *(reprinted by permission from* The Christian Science Monitor; *© 1969 The Christian Science Publishing Society; all rights reserved), November 6, 1969, p. B2.**

The Isles of Magic episode, the only weak part in this extraordinary tale, is not well-developed and is too crowded with sketchy adventures; attempts at rhyme here are unsuccessful.

Marianne Hough, in a review of "The Dragon of an Ordinary Family," in School Library Journal, *an appendix to* Library Journal *(reprinted from the September, 1970 issue of* School Library Journal, *published by R. R. Bowker Co./A Xerox Corporation; copyright © 1970), Vol. 17, No. 1, September, 1970, p. 94.*

THE PROCESSION (1969)

[Charles Mozley's illustrations] contribute to the poetic tone and dream-like mood of this fanciful original story. . . . [A gay procession] dances around the world and finally arrives at the castle of a young King, who is kept there by his guards and wise men. "'Law is a fine thing, and government a fine

long word,' said the wandering fellow, 'but what of the song at night by the fire? A King should hear this, once in his life?'" So the King, and his guards and wise men all run out and join the Procession. . . . Concludes the author: "Perhaps tomorrow they will knock at *your* door!" Except for this sentence, the philosophical overtones are generally not intrusive, and young readers and viewers will enjoy a concrete, lovely-to-look-at depiction of this natural approach to life as something which should be experienced and enjoyed directly. The large pictures and repetitive poetic text make the book a good read-aloud; *The Procession* will win itself many followers.

Cherie Zarookian, in a review of "The Procession," in School Library Journal, *an appendix to* Library Journal *(reprinted from the February, 1970 issue of* School Library Journal, *published by R. R. Bowker Co./A Xerox Corporation; copyright © 1970), Vol. 16, No. 6, February, 1970, p. 73.*

MRS DISCOMBOBULOUS (1969; U.S. edition as *Mrs. Discombobulous*)

On the whole an entertaining story, this tries much too hard—it employs coyness and excess verbiage, and makes a poor transition from reality to fantasy and back again. . . . Too wordy to hold the attention of a young audience, spoiled by too-cute touches like the concluding sentence, featuring clumsy washing machine/gypsy campsite backing and forthing, this is nevertheless sparked by flashes of humor. . . .

Euple Wilson, in a review of "Mrs. Discombobulous," in School Library Journal, *an appendix to* Library Journal *(reprinted from the February, 1970 issue of* School Library Journal, *published by R. R. Bowker Co./A Xerox Corporation; copyright © 1970), Vol. 16, No. 6, February, 1970, p. 73.*

The taming of a shrew in a rush and scurry of words, words chosen for their sound, not for any limitation of young understanding. ("Oh, she was a scold, a shrew, a vixen and a virago—and a proper tyrant and tartar to her poor husband. . . ."). . . . One day Mrs. D. is sucked into the washing-machine and finds an opponent worthy of her vocabulary; but, returning from a routed Baron, she admits it would be peaceful if she could learn to keep her temper. This strange little slice of life is served up with plenty of pepper and spice in the text. . . .

Margery Fisher, in a review of "Mrs. Discombobulous," in her Growing Point, *Vol. 8, No. 9, April, 1970, p. 1510.*

SAILOR JACK AND THE 20 ORPHANS (1970)

That Margaret Mahy! How fortunate that she wasn't destined to stay down under in New Zealand, that her stories were transported to bring pleasure to English-speaking children all over the world. Here is a rollicking tale from her store of talents, a seaworthy story of a friendly sailor who liked to spin yarns so much that he adopted a whole orphanage so he could always count on an audience. This book contains lots of action, lots of fun.

A review of "Sailor Jack and the 20 Orphans," in Publishers Weekly *(reprinted from the December 14, 1970 issue of* Publishers Weekly, *published by R. R. Bowker Company, a Xerox company; copyright ©*

1970 by Xerox Corporation), Vol. 198, No. 24, December 14, 1970, p. 39.

THE LITTLE WITCH (1970)

Mrs. Mahy has spun many fine tales for children. Here she creates . . . an enchanting story of a baby witch . . . with "lots of magic in her." It is a pleasant variation of the old theme of the "good spirit" who helps others rather than the traditional "wicked witch."

> *[Sister Teresa Clare], in a review of "The Little Witch," in* Catholic Library World, *Vol. 42, No. 7, March, 1971, p. 459.*

Margaret Mahy's particular gift is for turning an everyday anecdote into something slightly and attractively odd. Here, for instance, she has given a glimpse of a little girl running away and being found by her loving mother. The mood of affection and security is kept in the context of fancy, for the little girl is a witch and as she wanders through the city she leaves clues for her mother to follow in a trail of blossoms and the metamorphosis of the clock tower. . . . It is for fresh imagination that the author has won swift recognition. (pp. 1711-12)

> *Margery Fisher, in a review of "The Little Witch," in her* Growing Point, *Vol. 9, No. 9, April, 1971, pp. 1711-12.*

THE PRINCESS AND THE CLOWN (1971)

The princess's suitors, stung into mockery by her refusal to marry any of them, present her with a painted clown as a suitable wooer. To their consternation the trick backfires and the clown and princess are married. The high-flown, neo-Wildean manner in which the story is told seems to make the slight, romantic tale unduly portentous.

> *A review of "The Princess and the Clown," in* The Times Literary Supplement *(© Times Newspapers Ltd. (London) 1971; reproduced from* The Times Literary Supplement *by permission), No. 3640, December 3, 1971, p. 1520.*

The story is simple. . . . Unusually, there is no parental opposition [to the princess marrying the clown]. . . . The writing is inclined to go off into flights of fancy which are sometimes a little forced as in the descriptions of the princess, but these are brave failures and in many ways this is a splendid book. Possibly it may appeal more to adults than children and certainly it is not the best work of either artist [Carol Barker] or author, but at least neither can ever be accused of being boring or commonplace.

> *C. Martin, in a review of "The Princess and the Clown," in* The Junior Bookshelf, *Vol. 36, No. 1, February, 1972, p. 26.*

THE MAN WHOSE MOTHER WAS A PIRATE (1972)

Margaret Mahy's stories are always highly original and her new one features two loveable characters in the shape of a portly business man and his ex-pirate, pipe-smoking mother who longs to return to the sea. . . .

Mrs. Mahy must indeed have a great love of the sea herself for her descriptive prose is, at times, almost poetical. She has a wonderful way with words and an ability to convey sensations, sights and sounds, whatever her subject, which is aesthetically satisfying. . . . [This picture book] is recommended without hesitation.

> *Edward Hudson, in a review of "The Man Whose Mother Was a Pirate," in* Children's Book Review *(© 1973 Five Owls Press Ltd.; all rights reserved), Vol. II, No. 6, December, 1972, p. 180.*

[Margaret Mahy] goes in for lots of words and for complex stories. Her text will tell better than it reads. . . . A clever book, certainly, with a theme which is sophisticated for its potential readers.

> *Marcus Crouch, in a review of "The Man Whose Mother Was a Pirate," in* The Junior Bookshelf, *Vol. 36, No. 6, December, 1972, p. 369.*

Margaret Mahy makes her words bump and harrumph along in perfect gait with her eccentric landlocked characters until suddenly she bursts free, giving us a long eloquent taste of the sea: ". . . . He hadn't thought it would roll like kettledrums and swish itself on to the beach. . . . The little man opened his eyes and his mouth, and the drift and dream of it, the weave and wave of it, the fume and foam of it, flooded into him and never left him again."

Sam's dream turns out to be more wonderful than his expectations. To go beyond one's dreams—what exquisite delight! And that, plus Margaret Mahy's bouncy, poetic prose may make it worth the price, almost a pirate's ransom.

> *Diane Wolkstein, in a review of "The Man Whose Mother Was a Pirate," in* The New York Times Book Review *(copyright © 1973 by The New York Times Company; reprinted by permission), July 29, 1973, p. 8 [the excerpt of Margaret Mahy's work used here was originally published in her* The Man Whose Mother Was a Pirate *(reprinted by permission of Helen Hoke Associates),* Atheneum, 1972].

Collage illustrations [by Brian Froud] are, like the text, rather sophisticated for the picture book format of a story that depends on concepts rather than action for its appeal, the only humor being in the idea of the mother of a timid adult male as an ex-pirate. . . . No message except do-your-own-thing, with both the concepts and the vocabulary in conflict with format, and with the slightest of plots.

> *Zena Sutherland, in a review of "The Man Whose Mother Was a Pirate," in* Bulletin of the Center for Children's Books *(reprinted by permission of The University of Chicago Press; © 1973 by The University of Chicago), Vol. 27, No. 2, October, 1973, p. 32.*

Five-year-olds will miss the anti-establishment message and the seemingly unintended irony that the once-clerk, now-cabin boy is still taking orders; and, they will certainly be disappointed to find that the garrulous old lady talks plenty of sea poetry but nothing of piracy.

> *Janet French, in a review of "The Man Whose Mother Was a Pirate," in* School Library Journal, *an appendix to* Library Journal *(reprinted from the November, 1973 issue of* School Library Journal, *pub-*

lished by R. R. Bowker Co./A Xerox Corporation; copyright © 1973), Vol. 20, No. 3, November, 1973, p. 42.

THE FIRST MARGARET MAHY STORY BOOK: STORIES AND POEMS (1972)

Some of the stories in this book belong to the world that Margaret Mahy has already populated with witches, giants and dragons, but it is pleasant to discover that she can look at the ordinary world in a quiet, realistic way as well. . . . Life at domestic and at fantastic level displayed in tiny stories written in a prose unique in its quirks, its unexpected words and strong sense of direction. (pp. 2070-71)

> *Margery Fisher, in a review of "The First Margaret Mahy Story Book," in her* Growing Point, *Vol. 11, No. 6, December, 1972, pp. 2070-71.*

There is nothing quiet about Margaret Mahy. The words go off like fireworks, and they make a lovely display. . . . [The] words whirl and fly in all directions like sparks in the wind. Miss Mahy lives in New Zealand; her stories have the unselfconscious innocence of earlier writers, here.

> *"Telling Tales," in* The Times Literary Supplement *(© Times Newspapers Ltd. (London) 1972; reproduced from* The Times Literary Supplement *by permission), No. 3692, December 8, 1972, p. 1499.**

[Margaret Mahy] is known widely for her original picture book stories. . . . [The stories and poems in this book] are suitable in the main for children of six to eight years old and vary from the everyday happenings of childhood to delicate or amusing fantasy. . . Two of the stories, one of a lonely timid child and the other of the wonderful craftsman Green Needles who sews the colours and shapes and shadows of the countryside into the curtains and carpets, are particularly imaginative and perceptive. The best of the short poems on many themes would not disgrace Eleanor Farjeon.

> *Margery Fisher, in a review of "The First Margaret Mahy Story Book," in her* Growing Point, *Vol. 37, No. 1, February, 1973, p. 27.*

SEVENTEEN KINGS AND FORTY-TWO ELEPHANTS (1972)

Margaret Mahy's text is inconsequential, and one never discovers where the kings are going and why. Is her poem full of subtle allegory, or is it—as I hope and suspect—just for the fun and intoxication of words. A nice poem, whatever the meaning. . . .

> *Marcus Crouch, in a review of "Seventeen Kings," in* The Junior Bookshelf, *Vol. 36, No. 6, December, 1972, p. 365.*

Some of the verbal distortions may seem ill-advised, but this near-nonsense verse story has a strong romantic allure. The procession of kings passes through the jungle and all the animals see it. Then it moves on and is gone. This is all, but the imagination is stirred by the mood of mystery and magic the author creates.

> *A review of "Seventeen Kings," in* The Times Literary Supplement *(© Times Newspapers Ltd. (London) 1972; reproduced from* The Times Literary Sup-

plement by permission), No. 3692, December 8, 1972, p. 1498.

THE RAILWAY ENGINE AND THE HAIRY BRIGANDS (1973)

Margaret Mahy's story reads as if it were being told verbally to a group of children sitting round her in a circle, and indeed this is how it should be read. . . .

An old railway engine willed to two small girls, Mr. S. Heratick who runs a wet weather shop in a town where the sun always shines, an invasion by the ugly hairy brigands from the mountains . . . these are the ingredients of a highly original story which ends happily with the brigands being put to flight by the ferocious appearance of the steam engine bearing down on them followed by all the noisy children and barking dogs of the town. With her usual enlightened anticipation of the children's question: 'But what happened to the hairy brigands?', we are told in the last of the five short chapters into which the story is divided. . . . [This] is surely one of the best picture story books of the year so far for the six to eight-year-olds.

> *Edward Hudson, in a review of "The Railway Engine and the Hairy Brigands," in* Children's Book Review *(© 1973 Five Owls Press Ltd.; all rights reserved), Vol. III, No. 4, September, 1973, p. 109.*

This story has the inevitability of all good absurdity, with a Dickensian ebullience of dialogue and description. . . . A particularly satisfying story for reading aloud. (pp. 310-11)

> *Mary Hobbs, in a review of "The Railway Engine and the Hairy Brigands," in* The Junior Bookshelf, *Vol. 37, No. 5, October, 1973, pp. 310-11.*

THE SECOND MARGARET MAHY STORY BOOK: STORIES AND POEMS (1973)

Each story is a convenient bed-time or end-of-school-day length and, in spite of the fact that they are all from one hand, there is plenty of variety. At times Mrs Mahy only just avoids plunging off her tight-rope into the sloughs of whimsy and sentimentality. Her touch is not always as sure as it is in the best of her picture-book stories, but for the most part her peculiar blend of the fantastic and the familiar remains an attractive one.

> *"Picking and Choosing, 2," in* The Times Literary Supplement *(© Times Newspapers Ltd. (London) 1973; reproduced from* The Times Literary Supplement *by permission), No. 3742, November 23, 1973, p. 1438.**

In this collection, Margaret Mahy's now familiar, enchanting prose ranges from the everyday, comfortable happenings at home to the exquisitely fashioned worlds of wizards and bird-children. At neither extreme is anything other than perfectly expressed. . . .

There is a delightful touch of magic in **'The Merry-go-round,'** in which earthly generosity is rewarded with both earthly money *and* a lasting relationship with the silent but intensely happy wood people. . . .

[Despite] the publisher's recommendation for six to ten-year-olds, [this] would, I imagine, make an exciting addition to story-time for much younger listeners.

Margot Petts, in a review of "The Second Margaret Mahy Story Book," in Children's Book Review *(© 1974 Five Owls Press Ltd.; all rights reserved), Vol. IV, No. 1, Spring, 1974, p. 30.*

THE WITCH IN THE CHERRY TREE (1974)

With no more nefarious aim than obtaining some of mother's fresh baked cakes, the witch in David's cherry tree is further defused by her inability to outwit a typical preschooler. . . . Always one step ahead of his meek and admiring mother in anticipating the witch's ploys, David may have some ego-boosting function, but neither Mahy nor [illustrator Jenny] Williams gives the silly business any consequence or zing.

A review of "The Witch in the Cherry Tree," in Kirkus Reviews *(copyright © 1974 The Kirkus Service, Inc.), Vol. XLII, No. 6, March 15, 1974, p. 295.*

[David] is a hero in the James James Morrison Morrison tradition: he keeps himself and his mother out of trouble and outwits the witch every time. . . . Margaret Mahy tells the story crisply, with a restrained but effective use of imagery that contrasts favourably with the self-indulgent "poetical" language of some of her earlier stories. . . .

"In Safe Surroundings," in The Times Literary Supplement *(© Times Newspapers Ltd. (London) 1974; reproduced from* The Times Literary Supplement *by permission), No. 3760, March 29, 1974, p. 330.**

A story which evokes the cosiness of a wet day, with warmth and light and the smell of newly baked cakes indoors. . . .

The story is told in a clear and direct style, with nice touches of humour. . . . This is a pleasing fantasy for children from about three to six, and there is a recipe at the end, as a bonus, for making 'Gingerbread Witches'.

John A. Cunliffe, in a review of "The Witch in the Cherry Tree," in Children's Book Review *(© 1974 Five Owls Press Ltd.; all rights reserved), Vol. IV, No. 2, Summer, 1974, p. 55.*

What is it about Margaret Mahy's style that makes her picture books so absolutely right? Perhaps it is her ear for the music of sentences, their varying length and vigour. Perhaps also it is the slightly ironic acceptance of the marvellous by the author, and by the adults in her stories, so that one is never quite sure of the line between reality and make-believe. . . . [An account of the plot] does little justice to the vigour and immediacy of the narration: the ruse of the crumpled shape on the grass, for instance: "What wickedness! It was *not* the witch." It is absolutely necessary to read this delightful nonsense for one's self—aloud, of course. (pp. 202-03)

Mary Hobbs, in a review of "The Witch in the Cherry Tree," in The Junior Bookshelf, *Vol. 38, No. 4, August, 1974, pp. 202-03.*

STEPMOTHER (1974)

Jenny's father often calls her Princess and the new stepmother can be expected to follow fairy tale tradition, or so Jenny thinks. But it seems that this pretty young woman needs help her-self. . . . The happy shrewdness of this domestic vignette is enhanced by Margaret Mahy's prose, always unexpected. . . .

Margery Fisher, in a review of "Stepmother," in her Growing Point, *Vol. 13, No. 1, May, 1974, p. 2412.*

There is great sensitivity in the story and the developing relationship between [Jenny and her stepmother]. Margaret Mahy is a storyteller of repute, and well used to choosing just the right words to convey a feeling and sensibility hard to lay a finger on exactly.

The stark title of the book immediately raises the problem of the psychological effect of such a book on a child in such a situation. Until an older child or adult points out the "extraordinariness" of being black skinned or having a stepmother is the very young child aware of the problems involved? . . .

[There is magic] in this very delightful and wholly sympathetic story.

Jean Russell, in a review of "Stepmother," in The Junior Bookshelf, *Vol. 38, No. 4, August, 1974, p. 215.*

THE BUS UNDER THE LEAVES (1974)

One of the indignities of childhood is the way grown-ups expect friendships to happen automatically. *The bus under the leaves* has the sharp observation and easy manner of everything Margaret Mahy writes. Adam, who is sociable, is very ready to like David when he comes to stay with Mr. Miller next door, but David is unfriendly and disagreeable till he forgets himself in joining in the refurbishing of an old bus which makes an ideal playhouse. . . . Behind the happy circumstantial detail there is a shrewd appraisal of the small but important tensions of the middle years.

Margery Fisher, in a review of "The Bus Under the Leaves," in her Growing Point, *Vol. 13, No. 8, March, 1975, p. 2580.*

[*The Bus Under the Leaves*] is a lively story of a holiday. . . . Here is a story full of the simple pleasures of childhood, unspoilt by outside interference by adults or by the sensational happenings which so many writers consider essential to keep children's interest.

Eileen Colwell, in a review of "The Bus Under the Leaves," in The Junior Bookshelf, *Vol. 39, No. 3, June, 1975, p. 185.*

[The children's] adventures are simply, but realistically, told and the relationship between the children is convincing. The book is described on the inside cover as being suitable for seven to ten-year-olds, but the age group it would appeal to more is in fact the five to sevens. The story line is not strong enough for older children, and the vocabulary and presentation is for young children. . . . This is a very pleasant book for reading aloud, with plenty to capture the imagination. (p. 58)

Sheila Pinder, in a review of "The Bus Under the Leaves," in Children's Book Review *(© 1975 Five Owls Press Ltd.; all rights reserved), Vol. V, No. 2, Summer, 1975, pp. 57-8.*

CLANCY'S CABIN (1974)

A summer holiday adventure for three children living in New Zealand, whose parents give them permission to camp in Clancy's Cabin, a favourite place of their father's when he was a boy. Skip, the eldest, finds a treasure map. . . . The result is far more exciting than any of them could have imagined. . . . In very few words, Margaret Mahy can convey the differences between the three children; the serious, responsible elder boy, Skip, practical Marina and wild young Timothy. She remembers to put in the details of what the children eat and how they prepare it, and still leaves room for the excitement of the story. Unhesitatingly recommended for seven to twelve-year-olds.

> *Sylvia Mogg, in a review of "Clancy's Cabin," in* Chidren's Book Review *(© 1975 Five Owls Press Ltd.; all rights reserved), Vol. V, No. 1, Spring, 1975, p. 20.*

THE ULTRA-VIOLET CATASTROPHE! OR, THE UNEXPECTED WALK WITH GREAT-UNCLE MAGNUS PRINGLE (1975)

Boisterous, imaginative Sally dreads visits to Aunt Anne Pringle, who is fussy and insists on quiet, but little old Great-Uncle Magnus proves an unexpected ally. . . . [Margaret Mahy presents a] spirited defence of freedom for young and old alike in this spanking comedy.

> *Margery Fisher, in a review of "The Ultra-Violet Catastrophe," in her* Growing Point, *Vol. 13, No. 8, March, 1975, p. 2583.*

Margaret Mahy is the outstanding master of the short story for very young children. Although she is usually a partner in a picture book she does not really need the help of an illustrator; her words are well able to stand up for themselves. *Ultra-Violet Catastrophe* is a beautifully observed account of the friendship between a little girl and an old man. Pleasure in its fun is heightened by an appreciation of its essential truth.

> *Marcus Crouch, in a review of "The Ultra-Violet Catastrophe," in* The Junior Bookshelf, *Vol. 39, No. 3, June, 1975, p. 176.*

The alliance of the irresponsible old and the fancy free young (or vice versa, or whatever) is a currently common theme in children's books; this entry from New Zealand lacks the poignancy of some but is larky enough to carry the occasion.

> *A review of "Ultra-Violet Catastrophe: or, the Unexpected Walk with Great-Uncle Magnus Pringle," in* Kirkus Reviews *(copyright © 1975 The Kirkus Service, Inc.), Vol. XLIII, No. 19, October 1, 1975, p. 1122.*

The many similarities between youth and old age are effectively depicted in the marvelous relationship which develops in this quietly sentimental, yet lighthearted story. The text might be a little long for the very youngest lap-sitters, but it moves along quickly, and most children will have no difficulty getting involved.

> *Barbara Dill, in a review of "Ultra-Violet Catastrophe! Or the Unexpected Walk with Great-Uncle Magnus Pringle," in* Wilson Library Bulletin *(copyright © 1975 by the H. W. Wilson Company), Vol. 50, No. 3, November, 1975, p. 249.*

[While] the story line is more original than most, the inspiration for it is provided by uncaring, unthinking adults. In a modern version of the cross-generational story, the old man is treated as a child by his daughter and the little girl is constantly adjured by her mother to "keep clean." Old man and little girl, sent out to walk together because they are in the way of the "real" adults, have a glorious time together in a making-mud-pie fashion. . . . But in spite of the joie-de-vivre of their few hours together and the feeling the child is now armed with a sense of her own uniqueness and value, the deeper implication is that both will return to a world where they are not respected. The mother's slight softening toward dirty clothes at the end is not a page-turning surprise, but simply unbelievable, given her first presentation. (p. 262)

> *Sheila Egoff, "Picture Books," in her* Thursday's Child: Trends and Patterns in Contemporary Children's Literature *(copyright © 1981 by the American Library Association), American Library Association, Chicago, 1981, pp. 247-74.**

THE THIRD MARGARET MAHY STORY BOOK: STORIES AND POEMS (1975)

There is a wide range of mood and subject matter here from the ordinary and everyday—the boy who wanted a budgie and the girl who liked mending cars—to **"The Green Fair"**, a story of miniature magic that recalls Eleanor Farjeon or *Mossy Green Theatre*. Several pleasant poems and the sensitive animal drawings by Shirley Hughes make this an attractively diverse book. The quality of the writing is uniformly high and yet there is something a little stuffy about its tones.

> *Julia Briggs, "Whimsical Witching," in* The Times Literary Supplement *(© Times Newspapers Ltd. (London) 1975; reproduced from* The Times Literary Supplement *by permission), No. 3836, September 19, 1975, p. 1059.**

[*The Third Margaret Mahy Story Book*] has great charm, particularly in its use of language: words jump to the tongue and you want to read them aloud.

> *Anne Redmon, "No Kidding," in* New Statesman *(© 1975 The Statesman & Nation Publishing Co. Ltd.), Vol. 90, No. 2332, November 28, 1975, p. 688.**

THE BOY WHO WAS FOLLOWED HOME (1975)

With incredibly funny understatement Mahy stretches a joke into a fantastic but inexorably logical story with a surprise ending. By the time 43 hippos have made themselves comfortable on the family lawn, Robert's father calls in a witch to relieve the situation, and she does, in a way. . . . [Illustrator Steven Kellogg's] sense of the absurd has made connections with an author's experience in what appeals to children.

> *Betsy Hearne, in a review of "The Boy Who Was Followed Home," in* The Booklist *(reprinted by permission of the American Library Association; copyright © 1975 by the American Library Association), Vol. 72, No. 5, November 1, 1975, p. 370.*

THE GREAT MILLIONAIRE KIDNAP (1975)

What joy to read words like "capitalist" and "minion", "jugglement" and "jerrymander", not to mention "mumpish" and "mopish". The kidnapping of Somerset K. Wilberforce is a splendid subject, even at a time when children are well aware that kidnappings are normally no laughing matter. . . . Children will not get all the jokes (for instance, how the Likely family comes to have an Uncle Pygmalion)—but most of them will love this further evidence of Margaret Mahy's marvellously exuberant imagination. If plodding through easy readers equips children for this sort of fun, the hard work will have been well rewarded.

> *Ann Thwaite, "Verbal Limitations," in* The Times Literary Supplement *(© Times Newspapers Ltd. (London) 1975; reproduced from* The Times Literary Supplement *by permission), No. 3847, December 5, 1975, p. 1446.*

It is Margaret Mahy's skilful use of words and her feeling for the sound of them that makes this story, like many of her others, so appealing. The characters are entertaining and well rounded, the story amusing and will probably be best enjoyed when read aloud.

> *M. R. Hewitt, in a review of "The Great Millionaire Kidnap," in* The Junior Bookshelf, *Vol. 40, No. 1, February, 1976, p. 27.*

NEW ZEALAND: YESTERDAY AND TODAY (1975)

[*New Zealand yesterday and today* takes] a sane, well-balanced view of a country which is as much a Polynesian island as a part of the Commonwealth. Margaret Mahy writes fluently and is concerned personally with her subject. . . . [Her] account of early social reforms and the growth of the Welfare State is properly detailed and lucid. What I miss is the atmosphere of the country. What is the land like? its contours? the climate in various places? how are artists of town and pastoral plain and mountain tackling their subject? All this may seem to belong to the television screen, but the book would have been all the better—and it is very good—for a little more colour and pictorial detail. (pp. 2794-95)

> *Margery Fisher, in a review of "New Zealand Yesterday and Today," in her* Growing Point, *Vol. 14, No. 7, January, 1976, pp. 2794-95.*

[When] the book's selling power appears to be its writer's main consideration, the initial wooing of the reader can turn to the kind of mindless flattery which verges on the insulting. In an attempt to be informal and perky, Mrs Mahy often succeeds only in being chatty and inconsequential. There are thirty-nine chapter headings, but some of the chapters are less than a page (e.g. crops). In attempting a wide coverage of history, geography and 'social studies', she has done little more than resort to random information selection. Perhaps the book is really aimed at those children in English schools who, when asked to do a project, search eagerly for a single book on the topic, and then copy out large chunks of it, very neatly.

> *Alex McLeod, in a review of "New Zealand Yesterday and Today," in* The School Librarian, *Vol. 24, No. 1, March, 1976, p. 58.*

THE WIND BETWEEN THE STARS (1976)

Imagination is virtually impossible to define but Margaret Mahy has demonstrated it obliquely in many picture-book texts. . . .

[The wind is as much the centre of this] story as Phoebe herself, the wind which blows into people's lives and tempts them to "take their feet off the ground", to join and accept the anarchy of beauty and fancy. It is the wind between the stars which, rejected once by Phoebe as she pursues her childish games with Michael and again when they marry and she is absorbed in family life, wins her recognition of marvels when, as an old woman, white-haired and wrinkled, she opens the windows of her prim employer's house and is swept away. . . . (p. 2835)

Whatever children will make of the philosophy of the story, the idea of escape to freedom is plain enough, and the felicities of Margaret Mahy's prose need not be lost on them if the tale is read aloud, as it should be. The short text is packed with detail, with odd twists of phrase, with a constant move from plain narrative . . . to an intoxicating profusion of words (Miss Gibb's dresses "broke free, and soared and swirled around, high up around the chimney, curtseying, and bowing, mopping and mowing, in the air"). (pp. 2835-36)

> *Margery Fisher, in a review of "The Wind between the Stars," in her* Growing Point, *Vol. 14, No. 9, April, 1976, pp. 2835-36.*

Every page of Margaret Mahy's **The Wind Between the Stars** . . . is clearly her own. Even someone who did not know her other work would instantly recognize the book's individuality. This is not to say that there are not places where the author goes almost over the top (in the mode of de la Mare). . . . But the near excesses spring from realized emotion. . . .

> *Nancy Chambers, "The Individual Voice," in* The Times Literary Supplement *(© Times Newspapers Ltd. (London) 1976; reproduced from* The Times Literary Supplement *by permission), No. 3864, April 2, 1976, p. 381.*

DAVID'S WITCH DOCTOR (1976)

[There is] direct, domestic good sense [in] this new story. . . . How much affection for children there is in this pertinent anecdote of a "middle child" who is helped by a sympathetic and resourceful young doctor to find his own level in the family. A characteristic mixture of humour and shrewdness.

> *Margery Fisher, in a review of "David's Witch Doctor," in her* Growing Point, *Vol. 14, No. 9, April, 1976, p. 2859.*

David is suffering from a feeling of injustice as so many children do when adults impose their alien standards upon them. . . .

A homely and perceptive story typical of the author's empathy for children. . . . An amusing story for beginners.

> *Eileen Colwell, in a review of "David's Witch Doctor," in* The Junior Bookshelf, *Vol. 40, No. 3, June, 1976, p. 147.*

NONSTOP NONSENSE (1977)

The title of this book really is apt as both the writer and the illustrator [Quentin Blake] have come up with 128 pages of

sheer madness which starts even before the contents page! It is a delightful mixture of verse, story and zany illustration which is wholly infectious. By the end of the book, the reader will be glad indeed that Margaret Mahy and Quentin Blake haven't "learned more sense". A superb book.

> *Margaret Walker, in a review of "Nonstop Nonsense," in* Book Window *(© 1977 S.C.B.A. and contributors), Vol. 5, No. 1, Winter, 1977, p. 24.*

Versatile as ever, Margaret Mahy rings the changes on limericks and nonsense verses with, among other fictional treats, a group of anecdotes about the Delmonico family which involve confusions and adventures with words. Underlying many of her bizarre pieces (especially **"The Haunted Child"** and **"The Insect Kingdom that didn't get started"**) there is a tough philosophy recognising human folly and strongly dissenting from it.

> *Margery Fisher, in a review of "Nonstop Nonsense," in her* Growing Point, *Vol. 16, No. 6, December, 1977, p. 3232.*

Take a word and twist it round. Tie it in a bundle of literal meanings. Mix it up with inverted children, scatter-brained parents and frantic frogs and you have that fantastical jamboree: Margaret Mahy's **Nonstop Nonsense.**

This delightful volume has a freshness and vigour that's often lacking in "funny" books. Not so much a collection of outlandish ideas, it's a picture of life through boggle-eyed spectacles. . . . Of course there are fantasmagorical rhymes of the Edward Lear variety (What shall we put in the Christmas pudding? Hammers, nails, glue and paint it with spots). But Ms Mahy is far more enchanting amid the workaday chores of vacuum cleaners and dust "like speckles of gold and silver and freckles of rainbow".

> *Peter Fanning, "Twisty Broken Explosions," in* The Times Educational Supplement *(© Times Newspapers Ltd. (London) 1978; reproduced from* The Times Educational Supplement *by permission), No. 3269, February 3, 1978, p. 38.* *

One hundred and thirty pages of just what the title says it is. Children will quote their own favourites from this collection of Margaret Mahy's amusing verse and prose. . . . The jongles and jingles and jangles are full of tongue-twisting rhymes, and the stories are one galloping galaxy of nonsensical notions.

> *Berna Clark, in a review of "Nonstop Nonsense," in* The Junior Bookshelf, *Vol. 42, No. 3, June, 1978, p. 143.*

THE PIRATE UNCLE (1977)

Nick and Caroline are sent to stay with their hitherto unknown Uncle Ludovic, who proves to have a black beard, long hair and a moustache. He wears the most casual clothes, and is not ashamed of the fact that the children's mother rather dislikes him. This, he suggests, is because he is a pirate.

Mid-way through the story the reader realises that the whole thing is a spoof. None of the thrills hinted at is going to materialise. Uncle Ludovic is not a pirate, he is a perfectly ordinary—if slightly eccentric—boatbuilder. . . .

It is a pity that such comparatively lively writing should be expended on so disappointing and feeble a plot.

> *Ruth Baines, in a review of "The Pirate Uncle," in* The Junior Bookshelf, *Vol. 42, No. 2, April, 1978, p. 91.*

The Pirate Uncle at first sight seems to be one of those rare books which give adults and children almost equal rights of feeling and action, but in fact the adults prove to be cut to fit a junior tale almost too strictly. . . . Ludovic's own life-style as an unconventional boat-builder and his courtship of Rosie, divorced from a rich, insensitive business-man, are important to the plot but do not carry total conviction, for the mixture of almost suffocating liberalism and mock-childish fantasising never quite fits into the atmosphere of a holiday adventure enjoyed by a young brother and sister. (pp. 3326-27)

> *Margery Fisher, in a review of "The Pirate Uncle," in her* Growing Point, *Vol. 17, No. 1, May, 1978, pp. 3326-27.*

The author conveys all the joys of a golden summer on the New Zealand coast for town-bred children, and the half-belief, half-doubt which teases their minds in their contact with the quixotic personality of their uncle. The happy ending seems an integral, not contrived part of the story, and Uncle Ludovic keeps his ability to spring surprises on them. Margaret Mahy writes easily, and with a gusto which carries the reader with her. This is an enjoyable book, but more suited to the eight to eleven age range than the five to nines as suggested on the cover.

> *B. C. Bridgwater, in a review of "The Pirate Uncle," in* The School Librarian, *Vol. 26, No. 2, June, 1978, p. 138.*

THE GREAT PIRATICAL RUMBUSTIFICATION & THE LIBRARIAN AND THE ROBBERS (1978)

[Margaret Mahy is] one of the best of the reading-aloud writers. . . . Very lively, though basically mild, adventures and a good sense of all's-well-that-ends-well make this an ideal bedtime book.

> *Isabel Quigly, "The Reader's Skill," in* The Times Literary Supplement *(© Times Newspapers Ltd. (London) 1978; reproduced from* The Times Literary Supplement *by permission), No. 4000, December 1, 1978, p. 1398.* *

Two stories, both as wildly imaginative as their titles suggest Witty rather than humorous, they may appeal more to adults than to children, but one can never tell. The young will probably prefer the second story—Miss Laburnum the librarian is a figure they will recognise, and policemen and robbers strike a more familiar note than pirates—but even if the children don't enjoy the book, parents and grandparents will enjoy reading it to them.

> *R. B. Southern, in a review of "The Great Piratical Rumbustification" and "The Librarian and the Robbers," in* The School Librarian, *Vol. 27, No. 1, March, 1979, p. 39.*

The Great Piratical Rumbustification, is a joyous romp from start to finish. The story begins in spring when the local retired

pirates are feeling restless and in dire need of a pirate party. . . . The story of their more-than-successful party is told at a crackling pace, accelerating towards the climax of their rumbustification. A tale full of glee, skilfully told. . . . The second story, *The Librarian and the Robbers,* is not quite so successful but is none the less enjoyable.

> *Anne C. Ramsay, in a review of "The Great Piratical Rumbustification" and "The Librarian and the Robbers," in* Book Window *(© 1979 S.C.B.A. and contributors), Vol. 6, No. 2, Spring, 1979, p. 16.*

RAGING ROBOTS AND UNRULY UNCLES (1981)

Raging Robots and Unruly Uncles has, superficially, a look of decidedly heavy-handed exuberance. Yet appearances deceive. This little tale marshals its array of zany incidents and odd characters with absorbing skill, and offers a moral fable of exceptional ingenuity and wit.

Uncle Jasper strives in vain to bring up his seven sons (Caligula, Nero, Genghis, Tarquin, etc) in villainy; and the good Uncle Julian despairs of ever making his one daughter, the exemplary Prudence, quite virtuous *enough*. To create an especially subtle kind of havoc, the lads devise a perfect walking and talking doll which will outdo Prudence in goodness, and send it to Uncle Julian. Prudence (she is very good at electronics) constructs in turn a thieving and destructive robot which will outstrip Uncle Jasper and the boys in wickedness. Both households find Frankenstein in their midst. The moral is that either good or evil, taken to their absolute extremes, become impossible to perform, and also tedious. . . .

Margaret Mahy has compressed her intricate and eventful plot into an even smaller space than seems possible. . . . She runs through an extraordinary range of weird happenings, and yet lapses into scarcely a syllable of over-used material or facile obviousness. Her prose is both elegant and racy; and this brief, hilarious book offers many moments of the purest delight.

> *Alan Brownjohn, "Tendencies to Wildness," in* The Times Literary Supplement *(© Times Newspapers Ltd. (London) 1981; reproduced from* The Times Literary Supplement *by permission), No. 4103, November 20, 1981, p. 1357.**

To write nonsense requires a very light and deft touch. This story labours heavily at the start but ends on a satisfyingly inspired note. It has a moral: that you cannot make your children into what you want. . . .

The format of the book suggests a younger readership than would understand much of the vocabulary, but good readers of nine upwards will find things to chuckle over.

> *Janet Fisher, in a review of "Raging Robots and Unruly Uncles," in* British Book News *(© British Book News, 1982; courtesy of British Book News), Spring, 1982, p. 11.*

Raging Robots and Unruly Uncles has at least a strong moral (it is possible to have too much of a good thing) to provide some sense of direction while the exaggerated antics of the two robots . . . provide plenty of comic situations as they pursue their quarry. . . . Unfortunately, Mrs Mahy, having led up to a splendid chase and scene of mass destruction, fails to maintain the pace and the conclusion comes as something of a let down.

> *Valerie Alderson, "Junior Story Time," in* The Times Educational Supplement *(© Times Newspapers Ltd. (London) 1982; reproduced from* The Times Educational Supplement *by permission), No. 3433, April 16, 1982, p. 24.**

THE CHEWING-GUM RESCUE AND OTHER STORIES (1982)

You have to be slightly zany and off-beat to enjoy Margaret Mahy's stories for she always provides a bizarre touch. Many of the ingredients of traditional fairy stories are here, magic, dragons, princesses and happy endings, to name a few, and these are blended skilfully with unexpected and modern elements. **'The Chewing-Gum Rescue',** about five sisters and some goat thieves, is one of the less successful stories in the book, as I felt it was overstated. I thoroughly enjoyed most of the others, notably **'The Giant's Bath'** and **'The Singing Bus Queue',** For anyone who has ever climbed trees (and who hasn't?) **'The World's Highest Tray Cloth'** is a triumph, as the thrill and chill of going higher than is really safe or wise will strike a chord in many. . . . [The stories], which benefit from reading aloud, perhaps to seven- to nine-year-olds, are a rich and colourful collection.

> *Linda Yeatman, in a review of "The Chewing-Gum Rescue and Other Stories," in* British Book News *(© British Book News, 1982; courtesy of British Book News), Spring, 1982, p. 7.*

This is for older children, who might prefer to read the stories for themselves, though every teacher of junior classes ought to have a copy. Read *The World's Highest Tray Cloth* and see how much experience is encapsulated in such a seemingly straightforward story. Read the other stories for . . . [their] illogicality and freshness. . . . This is a fine book, by a fine writer. Well, we know that she's a fine writer because we know her work already; but this new book is something special.

> *Will Harris, "Once Upon a Time . . . ," in* The Times Educational Supplement *(© Times Newspapers Ltd. (London) 1982; reproduced from* The Times Educational Supplement *by permission), No. 3442, June 18, 1982, p. 28.**

Light-hearted fancy indeed—a journey down the plug-hole of a Giant's bath, the strange effects of taking off a glove, a boy practising to be an eagle; but in every story a firm domestic basis of relationships, meals, neighbours and in every story a veiled statement, whether it is that a hard-working parent tends to lose sight of her child's needs or (Margaret Mahy's firmest conviction, perhaps) that life needs humour and individuality if order and reason are to be any use at all. The last, long story, **'The Devil and the Corner Grocer',** follows out its Andersenian theme with brilliant confidence and an irresistible verbal wit. As always, a unique blend of comedy and rationale from this original writer.

> *Margery Fisher, in a review of "The Chewing-Gum Rescue and Other Stories," in her* Growing Point, *Vol. 21, No. 3, September, 1982, p. 3965.*

I wondered about all the alliteration in these stories, but children seem to find it funny and it's certainly catching. Perhaps I'm just splitting hairs, as this is a super set of stories for nine- and ten-year-olds that can be read aloud to younger children with riotous results. The stories that I particularly enjoyed are

'Gloves and gardens' (about a girl with green fingers) and 'The pumpkins of Witch Crunch': the former affectionately amusing, the latter frighteningly funny (or do I mean funnily frightening?). There is fantasy and/or humour in all these stories, and a touch of terror here and there. The comical cast of characters includes some bold and adventurous females.

> *Sheila Armstrong, in a review of "The Chewing-Gum Rescue and Other Stories," in* The School Librarian, *Vol. 30, No. 4, December, 1982, p. 339.*

There's less fizz but plenty of wonder, humour and quiet magic in a new collection from Margaret Mahy, **The Chewing-gum Rescue and Other Stories.** Each of us will have particular favourites, or particular favourites on different days. Mine for today are **'The Travelling Boy and the Stay-at-Home Bird'** . . . and **'The World's Highest Tray Cloth'**.

> *Peggy Heeks, "Fiction for 7 to 9: 'The Chewing-Gum Rescue, and Other Stories'," in* The Signal Review 1: A Selective Guide to Children's Books, *1982, edited by Nancy Chambers (copyright © 1983 The Thimble Press; reprinted by permission of The Thimble Press, Lockwood Station Road, South Woodchester, Glos. GL5 5EQ, England), Thimble Press, 1983, p. 28.*

THE HAUNTING (1982)

Here is an absolutely first-rate contemporary novel of the supernatural. The compelling story involves the "haunting" of eight-year-old Barney Palmer and the discovery of both a long lost great-uncle with psychic powers and a family curse—or is it? The principal characters—Barney and the members of his family—are beautifully drawn, and perhaps because they care so much for each other, readers care for them, too. Their growth and development as individuals and as members of a family unit are as important to the story as its supernatural chills, thrills and puzzlements, a fact that lends this genre book unusual richness. The story itself is believably written, although its several surprises are a bit too predictable and the denouement comes a bit too early.

> *Michael Cart, in a review of "The Haunting," in* School Library Journal *(reprinted from the August, 1982 issue of* School Library Journal, *published by R. R. Bowker Co./A Xerox Corporation; copyright © 1982), Vol. 28, No. 10, August, 1982, p. 119.*

The truth about an ancestral legacy of psychic powers that surfaces in each generation is eventually revealed in a surprising manner, but not before Barney—and the reader—are treated to some of the best spine-tingling episodes in recent fiction for this age group [grades 5-8]. Mahy handles suspense adroitly and characters with aplomb, enriching her story with well-drawn relationships—especially between the children and a much-adored stepmother. A dynamic first sentence will captivate its audience: "When, suddenly, on an ordinary Wednesday, it seemed to Barney that the world tilted and ran downhill in all directions, he knew he was about to be haunted again." A good candidate for reading aloud as well as alone.

> *Barbara Elleman, in a review of "The Haunting," in* Booklist *(reprinted by permission of the American Library Association; copyright © 1982 by the American Library Association), Vol. 79, No. 2, September 15, 1982, p. 117.*

Margaret Mahy has deserved her reputation as queen of the light fantastic with stories and picture-book texts which erupt with delightful visions. Now she displays a darker side in a full-length novel which centres on the possession of one sensitive, but ordinary, small boy. . . .

The Haunting manages to combine a realistic approach to family life—in which how you feel about your parents and yourself is actually important—with a strong and terrifying line in fantasy. The story is built round conversations over family meals which are linked by graphic descriptions of what is going on inside the head of Barney Palmer. . . .

What Margaret Mahy has achieved where many have failed is to write a psychological thriller alongside a tale of ghosts and magic. At any twist in the story, it is possible to make a nonfanciful reading and to see Barney's haunting as the production of an imaginative and fearful mind: he knows that his real mother died when he was born, and now his adored stepmother is pregnant and he fears he may cause her death, too. This neurotic interpretation is delicately suggested, and remains in the wings as the magical production unfolds. The details of dreams and nightmares are notoriously dull in the telling, but Margaret Mahy has a touch as deft as ever. The strange pictures of the mind invade with terrible clarity the ordinary geography of daily life. And the warmth and closeness that underlie the vigorous family dialogues bear no trace of sentimentality: it is possible to believe, for once, that we are such stuff as dreams are made on.

> *Sarah Hayes, "Unearthing the Family Ghosts," in* The Times Literary Supplement *(© Times Newspapers Ltd. (London) 1982; reproduced from* The Times Literary Supplement *by permission), No. 4146, September 17, 1982, p. 1001.*

Margaret Mahy has explored in many of her short stories the pattern of family relationships and in *The Haunting* she has given herself more space to devise another such pattern, sounding her special note of fantasy within an everyday situation. With her, fantasy is a matter of image, a way of indicating the individual quality of a person. When the girl Troy conjures up 'a tiny sun no larger than a mustard seed' or when Barney sees a ghostly child in blue velvet, the appearances depend on certain attributes of the people concerned. The book is in fact a powerful demonstration of the perils and rewards of imagination as it works through the Scholar family. . . . Margaret Mahy's plain, direct prose is the perfect instrument for dialogue, fresh and natural and full of glancing humour, which unerringly points to this or that element of personality. The interaction and interdependence of Barney, his father and stepmother, his sisters, his elderly relatives, are impressively worked out in this most original writer's first extended novel: it was well worth waiting for.

> *Margery Fisher, in a review of "The Haunting," in her* Growing Point, *Vol. 21, No. 4, November, 1982, p. 3985.*

When I started reading "The Haunting," I had to reach for a pencil. There were passages to be noted, phrases neatly turned, descriptions that took one's breath away. Pause, if you will, over a ghost who swings "from side to side, like an absent-minded compass needle searching for some lost North." . . . Consider Barney, who "felt Saturday sink into his bones even

before he woke up properly,'' and Tabitha, who had the ''important, excited look of a person swollen out with secrets.''

But Margaret Mahy is more than a wordsmith. Out of this wonderful welter of words emerge characters that are startlingly alive. There is Claire, the stepmother who belies everything bad we've ever heard about stepmothers; a father who is effectively ineffective; and the children: 8-year-old Barney, quiet, good and haunted; Tabitha, the talker and would-be writer; Troy, silent, ever watchful, the deep one. . . .

There are supernatural happenings and psychic powers, all packed into a ghost story that holds us until the last page is turned. . . .

But it is not only the stuff of the supernatural that matters here, for, as Claire says when everything has been resolved, ''We've all told one another things and come closer together.''

That in itself is a special kind of magic.

> *Colby Rodowsky, in a review of ''The Haunting,''*
> *in* The New York Times Book Review *(copyright ©*
> *1982 by The New York Times Company; reprinted*
> *by permission), November 21, 1982, p. 43.*

We know Miss Mahy best as a distinguished writer of texts for picture-books. It has always been clear that this is one of the most taxing of all literary exercises. It comes nevertheless as a surprise to discover what a commanding writer of the full-length novel she is. *The Haunting* is masterly in its conception and above all in the way it uses words to overcome scepticism and to give a vivid actuality to a fantastic theme. . . .

The theme, and the mechanics of its magic, are handled with the mastery of a virtuoso performer. But the strength of the book lies in the way Miss Mahy relates the fantasy to the relationships of ordinary life. The Scholars and the Palmers may be unusual but they are real people, and it matters greatly to the reader that the harmony of their lives should not be destroyed. Even Great-Granny Scholar, 'a terrible old lady, a small, thin witch, frail but furious', is not only convincing but sympathetic. These positive factors would in themselves make this a most memorable book. What lifts it into an altogether higher class is the way Miss Mahy tells her story, using words as if they came fresh from the mint. Here is Tabitha, on the subject of Great-Granny Scholar: '''I don't mind her being wrinkled. It's just that all her wrinkles are so angry. She's like a wall with furious swear words scribbled all over it.'''

> *Marcus Crouch, in a review of ''The Haunting,'' in*
> The Junior Bookshelf, *Vol. 47, No. 1, February,*
> *1983, p. 45.*

(John) Robert McCloskey

1914-

American author/illustrator and illustrator of picture books.

Characterized by authenticity, winsomeness, humor, and satire, McCloskey's eight books reveal the warmth and perception of his aesthetic vision as well as the influence of his personal background. *Lentil, Homer Price,* and *Centerburg Tales* present portraits of small-town America as perceived through the eyes of two authentic boys—the carefree harmonica player, Lentil, and the spirited but sensible Homer—both of whom critics liken to Tom Sawyer. *Blueberries for Sal, One Morning in Maine,* and *Time of Wonder* follow the growth of McCloskey's daughters, Sally and Jane, and furnish glimpses of family life and nature as observed on McCloskey's island in Maine's Penobscot Bay. *Make Way for Ducklings,* perhaps his most beloved work, is noted for its engaging depictions of the lively ducklings and their proud mother as well as for its accurate rendering of Boston in the 1940s. A versatile author/illustrator, McCloskey ranges his writing style from the simplicity of *Blueberries for Sal* to the broad humor and satire of the Homer Price adventures, the poetic prose of *Time of Wonder,* and the comical tall tale of *Burt Dow, Deep-Water Man;* his varied artistic techniques consist of charcoal and line drawings, soft watercolors, and vivid poster-style paintings. Although McCloskey thinks in pictures and is more comfortable as an illustrator, his texts are also well regarded.

As a youth in Hamilton, Ohio, McCloskey's great passions were music, drawing, and inventing mechanical and electrical devices, all of which figure in his books. After attending Boston's Vesper George Art School on a scholarship, he enrolled in the National Academy of Design in New York. As a student, McCloskey met the legendary May Massee, children's editor at The Viking Press. She convinced him to gather inspiration from the things he knew rather than produce the dragons and other examples of "great art" which he showed her. Humbled but not undaunted, McCloskey looked at his boyhood and created *Lentil,* which was hailed as a potential classic. His next book, *Make Way for Ducklings,* further established his reputation by earning the Caldecott Medal. It is a tribute to McCloskey's artistic excellence that his next five books included another Caldecott winner in addition to two Caldecott runners-up, making him the first illustrator to capture the Medal twice.

Critics are enthusiastic about McCloskey's works, and esteem him for putting quality before quantity. Reviewers praise the variety and harmony of his texts and illustrations and the way they support and enhance each other, as in *Time of Wonder* where the lyrical prose is interpreted in soft watercolors. They commend his ability to portray the nuances of people, nature, and situations realistically and humorously without talking down to his audience. His satire, seen most notably in the much-acclaimed *Homer Price,* is felt to be gentle rather than offensive. McCloskey is one of those rare authors who has little negative criticism. Critics appreciate his books and so do children. Two generations of readers have already been reassured and entertained by McCloskey's books, which give every indication of enduring as favorites. McCloskey received the Caldecott Medal in 1942 for *Make Way for Ducklings,* a

Caldecott Honor Book award in 1949 for *Blueberries for Sal,* a *New York Herald Tribune* Children's Spring Book Festival Award in 1952 and a Caldecott Honor Book award in 1953 for *One Morning in Maine,* and a Caldecott Medal in 1958 for *Time of Wonder.* He was accorded the Regina Medal in 1974 for his body of work.

(See also *Something about the Author,* Vol. 2; *Contemporary Authors,* Vols. 9-12, rev. ed.; and *Dictionary of Literary Biography,* Vol. 22.)

GENERAL COMMENTARY

ANNE CARROLL MOORE

No need in the book world has been so urgently felt during the past year as that for books giving true impressions of the United States. Robert McCloskey made his first contribution (all unconsciously, I feel sure) to this rich field with *Lentil,* a lively boy who rouses a small mid-western town with his harmonica; spirited, vigorous, true-to-life drawings which have the quality of a well-endowed cartoon and emanate from an original mind.

In *Make Way for Ducklings* . . . Mr. McCloskey takes the city of Boston for his background and in a series of large lithograph drawings reveals his instinct for the beauty of wild life and that of the city and a sure knowledge of ducks and their ways. . . .

There are some very beautiful drawings in this book which are prophetic of future work in the picture book field. I can think of no more welcome gift to send overseas or to children who are guests of our country as interpreting its spirit of real hospitality. (p. 381)

*Anne Carroll Moore, "The Three Owl's Notebook,"
in* The Horn Book Magazine *(copyrighted, 1941,
renewed 1969, by The Horn Book, Inc., Boston),
Vol. XVII, No. 5, September-October, 1941, pp. 380-
82.**

PUBLISHERS WEEKLY

[*The following essay was written by Ruth Sawyer, who won the
Newbery Medal for* Roller Skates *in 1937. She is also the author
of* Journey Cake, Ho!, *which McCloskey illustrated in 1953.
McCloskey married her daughter, Margaret.*]

To have a children's book authentic is good. To have it full of unconscious, unstrained humor, of a delicious sense of immediacy, to have it with a wide-angled appeal to almost any age—this is good too. But then, to have pictures so fine in workmanship and so finished in reproduction speaks as much for the craftsman as for the artist. It marks a rare ability to carry picture ideas through from the first penciled sketch to the last printer's proof with meticulous care and painstaking labor. All these things are supremely good. That this ability has been clearly recognized by all who have known and delighted in Robert McCloskey's illustrations is evidenced by his winning the Caldecott Medal. It pays, I think, a double tribute: to Bob, himself, and to those librarians, critics, editors and booksellers who stand as staunch guardians of the best in children's books.

Fun simmers between the covers of **"Make Way for Ducklings,"** a gentle fun bringing all it holds to full flavor, never boiling over, never over-cooking, and thereby losing those precious ingredients that can so easily be destroyed by too much and too long pressure. Fun simmered always in Bob's outbursts of reporting on the progress of the book while he was at work on it—on Mr. and Mrs. Mallard's duck's-eye view of the Gardens and Louisburg Square, on boys pelting on bicycles, on rotund policemen, and on a duck's nose for peanuts. No one can turn out pictures and script for such a book as **"Ducklings"** without experiencing himself a simmering of fun in the everyday run of things, without knowing a kind of magic that brings him into good fellowship with ducks and boys and policemen, and the whole external world. (p. 2348)

Milton Glick, that master of the graphic arts at the Viking Press, who has worked with Robert McCloskey on both **"Lentil"** and **"Make Way for Ducklings,"** points out briefly but adequately those qualities which have made for Bob's success. "Of Bob McCloskey's many outstanding qualities as a person and an artist the most remarkable is his desire to prepare his work so that it will look as well in the reproduction as in the original. His innate integrity has always made him view a technical handicap as a challenge rather than as a problem he can pass on to the publisher or the printer to solve."

George Miksch Sutton, ornithologist at Cornell, spoke of this same integrity the first time he met Bob. Bob had gone into the laboratory to study ducks—mallards. He spent hours handling wings, comparing bills and feet, feeling the texture of feathers, and making innumerable sketches. "I liked to watch him," said Dr. Sutton, "he made such a thorough job of it. I wish all illustrators had that same sense of honesty in what they undertake to draw. We ornithologists like to see the birds which go into children's books drawn right. So often an illustrator is willing to make any kind of a bird, when it ought to be a wren, or a robin, or a tomtit. And if it is going to be a mallard it should look like a mallard and not a pintail or a puddle-duck."

"Lentil" . . . I rate as perfect an American boy classic as **"Huckleberry Finn."** It is as full of boy-humor, boy-attitude, boy-cocksureness. Lentil, like Huck and Tom Sawyer, never missed a town trick. Let anything new or extraordinary happen and they were in the thick of it. I venture there is as much of the young Bob in Lentil as there was of the young Sam in Huckleberry Finn and Tom Sawyer. I like to remember what a good time the youngsters of our mid-western and eastern states had the year **"Lentil"** came out and Bob traveled from school-house to library, playing and drawing for them! He plays the harmonica, plays it for children as though he were remembering his own boyhood. He knows how to reach boys and girls. He knows how to make them whoop and chuckle or experience the absolute stillness of great expectancy. This I believe to be the true test of one who can encompass, both in heart and spirit, the enchanted realm we call childhood. (p. 2349)

Always, no matter what he did, Bob knew his goal and he picked his lodestar to steer by. Those who know him well have no doubt as to his destination, nor do they question his reaching it. I, for one, hope that when the time comes when he can do the water-colors, etchings, portraits he longs to do, he will not forget the realm of childhood, to which he has so much to give and of which he is so definitely an honorary member. And I hope that every year or so there may come out another book, as fresh, as invigorating and as captivating as **"Make Way for Ducklings,"** which has brought him the Caldecott Medal. I make another wish, and a prophecy, that he will not lose the shy gentleness that runs as strong and as compelling in him as his integrity. It looses a quality, a sort of depth charge to all he does, that brings to the surface the best that he can do. This quality is in **"Lentil,"** in that unconquerable urge to play on something and make a tune. It is in the end of **"Make Way for Ducklings,"** the last picture, the one of Mr. Mallard, waiting, Mrs. Mallard and the eight ducklings sharply outlined against the soft dusk of a Boston twilight, as they streak across the lake. It speaks in those few last words:

"And when night falls they swim to their little island and go to sleep." (p. 2350)

*"Robert McCloskey: Good Craftsman and Fine Art-
ist," in* Publishers Weekly *(reprinted from the June
27, 1942 issue of* Publishers Weekly, *published by
R. R. Bowker Company; copyright © 1942 by R. R.
Bowker Company), Vol. CXLI, No. 26, June 27,
1942, pp. 2348-50.*

MAY HILL ARBUTHNOT

One of the truest and most amusing commentaries on the modern child is a picture in *Homer Price,* the first in the chapter called **"The Case of the Cosmic Comic"**. . . . It is a drugstore scene. The "soda jerker" is wiping glasses; Homer is inhaling a coke through a straw; another boy is lost in the pages of the "Super-Duper" comic magazine, while a small child sits on his heels in front of a rack of comics. He is luxuriously licking an ice-cream cone as he broods lovingly over "Crime Does Not Pay," "Marvelous Men of Mars," "General Brave," and "Super-Duper," in endless poses of power and action. Here is the modern American scene as every one of us knows it, with not a detail missing, even to the cylinder of straws and the twisted-metal drugstore chairs. But the picture is more than

photographic; it is an interpretation of what a child is up to today—his odd credulity, his absorption in this new streamlined magic of the comics.

This is one of the first stories to spoof the comics and their devotees unmercifully and with hilarious results. (p. 378)

Homer Price shows that Robert McCloskey is not only an artist with a rare gift for humor and interpretative details but a writer who knows today's children. Whether Homer is following a **"Sensational Scent,"** part skunk and part robbers, or assisting with a doughnut machine that can't be stopped, or joining in a pageant celebrating the new prefabricated allotment to the town, the tales and the pictures are caustically amusing. Some of these yarns are a shade too extravagant and too incredible, but the annals of Centerburg have an astringent humor and they give promise of better tales to come. Boys are wearing this book ragged.

Children eight to twelve like *Homer Price,* and all ages enjoy *Lentil,* which is a juvenile *Main Street.* It is chiefly big pictures of a small town, with a slight tale centered on Lentil's inability to sing and on his consequent devotion to playing the harmonica. Every picture is a gem. You find yourself absorbed in the details: Lentil practicing in the bathtub, the familiar architecture of the small town, the exalted Soldiers and Sailors Monument with the squirrels beneath looking scandalized at Lentil's tootling—these and innumerable other little touches keep you looking and looking again.

Robert McCloskey's stories and pictures are outstanding in this too meager field of humorous realism. (p. 379)

> May Hill Arbuthnot, "Here and Now," in her Children and Books (copyright, 1947, renewed 1974, by Scott, Foresman and Company; reprinted by permission), Scott, Foresman, 1947, pp. 360-95.*

MARY HARBAGE

The talents which Robert McCloskey possesses are indubitably many. You need turn only a few pages in any one of his books to start thinking, "Artist," "Writer," "Humorist." (p. 251)

Whether Robert McCloskey in 1942 wanted to become known primarily as an outstanding author-illustrator of children's books makes little difference now. He certainly has achieved that position. Any individual who has received the Caldecott Medal once and has been *the* runner-up a little over a decade later can't help being recognized as one of the best of the children's illustrators.

An author who has among his satisfied following both the kindergarten-primary set as well as the middle grade group is most assuredly a writer with a sure touch for children. And of course being an author-illustrator requires a special blending of much creativity.

But it is not only the boys and girls who recognize his talents, for as you read the reviews and materials on his works in books about children's literature you are consistently pleased with the aptness of such descriptive phrases as—"bubbling glee," "full delicious flavor," "living out these rich and hilarious dilemmas with solemn devastating humor," "American comic genius in top form," "satire warm and genial and tolerant," "earnest young man," "shrewd and witty recording of familiar scenes" and, "a serious artist." (p. 252)

[In *Blueberries for Sal,* the little girl and her mother] are so well drawn in word and line by the author that you feel they must belong to him. And—by this time you expect McCloskey

to use his own world with the realities of every day living as the taking off spot for delightful tales. Another book (*One Morning in Maine*), and your assumptions are confirmed, for here is a taller, more mature Homer Price (it's the hair and the grin that give him away), with not only the same little girl and the same mother but now there is a small sister, Jane, joyously dancing her way into the book, trailing her nightie behind her. With such a growing family it is safe to say Robert McCloskey will never run out of situations as starters for stories. (p. 254)

In a way the teacher is fortunate who has not already introduced Robert McCloskey's books to her boys and girls . . . it is such a rewarding kind of fun. . . .

Part of the boys' and girls' delight in Homer was that he was just like them in so many ways—but unlike them he had the most astounding, flabbergasting, absurd adventures. You just couldn't tell what might happen next.

Children need lots of adventure and laughter and in *Homer Price* the chuckles start on the second page when he names his pet skunk, "Aroma." (p. 255)

Grownups are always getting so satisfyingly confused in the book. For instance, they identify the much bewhiskered stranger who comes to town as a modern Rip Van Winkle—even after he offers to use his musical-auto-contraption to rid the town of rats. It is Homer who sees that cotton is carefully put in each child's ears as a safeguard before they all start out to follow the rat catchers.

Usually I could manage to read the adventures of Homer Price in the solemn and serious way most appropriate to McCloskey's kind of humor. Always my efforts collapsed when it came to the part describing the pageant to celebrate one hundred and fifty years of progress in Centerburg. . . .

McCloskey's books have to be kept on the library table between readings—the pictures need to be savored slowly. The one of Homer's room delights many a boy whose mother may be a too fastidious housekeeper, the doughnut one is simply hilarious and many is the child who has traced the intricacies of the "musical mouse trap" right from the spot where it says "Watch Your Step" to the little door high above which is labeled "Enter Friend." (p. 256)

It is really just as much fun to introduce McCloskey's books to the younger set as to their older brothers and sisters. I took my first group of six year olds through *Make Way for Ducklings* and enjoyed with them the solutions to Mrs. Mallard's problems. . . . (p. 257)

But the most fun came as I appeared one Monday with a shiny new book in hand. Long before story time came, the secret was out—it was a new McCloskey book [*Blueberries for Sal*]. . . . Never have I known a more satisfying story for children. The parallel characters of Mother and Sal, Mother and Baby Bear, the rhythm and repetition of the text, the oneness of pictures and story—they made it a perfect read aloud time. (p. 258)

One Morning in Maine is just as satisfying, I'm sure, even though I haven't any first grade to help me discover just how and where.

Just as McCloskey didn't forget how young blueberry pickers are often tempted to become blueberry eaters, in this latest book he didn't forget about wishes to be made on first loose teeth . . . or little girls who ask many questions or the way in

which detail in pictures is beloved by those young readers who mostly "read" the illustrations.

The younger children will delight in the way Sal half tells her tooth-wish and then manages to keep it a secret—for a bit. They, too, will be unhappy when the tooth is lost—can wishes be made on *lost* teeth? Are dropped-out sea gull feathers good for making wishes? And what about worn-out spark plugs from an engine's motor? The way Sal fixes things up not only for herself but also for Baby Jane—who far from having all her baby teeth yet is still further from losing any—makes a solidly satisfying story.

There will be much joy shared in the big-sisterly attitude of Sal. Speaking of Jane, she says concerning an ice cream cone, "Hers is supposed to be vanilla so the drips won't spot." The children who need to know more about a happy kind of family living, that they respond to the people who understand them, that they have plenty of room in their lives for the fabulously fanciful as well as the every day factual, and that they need artists and authors who give of their best and don't "draw and write down" to them, then that long will he hold his enviable place among his peers—an author-illustrator whose old books are well beloved and fully savored and whose new ones are anticipated with delight—by teachers, librarians, parents, and their many, many children. (p. 259)

> Mary Harbage, "Robert McCloskey, He Doesn't Forget" (copyright © 1954 by the National Council of Teachers of English; reprinted by permission of the publisher and the author), in Elementary English, Vol. XXXI, No. 5, May, 1954, pp. 251-59.

MAY MASSEE

Lentil is a perfect picture of a Middle West small town. . . . Lentil, playing his harmonica on the way to school, of course is Bob. All of Bob's stories will be emanations of experience bubbling over into fiction that shows such acute observation, such humor and understanding, that there's more truth than fiction in it. . . .

Since **Make Way for Ducklings** we have received many newspaper clippings from cities in this country and abroad that tell of traffic being stopped to let a mother duck and her trail of ducklings cross in safety, but only Robert McCloskey could combine that happening with the story and beautiful pictures of the Mallards surveying Boston from the air to find the right place by the Charles River for a nest, the eggs, the ducklings and their safe journey to the Public Gardens and the swan boats, carefully watched by a true Irish policeman and numerous delighted citizens of Boston. (p. 3)

[Sixteen years later] we have three books that grew from the summers in Maine and naturally center around the children and their life there.

Blueberries for Sal was the first one. . . . How the children love the page where "Little Bear and Little Sal's mother and Little Sal and Little Bear's mother were all mixed up with each other among the blueberries on Blueberry Hill." It's a perfect funny book for three, four, five year olds. They see themselves as Little Sal and it's a huge joke getting mixed up with Little Bear. Meanwhile, they are unconsciously learning to "read" the pictures and to cultivate a respect for the excellent line drawings which not only tell the story but give a feeling of this country.

In **One Morning in Maine,** . . . Jane has joined the family and is toddling around between two and three years old. Sally is losing her first tooth. This is a family story, Mother giving children breakfast, collecting the empty milk bottles, comforting the bereft Sally and sending her out on the beach to help her father who is digging clams and will presently take the two children to town in their motor boat, which he'll have to row because a spark plug has worn out. Every page in that story establishes the delightful family relations, the imagination of a bright child, her sense of kinship with any animal or bird she meets—seal, gull, fish hawk, even clams. Everything that happens is pictured in vivid, lively drawings that perfectly satisfy a child's desire for "true" while the grown-up looking on can see the great beauty in some, the homely reality in others, the tender and amused sympathy of her father for Sally, the good natured fooling of the characters in the garage and the store. You can almost hear the artist's chuckle as he adds some bit of local color, adds another picture of Jane's activities, always, somehow, in the picture even if not of it. Child and grown-up are thoroughly entertained and ready to "read it again."

Time of Wonder has all the gaiety and spontaneity of the other two but the children are older now and their experience and appreciation have widened and ripened.

The book has everything that children and grownups love about the sea, the shore, and the quiet forests beyond—storm clouds piling up behind a rugged coast, rain-rings on the surface of a many-islanded sea, fiddleheads unfurling in a misty wood, bright boats in small, busy harbors. Like the children in the book, exploring the tops of giant trees felled by the hurricane, you too will walk where no one ever walked before.

In the first two of the trio Robert McCloskey had shown their island in Maine, its hills and its dales, the family and their home, their way of living, and the beauty of it all in black and white. Now he wanted to show it all in color. He wanted to paint the pictures for this book and paint them he did, though it took him three years of work to approach what he wanted— three years of painting and discarding and painting again. And even when the proofs came back from the printers, he said as he approved them, "There are some that I'd like to do over again."

The children who pore over the beautifully colored pictures and read the text will be very subtly taught to love and wonder at the world they live in and to appreciate the privilege of living in it. This, surely, is the best that we can give to children, and Robert McCloskey has well earned the Caldecott medal for the second time. . . . (pp. 4, 8)

> May Massee, "Robert McCloskey—Wins Second Caldecott Medal," in Junior Libraries, an appendix to Library Journal (reprinted from the April 15, 1958 issue of Junior Libraries, published by R. R. Bowker Co./A Xerox Corporation; copyright © 1958), Vol. 4, No. 8, April 15, 1958, pp. 3-4, 8.

MARGUERITE P. ARCHER

After fifteen years of almost undiminished popularity, Homer Price is becoming a classic hero to American children. (p. 287)

[The Homer Price books] are notable for their excellent illustrations. In an autobiographical sketch McCloskey wrote with tongue in cheek, "It is just sort of an accident that I write books. I really think up stories in pictures and just fill in between the pictures with a sentence or a paragraph or a few pages of words." Though the statement is an oversimplification when one considers the amount of work that obviously is ex-

pended on all of the McCloskey books, there is, indeed, more truth than fiction to this explanation of his method.

By examining McCloskey's picture-story books, one can readily see that the author-artist has done as he says and done it with pre-eminent success. (p. 289)

In addition to being an artist, McCloskey is a keen observer of human nature and of community life. While his picture-story books are based on the family life of father McCloskey, three other books of his are based on his own boyhood in Hamilton, Ohio. . . . From juvenile experiences, both personal and vicarious, he must have derived the wonderful flavor of *Lentil, Homer Price,* and *Centerburg Tales.* (pp. 290-91)

In *Lentil* we sense a small town band's importance to the community. Lentil himself is a boy preoccupied with learning to play the harmonica. The eight-year-old identifying himself with Lentil experiences a musical success story. Lentil is a boy who can neither sing nor whistle, but it is he who saves the day when the village band is unable to play a welcome for the homecoming of the town's first citizen. Lentil seems quite real to the child reader. . . .

Both Lentil and the town of Alto, Ohio (circa 1912) seem completely authentic. Every detail counts as the boy, the town and its people are so masterfully caricatured. *Lentil* is a picture-story book consisting mainly of wonderfully humorous charcoal drawings. . . . *Lentil* can well serve to introduce the young reader to the more maturely humorous side of Robert McCloskey. Having enjoyed *Lentil* in about the third grade, he is receptive to Homer in fourth or fifth grade. A few youngsters read about Homer in fourth grade; the majority of his fans are fifth-graders, and many youngsters "discover" him in sixth grade or later. (p. 291)

[The] reader soon realizes that extraordinary things happen to this boy. From the moment that Homer discovers a skunk is drinking the saucer of milk intended for Tabby, the reader knows that there will be lots of excitement. And there certainly is! One thing leads to another until Homer and his skunk, Aroma, catch some robbers.

Homer Price consists of six incidents in the adventurous life of the hero. The universal favorite among his adventures concerns **"The Doughnuts."** When his Uncle Ulysses' doughnut machine just won't stop making doughnuts, the situation gets worse and worse until Homer finally thinks of a plan to sell most of them. Meanwhile the reader has had a wonderful time. Even though *Homer Price* is a collection of illustrated stories, each one follows the declared McCloskey pattern of a story in pictures filled in with a few pages of words. The reader sees the action of the stories in one hilarious picture after another in his own mind as events go rollicking along. There is nothing vague about either Homer or the incidents in which he becomes involved. Both text and pictures stress the main action, delineate the characters, and round out the tales with effective and humorous detail. The stories in *Homer Price* are obviously fictional, but the enthralled reader has a feeling that they *could* be true (maybe).

Little mention is made of Homer's parents, but a number of characters besides Homer are well-drawn (both in pictures and text). The reader becomes well acquainted with the people that interest Homer—his uncle Ulysses, who runs a lunch room over in Centerburg and loves labor-saving devices; the town sheriff, who spends his time playing checkers and talking in a mixed-up way delightful to children; string-saving Uncle

Telly; a sandwich man passing through town; the bewhiskered stranger who turns out to be a modern Pied Piper (thwarted by Homer's precautions); and the self-centered thorn in the town's side, Dulcy Dooner. A child can learn a lot about human nature while reading *Homer Price.* He can also gain some perspective on small-town life through appreciation of McCloskey's satire. A community project has never been more thoroughly lampooned than has Centerburg's Pageant for "One Hundred and Fifty Years of Centerburg Progress Week."

Like McCloskey's boyhood interest in music, his juvenile ambition to be an inventor is also evident in *Homer Price.* Homer, too, is fascinated by machinery, and this fascination strikes a responsive chord in many young readers. Like many boys Homer is always "making something." In addition, some of the action centers around machines. These range from Homer's private elevator for Aroma to the bearded stranger's pickup-truck-sized musical mousetrap (that won't hurt the mice). The dilemma of modern man overwhelmed by the results of mechanization is depicted in **"Wheels of Progress,"** in which the mass erection of one hundred identically and completely pre-fabricated houses leaves the tenants frantically bewildered.

Centerburg Tales continues the saga of *Homer Price,* but the element of fantasy is much more marked. Although all of the tales in *Homer Price* (except for the one about the modern Pied Piper) might *possibly* have happened, the stories in *Centerburg Tales* simply could not be true. The fact that they are too tall to be true does not spoil the fun.

Half of the book revolves around Homer's Grandpa Hercules, a yarn-spinner beloved by all the children of Centerburg. In his stories the old man has Herculean strength and he makes himself the subject of many legends. Occasionally the men in Uncle Ulysses' lunch room doubt Grampa's veracity. (pp. 292-93)

When Grampa Herc is put "on the spot" by the men, it is Homer and his contemporaries who help him save face. They know how far the old man stretches the truth, but they certainly don't want him to stop doing it. (p. 293)

One of the unusual characteristics of Robert McCloskey as a children's author is that he does not "tell it all." Sometimes he hints and lets the reader guess what happened, especially in **"Mystery Yarn"** [in *Homer Price*]. This story concerns a contest between Homer's Uncle Telemachus and the sheriff for the hand of Miss Terwilliger, the town's knitting teacher, who has kept both of them spellbound for years with her delicious dinners. Miss T. enters the contest herself and—by subterfuge—manages to win; then she chooses Telly for her husband. The story may have been at least partially inspired by the Greek legend that Telemachus eventually wed the sorceress Circe, who worked at a loom and bewitched her male guests with drugged food and drink.

Another interesting feature which some children would note involves the illustrations. In **"The Case of the Sensational Scent"** the story concerns four robbers, but five are pictured in one bed. Here is an instance in which the author-illustrator is having his little joke with the serious-minded reader. In another story, when Grampa Hercules has lined up a flock of children at Uncle Ulysses' lunch counter to eat doughnuts and hear a yarn, little Sal is pictured (on the extreme left next to Homer) reaching for her doughnut. Later there are rear views of Sal. Such touches as these are likely to puzzle and then please observant children.

The frontispiece of *Centerburg Tales* features busts of the Greek Homer and of Mark Twain which are being mimicked by Homer Price and Freddy. The bust of Homer seems blind to the boys' activity. This indifference is doubly appropriate as the ancient Greek storyteller was in no position to object to anyone's aping of the tall tale aspects of Homeric legends. Twain, however, was very much interested in boys, and his bust seems to be eyeing the two youngsters with a slightly worried look of interest.

Aside from the fact that the last of the Centerburg tales is connected with a yarn of Twain's, there are some other relationships between Mark Twain's work and Robert McCloskey's. The exploit of Hopper McThud, Grampa Hercules' partner in **"Looking for Gold,"** reminds the reader of "The Jumping Frog of Calaveras County." It is not heresy to note that these two tales are very similar in character. Surely Twain would have been amused at this adaptation of his idea since he himself wrote a "Private History of the 'Jumping Frog' Story" in which he compares it to an old Greek tale of "The Athenian and the Frog." It might be highly interesting for some high school students to read McCloskey's story before reading Twain's. Difficult to read, Twain's story might become much more comprehensible after preliminary reading of **"Looking for Gold."**

Similarly, the children who enjoy reading about Henry Huggins and Homer Price in the intermediate grades would have a good background for appreciating *The Adventures of Tom Sawyer* in eighth or ninth grade. (pp. 294-95)

Marguerite P. Archer, "Robert McCloskey, Student of Human Nature," in Elementary English *(copyright © 1958 by the National Council of Teachers of English; reprinted by permission of the publisher), Vol. XXXV, No. 5, May, 1958, pp. 287-96.*

DORA V. SMITH

It is amazing, as one looks back, how in spite of the war, "reading as usual" was not forgotten. Robert McCloskey came forth with two "real boys" who gave both boys and girls a good laugh. *Lentil* . . . , however, is much more than a funny book. Its picture of the return of "the politician" from Washington and how Lentil saved the day with his harmonica is as authentic Americana as it is good humor. *Homer Price* . . . , who jumped from one predicament into another always to come out on top, is as real a boy as our country has produced. He needs no advertising—mere mention of his name produces a grin. (p. 51)

[*Make Way for Ducklings*] has given a new distinction to the Hub of the Universe. Families from all over the country visit Boston annually to spot the place where the ducklings had their nest. The author's insight into the care of the mother duck for her brood, the meticulous attention he gave to drawing each individual duck as it appears from picture to picture, the background of Boston Gardens as seen through the eyes of a duck, and above all, the duck's-eye view of the Irish policeman, who dominates the scene—all show the humor, the knowledge of children, and the care for infinite detail which place this story among the indispensable classics of childhood. The glee of the children knows no bounds when the proud mother and her none-too-steady little ones walk calmly across Charles Street, while all the traffic of Boston waits. *Blueberries for Sal* . . . with its exchange of mothers by Sal and the baby bear is particularly popular with children of the north woods, who know the incident could have happened. (p. 56)

Dora V. Smith, "Children's Books in World War II and Beyond—1940-1949," in her Fifty Years of Children's Books 1910-1960: Trends, Backgrounds, Influences *(copyright 1963 National Council of Teachers of English; reprinted by permission of the publisher and the author), National Council of Teachers of English, 1963, pp. 48-61.*

HELEN W. PAINTER

For many years children and adults have been calling for more from Robert McCloskey, one of the great figures in literature for children today. The fact that he has twice won the Caldecott Award for distinguished illustrations . . . attests to his artistic skill, which in workmanship and quality is extensive. But in both pictures and writing McCloskey has brought a gentle humor, what Ruth Sawyer calls "a simmering of fun in the everyday run of things" [see excerpt above]. This quality, plus the ability to portray facets of ordinary but real living which are familiar to all of us, creates a kind of magnet that draws us together. . . . Perhaps seldom has an individual in his representation of reality verging on the comic made greater use of his own background and personal characteristics in his work than has Robert McCloskey. (p. 145)

Surely the lesson on art which May Massee taught him long ago has never been forgotten in its emphasis upon his portraying what he knows best. Whether it is a boy, an invention, a musical instrument, the loss of a child's tooth, or an island, McCloskey writes from his own life with the authenticity, humor, and exaggeration that form his days and his zest for living. (p. 148)

Critics hailed *Lentil* as a boy classic, as a piece of authentic Americana, and as a book of appeal for all ages. Arbuthnot called it a "juvenile *Main Street*" [see excerpt above]. Readers seem to agree. Large-scale pictures look exactly right, with girls jumping rope, boys playing marbles, dogs slinking away from Lentil's squawks, birds laughing at his sounds, and a train crossing the bridge into town. All details, even to the wrinkled rug in the bathroom, are homespun and natural. Humor shines from the pages. . . .

[*Make Way for Ducklings*] is done in the same rich sepia toning as *Lentil,* with the drawings bleeding off the pages. . . . There are no small pictures. Each of the thirty-one is a large double-spread. To the person who knows, here *is* Boston: the State House, Louisburg Square, Beacon Hill, the Public Gardens' entrance, statues, the bridge over the pond, swanboats, the island—all present in authentic detail. The magnificent pictures of ducks and ducklings portray characterization and feathers to an exact degree. Even the uncritical observer would recognize the excellence of illustrations which made this work a true Caldecott winner. . . . (p. 149)

Homer is one of the best known of present-day book children who are earnest youngsters caught in ludicrous situations. . . . Perhaps one key to the popularity is that boys can identify well with friendly, ingenious Homer, who, like Lentil, in physical reality looks much like his creator. (pp. 151-52)

Perhaps children can meet themselves in each of the six tales, which afford some gay satire and some exaggeration. The writing is easy and flowing. . . . It is a book for older children, for teachers to read aloud or, even better, to tell. Just be sure to keep the inimitable McCloskey wording. . . . (p. 152)

It would be impossible to leave a discussion of *Homer Price* without referring to an explanation of McCloskey about the

"number of robbers that are in that bed," when Homer and Aroma make their sensational capture.

> I get letters and more questions about that because I put in this Homer story five robbers in the bed when I had only four in the story. Well, it's all a matter of miscounting. I was doing this story right when I was being inducted into the army. I don't know whether you know but in every book every square inch of space is counted. . . . I don't know who goofed . . . but suddenly they had this blank space right in the center of this story, and they wanted a picture in there so it didn't look empty. So here I was with the army breathing down my neck and they said, "Please make this picture," which I proceeded to do. That's how five men got in there instead of the four. It's a simple matter of bad arithmetic, starting with the design of the book.

When McCloskey wrote further adventures of Homer in *Centerburg Tales* . . . , laughter again poured forth, as in the gravitty-bitties episode (a spoof on cereal-box prizes) and in the story of the schoolteacher and the automatic juke box. Grampa Hercules adds some intriguing tall tales. There is a tug at the heart, though, in the kindness of the children who go to great lengths to make everything right, after the townspeople have ridiculed the old storyteller who got carried away with his yarn.

Except for *Centerburg Tales,* McCloskey's next three publications depicted his family and their summers in Maine. . . . The first such book was *Blueberries for Sal.* . . . The writing and the pictures give no hint of danger except to say that "she was old enough to be shy" when telling of Little Bear's mother and of Little Sal's mother. Young children adore the story and read the large pictures easily. The excellent line drawings and even the print are done in the deep color of blueberries. (pp. 153-54)

[*One Morning in Maine* is] a warm family story which also is full of homey details and affection. There are pictures of Sal squeezing toothpaste on Jane's brush, Sal patting the dog as mother explains that a loose tooth means that she has become a big girl, Jane peering from her high chair at the cat drinking spilled milk, Sal telling animals and birds about her tooth and then getting her father to help look for it in the mud where they had dug clams, McCloskey rowing to the store because the outboard motor would not start, and the storekeeper giving a vanilla ice cream cone to Jane "so the drips won't spot." Beautiful dark blue double-page spreads give a reader a feeling of the island, the water, and the coast in a most impressionable way. The family, of course, is real, as are the English setter, Penny, and the black cat, Mozzarella. The village is the actual one to which the McCloskeys go for supplies. (p. 154)

[*Time of Wonder* is a] slight but rhythmic story . . . of the beauty of the island during changes of season and tide, and of the coming of the storm. . . . A safe, familiar world meets the hurricane but with the security of close family relationships. Children can see beauty in the paintings. The forest quiet with the sound of growing ferns, the soft greens of slowly unfurling fiddleheads, the spreading rain-rings on water, the ghostly gray and yellow fog, the bright stars and their reflections, the lighted window as the dark winds of the hurricane close in on house and forest—all are effective representations to show nature. Here a child reads about real things. . . . (pp. 154-55)

Sal and Jane are a little older and thus the book is for the older child, but the splendid pictures and poetic prose are for children of all ages. (p. 155)

[*Burt Dow: Deep-Water Man*] is a tall tale in bold and lavish color. Burt Dow pulls a Jonah-act when a whale gives him refuge in a storm, because the old fisherman had done the whale a favor by putting a peppermint-striped band-aid over the hole in its tail where a cod hook had snagged it. The typical McCloskey humor shows in many places besides the unrealistic plot, as in the name of the dory, the *Tidely-Idley;* the giggling gull, whose tittering and teetering are extremely expressive; in the paint on the boat planks, identifiable as the leftover pink from Ginny Poor's pantry or the tan trim from Capt'n Haskell's house; and in the old-fashioned pitcher pump in the boat for bailing out the water. Similarly humor appears in the text as, when the whale said, "Ah-H-H!" in the classic tradition, Burt set the throttle and guided the *Tidely-Idley* into the whale's mouth and "navigated the length of the gullet and into the whale's tummy, without so much as touching a tonsil on the way down!" In fact, the frontispiece truly establishes the tone of exaggerated nonsense for the whole book, for it shows the giggling gull mischievously making webbed tracks through pink paint spilling from an overturned bucket.

The story is a Maine tale. McCloskey has explained that Burt is a real person, a retired deep-water man or one who has sailed vessels all over the world. The book was planned almost entirely before pencil was put to paper and, while the first drawing was changed, the "text read almost exactly as it did in my first draft." (pp. 155-56)

McCloskey's imagination, industry, and integrity have been the subject of many critical comments. McCloskey himself says that "no effort is too great to find out as much as possible about the things you know you are drawing. It's a good feeling to be able to put down a line and know that it is right" [see excerpt below].

Perhaps it is this feeling which somehow is communicated to children that satisfies their desire for things to be true. Perhaps, too, it is this careful workmanship which has made him a thorough but rather slow producer. . . . Though people in television and other media have approached him, he cannot "write to order." He mentions that he had a letter asking him to rewrite *Homer Price* with a limited vocabulary, with Uncle Ulysses being made Uncle Jim, for example. "I don't approve of writing or drawing down to children. Leave *Homer* as it is."

Exactly how does he work, anyway? All of his books start as pictures, he says, and with an idea inside his head.

> I think in pictures. All of my training has been as an artist. I don't know anything about children's literature or I've never taken any courses in writing. I fill in between pictures with words. My first book I wrote in order to have something to illustrate.

Cutting, adding, pasting, he comes up with a "bundle of scraps" of words and sketches, but, while the preliminary material may not look like much, he "has captured an idea." Then he works on pictures and writing.

> I used up some four boxes of pencils just making preliminary roughs for *Burt Dow.* There are sometimes as many as twenty or thirty drawings before I turn out the one you see in the book— not completed drawings, of course, but just

IT'S RAINING ON *YOU!*

From Time of Wonder, *written and illustrated by Robert McCloskey. The Viking Press, 1957. Copyright © 1957 by Robert McCloskey. Reprinted by permission of Viking Penguin Inc.*

finding out and exploring the best possible way of presenting this particular picture.

Usually it takes about two years from the time he first starts writing the story until it ends as a finished book. (pp. 156-57)

In emphasizing the importance of drawing and its relationship to his work, McCloskey speaks clearly in [the film] *The Lively Art of Picture Books.* . . .

> [Hands] play a part in drawing but it's an automatic part like shuffling cards or knitting. Drawing is most of all a way of seeing and thinking. Let me explain. Drawing a tree you must think of the relationship and proportion of twigs to branches, to trunk, even the roots that you do not see; and you must feel the balance and thrust of this growing thing and its relationship to other trees, a rock, the ocean.
>
> Your hand is trained, of course, . . . but your mind is ticking away like mad. It's racing and comparing and thinking a thousand things that no one will ever see in the picture, but the picture will be different for your having thought of them.
>
> (p. 157)

Most of my friends and neighbors just don't seem to see as I do, even looking at simple things like a ball of string. . . . But I'm not a nut, really, as anybody can see. I have one foot resting on reality and the other foot planted firmly on a banana peel.

Finally, though he speaks with the splendid and unconscious humor that pervades his living and his work, McCloskey feels very serious about the place of drawing and design in the education of children. In his second Acceptance Speech for the Caldecott Award, he pleaded for the teaching of design so that children can come to appreciate art in a land "fast acquiring an environment of machines, by machines, for machines." He wanted children to be helped "really to see and evaluate" their surroundings. He spoke of such elements as repetition, rhythm, color, texture, form, and space relationships affecting our lives and urged that we put design to work in creating beauty.

While in other writing and pictures, McCloskey has shown "Progress" and machines, perhaps he has expressed himself no more splendidly about them than in the modern housing episode in *Homer Price*. However, he does not leave us discouraged; the satire becomes almost kind. . . .

So here we have an added dimension to Robert McCloskey, a gifted man with spirited, unforgettable pictures; with control

of line ranging from soft, quiet beauty to genial exaggeration; with rare ability for humor and the interpretation through realistic details, of which children never tire; and with the "feel" of America permeating all his production. (p. 158)

Helen W. Painter, "Robert McCloskey: Master of Humorous Realism" (copyright © 1968 by the National Council of Teachers of English; reprinted by permission of the publisher and the author), in Elementary English, Vol. XLV, No. 2, February, 1968, pp. 145-58.

CHARLOTTE S. HUCK AND DORIS YOUNG KUHN

In a perfection of words and watercolors, Robert McCloskey has captured the changing mood of the Maine coast in his *Time of Wonder*. Using soft grays and yellow, he has conveyed the warmth and mystery of the early morning fog in the woods. His ocean storm scene, on the other hand, is slashed with streaks of dark blues and emerald greens, highlighted by churning whites. The text is no longer quiet and poetic, but races along with "the sharp choppy waves and slamming rain." The storm subsides, the summer ends, and it is time to leave the island. The beauty of this book will not reach all children; but it will speak forever to young and old alike who have ever intensely loved a particular place on this earth. Words and pictures so complement each other that the reader is filled with quiet wonder and nostalgia when he sees the family's boat slip into the sunset and reads the poetic prose [ending]. (p. 112)

Robert McCloskey has caught the excitement of every-day living in his wonderful book, *One Morning in Maine*. . . . This is a joyous story that should be shared with five- and six-year-olds who may be losing more teeth than Sal. (p. 128)

[*Make Way for Ducklings*] has become a classic for primary children. No child worries about the vintage of the cars in this story, for he is too concerned with the safety of Mrs. Mallard and her ducklings in the bustle of Boston traffic. (p. 134)

Probably the classic of modern humorous stories is McCloskey's *Homer Price*. The six chapters of this book present extravagant yarns about life in Centerburg as aided and abetted by Homer and his friends. . . . **"The Case of the Cosmic Comic"** is pure satire, on the child's level, however. Probably the favorite Homer Price story is that of the doughnuts. . . . The story of *Lentil* by McCloskey is really a picture story book for all ages. . . . [The stories] are told in the American tradition of the tall tale. Homer Price has almost become the legendary hero of all modern American boys. (p. 375)

Charlotte S. Huck and Doris Young Kuhn, "Picture Books" and "Modern Fantasy and Humor," in their Children's Literature in the Elementary School *(copyright © 1961, 1968 by Holt, Rinehart and Winston, Inc.; reprinted by permission of Holt, Rinehart and Winston, Publishers, CBS College Publishing), second edition, Holt, Rinehart and Winston, 1968, pp. 95-155, 331-84.**

NORAH SMARIDGE

To get their full flavor, the books of Robert McCloskey should be read at just the right age. *Make Way for Ducklings*, for instance, is the picture book par excellence for reading in the first and second grades. No other age group would be so concerned about Mrs. Mallard and her ducklings as they brave the Boston traffic. And how these small children would enjoy hearing that the author kept six ducklings in the bathtub of his New York City apartment while he made sketches! How absurd they would find the idea—and how they would love it!

Homer Price, too, is best appreciated by boys and girls at a special stage, the stage that relishes tall tales and wild exaggeration. The innocently outrageous Homer does things which they would give a lot to do themselves. (p. 106)

Even the most exaggerated [of McCloskey's eight books] have the ring of truth, and are rich in his humor and love of life. (p. 107)

[*One Morning in Maine* is] a tragi-comic experience with which young readers quickly identify. The whole family appears in the story, and the understanding of the parents is warmly sensed. (p. 110)

[In *Time of Wonder,* the] rhythmic text and softly colored pictures wander over the landscape of Mr. McCloskey's island, impressing young readers with the beauty of land, sky, and water, and acquainting them with its people, animals, and plants. The weather plays an important part, changing mood and scene as the fog lifts, the hurricane blows, or winter winds grip the island. In this book, for the first time, McCloskey uses deep water colors; he aims, not at realism, but at conveying an atmosphere of quiet and mystery. (pp. 110-11)

With Homer Price well on his way to becoming the legendary hero of all-American boys, McCloskey wrote a second book of his adventures in *Centerburg Tales*. . . . Here again is small-town life, real but magnified and highly colored, as lived by Homer and his friends. Together, *Homer Price* and *Centerburg Tales* form what is probably the classic among modern humorous stories.

In 1963, McCloskey brought out the last of his Maine tales, *Burt Dow: Deep-Water Man*. The bold, richly colored pictures are full of movement and wild humor. . . . The tallest of sea stories, this one is happily preposterous, the more so because the author-illustrator tells us that Burt is a real person who once sailed vessels around the globe. (pp. 111-12)

Children, for the most part, relish funny stories. They love pure nonsense. They like to laugh. And today, in a land "fast acquiring an environment of machines, by machines, for machines," that laughter has become a very special need. Robert McCloskey, with his special brand of humorous realism, is filling that need. (p. 112)

Norah Smaridge, "Robert McCloskey," in her Famous Author-Illustrators for Young People *(copyright © 1973 by Norah Smaridge; reprinted by permission of Dodd, Mead and Company, Inc.), Dodd, Mead, 1973, pp. 106-12.*

ANNIS DUFF

My first meeting with Robert McCloskey was rather like renewing acquaintance with someone I had known when he was a boy. For it was in the person of Lentil that I had met him years before, happily in company with my eight-year-old daughter. Together we had enjoyed the adventures of that insouciant youngster who played his harmonica in the bathtub and with fine resourcefulness thwarted Old Sneep's attempt to sabotage the mayor's grand welcome to Col. Carter.

Then there was *Homer Price,* again the solemnly enterprising boy who could have been Robert McCloskey himself, given the same circumstances and the same society of characters. He became our family friend, as real as any of the boys we knew and a good bit more alive than some.

Blueberries For Sal, with setting and occupation so precisely like those of our island summers, made as direct an appeal as

a letter from a like-minded friend—except that none of our friends, gifted as many of them are, could have drawn those superb pictures! . . .

Robert and I met in New York, when I had become an editor of children's books at The Viking Press, and was one day delegated to be his hostess at lunch. (p. 382)

One thing I learned about him that day is that it's almost impossible to be with him in any circumstances without laughing, for he has not only an engaging sense of fun, but the kind of philosophical humor that appreciates the absurdities and the rueful comedy of the human condition in general and his own involvement in it.

But I learned a good deal more than that. I began to understand what it is that gives his books such warmth and wisdom and durability. Later on, describing my impression of him, I said he was one of the *goodest* people I had ever encountered. And through the years since, as his work has grown in stature and our friendship has deepened, that impression has never altered. His artistic gifts are without question of a very high order; and his gifts as a writer have an astonishing range, from the affectionate simplicity of *Make Way For Ducklings, Blueberries For Sal* and *One Morning in Maine,* through the inspired drollery of *Lentil* and *Homer* and the joyous spoofing of *Burt Dow,* to the majestic, yet touching, beauty of *Time of Wonder.* But it is in the way he uses these gifts that his great strength lies.

Every one of his books is an honest expression of Robert McCloskey as a person. Never once has he been willing to allow the publication of anything, however much work and thought he may have put into it, that does not in the end command his own belief in its rightness. There was one occasion when he brought into the Viking office the well-developed sketch-dummy and manuscript of a book that, as I remember, he intended to be his first work in full color. The setting was a town in Mexico where he had spent several winters, and all of us who read the story and studied the pictures were captivated by their gaiety and brilliance and movement. We were keen to have him prepare the finished artwork ready for publication as soon as was reasonably possible.

But time went by, nothing was forthcoming, and we began to be a little uneasy. As it proved, Robert was uneasy too; for the longer he worked on his drawings the more convinced he became that his understanding of Mexican people was too shallow to give him the right to use them as characters in a story that might seem to be making fun of them. And that was that. A jolly book may have died a-borning, but the integrity of its "responsible inventor," in Beatrix Potter's term, remained uncompromised.

The Oxford Dictionary provides a variety of definitions for the word 'integrity,' and two of these apply themselves with particular pertinence to Robert McCloskey and his attitude toward his work: "the condition of having no part or element wanting"; "uprightness, honesty and sincerity." It is my firm belief that a salient reason for children's perennial love of his books lies in their—the children's—recognition of this integrity. All the fun, the kindliness, the beauty of writing and pictures, have, of course, irresistible appeal to the young fry. But the underlying *truth* of the books communicates itself in a subtle way to their deeper understanding. Robert McCloskey plays delightfully with his audience, but he always plays fair.

It is heartening to find, in this queer world where so much that is spurious wins the plaudits of a sensation-sated public, that

bone-deep quality should be recognized and respected. Children and grown-ups alike hold Robert McCloskey and his books in high esteem. . . . (pp. 382-83)

Annis Duff, "Robert McCloskey: Man, Author, Artist, All-of-a-Piece," in Catholic Library World, *Vol. 45, No. 8, March, 1974, pp. 382-83.*

JOHN ROWE TOWNSEND

[Just] as most authors are at best indifferent illustrators, so are most artists indifferent writers.

Robert McCloskey is exceptional in being a recognized author. . . . The broad humour and short but strong story-lines of his *Make Way for Ducklings* [and *Blueberries for Sal*] have kept these two cheerful books popular through the succeeding decades. I am sorry that McCloskey's *Time of Wonder* . . . , a description in words and pictures of a vacation in Maine, is not published in Britain. The text, drawing the reader in by the use of the second person—'suddenly you find that you are singing too', etc.—is possibly a shade overwritten, but this is a lovely picture book, full of light and air and water, and with a sense of wonder that justifies the title. (p. 315)

John Rowe Townsend, "Picture Books in Bloom: U.S.A.," in his Written for Children: An Outline of English-Language Children's Literature *(copyright © 1965, 1974 by John Rowe Townsend; reprinted by permission of Harper & Row, Publishers, Inc.; in Canada by Kestrel Books), revised edition, J. B. Lippincott, Publishers, 1974, pp. 308-20.**

SAM LEATON SEBESTA AND WILLIAM J. IVERSON

[In *Homer Price* and *Centerburg Tales,*] Homer, an engaging character, is usually in the midst of an overwhelming problem and is doing his straightforward best to solve it. The townspeople are recognizable types and generally pleasant. The episodic adventures, each complete in itself, contain splendid exaggeration (a doughnut machine that won't stop production), literary allusion (a pied piper named Mr. Murphy who demonstrates a musical mousetrap), and local lore (ragweed plants that burst out of the greenhouse to threaten all hay fever victims). In at least two instances (the skunk-and-robbers chapter and the knitting chapter) the illustrations provide the clue to the story's secret and McCloskey leaves you to work it out. The writing style is precise, providing an excellent context for a rather difficult vocabulary; many chapters, including the famous doughnut incident, invite exciting dramatizations. (pp. 199-200)

Sam Leaton Sebesta and William J. Iverson, "Fanciful Fiction," in their Literature for Thursday's Child *(© 1975, Science Research Associates, Inc.; reprinted by permission of the publisher), Science Research Associates, 1975, pp. 177-214.**

BARBARA BADER

[Lentil] is the all-American small-town boy, not only natural but, in the popular imagination, typical—another Skeezix or Tom Sawyer. And like *Miki* and *Ola, Hansi* and *Little Leo,* the book goes by his name, a real story about a real boy not very different from Bob McCloskey. . . . (p. 154)

More than most, *Lentil* is a book of drawings, a book of big drawings, double-page spreads every one, filling the pages or seeming to, which is also to say that it is less than most a book of separable illustrations. . . . The library, the park, the monument are all there along Lentil's route, and the jaunty comic flavor is always there, whether in the look of the storekeeper

From Homer Price, *written and illustrated by Robert McCloskey. The Viking Press, 1949. Copyright 1943, renewed © 1971 by Robert McCloskey. Reprinted by permission of Viking Penguin Inc.*

who has taken out harmonica after harmonica or in the pose—arms out, chin up—of the well-fed Columbia who crowns the monument. McCloskey has his fun too with the dogs and cats who flee when Lentil opens his mouth to sing; with the townspeople who read of the Colonel's return with the rapt attention due a great event; with the musicians miserably puckered up, the mayor unable to get out a word of welcome, the bald, corpulent umbrella-carrying colonel.

In part this is cartooning of the old sort, kidding everybody, but Alto, Ohio . . . is also the recognizable small town we soar toward on the endpapers, and it too is omnipresent, sketched in with McCloskey's litho crayon. The quick sureness of the drawing and the fullness of the scene, together with the familiar figure of Lentil, give us the feeling that we have in a novel, of stepping into an ongoing life. It is a life that McCloskey has drawn into existence.

In *Make Way for Ducklings,* however, each opening is a story in itself. There is always something interesting going on, the drawing of the ducks, particularly, is lively and lifelike, the views of the Boston Public Garden, the State House et al are, cliché or not, breathtaking; but there is no basis for every drawing's being the same size or for everything's being so big, for a soft-focus panorama of the park and a realistically detailed depiction of the ducks and a caricature of a frantic policeman each to spread over two pages. There is also the question of whether the three manners are not themselves incompatible.

For children, however, interesting is better than perfect, and children love the scenic flights and the baby ducks and the tubby policeman equally and uncritically. Perhaps not quite equally: the long march of Mrs. Mallard and her brood from the Charles River, where for safety's sake the mallards build their nest, to the Public Garden with its swan boats and promise of peanuts—that perky single-file procession, startling passersby on the sidewalk, holding up traffic at the intersections—is a high point in picturebook drama. . . . (pp. 155-56)

Blueberries for Sal is so much of a piece artistically that, contrariwise, one takes what happens for a natural occurrence. . . .

The two mothers are equally absorbed in thoughts of next winter, Little Sal and Little Bear are both scrambling, bright-eyed children, and the lay and look of the land are everywhere an active part of the story. The hill sweeps up and over, spiky evergreens stand dark against the sky, tree trunks measure the distance as Little Sal sets out, all-awkward, all-alert, to find her mother. . . . The expanse is boundless but, crisply defined, the setting has character and she has personality. . . . (p. 156)

An island in the sky is *Blueberries for Sal*—printed, appropriately, in deep blueberry blue.

One Morning in Maine . . . is more in the nature of a home movie. . . . [*Time of Wonder*] is all rapt description and shimmery pictures. Neither expresses a child's feelings so much as

an adult's feelings about children, the good life and, in *Time of Wonder,* the wonderfulness of words. . . .

Lentil led also to *Homer Price.* . . . Here indeed was Mark Twain reconstituted . . . [and with the further doings of Homer, *Centerburg Tales*], it demonstrated, if anything more was required, McCloskey's mastery of the comic anecdote. . . . Moreover, in *Make Way for Ducklings,* known wherever picturebooks are known, he can be said to have created a modern young counterpart of the old-time whopper or, embellishing a real incident, a new American legend. (p. 157)

> *Barbara Bader, "The American Line," in her* American Picture Books from Noah's Ark to the Beast Within *(reprinted with permission of Macmillan Publishing Company; copyright © 1976 by Barbara Bader), Macmillan, 1976, pp. 140-57.**

MARGARET MATTHIAS AND GRACIELA ITALIANO

Robert McCloskey adjusts his artistic style to enhance the nature of the story he tells. The brown and white lithographs in *Make Way for Ducklings* are drawn in detail providing an excellent "duck's-eye-view" of Boston where Mr. and Mrs. Mallard must raise their family. This technique is particularly appropriate in creating the soft texture of the duck's plumage. In contrast, for *Time of Wonder,* McCloskey chose watercolors to paint his world of sea, bays and islands. His representation of this environment in color zones is superb. Color prevails: it delineates figures, creates setting, and establishes mood. McCloskey, as a master of visual storytelling, chooses his medium and uses it to fit the essence of the story. (pp. 164-65)

> *Margaret Matthias and Graciela Italiano, "Louder Than a Thousand Words" (a revision of a talk originally delivered at the Association for Childhood Education International Conference, Chicago on September 18, 1981), in* Signposts to Criticism of Children's Literature, *edited by Robert Bator (copyright © 1983 by the American Library Association), American Library Association, 1983, pp. 161-65.**

LENTIL (1940)

[He] was—he is, indeed, for I refuse to let him grow up a day or change in any particular—a gangling lad with music in his heart and a weight on his mind. Like Charles Lamb, though temperamentally inclined to music, he was incapable of a tune. . . . Thus the harmonica was a gift from heaven even if he bought it himself (from a hardware store you'll recognize). Lentil played it rapturously, continuously. He kept on playing it, past the palatial residence of Colonel Carter, past the Alto Public Library given by that leading citizen and through Carter Memorial Park where he had caused the Soldiers and Sailors Monument to be erected in 1909. By this time you want Lentil never to stop going. Your home town is coming back, house by house, in the pictures.

The Colonel comes back too, and the town band turns out to meet him at the station. Next moment you find out why you are looking down at the scene from the roof of the station. In the next you learn why the band can't play a note. I won't tell you. It will be worth getting the book to find out, and to see Lentil with his legs over the back of the Colonel's car, leading the marchers with the great man taking a turn at the harmonica when Lentil's wind began to give out. I suspect it was only politeness on his part thus to let the Colonel have a chance.

This book may not be that "second Ferdinand" so often promised, but in the opinion of this reporter it qualifies on more than one count for this position. Its strongest claim is this: the second Ferdinand, whatever it may be, won't be in the least like the first one.

> *May Lamberton Becker, in a review of "Lentil," in* New York Herald Tribune Books, *April 28, 1940, p. 8.*

Big, vigorous, amusing pictures in black-and-white. . . . They are so good it is a pity that the text is somewhat creaky in its attempt at homespun humor.

> *Katharine Sergeant White, in a review of "Lentil," in* The New Yorker *(© 1940, 1968 by The New Yorker Magazine, Inc.), Vol. XVI, No. 14, May 18, 1940, p. 80.*

The drawings are true to the place and people they describe, but the essential humor of the artist's treatment lends itself to a frolic. . . .

Boys and girls from 9 on are entertained by Lentil's problems and his final triumph as a musician, but it is the older boys and girls and adults who are particularly appreciative of the humor and human nature of the drawings, and who enjoy also the bold line, originality and ease of this young artist's work.

Robert McCloskey, in **"Lentil,"** has added to the gayety of life and provided a book that, along with its fun, truly illustrates the American scene.

> *Anne T. Eaton, "In the Middle West," in* The New York Times Book Review *(copyright © 1940 by The New York Times Company; reprinted by permission), May 19, 1940, p. 10.*

Here is a piece of authentic Americana. To anyone who knows the small middle western town, the pictures in this book will be a special delight: the very air is unmistakable. . . . Lentil himself, and the other citizens, as well as the buildings on Main Street, are drawn with understanding and humor. . . . *Lentil* is something of a classic in [the line of picture books, illustrated in black and white, designed to represent American life]! Its interest isn't limited to children of picture book age.

> *Josephine Smith, in a review of "Lentil," in* Library Journal *(reprinted from* Library Journal, *June 1, 1940; published by R. R. Bowker Co. (a Xerox company); copyright © 1940 by Xerox Corporation), Vol. 65, No. 11, June 1, 1940, p. 502.*

The little tale, not altogether innocent of satire, has the very atmosphere of small-town life and custom in it, and into the setting the gangling, tow-haired, obstinate small boy fits as surely as the harmonica fits his capacious, grinning mouth.

> *Margery Fisher, "Who's Who in Children's Books: Lentil," in her* Who's Who in Children's Books: A Treasury of the Familiar Characters of Childhood *(copyright © 1975 by Margery Fisher; reprinted by permission), Holt, Rinehart and Winston, 1975, Weidenfeld and Nicolson, 1975, p. 172.*

MAKE WAY FOR DUCKLINGS (1941)

AUTHOR'S COMMENTARY

I'm not an authority on children's literature, or on graphic arts, or on children's illustration. In fact, I'm not a children's il-

People would smile and wave hello to Lentil as he walked down the street, because everyone in Alto liked Lentil's music; that is, everybody but Old Sneep. Old Sneep didn't like much of anything or anybody. He just sat on a park bench and whittled and grumbled.

From Lentil, *written and illustrated by Robert McCloskey. The Viking Press, 1940. Copyright 1940, renewed © 1968 by Robert McCloskey. Reprinted by permission of Viking Penguin Inc.*

lustrator. I'm just an artist who, among other things, does children's books.

I didn't start life training with any burning desire to create little gems for the young or give my all for good old children's books. But like a musician who likes to have his music listened to, the architect who likes to build houses that are homes, I like to have my pictures looked at and enjoyed. I grew a bit tired of turning out water colors by the ream and having only one in four hundred ever find a useful spot on a wall, the others stored in portfolios in some gallery or with canvases in a dusty studio corner. Yes, I'm working on children's illustration. I'm proud of that. But I'm still for hire—to paint, sculp, whittle, or blast if it's on some job that will bring pleasure and be used, whether it be in a bank, post office, or chicken coop. (p. 277)

The thing that I can talk about which might be of interest to librarians is how the duck book was constructed and put together.

Most of my friends think it happened something like this: One day I was sitting on a park bench in Boston reading the want ads of the *Transcript* when I just happened to notice all the birds in the park. I thought to myself, "Why not write a children's book about pigeons?" So I started writing a book about pigeons, only pigeons were too hard to draw, so I changed the pigeons into ducks. . . .

Now it wasn't quite like that but oddly enough this story *did* start in Boston. While living on Beacon Hill I walked through the Public Gardens every day on my way to art school in the Back Bay section. I noticed the ducks in those days but no ideas in that direction ever entered my head. I was studying to be an artist, and I was hell-bent on creating *art*. My mind in those days was filled with odd bits of Greek mythology, with accent on Pegasus, Spanish galleons, Oriental dragons, and all the stuff that really and truly great art is made of. I liked those ducks and I enjoyed feeding them peanuts, all good relaxation, I thought, for a mind heavy-laden with great art thoughts. It never would have occurred to me to *draw* those things or to *paint* them unless they were in a deep forest pool with a nude, perhaps, and a droopy tree and a gazelle or two, just to improve the composition. That gives you a vague idea of the way things stood. But I don't regard the time and thought as wasted. I certainly got rid of a lot of ham ideas at an early age.

It was at this time that I made my first visit to New York. I came with a list as long as my arm of things to do and see—the decorations at Radio City, the Hispanic, Metropolitan, Modern, Science and Industry, and Natural History Museums, and Grand Central Galleries, too, of course. I did it up brown, mind ticking all the time. Today there are two things from that trip I remember. I went to call on an editor of children's books. I came into her office with my folio under my arm and sat on

the edge of my chair. She looked at the examples of great art I had brought along (they were woodcuts, fraught with black drama). I don't remember *just* the words she used to tell me to get wise to myself and shelve the dragons, Pegasus, limpid pool business, and learn how and what to "art" with. I think we talked mostly of Ohio.

The other thing I remember is that she took me out to dinner. The food was Long Island duckling.

I went back to Boston a very puzzled art student. It was about this time that I started to draw and paint everything and anything. I lost my facility for making up droopy trees and the anatomy of non-existent dragons and gazelles. Why, I even drew ducks.

When a job took me back to Boston a few years later the idea of the book took shape. And by the time I had returned to New York it was on paper, in a very rough draft which I took to my publisher.

When I started making the final sketches for this book, I found that in spite of my various observations of mallard duck anatomy and habits, I really knew very little about them. I went first to the Natural History Museum in New York, where I took careful notice of the two stuffed mallards that were in the cases. Then I went to the Museum Library and found a top view of a duck's cranium, with minute measurements and a rough estimate of how many years ago ducks were fish. But hidden somewhere I found valuable information on the molting and mating habits of mallards.

At this time I had the good fortune to meet an ornithologist, George Sutton, and with his kind help I found out a great deal about mallards, studying markings on skins and making notes on wings. At last I had knowledge that I could use, but not enough. I needed models.

Time and finances would not allow such a simple solution as going where there were wild mallard ducks. I had to acquire them, so I went early one cold New York morning to Washington Market and found a poultry dealer. "I would like to acquire some mallard ducks," I said, and I was promptly shown a very noisy shipment that had just come in from the South. I looked in the cages and tried to pick out a pair that were not adulterated with puddle duck. I pointed to a duck and the dealer promptly made a grab in the cage, coming out with a squawking bird held tight around the neck. This process was repeated four times before the two of my choice were caught. Each time a bird was yanked out by the neck. I could not bear to see those two mistakes tossed back into the cage so I bought all four, a neat little duck cage about 3 x 5 feet in area and just high enough, and a half-bushel of mash, all for under two dollars.

With pride I took my purchases home to the studio and displayed them to Marc Simont, my roommate at that time. (Marc is another artist who does children's illustrations once in a while.) He didn't even bat an eye when he found that all six of us were going to live together. The ducks had plenty to say—especially in the early morning.

I spent the next weeks on my hands and knees, armed with a box of Kleenex and a sketch book, following ducks around the studio and observing them in the bath tub.

If you ever see an artist draw a horse, or a lion, or a duck, the lines flowing from his brush or crayon in just the right place so that all of the horse's feet touch the ground, the lion couldn't be mistaken for a pin cushion, and the duck *is* a duck,

and you think "My, how easily and quickly he does that, it must be a talent he was born with,"—well, *think* it if you must but don't *say* it! Little you realize what might be going into that drawing—day after day of following horses in a meadow with hot sun, prickles, and flies, or coming home from the Zoo exhausted at night with the people in the car looking about and trying to place that distinctive smell, or what splashing and housemaid's knee is behind each nonchalant stroke of that duck's wing!

The next step was a trip back to Boston to make sketches for my backgrounds—parks, bridges, fences, streets, stores, and book shops. Returning to New York, I brought a half-dozen ducklings home and filled more sketch books—with happy ducklings, sad ducklings, inquisitive ducklings, bored ducklings, running, walking, standing, sitting, stretching, swimming, scratching, sleeping ducklings.

All this sounds like a three-ring circus, but it shows that no effort is too great to find out as much as possible about the things you are drawing. It's a good feeling to be able to put down a line and know that it is right. (pp. 278-82)

> *Robert McCloskey, "The Caldecott Medal Acceptance" (originally an address delivered before the Section of Library Work for Children, American Library Association in Milwaukee, Wisconsin on June 23, 1942), in* The Horn Book Magazine *(copyrighted 1942, renewed 1969, by The Horn Book, Inc., Boston), Vol. XVIII, No. 4, July-August, 1942, pp. 277-82.*

These large pages afford space for what amounts to a personally conducted tour of Boston and environs. That this tour is laid out and conducted by a family of mallard ducks cannot cramp Mr. McCloskey's dashing style or contract his range of action. . . . [The duck family's trek] makes a good excuse for large, gay drawings, on the scale of those in **"Lentil,"** of what you can see in Boston.

These ducks nested up the Charles, not too far from a friendly policeman, and at this point in the story they have space enough to be almost life-size, taking two pages at once. The same spread permits lovely effects when they reach the highway and a Boston panorama begins, picturesque street views pointed by comic duck doings. The book has the breath of Boston.

> *May Lamberton Becker, in a review of "Make Way for Ducklings," in* New York Herald Tribune Books, *August 31, 1941, p. 6.*

The solemn procession up Beacon Hill and down again, with its attendant excitement, is a hilarious experience which children will inevitably have to share with any grown-ups fortunate enough to catch a glimpse of this picture-book, one of the merriest we have had in a long time. Mr. McCloskey . . . has told the story in very few words, with a poker-faced gravity which underscores the delightful comedy of his pictures—fine large pictures, strongly drawn, which, for all their economy of line, have a wealth of detail so that one turns the pages again and again to be sure not to miss a single bit of the fun.

> *Ellen Lewis Buell, in a review of "Make Way for Ducklings," in* The New York Times Book Review *(copyright © 1941 by The New York Times Company; reprinted by permission), October 19, 1941, p. 10.*

McCloskey's drawings [in **Make Way for Ducklings**] have a great deal of variety and interest, achieved through a change

of scale and pace. He has wisely chosen a warm color to overcome the usually unhealthy pallor of offset. The cleverness of his manipulation of the crayon has some tendency to cheapen the whole very capable effect.

The successful way in which McCloskey has changed the pace of his pages brings up one of the most important factors involved in a picture book, and that is variety. The audience should not get the feeling that it has seen this one before. It is particularly important that there be constant changes in the silhouette. (p. 450)

> *Warren Chappell, "Illustrations Today in Children's Books," in* The Horn Book Magazine *(copyrighted, 1941, renewed 1969, by The Horn Book, Inc., Boston), Vol. XVII, No. 6, November-December, 1941 pp. 445-55.**

Among the fine picture books on the Caldecott Award list is Robert McCloskey's **Make Way for Ducklings,** long a favorite with American children. In **Make Way for Ducklings** we find the modern technique of "bleeding" illustrations off the pages in order to obtain a maximum of pictorial effect. There is no white space in this book. McCloskey sweeps his pencil across the doublespreads which make up his story, so that there is great dramatic action. And there is detail, too, buildings, cars, people and the ducks themselves. Children, whose eyes are microscopic, never tire of such detail. (p. 308)

> *Esther Averill, "What Is a Picture Book?" in* Caldecott Medal Books: 1938-1957, *edited by Bertha Mahony Miller and Elinor Whitney Field (copyright © 1957 by The Horn Book, Inc., Boston), Horn Book, 1957, pp. 307-16.**

Each two-page spread of the book shows bold use of line and white space. Words and pictures were printed in the same ink—a rich sepia with no other color in the book.

The drawings themselves have such variety that interest mounts from one double spread to the next. Take a slow look at the eight ducklings in any of the pictures and you will see that each one is different. As they stand on the edge of the pond with their mother, each tiny quacker shows consternation, but in a different way. On the next two-page spread, which pictures the first lesson in swimming and diving, every little one registers delight in his own way. One duckling is diving head first, another is standing up flapping his wings, another is courting an insect overhead. Each time you look you are likely to see something more.

Unusual perspectives add interest, too—first with the Mallards looking down on the pond in Boston Public Garden, then flying over Beacon Hill where the people look no larger than specks of dust, or plunging in the pond with park-bench sitters small in the distance.

When Michael, the policeman, comes to the rescue, his great bulk spreads across one page and into the other while the Mallards are tiny figures in a¾-inch spot. The swimming lesson is a close-up of the ducks, with Mrs. Mallard measuring a good eleven inches on the two-page spread and her ducklings almost life size.

From page to page there is a change of pace that is intriguing. Catastrophe threatens when a "horrid rushing" bicycle almost mows down the senior Mallards. Peace is restored until they meet up with honking automobiles. Michael's shrill whistle averts catastrophe and again peace and security prevail. . . .

In the end the Mallards triumphed over the machines that threatened them. But theirs was a search for peace and beauty in the midst of the crowds and traffic of Boston. Perhaps the Mallards' experience qualifies them to be called the vanguard of the exurbanites. Certainly **Make Way for Ducklings** is one of Bob McCloskey's first protests against the overwhelming mechanization of our society. (p. 147)

> *Nancy Larrick, "Robert McCloskey's 'Make Way for Ducklings'" (copyright © 1960 by the National Council of Teachers of English; reprinted by permission of the publisher and the author), in* Elementary English, *Vol. XXXVII, No. 3, March, 1960, pp. 143-48.*

[Robert McCloskey] relies on the intimate study of nature to draw his readers into the sensitive, secure world of **Make Way for Ducklings.** (p. 247)

McCloskey's accurate geographical information, both in text and illustrations, lends credence to this tale, as do his anatomically accurate drawings of ducks and ducklings in flight and on foot. But what these illustrations, the gentle, soft drawings of the birds against the backdrop of a thriving, harsher city, do is pull the reader into the sensitivity of the story. The champion of humankind, or birdkind, Michael, the policeman, protects these innocent ducks and ducklings from the dispassionate, bustling city.

The graceful pictures, all in brown and white, often studies of family interaction, childrearing, and natural history, encompass and reinforce the simple, yet touching, saga of the survival of the Mallard family. McCloskey does not embellish his book with elaborate colors (even the text is brown) or complex technique; his execution is a combination of clean lines and gentle shading that helps tie together two incongruous entities: the city and the Mallard family. The compromise is provided; once their clan is of sufficient age to protect themselves, the Mallards return to the Public Garden via the busy streets of Boston. Only with the help of the symbolic heart of the city, Michael, do the Mallards safely survive.

McCloskey's work remains a favorite with children as he offers them the chance to identify with the triumph of small over big; young over old; innocence and naiveté over experience and maturity. (pp. 247-48)

> *Linda Kauffman Peterson, "The Caldecott Medal and Honor Books, 1938-1981: 'Make Way for Ducklings'," in* Newbery and Caldecott Medal and Honor Books: An Annotated Bibliography *by Linda Kauffman Peterson and Marilyn Leathers Solt (copyright © 1982 by Marilyn Solt and Linda Peterson; reprinted with the permission of Twayne Publishers, a division of G. K. Hall & Co., Boston), G. K. Hall, 1982, pp. 247-48.*

HOMER PRICE (1943)

Rollicking fun breaks through every page and picture in Robert McCloskey's new book. In six hilarious episodes he introduces a genuine small boy in the best Tom Sawyer tradition, living in a truly American town in the mid-west. The vigorous pictures in cartoon style, yet with details of astonishing machines, almost tell the stories, but the text tells more about Homer, and that we need to know for refreshment and laughter. He promises to be one of the permanent notables among children's book

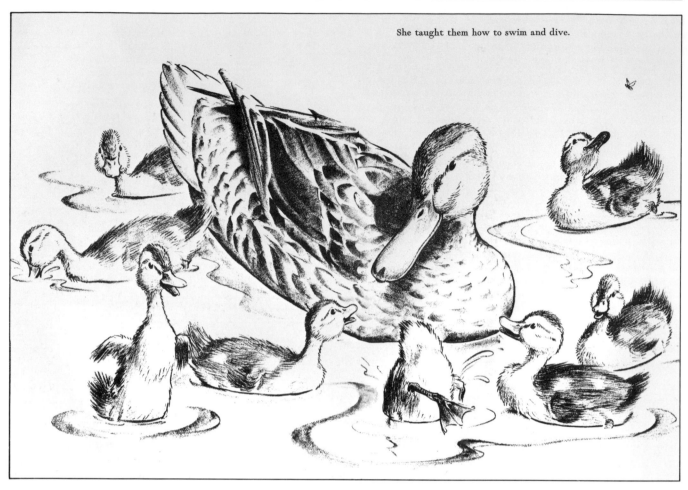

She taught them how to swim and dive.

From Make Way for Ducklings, *written and illustrated by Robert McCloskey. The Viking Press, 1941. Copyright 1941, renewed © 1969 by Robert McCloskey. Reprinted by permission of Viking Penguin Inc.*

characters. It is hard to choose a favorite story, but the doughnut one is certainly irresistible. (pp. 408, 410)

Alice M. Jordan, in a review of "Homer Price," in The Horn Book Magazine (copyrighted, 1943, renewed 1971, by The Horn Book, Inc., Boston), Vol. XIX, No. 6, November-December, 1943, pp. 408, 410.

Here is a book that is as American, as contemporary and as real as though we could walk into the next street and there find Homer mending radios, catching burglars with the help of Aroma, his pet skunk . . . and indulging in other adventures which have a bubbling, unexpected humor and the entire reasonableness of genuine nonsense.

Readers of **"Lentil"** and **"Make Way For Ducklings"** know how amusing and at the same time how convincing Robert McCloskey's drawings are, and in this latest volume the pictures contribute as importantly as the text to make Homer (even though his exploits are in a vein of fine exaggeration) a very real and characteristic American boy. Here, too, with a humorous absurdity that never destroys the truth of the picture, are small-town life and the personalities one finds there.

Anne T. Eaton, "Small-Town Boy," in The New York Times Book Review (copyright © 1943 by The New York Times Company; reprinted by permission), November 14, 1943, p. 6.

This is to welcome Homer Price to Tom Sawyer's gang, that immortal and formidable band of boys of American fiction. For this boy is a real boy, thinking out loud and living out these rich and hilarious dilemmas with solemn and devastating humor. The way Homer and his friends of Centerburg cope with, and master, such surprising emergencies with implications as radio robbers, Superman, musical mousetraps, ferocious doughnut machines, housing problems, and mass production is the American comic genius in its top form. The stories, too, have all the excitement of the fantastic and incredible, so convincingly woven into the daily life of the Mid-Western small town as to seem as honest-to-goodness true as the front page of the *Westport Town Crier*. And above all, each one is in every line, good fun from start to finish.

What I want to speak about especially is the pictures. This guy McCloskey can draw and I don't mean just good academy. The way these boys fit into their pants, wear their shirts, and the way the folds of their clothes pull with every movement is all there to intensify vivid humor and real character. This humorous reality pervades even the objects in each scene so that you get the full delicious flavor out of every detail of Homer's room and the unforgettable barber shop. The double-page drawing of the historical pageant is a classic of small-

town celebration. And so one goes over these drawings again and again with renewed delight in all their details. The doughnut counter, the ice cream parlor, and above all the impossible machines and gadgets that operate so convincingly, must not only be copyrighted but patented!

The satire is warm and genial and tolerant so that you feel these pictures are the autobiography of a generous mind as well as a shrewd and witty recording of familiar scenes. It is the true comedy of democracy in the great American tradition of A. B. Frost, of Kemble, and of Peter Newell, all the more so that McCloskey is entirely unaware of it. The laughter is in the drawing itself; you get the fun of the thing visually and even especially without the words.

It is America laughing at itself with a broad and genial humanity, without bitterness or sourness or sophistication. The whole thing culminates magnificently in the final story when "the wheels of Progress" come to Centerburg, and here McCloskey puts on a full philharmonic of fun and satire in the dilemma and the triumph of modern housing. One closes the book with the comforting feeling, however, that although Centerburg can and does take the machine age in its stride, the salt and character, the humanities and individualism of Our Town remain triumphant and that democracy will keep her rendezvous with destiny, musical mousetraps, and all. (pp. 425-26)

> *James Daugherty, in a review of "Homer Price,"* in The Horn Book Magazine (*copyrighted, 1943, renewed 1971, by The Horn Book, Inc., Boston), Vol. XIX, No. 6, November-December, 1943, pp. 425-26.*

Books that are genuinely humorous may be rare but they are also very likely to survive from one generation to the next. . . . [One] of these rare books is **Homer Price**. . . . Robert McCloskey's claim that he merely thinks up words to tie his pictures together is scarcely born out in **Homer Price.** It may be one of those books that authors claim write themselves. Whatever the circumstances, Homer is revealed in story as well as pictures with complete spontaneity. . . . Homer is a typical American boy and, as extravagantly funny as his exploits often are, there is far more truth in this glimpse of America than in many seriously purposeful books. (p. 574)

> *Ruth Hill Viguers, "Experiences to Share," in* A Critical History of Children's Literature *by Cornelia Meigs, Anne Thaxter Eaton, Elizabeth Nesbitt, and Ruth Hill Viguers, edited by Cornelia Meigs (reprinted with permission of Macmillan Publishing Company; copyright © 1953, 1969 by Macmillan Publishing Company), revised edition, Macmillan, 1969, pp. 567-600.**

[**Homer Price**] is a masterful creation relying upon an adroit weaving of realism, developed through the setting and characters, and of inane situations into a seemingly practical picture that has rarely been matched. Young people continue to read about Homer Price and to chuckle over the wild situations that take place in this commonplace small town.

Part of **Homer Price**'s charm today is that this story is built around a rather ordinary family whose middle class lifestyle and aspirations are a reflection of a natural slow-paced town from another era. Throughout the book no pressures for achievement are placed upon Homer. Instead, he and his friends roam freely within the neighborhood. Homer has his own dreams and plans, associates with townsfolk as divergent as Uncle

Ulysses, the sheriff, and Uncle Telly. His parents are only fleetingly seen; when they are, they are never quarrelsome or overbearing. Within this secure, leisurely atmosphere Homer is an eye witness to extraordinary events. Yet McCloskey's style is so carefully paced, the action so low key, and Homer so steadily etched that the ridiculous seems practical.

Part of the book's magic for youngsters is McCloskey's humorous sketches. A notable artist in the field of children's literature . . . , McCloskey has meticulously reinforced his text with black and white illustrations. Thus, the reader sees Homer's room as a boy's dream: it is just cluttered enough to cause a fastidious housekeeper some qualms but full of enough contraptions, tools, and boyhood memorabilia to make it exciting. And Homer himself is pictured disheveled enough to assure any child that he is real. But what is especially reassuring is that nowhere, either in the text or in the pictures, are the adults demanding that Homer straighten up and change his ways. He is given breathing and growing room, unaffected by peer or social pressures. Thus, the reader is not watching Homer's growth (since he often already seems one of the wisest persons involved in each of the town's escapades), but is embarking upon a relaxed group of adventures which will both entertain and stimulate the imagination. Throughout the book McCloskey has used unusual inventions, each humorously depicted in his illustrations, as the stimulus for the story's actions. The child reading these adventures can become engrossed in a fantastic world inhabited by eccentric but endearing grownups. Even though this small town's citizens are engaged in some of the most ludicrous predicaments they are lovingly portrayed; the people themselves never become slapstick caricatures.

Robert McCloskey's book will remain a children's favorite. It has no heavy thematic implications, though there is an indirect allusion to the foibles of society's fascination with and devotion to popular culture. (pp. 375-76)

There are several reasons a film producer would want to recreate Homer: the book contains a good deal of light hearted humor; it has lengthy portions of realistic dialogue within the text; the characters are actively involved in unusual situations; each chapter is independent of the others and could be used by itself as a dramatic episode. But it is difficult for film to fully capture McCloskey's careful blending of setting, mood, and language. Once the careful balance among these elements is destroyed, the literary qualities will be lost. (p. 376)

> *Jill P. May, "How to Sell Doughnuts: Media and Children's Literature" (copyright © 1979 by the National Council of Teachers of English; reprinted by permission of the publisher and the author), in* Language Arts, *Vol. 56, No. 4, April, 1979, pp. 375-79.*

BLUEBERRIES FOR SAL (1948)

Out of his life on a Maine island and his pleasure in his child, Sally, Bob McCloskey has evoked the very essence of Maine and childhood in this picture book of a little child's blueberrying with her mother. From the book jacket with Little Sal looking like a pixie in a blueberry patch and the endpapers showing Peggy McCloskey and Little Sal canning blueberries in the McCloskey kitchen to the last picture with Little Bear and his mother and Little Sal and her mother going down opposite hillsides, it is a delight to the eye.

Looking at the pictures, one can hear the firm little berries hit the bottom of the tin pail "kuplink, kuplank, kuplunk," the sound of wings beating as the cawing crows take flight and feel the fresh, salt winds blowing across sunlit rocky hillsides grown with evergreens and blueberries. The delightful little story is touched with humor and has something of the quality of a folk tale.

> *Helen Masten, in a review of "Blueberries for Sal,"* in New York Herald Tribune Weekly Book Review *(© I.H.T. Corporation; reprinted by permission), October 3, 1948, p. 8.*

Robert McCloskey's text and pictures for **"Blueberries for Sal"** are lithographed in a dark blue on white, with page after page of handsome double-spreads. The endpapers contain the kind of humorous detail which has helped make a perennial favorite of **"Make Way for the Ducklings,"** and which is lacking in the rest of this new book's pages. The slight story and its setting, which is limited to one side or the other of a hill, scarcely seems to warrant such expansive and expensive treatment.

> *Gladys Crofoot Castor, in a review of "Blueberries for Sal,"* in The New York Times Book Review *(copyright © 1948 by The New York Times Company; reprinted by permission), October 24, 1948, p. 45.*

Fortunately for children everywhere [Robert McCloskey has created] a rare gift for Christmas or the birthday of a three-year-old. In *Blueberries for Sal* . . . Mr. McCloskey has done some of his best drawing—as true to the life line of the Maine coast as to the living child and her mother in their search for blueberries on their island. Beauty, truth and the sure line of an artist who has thoroughly mastered his technique set this book apart in a season offering a much greater variety of picture books than last year. If the Caldecott Award had not already been given to *Make Way for Ducklings,* it should go to *Blueberries for Sal.* As it stands, the book emphasizes our debt to an artist who has met this difficult era with complete integrity.

Robert McCloskey has kept on drawing in terms of his own observation and perception. He has known the American child at different stages of growth, beginning with the zestful Lentil

and his harmonica, the forerunner of Homer Price. It may seem strange to those who think of McCloskey chiefly in terms of **Lentil** and **Homer Price** that he should be able to render so sensitive a perception of the three-year-old Sally and her interests as will never cause her embarrassment in years to come— a major accomplishment in this day of the "modern child."

> *Anne Carroll Moore, in a review of "Blueberries for Sal,"* in The Horn Book Magazine *(copyrighted, 1948, renewed 1975, by The Horn Book, Inc., Boston), Vol. XXIV, No. 6, November-December, 1948, p. 434.*

One of the year's most delightful picture books. . . . All the color and flavor of the sea and the pine-covered Maine countryside are captured in the enchanting pictures which are sure to delight all ages. A MUST for schools, libraries, and homes.

> *Helen M. Brogan, in a review of "Blueberries for Sal,"* in Library Journal *(reprinted from* Library Journal, *December 15, 1948; published by R. R. Bowker Co. (a Xerox company); copyright © 1948 by Xerox Corporation), Vol. 73, No. 22, December 15, 1948, p. 1826.*

Robert McCloskey's sure and confident hand brings the inquisitive innocence of childhood to his pictures, all of which are done in navy "blueberry" and white. Clean, sharp lines against white create contrasts both subtle and dramatic. Areas of solid color juxtaposed with areas of stark white and hatched, shaded areas provide definite, bold patterns that move the eye across the page and right onto the next. The sharply hatched areas and the modeling of darks and lights soften with distance, which serves to accentuate the value patterns.

McCloskey taps, with sentimental innocence, the sometimes frightening independence of childhood and parallels Little Sal and Little Bear in a tightly constructed, simple tale.

> *Linda Kauffman Peterson, "The Caldecott Medal and Honor Books, 1938-1981: 'Blueberries for Sal',"* in Newbery and Caldecott Medal and Honor Books: An Annotated Bibliography *by Linda Kauffman Peterson and Marilyn Leathers Solt (copyright © 1982 by Marilyn Solt and Linda Peterson; reprinted with the permission of Twayne Publishers, a division of*

From Blueberries for Sal, *written and illustrated by Robert McCloskey. The Viking Press, 1948. Copyright 1948, renewed © 1976 by Robert McCloskey. Reprinted by permission of Viking Penguin Inc.*

G. K. Hall & Co., Boston), G. K. Hall, 1982, p. 277.

CENTERBURG TALES (1951)

Ever since the publication of **Homer Price** boys and girls who felt close kinship with him have been calling for more. In **Centerburg Tales** . . . Robert McCloskey has given them six new tall tales of his own invention with the characterful pictures which are so integral a part of the stories.

Everyone will claim a favorite and mine is the utterly hilarious one of the new automatic juke box in Uncle Ulysses' lunchroom. I haven't had such a laugh since reading Bob Davis's *Tree Toad.* There is appreciation of human relationships in any small town at the back of these stories. One feels at home in Centerburg, it's so folksy.

> *Anne Carroll Moore, in a review of "Centerburg Tales," in* The Horn Book Magazine *(copyrighted, 1951, renewed 1979, by The Horn Book, Inc., Boston), Vol. XXVII, No. 2, March-April, 1951, p. 94.*

Homer Price has already made a permanent place for himself in the lists of favorite books of children throughout the country and one can easily imagine their rejoicing when they learn that here is another book about him,—as good as the first and maybe even a little better. Grampa Hercules adds a great deal with the tall tales he tells on every possible occasion; and as usual, everything that happens to Homer is a bit on the "tall" side, too. Pictures and story show a real, live American boy with a knack for getting into hilarious adventures that make perfect reading aloud for children from eight to twelve.

> *Jennie D. Lindquist and Siri M. Andrews, in a review of "Centerburg Tales," in* The Horn Book Magazine *(copyrighted, 1951, renewed 1979, by The Horn Book, Inc., Boston), Vol. XXVII, No. 3, May-June, 1951, p. 179.*

For some five years now boys have been asking for another book "just like **'Homer Price.'**" It is good news for them that the ingenious young hero of Centerburg, Ohio, has returned; so has Uncle Ulysses, proprietor of the fabulous doughnut machine, and the twisted-tongue sheriff. Sharing honors with Homer is his Grampa Hercules, who tells some truly remarkable tales and is then trapped into proving one. . . .

These stories start the book off at a somewhat slower pace than that of **"Homer Price,"** but they are in the grand American tradition. Homer's own adventures really get under way when the giant ragweed sprouts. They end in a hilarious evening of singing and dancing when a mysterious stranger slips a hypnotic record into Uncle Ulysses' juke-box. Homer moves through all this grand nonsense as canny and resourceful as ever, and somehow always remains a real boy. Proof of this is seen in Mr. McCloskey's illustrations.

> *Ellen Lewis Buell, "Return of Homer Price," in* The New York Times Book Review *(copyright © 1951 by The New York Times Company; reprinted by permission), May 6, 1951, p. 22.*

Yes, that hilarious boy is back, along with a lot of characters who keep life in a small town exciting for a person like Homer. Half this book is Grampa Herc's: he tells some very tall tales, one of which involves him in the plans of two dry-cereal promoters. The children help him to outwit these slick strangers

with their "Gravitty Bitties." The rest of the book is Homer's, but he is less a main actor than before, and the sly satire at provincial doings is a bit more adult.

Boys of ten to twelve will laugh as an adult cannot, at the last tale where the bewitched citizens make a shambles of the Dewey decimal system in the library, all due to a record slipped into the new jukebox by a dark stranger. But we all join in hearty laughter at and praise of the many pictures, funnier than ever. And for Grampa Hercules alone, the book is worth the money.

> *Louise S. Bechtel, in a review of "Centerburg Tales," in* New York Herald Tribune Book Review, *May 13, 1951, p. 17.*

All who have enjoyed **Homer Price** will delight in the further adventures of Homer, his Centerburg neighbors, and the indomitable Gramp, whose powers of invention are second to none. In these refreshingly different tall tales there is a good deal of warm-hearted entertainment which is almost unrivaled in its spontaneity, feeling for real personalities, and colorful and original situations. The lively and amusing illustrations by the author complement the text. Recommended.

> *Helen M. Brogan, in a review of "Centerburg Tales," in* Library Journal *(reprinted from* Library Journal, *June 15, 1951; published by R. R. Bowker Co. (a Xerox company); copyright © 1951 by Xerox Corporation), Vol. 76, No. 12, June 15, 1951, p. 1034.*

ONE MORNING IN MAINE (1952)

[This has the] sense of belonging to a family, of a happy normal part of childhood on the Maine seacoast, of enough happenings that might be true to capture that recognition appeal so important in reading for all ages. . . . [In] both text and pictures this has strong appeal.

> *A review of "One Morning in Maine," in* Virginia Kirkus' Bookshop Service, *Vol. XX, No. 4, February 15, 1952, p. 123.*

The same island off the Maine coast that was the background for the meeting of Sal and the bear cub (**"Blueberries for Sal"**) is the scene of this beautiful picture book. The endpapers with their cool greens and blues and the white gulls flying express the very essence of the New England coast. The dark blue ink that is used throughout the book is exactly the color to convey the feel of Maine—the rocks and the pine trees, the shore line and the water. It is right, too, for the interior scenes when the family is getting up and having breakfast. Looking at the breakfast scene we wonder how Sal can bear to turn her back on that enchanting view through the screen door! When the outboard motor fails Sal's father is obliged to row his two small daughters across to the mainland. His expression when the motor fails to start is as funny as the expression on the face of Homer Price when he is struggling with a gadget. The drawing of the village with its church and garage on the little hill above the harbor is typical of so many of the coast villages. Mr. Condon, the storekeeper, and his friends may be found in almost any small store in the State of Maine. As we follow the story of Sal and her lost tooth we feel as refreshed as though we had spent a day with them on their island. Beauty and humor and the integrity of an artist who is always close to the thing that he dramatizes make this one of the outstanding picture books of this year—and perhaps of many years.

Mary Gould Davis, in a review of "One Morning in Maine," in The Saturday Review, *New York, Vol. XXXV, No. 19, May 10, 1952, p. 48.*

["One Morning in Maine"] will delight those of four to eight who know about losing that first wobbly tooth. The pictures will alternately amuse those small ones the age of Sal, and charm the grown-ups who share this artist's love of shores where the pines meet the big red rocks, where a loon plunges in mirror-green water, where a seal might poke up his nose to see a little girl with a hole in her mouth. . . . You will laugh at Mr. McCloskey starting his outboard motor, and enjoy every minute of the visit to the village on the mainland. . . .

Here is the Homer Price man drawing his elegant machinery again, and his country-store people, and careful helpings of Hancock County Ice Cream. It is chiefly the book of engaging young Sal, a busy, real, far from "pretty" small girl. Lots of other fathers will love to share such pages with lots of girls just like Sal, and dream of the same doings on some happy morning in Maine. Those merry heads on the cover, windblown against the dark blue sea, give the true spirit of a fine new picture book.

Louise S. Bechtel, in a review of "One Morning in Maine," in New York Herald Tribune Book Review, *May 11, 1952, p. 7.*

The loss of a first tooth is always a momentous occasion in a young child's life. All the anxiety, excitement, and anticipation that are part of this important event are movingly captured in this warmly written story. . . . The large double-page lithographs in dark blue filled with the feeling of the woods, beach, and sea along the coast of Maine add to the magical quality of the day.

Constantine Georgiou, "Realism in Children's Literature: 'One Morning in Maine'," in his Children and Their Literature *(© 1969 by Prentice-Hall, Inc.; all rights reserved; reprinted by permission of the author), Prentice-Hall, Inc., 1969, p. 392.*

Great satisfaction may be experienced upon introduction to the characters of *One Morning in Maine*. Both text and illustrations realistically tell of a child's reaction to losing her first tooth. It is a story that brings joy and excitement to everyday living and to just growing up. (p. 12)

[The] quality of keen sensitivity to what children are like, and also to what they like, is apparent in *One Morning in Maine*—or in any of McCloskey's books, for that matter. In this picture book, the story line and the beautiful dark blue, double-page spreads enable the child to read about things that are important to him. In a genial satirical manner such meaningful realities of childhood as the following are considered: one must learn how to squeeze toothpaste onto the toothbrush, one must realize that a loose tooth means that one is growing up, and one must consider the fact that the vanilla ice cream cone (as opposed to a chocolate one) should be given to a little sister "so the drips won't spot." (pp. 12-13)

Patricia Cianciolo, "Appraising Illustrations in Children's Books," in her Illustrations in Children's Books *(copyright © 1970, 1976 by Wm. C. Brown Company Publishers), second edition, Brown, 1976, pp. 1-27.**

Robert McCloskey's navy and white illustrations and sensitive text reflect the familiarity the author/artist must have felt for his subject. The everyday events of childhood and the routine of a life spent near the water are both apparent in the illustration of a father and daughter's interaction in this northeastern environment.

From One Morning in Maine, *written and illustrated by Robert McCloskey. The Viking Press, 1952. Copyright 1952, renewed © 1980 by Robert McCloskey. Reprinted by permission of Viking Penguin Inc.*

The fuzzy, crayonlike illustrations, highlighted with and in contrast to the sharp crisp lines used to accentuate or define a shape, are of the style of **Blueberries for Sal.** . . . The same careful attention is given to the play of lights and darks in each carefully arranged composition, and a little distance gives the illustrations more definite patterns of light and dark. It is McCloskey's own experiences, though, that bring this story, its characters, and the illustrations to life. (p. 295)

> *Linda Kauffman Peterson, "The Caldecott Medal and Honor Books, 1938-1981: 'One Morning in Maine',"* in Newbery and Caldecott Medal and Honor Books: An Annotated Bibliography *by Linda Kauffman Peterson and Marilyn Leathers Solt (copyright © 1982 by Marilyn Solt and Linda Peterson; reprinted with the permission of Twayne Publishers, a division of G. K. Hall & Co., Boston), G. K. Hall, 1982, pp. 294-95.*

TIME OF WONDER (1957)

[The author presents **Time of Wonder**] in prose that has the quality of poetry and in beautiful full-color pictures to show children "the time of the world go by" on a Maine island, from a foggy morning in spring, through summer days, a hurricane, and the approach of fall. He has succeeded in transferring his love for the island to the printed page and as you listen to his words and look at his pictures you feel that every day and every season is a "time of wonder." This is entirely different from any book he has done before, and he has made it a thing of great beauty.

> *Jennie D. Lindquist, in a review of "Time of Wonder,"* in The Horn Book Magazine *(copyrighted, 1957, by The Horn Book, Inc., Boston), Vol. XXXIII, No. 6, December, 1957, p. 480.*

What pleasure the new picture book by Robert McCloskey gives! **"Time of Wonder"** is a paean in words and lovely water colors of youth, of summer holidays, and of the beauties of Penobscot Bay. The great sweeping pictures have the luminous quality that is the peculiar charm of this medium. The bright almost unreal colors of a "blue Maine day" contrast with soft and subtler shades, abstract patterns mingle with scenes of realism. . . .

As in **"One Morning in Maine"** and **"Blueberries for Sal,"** the author speaks to children through the experiences of his own little girls, grown now to be about eight and ten, we should guess. There is no plot, but the descriptions have a certain narrative interest to appeal to young listeners. We get an airplane glimpse of the children's summer cottage on a point jutting out into the many-islanded bay, then two tiny figures "watch the time of the world go by" as a rain cloud approaches; later fog comes and lifts suddenly. There are scenes of sailing, swimming, sand-pleasures, rowing both in the dusk and at night, and finally, before the departure for the winter, a dramatic sequence: the hurricane warnings, . . . the preparations for safety, the great blow itself and the strange world the morning after.

Pictures and words vividly evoke the McCloskey's Point and their part of the bay and convey their unique charm. We return again and again to the marvelous glimpse of the hurricane, to the picture of the after-swells dashing across the point or to the little girls exploring the shadowy waters in a twilight-blue world.

> *Margaret Sherwood Libby, in a review of "Time of Wonder,"* in New York Herald Tribune Book Review *(© I.H.T. Corporation; reprinted by permission), December 15, 1957, p. 9.*

[*May Massee was the editor of most of McCloskey's books. In his second Caldecott Award Acceptance Speech (August, 1958), McCloskey said: "I must tell you that in awarding* Time of Wonder *a prize, you are really awarding a prize to May Massee. It is her book, almost as surely as if she had held the brush in her hand. Without her it never would have been done. Without May Massee, I should never have dared think in terms of so much color and so much paper. Without her patience and faith, I might never have finished the job."*]

Robert McCloskey is philosopher-poet-painter, and he needed the gifts of all three to make **Time of Wonder**—the philosopher's gifts to wonder about the ways of nature in sea and sky and islands, and the ways of children growing happily to understand and love their life on one of those Maine islands, from early spring to late autumn. He needed the poet's gift to see clearly and to choose just the right words to make everything vivid for his readers. He needed the gifts of the painter to make the pictures which will be pored over by thousands and thousands of fascinated children, old and young, who will become just a bit philosophers, poets, and painters in the degree that they love the book.

> *May Massee, in a review of "Time of Wonder,"* in Wisconsin Library Bulletin, *Vol. 54, No. 1, January-February, 1958, p. 83.*

The change of seasons on an island in Penobscot Bay is the subject of McCloskey's stunning new picture book. A dramatic change of pace for the author marks this book in its treatment of pictures and text. The pictures are in wonderful, muted, imaginative colors, with the human figures in minor focus, and the landscapes most important. Not a story but a lyrical description of a loved region. Recommended for all ages and all libraries, as a distinguished picture book. (pp. 34-5)

> *Dorothy Garey, in a review of "Time of Wonder,"* in Junior Libraries, *an appendix to* Library Journal *(reprinted from the February, 1958 issue of* Junior Libraries, *published by R. R. Bowker Co./A Xerox Corporation; copyright © 1958), Vol. 4, No. 6, February, 1958, pp. 34-5.*

In a departure from his usual style of writing and of book illustration, McCloskey's latest offering is a kind of prose poem in full color. It is more a mood piece than a story. . . . The artist's people are less successfully portrayed in color than in the black-and-white of his earlier books, but his landscapes, which are really the most important part of the book, are wonderfully evocative of the beauty of the Maine coast and of the power of the storm. Although the format is that of a picture book, the major appeal will be for children older than the traditional picture-book age who can appreciate the rhythmic beauty of the language and the mood that is being portrayed. An excellent volume for home libraries where the entire family will find much to share and enjoy.

> *Zena Sutherland, in a review of "Time of Wonder,"* in Bulletin of the Children's Book Center *(reprinted by permission of The University of Chicago Press), Vol. 11, No. 7, March, 1958, p. 71.*

McCloskey's style is full of language which mimics the storm and its ensuing calm. As fall approaches, the memories of the

past months allow for reflection—reflection on the unanswerable secrets of nature.

Robert McCloskey records this nearly religious experience with nature in a predominantly blue and green palette. The watercolor illustrations, which lap over the center of the book, leaving the far left for the text, are conspicuously void of the expressive lines of other McCloskey books. The medium takes control and interprets the emotional responses appropriate to the text through the color and the natural characteristics of the paint.

The blues and greens are well suited to producing the visual effects of the water, fog, storm, and sunshine that are integral to the book's theme. The style, because of the manner in which McCloskey has used his medium, has less detail and is more expressionistic, demanding more from the viewer. (pp. 311-12)

> *Linda Kauffman Peterson, "The Caldecott Medal and Honor Books, 1938-1981: 'Time of Wonder'," in* Newbery and Caldecott Medal and Honor Books: An Annotated Bibliography *by Linda Kauffman Peterson and Marilyn Leathers Solt (copyright © 1982 by Marilyn Solt and Linda Peterson; reprinted with the permission of Twayne Publishers, a division of G. K. Hall & Co., Boston), G. K. Hall, 1982, pp. 311-12.*

BURT DOW, DEEP-WATER MAN: A TALE OF THE SEA IN THE CLASSIC TRADITION (1963)

Old sailors never give up and Burt Dow, one of the Maine breed (who surely must be a descendent of New England's classic Old Stormalong) is as doughty as any. When he inadvertently catches a whale by the tail, he patches up his unwelcome victim with a Band-Aid and then, caught in a big blow, goes Jonah one better sliding, boat and all, right down into the whale's belly. Once in, can he get out? He does, most ingeniously, and sails smack into a whole school of whales—pink, blue, magenta, green. How Burt handles that situation will tickle any youngster with an appreciation of the ridiculous.

This is broad comedy—a whopper—and if Robert McCloskey is a little long-winded in getting the story under way, he makes up for that with plenty of action. Color plays an important part in this tall tale, and Mr. McCloskey . . . emphasizes this theme in dazzling shades and in bold, poster-style patterns. That rainbow-colored school of whales is something to see.

> *Ellen Lewis Buell, in a review of "Burt Dow: Deep-Water Man," in* The New York Times Book Review *(copyright © 1963 by The New York Times Company; reprinted by permission), October 6, 1963, p. 42.*

Splashy colors, wondrous whales, and the author's faultless characterization (even in so simple a story) make this not only

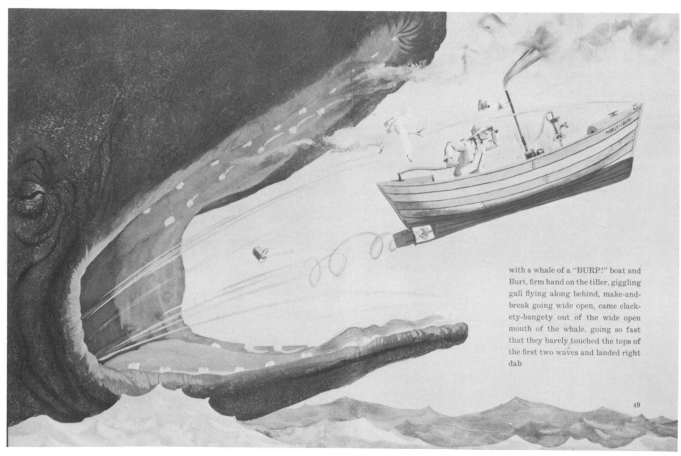

with a whale of a "BURP!" boat and Burt, firm hand on the tiller, giggling gull flying along behind, make-and-break going wide open, came clackety-bangety out of the wide open mouth of the whale, going so fast that they barely touched the tops of the first two waves and landed right dab

49

From Burt Dow, Deep-Water Man: A Tale of the Sea in the Classic Tradition, *written and illustrated by Robert McCloskey. The Viking Press, 1963. Copyright © 1963 by Robert McCloskey. Reprinted by permission of Viking Penguin Inc.*

in the classic tradition of the sea, but in the surefire tradition of the author.

Patricia H. Allen, in a review of "Burt Dow, Deep-Water Man," in School Library Journal *an appendix to* Library Journal *(reprinted from the November, 1963 issue of* School Library Journal, *published by R. R. Bowker Co./A Xerox Corporation; copyright © 1963), Vol. 10, No. 3, November, 1963, p. 56.*

Robert McCloskey has insured his place in the children's hall of fame already with his **"Make Way for Ducklings"** and this will not detract from it. He has again shown his remarkable genius with a paint brush. That his story cannot quite decide whether to be a mere whimsical stretch of the imagination or an out-and-out fairy tale in the mood of Pinocchio won't matter too much to children who like to hear about whales swallowing people no matter how often it has been done; and it won't matter at all to children who like pictures, for they will be caught up in the wonderment of a McCloskey-painted world long after the story ceases to absorb them. The enchanting scenes of Burt Dow making off with his multicolored dory into the wild, purple sea and meeting pink-mouthed whales really needs no text at all. It's a deep water voyage into art.

Guernsey Le Pelley, "A Picture Is Worth 10,000 Whales—From A to Zizzer-Zazzer-Zuzz: Seeworthy Fun and Otter Nonsense," in The Christian Science Monitor *(reprinted by permission from* The Christian Science Monitor; © 1963 The Christian Science Publishing Society; all rights reserved), November 14, 1963, p. 2B.**

A rip-roaring tall tale. . . . Every page but one (which is black) is in bright color, the startling pictures stretch across the page completely (so that the text is usually printed over color) and are in a massive bold poster-like technique combined with more subtle painting of sky and sea. Mr. McCloskey is exaggerating his color effects in a tall-tale way just as he exaggerates in words, contrasting charming shore scenes and brash designs of splotches, whales' tails and a shocking pink and green boat sitting like a cut-out on the softly mottled green waves. . . . The means [Burt Dow] uses to force the whale to spew him forth (splashing bilge water, cup grease and assorted paints on the poor whale's quivering tummy) and his problems when surrounded by a whole school of whales, all waving their tails at him because they wish to be decorated with band-aids, is certainly a whale of a tale.

Burt Dow belongs to the immortal company of Paul Bunyan and Pecos Bill. He, with his giggling gull, will chug eternally in the leaky Tidely-Idley through the colder, rougher waters that are remarkably like those down East, off the rocky shores of Maine.

Margaret Sherwood Libby, "A Sailor's Whale of a Tale," in Book Week—The Sunday Herald Tribune *(© 1963, The Washington Post), November 24, 1963, p. 22.*

The exaggerated nonsense of the visit to the whale's interior and the invasion of whales all wanting band-aids is in contrast to the lighter fun of the giggling gull and the name of Burt's boat, *Tidely-Idley*. The treatment of the story in the illustrations is definitely right. Instead of the naturalistic pictures of *Time of Wonder* with their feeling of spray and wind, this book is deliberately unrealistic. Some illustrations are flat and poster-like; the sea is always a painted sea, never a wet sea. Even the splashes look like sprays and blobs of paint, not water. Nevertheless, the effects are spectacular with spreads of color—pink, yellow, blue, green, black, and soft in-between tones. The whale is wonderful, and the armada of whales stretching across the page is handsome. . . . This new [tall tale] should find a wide and delighted audience. (pp. 592-93)

Ruth Hill Viguers, in a review of "Burt Dow: Deep-Water Man," in The Horn Book Magazine *(copyright © 1963, by The Horn Book, Inc., Boston), Vol. XXXIX, No. 6, December, 1963, pp. 592-93.*

Graham Oakley

1929-

English author/illustrator of picture books and illustrator.

Oakley is recognized as a gifted storyteller and illustrator of fantasies which serve as social commentaries on contemporary society. His *Church Mice* series centers on the lively mice and their long-suffering guardian, Sampson the cat, who are vestry residents in the parish church of Wortlethorpe, a fictitious British town. The animals star in frenzied adventures which focus on personal threats to Sampson and the mice or involve unsuccessful attempts to raise money for the church. Oakley utilizes these plots to lampoon such figures as scientists (*The Church Mice and the Moon*), media people (*The Church Cat Abroad*), and a hippie curate (*The Church Mice at Bay*). Elaborate, comical illustrations and witty, understated texts characterize the series, which critics consider delightful and rich in humor. Oakley has also produced two other popular works. *Graham Oakley's Magical Changes* is a wordless flip book which uses different combinations of tops and bottoms to change scenes. Reviewers deem it both brilliant and disturbing for its merging of surrealism, satire, and comedy. *Hetty and Harriet*, the story of two hens searching for a better home, gives a humorous presentation of Oakley's distaste for modern technology.

A former assistant designer at the Royal Opera House and set designer for the BBC, Oakley views himself primarily as an illustrator, yet critics praise the unity of his pictures and texts. Oakley's watercolor illustrations incorporate abundant detail, varied perspectives, and pervasive drollery. His love of animation is especially well depicted in crowds of mice, where each one remains a busy individual. Employing dry wit, adult humor, and restrained language in his writing, Oakley frequently draws outlandish pictures which add hilarity and further meaning to stories already rich in action. While most reviewers applaud his talent for weaving an extraordinary amount into his illustrations, others feel he clutters his pages. Some critics comment that his wit and language are too sophisticated or too British at times for American children. However, they agree that Oakley's books, which blend adventure with allusion, can be relished by the entire family. Both *The Church Mice Adrift* in 1977 and *The Church Mice in Action* in 1982 were highly commended by the Kate Greenaway Medal committee. In 1980, *Graham Oakley's Magical Changes* received a *Boston Globe-Horn Book* special citation.

(See also *Something about the Author*, Vol. 30 and *Contemporary Authors*, Vol. 106.)

AUTHOR'S COMMENTARY

[*In the following interview by Barbara A. Bannon, Oakley comments on his* Church Mice *series.*]

Children in Britain, the United States, Germany and Japan enjoy his books. So do cat-lovers of all ages. And if there are mice-lovers among us—and there must be—they should be the most appreciative of all. . . .

[In six picture books] Graham Oakley has invented Wortlethorpe (a British provincial town caught between the past and

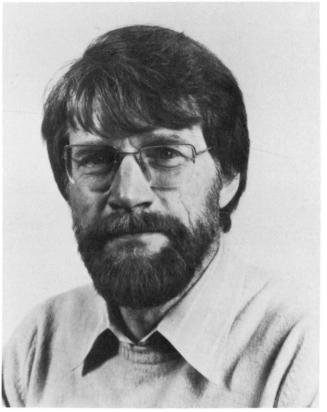

the present), the local Anglican parish church of St. John, and a most endearing group of undercover vestry residents—the church mice. Presiding over all in a bumbling but totally well-intended fashion is Sampson, the church cat, large, orange and dedicated to being A Friend to Mice. . . .

Oakley had been working as a free-lance illustrator of children's books for Macmillan of London when he began to think of a country town like Wortlethorpe as the basis of a series of picture books for children. "I was going to open with a high view on top of the town and a series of stories about each building," he says, "starting with the church and moving on to the library and the town hall, but the first book, **'The Church Mouse'** was so successful I never got to the library."

"No, I don't have a cat myself, but I've always collected photographs of them. I try not to let anything human creep into my portrayal of Sampson, to keep him looking like a cat at all times. He does just what a cat would do in any situation, when he is frightened, happy, puzzled.

"The church mice, on the other hand, are easy to anthropomorphize, and I think it's no great affront to nature to do so." (Oakley's mice have distinctive "personalities" and attitudes.)

As Oakley sees it, "I think the picture book for young children should be the work of the same person as author of the plot

and illustrator. I am essentially a drawer of pictures rather than a writer of words. I'm very opposed to pictures in children's books that look like paintings in a gallery. What I want to do is to use as few descriptive passages as possible, to show almost everything in pictures. With picture books being so expensive and the limitations of a 32-page format, I think it is the artist's duty to cram in as much as possible. You must use every inch of space.''

The church mice-church cat books are indeed fascinating in their wealth of colorful detail. You can go back again and again and discover something new as in the mice protest march in **"The Church Mice at Bay,"** where the smallest signs proclaim "MICE ARE NICE," "SMALL IS BEAUTIFUL," "MICE ARE PEOPLE," "RICE FOR MICE."

The general idea in each of the church mice books is that the mice are threatened and must overcome that threat triumphantly, with Sampson's sometimes misguided aid.

"I try to think, 'How could a little creature get rid of a man?'" Oakley says. "The devices have to be contrived. I suppose what I'm trying to do is create a James Bond-type story on the mice level." (p. 74)

With, as Oakley put it, "Sampson as their muscle," the two completely alien animal species prove by compromise and sharing "they can rub along together. It's not that untrue to nature. Cats brought up with mice won't attack them any more than a dog and cat brought up together will attack each other."

Oakley plans to continue the church mice stories "until I think I have done the best I can do, but not necessarily at the rate of one a year. We always have great trouble finding a title. One reason is the possessive of 'mice.' 'Mice's' and 'Mouse's' are two of the great anomalies of English grammar." (p. 75)

> *A conversation with Graham Oakley, in* Publishers Weekly *(reprinted from the February 26, 1979 issue of* Publishers Weekly, *published by R. R. Bowker Company, a Xerox company; copyright © 1979 by Xerox Corporation), Vol. 215, No. 9, February 26, 1979, pp. 74-5.*

GENERAL COMMENTARY

BERNICE E. CULLINAN with MARY K. KARRER and ARLENE M. PILLAR

Graham Oakley achieves a superlative blend of text and pictures in *The Church Mouse* . . . , which is one of a series. . . . Each story is a riotous adventure in chaos, in which the extravagant illustrations add comedy to the rather droll, understated text. For example, in *The Church Mice at Bay* . . . the text states that the mice had hoped the vicar's summer replacement would be "a nice quiet young chap." The next page has only two words—"He wasn't"—but a picture that is a panorama of outlandish jumble; a car decorated with flowers, butterflies, and peace doves tears into the driveway leaving scattered pedestrians, shattered milk bottles, an overrun bicyclist, and startled mice in its wake. (pp. 146-47)

> *Bernice E. Cullinan with Mary K. Karrer and Arlene M. Pillar, "Picture Books," in their* Literature and the Child *(copyright © 1981 by Harcourt Brace Jovanovich, Inc.; reprinted by permission of the publisher), Harcourt Brace Jovanovich, 1981, pp. 115-60.**

THE CHURCH MOUSE (1972)

If the anti-humanisation members of the reading public wanted a manifesto, they couldn't do better than to use the ringing words of eight-year-old Liz Sandison about mice that "talk and wear clothes and cook and things, mice that have names like people". This splendid character in Jane Duncan's *My friends the hungry generation* gets to the heart of the matter:

> "I can't be doing with lies. You know as well as I do that mice can't eat a morsel without going to the loo. If they get in a cupboard, they leave a ghastly mess of little black things. How would they get along in pink frilly pants?"

Graham Oakley's mice don't wear pink frilly pants; indeed, they are triumphantly mouselike except in the one crucial aspect. He has devised so many ingenious schemes (such as the prone-position brass polishing efforts of the mice and the pyramid of 55 of them on top of Sampson the cat by which they reach the bell-rope to warn the townsfolk that a burglar is after the church plate) that I don't believe a half-fanciful, half-viable lavatorial system would be beyond him.

I hope my objection will focus attention on one of the outstanding virtues of this picture-book—the otherwise satisfactory balance between fancy and fact. Vicar and congregation, burglar and car, tombstones and carpeting, are all as English as crumpets. Nothing is distorted. Simply, the author/artist has stepped aside to look at the 'busy little town' and its church not from a human angle but as the church cat and his friend Arthur the church mouse see it. Their alliance is plausibly explained. Sampson "had listened to so many sermons about the meek being blessed and everybody really being brothers that he had grown quite frighteningly meek and treated Arthur just like a brother", and he was ready to support the mouse when he asked the parson if he could invite his town friends to live in the church rent free in return for such odd jobs (like confetti-collecting) as a mouse could reasonably do. Unfortunately, one Harvest Festival, Sampson, weary after a night of mouse-baby-sitting, fell asleep during the sermon and "dreamt he was back in the days before he was reformed. When he woke up he found he was not dreaming. He was chasing mice all over the church". The congregation rebelled, notice to quit was served on the mice, but that night the burglar came. . . .

The story goes with a swing and the slapstick and circumstantial detail are livened with a measure of wit. . . . Adults and children alike could enjoy reading the memorial plaque to a certain 'pious citizen' of the parish, Richard Turpin, or noticing what the mouse assembly collected for seats or admiring the range of expression which the artist has given to his cat and mice without affronting Dame Nature in the least. As for his suave colouring—predominantly purple, hard blue and gold—and the easy correlation of text and illustration, these must be studied with care, for there is a great deal to be seen and admired. Picture-books are no longer only the property of an infant élite; this one should be handed round the family, to provide heartwarming pleasure for all. (pp. 2027-28)

> *Margery Fisher, in a review of "The Church Mouse," in her* Growing Point, *Vol. 11, No. 5, November, 1972, pp. 2027-28.*

The text is richly interlarded with beautifully detailed illustrations showing the mice indulging in all manner of fascinating activities, from polishing brasses and staggering about with huge piles of confetti to rolling up a burglar in a carpet. Graham

From The Church Mice at Bay, *written and illustrated by Graham Oakley. Atheneum, 1979. Copyright © 1978 by Graham Oakley. Reprinted with permission of Atheneum Publishers, New York. In Canada by Macmillan Publishers Ltd., London.*

Oakley shows in this book how effectively words and pictures can be grafted together so that our understanding of the story depends on the combination of the two.

> *"In the Garden of Eden," in* The Times Literary Supplement *(© Times Newspapers Ltd. (London) 1972; reproduced from* The Times Literary Supplement *by permission), No. 3687, November 3, 1972, p. 1327.**

Graham Oakley is an extremely talented artist, and this book has quite outstanding pictures—richly coloured, imaginative and often witty. The story . . . is an appealing one, but the tone of the story is not entirely in harmony with the illustrations. The humour is too adult, and there are some unfortunate usages of words—the townsfolk are "peevish" when a burglar attempts to steal their church candlesticks. A pity. (pp. 759-60)

> *Ruth Marris, in a review of "The Churchmouse," in* The Spectator *(© 1972 by* The Spectator; *reprinted by permission of* The Spectator), *No. 7533, November 11, 1972, pp. 759-60.*

Good for Graham Oakley! . . . [He] has succeeded in creating a book for children—not "children of all ages," but *children,*

ages 5 to 9, give or take a few birthdays. **"The Church Mouse"** . . . is not another sly, tongue-in-chic production insinuating mysterious "levels." It is an intelligent book, combining simplicity and sophistication, and it doesn't condescend. It is a well-integrated picture story, with a text almost as special as the art work. . . .

How anxious Arthur and the other mice (with the aid of a contrite and clever Sampson) save the situation and their own subsistence is told with a lively touch of nonsense that children—of all ages—should find irresistible.

> *Judy Noyes, in a review of "The Church Mouse," in* The New York Times Book Review *(copyright © 1972 by The New York Times Company; reprinted by permission), December 10, 1972, p. 8.*

The manner of the telling of this tale is, at best, chummily unpretentious and, at worst, over-written and facetious, but the words are really only so much excuse for Mr. Oakley to display his virtuosity as an illustrator. In contrast to the artistic colourists or the two-dimensional simplifiers, Mr. Oakley is a realist. Every colour drawing on every page-opening is rich in precisely observed detail. The carving round a font—and the paper boat floating in it—the inscriptions on match-boxes and wall-tablets, all bear witness to Mr. Oakley's delight in trivia,

Sampson himself did baby-sitting, and *they* didn't mind a bit about hurting his feelings, or any other part of him for that matter.

From The Church Mouse, *written and illustrated by Graham Oakley. Atheneum, 1972. Copyright ©*
1972 by Graham Oakley. Reprinted with permission of Atheneum Publishers, New York. In Canada by
Macmillan Publishers Ltd., London.

and they are backed up by the care that he has lavished on the total composition of every scene. At times there is a harshness in the patina of the printing inks, at times one has a queasy feeling of being inundated by pictures, but there is evidence enough that Oakley, refined like Samson, will prove a formidable picture-book artist.

> *Brian W. Alderson, in a review of ''The Church Mouse,'' in* Children's Book Review *(© 1973 Five Owls Press Ltd.; all rights reserved), Vol. III, No. 1, February, 1973, p. 9.*

Although the picture-book format is more appropriate for the primary-grade level, the play on clichés (e.g., ''leopard in sheep's clothing'' and ''a wolf couldn't change its spots'') will be missed by children below grades five or six who are not familiar with their usual usage. Children will enjoy the funny details which abound in the story and color illustrations, but the pictures are extremely cluttered. (pp. 65, 67)

> *Elsie F. Schott, in a review of ''The Church Mouse,'' in* School Library Journal, *an appendix to* Library Journal *(reprinted from the May, 1973 issue of* School Library Journal, *published by R. R. Bowker Co./A Xerox Corporation; copyright © 1973), Vol. 19, No. 9, May, 1973, pp. 65, 67.*

THE CHURCH CAT ABROAD (1973)

Perhaps [*The Church Cat Abroad*] is not quite such a neat piece as the first story about Sampson, but it is still support enough for the alert, infinitely detailed illustrations, in which the author exploits his talent for interstitial reading matter. Don't miss, for example, the title of an artist's book or the readable part of the reporter's notebook or. . . . Definitely a book to savour slowly.

> *Margery Fisher, in a review of ''The Church Cat Abroad,'' in her* Growing Point, *Vol. 12, No. 4, October, 1973, p. 2245.*

Mr. Oakley's very funny story and his even funnier illustrations—copious, painstakingly detailed and packed with jokes to delight all ages—take the three adventurers into numerous situations rich with comic possibilities, and he exploits every one of them to the full. Special gems are the seedy agent's office papered with photographs of identical starlets, the exotic South Sea island where Sampson is to make a cat food commercial for a neurotic director in a safari hat, Batman T-shirt and Zapata moustache . . . and, finally, a cage at the zoo, where the three friends take umbrage at a welter of descriptive labels casting unpleasant aspersions on their moral characters and personal habits.

"Talking to the Animals," in The Times Literary Supplement *(© Times Newspapers Ltd. (London) 1973; reproduced from* The Times Literary Supplement *by permission), No. 3742, November 23, 1973, p. 1440.**

In order to raise money to repair the roof of his vestry home, church cat Sampson (abetted by two clever church mice) lands a job in a TV cat food commercial. . . . Although the intended audience of five- to nine-year-olds won't know the meaning of "roguish," "nonchalant," "mollycoddled," etc., and will find the text tough going, they can follow the story from the superb full-color illustrations filled with delightful double entendres and detailed down to the old cigarette butts on an actor's agent's carpet.

M. K. Pace, in a review of "The Church Cat Abroad," in School Library Journal, *an appendix to* Library Journal *(reprinted from the December, 1973 issue of* School Library Journal, *published by R. R. Bowker Co./A Xerox Corporation; copyright © 1973), Vol. 20, No. 4, December, 1973, p. 44.*

Having gained an immediate success with **The Church Mouse,** which was highly acclaimed as one of the best children's picture books of 1972, it was natural to await Graham Oakley's next book with a sense of eager anticipation. Now that it has appeared one can make a comparison and say at once that many of the expectations have been lived up to in **The Church Cat Abroad** but there is one reservation. . . . [The book has] a story full of humorous incidents and superb illustrations. Graham Oakley is a true artist of the highest calibre with an ability to create and exploit humorous situations to the full. He has proved in his new book that his talents are not limited to situations purely involving his principal cat and mouse characters, for his TV agent and camera crew, his tropical animal life, his shipful of scientists and a host of other incidental characters are all drawn and painted with the eye of a talented analytical artist. The reservation mentioned alludes only to Graham Oakley's sense of humour. He is very funny but his humour borders near to the zany and he must be careful not to contrive situations purely as a medium for his humour, much of which, while easily appreciated by adults, will not receive the same response from children. One looks forward to the expanding use of his many talents developing ideas outside the well worn cat and mouse syndrome.

Edward Hudson, in a review of "The Church Cat Abroad," in Children's Book Review *(© 1974 Five Owls Press Ltd.; all rights reserved), Vol. IV, No. 1, Spring, 1974, p. 12.*

THE CHURCH MICE AND THE MOON (1974)

The Church Mice and their feline friend Sampson are becoming progressively less convincing as their adventures move further from the village where they were first spotted by delighted readers. Arthur and Humphrey, heroes of this third book, are kidnapped and given intensive training for a rocket flight but Sampson interferes with the wiring of the rocket and turns the moon flight into a farce in which the Mayor is discomfited and the two inventors are reduced to begging in the street. The pictures are as full of sly detail as ever, and colour is skilfully managed, but there is something mechanical about the whole book.

Margery Fisher, in a review of "The Church Mice and the Moon," in her Growing Point, *Vol. 13, No. 6, December, 1974, p. 2541.*

On re-appraising Graham Oakley's cat and mice stories, I am reminded of a book I read some years ago called *The Englishness of English Art,* for Graham Oakley does, indeed, epitomise the Englishness of English picture books. In his latest volume, as in **The Church Mouse** and **The Church Cat Abroad,** he has brought a delightful freshness and sensitivity to the English scene and way of life which he uses as a backcloth for the outrageous adventures of Sampson, the Church Cat, and his cohort of friendly mice. If one can accept the extraordinary happenings at face value and not delve too deeply into their impracticalities, Graham Oakley's witty stories are books to be *enjoyed*—and how often is this vital ingredient missing from children's picture books. . . .

One illustration combines all Graham Oakley's talents: it shows Sampson, perched on the capsule which is floating down the river, fighting off an attack from two ferocious swans. 'Sampson was wondering why poets were always writing about swans'. A picture book which will add to Graham Oakley's status as an illustrator. One awaits his future output with enthusiasm.

Edward Hudson, in a review of "The Church Mice and the Moon," in Children's Book Review *(© 1975 Five Owls Press Ltd.; all rights reserved), Vol. V, No. 1, Spring, 1975, p. 14.*

The humor—dry British wit and understatement—may be too sophisticated for some young Americans, but those who take the time to examine the wonderfully detailed illustrations will be amply rewarded with chuckles.

Cherie Zarookian, in a review of "The Church Mice and the Moon," in School Library Journal *(reprinted from the April, 1975 issue of* School Library Journal, *published by R. R. Bowker Co./A Xerox Corporation; copyright © 1975), Vol. 21, No. 8, April, 1975, p. 46.*

Long and involved is the story crammed into Graham Oakley's **"The Church Mice and the Moon."** . . . Its dry British wit will appeal to people who delight in tongue-and-cheek talk. The pictures are full of detailed realism that will be enjoyed even by those too restless to follow the text. Letting the art carry more of the story would have speeded up this [book]. . . .

Alice Bach, in a review of "The Church Mice and the Moon," in The New York Times Book Review *(copyright © 1975 by The New York Times Company; reprinted by permission), May 4, 1975, p. 42.*

Graham Oakley [sends] up things other than a moon-capsule containing Arthur and Humphrey, astromice. He sends up scientists ("they agreed they hadn't seen what they'd seen because if they had it would prove that certain things existed which every good scientist knew jolly well didn't"); he sends up the media men, and he sends up the civic authorities. It's all enormous fun for kids of about nine. . . . The pictures, as in the earlier volumes, are overrun with mice, tin cans, newspapers, labels, tombstones—to which scientific instruments have now been added. A picture book, yes; but for the older child with an interest in science and a sense of humour.

Elaine Moss, "Fiction 2, Stories for 8-11 Year Olds: 'The Church Mice and the Moon'," in Children's Books of the Year: 1974, *edited by Elaine Moss (© Elaine Moss 1975), Hamish Hamilton, 1975, p. 54.*

THE CHURCH MICE SPREAD THEIR WINGS (1975)

Graham Oakley writes in a very sophisticated way which is highly amusing for adults but much less meaningful for children; however, though the satirical overtones may be lost on them, *The Church Mice Spread Their Wings* has many redeeming features; not the least of them is a very endearing cast of characters. (p. 1452)

> Lesley Croome, "Strengthening the Imagination," in The Times Literary Supplement (© Times Newspapers Ltd. (London) 1975; reproduced from The Times Literary Supplement by permission), No. 3847, December 5, 1975, pp. 1452-53.*

When the church mice and Sampson the cat try to escape "the rat race" they find a jaunt to the country less than idyllic: their journey home through exotic terrain (they think a sand and gravel company is the Sahara Desert) is fraught with danger (they mistake a garden hose for a mouse-eating snake). Humphrey and Arthur are carried to the church belfry by a hungry owl, make their escape on a paper airplane, crash land in the parson's corn flakes, and are home in time for their own funeral. Oakley's fourth picture book starring the church mice is as humorous as ever. The full-color illustrations are filled with marvelously funny details that perfectly complement the story's wit. Certain concepts and British phrases may be confusing to younger American children, but those willing to . . . *Spread Their Wings* with these mice will be amply rewarded. (pp. 62-3)

> Andrew K. Stevenson, in a review of "The Church Mice Spread Their Wings," in School Library Journal (reprinted from the April, 1976 issue of School Library Journal, published by R. R. Bowker Co./A Xerox Corporation; copyright © 1976), Vol. 22, No. 8, April, 1976, pp. 62-3.

["**The Church Mice Spread Their Wings**"] fairly bulges with extravagant detail. British author-artist Graham Oakley must have spent a year painting the pictures for . . . [this story], the fourth book in his glorious series about these mischievous rodents. There are 126 mice in the first illustration alone, each one completely mouselike but each doing something different with an almost human perfection of gesture: dancing, playing bowls, strolling under a flower umbrella, kissing another mouse under a rosebush, finding out by means of the buttercup test whether another mouse likes butter. All 51 vastly populated pictures are printed in the dazzling colors of nature itself, and thus this book is a little more expensive than the rest. But a Graham Oakley should be thought of as a lifetime investment in rapture. Open on a coffee table it will provide all comers with a half hour of guaranteed pure happiness. My favorite illustration is the double-page spread of two mice escaping from the church belfry in a paper airplane that goes *swoop, swoop*, right before your eyes, and heads for the window of the parsonage. The humor of the text is a little heavy-handed, but the pictures are made with joy and loving care and passion. (I said passion.)

Even though it is a funny book, the lavish portrayal of the natural world in "**The Church Mice Spread Their Wings**" is closer to the spirit of the first chapter of Genesis than is a new book about Adam and Eve, "The Very First Story Ever Told" [by Lisl Weil].

> Jane Langton, in a review of "The Church Mice Spread Their Wings," in The New York Times Book Review (copyright © 1976 by The New York Times Company; reprinted by permission), May 2, 1976, p. 46.

THE CHURCH MICE ADRIFT (1976)

Graham Oakley's Church Mice are now established favourites in the eight to ten age group where, along with Tin Tin and the Asterix and Captain Najork they have led a revolution in order to establish the respectability of full colour picture-books, with sophisticated texts, as reading matter for older children. *The Church Mice Adrift* rises triumphantly, as did its predecessors, over an old-fashioned layout that includes a two-column text and pictures of not very prettily assorted or finely balanced rectangles. But the fecund exuberance of Graham Oakley's witty words and the teeming details of his pictures need this rigid control which brings with it a feeling of compressed yet explosive rush, tumble and hurry that accentuates the fun. In this story mice, storms, rats, demolition, eviction and rivers in spate are enough to ruffle the fur, flatten the ears, test the wits and almost (but not quite) outflank the ingenuity of doughty old Sampson . . . who, as usual, brings the mice safely home to the vestry.

> Elaine Moss, "A Delicate Balance," in The Times Literary Supplement (© Times Newspapers Ltd. (London) 1976; reproduced from The Times Literary Supplement by permission), No. 3900, December 10, 1976, p. 1551.*

Oakley is as sharp as ever in this fifth church mice episode: the humorously detailed illustrations not only accentuate the wry wit but often are a story unto themselves. Some of the fun may be over the heads of younger listeners, but there are still enough laughs here for everyone.

> Andrew K. Stevenson, in a review of "The Church Mice Adrift," in School Library Journal (reprinted from the April, 1977 issue of School Library Journal, published by R. R. Bowker Co./A Xerox Corporation; copyright © 1977), Vol. 23, No. 8, April, 1977, p. 56.

[In "**The Church Mice Adrift**," we are soon] fast adrift in another of Mr. Oakley's elaborate plots.

The illustrations are almost as good as a visit to England. In delightful detail that moves the story forward, I counted no less than 20 buildings on one page, and some 65 mice in another—each and every mouse unique and doing his own thing.

Old-school story telling that holds attention.

> Gene Langley, "The Care and Feeding of Hippos," in The Christian Science Monitor (reprinted by permission from The Christian Science Monitor; © 1977 The Christian Science Publishing Society; all rights reserved), May 4, 1977, p. B4.*

In his splendid picture books about an excitable horde of church mice and their courageous protector-cat, Graham Oakley reminds me of God. For one thing he has an Olympian view, like God, who somehow sees the whole universe at once; and for another he seems to have a sort of zoom lens for small detail, again like God, who sees the least sparrow fall.

Consider the first picture in his book. We look down on an entire English village, complete with river, bridge, shops, church,

From The Church Mice Spread Their Wings, *written and illustrated by Graham Oakley. Atheneum, 1976. Copyright © 1975 by Graham Oakley. Reprinted with permission of Atheneum Publishers, New York. In Canada by Macmillan Publishers Ltd., London.*

cemetery, people, prams and cars. In the foreground the bull-dozers and wrecking balls of the Heritage Demolition Company are insanely destroying the oldest houses in order to erect a monstrous cube of steel and glass (see the billboard of the Wortlethorpe Town Planning Department). Turn the page. Zero in on the gang of rats deserting the falling building. From here on it is all mayhem in hilarious glowing color, both in vast panoramas and in mousy microcosm. . . . Oakley draws like an angel, whether his brush is outlining an almost invisible quivering whisker or washing in the green shimmer of a lush riverscape.

My husband says this book is racist, because the mice are pale and the rats are dark brown. But I think it is merely the age-old collision of virtue and vice. Behold the debauchery and gluttony of the rats at table, what a scene of carnage! Garbage flying, the floor awash with slop! Oh, how it preaches of the fall of man! O, the symbolism, O, the theological overtones!

Well, forget the theological overtones. The book is a wonder with or without overtones. I hope the brilliant author-artist will still be painting pictures when he is 99, like Titian, turning out new books about the church mice, cranking up from the bottomless well of his genius the same old Oakley bucket.

> *Jane Langton, in a review of "The Church Mice Adrift," in* The New York Times Book Review

> *(copyright © 1977 by The New York Times Company; reprinted by permission), May 8, 1977, p. 41.*

THE CHURCH MICE AT BAY (1978)

When the Vicar goes on holiday his locum, the ultimate in trendy costume, idiom and behaviour, unsettles Sampson and the mice. . . . Sampson wins in the end, though, escaping from the local pound to lead a riotous procession of cats, dogs and mice through the town to the discomfiture of the curate, an involuntary streaker. This robustly topical instalment in the Wortlethorpe saga lends itself to Graham Oakley's comically deft style; perhaps he has never so skillfully used shape and colour to express personality.

> *Margery Fisher, in a review of "The Church [Mice] at Bay," in her* Growing Point, *Vol. 17, No. 5, January, 1979, p. 3450.*

Old friends of the Church Mice and Sampson the cat will probably love this, but it won't win any new adherents. . . . Older kids who can appreciate the bits and pieces of subtle jokery in the busy pictures are the audience for this. Little ones will like, most of all, the dozens of tiny little mice tracing "THE END."

From The Church Mice Adrift, *written and illustrated by Graham Oakley. Atheneum, 1977. Copyright © 1976 by Graham Oakley. Reprinted with permission of Atheneum Publishers, New York. In Canada by Macmillan Publishers Ltd., London.*

Marjorie Lewis, in a review of ''The Church Mice at Bay,'' in School Library Journal *(reprinted from the March, 1979 issue of* School Library Journal, *published by R. R. Bowker Co./A Xerox Corporation; copyright © 1979), Vol. 25, No. 7, March, 1979, p. 143.*

Sampson, the Wortlethorpe church cat, and his friends the church mice are familiar objects in the children's book scene, but familiarity breeds respect, affection and admiration. Here surely is one very good way of writing for children. The fantasy is based firmly in the realities of modern life. . . . It is not only Sampson's colouring that reminds us of *Orlando the Marmalade Cat;* the quiet humour and the attention to the most minute detail are strongly reminiscent of Kathleen Hale. Here is fun and sound observation and a relevant theme, and not a scrap of adult condescension. (pp. 99-100)

Marcus Crouch, in a review of ''The Church Mice at Bay,'' in The Junior Bookshelf, *Vol. 43, No. 2, April, 1979, pp. 99-100.*

The tale, although amusing, serves as a vehicle for the characteristic illustrations, used as a witty commentary on the hippie scene and on life in a small English city—garden parties and all. The mice are undoubtedly among the most expressive ever drawn, and poor old Sampson is one of the most put-upon of cats.

Ann A. Flowers, in a review of ''The Church Mice at Bay,'' in The Horn Book Magazine *(copyright © 1979, by The Horn Book, Inc., Boston), Vol. LV, No. 3, June, 1979, p. 294.*

I feel that some children's books are so enjoyable to read that I want to read them twice in one sitting, and even sneak in a third look, too. This particular author-illustrator, Graham Oakley, has charm and wit and the perseverance to publish. This excellent book is the fifth in a series . . . and, believe me, the quality is still at its peak. ***The Church Mice at Bay*** . . . is a comic masterpiece. Busy, active and colorful pictures, with one crazy detail after the other, weave in and out of the marvelously humorous text. What a lark!

A review of ''The Church Mice at Bay,'' in The Babbling Bookworm *(copyright 1979 The Babbling Bookworm Newsletter), Vol. 7, No. 10, November, 1979, p. 3.*

GRAHAM OAKLEY'S MAGICAL CHANGES (1979)

With his split-page ***Magical Changes*** . . . Graham Oakley leaves the vestry and Church Mice behind and embarks on a technical

experiment in picture-book making that is likely to become a landmark in the history of the genre. Down-market split-page books we have had: spiral-bound bits of predictable fun and games where freakish incongruity is a quick joke, and meaningless. Oakley's joke is of huge dimension, and symbolic. He is exploring the free-floating human psyche with its surreal associations, often grotesque and disturbing in the manner of Dali and Magritte, but funny too. Humour plays a large part in the subconscious. Most of us can remember waking up from a dream laughing—not as often as in a cold sweat, mind you, but it happens. What Graham Oakley has succeeded in doing in this graphically ingenious picture book is to give the 'reader' (there is no text) the sensation of the ever-changing dream.

The pages are split in half horizontally. Each left-hand page has six stems bled off the top edge of the bottom picture, and six bled off the bottom edge of the top. (The right-hand page has four thicker stems similarly placed.) So, to take just one progression out of thousands of possible permutations, six city gents with six umbrella handles held aloft find themselves with, first page, the expected umbrella on top: turn over the top half and six legs of three Pterodactyls attach themselves to the umbrella handles, then the fan vaulting of a decaying cathedral (six slender pillars), then six lollipops, six clothes-lines with floating underwear, six strands of spaghetti being wound up by a gigantic fork. And the expression on the faces of the six city gents is immutable (because it's the same painting throughout). These Jungian jokes and Freudian frolics are for people who don't feel threatened by the four posts of their bed (right-hand page) supporting a Gothic railway arch with train thundering across, the Trojan Horse, four guttering candles, or four giant swans' heads. Design is the basis of this extraordinary book because only the most careful planning (and immaculate printing and binding) enables the images to flow.

This is a painter's book. (pp. 4-5)

> Elaine Moss, "W(h)ither Picture Books? Some Tricks of the Trade," in Signal (copyright © 1980 The Thimble Press; reprinted by permission of The Thimble Press, Lockwood Station Road, South Woodchester, Glos. GL55EQ, England), No. 31, January, 1980, pp. 3-7.*

Magical Changes is the sort of book that defies classification. The author is well known for his lavishly illustrated story books and there is no doubt that the mechanics alone of his latest work . . . are enough to fascinate almost anyone old enough to turn the pages. But the drawings themselves and their extraordinary variety, have a surreal quality that gives them a wider appeal. It is well worth a detour into the children's section of the bookshop.

> Mary Anne Bonney and Susan Jeffreys, in a review of "Magical Changes," in Punch (© 1980 by Punch Publications Ltd.; all rights reserved; may not be reprinted without permission), Vol. 278, January 16, 1980, p. 113.

As far a cry as conceivable from **"The Church Mouse"** and other picture books about the Church Mice and their friend Sampson the cat, Oakley's new *chef d'oeuvre* is astonishing. Perfectly normal paintings in rich colors appear on pages split horizontally so that the images become quite different when tops or bottoms are turned, distorting things into comic or fearful surrealism. . . . [This] wordless wonder proves again that the British artist is *really* something else.

A review of "Graham Oakley's Magical Changes," in Publishers Weekly *(reprinted from the February 15, 1980 issue of* Publishers Weekly, *published by R. R. Bowker Company, a Xerox company; copyright © 1980 by Xerox Corporation), Vol. 217, No. 6, February 15, 1980, p. 110.*

Strange and wonderful, droll and disquieting are the many images in this wordless, storyless book of fantastic visual combinations. . . . Ruins, ritual gatherings, and exotic plants mingle to invoke the spirit of Ozymandias. With careful, rich realism gone a little mad, with wit and audacity in subject and scale, these preposterous and jolting images call us back for another look, another more outrageous pairing.

> Mary B. Nickerson, in a review of "Graham Oakley's Magical Changes," in School Library Journal (reprinted from the May, 1980 issue of School Library Journal, published by R. R. Bowker Co./A Xerox Corporation; copyright © 1980), Vol. 26, No. 9, May, 1980, p. 62.

Graham Oakley has touched the eye, the imagination, and the emotions at a depth where words seem inadequate to describe the genius of this book. . . . [Each page] can be mixed and matched in over 4,000 combinations. . . . And that's where the fun begins—especially for teachers. Pick a combination at random, ask your students to write a story about what has led up to—six proper Englishmen carrying wash above their heads rather than umbrellas. I guarantee you'll never have to invent a theme topic again. Every classroom and library ought to own a copy of this educational and entertainment bonanza. It is brilliant and bizarre.

> Leigh Dean, in a review of "Graham Oakley's Magical Changes," in Children's Book Review Service (copyright © 1980 Children's Book Review Service Inc.), Vol. 8, No. 11, June, 1980, p. 103.

[Graham Oakley] presents us with thirty-two scenes—some strange and macabre, some ordinary, some drawn from legend and folklore. . . . The initial enjoyment of this book comes from seeing the incongruities that result from a flip of the page. However, the book seems to have deeper implications. Many of the basic pictures are, in themselves, satiric: a statue erected to the memory of mayors past and present shows four ravenous sharks; looking at a giant ruined statue an archaeologist sits on a huge hand resting in the sand; villagers stare in amazement at a giant holding six lollipops. The combinations are equally satiric: thus a slip of a half page shows the lollipops protruding from a burial urn—life and death are strangely juxtaposed. By creating such juxtapositions between the ordinary and the fabulous Oakley emphasizes the strangeness of life. Most books with half pages for flipping are gimmicks; *Magical Changes* is not—it offers an often humorous, often ironic commentary on life.

> Jon C. Stott, in a review of "Magical Changes," in The World of Children's Books (© 1981 Jon C. Stott), Vol. VI, 1981, p. 26.

THE CHURCH MICE AT CHRISTMAS (1980)

As in Graham Oakley's first book of the series, . . . the capture of a thief (this time in a Santa suit) leads to [a] happy conclusion. The pictures are very dark-toned, and the amount of detail per picture, many times two-to-a-page, can be overwhelming.

From Graham Oakley's Magical Changes, *illustrated by Graham Oakley. Atheneum, 1980. Copyright © 1979 by Graham Oakley. Reprinted with permission of Atheneum Publishers, New York. In Canada by Macmillan Publishers Ltd., London.*

Yet, the usual antics will engage those who have followed Arthur from his early days as a lone church mouse.

> *A review of "The Church Mice at Christmas," in* School Library Journal *(reprinted from the October, 1980 issue of* School Library Journal, *published by R. R. Bowker Co./A Xerox Corporation; copyright © 1980), Vol. 27, No. 2, October, 1980, p. 162.*

High praise for Graham Oakley's **The Church Mice at Christmas**. . . . Yes, it's the same set of characters, but the book is as visually exciting as any of its half-dozen predecessors. What richness in these pictures! The mice provide the action (they try to earn funds for a party) but the cat, their gentle protector, by his sheer expressive appearance, inspires the range of emotions that make these books stay in the minds of under eights.

> *Naomi Lewis, "Marriages of True Minds," in* The Times Educational Supplement *(© Times Newspapers Ltd. (London) 1980; reproduced from* The Times Educational Supplement *by permission), No. 3361, November 21, 1980, pp. 29-30.**

[Just how the successful solution to raising money] is found, makes a very funny book. The story really is the least of the book's success—far better to examine Oakley's drawings in detail. They are marvellous and well up to his usual high standard. This will please the whole family. (p. 6)

> *"Spyglass—1980," in* Book Window *(© 1980 S.C.B.A. and contributors), Vol. 8, No. 1, Winter, 1980, pp. 6, 8-10, 12.**

The seventh adventure of Sampson the church cat and the resident mice is another astonishing feat, Oakley's sober storytelling boosting the hilarity and his smashing paintings brimming over with tiny, comic touches. . . . In an adroit finish to his suspenseful tale . . . the British author-illustrator brings

Father Christmas to the rescue. . . . Such a party there never was in Wartlebury Close, with enough goodies to make everyone sick for days.

> *A review of "The Church Mice at Christmas," in* Publishers Weekly *(reprinted from the January 9, 1981 issue of* Publishers Weekly, *published by R. R. Bowker Company, a Xerox company; copyright © 1981 by Xerox Corporation), Vol. 219, No. 2, January 9, 1981, p. 76.*

There are some books that evoke envy in me of those who can enjoy them as children. Graham Oakley's **The church mice at Christmas** is one of these. It is the latest book in a charming and excellently-illustrated series. . . . The text is full of wit and sparkle but it is the detailed expressiveness of the pictures that will make children return to it again and again.

> *Caroline Wynburne, in a review of "The Church Mice at Christmas," in* The School Librarian, *Vol. 29, No. 1, March, 1981, p. 34.*

HETTY AND HARRIET (1981)

Hetty and Harriet, an ill-assorted pair of hens, leave the farmyard in search of "the perfect place for us." At least that is Harriet's objective, and Hetty goes along, partly because Harriet bullies her, partly for want of anything better to do. They encounter hideous dangers in the country and the town and, worst of all, in an 'Egg Production Plant.' . . . At last they reach the absolutely perfect place, their own home farmyard. Mr. Oakley is as much at ease in these settings as he is in the Church Mouse's pad. He uses to the full one of the great advantages of the author-illustrator; that is, he moves the action forward jointly in words and pictures, never wasting the one when the other can do the job more effectively. Children will like especially the unfamiliar viewpoints for familiar scenes, for example, the aerial view of Hetty and Harriet snarling up the traffic in the town centre. Mr. Oakley is equally sure with animals, people and architecture and machinery. Enchanting stuff this, as sound in its social implications as it is excellent fun.

> *Marcus Crouch, in a review of "Hetty and Harriet," in* The Junior Bookshelf, *Vol. 46, No. 1, February, 1982, p. 19.*

What a delight it is to find a picture story book which offers so much! Hetty and Harriet are . . . portrayed with such affection, humour and realism that they nearly step clucking out of the pages. Furthermore, parts of the story are told entirely in the pictures which calls for a joint exploration by reader and listener of the beautiful and detailed illustrations. This adds greatly to the joy of reading and sharing the book. Graham Oakley has developed his own special blend of lifelike representation and fantasy in contemporary children's books and **Hetty and Harriet** is a superb example of his skill.

> *Linda Yeatman, in a review of "Hetty and Harriet," in* British Book News *(© British Book News, 1982; courtesy of* British Book News), *Spring, 1982, p. 3.*

For those who thought that Oakley could only perceive life through the eyes of church mice, this tale of two wandering hens will prove his versatility. . . . The telling is, as usual, simple, but in the King's English ("There were pickings to be had, but they felt that the company was a bit low."); and the story moves with a pace that keeps urging us to turn the pages.

From Hetty and Harriet, *written and illustrated by Graham Oakley. Atheneum, 1982. Copyright © 1981 by Graham Oakley. Reprinted with permission of Atheneum Publishers, New York. In Canada by Macmillan Publishers Ltd., London.*

Physically, the text is welded with the pictures to make a solid unit. Oakley uses all kinds of pictorial devices to maintain the narrative pace, and double-page spreads are uniquely designed. Some images evoke horror (the laying room of the Techno-Egg factory); some generate mystery (the hellish rainy-night exterior of the Fowlfare works, made from an old church); and others create excitement (eight vertical picture-strips of the chickens running for their lives). Details of nature, or tongue-in-cheek signs in town, abound. Both text and illustration exude the joy of fine storytelling.

> Kenneth Marantz, in a review of "Hetty and Harriet," in School Library Journal *(reprinted from the April, 1982 issue of* School Library Journal, *published by R. R. Bowker Co./A Xerox Corporation; copyright © 1982), Vol. 28, No. 8, April, 1982, p. 61.*

Graham Oakley is one of the craftiest picture-book people working today. He drives along his solid, classic story like a film director, pacing an enormous variety of far, close and moving full-color "shots" against tender prose that keeps readers always rooting for the little hens. . . . It's a marvelous book, and one of the least obvious testimonies to heroines-as-heroes I know.

> Elaine Edelman, in a review of "Hetty and Harriet," in The New York Times Book Review *(copyright ©*

1982 by The New York Times Company; reprinted by permission), May 30, 1982, p. 14.

The story has many exhilarating moments, but its length becomes a flaw. On the other hand, the full-color detailed scenes are superb; they are planted in a layout that varies from two-page spreads to cartoon strips. The unusual perspectives Oakley uses, especially notable in the picture at the egg factory and at a traffic roundabout, command attention. This hen's-eye view of life will be used most effectively as a discussion piece or told a bit at a time. (pp. 1369-70)

> Ilene Cooper, in a review of "Hetty and Harriet," in Booklist *(reprinted by permission of the American Library Association; copyright © 1982 by the American Library Association), Vol. 78, No. 20, June 15, 1982, pp. 1369-70.*

This is a splendid book for it can be read at many levels, and says many things in a diversity of ways. In addition, it is likely to find a readership amongst those still daunted by pages of unbroken text and yet able to maintain a sense of story at a more complex level than that provided by most picture story books. . . . The text carries the narrative along in fine style, using direct and specific language; and its partnership with Graham Oakley's familiarly detailed and apt illustrations will

help any child stuck for a word here and there. It also reads aloud exceptionally well, making it a most useful addition to collections in junior classrooms.

> *Gabrielle Maunder, in a review of "Hetty and Harriet," in* The School Librarian, *Vol. 30, No. 4, December, 1982, p. 343.*

THE CHURCH MICE IN ACTION (1982)

[*The Church Mice in Action*], the latest exploit in Graham Oakley's notable saga, has a quite manic plot about a cat show which Sampson submits to entering because the church roof needs mending; his kidnapping by some dreadful men on a tandem bicycle and his rescue by an ingenious team of mice. It has to be said that where the matchless Sampson does not appear on the page, the standard tends to drop. Landscapes are usually fine but humans of all kinds become unspeakable grotesques—as you will see here. Sampson himself remains perfection, however ignoble the scene.

> *Naomi Lewis, "Once upon a Line," in* The Times Educational Supplement *(© Times Newspapers Ltd. (London) 1982; reproduced from* The Times Educational Supplement *by permission), No. 3464, November 19, 1982, p. 32.**

[*The Church Mice in Action*] is one of the few visually funny new children's books I've seen this year, in which the humour is an integral part of the story, unforced, unstrained. Oakley combines closely observed, realistic paintings of cats with wonderfully anthropomorphised mice, which make human gestures and grimaces, as they win their fight against great odds. (p. 25)

> *Patrick Skene Catling, "Wild Things," in* The Spectator *(© 1982 by* The Spectator; *reprinted by permission of* The Spectator), *Vol. 249, No. 8056, December 4, 1982, pp. 24-6.**

[Humphrey and Arthur's] escapades provide a hilarious story that is extended through Oakley's clever, detailed interpretation of the events. Full-color illustrations vibrate with action and visualize much that is never related in the text, making this another comic masterpiece in the chronicles of the Wortlethorpe church vestry.

> *Barbara Elleman, in a review of "The Church Mice in Action," in* Booklist *(reprinted by permission of the American Library Association; copyright © 1983 by the American Library Association), Vol. 79, No. 16, April 15, 1983, p. 1096.*

It is certainly a remarkable achievement that after eight books the church mice are as delightful as ever—maybe even more so. . . . Humphrey and Arthur go to [Sampson's] rescue and succeed in freeing him from as inept a pair of Laurel and Hardy villains as have ever taken part in a comic chase. A funny,

absurd book decked out with detailed illustrations showing all sorts of wonderful mice.

> *Ann A. Flowers, in a review of "The Church Mice in Action," in* The Horn Book Magazine *(copyright © 1983 by The Horn Book, Inc., Boston), Vol. LIX, No. 4, August, 1983, p. 434.*

In *The Church Mice in Action,* Graham Oakley creates a book for all ages by combining satiric cartoons, a tongue-in-cheek literary style, and a cleverly improbable story line. Oakley is a social documentarian in his drawings of bloated, Daumier-like politicians, and yet he includes characters who are well within a child's range of comprehension and empathy.

As a narrative, this tale follows the trickster tradition, but its self-conscious treatment creates social satire. The mice, for example, argue about whether luring the cat show participants into combat is "unsporting" and "downright un-British." After the mad chase, similar schemes from the mouse community's clever, ne'er-do-well member are promptly rejected.

Oakley renders most of the humans as such low-down types that the mice tricksters seem honorable by comparison. He crowds people together in their ruffled, leopard-skin pantsuits and acrylic teeth, surrounds them with urban congestion, and contrasts them with peaceful landscapes and an appealing population of animals. The mice are grouped in well-planned masses with effective backgrounds of negative space. Oakley designs several pages with special attention to the whole array of modeled mice forms. The figures blend into one another and create a soft mass of delicate, textured browns. The individual antics of these rodents are handled with precision and great humor.

> *Donnarae MacCann and Olga Richard, in a review of "The Church Mice in Action," in* Wilson Library Bulletin *(copyright © 1983 by the H. W. Wilson Company), Vol. 58, No. 2, October, 1983, p. 131.*

Page design is not Graham Oakley's forte, but his newest Church Mouse book, *The Church Mice in Action,* is as lively, witty, inventive, and entertaining as the others. . . .

Oakley tells the story in straight-faced prose spattered with verbal jokes that dare you to laugh. But the frenetically busy pictures are full of funny details that flesh out the text and give it higher flights of fancy and joy. The organic incongruity of text and picture is part of the genius of this deliciously British series.

> *Elaine Moss, "Picture Books for 9 to 13: 'The Church Mice in Action'," in* The Signal Review 1: A Selective Guide to Children's Books, 1982, *edited by Nancy Chambers (copyright © 1983 The Thimble Press; reprinted by permission of The Thimble Press, Lockwood Station Road, South Woodchester, Glos. GL5 5EQ, England),* Thimble Press, *1983, p. 19.*

Katherine (Womeldorf) Paterson

1932-

American author of fiction and short stories, and critic.

Drawing from her life and philosophical concerns, Paterson creates historical and contemporary fiction which captures the attention of pre-teens and critics. Her novels center on young characters who overcome stressful situations and gain personal strength by confronting such issues as sibling rivalry, death, and accepting the limitations of themselves and others. Using settings in the United States, Japan, and China, Paterson emphasizes the importance of environmental and cultural influences in each character's life. Four of her eight novels—*The Master Puppeteer, The Great Gilly Hopkins, Bridge to Terabithia,* and *Jacob Have I Loved*—have won the most prestigious honors the United States offers for children's literature.

Paterson has said that the writer's background is a significant factor in the shape and content of a book. Born in China, she lived there with her missionary parents until the age of twelve. The wife and daughter of Southern Presbyterian ministers, she has a doctorate in theology and worked for several years as a missionary in Japan. Although her works have spiritual and emotional depth, they are seldom considered didactic or overtly religious. Her first three novels, set in twelfth and eighteenth century Japan, give an accurate historical and cultural view of that country without losing suspense or impact. Developing from her fascination with Japanese puppet theater, *The Master Puppeteer* is her best work in this genre. This book is valued for its interesting detail, the development of its characters, and for Paterson's skillful building of tension and climax.

While Paterson's historical fiction is noted for its suspense, her contemporary novels are praised mainly for characterization. Written as Paterson's attempt to face the issue of death after her son's best friend was killed, *Bridge to Terabithia* is one of her most powerful novels. It focuses on the friendship of a rural boy with traditional values and a city girl with liberal ideas and on how Jess deals with Leslie's death. *Terabithia* is acclaimed for the strong personalities of Jess and Leslie and the realistic interplay and changes in their contrasting backgrounds. It is also appreciated for Paterson's portrayal of the psychological effects of death and her simple, expressive narration. *Jacob Have I Loved,* about a maturing girl and her struggles to overcome resentment towards her twin sister, is Paterson's personal search into sibling rivalry and how this tension increased through her religious and literary influences. Although readers of this book questioned the necessity of the final chapter and others wondered about the harsh endings of *Terabithia* (Leslie's death) and *The Great Gilly Hopkins* (a foster child's separation from the replacement mother she comes to love), most commend the overall quality of her works. Paterson states that her main objective, besides writing a story for the lonely child in herself, is to present a well-written story which will absorb the imaginations and emotions of children and give them a sense of hope; from the response of her readers it is clear that she achieves this goal. Paterson won the National Book Award for *The Master Puppeteer,* 1977, and *The Great Gilly Hopkins,* 1979; *Bridge to Terabithia* received the Lewis Carroll Shelf Award and the Newbery Medal, both in 1978.

Photograph by Rosalind Anglin; courtesy of E. P. Dutton

The Great Gilly Hopkins won the Christopher Award, 1978, the Newbery Honor Book selection, 1979, and numerous child-selected awards. *Jacob Have I Loved* was an American Book Award finalist, 1980, won the Newbery Medal, 1981, and the University of Southern Mississippi de Grummond Collection Medallion in 1983. Paterson also received the Kerlan Award, 1983.

(See also *Contemporary Literary Criticism,* Vol. 12; *Something about the Author,* Vol. 13; and *Contemporary Authors,* Vols. 21-24.)

AUTHOR'S COMMENTARY

As one who writes books for children, the question I want to discuss is one of aim—the aim of the writer who writes for children. In referring to aim, I do not mean aim as goal or target in terms of trying to hit someone. I am not chasing children about with a weapon. What I'm talking about is my aim, my intention. What in the world am I trying to do? (p. 325)

[My] aim, like that of most writers of fiction, is to tell a story. My gift seems to be that I am one of those fortunate people who can, if she works hard at it, uncover a story that children will enjoy.

There is as much loose talk these days about creativity as there is about self-expression. But those of us who are mortal do

not create *ex nihilo*—out of nothing—any more than we simply express ourselves. We seek, in Madeleine L'Engle's phrase, to "serve the work." . . . (pp. 325-26)

The gift, you see, is possibility. The aim of the writer is, like Michaelangelo's, to chip away at the block of marble to reveal the statue within it.

That is one reason why I am often at a loss to answer questions like: "Why is Maime Trotter fat?" I don't know why Maime Trotter is fat or why she is semi-illiterate or why she isn't a good housekeeper. That's the way she was when I first met her. One of the reasons I must rewrite a book, some portions of it many times, is because the story is teaching me slowly what it is about and who its people are. Occasionally, as in the case of Maime Trotter, they arrive full grown and I can see them at once. But, usually, I see through a glass darkly and must write patiently day after day, trying to find my way to the story that wants to be told and the people who are to be revealed in its telling.

It is a humbling experience to be at the service of a work. It reminds me of the feeling I remember when holding my first-born, who was a tiny, beautiful baby. I said to myself when I was going through that proverbial second day low in the hospital: "Here he is, perfect, and I'm going to ruin him." Well, of course, that was a delusion of grandeur on my part. I have had some power over his life, but not really so much as I feared. He was much too intelligent and humorous and strong-willed to be ruined by the likes of me. On the other hand, it would be silly to say that stories cannot be ruined by writers; they can be and have been. But the marvelous thing to behold in your own work or the work of other writers is the story that overcomes the weakness of the writer. (p. 326)

Story tellers and artists are very unsatisfactory creatures to the bulk of society. The more faithful they are to serving the work they have been given, the less receptive they are to advice on how the world is to be served by this work. I am blessed in that I have an editor who likes what I do, who never tries to tell me how to do my job, but who also never hesitates to point out those instances when it appears to her I have not done what I set out to do.

When I was trying in *Bridge to Terabithia* . . . to go from a cry of pain to a fully realized story and having difficulties in the process, she asked me: "What is this story about? Is it a story about death or a story about friendship?" Up until that moment I had assumed it was a story about death, but her question made me realize that *Bridge* wasn't, in fact, a story about death. It was a story about friendship, and although all mortal friendships come to an end, death is not always the most painful ending. . . .

I had had so much flack about the ending of *Jacob Have I Loved,* . . . Newbery seal notwithstanding, that I finally asked [*Horn Book* editor] Paul Heins point blank about it. "Well," he said, "many people have trouble with your ending because they read *Jacob* as a quest for self-knowledge. If that is the story, perhaps it should end when Louise leaves the island. But," he went on, "it's not a story about self-knowledge, it is a story of reconciliation, so it must come full circle."

Paul Heins is right. It is a story of reconciliation. In my mind you do not title a book *Jacob Have I Loved,* even ironically, if you cannot somehow come to love Jacob before it is over. I know Paul and I are right about what the story intended. I must ask myself: If I had served the work more faithfully could

I have made that intention clearer to others? Maybe so. Maybe not. The book is out of my hands now. It is not like a play with tryouts in Norfolk and New Haven and frantic rewritings right up to and sometimes well after opening night. The book must stand as it is. I leave it to the mercy of the reader.

I realize my emphasis has been on the aim of the writer, and I have said very little about writing for children. But it seems important to me to make this emphasis because to borrow and bend Flannery O'Connor: If a children's book is not good in itself, it's not going to be good for children either. Most of us have a concern for some child or some group of children. We have, at least I know I have, certain beliefs as to what might be good for that child and what might be damaging. We are prepared to go to considerable trouble to protect our children from that which we think might injure them and to try to obtain those things which we think will be good for them.

Because people are eager to have things which will help their children, they say to someone who writes for children: Please write a story about such and such. (p. 327)

After I had written *The Sign of the Chrysanthemum* . . . , one of my good friends who is an ardent feminist asked me to make my next book about a girl, a strong person who overcomes many odds, because, she said, her daughter needed such a book. . . . I thought I could do just that, write a book about a strong girl who overcomes many odds and who would serve as a role model for my friend's daughter and maybe my own two daughters as well. It started out all right, but the more I listened to the story, the more I realized that my strong girl was also selfish and vain and would be brought low by her flaws as well as exalted by her strengths. She turned, you see, in the course of the story, into a human being, set in a specific time in history and in an actual geographical location, both of which conspired against her budding feminism. By the time I'd finished, I thought I'd written a pretty good story, but I knew my friend was going to be sadly disappointed.

I am sure I am not the only writer who can't understand sometimes what a reviewer means, and I think this is often because a writer can no more separate setting, characterization, plot, and theme in her own books than a mother, looking at a beloved child, breaks him down into bone structure, muscular system, psychological development, etc. Now, of course, there are occasions when some part of the child demands particular attention. I've been asked to direct my attention to vast expanses of adolescent skin lately. But even while I'm obediently looking at the skin, there is a voice coming out from under it, crying: "Why me? Why not John? Why do I always get zits just before a party? Never John." And I'm not even allowed to study the skin objectively and in peace.

One review I had trouble understanding was for *The Great Gilly Hopkins*. . . . Let me just share the final paragraph: "It's not that *The Great Gilly Hopkins* isn't a good read, it's just that it would have been a better story without mixing up race relations, learning disabilities, the important relationships between young and old, *and* a terrific young girl who gamely comes to terms with her status as a foster child" [Bryna J. Fireside, 1978; see excerpt below]. Huh? Put that way, it sounded as though I'd tried to take nearly every social problem in America and cram them into one story. No one but a fool would do that, and I spend a lot of time assuring myself that I am not a fool. So what had I done wrong? What had I done to give this obviously intelligent reader the idea that I intended to write the higgelty-piggelty story she was describing?

At last I realized what had happened. I had set the story in Takoma Park, Maryland—or a place strangely like Takoma Park. Unlike most American communities, Takoma Park is wildly heterogeneous. We lived across the street from an upper middle class black couple. On either side of us were highly educated white couples, one household the more traditional male and female combination, the other entirely male. We were diagonally across the street from a black family with two children of their own and a changing cast of foster children, just up from a retired white couple who were struggling to get by on a fixed income, around the corner from an elderly handicapped widow, down the street from a Roman Catholic family with 13 children. If I keep going, the neighborhood will present every sociological configuration in our country. . . . What I had done was set my story in a toned down version of an actual community, but even toned down, it seemed unbelievable to a sophisticated reviewer for *The New York Times*. Gilly was dealing with people who live in such a variegated community, not with an assortment of social issues. But I had failed to make that community real to at least one reader.

I once heard a writer express anger toward an editor who had complained that she could not tell where the writer's story was taking place. The writer said, "It didn't matter where the story was taking place. It could have taken place *anywhere*." I cannot believe that particular writer believed what she was saying. She is too fine a writer. She knows as well as I do that a story can no more take place *anywhere* than a human being can exist *nowhere*. One of the most ancient heresies of the Christian faith is gnosticism. The Gnostics distrusted matter. They believed that matter was evil and only pure spirit was good. Gnosticism not only makes for bad religion, it makes for terrible fiction. The world of the story must be created or recreated in concrete detail. Matter matters, and part of the process of uncovering a story lies in discovering the appearance, feel, smells, sounds, and even the tastes of the world in which it unfolds.

One reason *Jacob Have I Loved* was so long in the writing was because for months I did not know where the story was taking place. Once I knew *where*, the setting itself was so much a part of the plot and had so much to do with developing the characters that I could not possibly separate out the elements. For example, in my first vague feelers toward the story I had known that theology (either good or bad) was going to have a place in the story. When I found the setting—islands in the Chesapeake Bay—I found communities that were more closely tied to religious commitment than even I would have thought existed in America today. There was no need to hunt about for metaphors—the setting lavished them upon me—which, indeed, I believe any setting will, if the writer will look closely enough, and if it is the proper world for the story which is being told.

Often people interested both in children and in books will want to tell a writer about setting, as though a story could be switched from one place to another like a traveling circus. Back when I had written only historical fiction set in Japan, adults would say to me: "You shouldn't set your stories in Japan. Children are not going to read them. They will only read books about children just like themselves. Children have to be able to immediately identify with the characters in a book." I would bite my tongue not to remind them that I didn't know a single American child who was a timid barnyard pig. I was convinced then, and am still convinced, that there are plenty of American children adventurous enough imaginatively to read about char-

acters who are not carbon copies of themselves. My task is to make what might be an exotic world so real that the reader will be able to enter it, to see and smell and hear and taste it. A historical novel or a novel set in a distant or unknown world is not primarily an opportunity to teach the reader about another culture. It is a story, and there is no place in a story for deliberate didacticism. What the writer must do is supply those concrete details that will make this world real to the reader and thus bring this story to life. I went to Deal Island one day primarily to sniff, because Virginia had complained that she couldn't quite smell Rass Island.

The very language of the book, the metaphors, must belong to the world of the story. Louise's language is the language of the water which she loves and of the Bible which she thinks she has rejected, but which is as much a part of her blood as the bay itself. Takiko, a musician living on another island in another age, speaks a different language.

The daughter of a samurai does not cry out in childbirth. Within her head Takiko laughed at the injunction. It was as though her very body was the *koto* of a god whose powerful hand struck a chord so fierce that for the wild moment she became the storm music of the sea. Then throbbing, ebbing, the great wave would pass over her, and she would drift on the surface of the water, the sun warm upon her face until another stroke upon the strings.

"I am mixing it all up. She smiled. I am music and storm and strings. I am Izanami as She brooded over Creation". . . . (pp. 327-29)

Now some critics would contend that a scene in which the central character is obviously giving birth to a baby has no place in a children's book. By using this example, I am driven toward the question I have been avoiding. What is the difference between writing for children and adults, if all you care about is the story itself.

In Connecticut last January, a librarian asked me if I were conscious of an audience as I write—as you see, I'm not. I'm conscious of story. But there are two points at which the audience comes into sight, though not, perhaps, as you might wish. In the first place, although a story seems to choose me rather than vice versa, still, intellectually, I know there is psychological method in this seeming madness. When you see a repetition of behavior, no matter how irrational that behavior might appear in isolation, you can bet there's a reason for it. Why do I keep writing stories about children and young people who are orphaned or otherwise isolated or estranged? It's because I have within myself a lonely, frightened child who keeps demanding my comfort. I have a rejected child, a jealous and jilted adolescent inside who demands, if not revenge, a certain degree of satisfaction. I am sure it is she, or should I say they, who keep demanding that I write for them.

I'm often asked why I don't write for adults, and since I'm not quite sure myself, I give a variety of answers with varying degrees of veracity. I have been known to say it's because I find adultery a rather boring subject. But that can't be the whole truth. (p. 329)

I seem to be in tune with the questions my children and their friends are asking. Is there any chance that human beings can learn to love one another? Will the world last long enough for me to grow up in it? What if I die? And the question they ask, but would never formulate this way, the ancient question of the psalmist as he gazed at stars millions of light years away:

"What is man that thou art mindful of him?" Not all children are interested in these questions, I know, but enough seem to be that the publishers feel it is worthwhile to keep printing my simple melodies drawn from these haunting themes.

But any worthy reasons I might put forth are overbalanced by the personal one. I write out of my own needs. The woman in me is nearly overwhelmed by the abundance she has been given. Further growth of my soul will, I do not doubt, expose great areas of need of which I am not currently aware. Someday I may need to write quite different books. But this is not the time or place to speculate on my work or on my psyche.

If, as I say, my first audience is my own young self, the time comes when I must be concerned with the audience outside myself. After the story is written down (which may take more than one draft; it certainly takes many rewritings of certain parts of the story); after, as I see it, the idea has become a recognizable story on paper, I must turn my efforts from serving the story—art for art's sake, as it were—to how best this story can be shared. I want to tell this story in such a way as to enlist the imaginative cooperation of the intended reader. This reader will be young, will have less experience of life than I, and will probably not have traveled to the place where the story takes place. I am not going to change the intent of this story to try to please her, but I am going to do everything in my power to make the story live for her, to make it dramatically clear to her. She may not like how the story ends, but I want her to see that this ending is the inevitable one. I want her to want to keep reading, to wonder with a pounding heart how it will all come out; and then, when she comes to the final page, I want her to say: "Of course! It had to be. No other ending was possible. Why didn't I realize it all along?" No one could fault me for wanting too little.

Up to this point I have jealously guarded my story, regarding it as so fragile that it will shatter like a dandelion puff if another soul breathes in its direction. But now my concern is not simply the story itself but the sharing of it. I need other eyes and intellects to read it and tell me to what extent I have succeeded or failed. (pp. 329-30)

I have also in the case of several of the books read them aloud to one or more of my children. This is not because I think my children can give me the quality of help that my husband or editor or a friend like Gene Namovicz can. Children, even clever ones like mine, tend to say "I love it" or "I don't like it" without being able to articulate exactly what it is that makes them love or dislike a story. In the very act of reading aloud, however, my ear picks out flaws in the music of the book. Each book has its own music, and reading aloud is the best way I know to hear when you have hit the wrong note or lost the proper rhythm. It is also helpful because, even if the children are not as articulate as the adult critics, they are less polite. A snore or a "Huh?" or a getting up and going to the refrigerator can be easily understood by the dullest of writers.

"My task," says Joseph Conrad, "which I am trying to achieve is, by the power of the written word to make you hear, to make you feel—it is, before all, to make you *see*. That—and no more: and it is everything. If I succeed, you shall find there according to your deserts: encouragement, consolation, fear, charm—all you demand—and, perhaps, also that glimpse of truth for which you have forgotten to ask." . . . (p. 330)

My task, my aim as an author who writes for children, is not so different. My aim is to engage young readers in the life of a story which came out of me but which is not mine, but ours.

I don't just want a young reader's time or attention, I want his life. I want his senses, his imagination, his intellect, his emotions, and all the experiences he has known breathing life into the words upon the page. It doesn't matter how high my aim or how polished my craft. I know that without the efforts of my reader, I have accomplished nothing. The answer to the old puzzle about the tree falling in the unpopulated wilderness is that it makes no noise. I have not written a book for children unless the book is brought to life by the child who reads it. It is a cooperative venture. My aim is to do my part so well that the young reader will delight to join me as coauthor. My hope (for there are no guarantees) is that children in succeeding generations will claim this story as their own. (pp. 330-31)

Katherine Paterson, "The Aim of the Writer Who Writes for Children," (copyright, 1982 by the College of Education, The Ohio State University; reprinted by permission of the author), in Theory into Practice, *Vol. XXI, No. 4, Autumn, 1982, pp. 325-31.*

GENERAL COMMENTARY

BERNICE E. CULLINAN WITH MARY K. KARRER AND ARLENE M. PILLAR

[In *The Great Gilly Hopkins*] Galadriel, called Gilly, wants to be with her mother despite the fact that Maime Trotter provides her with a loving home. Katherine Paterson expresses Gilly's longing in literary allusions from folklore that conjure images that help readers visualize inner feelings. Her alternation of short terse sentences and long complex ones heightens tension and expands the dramatic action. Like the protagonist in her *The Master Puppeteer,* she is a master of her craft, her memorable stories are marked with imagery evoked by vivid language and with a believability that derives from her use of many characters and incidents drawn from life. . . .

Readers take strength from her dramatic stories, rich with feeling, to face heartache in their own lives. (p. 316)

Bernice E. Cullinan with Mary K. Karrer and Arlene M. Pillar, "Contemporary Realism," in their Literature and the Child *(copyright © 1981 by Harcourt Brace Jovanovich, Inc.; reprinted by permission of the publisher), Harcourt Brace Jovanovich, 1981, pp. 289-328.**

ANTHEA BELL

If the American author Katherine Paterson had been writing a century ago, her evident Christian commitment would not, of course, have been anything out of the ordinary. Instead it would have been the expected norm, with a large area of common ground known to exist between the writer, her readers and her reviewers. But how does an author deal with such a commitment now, when the common assumptions are not nearly so widespread, and to express them explicitly may alienate rather than attract? . . .

Looking at Katherine Paterson's novels, I think the use she makes of her beliefs in them is something of a phenomenon for the late twentieth century, and an interesting one. Perhaps the use she does *not* make of them is even more interesting.

Her Christianity is not that of the more recent born-again or charismatic movements; hers is the traditional Presbyterian variety, and has been with her from childhood. The daughter of missionaries who worked in China, she was herself a mis-

sionary in Japan for four years: hence her interest in Japanese history and culture, and the settings of her first three books.

These three are very different from the work that followed them, which represents a complete change of direction. . . . (p. 73)

I do not know if the present decline in popularity of the historical novel in English-language children's publishing had anything to do with this change of direction. The convention of the genre to which Paterson's first three books belong is that which takes a central figure, boy or girl, at a moment of personal crisis, and uses him or her to illumine a given period of history. Except in the case of some outstandingly original writers, this seam does appear at the moment to have been largely worked out.

Of this genre, Paterson's three Japanese novels are good examples: her fascination with the background material is plain. She dwells lovingly on the mystique and technicalities of the swordsmith's art in *The Sign of the Chrysanthemum*, on courtly etiquette and historical incident in *Of Nightingales That Weep*, and in particular on the stylized conventions of the Japanese puppet theatre in *The Master Puppeteer*. She is good on Japanese conventions altogether. The reader learns a good deal about the leisurely and (to the impatient Western mind) excessive cultivation of polite small talk, in contrast to sudden moments of savagery such as the cutting off of a boy's hand in *The Master Puppeteer*, about the acceptance of suicide as an admirable act. . . . I am not so sure about the frequent quotations from Japanese poetry in the author's first book; there's a limit to the amount of Japanese poetry in translation most people want, and it is an acquired taste anyway. But the summaries of the puppet-play texts in *The Master Puppeteer* are intriguing. These historical novels are all enjoyable, but whether or not Katherine Paterson's change of direction was all her own idea or prompted by a publisher's editorial suggestion, it was in turning to the twentieth century that she found her own and original voice.

Bridge to Terabithia, the book in which she made the break, is the story of a friendship. (pp. 74-5)

Some two-thirds of the way through the book, there is an episode which bears all the signs of being central to the theme, and yet which turns out otherwise. Jess's family are once-a-year churchgoers, attending by force of habit at Easter, and they take Leslie along with them. Subsequently there is a conversation between the children. On the one hand, Jess and his little sister May Belle unthinkingly accept the authority of the Bible. ('You gotta believe the Bible, Leslie . . . 'cause if you don't believe the Bible God'll damn you to hell when you die.') On the other hand, sensitive Leslie, apparently totally unacquainted with the Christian tradition, is impressed. 'Gee, I'm really glad I came . . . the whole Jesus thing is really interesting, isn't it? . . . All those people wanting to kill him when he hadn't done anything to hurt them . . . it's really kind of a beautiful story—like Abraham Lincoln or Socrates—or Aslan.'

Now this is pushing it a bit. Merely on the level of probability, are we to suppose that an intelligent child of Leslie's literary background, conversant with the story lines of *Hamlet* and *Moby-Dick,* and owner of all the Narnia books, will not have spotted the fact that C. S. Lewis wrote religious allegory, and that Aslan *is* Jesus? And articulate as she also is, wouldn't she, if she could not work out the meaning of the allegory for herself, have inquired of her parents or teachers? A total lack

of general knowledge about the Gospel stories doesn't fit in with the rest of her mental equipment.

As I said, the passage *looks* central, because it points very obviously forward. May Belle concludes the conversation. 'But Leslie . . . what if you *die*? What's going to happen to you if you *die*?' For that is just what Leslie is going to do. Stormy weather fills the creek bed with torrential water, and swinging across on her way to Terabithia, Leslie hits her head, falls in and drowns. Jess has been spending a wonderful day in Washington, visiting the National Gallery with pretty Miss Edmunds from his school, and knows nothing about the accident until he gets home to hear that Leslie is dead. The remaining part of the book is a faithful and very moving depiction of the nature of his grief, and its various successive stages of manifestation. Jess goes through them all: inability to take in the fact of bereavement, numbness, a certain detached satisfaction in observing that he will be the centre of interest at school as the dead girl's friend. Then, as the difficult reality forces its way into his mind, come the classic reactions of guilt, anger and blame. 'Leslie had failed him. She went and died just when he needed her the most.' Finally, he progresses through the small, healing ceremonies of grief to acceptance and a readiness, as he lets little May Belle into the kingdom of Terabithia, to look forward and build on his friendship with Leslie.

If one goes back again to reread the apparently central passage in which the reader is invited to smile at Jess and May Belle's shallow misapprehensions about Christianity, while appreciating that Leslie instinctively sees the point of it, one finds it does not really relate much to the book either before or after the scene. The issue of death has not been balked, or any easy religious comfort offered. It is as if, just for once, didacticism had got the better of the author, and she then realized it did not ring true. I have dwelt on this passage not from a wish to pick unfairly on what seems to me Paterson's one real lapse, but because it *is* just for once, and it *is* her one real lapse. The book stands perfectly well without it. Leslie may seem irritatingly precocious at times, but then she would have been (one likes Jess's puncturing of her literary idiom when she launches into her 'queenly' mode of speech—'Methinks some evil being has put a curse on our beloved kingdom.' 'Damn weather bureau,' Jess mutters, and then feels he has let her down). But it is her effect on Jess that counts.

Leaving aside one or two moments in Katherine Paterson's short stories about Christmas, collected in one volume as *Star of Night,* she never appears to be offering her readers anything like a sermon again. The stories, being occasional pieces all written for the same occasion but in different moods, are not necessarily all for children: I imagine that a sombre story of a mother's persistent depression after a stillbirth was originally written for adults. There is also a good piece of light comedy among them—**'Woodrow Kennington Works Practically a Miracle'**—and a story featuring an aggressive foster child, Genevieve, who is a close relation of Paterson's memorable heroine in her next full-length novel after *Bridge to Terabithia.*

The Great Gilly Hopkins is a work of true comedy. In fact it has a much more pervasive religious element than its predecessor, but the religious theme is cleverly amalgamated with the whole: the overriding impression is of the original character of the heroine. Gilly's real name is Galadriel, inflicted on her by her mother Courtney, a member of the flower-child, Tolkien-crazed generation, who has abandoned her daughter to a succession of foster homes. Gilly, determined never to ask anybody for help, aggressively invites rejection. Hasn't she

got her own resources to sustain her? They include pride, a quick mind and defiantly childish but inventive wisecracking humour, lack of scruples, a talent for terrifying other children with her 'barracuda smile', and an ability to run rings around her teachers by her 'time-honoured trick of stopping work just when the teacher had become convinced she had a bloody genius on her hands'.

Gilly cultivates toughness in a big way. Actually, of course, she is not half as tough as she makes out. Her Achilles heel is her romantic vision of a beautiful, loving mother, and she cherishes a glamorous photograph of Courtney. A professed anti-Pollyanna, it's mother-love she craves, but only from her real mother. She doesn't want anyone else softening her up, and she very soon feels threatened by the trio consisting of her warm-hearted, huge foster mother, Maime Trotter, seven-year-old William Ernest Teague, Trotter's other foster child, and blind, black old Mr. Randolph, who comes over for his meals. In the proper tradition of comedy, Gilly is duly softened up despite herself, but just as she has made friends and accepted the possibility of love, a letter written to her mother complaining of her foster home rebounds on her: the classic example of the letter you write to let off steam and then regret sending. '''The foster mother is a religious fanatic. Besides that she can hardly read and write and has a very dirty house and weird friends. There is another kid here who is mentally retarded. I am expected to do most of the work including taking care of him. . . .''' Courtney is sufficiently alarmed by this to pass the news on to her own mother, who has not heard from her in thirteen years and didn't even know of her grandchild's existence, and who now turns up, with the inspired mistiming of good farce, just as all appearances suggest that Gilly, struggling to nurse the other three through flu, really is in the dire straits of which she had complained.

By this time one has realized that Maime Trotter is not only the representative of human goodness—criterion and yardstick, the standard by which the behaviour of others is to be measured—but also the representative of Christianity. And Katherine Paterson neatly disarms the non-Christian reader who might find this hard to take by letting Gilly herself attack her, with some slight basis in fact. 'Not everything in the letter to Courtney had been absolutely true,' she thinks after sending it, 'but surely the part about Trotter being a religious fanatic was.' For Gilly's youthful arrogance leads her into the intellectual snobbery of looking down on Maime Trotter, as well as old Miss Applegate the Sunday School teacher, and the young preacher who has trouble with his grammar. Trotter's Christianity is simple, fundamentalist; she refers frequently to the Good Book, and to taking the Lord's name in vain, but while she may not be 'smart' she is wise, warm and loving. When she boasts, 'I never met a kid I couldn't make friends with', causing unregenerate Gilly to want to throw up, she turns out to be telling only the simple truth. It takes some doing to create a genuinely good character who comes to life as successfully as Maime Trotter, and it is delightful to watch the author steer skilfully around all the possible pitfalls involved.

'Rescued', now much against her will, from her foster home, Gilly has learnt enough from Trotter and the others to make a real effort at settling in with her grandmother, despite that lady's nervously fluttering manner. By now Gilly can sympathize with her—son and husband dead, daughter estranged—and thinks that only since living with Maime Trotter 'did she understand a little what it meant to have people and then lose them'. For she misses her friends badly, and there is one last

and very nasty trial to come: under compulsion from her mother, who has sent the fare, Courtney turns up for Christmas. As all but Gilly could have foreseen, she is a severe disappointment to her daughter: not, of course, the radiant figure of Gilly's imaginings, but 'a flower child gone to seed', who only too plainly isn't interested, and doesn't plan to stay more than two days, let alone take Gilly away with her. But a phone call to Maime Trotter, who sensibly and lovingly points out that 'all that stuff about happy endings is lies', helps Gilly pull herself together to face life constructively.

The whole novel is permeated with the ideal of Christian charity (love in the sense of *agape*), but it is never obtrusive, and to get the balance just right in a work of high comedy is remarkable: the construction of the book, that vital factor in comedy, is a joy too, and Gilly must be one of the most appealing of modern heroines. One wonders with mild interest if the swing of fashion will make Gilly, the would-be anarchist, as outdated fifty years hence as Pollyanna herself. Maybe or maybe not, but she is certainly a child for and of our times.

Bridge to Terabithia and *The Great Gilly Hopkins* are very different from each other (unlike the author's three Japanese novels, which are all from the same mould), and her next book, the Newbery Medal winner *Jacob Have I Loved*, is different again. A bleaker work than its immediate predecessor, it lacks that strong comic element but has strengths of its own. Set at the time of Pearl Harbour and the following war years, it is told through the eyes of the first-person narrator, Louise Bradshaw, who lives with her family on Rass Island in the Chesapeake Bay, where her father is a waterman catching crabs and oysters. She is a prickly, complex character, and has a troubled girlhood marred by resentment and jealousy of her twin sister Caroline, who is talented, musical and charming, apparently favoured by Fortune as well as everyone who knows her. . . . Her growing up is a painful struggle to come to terms with her own self-pity and her hurtful comparison of herself with Caroline at every step.

In this book, the period and atmosphere count for a great deal as part of the narrator's background as well as for their own sakes. It is through work that Louise begins to fight free of her own besetting demons: work first helping her father . . . then her own work studying on the mainland. (pp. 75-80)

The Rass islanders are reared in a tradition of puritanical Methodism, as exemplified by the girls' text-citing Grandma. It is Grandma's nasty Biblical crack, directed at Louise—'Jacob have I loved, but Esau have I hated'—that provides the book's title. One expects, then, knowing of the author's religious commitment from her earlier works, that there will be a pervasive Christian element here too; in fact it is less prominent than in *The Great Gilly Hopkins*. Grandma is the most overtly religious person in the book, and her fervour borders on the comic as she becomes slightly dotty with age, accusing her kind and clean-living daughter-in-law of all manner of Old Testament whoredoms. Grandma is saved from becoming too much a native of Cold Comfort Farm by Louise's realization that she still, after many decades, is 'haunted by a childish passion' for the Captain; the maturing girl's sympathy is aroused for the old lady.

As for Louise herself, however, rocked back on her heels by the discovery that the speaker in that statement of bias over Jacob and Esau is not a fallible human being—not Isaac or Rebecca—but God himself, she has turned away from religion. She loses interest in churchgoing and does not pray any more,

resolving, a little like Gilly Hopkins, that she must rely on her own strength to outface a hostile world. Interestingly, that is what she more or less does. . . . [Katherine Paterson has been asked] how she dared depict Louise's loss of faith—wasn't she afraid of losing her own? This notion was easily enough parried by a firm believer who is also an experienced creator of characters that are not just extensions of herself: but in the book she is content, as it were, to let Louise go her own way. It is not suggested that she regains her faith; indeed, it is indicated that she remains pretty lukewarm. Her husband is a Catholic, but 'has never suggested that I ought to turn Catholic or even religious'. I suspect that Katherine Paterson herself would agree with another scrupulously thoughtful writer, Emily Dickinson, that 'The abdication of belief / Makes the behaviour small / Better an ignis fatuus / Than no illume at all'. But she does not impose such a view on her character.

Christianity is present in the book, not just in Grandma's rantings, but more as part of the background than as a thread in the story: I think we are to take it that the island traditions have inevitably helped to form Louise's character and give her the strength to cope with her difficulties. The learning of charity is a strong theme too, though no one specifies that it is necessarily Christian charity. The story ends, neatly and movingly, where it began, with twins: delivering the two babies, Louise finds herself in her turn paying more attention to the weaker child. By now she can understand and forgive the past, but she urges the parents to show the stronger twin affection too.

My personal preference is for the serio-comic verve of *The Great Gilly Hopkins,* but *Jacob Have I Loved* is also a very fine novel in its different way. And I do admire Katherine Paterson's ability—increasingly sure from *Bridge to Terabithia* onwards—to make her own Christian convictions evident while not letting them become obtrusive: that is an achievement to impress the least religious of serious readers. (pp. 80-81)

> *Anthea Bell, "A Case of Commitment," in* Signal *(copyright © 1982 The Thimble Press; reprinted by permission of The Thimble Press, Lockwood Station Road, South Woodchester, Glos. GL55EQ, England), No. 38, May, 1982, pp. 73-81.*

THE SIGN OF THE CHRYSANTHEMUM (1973)

At the death of his mother, the boy Muna makes his way from an impoverished island to ancient Heiankyo, to locate his father whom he never knew—a great samurai with a chrysanthemum tattoo on his shoulder. In the twelfth-century world of noble samurai life degraded by divisive warfare between rival clans, thirteen-year-old Muna ("no name") fortunately finds hospitality with a famous swordsmith. Although the boy's search is fruitless and his dreams demolished, Muna finds himself. . . . The storytelling holds the reader by the quick pace of the lively episodes, the colorful details, and the superb development of three important characters: the confused but sometimes quick-witted boy; the philosophical, deeply kind Master; and Taka-nobu, a renegade samurai warrior, now a completely amoral drifter who takes advantage of Muna's innocence.

> *Virginia Haviland, in a review of "The Sign of the Chrysanthemum," in* The Horn Book Magazine *(copyright ©1973 by The Horn Book, Inc., Boston), Vol. XLIX, No. 5, October, 1973, p. 468.*

There are crudely melodramatic elements: a cruel thief who befriends Muna, a beautiful orphan girl forced into prostitution

by her uncle, a noble swordsmith who, conveniently, longs for a son. However, the book is fast paced and insightfully describes Muna's intense, erratic search for identity.

> *A review of "The Sign of the Chrysanthemum," in* The Booklist *(reprinted by permission of the American Library Association; copyright © 1974 by the American Library Association), Vol. 70, No. 10, January 15, 1974, p. 545.*

There is an impressive list of acknowledgements at the start of the book which implies considerable research. Certainly the background has the feel of authenticity, and Muna's wanderings in search of his father make an original and unusual story.

> *Valerie Alderson, in a review of "The Sign of the Chrysanthemum," in* Children's Book Review *(© 1975 Five Owls Press Ltd.; all rights reserved), Vol. V, No. 2, Summer, 1975, p. 78.*

The book is about pain, wisdom, choosing, and growing up, but it is far from didactic. The story is exciting, moving and unpredictable, and is presented with precision and economy of language. . . . [With] fine judgment Katherine Paterson introduces at appropriate points in the narrative fragments of Japanese poetry that would have been known in twelfth-century Japan.

> *Graham Hammond, "Feminine Insights," in* The Times Literary Supplement *(© Times Newspapers Ltd. (London) 1975; reproduced from* The Times Literary Supplement *by permission), No. 3836, September 19, 1975, p. 1056.**

OF NIGHTINGALES THAT WEEP (1974)

[This is a] tough, moving novel. . . . Mrs. Paterson's story focuses on the fortunes of a young girl caught up in the maelstrom of wartorn medieval Japan. . . .

Author Paterson has drawn a vivid picture of 12th-century Japan—from the lowly huts of the peasants who scrabbled an uncertain existence out of the soil, to the palaces of the highborn who enjoyed a more lavish, if just as precarious, style of life. Her feeling for the rawness and vitality of history makes the events of eight centuries ago seem hauntingly relevant, humanly near.

> *Jennifer Farley Smith, in a review of "Of Nightingales that Weep," in* The Christian Science Monitor *(reprinted by permission from* The Christian Science Monitor; *© 1974 The Christian Science Publishing Society; all rights reserved), November 6, 1974, p. 9.*

The period in Japanese history (1180-85) is recreated well; however, Takiko's reformation (apparently due to disfigurement and rejection) is unbelievable, and the story is not as well characterized nor involving as the author's *Sign of the Chrysanthemum.* . . .

> *Dora Jean Young, in a review of "Of Nightingales that Weep," in* School Library Journal *(reprinted from the January, 1975 issue of* School Library Journal, *published by R. R. Bowker Co./A Xerox Corporation; copyright © 1975), Vol. 21, No. 5, January, 1975, p. 56.*

This lush, romantic story is set in twelfth-century Japan. The exotic location and the distance in time make its sentiments

palatable—just. It has something of the formality and simplicity of a retold folk tale. Its moral message is clear: that beauty is skin-deep.

The underlying theme is derived from the concept of loyalty and the ways in which it can be expressed. Takiko, daughter of a samurai, is lady-in-waiting to Princess Aoi when she becomes infatuated with a warrior from a rival clan. The subsequent story involves slaughter, mass suicide, death from plague and ultimate betrayal; but Takiko's own brand of courage enables her to face reality and come to terms with it. If there is an element of masochism in her final choice of husband, her decision is none the less fitting in terms of the plot. . . .

The elaborate, poetic and violent qualities of life in feudal Japan are sympathetically evoked. Occasionally the story seems to require a more oblique or individualistic touch—but on the whole the author's method works well.

> *Patricia Craig, in a review of "Of Nightingales that Weep" (© copyright Patricia Craig 1977; reprinted with permission), in* Books and Bookmen, *Vol. 22, No. 6, March, 1977, p. 66.*

[*Of Nightingales that weep*] could satisfy adolescents and adults alike with its exotic flavour and mature handling of character. . . . The unfamiliar pattern of events and the alien concepts of love, loyalty and ceremony which guide the characters are made clear in a story based on scholarship and on knowledge of the country whose contours and vegetation are skilfully used as background to a deliberate, convoluted narrative.

> *Margery Fisher, in a review of "Of Nightingales that Weep,"* Growing Point, *Vol. 15, No. 8, March, 1977, p. 3066.*

I must admit to a distinct reluctance to read this book. The clan wars of twelfth century Japan are, to put it no more strongly, not a popular subject with English readers. The mindlessly brutal wars and the formality of court life make so sharp a contrast that it is difficult to bridge the gap between them. However, once started *Of Nightingales That Weep* turns out to be a hypnotically dominating book. . . .

Mrs. Paterson tells the strong, action-filled narrative quietly, making its most powerful effects by understatement. (p. 239)

> *Marcus Crouch, in a review of "Of Nightingales that Weep," in* The Junior Bookshelf, *Vol. 41, No. 4, August, 1977, pp. 239-40.*

THE MASTER PUPPETEER (1975)

The world of traditional puppet drama—both the glittering artifice onstage and the role-playing that continues behind the scenes—becomes a fantastic backdrop to the mystery that engulfs Jiro. . . . The deep bond between Jiro and the puppetmaster's son Kinshi, both apparently unloved by their demanding fathers, forms this adventure's stable core, but Paterson's ability to exploit the tension between violence in the street and dreamlike confrontations of masked puppet operators is what makes this more lively and immediate than her other, equally exacting, historical fictions.

> *A review of "The Master Puppeteer," in* Kirkus Reviews *(copyright © 1976 The Kirkus Service, Inc.), Vol. XLIV, No. 2, January 15, 1976, p. 71.*

The make-believe world of the Japanese puppet theatre merges excitingly with the hungry, desperate realities of 18th century Osaka in this better-than-average junior novel. Although the ending is abrupt and the character motivation sometimes vague, the work maintains a successful degree of suspense. . . . Paterson's details of the unrest of the poor and the arrogance of the wealthy merchants in feudal Japan ring true.

> *Violet H. Harada, in a review of "The Master Puppeteer," in* Children's Book Review Service *(copyright © 1976 Children's Book Review Service Inc.), Vol. 4, No. 8, March, 1976, p. 73.*

Making economical use of detail to set scene and atmosphere, the author has chosen a period of lawlessness when Japan's old samurai tradition was dying and set against the teamwork and discipline of the puppeteers. Many of the themes in *The Sign of the Chrysanthemum* [and *Of Nightingales That Weep*] . . . reappear in this novel which should be very popular for its combination of excellent writing and irresistible intrigue.

> *Dora Jean Young, in a review of "The Master Puppeteer," in* School Library Journal *(reprinted from the March, 1976 issue of* School Library Journal, *published by R. R. Bowker Co./A Xerox Corporation; copyright © 1976), Vol. 22, No. 7, March, 1976, p. 117.*

Like intricate embroidery, Paterson's story has deftly woven threads of several patterns that combine to make a cohesive and dramatic whole. . . . The plot is skilfully constructed, the characters are strong, and the historical background is as interesting as the details of the puppet theater. Good style, good story.

> *Zena Sutherland, in a review of "The Master Puppeteer," in* Bulletin of the Center for Children's Books *(reprinted by permission of The University of Chicago Press; © 1976 by The University of Chicago), Vol. 29, No. 11, July-August, 1976, p. 181.*

In an engrossing story . . . the author has blended a literate mix of adventure and Japanese history with a subtle knowledge of young people. (p. 114)

In memorable prose that maintains a delicate balance between humor and tragedy, the author describes how Jiro ventures into the burning streets looking for his crazed starving mother only to find his father who is not ill, but one of Saburo's band. . . .

Jiro's struggle to master his own physical and emotional hunger, together with his strong feeling of attachment to his friend Kinshi, is a dramatic recreation of the childhood pattern of many children. His personal growth in having to discipline himself within the rules of the Hanaza community while dealing with his family problems and the surrounding world serves as a fine example for today's young. Also important are the secondary themes concerned with the values of learning a skill and occupation and of understanding that young people living in historical times and belonging to other cultures often faced problems and had feelings similar to those of today's youth. (p. 116)

> *Diana L. Spirt, "Forming a View of the World: 'The Master Puppeteer'," in her* Introducing More Books: A Guide for the Middle Grades *(copyright © 1978 by Diana L. Spirt; reprinted by permission of the author), R. R. Bowker Company, 1978, pp. 114-17.*

BRIDGE TO TERABITHIA (1977)

AUTHOR'S COMMENTARY

The summer our son David was three years old he fell in love with bridges. I understood just how he felt, being a lover of bridges myself, and coming home from Lake George, the whole family took delight in the bridges along the way. We were spending the night with our Long Island cousins; it was well after dark, and everyone was getting cranky by the time the last bridge was crossed.

"When is the next bridge, Mommy?" David asked.

"There aren't any more," I told him. "We're almost at Uncle Arthur's house now."

"Just one more bridge, Mommy, please, just one more bridge," he said, believing in his three-year-old heart that mothers can do anything, including instant bridge building.

"There aren't any more bridges, sweetheart, we're almost there."

He began to weep. "*Please,* Mommy, just one more bridge."

Nothing we said could console him. I was at my wits' end. Why couldn't he understand that I was not maliciously withholding his heart's desire—that there was no way I could conjure up a bridge and throw it in the path of our car? When would he know that I was a human being, devoid of any magic power?

It was later that night that I remembered. The next day I could give him a bridge, and not just any bridge. The next day I could give him the Verrazano Bridge. I could hardly wait.

That is the last and only time I was given credit for building the Verrazano Bridge, but it occurs to me that I have spent a good part of my life trying to construct bridges. Usually my bridges have turned out looking much more like the bridge to Terabithia, a few planks over a nearly dry gully, than like that elegant span across the Narrows. There were so many chasms I saw that needed bridging—chasms of time and culture and disparate human nature—that I began sawing and hammering at the rough wood planks for my children and for any other children who might read what I had written.

But of course I could not make a bridge for them any more than I could conjure one up that night on Long Island. I discovered gradually and not without a little pain that you don't put together a bridge for a child. You become one—you lay yourself across the chasm.

It is there in the Simon and Garfunkel song—"Like a bridge over troubled waters / I will lay me down." The waters to be crossed are not always troubled. The land on the other side of the river may be flowing with joy, not to mention milk and honey. But still the bridge that the child trusts or delights in—and in my case, the book that will take children from where they are to where they might be—needs to be made not from synthetic or inanimate objects but from the stuff of life. And a writer has no life to give but her own.

My first three novels were set in feudal Japan, but I never considered them remote from my life. I had left Japan seven years before I wrote the first of them, but in writing them, I had a chance to become almost Japanese again, and if you know me, you know that Muna and Takiko and Jiro are me as well. Yet of all the people I have ever written about, perhaps Jesse Aarons is more nearly me than any other, and in writing

this book, I have thrown my body across the chasm that had most terrified me.

I have been afraid of death since I was a child—lying stiffly in the dark, my arms glued to my sides, afraid that sleep would seduce me into a land of no awakening or of wakening into judgment.

As I grew up, the fear went underground but never really went away. Then I was forty-one years old with a husband and four children whom I loved very much, my first novel published, a second soon to be and a third bubbling along, friends I cared about in a town I delighted to live in, when it was discovered that I had cancer. (pp. 362-63)

But even though the operation was pronounced successful and the prognosis hopeful, it was a hard season for me and my family, and just when it seemed that we were all on our feet again and beginning to get on with life, our David's closest friend was struck and killed by lightning. (p. 363)

We listened to him and cried with him, but we could not give Lisa back to him, these mere mortals that he now knew his parents to be.

In January I went to a meeting of the Children's Book Guild of Washington at which Ann Durell of Dutton was to speak. By some chance or design, depending on your theology, I was put at the head table. In the polite amenities before lunch someone said to me: "How are the children?"—for which the answer, as we all know, is "Fine." But I botched it. Before I could stop myself I began really to tell how the children were, leading my startled tablemates deep into the story of David's grief.

No one interrupted me. But when I finally shut up, Ann Durell said very gently, "I know this sounds just like an editor, but you should write that story." (p. 364)

I thought I couldn't write it, that I was too close and too overwhelmed, but I began to try to write. It would be a kind of therapy for me, if not for the children. I started to write in pencil on the free pages of a used spiral notebook so that when it came to nothing I could pretend that I'd never been very serious about it.

After a few false starts, thirty-two smudged pages emerged, which made me feel that perhaps there might be a book after all. In a flush of optimism I moved to the typewriter and pounded out a few dozen more, only to find myself growing colder and colder with every page until I was totally frozen. The time had come for my fictional child to die, and I could not let it happen.

I caught up on my correspondence, I rearranged my bookshelves, I even cleaned the kitchen—anything to keep the inevitable from happening. And then one day a friend asked, as friends will, "How is the new book coming?" and I blurted out—"I'm writing a book in which a child dies, and I can't let her die. I guess," I said, "I can't face going through Lisa's death again."

"Katherine," she said, looking me in the eye, for she is a true friend, "I don't think it's Lisa's death you can't face. I think it's yours."

I went straight home to my study and closed the door. If it was my death I could not face, then by God, I would face it. I began in a kind of fever, and in a day I had written the

chapter, and within a few weeks I had completed the draft, the cold sweat pouring down my arms.

It was not a finished book, and I knew it, but I went ahead and did what no real writer would ever do: I had it typed up and mailed it off to Virginia before the sweat had a chance to evaporate. (pp. 364-65)

Finally she called. "I laughed through the first two thirds and cried through the last," she said. So it was all right. She understood, as she always has, what I was struggling to do. And although she did not know what was happening in my life, she did not break the bruised reed I had offered her but sought to help me weave it into a story, a real story, with a beginning, a middle, and an end.

"We need to see Leslie grow and change," she said. And suddenly, from the ancient dust of the playground at Calvin H. Wiley School, there sprang up a small army of seventh-grade Amazons led by the dreadful Pansy Something-or-Other, who had terrorized my life when I was ten and not too hard to terrify.

"You must convince us," Ann Beneduce added, "that Jesse has the mind of an artist." This seemed harder, for I certainly don't have Ann's kind of artistic vision. I started bravely, if pompously, reading the letters of Vincent Van Gogh, and when they didn't help, I went, as I often do, to my children.

"David," I asked, feeling like a spy, "why don't you ever draw pictures from nature?"

And my nine-year-old artist nature-lover replied, "I can't get the poetry of the trees." It is the only line of dialogue that I have ever consciously taken from the mouth of a living person and put into the mouth of a fictitious one. It doesn't usually work, but that time it seemed to.

I have never been happier in my life than I was those weeks I was revising the book. It was like falling happily, if a little crazily, in love. I could hardly wait to begin work in the morning and would regularly forget about lunch. The valley of the shadow which I had passed through so fearfully in the spring had, in the fall, become a hill of rejoicing. (pp. 365-66)

I have never ceased to love the people of this book—even the graceless Brenda and the inarticulate Mrs. Aarons. And, oh, May Belle, will you ever make a queen? I still mourn for Leslie, and when children ask me why she had to die, I want to weep, because it is a question for which I have no answer.

It is a strange and wonderful thing to me that other people who do not even know me love Jesse Aarons and Leslie Burke. I have given away my own fear and pain and faltering faith and have been repaid a hundredfold in loving compassion from readers like you. As the prophet Hosea says, the Valley of Trouble has been turned into the Gate of Hope. (p. 366)

In talking with children who have read *Bridge to Terabithia*, I have met several who do not like the ending. They resent the fact that Jesse would build a bridge into the secret kingdom which he and Leslie had shared. The thought of May Belle following in the footsteps of Leslie is bad enough, but the hint that the thumb-sucking Joyce Ann may come as well is totally abhorrent to these readers. How could I allow Jesse to build a bridge for the unworthy? they ask me. Their sense of what is fitting and right and just is offended. I hear my young critics out and do not try to argue with them, for I know as well as they do that May Belle is not Leslie, nor will she ever be. But

perhaps some day they will understand Jesse's bridge as an act of grace which he built, not because of who May Belle was but because of who he himself had become crossing the gully into Terabithia. I allowed him to build the bridge because I dare to believe with the prophet Hosea that the very valley where evil and despair defeat us can become a gate of hope—if there is a bridge. (pp. 366-67)

> *Katherine Paterson, "Newbery Award Acceptance" (copyright © 1978 by Katherine Paterson; reprinted by permission of the author; originally a speech given at the meeting of the American Library Association in Chicago, Illinois, on June 27, 1978), in* The Horn Book Magazine, *Vol. LIV, No. 4, August, 1978, pp. 361-67.*

Jess' ambition is to be "the fastest runner in the fifth grade," and he is well on his way when Leslie arrives on the scene . . . and beats him in a race. The two quickly find they have much in common—and each has something to give the other. . . . The two friends build a secret hideout and invent an imaginary kingdom they call Terabithia, but soon torrential rains make it risky for them to get there. When Jess gets back from a day trip to nearby Washington, D.C. with a teacher he learns that Leslie drowned trying to reach their meeting place and reacts first with shock, then selfishness, and finally grief. . . . [He] decides how to best memorialize Leslie and what she meant to him. Not only is the story . . . unusual because it portrays a believable relationship between a boy and a girl at an age when same-sex friendships are the norm but it also presents an unromantic, realistic, and moving reaction to personal tragedy. Jess and Leslie are so effectively developed as characters that young readers might well feel that they were their classmates.

> *Jack Forman, in a review of "Bridge to Terabithia," in* School Library Journal *(reprinted from the November, 1977 issue of* School Library Journal, *published by R. R. Bowker Co./A Xerox Corporation; copyright © 1977), Vol. 24, No. 3, November, 1977, p. 61.*

Friendship, that relationship so important to happiness, and so curiously unsung in literature, is the subject of Katherine Paterson's lyrical novel *Bridge to Terabithia*. Not the kind of "friendship" which is now so familiar on the children's book list—a kind of proto-sexual, cut-me-down love—but a real marriage of minds between children whose imaginative gifts cut off from others and bind them together. . . .

Katherine Paterson gives us only the briefest glimpse of Terabithia; the purpose of the book keeps the reader in the real world from which Terabithia is an escape. And when a shocking and irrevocable breach separates Jess and Leslie, he finds a bridge in their dream kingdom strong enough even to forge a link between life and death.

This is a Newbery Medal winning book, and its quality is evident from the first page—yet hard to describe. Accurate and convincing in its details of everyday life, school playground tussles, poverty and work, it is never banal. It is tender and poetic without ever being sentimental, written in simple language which, never fails to carry the emotional charge. Author Paterson is a fine writer who never puts a foot wrong, but her

distinctive flavor comes from a serenity of vision which is uniquely hers.

Jill Paton Walsh, "Novels for Teens: Delicate Themes of Friendship, Fantasy," in The Christian Science Monitor *(reprinted by permission from* The Christian Science Monitor; © 1978 The Christian Science Publishing Society; all rights reserved), May 3, 1978, p. B2.**

American children's fiction, from Huck and Tom onwards, has been strong on dream kingdoms, and their souring into the reality of home or school demands. Yet in dreams begin responsibilities, and out of play may evolve complex and important relationships whose outcome may be an increase in self-knowledge. Katherine Paterson's *Bridge to Terabithia* belongs firmly to this tradition, to which it makes a distinguished, if not absolutely original contribution. . . .

The story is related with considerable psychological insight as Jess's initial resentment changes through pity to liking and love. We are shown those unspoken yet accurately observed customs that govern school conduct. . . . The climax of the story, Leslie's sudden death, is very carefully built up, and vividly portrays the succession of feelings such an experience may bring—disbelief, numbness, violent distress. In the end Jess comes to terms with this event, so deeply fraught with guilt for him, with a sweet reasonableness that most adults would be hard put to achieve. At moments Jess's behaviour convincingly includes the irrational, aggressive and perverse impulses so characteristic of childhood, yet by making him also the first person narrator Katherine Paterson has associated him a little too closely with her own fine moral discriminations, and has thus weakened him, ultimately, as a character. But this is a small flaw in a book that has so much excellence about it.

Julia Briggs, "Know Thyself," in The Times Literary Supplement *(© Times Newspapers Ltd. (London) 1978; reproduced from* The Times Literary Supplement *by permission), No. 3991, September 29, 1978, p. 1082.*

American children's books, having faced up to class and sex, are now tackling death, the ultimate taboo subject. But it would be unfair to classify this book as trendy; it handles the subject tenderly, offering a romantic and healing way of facing the fact of death. . . . One is left wondering whether there is any way to live in Terabithia, or whether the romantic world of chivalry and imagination can only be discovered outside life; because such questions reverberate one recognises this as a serious and valuable book.

Dorothy Nimmo, in a review of "Bridge to Terabithia," in The School Librarian, *Vol. 27, No. 2, June, 1979, p. 165.*

[*Bridge to Terabithia*] is a memorable story of the friendship between Jess, a quiet, introspective farm boy, and Leslie, a spirited, imaginative girl. . . . Their relationship is beautifully developed and shows young readers that girls and boys can indeed be real friends. However, at the end of the story, the author surprises us by having Leslie die accidentally. This leaves the disturbing suggestion that perhaps such a friendship was, after all, too unreal to sustain. We realize, too, after the tears dry, that this is ultimately not a story about friendship at all, but about a young boy whose limited world is opened up by a temporary visit from an almost mystical character—this

is a contemporary fairy tale. Leslie serves, in fact, less as a friend than as an enabler, and Jess clearly realizes this at the end of the story. . . .

In spite of these reservations about the underlying messages in the book—and one or two offensive references to Native Americans, *Bridge to Terabithia* is an outstanding novel for young people, and its surface plot of a mutual girl-boy friendship remains a valuable one. (p. 21)

Sharon Wigutoff, "An Antidote to Series Romances: Books about Friendship," in Interracial Books for Children Bulletin *(reprinted by permission of* Interracial Books for Children Bulletin, 1841 Broadway, New York, NY 10023), Vol. 12, Nos. 4 & 5, May-August, 1981, pp. 21-2.*

[Katherine Paterson uses] words to paint panoramas for the imagination. (p. 103)

In *Bridge to Terabithia*, Katherine Paterson describes Jesse's feelings as "mad as flies in a fruit jar" and bubbling inside him "like a stew on the back of the stove." At another point we are told, "it seemed to him that his life was delicate as a dandelion. One little puff from any direction, and it was blown to bits." . . . The book also contains large metaphors, such as the meaning of Terabithia and what the bridge represents. The dandelion image can be particularly meaningful for teachers who would want to impart the beauty of language to students. (pp. 103-04)

The story is full of small meaningful events, school encounters, and the beautiful growth of the friendship between Leslie and Jess. . . .

Three fifth-grade girls, discussing this story, appreciated the sense of hope evident in the ending: "Only at one little part it made you sad. But the very ending I loved because it made you feel, like, happy again." Another response to the ending: ". . . if you feel sad about something, you shouldn't try to forget it, but you should try to get over it as much as you can so you can enjoy things, because life shouldn't be something where you can't enjoy anything." All three felt that the story showed them that you could, and should, "get over" the death of a friend and that Jess was a good model of how they might react if they were in similar circumstances. (p. 317)

Older students are drawn to . . . [this] well-crafted novel because it is both gripping and memorable, its images evocative. . . . It celebrates the vision of imagination and touches children's hearts. The wealth of emotions and insights in the book hold potential for rich response from a number of perspectives.

The fact that children pass the book gently along to their best friends, and that its pages are dog-eared, testifies to the strong aesthetic response it elicits. Katherine Paterson enables readers to validate the depths of friendship, comparing her story with what they know. Where the match is true, some of Jesse's and Leslie's courage and strength pass into the reader's own fiber. Further, just as Leslie's move to rural Virginia enabled her to see how others lived, so do readers expand their understandings of life and friendship by reading about this special relationship.

Likewise, Jesse's growth, in daring to be different, and his coming to terms with grief at Leslie's death serve readers as virtual experience or rehearsal for life.

Some teachers may want to help children probe *Bridge to Terabithia* from a structuralist perspective—focusing on the well-

developed characters for example. Leslie's intelligence and imagination raise Jesse's consciousness and inspire him to move toward maturity. . . . Just as Jesse finds in Leslie a model to emulate, so, too, can readers find a mirror of their own development or a window through which they view the lives of others.

Discussion of characterization is appropriate to this text once students respond to Jesse and Leslie as believable characters. They can then proceed to an examination of minor characters, including a consideration of the role they play in shaping the story. A discussion of the way the respective families interact with their children—how differently Jesse and Leslie were reared—can lead to penetrating insights for children about how this story relates to their own lives.

It could also be fruitful to discuss the effect of other elements in the story, such as point of view and setting. Or, the story as a whole may be compared with other works of contemporary realistic fiction dealing with the death of a child, such as Smith's *A Taste of Blackberries,* Greene's *Beat the Turtle Drum,* and Lowry's *A Summer to Die.*

Katherine Paterson marks her story with another important element—language, and the role it plays in both circumscribing Jesse's life and then freeing him. Paterson vividly contrasts the language of the Aarons family with that of the Burkes, and highlights Jesse's growth with changes in his language. Initially he speaks a restricted Appalachian dialect and turns to Leslie to make the magic in Terabithia. As the story draws to a close, he is making the magic himself. . . . The process of language growth itself develops into a theme about the way in which language can either delimit or enlarge one's world.

From the perspective of theme, the story centers on the importance of life continuing aftcr tragedy. Rather than being destroyed by his friend's death, Jesse builds on the legacy Leslie leaves him and continues Terabithia, passing it on to his younger sister, May Belle. In the final scene, he puts flowers in May Belle's hair and leads her across the newly constructed bridge, his belief in the promise of life shining in his words as he says to her:

> "Can't you see 'um?" he whispered. "All the Terabithians standing on tiptoe to see you."
>
> "Me?"
>
> "Shhh, yes. There's a rumor going around that the beautiful girl arriving today might be the queen they've been waiting for."

Jesse's act of love honors Leslie's life.

If looked at from an archetypal perspective, Jesse's journey toward maturity can be viewed as a variation of the quest. Leslie's death is analogous to the trials that must traditionally be endured before the goal, in this case maturity, is attained. Jesse is aware of being put to the test; Paterson writes:

> As for the terrors ahead—for he did not fool himself that they were all behind him—well, you just have to stand up to your fear and not let it squeeze you white. Right, Leslie? Right.

Children draw conclusions from discussions of larger meanings, making comparisons with other stories embodying similar quests. They will evaluate this story in terms of other literature they have experienced and use it as a basc for evaluating texts read in the future.

Terabithia, in its metaphoric sense, stands for the world of possibilities sometimes reached through the painful process of maturation. There, Leslie helps Jesse to recognize his potential. Probing of the text is enhanced by recognizing how this pervasive metaphor shapes the story. (pp. 500-01)

> *Bernice E. Cullinan with Mary K. Karrer and Arlene M. Pillar, in their* Literature and the Child *(copyright © 1981 by Harcourt Brace Jovanovich, Inc.; reprinted by permission of the publisher), Harcourt Brace Jovanovich, 1981, 594 p.**

THE GREAT GILLY HOPKINS (1978)

AUTHOR'S COMMENTARY

I wrote this book because, by chance rather than by design, I was for two months a foster mother. Now, as a mother, I am not a finalist for any prizes, but on the whole I'm serviceable. I was not serviceable as a foster mother, and this is why: I knew from the beginning that the children were going to be with us only a short time, so when a problem arose as problems will, I'd say to myself, "I can't really deal with that. They'll be here only a few weeks." Suddenly and too late, I heard what I had been saying. I was regarding two human beings as Kleenex, disposable. And it forced me to think, what must it be like for those thousands upon thousands of children in our midst who find themselves rated disposable? So I wrote a book, a confession of sin, in which one of those embittered children meets the world's greatest foster mother. Virginia Buckley said that my characters were mythic; a critic being less kind used the word *unbelievable.* I knew when I wrote the book that Gilly and Trotter were larger than life. I did it deliberately, to get attention, like that unknown lover who wrote across the underpass near our house in letters ten feet high, "I LOVE YOU, GRACE KOWASKI."

But the wonderful thing about being a writer is that it gives you readers, readers who bring their own stories to the story you have written, people who have the power to take your mythic, unbelievable, ten-foot-high characters and fit them to the shape of their own lives. I met one of these people the other day.

A teacher had read aloud *The Great Gilly Hopkins* to her class, and Eddie, another foster child, hearing in the story of Gilly his own story, did something that apparently flabbergasted everyone who knew him. He fell in love with a book. Can you imagine how that made me feel? Here was a twelve-year-old who knew far better than I what my story was about, and he did me the honor of claiming it for himself. (pp. 402-03)

Flannery O'Connor says this about herself when she was Eddie's age: "I was a very ancient twelve. My views at that age would have done credit to a Civil War veteran. I'm much younger now than I was at twelve or anyway, less burdened. The weight of the centuries lies on children. I'm sure of it."

So I, who have grown younger and less burdened with the years, count it a singular grace when what began for me as a confession of sin seems to lift, if only for a moment, the weight of the centuries from some young shoulder. (p. 403)

> *Katherine Paterson, "National Book Award Acceptance" (copyright © 1979 by Katherine Paterson; reprinted by permission of the author; originally a speech given at Carnegie Hall, New York City, on April 25, 1979), in* The Horn Book Magazine, *Vol. LV, No. 4, August, 1979, pp. 402-03.*

This is quite a book! It confronts racism, sexism, ageism, I.Q.ism and just about all the other prejudices of our society. Don't be scared off, though, the author manages rather well. Gilly is a high-keyed heroine—we can fear her, admire her, envy her, be angry with her, and be relieved to be ourselves. To survive in the foster care system a child must develop fantasies and defenses. Yet these same patterns are also counterproductive —they make it terribly difficult for a child to adjust to and be accepted by a family. . . . Katherine Paterson writes sensitively, with humor and love. Although few children share Gilly's experiences, most will be entranced by her and involved in this book. Definitely a worthwhile addition for a school library.

> *Ellen M. Davidson, in a review of "The Great Gilly Hopkins," in* Children's Book Review Service *(copyright ©1978 Children's Book Review Service Inc.), Vol. 6, No. 9, April, 1978, p. 89.*

Katherine Paterson has a rare gift for creating unusual characters who are remarkably believable. She accomplishes this with sure, swift strokes, making even minor characters multifaceted. Her fine talent works against this story, however, because too much is attempted in one book. . . .

Hopeful that her mother will rescue her once she knows how much she is needed, Gilly preserves her integrity by being both brilliant and tough. But Gilly's well-defined anger and intellect are no match for the cast of characters she faces in her latest foster home and in her integrated school. Maime Trotter, her new foster mother, is a 200-pound hulk of a woman who is not only semi-literate, but is sincere when she gushes sentimentality, scripture and clichés. She hovers like an over-stuffed mother hen around her other foster child, 7-year-old William Ernest, who always looks frightened and is probably retarded. Then there is blind Mr. Randolph, a courtly old and gentle black man who comes to eat dinner with them every night. . . .

[Her] teacher, Miss Harris, regal and statuesque, who towers over the principal even without her magnificent Afro hairdo, is decidedly cool to Gilly's intellectual achievements. . . . When Gilly attempts to humiliate the teacher by sending her a vicious racist card, Miss Harris responds to the child's anger, not the message.

More surprises are in store for Gilly, including a maternal grandmother, who upon discovering the existence of her granddaughter, not only does the "right" thing, but apparently is going to enjoy having a second chance at mothering.

It's not that **"The Great Gilly Hopkins"** isn't a good read, it's just that it would have been a better story without mixing up race relations, learning disabilities, the important relationships between young and old, *and* a terrific young girl who gamely comes to terms with her status as a foster child.

> *Bryna J. Fireside, "Two Orphans without Mothers," in* The New York Times Book Review *(copyright © 1978 by The New York Times Company; reprinted by permission), April 30, 1978, p. 54.**

Here is a book which, having a choice to make between a happy ending and a hard one—both being reasonable—chooses the latter, thereby finally declaring itself as something rather different from what it has led the readers to expect. For the story line has healthy antecedents in literature from *Oliver Twist* onward: an abandoned child, stranded in a bizarre place among bizarre people, learns how to value herself and others. Not that Gilly Hopkins is a typical Dickens hero; she resembles the Artful Dodger more than she does Oliver, for she is a wise-cracking, angry, self-protective youngster who expects to depend on no one but herself. Nevertheless, she has her own brand of innocence and her own dreams. (p. 1)

Katherine Paterson develops her characters thoroughly, avoiding the common pitfalls of stories of this type. While she eschews Dickensian sentimentality, she is strong on humor, and her writing is clear, inventive, and—except for a single line from the social worker, "God help the children of the flower children,"—entirely nonjudgmental. Gilly is a liar, a bully, a thief; and yet, because Paterson is interested in motivations rather than moralizing, the reader is free to grow very fond of her heroine—to sympathize, to understand, to identify with Gilly, and to laugh with her.

Still, the parallels to Dickens and others of his ilk are not unimportant. Familiarity with patterns in fiction directs the reader's expectations towards an ending to Gilly's story that is quite different from the one Paterson has chosen. For in spite of the hopelessness of the principal characters' situations, they are all full of hope—they are good-humored, steadfast, loving, and even happy. They are, in other words, larger than life in a very particular way: they have a greatness of spirit which takes them a shade beyond reality. There is here, as with Dickens, an element of affectionate overdrawing, almost of caricature, and insofar as that element is present, the expectation is created for an ending which rewards these people's suffering.

Yet, when Gilly's mother appears in the closing chapter, she shows herself to be real in a flat, uncompromising way that her fellow characters are not. For her Paterson shows no affection, and she and the denouement she brings seem less than Gilly deserves. It is as if this book, as a movie, were filmed in the soft, warm, misty color that can find beauty even in a London alley, and then, at the end, turns suddenly to harsh black-and-white.

Paterson intended this to be the case—that seems clear. As Mrs. Trotter says to Gilly at the close of the story, "You just fool yourself if you expect good things all the time. They ain't what's regular—don't nobody owe 'em to you." True enough, and therefore fair enough. The novelist is free, these days anyway, from obligations, and that is probably a good thing. Perhaps, for Gilly, her days spent with Mrs. Trotter and William Ernest and Mr. Randolph can be compared, in a classic sense, to Dorothy's days in Oz: they are the true fantasy world of the hero from which he must at the end return, enriched but sobered, to reality.

In any case, *The Great Gilly Hopkins* is a finely written story. Its characters linger long in the reader's thoughts after it is finished. What Paterson has done is to combine a beautiful fairness with her affection for her creations, which makes them solidly three-dimensional. And that by itself, even if there were nothing else—and there is a great deal else—would be sufficient to make this a book worth reading. (pp. 1-2)

> *Natalie Babbitt, "A Home for Nobody's Child," in* Book World—The Washington Post *(© 1978, The Washington Post), May 14, 1978, pp. 1-2.*

Unfortunately it is easy to be alienated by [Gilly's anti-social] behaviour. Gilly's first encouraging response to people who are trying to help and love her is deferred until page 52. This

means that for more than a third of the book she is thoroughly objectionable, swearing, being as rude as possible, and resorting to physical violence. . . .

This is a worthy and well intentioned attempt to help young readers understand the problems of their deprived contemporaries. It is just a pity that Gilly has to be so unpleasant for so long.

> *Ruth Baines, in a review of "The Great Gilly Hopkins," in* The Junior Bookshelf, *Vol. 43, No. 5, October, 1979, p. 283.*

A tough, funny book with a tough, funny heroine. Recognisably from the Byars-Hamilton-Zindel school, the novel has a wry humour all its own. Gilly, Maime, William Ernest and Mr Randolph are all memorable and the central character's search for a moral basis has a poignancy which never becomes soft-centred.

> *Dennis Hamley, in a review of "The Great Gilly Hopkins," in* The School Librarian, *Vol. 27, No. 4, December, 1979, p. 383.*

The book is outstanding in characterization, theme, and style. The character of Gilly is believable and consistent and will remain in a reader's mind long after details of plot are forgotten. Although her actions, speech, and the comments of other characters reveal her, it is her thoughts that contribute most to the characterization. They reveal the reason for her tough exterior: it is her defense against being hurt. . . . The predictable ending to Gilly's story would have been finding happiness with Maime Trotter and becoming reconciled to the fact that her mother is not going to come for her. Gilly does find happiness with Maime but she has to leave it, as a result of her own actions— it was her letter that brought her grandmother. In a time when self-centered happiness has been an often expressed goal in both life and literature, it is noteworthy when the heroine—as Gilly does in the end—learns to do things she has to because it is her duty. . . . Much lively dialogue, appropriate imagery, and humorous incidents—such as Gilly beating up six boys in one noon recess—save the story from pathos. (p. 218)

> *Marilyn Leathers Solt, "The Newbery Medal and Honor Books, 1922-1981: 'The Great Gilly Hopkins'," in* Newbery and Caldecott Medal and Honor Books: An Annotated Bibliography *by Linda Kauffman Peterson and Marilyn Leathers Solt (copyright © 1982 by Marilyn Solt and Linda Peterson; reprinted with the permission of Twayne Publishers, a division of G. K. Hall & Co., Boston), G. K. Hall, 1982, pp. 216-18.*

ANGELS AND OTHER STRANGERS: FAMILY CHRISTMAS STORIES (1979; British edition as *Star of Night: Stories for Christmas*)

With dexterity, [Paterson] creates nine insightful stories that stir the emotions while reflecting the joy of the Christmas season. . . . [These] tales celebrate the birth of Jesus through the loneliness, fears, hopes, and simple beliefs of men, women, and children but never lapse into sentimentality or zealous pomposity. A man searches for his runaway son, a boy stages a "miracle" for his younger sister, a woman finds new meaning in a perfect Christmas on a lonely highway, a Japanese pastor gives a wondrous Christmas celebration for a single, war-torn child. Such scope offers a broad base for family sharing where nuances of meaning can be discussed and savored.

> *Barbara Elleman, in a review of "Angels and Other Strangers: Family Christmas Stories," in* Booklist *(reprinted by permission of the American Library Association; copyright ©1979 by the American Library Association), Vol. 76, No. 2, September 15, 1979, p. 126.*

Critics and the many readers who have praised Paterson's previous books will probably mark this splendid collection A + . Each story concerns a surprising spiritual gift bestowed during the Christmas season to people who need it desperately. One is Maggie in **"Maggie's Gift,"** a rotten kid in spades. Lonely retiree Mr. McGee spends his skimpy social-security check to provide holiday cheer for Maggie and her tiny brother, Edgar, only to be thanked by the girl's jeers and sneers. The switch in her viewpoint and its cause make this a divinely funny vignette. The other stories star entirely different characters and situations, making up a group of impressive entertainments, written with warmth and style.

> *A review of "Angels and Other Strangers," in* Publishers Weekly *(reprinted from the September 24, 1979 issue of* Publishers Weekly, *published by R. R. Bowker Company, a Xerox company; copyright © 1979 by Xerox Corporation), Vol. 216, No. 13, September 24, 1979, p. 104.*

Paterson's well-tuned, sentimental Christmas stories seem less well suited to a children's book than to a family magazine, especially a church magazine. . . . Of the nine, three effect epiphanies of sorts in church; in another a child runs to church for comfort (and finds it with the Sunday-school teacher next door). . . . [Several stories] set up encounters between comfortable middle-class Protestants and others who are poor, black, and/or outcast; in these Paterson does well with the interplay, and she never falsifies the characters on either side or overplays her hand. This is several notches above the usual Christmas story collection, and a boon for groups concerned with the meaning of the holiday.

> *A review of "Angels and Other Strangers," in* Kirkus Reviews *(copyright © 1979 The Kirkus Service, Inc.), Vol. XLVII, No. 20, October 15, 1979, p. 1211.*

With her gifts of insight and compassion the author weaves stories about miracles of the Christmas season—miracles that take place on a truly human level. Each story is based on the Christian message of the birth of Christ and the significance that message takes on for the characters. She writes of the poor, the desolate, and the lonely as well as of the arrogant, the complacent, and the proud. . . . In the title story a woman who is stranded on a dark, cold night learns from her son that she can trust the big man who offers them help. And in **"Broken Windows"** a rather stuffy old minister is brought down from his pulpit to face a destitute family in his congregation. Through confrontations such as these, the lowly are raised up and the proud are brought low. The stories are deeply moving and filled with humor. They are based not on a formal, theoretical Christianity but on a faith that is rich with human understanding.

> *Karen M. Klockner, in a review of "Angels and Other Strangers: Family Christmas Stories," in* The Horn Book Magazine *(copyright © 1979 by The Horn Book, Inc., Boston), Vol. LV, No. 6, December, 1979, p. 650.*

Katherine Paterson's book is a real contribution to the literature of Christmas, not just a nice Christmas gift-book. Although it is very much a book of our times, the message is as timeless and universal as the message of Christmas itself.

Here are nine short-stories about Christmas, mostly in America although there is one terrifying and heartening tale from Japan. They are all the product of an observant eye and a sympathetic heart, sometimes operating through the medium of humour, sometimes through tragedy. . . . They are not stories for children, but all the family might welcome them in a quiet half-hour while the turkey settles.

Marcus Crouch, in a review of "Star of Night," in The Junior Bookshelf, *Vol. 45, No. 1, February, 1981, p. 31.*

JACOB HAVE I LOVED (1980)

AUTHOR'S COMMENTARY

Whenever I speak, one of the questions sure to be asked during the question-and-answer time is "How long does it take to write a book?" as though books, like elephants or kittens, have a regular and therefore predictable gestation period. Often I will begin my reply by asking, "Which book?" trying to indicate that each book is different and has its own unique history. There is, however, one answer that would be true in every case, but whenever I try to put it into words I find myself swimming in pomposity. The correct answer, you see, is this: It has taken all my life to write this book. Maybe longer.

The conflict at the core of *Jacob Have I Loved* began east of Eden, in the earliest stories of my heritage. Cain was jealous of his brother, and, we are told, "Cain rose up against Abel his brother and slew him." If, in our Freudian orientation, we speak of the basic conflict as that between parent and child, the Bible —which is the earth from which I spring—is much more concerned with the relationships among brothers and sisters. "A friend loveth at all times," says the writer of Proverbs, "but a brother is born for adversity." They never taught us the second half of that verse in Sunday School.

The fairy tales, too, are full of the youngest brother or sister who must surpass his supposedly more clever elders or outwit the wicked ones. In *The Uses of Enchantment* . . . Bruno Bettelheim suggests that a great deal of the apparent rivalry between brothers and sisters in fairy tales is in actuality an Oedipal conflict, since the usual number of brothers or sisters is three. In the stories of two brothers or sisters, Bettelheim suggests that the story is about the divided self, which must be integrated before maturity can be attained. Although both of these explanations make sense, I do not think we can avoid the most obvious meaning of the stories, which is that among children who grow up together in a family there run depths of feeling that will permeate their souls for both good and ill as long as they live.

I was the middle child of five, swivel position, the youngest of the three older children and the oldest of the three younger. Although I can remember distinctly occasions when I determined that someday I would show my older brother and sister a thing or two, and I have no recollection that my two younger sisters were plotting to do me in, still the stories in which the younger by meanness or magic or heavenly intervention bested the elder always bothered me. They simply weren't fair. The divine powers, whether the Hebrew God or the European fairy, always weighted the contest. And although the civilized Cal-

vinist part of my nature spoke in quiet tones about the mystery of divine election, there was a primitive, beastly part, a Caliban, that roared out against such monstrous injustice. Novels, I have learned, tend to come out of the struggle with the untamed beast. (pp. 117-18)

How do you begin a book? People always want to know how you begin. If only I knew. Think of all the agonizing days and weeks I could have spared myself, not to mention my long-suffering family. They know better than to ask me about my work when I'm trying to start all over again. My replies are never gracious. There must be a better way. My way is to write whatever I can, hoping against hope that with all the priming the pump will begin to flow once more.

Here is a sample from those dry, dry days in the fall of 1977:

> Her name is Rachel Ellison but I don't know yet where she lives. It might be in the city or in the country. It might even be Japan. It seems important to know what her parents do. How does religion come into the story? Will Rachel be burdened by guilt as well as everything else? Will her relationship to God play counterpoint to her relationship to her brother? I said brother, but perhaps after all it has to be a sister. I'm avoiding sister because it comes too close to home. Am I contemplating a book I can't write? The feelings start boiling up everytime I begin to think about it. All raw feeling. No story. There has to be a story. There has to be a setting. There has to be something more than boiling anger. Why am I angry? . . . Where is the key that turns this into a book? Jacob and Esau. Cain and Abel. Rachel and Leah. Prodigal and elder brother. Joseph and his brothers. The sons of David. Lord, make my brother give me the portion of the inheritance that comes to me. Maybe Rachel's brother is an adopted South Asian war orphan. Sister.
>
> Excitement to pity to rage to hatred to some kind of accommodation. Step one: Go to the library and find out everything possible about Southeast Asian orphans. . . .

And I was off on a wild-goose chase that lasted for days.

All November and December were spent in pursuit of similar geese. How long this would have gone on I have no way of knowing, but Christmas came and with it a gift of grace. It was not even intended as a gift for me. My sister Helen gave our son John a copy of William Warner's *Beautiful Swimmers: Watermen, Crabs, and the Chesapeake Bay*. . . . I began reading it during those low after-Christmas days, and by the time the new year dawned I had a place to set my story, the Chesapeake Bay, less than an hour from my front door.

In the Bay there are many islands, most of which are not inhabited. Two of these islands, Smith and Tangier, are separated by miles of water from the rest of America. Even now, with television, telephones, and—in the case of Tangier—an airstrip, they seem a world apart. My story was going to be chiefly about a young adolescent who felt terribly isolated. Of course, all fourteen-year-olds who are not social clones feel isolated, but what better way to show this isolation than an island? Rass—the name for my island squirted up from my subconscious and has yet to reveal its source or meaning—

Rass would be none of the actual islands, but something like all of them.

Now I began going to the library as well as to the Bay to find out everything I could about the Chesapeake. At the same time I began setting down on scraps of paper and three-by-five cards ideas as they would occur, things that might happen in the story.

> What about a grandmother or other live-in relative who spouts pietisms? She may be one who brings up "Jacob have I loved. . . ." theme.
>
> Old man gets off ferry. He left thirty years before and has come back. Takes shack at farthest end of island to live as recluse.
>
> Make the kid sentimental— moons over tombstone—tries to convert friend who is boy to sentimentality.

These are bound with the same sturdy rubber band that holds notes taken from reading and observation.

> pain of being stung in the eye by jellyfish.
>
> how peelers are separated
> 2 wks. to go—snots, greens, white sign crabs
> 1 wk.—pink sign
> hrs. to go before busting—rank, red sign
>
> reactions to thunderstorms
> chopped down mast
> climbing up it swinging hatchet at the almighty-daring God to meet him halfway—
>
> cats around garbage dump scavenging. Big cats.
>
> wintering birds on Smith
> "Oh, my blessed, what a noise."

There is another large pack of four-by-six cards, but I think all those notes were collected much later. I think so, not that I ever seem capable of dating, but the cards are ones I remember buying at Gray's Pharmacy in Norfolk. So between the first batch of cards and the second, there came the January 1978 announcement of a Newbery medal, the acceptance, the knowledge that after thirteen years in Takoma Park we would be moving, the discovery of my mother's terminal cancer, the choice of *Gilly* as the Newbery Honor Book, the move to Norfolk, Mother's death, and a National Book Award. That is not everything that happened in our lives between the fall of 1977 and the spring of 1979, but it may give you some idea why poor *Jacob* was languishing.

But even as I present to you these impeccable excuses, I know in my heart that the reason I nearly despaired of finishing this book was more the internal storms it stirred up than those that came from without. I was trying to write a story that made my stomach churn every time I sat down at the typewriter. "Love is strong as death," says the writer of the Song of Songs, "jealousy is as cruel as the grave." I did not want ever again to walk the dark path into that cruelty.

Yet even while I was having trouble going back into my young self, I was being drawn more and more into the world of the book. I knew that in Rass I was trying to create a facsimile of the Bay islands, but my feeling as I worked was not so much that of a creator as that of an explorer. Here was a hidden world that it was my task to discover. If I failed, this world would remain forever unknown.

I do not mean by this that I thought I had a monopoly on the Chesapeake Bay. Not long after I had begun work on my book, James Michener's massive *Chesapeake* (Random) was published. I read it with dread, fearing that he might have preempted me, might have discovered my world. But he hadn't. He couldn't have. The Chesapeake world I was exploring was mine alone. No other living soul had access to it unless I could somehow reveal it in *Jacob.* I think I have finally learned that no one can steal your novel from you. No matter how closely his material may come to yours, he can only write his story, and you, yours—the intricate design of an individual life upon some portion of the outside world. I knew, for better or worse, that if I did not write *Jacob,* it would never be written.

I say my world, my story, but it hardly ever felt like mine. For one thing, it refused to obey my rules. I have always sworn that I would never write a book in the first person. It is too limiting, too egotistical. And yet, the book refused any voice but Louise's. "Oh, well," I said to myself, "I'd better get it down any way I can in the first draft. In the next draft I can write it properly."

At some point I wrote a very peculiar note to myself. Not content with writing a book in first person, I apparently was thinking of writing it as three first-person stories—one for Louise, one for Caroline, and one for Call. "Perhaps," I added, "end with a fourth section which goes back to Sara Louise and ties the story together."

Heavens above. I think the only reason this book ever got written is that I would regularly lose all my notes. I must remember that next time. Take all the notes you wish, but do not fail to lose them once you start. (pp. 119-23)

Among my notes I found this one written while I was stalled one day during August of 1979. I can date it because it is written on Gene Namovicz's electric typewriter and is full of stray *l*'s and *k*'s.

> There is another sibling rivalry in the story of Jacob. It is, of course, the story of Leah and Rachel. "Jacob have I loved—" Poor Leah, the homely elder sister. Married in trickery to the man passionately in love with her younger sister. She goes to his bed and must lie there and bear his seeing who she is. Watch his face as the truth of his father-in-law's treachery dawns. His disappointment. How does he react? What does he say? Even if, and it is hard to believe he might have been, even if in his own disappointment he remembers her pain and tries to be tactful and kind, that very kindness would be next to unbearable, if Leah loves him at all. Esau's grief is nothing compared to Leah's. She must watch her husband go joyfully to her sister and joylessly come to her. But God does give her many sons. That would be a comfort if we did not know that Rachel, who only has two sons, is the mother of Joseph—that younger brother of all younger brothers. This puts a new dimension into the phrase, "Jacob have I loved. . . ." It is a woman speaking now, a wronged and grieving woman, not God. The loving is not here a matter of divine election but of the eternal weight of women who have neither the beauty of Rachel nor the cleverness of Rebekkah. What shall we do for the Leahs?

The only thing I can do for the Leahs, the Esaus, and the Louises is to give them now, while they are young, the best, the truest story of which I am capable. I have learned, for all my failings and limitations, that when I am willing to give myself away in a book, readers will respond by giving themselves away as well, and the book that I labored over so long becomes in our mutual giving something far richer and more powerful than I could have ever imagined. I thank you, and I thank God that I have been allowed to take part in this miracle once again. (pp. 124-25)

> *Katherine Paterson, "From the Newbery Medal Acceptance, 1981: 'Jacob Have I Loved'" (originally a speech given at the meeting of the American Library Association in San Francisco on June 29, 1981), in her* Gates of Excellence: On Reading and Writing Books for Children *(copyright © 1981 by Katherine Paterson; reprinted by permission of E. P. Dutton, Inc.), Elsevier/Nelson Books, 1981, pp. 116-25.*

[The author] of **Bridge to Terabithia** has again written a story that courageously sounds emotional depths. Acknowledging her great interest in life in Chesapeake Bay, she describes the activities of the watermen living on a sparsely inhabited island during World War II and shows how the ethos of its isolated, strict Methodist community affected the thoughts and feelings of a rugged but sensitive and intelligent girl.

From the comparatively tranquil outlook of adulthood, Sara Louise Bradshaw tells of her turbulent adolescence, confessing her resentment at the attention paid to her beautiful twin sister Caroline—younger by a few minutes—who had been pampered from birth because of physical frailty and was universally admired for her musical accomplishments. Wheeze—as Sara Louise was called—constantly felt ignored, and like Esau in the Bible she considered herself deprived of her birthright. (p. 622)

In addition to evoking the atmosphere of the remote island and the stark simplicity of its life—even supplying considerable detail about the ways and means of its shellfish industry—the author has developed a story of great dramatic power; for Wheeze is always candid in recounting her emotional experiences and reactions. At the same time, the island characters come to life in skillful, terse dialogue; Wheeze's grandmother actually touches on a daemonic dimension. The everyday realism, the frequent touches of humor, and the implications of the narrative speak for themselves; the Biblical allusions add immeasurably to the meaning of the story and illuminate the prolonged—often overwhelming—crisis in the protagonist's life. And the tension of the narrative is resolved in a final harmony best expressed by the concluding line of Milton's *Samson Agonistes:* "And calm of mind, all passion spent." (pp. 622-23)

> *Paul Heins, in a review of "Jacob Have I Loved,"* in The Horn Book Magazine *(copyright © 1980 by The Horn Book, Inc., Boston), Vol. LVI, No. 6, December, 1980, pp. 622-23.*

The attractiveness of this novel lies in its author's choice of setting, how she uses that setting to intensify the theme of sibling rivalry. . . .

It is to the author's credit as an astute psychological observer that she succeeds in making Louise's agonizing physical crush on the 70-year-old [Captain Wallace] into a perfectly natural transition to womanhood for a complex girl like Louise. And

there is a subtle and realistic paradox in the fact that, though the Captain gives Louise the counsel that sets her free, it is Caroline to whom he gives his money, so she can pursue her musical career.

> *Gail Godwin, in a review of "Jacob Have I Loved" in* The New York Times Book Review *(copyright © 1980 by The New York Times Company; reprinted by permission), December 21, 1980, p. 25.*

Katherine Paterson, winner of almost every imaginable award in the realm of children's literature and deserving of that recognition, has written a breath-taking novel for older children and adults. Her narrative-as-memoir strikes the consistently wry tone of one looking back on youth, a state described by one of her characters as "a mortal wound." Even so, each incident and feeling in the life of her young protagonist rings true because the younger voice is so alive and direct. This is a book full of humor and compassion and sharpness; it tells a story as old as myth and as fresh as invention.

The final chapters could easily become another book and seem extraneous to this one. They contain two episodes that would diminish a less powerful novel. One is Louise's ready acceptance of discouragement about becoming a doctor, and the other is the ending in which Louise as midwife delivering twins nearly forgets the healthy infant in her zeal to save the weak one, and then, remembering, urges the grandmother to hold him close while she herself nurses the frail sister. It is a pointed resolution; the author, like Louise and Call explaining their jokes to each other, insists: "Get it?"

But we have already gotten it, for the earlier, more apt ending tells us all we need to know after Louise's mother says she will miss Louise *more* than she has missed the exquisite sister.

> *Betty Levin, "A Funny, Sad, Sharp Look Back at Growing Up" (© 1981 The Christian Science Publishing Society; all rights reserved; reprinted by permission of the author; revised by the author for this publication), in* The Christian Science Monitor, *January 21, 1981, p. 17.*

This Newbery Medal winner does not have the crackling wit of the author's **The great Gilly Hopkins**. But it has subtleties of a different sort—no less effective. . . . Dawning adulthood, the close fishing community, the upheavals of the war years—all are chronicled in delicate prose with a firm narrative impetus. There is humour too. Look carefully at the superb dialogue when Louise tries to tell jokes to the literal and entirely humourless Call. Katherine Paterson is a remarkable novelist.

> *Dennis Hamley, in a review of "Jacob Have I Loved," in* The School Librarian, *Vol. 29, No. 4, December, 1981, p. 349.*

["**Jacob Have I Loved**" is] a deserved winner of the Newbery Medal. It . . . manages to bring in all the principal themes of adolescence without ever appearing contrived. . . . But while teenage readers may recognise echoes of some of their own inevitable personal frustrations in all this, they will also have their imaginations stretched by the fine descriptions of life in a fishing community, and may even be fortified by the stoical, almost happy ending. (p. 11)

> *Nicholas Tucker, "Teenage Novels Here and from America," in* Books for Your Children *(© Books for Your Children 1982), Vol. 17, No. 1, Spring, 1982, pp. 11-12.**

In her writings and conversations about her work, Katherine Paterson repeatedly raises issues which emerge as artistic challenges for her. Among these are her commitment to the young reader's right to an absorbing story and her difficulties with plotting. Herself imbued with the Christian spirit, all Paterson's stories—whether they are set in feudal Japan or World War II Chesapeake Bay—dramatize a young protagonist's encounter with the mysteries of grace and love. Her published work reveals that many of Paterson's problems with plot may derive from the challenge of discovering and sequencing a series of episodes that will present honestly and nondidactically a theme that has no sequence in it, something "other than a process and much more like a state or quality." A plot, as C. S. Lewis says, "is only really a net whereby to catch something else." For Paterson in her latest novel, *Jacob Have I Loved,* that something else is the experience of swift and sudden release from hatred and vengefulness through the acceptance of and cooperation with selfless love. (p. 180)

Typically Patersonian, *Jacob Have I Loved* is a tightly woven novel; each character, each episode, each speech, each image helps to incarnate that which the author is imagining. The net which catches and binds together the whole is her adroit manipulation of several levels of story: the story which the adolescent Sarah Louise ("Wheeze") Bradshaw tells of and to herself in her attempt to comprehend the meaning of the life she is daily living; the story that the young mother and midwife Sarah Louise tells through the configuration of characters and events she selects from her memory of her tumultuous teen years rounded by the insights and incidents she adds from a maturer perspective; and the Bible stories of Jacob and Esau in the Old Testament and the birth of Christ in the New, which provides an allusive frame for the other two story levels, and which add resonance to, universalize, Louise's personal experience.

In the narrative present of most of the story, the protagonist, Wheeze Bradshaw, the elder twin by a few minutes of beautiful, fragile, talented Caroline, so envies and resents her sister's ever-present place in the limelight that she is blinded both to her own worth and to others' appreciation of that worth. The isolation of the Bradshaws' island home, Rass, and the strict Methodist ethos provide the appropriate desert setting for the nebulous guilt that presses on Louise, for the starkly simple good and evil of her family and friends, and for the human encounters which prepare her for the insights which coalesce swiftly and forcefully at the end of the novel.

Envious not only of her sister's beauty and fragility which, from the moment of Caroline's birth, have caused the family so much concern, but also of her musical talent and the sense of purpose which that talent gives her, Louise relies on fishing with Call Purnell, a reliable but prosaic boy, for friendship and to earn extra money for the family's coffers. That she, from the beginning a healthy and a good child, has not caused her family a moment's worry is of grave concern to Louise. The story she tells herself is that lack of worry symbolizes lack of love. When after years of absence Captain Wallace returns to his home at the tip of the island, Louise and Call help him to restore his house and become his friends. After a hurricane destroys his house, Louise compassionately embraces him and discovers, in an agony of bliss and shame, that she is in love with the Captain, old enough to be her grandfather. Her ensuing guilt is intensified by the bitter hurt she feels at Caroline's intrusion into the Captain's friendship. (pp. 181-82)

Telling herself that God had judged her before she was born and had cast her out before she took her first breath, Louise stops going to church and doesn't pray any more. With the young men, including Call, now off in the armed forces, fighting WWII, Louise settles into a working man's life, crabbing and oystering with her father on his boats. Almost imperceptibly, step by tiny step, she begins her ascent from her spiritual dark night through encounters with those closest to her, sacramental encounters because they are the occasions of insights that lead her ultimately away from her rancorous obsession with herself and her sister to understanding and faith and hope. (p. 182)

Because Grandmother Bradshaw hates the sea and refuses to cross even the narrow strip of bay to the mainland, Louise stays with her when the others go to New York for Caroline's Christmas wedding [to Call]. Then it is that Grandmother shocks Louise with the story of her own unrequited love for Captain Wallace. Louise feels "as though [she has] stumbled off a narrow path right into a marsh." . . . In—and for—a flash she realizes that the old woman's viciousness results from a thwarted childish passion she's carried all her life, a festering wound that has embittered her. Later that same Christmas Day, Captain Wallace leads Louise to further disquieting realizations. First, that though she wants something, she does not want to marry Call; she is not cut out to be a woman on Rass— a man perhaps, but not a woman. Second, that the Captain has always regarded her as capable of doing anything she put her mind to, but that he helped Caroline because she knew what it was she wanted to do. Finally, she realizes that to keep hiding behind the excuse that no one has given her a chance will be to continue along the stony path of self-deceit. She must decide what it is she wants to do and muster the courage to do it.

Although it would be too dramatic to say that Louise was reborn on that Christmas, certainly at this winter solstice, when light begins its annual ascension, dimensions of the girl long dormant begin to stir. She has not yet, however, relinquished the story of herself as an Esau damned by God. When her grandmother in a demon frenzy calls her mother a whore, Louise, who had been calculating such revenge for months, retaliates in Grandmother's style, hurling at her verses from Proverbs about the evils of living with a contentious woman. Surprised when Grandmother hits her hard on the head, she nonetheless takes satisfaction in her pain: "I was deserving of punishment. I knew that. Even if I was not quite clear what I deserved it for." . . . What Paterson suggests through the juxtaposition of these incidents is that Louise knows subconsciously that, like her grandmother, she carries within her the seeds of viciousness—a searing bitterness rooted in what she tells herself are undeserved favors and affection for her sister. On the conscious level she realizes only that, "I'm not going to rot here like Grandma. I'm going to get off this island and do something." . . . (p. 183)

Louise's smoldering anger climaxes, erupts, and thereby begins to dissipate in a conversation with her mother, a self-contained, nonobtrusive woman, who has such respect for her daughters' individuality that she will never attempt to make the girls over into images of herself. Like any idealistic youth whose illusions crash, Louise suffers shock and resentment when her mother suggests that she may be expecting too much from life, that far away places, dashing people, and exotic careers are not so romantic as they sound. At this point Louise is not able to absorb the idea that life may be satisfying, that a person may

do something that makes a difference in the world, though the world does not stop to applaud publicly. What does surface in her consciousness—something she has heretofore been only vaguely aware of—is that she has never before said she wanted to leave Rass because she has been afraid to, and that her parents love her, want her to have her chance to make her own way, and will miss her when she leaves. In a passage rendered more than poignant by typical Patersonian understatement, Louise asks, "'As much as you miss Caroline? More,' [her mother] said, reaching up and ever so lightly smoothing my hair with her fingertips. I did not press her to explain, [the reflective Louise says]. I was too grateful for that word that allowed me at last to leave the island and begin to build myself as a soul, separate from the long, long shadow of my twin." . . . (pp. 183-84)

The story of Louise's turbulent adolescence ends with that awareness. There are those who argue that *Jacob Have I Loved* would be a better novel if it too ended here. The subsequent and final two chapters do compress many events and much time in a very little space. However, they are essential to complete the webbing of the stories; and their swiftness and brevity are entirely in keeping with the nature of the events they record. Louise realizes the nature and power of love, which comes to her, her spirit now having been prepared as fertile soil for the good seed, instantaneously, with the concentrated force of a revelation. (p. 184)

In the last chapter the novel comes full circle. Like her mother, Louise has left home for a country at once different from and the same as that in which she grew up. She has married for love a man who, like her father, is in tune with nature, and she becomes a mother. In the last scene, she assists at the birth of twins, the second-born of whom has only the shakiest hold on life. In her effort to preserve that frail flame, Louise, having delegated the care of the stronger baby, temporarily forgets its existence. Recalling her own grandmother, she belatedly remembers that the child should be held and cuddled, not left in a cold basket. Admittedly, the episode is contrived (all art is), but, like the ending of a fairy tale, it completes the story with a balance and a harmony that are aesthetically satisfying.

Hours later, walking home in the crystal, starlit winter night, Louise hears a melody "so sweet and pure that [she] had to hold [herself] to keep from shattering." . . . The melody comes to her from a memory of her sister singing in a Christmas pageant which 13-year-old Louise had suggested her school cancel because its celebration was inappropriate to the suffering caused by Pearl Harbor and the War. With that delicate, subtle touch Paterson resolves the stories of Louise and of Jacob, ending the novel in a passage representative of her facility in drawing together disparate symbols and themes in a final, consummate image and of her exquisite use of language. The circular pattern of the novel functions symbolically on two levels. On one, it is an ironic correlative of the self-enclosed, isolated Rass and of the adolescent Louise, reenforcing the theme of entrapment. On another, it is the prophetic emblem of completion, of perfection, and reenforces the wholeness to which Louise is restored when she is able to discard her conception of herself as an Esau hated by God. (p. 185)

The irony implied by the title seems to go beyond Louise's misunderstandings to suggest to the reader, perhaps to the protagonist herself, that God, if he is all-knowing and all-loving, must himself have spoken those words ironically.

The net which catches these meanings is skilfully woven by the artist's use of the three stories. The story of the older

Louise, who in her twenties has gained insights from and into her adolescent experience, extends and adds objectivity and meaning to the story of the teen-aged narrator. Setting both in the allusive frame of representative stories from the Old and New Testaments, which tell of, respectively, the mysteries of God's displeasure with and love for humankind, not only suggests the story of redemption, but connects Louise's story to the ages.

It goes without saying that the young reader need not be consciously aware of the ironies and complexities of the novel to sense and be satisfied by the rightness with which they are integrated into a whole. The power of *Jacob Have I Loved* does not depend upon the reader's discerning the third level of story. Nor is the novel's effect diminished if a reader rejects Christianity. Paterson's subtle art incorporates the third dimension inobtrusively, to be discovered and to enrich the story. For those who do not discover it, the story still works. Without violating the norms of realism, though perhaps stretching them to include a coincidence more possible than probable, it incorporates the wisdom of myth and fairy tales. Like them, *Jacob* expresses what G. K. Chesterton has identified as the sense that life is not only a pleasure but a kind of eccentric privilege. One way of accounting for this world, which does not after all explain itself, the one which Paterson as well as Chesterton seems to accept, is that it may be a miracle with a supernatural explanation. People must be humble and submit to the limitations of the world, limitations which they may not understand. In the land of fairy, people pay for their pleasures with symbolic sacrifices. If Cinderella questions why she must leave the ball by midnight, the fairy godmother may validly query why she is allowed to be there until that time. Readers of fairy tales will grasp Louise's parallel with Cinderella. She understands, at the end of her spiritual journey, that if the mysterious power at the center of the universe (call it God as Christians do, a fairy godmother, or what name you will), if God be for her, who is "poor on'ry" folk, why should He not be against her? She is at last able to believe what is, after all, more difficult to accept, that God is for her. Though she can believe, the truth evades her understanding, and she wonders as she wanders. It is that wondering which brings the novel back to the world of realism, a world in which the ends are never all neatly knotted. *Jacob Have I Loved* is a moving novel because the skillful, if not always perfect, plotting achieves one of the functions of art: within the form of the realistic novel it does capture and "present what the narrow and desperately practical perspectives of real life exclude." In so doing, "it lays a hushing spell on the imagination." (pp. 186-87)

M. Sarah Smedman, "'A Good Oyster': Story and Meaning in 'Jacob Have I Loved'," in Children's literature in education (© 1983, Agathon Press, Inc.; reprinted by permission of the publisher), Vol. 14, No. 3 (Autumn), 1983, pp. 180-87.

REBELS OF THE HEAVENLY KINGDOM (1983)

Paterson presents a haunting story about people working out their complex destinies in China during the 19th century. Wang Lee, young son of starving peasants, is the victim of bandits who seize and carry him away from home during the Taiping Rebellion against the Manchu regime. Wang Lee meets Mei Lin when members of her undercover society, dedicated to the Heavenly Kingdom of Great Peace, save him from his captors. Paterson follows the group in their fight to overthrow the enemy and establish justice for all in their country. There are exciting

passages while battles rage and betrayals threaten unity, conflicts almost overshadowed by Wang Lee's dilemma as he tries to understand the rebels' philosophy and gain the love of Mei Lin. It is a story on the epic scale, skillfully crafted.

> *A review of "Rebels of the Heavenly Kingdom," in* Publishers Weekly *(reprinted from the May 6, 1983 issue of* Publishers Weekly, *published by R. R. Bowker Company, a Xerox company; copyright © 1983 by Xerox Corporation), Vol. 223, No. 18, May 6, 1983, p. 98.*

The historical and cultural details are vivid, the book giving a great deal of information about the country as well as about the Heavenly Kingdom and its warriors. . . . This is a fascinating story, and well-told; if it does not have the emotional impact of Paterson's earlier historical fiction (*Of Nightingales That Weep, The Master Puppeteer*) it has pace and color, and it is particularly interesting in its reflection of cultural diffusion, as the militant leaders of the Taiping Rebellion fuse their interpretation of Christian doctrine with their own traditions.

> *Zena Sutherland, in a review of "Rebels of the Heavenly Kingdom," in* Bulletin of the Center for Children's Books *(reprinted by permission of The University of Chicago Press; © 1983 by The University of Chicago), Vol. 36, No. 11, July-August, 1983, p. 216.*

Wang and Mei Lin are swept into the marches and battles of the Taiping and experience an endless parade of death and violence. Separated during the course of the war campaigns, their ultimate meeting and marriage seems almost an anticlimax after the fearful ordeals they have endured. The book portrays a sweeping panorama of human experience during a bitter period of Chinese history, but Wang and Mei Lin emerge less as real people than as pawns flung hither and thither by the tides of war. As always, the author's control over her material lends credibility to the writing and sheds light on a time which will be unfamiliar to most readers; some of them, however, may miss the involvement of heart and emotion which is so noticeable in her other work.

> *Ethel R. Twichell, in a review of "Rebels of the Heavenly Kingdom," in* The Horn Book Magazine *(copyright © 1983 by The Horn Book, Inc., Boston), Vol. LIX, No. 4, August, 1983, p. 456.*

[Wang Lee's] rise and fall and his recapture by the kidnappers while on a spying mission are stark and gripping; his ecstasy and growing disillusionment as the killings increase and spread to civilians in the name of peace are well conveyed. More closely bound to specific events and causes than Paterson's Japanese historic fiction, this book will have to be introduced. A **"Note to the Reader"** provides some background information about the events and the times, but Paterson does not adequately integrate the historical facts into the story. Often the characters are vehicles for the theme rather than individuals in their own right. However, Paterson has written a strong adventure tale whose parallels to today's cults and movements could lead to interesting discussions.

> *Ruth M. McConnell, in a review of "Rebels of the Heavenly Kingdom," in* School Library Journal *(reprinted from the September, 1983 issue of* School Library Journal, *published by R. R. Bowker Co./A Xerox Corporation; copyright © 1983), Vol. 30, No. 1, September, 1983, p. 138.*

[*Rebels of the Heavenly Kingdom*] reconstructs meticulously an alien way of life, in a country and time where women counted for little.

The story is beautifully told. The dialogue often translates literally picturesque Chinese expressions, and again the reader learns without realising, detail of the traditional Chinese way of life and thought, besides having brought home vividly the utter poverty and devastation of starvation in any land over which battles have raged and plunderers looted. (p. 255)

> *Mary Hobbs, in a review of "Rebels of the Heavenly Kingdom," in* The Junior Bookshelf, *Vol. 47, No. 6, December, 1983, pp. 254-55.*

Appendix

THE EXCERPTS IN CLR, VOLUME 7, WERE REPRINTED FROM THE FOLLOWING PERIODICALS:

The American Review of Reviews
The American Scandinavian Review
Appraisal: Children's Science Books
Appraisal: Science Books for Young People
The Babbling Bookworm
Best Sellers
Book Week—The Sunday Herald Tribune
Book Week—The Washington Post
Book Window
Book World—The Washington Post
Bookbird
Booklist
The Booklist
Books
Books and Bookmen
Books for Keeps
Books for Your Children
British Book News
Bulletin of the Center for Children's Books
Bulletin of the Children's Book Center
Catholic Library World
Chicago Tribune
Children's Book Bulletin
Children's Book News
Children's Book Review
Children's Book Review Service
Children's Literature: Annual of The
 Modern Language Association Seminar
 on Children's Literature and The
 Children's Literature Association

Children's Literature Association Quarterly
Children's literature in education
The Christian Science Monitor
Curriculum Review
Dance Magazine
The Economist
Elementary English
Grade Teacher
Growing Point
The Horn Book Magazine
Instructor
Interracial Books for Children Bulletin
The Junior Bookshelf
Junior Libraries
Kirkus Reviews
Kirkus Service
Language Arts
Library Journal
The Listener
Lively Arts and Book Review
The National Observer
The New Republic
New Statesman
New York Herald Tribune Book Review
New York Herald Tribune Books
New York Herald Tribune Weekly Book
 Review
The New York Times Book Review
The New Yorker

Print
Publishers Weekly
Punch
The Reading Teacher
Saturday Review
The Saturday Review, New York
The Saturday Review of Literature
Scandinavian Studies
School Arts
The School Librarian
The School Librarian and School Library
 Review
School Library Journal
Scientific American
Signal
The Spectator
Supplementary Educational Monographs
Theory into Practice
The Times Educational Supplement
The Times Literary Supplement
Top of the News
The United States Quarterly Book Review
The Use of English
Virginia Kirkus' Bookshop Service
Virginia Kirkus' Service
Wilson Library Bulletin
Wisconsin Library Bulletin
The World of Children's Books
Young Readers Review

THE EXCERPTS IN CLR, VOLUME 7, WERE REPRINTED FROM THE FOLLOWING BOOKS:

Arbuthnot, May Hill. Children and Books. *Scott, Foresman, 1947.*

Arbuthnot, May Hill. Children's Reading in the Home. *Scott, Foresman, 1969.*

Bader, Barbara. American Picturebooks from Noah's Ark to the Beast Within. *Macmillan, 1976.*

Bator, Robert, ed. Signposts to Criticism of Children's Literature. *American Library Association, 1983.*

Berendsohn, Walter A. Selma Lagerlöf: Her Life and Work. *Translated by George F. Timpson. I. Nicholson & Watson Ltd., 1931.*

Björkman, Edwin. Voices of To-Morrow: Critical Studies of the New Spirit in Literature. *Mitchell Kennerley, 1913.*

Books for Children: 1960-65. *American Library Association, 1966.*

Broderick, Dorothy M. An Introduction to Children's Work in Public Libraries. *The H. W. Wilson Company, 1965.*

Carr, Jo, ed. Beyond Fact: Nonfiction for Children and Young People. *American Library Association, 1982.*

Chambers, Nancy, ed. The Signal Review 1: A Selective Guide to Children's Books, 1982. *Thimble Press, 1983.*

Cianciolo, Patricia. Illustrations in Children's Books. *2d ed. Brown, 1976.*

Crouch, Marcus, and Ellis, Alec, eds. Chosen for Children: An Account of the Books Which Have Been Awarded the Library Association Carnegie Medal, 1936-1975. *3d ed. The Library Association, 1977.*

Cullinan, Bernice E.; Karrer, Mary K.; and Pillar, Arlene M. Literature and the Child. *Harcourt Brace Jovanovich, 1981.*

Dreyer, Sharon Spredemann. The Bookfinder: A Guide to Children's Literature about the Needs and Problems of Youth Aged 2-15: Annotations of Books Published 1975 through 1978, Vol. 2. *American Guidance Service, Inc., 1981.*

Eakin, Mary K., ed. Good Books for Children: A Selection of Outstanding Children's Books Published, 1950-65. *3d ed. University of Chicago Press, 1966.*

Eaton, Anne Thaxter. Reading with Children. *Viking Press, 1940.*

Egoff, Sheila. Thursday's Child: Trends and Patterns in Contemporary Children's Literature. *American Library Association, 1981.*

Egoff, Sheila, ed. One Ocean Touching. *The Scarecrow Press, 1979.*

Fisher, Margery. Who's Who in Children's Books: A Treasury of the Familiar Characters of Childhood. *Holt, Rinehart and Winston, Weidenfeld & Nicolson, 1975.*

Georgiou, Constantine. Children and Their Literature. *Prentice-Hall, Inc., 1969.*

Hoffman, Miriam, and Samuels, Eva, eds. Authors and Illustrators of Children's Books: Writings on Their Lives and Works. *R. R. Bowker Company, 1972.*

Huck, Charlotte S., and Kuhn, Doris Young. Children's Literature in the Elementary School. *2d ed. Holt, Rinehart and Winston, 1968.*

Human—and Anti-Human—Values in Children's Books: A Content Rating Instrument for Educators and Concerned Parents. *Racism and Sexism Resource Center for Educators, 1976.*

Hürlimann, Bettina. Three Centuries of Children's Books in Europe. *Edited and translated by Brian W. Alderson. Oxford University Press, 1967.*

Johnson, Edna; Sickels, Evelyn R.; and Sayers, Frances Clarke. Anthology of Children's Literature. *4th ed. Houghton Mifflin, 1970.*

Kingman, Lee; Foster, Joanna; and Lontoft, Ruth Giles, eds. Illustrators of Children's Books: 1957-1966. *Horn Book, 1968.*

Klemin, Diana. The Art of Art for Children's Books: A Contemporary Survey. *Potter, 1966.*

Kohnstamm, Dolf. The Extra in the Ordinary: "Children's Books by Dick Bruna." *Rev. ed. Merces Americanae n.v., 1979.*

Lanes, Selma G. Down the Rabbit Hole: Adventures and Misadventures in the Realm of Children's Literature. *Atheneum, 1972.*

Larsen, Hanna Astrup. Selma Lagerlöf. *Doubleday, Doran & Company, Inc., 1936.*

Lukens, Rebecca J. A Critical Handbook of Children's Literature. *Scott, Foresman, 1976.*

MacCann, Donnarae, and Richard, Olga. The Child's First Books: A Critical Study of Pictures and Texts. *Wilson, 1973.*

MacCann, Donnarae, and Woodard, Gloria, eds. The Black American in Books for Children: Readings in Racism. *The Scarecrow Press, 1972.*

Marble, Annie Russell. The Nobel Prize Winners in Literature. *D. Appleton and Company, 1925.*

Maule, Harry E. Selma Lagerlöf: The Woman, Her Work, Her Message. *Doubleday, 1926.*

Meigs, Cornelia; Eaton, Anne Thaxter; Nesbitt, Elizabeth; and Viguers, Ruth Hill. A Critical History of Children's Literature. *Rev. ed. Edited by Cornelia Meigs. Macmillan, 1969.*

Miller, Bertha Mahony, and Field, Elinor Whitney, eds. Caldecott Medal Books: 1938-1957. *Horn Book, 1957.*

Monroe, N. Elizabeth. The Novel and Society: A Critical Study of the Modern Novel. *University of North Carolina Press, 1941.*

Moss, Elaine, ed. Children's Books of the Year: 1974. *Hamish Hamilton, 1975.*

Paterson, Katherine. Gates of Excellence: On Reading and Writing Books for Children. *Elsevier/Nelson Books, 1981.*

Peterson, Linda Kauffman, and Solt, Marilyn Leathers. Newbery and Caldecott Medal and Honor Books: An Annotated Bibliography. *G. K. Hall & Co., 1982.*

Sadker, Myra Pollack, and Sadker, David Miller. Now Upon a Time: A Contemporary View of Children's Literature. *Harper & Row, 1977.*

Sale, Roger. Fairy Tales and After: From Snow White to E. B. White. *Harvard University Press, 1978.*

Sebesta, Sam Leaton, and Iverson, William J. Literature for Thursday's Child. *Science Research Associates, 1975.*

Smaridge, Norah. Famous Author-Illustrators for Young People. *Dodd, Mead, 1973.*

Smith, Dora V. Fifty Years of Children's Books 1910-1960: Trends, Backgrounds, Influences. *National Council of Teachers of English, 1963.*

Spirt, Diana L. Introducing More Books: A Guide for the Middle Grades. *R. R. Bowker Company, 1978.*

Topsöe-Jensen, H. G. Scandinavian Literature: From Brandes to Our Day. *Translated by Isaac Anderson. The American-Scandinavian Foundation—W. W. Norton & Company, 1929.*

Townsend, John Rowe. Written for Children: An Outline of English-Language Children's Literature. *Rev. ed. Lippincott, 1974.*

Townsend, John Rowe. A Sounding of Storytellers: New and Revised Essays on Contemporary Writers for Children. *J. B. Lippincott, 1979.*

Tucker, Nicholas. The Child and the Book: A Psychological and Literary Exploration. *Cambridge University Press, 1981.*

Wintle, Justin, and Fisher, Emma. The Pied Pipers: Interviews with the Influential Creators of Children's Literature. *Paddington Press, Ltd., 1974.*

CUMULATIVE INDEX TO AUTHORS

This index lists all author entries in *Children's Literature Review* and includes cross-references to them in other Gale sources. References in the index are identified as follows:

AITN: *Authors in the News*, Volumes 1-2
CA: *Contemporary Authors* (original series), Volumes 1-110
CANR: *Contemporary Authors New Revision Series*, Volumes 1-11
CAP: *Contemporary Authors Permanent Series*, Volumes 1-2
CA-R: *Contemporary Authors* (revised editions), Volumes 1-44
CLC: *Contemporary Literary Criticism*, Volumes 1-27
CLR: *Children's Literature Review*, Volumes 1-7
DLB: *Dictionary of Literary Biography*, Volumes 1-26
DLB-DS: *Dictionary of Literary Biography Documentary Series*, Volumes 1-4
DLB-Y: *Dictionary of Literary Biography Yearbook*, Volumes 1980-1983
NCLC: *Nineteenth-Century Literature Criticism*, Volumes 1-5
SATA: *Something about the Author*, Volumes 1-34
TCLC: *Twentieth-Century Literary Criticism*, Volumes 1-12
YABC: *Yesterday's Authors of Books for Children*, Volumes 1-2

Author Index

CUMULATIVE INDEX TO NATIONALITIES

CUMULATIVE INDEX TO TITLES

Title Index

Title Index

Title Index

Title Index